herbert bayer

the complete work

arthur a. cohen

.

This book was set in Helvetica by Typographic
House, printed by Daniels Printing Company, and
bound by Publishers Book Bindery, Inc., in the
United States of America.

Library of Congress Cataloging in Publication Data

Cohen, Arthur Allen, 1928–
 Herbert Bayer: the complete work.

 Bibliography: p.
 Includes index.
 1. Bayer, Herbert, 1900– . I. Title
N6537.B24C63 1984 709′.2′4 83–25606
ISBN 0–262–02206–0

For Robert O. Anderson,
whose spirited advocacy of the art of Herbert Bayer made this book possible

To Alvin Lustig (1915–1955), who first opened my eyes

herbert bayer: the complete work
arthur a. cohen

errata

page 3
 second line of caption: change "Allan Gitterman" to"Allan S. Ghitterman"

page 13
 third line of upper caption: change "Duisberg" to "Duisburg"

page 14
 second and third lines of upper caption: change "Lehbruck" to "Lehmbruck" and "Duisberg" to "Duisburg"

page 52
 first line of caption: change "1939/15" to "1939/35"

page 59
 first line of caption: change "1944/13" to "1944/34"

page 67
 first line of lower caption: change "1950/41" to "1950"

page 74
 first line of lower caption: change "1954/61" to "1954/41"

page 76
 first line of caption: change "1954/67" to "1954/69"

page 125
 second line of caption: delete ", Paris"

page 133
 first line of upper caption: change "1975/63" to "1976/63"

page 144
 second line of caption: change "acrylic" to "pencil drawing"

page 234
 line 6 of text should read "its impetus. Mortimer Adler selected the quotations. Much more to the point was that Charles Coiner of N. W. Ayer and Bayer commissioned"

Contents

Foreword

I think I owe it to the reader of this book to express my thoughts about the bauhaus, even though that chapter in my life ended long ago. considering the many conflicting opinions, false interpretations, and misunderstandings that surround this movement, it is not easy to be impartial. rather than submit an art historical polemic or attempt to write an objective account of my involvement, I will simply express what the bauhaus meant to me and what it has contributed to my work as I look back on that period of my life from the vantage point of eighty-four years.

I was twenty-one years of age when I first entered the bauhaus and brought with me an enthusiasm for the new and the unknown. I had not previously attended art school; I had some experience in the area of design, but the teaching methods and educational ideas of the bauhaus were utterly new to me. I entered the workshop for wall painting as an apprentice with a view to passing an examination after three years, but my interests were in the disciplines of typography and communication as well. I was made master of this workshop at the bauhaus in dessau because of previous experience acquired in the areas of graphic design and typography in linz and darmstadt.

in new york in the late 1930s and early 1940s judgment of artists and art movements was much influenced by the fashions of the moment. in some circles, an artist who confessed that he had belonged to the bauhaus was disdained. some former members of the bauhaus felt tainted by the association and went so far as to deny that they had ever been there. personally I have never refused to acknowledge that the bauhaus gave me a way of life and work and a design philosophy suitable for dealing with the problems of the contemporary artist. it never entered my mind to minimize the importance of the bauhaus, for my years at the bauhaus had a formative influence on my subsequent pursuits.

I later missed the spirit of a group or community of artists that could accommodate disagreement as well as harmony of thought. the bauhaus set off an explosive charge whereby the individual spark raised the temperature of the whole group.

as an institution the bauhaus was short-lived, but as an idea its presence can still be felt in art teaching methods and in the design of the environment that surrounds us today.

the bauhaus gave me clear principles for the creative process, a practical way of working, and an all-inclusive attitude toward the disciplines of the arts.

the changes of direction and development in my artistic outlook that have taken place over the years did not evolve according to a preconceived plan but rather followed a natural progression. the almost exclusive occupation I had with two dimensions as graphic designer, for example, soon called for extension into a third dimension. exhibition design offered great opportunities. from then on, there was even less of a separation or boundary between disciplines, and the traditional distinction between "fine" and "applied" art became increasingly suspect to me.

the products created in the bauhaus workshop bear the signature of their time of origin. most of the work represented in these pages was produced after I left the bauhaus and shows a personal handwriting of its own. only in spirit can it be linked to the bauhaus

design ideology. I left the bauhaus in order to move away from theory to practice. encountering different tasks and adjusting to new working methods compelled me to apply myself to the problems of the moment. the bauhaus existed only as memories.

although the bauhaus has once again acquired tremendous contemporaneity, the idea of working in multidisciplines was not especially singled out, promoted, or taught there. this idea simply evolved through the belief that the total environment should be the focus of art. it is through collaboration of artists, scientists, and engineers that the large tasks of shaping our surroundings, creating images of businesses, and forging corporate identities will be accomplished. the artist of the future will then to a greater degree be an inseparable part of the human scene.

it should be remembered that the total personality is involved in the creative process. it is not performed by the skilled hand alone, not conducted by the intellect alone, but by a unified process in which "head, heart, and hand" play a simultaneous role.

herbert bayer
january 1984

Preface and Acknowledgments

It is hard to reconstruct the train of circumstances that compelled me to undertake this comprehensive essay on the work of Herbert Bayer. I had vowed after I completed my monograph on *Sonia Delaunay* (Harry N. Abrams, Inc., 1973) to cease and desist. That volume occupied me for many months with endless niggling and elusive details, and I resolved when it was published that I had no further need to contribute to the scholarship of twentieth-century art. Clearly, I have broken my resolution. I can account for my flight from determination by more than an appeal to shiftless will.

During the middle 1970s I became occupied with the history of avant-garde typography and design and later collaborated with my wife, the painter Elaine Lustig Cohen, on a series of portfolios, *The Avant-Garde in Print* (A. G. P. Matthews, Inc., 1982). Moreover, through my company Ex Libris I became increasingly knowledgeable about the printed materials and graphic ephemera produced and, in turn, generating movements and cross currents in the European flux of modern art.

Toward the end of the last decade I remet with Herbert Bayer at the time he was beginning to think about cooperating with the production of a comprehensive work on his career. Of course, I knew of Bayer as a master typographer, exhibition designer, and photographer, but I was less familiar with his painting, sculpture, and environments. I began to study this unfamiliar body of his work and was amazed at its richness and fecundity. Here was a comprehensive artist; moreover, an artist of immense grace and modesty. It became evident that we were meant for each other: his kindness and unfailing openness captivated me, and, I suppose, my own energy and enthusiasm were infectious. It has been one of the happiest collaborations imaginable. Herbert and his wife, Joella, a knowledgeable, buoyant, and consummately gracious ally, could not have been more helpful, opening their archives to my insistent scrutiny, making available the pictures, drawings, and photographic documentation needed for such a project, submitting to hours of interviews, answering my numerous detailed questionnaires, supplying me with all the necessary paraphernalia of scholarship. On the several occasions when I visited them at their home in Montecito during the course of writing this work, their hospitality and warmth were deeply appreciated.

I have enjoyed the help and cooperation of many people: Gwen Chanzit, curator of the Herbert Bayer Archive at the Denver Art Museum, assisted me mightily in the early stages of my research by guiding me through the meticulous files of the Archive and making available to me documentary photographs necessary for the project; Magdalena Droste of the Bauhaus-Archiv, who wrote the excellent text on Bayer's design activities before his emigration to the United States in 1938, was particularly helpful in dealing with my inquiries; Yves Alain-Bois shared with me his reflections on Bayer's earthworks; Philippe Daverio of Galleria Daverio, Milan, helped me locate certain paintings and documents; Egidio Marzona, the remarkable German art publisher, and Marion and Roswitha Fricke, book dealers of Düsseldorf, made available to me Bayer documents and important correspondence relating to the Bauhaus years. Others who answered questions and rendered me assistance on specific points include Walter Allner, Wolf

Herzogenrath, Margit Rowell, Kenneth Snelson, Trevor Winkfield, L. Fritz Gruber, and Tim Gidal. To all of them I extend my deepest thanks.

Merry Ann Pursel, Herbert Bayer's office assistant in Montecito, and Paul Hobson, his skillful painting assistant, helped me in ways too numerous to mention, not the least of which was the preparation of materials for my several visits and the answering of my interminable queries regarding details of dates, dimensions, and diapositives. Everett Potter undertook the exacting task of integrating a variety of contradictory bibliographies and forming of them one that made sense. Elliot Junger, a young translator, rendered Herbert Bayer's German prose into English. My grateful thanks to them. And to George Kaneko, Herbert Bayer's longtime associate on numerous corporate design projects, who first brought the notion of this volume to the responsive attention of Robert O. Anderson, chairman of the board of Atlantic Richfield. Mr. Anderson responded with his usual great generosity and enthusiasm. And last in the sequence of events, thanks to Louis Danziger, the eminent graphic designer, who prepared the multimedia program on Herbert Bayer's career that was shown at the International Design Conference at Aspen in 1979. More than anyone else, Lou Danziger was instrumental in persuading Herbert Bayer that I was up to the assignment.

Finally, my grateful appreciation to Melba Larose, who typed and retyped portions of this manuscript, correcting my spelling as she went along, managing the frequently inscrutable first drafts that I presented to her. To Roger Conover, poet and biographer, who acts as editor for books of this kind at The MIT Press, my particular gratitude. He is a superb editor: tactful, generous, skillful, and subtle in his judgments. Several times I was beside myself with the immensity of the task and Roger rescued me by his cooperativeness. No less critical to the success of this project was Sylvia Steiner, designer for The MIT Press, whose immediate grasp of the complex issues of translating this book to type in the spirit and practice of Herbert Bayer facilitated its realization. My particular thanks to Susanna Kaysen for a remarkably sensitive and careful editorial review of the manuscript. Finally, but not in order of importance, my wife, Elaine Lustig Cohen, who despite thinking me mad for taking on such a project was patient with my irritability throughout and acted as critical first hearer to much of the material. As graphic designer, typographer, interior designer, master of signage, and over the past fifteen years as a painter in the constructivist mode, her judgment was always astute and to the point. Clearly, I thank her with love and even more thank her first husband, the great designer and design teacher, my first pair of eyes when he was losing his, Alvin Lustig.

Arthur A. Cohen
May 9, 1983

Introduction

It has been a commonplace to describe Herbert Bayer as a Renaissance man. The more casual this appellation, the greater its misuse and misconstruction. It has led critics and journalists to praise the breadth of Bayer's enterprise, its many facets and disciplines, while releasing them from the responsibility of examining his production. The fact that Herbert Bayer has been a painter, sculptor, architect, exhibition designer, creator of environments, typographer and graphic designer, photographer, consultant to corporations, and executive of advertising agencies suggests for many a range of application at once laudable and suspect. It is not accredited (in a period when artists have become specialists) that a single gifted human being, working primarily without staff and assistants, could have sustained a career as varied in discipline, as productive in quantity, and as elevated in quality as Bayer's has been. Something, it is suspected, must be inferior, defective, inadequate, for no one can be excellent in everything. And yet the issue is not one of range, quantity, or level of excellence but rather the indifference that Bayer has maintained throughout his long career to the establishment of an accurate canon of reception and interpretation of his work, which has abetted the alternately hymnic or dismissive manner in which his work is described.

Herbert Bayer may be a Renaissance man—capable of working in many disciplines—but such Renaissance men in this century cannot possibly, it is claimed, be equally masterful in all their undertakings. If the painter is praised, the designer is ignored; if the designer is recognized, the painter is underrated; if the photographer is admired or the exhibition designer celebrated, his practice of more private and solitary arts is downgraded. In one sense it is legitimate to propose that Bayer is better at some things than at others—that his work in certain of his undertakings is more original and innovative (if originality and innovation are primary values) or more personally stamped and accented (if personal signature and individuality are primary values) or more socially useful and instructive (if the utility and application of his arts are considered pivotal). But to deny that there are superb examples, whole units of excellence in each of the disciplines in which he has worked, is to reject a balanced and unpolemic view strongly at odds with the ideologists of specialization.

Bayer has acquired no received opinion, no support system, no consensual rendition of his achievement that secures his work from carping or, worse, indifference. Those who know his work in all its complexity admire less the quality of breadth than they do the painstaking labor, moral integrity, dedicated application, and bold imagination that has brought it to maturity. There is no way of celebrating a body of work other than to make it known and in making it known to clarify the sources from which it arises, the issues that inspire it, the problems it sets out to solve, and the solutions it develops. The task of the critic and the historian is to display the work in its panoply, to make clear its ground, and to express conviction about its significance. The text cannot persuade. Only the work can do that, but the function of the text and its illustration is to direct the perspicacious to the work. The work will take care of the rest.

Herbert Bayer's work is imperfectly known both in the United States and in Europe. Western Europe—principally Germany,

Austria, Switzerland, where Bayer has exhibited often–is more familiar with his work prior to his emigration to the United States in 1938. His photography was known abroad years before it was shown in his adopted homeland, and Europe was familiar with his graphic design, typography, and exhibition design well before he arrived in the United States. However, Bayer's painting from the 1950s to the present has received wider exposure in the United States than in Europe. Only now have retrospectives been undertaken in Germany that close the gap between Bayer's well-known participation in the Bauhaus and his development of an incipient "surrealist" style and the chromatic and metaphysical paintings of the past twenty years. Europe knows a partial Bayer; America knows a partial Bayer. In part, then, the undertaking of this book is to introduce both portions to each other and to clarify the larger unity out of which and toward which they have grown–the disciplined art and imagination of the integral Bayer.

In other words, there are no Renaissance men in the twentieth century, and those who are called such are merely being damned with insupportable praise. The gifted and ingenious of this century are men of this century, buffeted and misconstrued as artists in this century often are. Herbert Bayer is no different. He is not to be compared with those two quintessential Renaissance artists Leon Battista Alberti and Leonardo da Vinci. Neither Alberti nor Leonardo is clarified by the comparison and Bayer is surely obscured. The Renaissance man is a journalist's cliché. It means nothing and illuminates less. The fact remains that Bayer has talked little and made much, that he has developed, at best, a schematic ideological outline as "visual communicator" that sustains and advances the unity of his work but cannot begin to explain the technical mastery that enables him to move easily from painting to architecture to environmental design and earthworks to typography and advertising. Critical to such fluency is not its fluidity, for Bayer is anything but shallow; rather it is that the visual imagery of Bayer's paintings and sculpture flows from an attitude toward problem solving in which the hard line between "fine art" and design is not preserved. Too often the painter demeans the designer (and even more the designer-become-painter) precisely because the painter cannot execute the practical tasks of design and frequently cannot even describe the nature of the problem. Very few important painters have been major designers, but the design of those who were able to transact their vision in both disciplines was elevated in its range of allusions and reference by the imaginative resource that supplied their painting as well. The ability of Kurt Schwitters, László Moholy-Nagy, El Lissitzky, Alexander Rodshenko, Herbert Bayer to move back and forth between the private and the public imagination and its products have left them not weakened or confused but invigorated and challenged. There was no gap other than one of level of address and reference or specificity of intention and means.

The Structure of the Book

From his earliest years Herbert Bayer has been a painter and a draftsman. Painting has been, as he has testified, at the very center of his imaginative life. Even during the years when he taught at the Bauhaus or managed design agencies in Berlin or mounted exhibitions at the Museum of Modern Art in New York or served as consultant on architecture and design to the Container Corporation of America and more recently to the Atlantic Richfield Corporation, Bayer painted. Painting informed Bayer's management of the primary visual language that he adapted and employed as designer and design consultant. It is appropriate, therefore, that the principal critical essay in this volume should deal with Bayer's work as a painter. Moreover, it is appropriate, since painting governed his creative life, that the detail and event of his life should appear in this essay rather than be removed to the biographical abstract that introduces the appendixes. The first major section of this study deals, therefore, with Herbert Bayer: painting, sculpture, environments.

Following an extended discussion of Bayer's creative activity as painter, sculptor, and maker of environments, three shorter essays take up Bayer's interpretation and rendering of his vocabulary in typography and graphic design, photography, and exhibition and architectural design. These sections reflect the principal areas in which Bayer's imagination has applied the premises of his visual language to the so-called applied or mechanical arts. As will be seen, these disciplines entail modifications and exegeses of his primary language, but in every case the interest has been to turn the private imagination to public use, to enhance and transform public vision, to clarify, simplify, and enrich the sensibility of public visual discourse.

Since Bayer has not been without his own voice, although he has talked far less than many artists and somewhat more than artists who remain in the studio, I thought it important to bring together a suggestive anthology of Bayer's writings and comment on his work and times. I have gathered the writings by Bayer that were accessible and, having eliminated repetitions and those previously published in book form, have presented an anthology documenting Bayer's commentary on photography and exhibition design, his often brilliant interpretations of his painting series, works of sculpture (some of which are quoted in the body of my first essay), as well as more general essays, such as his remarks at the Goethe Bicentennial held in Aspen in 1956. These selected writings form at best a verbal conspectus, a gloss of Bayer's visual language, and are in that respect less efficient than the visual images themselves.

The volume concludes, as is de rigueur, with an indispensable technical apparatus. The illustrated biographical chronology sets forth events and episodes of personal significance and public interest that have not necessarily found their way into the text. There follows a comprehensive but by no means exhaustive listing of Bayer's exhibitions throughout the world and a comprehensive bibliography that improves and expands the one published earlier in *herbert bayer: painter designer architect* (40).*

*Numbers in parentheses indicate the reference in the bibliography; page number(s) follow the reference number, if relevant.

A Note on Illustration

It can hardly be imagined how much material was available for reproduction in color and black and white for documentation of the argument of the text. If one includes the several thousands of pages of Bayer's drawing notebooks and journals, as well as preliminary drawings and scale enlargements of small works on paper to their transformation on canvas, the number of works from which I have been able to choose probably exceeds four thousand. If one adds to this the volume of his graphic design in all its forms and permutations, his drawings for interior installations, architectural drawings, photographic prints, lithographs and serigraphs, maquettes for sculptures and environments, sketches for tapestries and wall hangings, the total would be overwhelming. Fortunately, although Bayer has conserved much, he has not saved all. The Bayer Archive at the Denver Art Museum maintains a brilliant study collection of Bayer's work in all media, and the Bauhaus-Archiv in Berlin (supplemented by a fine small collection at the Busch-Reisinger Museum in Cambridge, Massachusetts) and smaller collections elsewhere maintain significant units of Bayer's oeuvre; however, the work of selecting illustrations has been painstaking and exhaustive. In this undertaking, the artist's cooperation has been indispensable. The final selection of the color reproductions and black-and-white illustrations in this book, although continuously refined by Herbert Bayer's careful questioning of my response to his work, has been my own. The determination of what to show has been dictated by the emerging logic of my text. Indeed, were the king finally naked, the choice would be easy, but in Bayer's case the king is fully clothed and the need of the judicious critic is to discriminate between the rich substance of his achievement and less essential oddments that may beautify but do not transform. With such riches to choose from, the selection of works to be reproduced is as much an interpretation of the body of his work as the text itself. But this is unavoidable and as it should be. What is illustrated is part of the interpretation and as such is the merest portion of the total oeuvre. Short of a catalogue raisonné of Bayer's complete work, the immensity of his production and its overall excellence would remain undocumented. This volume, however, is the inevitable and, I hope, the right beginning.

A Note on Certain Eccentricities

Many years ago, while it was still possible, Bayer adopted the convention of adding to the title of each work the year of its composition and an inventory number that situated it in the sequence of the year's production. For instance, *Potpourri Géométrique* (the first picture cited in this text) is followed by 1973/84, meaning that it was the eighty-fourth work completed during 1973. This system has not been employed for graphic design, architecture, photography, or exhibition design, although virtually every other group of works, particularly when first reflected in finished drawing, carries a year and inventory identification.

Unfortunately, consistency has not been as easy to establish in the titling of drawings and paintings in German and English. Since Bayer hardly exhibited his painting in Europe prior to his emigration and little of it passed into public or private hands during that period, pictures did not become known by their proper titles until they had crossed the Atlantic and acquired a new language. For this reason some pictures that were frequently exhibited in Germany during the late 1920s and '30s were given and retained their German appellation, whereas others—despite having been painted at the same time—are cited only in the English titles they first bore in public exhibitions after Bayer's emigration. This seeming clarity is darkened by the fact that in many cases, when those same pictures returned to Europe for exhibitions in Austria and Germany from the 1950s until now, curators used—undoubtedly with Bayer's tacit approval—German titles for works painted in Germany. We will have to be content, therefore, with a bilingual oeuvre.

A most difficult decision for us was to determine the case in which the text of this volume would be composed. It will be known to some readers—and will become clear to all the rest—that Bayer has been committed since 1925 to the use of a lower-case alphabet for all handwritten, typed, and printed materials. The reasons for this are discussed in the text; however, such a lifelong conviction, substantiated by continuous practice in his office and extending even to handwritten documents and his own signature, are clearly supplanted in this book by the more conventional and familiar usage of upper and lower case. I must confess that, while admiring Bayer's reasonable tenacity, I have not been persuaded. Too many years of ingrained practice on my part militated against any easy submission to Bayer's conviction. We reached the compromise of setting all texts directly quoted from conversations with Bayer or material selected for transcription from his writings (and even bibliographic citations rendered in his preferred minuscules) in lower case. The single exception is the capital letter *I*, which in recent years Bayer determined should be the permissible exception to his rule because, as he observed, the lower case *i* is quite ugly and, by itself, unreadable. The reader is forewarned then about this novelty in the composition of the text.

I. Painting, Sculpture, Environments

A rigorous geometry–the repertoire of shapes that can be devised and supported by Euclidean analysis–underlies many of the most startlingly sensuous and tragic pictures in the history of Western art. Although the break with traditional perspective advanced by Cézanne and relentlessly explored by the Cubists seemed at the time to have ended the dependence of painting upon its invisible geometrical scaffolding, Apollinaire (1880–1918) was surely right in observing that "geometry is to the plastic arts what grammar is to the writer's art."[1] Appolinaire was not merely reasserting the obvious, although part of his critical genius lay in the gift of recollecting what the early twentieth century (in its enthusiasm for the new) was only too willing to forget. Rather, Apollinaire was attempting to walk the narrow path between the old view of geometry as indispensable to the structure of painting (what he called the allusion of three-dimensional space implicit in all painting since the discovery of perspective) and the newer outlook, in which the immensity of space and its plastic expression imply a non-Euclidean fourth dimension. Apollinaire was certainly aware that the so-called fourth dimension was grounded on little more than intuition of the infinite and the wish of painters to find support for their pictorial program in quasi-scientific formulations that relied more often on theosophical doctrines than on scientific empiricism. Whatever the reason, geometry remains the large term of twentieth-century art–Euclidean geometry par excellence (as most educated painters were familiar with the language of forms developed from Euclid's repertoire of definitions and axioms) but also the non-Euclidean systems of Georg Riemann (1826–1866) and Nikolai Lobachevsky (1793–1856). However, these systems were invariably ill digested and reduced principally to the assertion of an open system of possibilities, where odd forms, asymmetric shapes, and an improbably immense space became intellectually defensible and aesthetically viable.

Herbert Bayer, from his earliest nature drawings of 1919 to his most recent paintings, has been a geometrician. But geometry as understood by the unsophisticated, a method of objectification and distancing bonded to formal structures and limited by the requirements of an ironclad system of rules, would hardly apply to Bayer's work. Geometry has been for him precisely as Apollinaire suggested, a grammar, not a text, a means of exploration, not a law giver of authoritative codes. Geometry has meant to Bayer the repertoire of precisely proportioned forms–forms that can be plotted and diagrammed, to be sure, but forms that are endless to imagination and whose relations to one another can be at one and the same time private and sensual, public and natural, intuited and metaphysical, fabulated and dreamed. All that is required for such an open vocabulary of forms is that once the first straight line has been set down or curve plotted, the relations between it and the space around it acquire a kind of order, command a kind of color, suggest a logic of development. Bayer works from intuition–that is, his geometry is all inside–but once the intuition has made its first mark, forms imply. It is the notion of implication that becomes decisive–which forms lead where? With what other form is this logorhythmic shell shape compatible? Which colors accentuate the faceting of a complex pentagonal structure or allude a distorted rhombus? Suddenly from geometry all nature arises–

compelling and intrusive, gentle and calm, limitless and immense. Bayer's view of nature derives from his essential vision of its geometry, a universe founded on an explicit foundation of compatible (and sometimes aggressively incompatible) forms.

During 1973, Bayer interrupted a series of paintings dominated by different impulses and considerations and completed a small acrylic that he called *Potpourri Géométrique* 1973/84. As its title suggests, this painting is a gathering of geometrical forms, mostly solids scrupulously parsed but also two-dimensional parallelograms and curves in precise additive progressions. The drama of this small picture is in the perfect placement of the thirteen elements on the canvas, the rich, volatile color scheme used to diagram and elaborate each of the geometric shapes and their parts, and the installation of a color chart fashioned of small squares framing the upper right margin of the picture and a small black and white segmented line centered at the bottom. It is a simple picture, but deceptively so. The geometric forms float upon the beige ground of the paper; only the pencil lines of the large grid indicate that the space is right before the viewer's eyes. Flat space, pre-Copernican in its utter flatness, filled with shapes that nature displays and the geometrician invents, all basic lessons in descriptive geometry.[2]

Brilliantly colored in various tones of red, purple, yellow, blue, pink, green, orange, brown, sparingly black and white, *Potpourri Géométrique* would be a riot of warring colors were not each shape distinct, integral, and discrete. In the center of the picture overlaying each other, pointing to infinite spaces above and below, are checkered patterns of red, white, and blue tiles moving toward the perspectival asymptote. This, the largest and dominant form, is surrounded by shell shapes, scalloped in tones of green, one of whose elements is detached and only barely touching its parent mass, circles analyzed into lozenges of pink and purple, triangles and cones, parallelograms and squares, Fibonacci progressions—all of them capable of reduction to the harmonic proportion that lies at the base of Bayer's geometry: the Golden Section.

Deriving from classical geometry the harmonic rhythm of the Golden Section (a proportion that supports much of classical and modern art), *Potpourri Géométrique* is more than a potpourri—a medley and mix of geometric elements. Rather, considered as the beginning of a life summation, this painting, from which five years later were to come his sovereign series of "Anthology" paintings, reflects Bayer's wish to present a synoptic overview of his whole life in painting and art, a visual repertory that, as the series unfolds, brought into play elements of his work from the earliest so-called surrealist paintings of the 1920s and early '30s, the "Signs and Signals" paintings of the early 1940s, the observations of mountain convolutions and unheavals, the soft form paintings of the 1950s, the chromatic gates and the pure chromatic pictures of the 1960s and early '70s, and all the subseries and smaller groups that spin off the primary images of each major grouping. Bayer has thrown nothing away, letting go one problem in order to explore another; nothing in his oeuvre is final. Each older series of paintings, pursued exclusively while at the center of his reflections, is gathered up and rehearsed again in the series that follows, earlier elements writ larger or reduced to grace notes but never completed and filed away. This is particularly clear and critical in the "Anthology" paintings, which began in 1973 and continue to the present. The preliminary pencil sketches that lay out the basic structure are elaborated in small gouaches or acrylics on paper and then translated with frequent modification to large canvas, the shapes permutated by the introduction of color and the pressure that color exercises on the dominance and recession of forms. But throughout all these paintings, those familiar with the whole of Bayer's work will find reassertions of interests and elements that go back to his earliest formation as an artist.

The primary focus was always the intimacy and awe with which the observant eye encountered the natural—sometimes nature as wondrous and feeling, almost anthropomorphic in character, certainly more generous and merciful than man, at other times baleful and immense, overpowering and irrepressible, unlimited and awesome, for whose caprice and indifference man's nervous wish to placate and control is no match. But more often than either of these humanist interpretations of nature is the evident Bayer neutrality, his willingness to describe and set down a reality (natural and supernatural, cognizable and transcendent) that has no opinion on man and his works, but bestrides us without emotion. Nature's immensity, whose domain only arrows and pointers can indicate beyond the canvas edge, is perceived as so vast that only one control remains available to the ordinary creature—the knowledge that its welter yields to the abstract vocabulary of science and geometry and that mathematics is able to organize the numbers and proportions that express clearly the structure through which nature moils.

Bayer, himself neither intellectual nor seer, perhaps sagacious observer with a mythical bent, but clearly a man of *techné*—the civilization of the arts that employ science, astronomy, geography, mathematics—suggests that nature, too, has its own structure, its own regularity and rhythm. Bayer observes and, more than rendering his observation with detailed objectivity, looks beneath the surface to unfold how nature appears to work, its layering and faceting, its regularity and harmony. And all this is represented in an assortment of bright colors set into a spatial field of blues, browns, grays, or greens, employed by Bayer as a kind of visual pedagogy, seducing the viewer to see such beautiful regularities as dense and bright or ominous and sensual.

Bayer began to explore this recapitulation of his vocabulary during his own and the century's early seventies. At this juncture of his life, a decade later, he continues to produce the most profound and serene works of his career, summarizing himself, annotating and reobserving the discoveries of a lifetime. It is appropriate to return to the beginning, to rehearse origins and development until this point is reached again and the series of paintings he calls "Anthology" can be scrutinized in detail, all the rest of his work now behind him and clear in view.

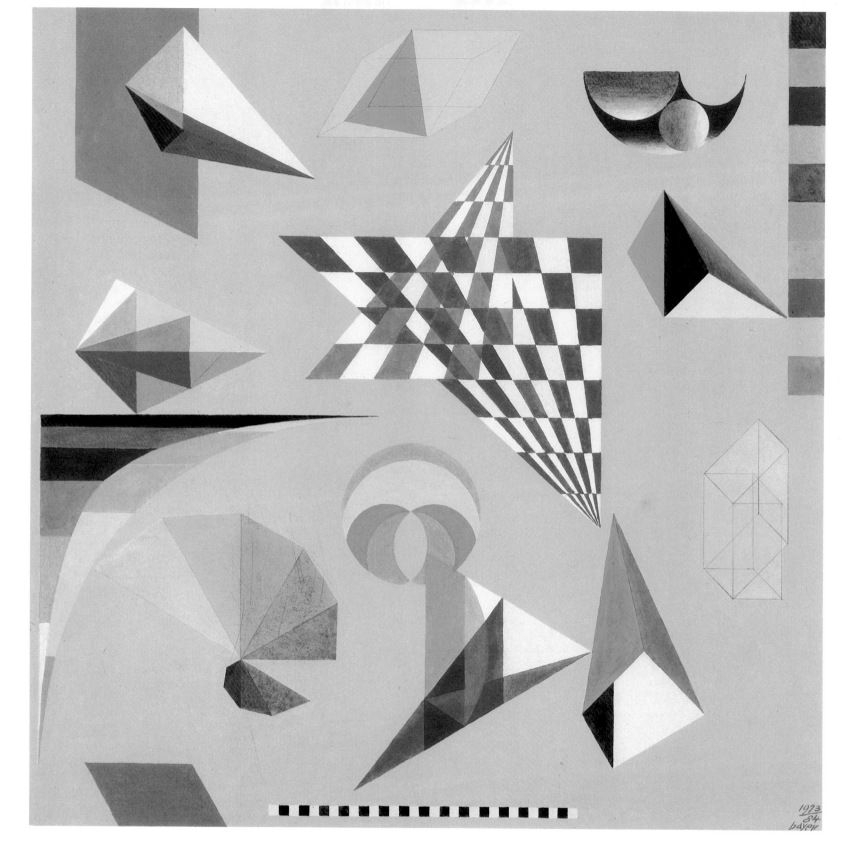

Potpourri Géométrique 1973/84, acrylic, 20 x 20".
Collection Mr. and Mrs. Allan Gitterman.

1. Painting: 1919-1982

Herbert Bayer was born April 5, 1900, in Haag am Hausruck, a small peasant village in the western part of upper Austria, some fifty miles from Salzburg and not far from the city of Linz. The second of four children born to Maximilian and Rosa Simmer Bayer, he was early cast as a loner, the independent child who seemed unusually aloof and withdrawn in a village where communal amusement and recreation were the norm. His father, a government tax collector, made his rounds to the cluster of houses that dotted the valley in which Haag was situated and to remote farms in the high mountains surrounding the area. Often accompanied by Bayer and his two brothers, their father would hike into the mountains to visit a distant farmstead, pass the night and return the next day. Although his father was a dour and uncommunicative man, more comfortable in the neighborhood tavern among his cronies than at home with his family, Bayer's mother, despite her lack of education, encouraged her second son, approving his quiet and serious disposition. It was she who was responsible for the fateful gift of the child's watercolor box.

Recollecting the circumstance of that childhood gift, Bayer wrote,

when I was a small child . . . we used to play in the garden of the courthouse on which a window of the county jail opened. Sitting on the windowsill, we often conversed with the prisoners. I had already shown interest in painting and was given a small watercolor box. the untutored, uninhibited creative expressions of children were not encouraged at the time, so I began by copying from a picture book of generalized wisdom called *over land and sea*. one day, I took my paint box to the prisoners, all petty criminals, thieves or derelicts. one of them used it to paint an unforgettable picture in my presence.

for obvious reasons, he painted a fortress on a hill with high walls and towers and a few small windows placed very high up. having no water at hand, he wet the brush with his mouth. I later tried without success to repeat the olive-green coloring which he produced with his chewing tobacco-tinted saliva. this is my first clear recollection of image-making with paint and brush (40:9).

However one construes the fortuity of the watercolor box, one must assume that Bayer's later recollection of his captivation with the mountains of the Salzkammergut was an even greater presentiment. The craggy, mysterious, snow-capped mountains and the dense foliage of the easternmost edge of the Bavarian forests (in whose innards gruesome horrors of the Thirty Years' War had transpired and were still remembered and narrated) undoubtedly gave Bayer's imagination the charged and laden quality that reemerges many years later, subdued and transformed into his abstractions of the destructive implements of peasant scythes and spears ("Signs and Signals") and of mountains and their violent permutations.

Bayer's fascination with mountains and mountaineering was intensified by his early participation in the activities of the Wandervogel, an outdoors movement that had spread throughout the German-speaking European world, emphasizing hiking, nature, folk traditions and music, and the more traditional values of Germanic culture. As a Wandervogel, Bayer spent extended periods

in the isolated peasant villages of the region, learning their folk art and music and making sketches of peasant houses, ornaments, and implements. As a young man, both before and after the family's removal to Linz in 1912, Bayer often went off into the mountains by himself, guitar over his shoulder and sketchbook in his rucksack, to pass his free hours in the remote peasant hamlets. It was, as Bayer recalls it, a happy but solitary childhood.

Although Bayer completed Real Gymnasium in Linz, his favorite subjects being history and particularly descriptive geometry (as well as projective geometry, which required considerably more algebra), his range of interests beyond mathematics, history, and natural sciences was not extensive. Moreover, as he has often stressed since, he received no formal art education, even education in the history of art. Bayer's family hoped that, given his youthful passion for drawing, he would enter an art academy in Vienna and matriculate there as a student of fine arts, but that ambition was shattered by the premature death of his father when Bayer was seventeen. A considerably older Linzer friend of young Bayer, an art historian of Austrian Gothic and baroque art, Dr. Gustav Guggenbauer, shared with him his knowledge of Austrian folk art.[3] Bayer preferred folk art to the sophisticated arts then making their appearance as Jugendstil, but he had the opportunity of seeing at Guggenbauer's the books of Meier-Graefe and others that gave him his earliest, albeit secondhand exposure to impressionism. By and large, however, his direct knowledge of the arts was restricted to extraordinary examples of baroque architecture exemplified in the churches and public buildings of Linz and Salzburg as well as the decorative forays made by the Jugendstil and Vienna Secession into the domestic environments of the bourgeoisie.

Since it was no longer financially possible for his family to send him to Vienna after the death of his father, Bayer undertook an apprenticeship with the Linz architect and designer Georg Schmidthammer,[4] following completion of eighteen months' military service during the final years of the First World War. It was in Schmidthammer's arts and crafts atelier that Bayer first became familiar with the principal figures of the Vienna Secession, Gustav Klimt, Egon Schiele, the architect Josef Hoffman, and with the early activities of the German Werkbund, which actively promoted collaboration between art and industry.

The watercolors and pencil drawings Bayer preserved from the period 1917–1919, lightly influenced by Van Gogh and Munch, were principally landscapes and cityscapes, whose most wild and threatening characteristic were the gnarled, ancient fir trees whose naked, wintry limbs often obscured churches and farmhouses before which they stood or, as in several cityscapes (particularly a watercolor of Lübeck done in 1925), cast their green upon the face of the buildings or were bunched together beneath red-topped, densely packed houses. The drawings of those years, for the most part romantic in feeling, are lovely but unexceptional. What they demonstrate is early passion and early competence, and, in several examples, a penchant for the grotesque and macabre.[5]

During his term of service in Schmidthammer's studio, Bayer learned the rudiments of architectural drafting, techniques of graphic design, package design, porcelain painting, and other procedures of the traditional arts and crafts atelier, all executed in the somewhat elaborate and ornamental style of the Secessionists. In 1920, having outgrown the provincial atmosphere of Linz, Bayer left Austria for Germany, attaching himself as assistant to the Viennese-born, Berlin-based architect Emmanuel Josef Margold,[6] whose workshop was then located under the patronage of Grand Duke Ernst Ludwig of Hesse, in the Darmstädter Künstler Kolonie the duke had founded on the Mathildenhöhe, a knoll on Darmstadt's outskirts. The group included architects such as Josef Maria Olbrich and Peter Behrens, who constructed houses in the grand duke's preserve that were marked by their piling of geometric ornamentation upon a basic cubic form.[7]

The catalyst for major change was Bayer's fortuitous discovery in 1920 of Vassily Kandinsky's *Über das Geistige in der Kunst* (*Concerning the Spiritual in Art*),[8] first published in 1912. Bayer was by then a skilled architectural draftsman and watercolorist, fledgling designer without formal education, without knowledge of the history of art, captivated by nature and the outdoors, saturated by the psychological aura of Austrian Catholicism, but by temperament more mystically inclined than conventionally religious. No text could have been more appropriate than Kandinsky's.

Concerning the Spiritual in Art is divided into two parts. The first sets forth the spiritual pyramid by which Kandinsky moves the reader from the material (and materialist) foundations of art toward its spiritual climax, driving the artist from the outside inward, and from internality to spirituality. The logic of the text, at times crude and heavy-handed in its polemic, but dauntless and utterly moral in its intention, is to persuade toward abstraction by enforcing a rigorous aesthetic Platonism that commends the unseen, the underlying, the internal, the cosmic structure, the synaesthetic commingling of the senses until what emerges finally is a virtual union of painting and music, colored sound and reverberating color. Although argued with a plethora of quotations and apothegms from Goethe, Tolstoy, and Shakespeare and references to Leonardo, Dürer, Cézanne, Schönberg, Scriabin, and many others, both eminent and cranky, the book turns from lofty exposition to the special issues of painting, principally those revolving about color and the palette of harmony. The question of color, critically important for the argument of Kandinsky's doctrine of abstraction as it had developed to that time, grew out of Kandinsky's wish to orchestrate a pedagogy of inwardness, a teaching that would direct the viewer (or young artist) from preoccupation with external subject matter to the internal bases from which Kandinsky's field of critical force–"internal necessity"–would be catalyzed.[9] "The spirit," Kandinsky wrote, "like the body, can be strengthened and developed by frequent exercise: just as the body, if neglected, grows weak and finally impotent, so the spirit perishes if untended. The innate feeling of the artist is the biblical talent which must not be buried in the earth. And for this reason it is necessary for the artist to know the starting-point for the exercise of his spirit The starting-point is the study of color and its effects on men.[10]

The argument of *Concerning the Spiritual in Art* is, therefore, essentially didactic, even moralistic. It is less an essay in aes-

thetic theory than a formulation of the appropriate frame of mind in which to pursue the lofty, exalted, transforming discipline of art. The truthful artist—that is to say, the artist who works through the alarums of the external world toward the rigors of interior search—is contributing not only to the making of a finer art that will recapitulate the great spiritual ages of the past but to a utopia of the future whose consequence will be, more than aesthetic harmonics, cosmic harmony. Although Kandinsky maintained reservation about Rudolf Steiner and Madame Blavatsky, two theosophists whose texts he quotes, his reservations result more from his sense that they were not artists and hence could not put the matter correctly. For him, the coalescence of art and music would liberate sight and sound, and these in turn, brought to conversation and intimacy, would ransom the deteriorating, materialist culture that threatened Europe and, by the time of Bayer's reading of Kandinsky's text, had nearly destroyed it.

At this juncture of his life Bayer was ready to be taught, and the Kandinsky who spoke to him was clearly the pedagogue par excellence. Although Bayer has admitted recently that he cannot precisely remember which parts of Kandinsky's thesis appealed to him, he distinctly recalls the feeling of having found in Kandinsky's authoritative and confident voice a teacher who addressed him and his situation.[11]

At about the same time Bayer saw (probably in Margold's office) a copy of the famous Bauhaus manifesto of April 1919, in which Walter Gropius set forth in stirringly formal German his call: "Architects, sculptors, painters, we must all return to the crafts." "Art is no 'profession,'" Gropius continued. "There is no essential difference between the artist and the craftsman. The artist is an exalted craftsman. In rare moments of inspiration, moments beyond the control of his will, the grace of heaven may cause his work to blossom into art. But proficiency in a craft is essential to every artist. Therein lies a source of creative imagination. Let us create a new guild of craftsmen, without the class distinctions that raise an arrogant barrier between craftsman and artist. Together let us desire, conceive and create the new building of the future, which will embrace architecture *and* sculpture *and* painting in a single unity and which will one day rise toward heaven from the hands of a million workers like the crystal symbol of a new faith" (11:18–19; 187:31–33). Gropius's brief text, introduced by Lyonel Feininger's famous woodcut *The Cathedral* (also known as *The Cathedral of Socialism*) particularly impressed the visually acute Bayer, who recalls that it moved him to believe that the Bauhaus was utopian and romantic in one.[12]

Bayer queried Margold about the Bauhaus and recalls that Margold reported to him the rumor that during the entrance examination, applicants were locked in a dark room, thunder and lightning were fabricated to induce a state of anxiety and, depending on how well the applicant was able to record his reactions to the experience in drawing or painting, it was decided to accept or reject him (40:10).

The virtual simultaneity of Bayer's reading of Kandinsky and his discovery of the Bauhaus were conflated by Bayer into the conviction that Kandinsky must already be teaching at the Bauhaus and, hence, that to the Bauhaus he must go. Although he arrived at the Bauhaus more than a year before Kandinsky joined the faculty, negotiations were already underway between Gropius and Kandinsky by the end of 1921 and the renewal of Kandinsky's friendship with Klee, whom he had met a decade earlier, settled Kandinsky's decision to come to Weimar in June 1922. But Bayer, sure that Kandinsky had already arrived and premonitory in his conviction that during the early 1920s Kandinsky and Gropius spoke alike, took his leave from Margold and, without money, hiked from Darmstädt to Weimar.

The Bauhaus Years: 1921–1928

Herbert Bayer arrived in formal Austrian peasant *Tracht* in the office of the founder and director of the Staatliches Bauhaus in Weimar, Walter Gropius, in October 1921. As Bayer recalls their meeting, Gropius was seated at his desk, beneath a large cubist Léger, dressed in his familiar black trousers with white shirt and black bow tie, extremely elegant, handsome, intense. The interview, Bayer remembers, centered mostly on Gropius's exposition of the goals of the Bauhaus and Bayer's presentation of his portfolio of work, which included by that time many executed designs for posters, stationery, package designs, as well as pen and pencil drawings, watercolors, and several linoleum cuts. By comparison with many of the students who had come to attend the Bauhaus, Bayer's achievements made clear that he was already skilled in the handling of form and color, that his practical training fit neatly into the communal program the Bauhaus pursued. Although he attended Itten's Vorkurs (a required preliminary course) several times, he was exempted by Gropius from being a probationary entrant to the Bauhaus.

The Bauhaus to which Bayer had come was little over eighteen months old, but in that brief life and its somewhat longer period of gestation it had already become an institution of considerable notoriety. Despite its conspicuous misinterpreters, the Bauhaus was never monolithic. It was not engaged in the formation and imposition of a style but, rather more difficult for critics who resist subtle distinctions, in the research of an idea. The idea itself, neither simplistic nor naïve, went through a series of morphological transformations that require us to acknowledge Wolf Herzogenrath's contention that there were not one but at least five periods in the evolution of the Bauhaus.[13]

It is appropriate in a discussion of the sources of the art of Herbert Bayer to spend some time rehearsing the essential information that characterizes the foundations and unfolding of the Bauhaus. Bayer has never denied the critical role the Bauhaus played in the development of his aesthetic and social sensibility. He has correctly insisted that the Bauhaus was the pivotal event of his past and that although he has survived and grown beyond his origins, he has always regarded himself as having been formed in the Bauhaus crucible. Whatever Bayer knew before his arrival at the Bauhaus during the fall of 1921, he has always regarded it as being of little or no significance in relationship to what he came to learn during his Bauhaus years.

Unfortunately, it has not been easy establishing a coherent redaction of the history of the Bauhaus, charged as that history is with severe and far-reaching combat of aesthetic, social, and

political ideology. By the very loftiness of its initial formulations, the Bauhaus lent itself to such swirling confusion. On the one hand it presented itself as successor to an already established institution for the teaching of arts and crafts and, as such, was heir to a patrimony whose premises it rejected. On the other hand it sought to devise a principle and a pedagogy that, despite its superficial resemblance to trends already well established in Germany by both conservative art academies and the more radical postwar Workers Council on the Arts (Arbeitersrat für Kunst), would eventually break connection with both and define an educational doctrine that was innovatively new rather than reminiscent of a familiar past. The genius and the persona of the Bauhaus were undeniably Walter Gropius.

Walter Gropius and the Founding of the Bauhaus

Walter Gropius was born on May 18, 1883, into a Berlin family distinguished in the arts and architecture. After completing his formal education in the schools of architecture of the Berlin and Munich Hochschule, Gropius became principal assistant in the Berlin office of Peter Behrens, then attending to the monumental and detailed commissions of Emil Rathenau's Allgemeine Elektrizitäts Gesellschaft. Gropius, aware of the dead end to which the arts and crafts movement—imported from England's Henry Cole, John Ruskin, and William Morris—had come, was already searching for another formulation.

The arts and crafts movement, seeking to establish a rapprochement if not an entente between the machine-made product of the industrial revolution and the claims to beautification advanced by technically competent artists, had already produced in England a surge of energy devoted to the ornamentation and design of furnishings and materials for the exterior design and interior decoration of private dwellings. Unfortunately, having refused to compromise methods of production by the use of machine processes, William Morris's arts and crafts movement had become the precious adjunct of precisely the bourgeois sensibility Morris otherwise claimed to suspect. His works were few in number, expensive in price, and whatever their elegance, fated by style to be little more than architectural ornamentation and domestic beautification. The movement failed, but not before the significant texts of both Morris and his champion, John Ruskin, had passed into the German language and inspired a new and attentive following.

German society, not vastly different from English society at the turn of the century, was nonetheless more rigidly structured. At the same time as Germany's cultured bourgeoisie sought to improve and progress, its military and civil bureaucracy conducted the affairs of the nation as though it were a separate caste, unresponsive to the willingness of its own bourgeoisie to experiment. In consequence, although the arts and crafts movement found its counterpart in Germany's Jugendstil, it was subjected from the outset to a continuous barrage of attack. Not even ornamental exploration was welcome in Wilhelmine Germany. Nevertheless, in the same year that Peter Behrens was appointed architect and art director of Rathenau's A.E.G. and commissioned to build its factory, the German Werkbund was established in Munich by the architect Hermann Muthesius and the Dutch architect Henry van de Velde, who had been acting since 1902 as director of the Weimar School for Arts and Crafts, which the grand duke of Sachsen-Weimar had appointed him to construct and direct.

The Werkbund was without analogue. The notion of effecting a synthesis between technology—the "machine style"—and William Morris's arts and crafts movement was first proposed by Hermann Muthesius, a German architect who had passed some time in England and had come to admire its methods of building. However, despite the considerable impact the Werkbund had on both industry and the artist-craftsman, it was unable to devise any significant method for incorporating technology into craft fabrication or to induce artists to give more than lip service to the goals of penetrating emerging industrial technology. With the exception of brilliant works of craft production developed under its auspices or significant exhibitions of its products at trade fairs and at such architectural triumphs as the Weissenhof Housing Project in Stuttgart fairly late in its career (1927), the Werkbund, in Muthesius's judgment didn't "know where we are drifting." The romantic penumbra that had long surrounded the individual artist continued to adorn him and, despite the needs of a different age and the requirements of an altered culture, the artist-craftsman continued to regard his work as inimical to machine adaptation or the requirements of technology.

Walter Gropius, one of the younger leaders of the Werkbund movement, was aware that the fundamental problem of its ideology was the absence of an encompassing pedagogy. It is impossible to produce a machine-oriented craft or a modern aesthetic for an architecture encompassing the materials and procedures of fabrication already experimentally developed for industry without an institution for the training of the modern artist-craftsman. It was a problem not unknown to Gropius. In 1910, shortly after the founding of the Werkbund, Gropius and Behrens had written a *Memorandum on the Industrial Prefabrication of Houses on a Unified Artistic Basis* (11:13–14). Deriving many of their notions from conceptions for modular housing developed by Frank Lloyd Wright, they had insisted on conceiving architecture as a Gesamtkunstwerk, a total artistic enterprise, in which all of the available techniques of industrial fabrication would be united with the most inventive creations of the artist to develop a building where interior and exterior would be subjected to the same critical scrutiny, with a view to achieving economy of means and coherence of result. The following year the enlightened industrialist Karl Benscheid had the wit and bravery to commission Gropius to build the Fagus Works, a shoe-last factory near Aelfeld in North Germany. There, moving beyond Behrens's A.E.G. factory, Gropius stripped masonry from the building's skin and in its place installed a steel-framed structure ribboned with glass windows to redefine the function of walls, a novelty as original as it proved shocking.[14] Several years later, in 1914, Gropius's office building at the Werkbund exposition in Cologne augmented the breakthroughs at Aelfeld. Both buildings succeeded in dispensing with the ponderous massiveness of traditional architecture, realizing a lightness and grace made possible by the new materials of building construction.

Gropius always began with architecture. It was the hub around which everything else turned, the principal art of modernity, reconciling the requirements of modern technology with the emerging vanguard aesthetic. But it did not happen all at once. While still serving as an officer in the German army during the First World War, Gropius was devising for the grand duke of Saxe-Weimar a novel scheme of art education in response to his invitation to replace Henry van de Velde, whose "enemy" status as a visiting Belgian compromised his suitability as director of the Weimar Art Academy. Gropius proposed combining the Weimar Art Academy and the Weimar Arts and Crafts School into a single institution, which would serve as "a consulting art center for industry and the trades" (11:14). Gropius received authorization at the end of March 1919 to change the name of the Grand-Ducal Saxon Academy of Art, situated in a building designed by van de Velde, to Staatliches Bauhaus, combining the intentions of the Academy of Art (already abandoned by its faculty) with the School of Arts and Crafts, whose faculty was intact but whose facilities were substandard.

At its outset, the Staatliches Bauhaus reflected the compromise implied by the combination of the formal academy of art and the craft workshops of the Weimar Arts and Crafts School. It is not clear whether Gropius endorsed the amalgamation or accepted the necessity of conjoining them as the only means of establishing a foundation on which to build. Whatever the case, Gropius devised a system of education in which every Master of Form (those teachers whose gifts lay in the articulation and practice of the theoretical elements of all the arts—form, color, materials, structure, geometry) worked with a Master Craftsman who understood methods of weaving, glassmaking, furniture construction, wall painting, printing, and bookbinding. In several cases the master craftsmen came over from the Arts and Crafts School, augmented by the early appointment of Masters of Form Lyonel Feininger, Gerhard Marcks (who ran the pottery workshop at an outstation of the Bauhaus in Dörnburg), and Johannes Itten.

The Bauhaus student was obliged at the outset of his instruction to take the Vorkurs, a fundamental program devised by Itten from the color and form theory of his own teacher Adolf Hölzel, a Viennese master whose system of instruction demanded the fullest exposure of the student to all materials (however seemingly unaesthetic in traditional usage), the abandonment of presuppositions regarding the artist and the artist's mission, and the opening of the student to his own potentialities and the unrecognized potentialities of his chosen medium. Itten demanded that his students be unconstricted by aesthetic ideology in order to acquire a discipline arising from a free and untrammeled approach to plastic problems. Employing, as Itten did, cultic notions and disciplines enforced by his own religious crotchets—notably his attachment to the cult of Mazdananism[15]—his students in the Vorkurs, abetted by the sympathetic painter Lothar Schreyer and a fully inducted female disciple, made of the Vorkurs as much a cultic phenomenon as an introduction to the forms and materials of the arts. Breathing exercises, vegetarian diet, periods of retirement and contemplation, habits of silence and solitary activity, early gave the Bauhaus a quasi-monastic atmosphere, punctuated principally by the enthusiastic energy of the young postwar German (but also non-German) students who were poor, unfocused, and desperately serious (213:54–59).

The expressionist Bauhaus, initially conceived by Gropius as a Bauhütte, a medieval guild where artist and craftsman were bound together in the training of apprentices, journeymen, and mature masters, easily succumbed to the powerful presence of Itten, whose doctrine of the arts as the elevated and transfigured integration of aesthetics and technique defined the fundamental education of the Bauhaus student. In those early years, student work was virtually without relevance to the craft industry to whose service Gropius imagined it could be dedicated. Moreover, the reigning expressionist and pietist atmosphere gave Theo van Doesburg, who had established himself in Weimar in 1921 in order to offer alternative courses in his emergent neoplastic aesthetic, much opportunity to subject the Bauhaus to strenuous criticism for its wishy-washy, romantic-expressionist tendencies.[16]

In those early years and for some time after, no architecture was taught at the Bauhaus, as Gropius thought his staff ill prepared for such an undertaking and his students unsuited to such an exacting discipline. Also, omitted from the curriculum was all formal teaching in painting, sculpture, and the history of art. Correctly so, as it turned out. What was uppermost in Gropius's program was to devise an education that was always turned toward application; not application for the sake of practicality, although the need for commissions and contracts as a way of improving the meager finances offered by the state government was high on the agenda, but application as the testing ground for the principles and theoretical abstractions of the arts in their traditional separateness and purity. Any art without connection with the immediacies of daily life was simply ignored. Although a source of much chaffing and concern to Kandinsky, Klee, Feininger, and Oskar Schlemmer, who complained that they had no time to do their own work—despite the fact that they were not required to criticize student work at the Bauhaus and independent student work in painting, sculpture, and design fell outside the purview of the curriculum—it was generally conceded by all the masters that their attention to the elements of the arts and the emerging pressure to give clear and concise formulation to their notions of color, space, form, and figuration in painting made their teaching of the fundamentals of the arts of tremendous significance not only to their students but to themselves. As much as Kandinsky, Klee, and Schlemmer shaped the attitudes of their students, so their own work at the Bauhaus was of a different order and intensity than the work that preceded their tenure, moved as they were by the community of fellow artists and the camaraderie of such dedicated students.

The documentary literature on the Bauhaus describes fully the arrival and departure of its masters, the controversies within its community, the abrasive charges and counter-charges that undermined its stability in Weimar and finally obliged its dissolution there and removal to Dessau in 1925, but little in the literature makes clear causalities and consequences. It is not clear whether Gropius's appointment of Moholy-Nagy in 1923 was provoked by the unacceptability of Theo van Doesburg, who hankered for an

appointment,[17] or whether that appointment was responsible for the departure of Johannes Itten and Lothar Schreyer slightly afterward,[18] whether decisions regarding staff and program were responses to social *forces majeures* or reflected ideological shifts on the part of Gropius or the masters' council, which consulted and advised him on policy. These issues of causality have been left vague, one suspects, because it is difficult to write history while the living are still supplying interpretations.[19] Whatever the case, the Bauhaus began to respond to the traumatic assault of the increasingly conservative ruling patriarchy of Weimar, the accusations of "culture Bolshevism" hurled by the rightist representatives of the völkisch-soziale Block and the tacit condescension of the majority conservative parties, and the pressure that such provocation placed on Gropius for continuous public relations and polemics.[20] By the end of 1923, after the presentation of the first Bauhaus Exhibition, which was adjudged a mixed success, and the right-wing victory in the elections of February 1924, the Bauhaus came under increasing attack from the outside and the need for Thuringian reformation within.

The expressionist *Tendenz* that described the Bauhaus from its founding through 1923 had left its students with little grasp of the requirements of industry for viable and producible designs. As a result little needed income was generated by the sale of licenses and products. Such income was of critical importance as the support of Weimar was reduced by the massive German inflation and cutbacks in the underwriting of student grants and administrative finances.[21] Expressionism was acceptable for launching the Bauhaus, but art without technics became a theoretical deprivation and a practical luxury. Moreover, Itten's ideological control of the students had tended to polarize both students and faculty, producing fanatic support as well as implacable hostility. The Vorkurs was clearly the most powerful vehicle for the definition of the Bauhaus aesthetic. Whatever the genius of Kandinsky or Klee as teachers, they were involved at that period in the wall-painting and metal workshops of the curriculum, while Itten and his colleagues controlled the single required course at the Bauhaus. Whoever controlled the Vorkurs, one can well argue, controlled the students and, indeed, the ideological face the Bauhaus presented to the art community at large. This was clearly demonstrated by the Bauhaus Exhibition of 1923 where, despite the admirable catalogue raisonné that it published and the construction of the first Bauhaus housing unit, "Am Horn," designed by Georg Muche and executed and furnished by Bauhaus students, Gropius would have preferred to avoid the public presentation of less than mature work by this group of students.

The appointment of László Moholy-Nagy, whom Gropius had met in Berlin after his exhibition of constructivist work at Der Sturm Galerie (1922), served notice on Theo van Doesburg that his agitation for neoplasticism and against Bauhaus expressionism was not to succeed and confronted Johannes Itten with a clear opponent—one moreover favored by Gropius as his replacement. Itten resigned in 1923 and the Vorkurs was turned over to Moholy-Nagy. Moholy arrived before the mounting of the Bauhaus Exhibition of 1923; he designed its catalogue raisonné (Herbert Bayer designed the binding) and contributed significant essays to the volume's exposition of Bauhaus aims and objectives. Although Gropius is credited with the formulation of the theme of the exhibition—a theme that came to describe the second phase of the Bauhaus, bridging its closing years at Weimar with its opening years in Dessau—one hears behind Gropius's formulation of "art and technics, a new unity" the insinuations of Moholy-Nagy.

Moholy was that rare agitant personality who kept everyone on edge, arguing, explaining, dogmatizing views that disconcerted the easygoing Bauhaus community. Although he had studied to be a lawyer and had left the law, served in the Hungarian army during the war, associated himself with the extreme left during the Hungarian uprisings of the postwar period, Moholy was in the deepest sense a nonpolitical person. The trauma of postwar Germany—a defeated and collapsed nation—was not his. Moholy was on to a utopia long before most Germans had awakened to their defeat. It is no wonder that his arrival at the Bauhaus served both to provoke change and to consolidate a shift in position that, at the outset, was received with hostility by a number of the Bauhaus masters. Lyonel Feininger, writing to his wife on July 28, 1923, expostulated (196:10): "*Art and Techniques: A New Unity* is the slogan on our Bauhaus poster. Oh dear, is there really no more to being an artist than to be saddled with technique?" Of course, Feininger was misunderstanding, but he was voicing criticism shared by other Bauhaus masters.[22]

As early as 1921, Gropius was under pressure to deal with the predominance of expressionism in the Bauhaus aesthetic. Although he had himself installed the expressionist approach to art—with its interest in the plastic articulation of unconscious mood, its often mystical-religious vagueness, its emphasis on a technique freed from historical presuppositions—there is little question that Gropius was sympathetic to expressionism in painting to precisely the extent that he was opposed to it in architecture. Since he had not yet worked out his own integration of art and the machine, he was able to see architecture and the building as the quintessential modern formulation of an advanced style, but his care or preoccupation with painting was distinctly secondary. The Bauhaus was *ab initio* framed by a contradiction—a pedagogy directed toward the making of the "new house," that is, a pedagogy which insisted that everything going on inside the "new house" (furniture, metal fixtures, books and their bindings, lighting, paintings, glass utensils and kitchenware, as well as dance and performance that might be performed to entertain guests) be brought under the aegis of a comprehensive modern aesthetic, but which, nonetheless, had no department of architecture. Gropius wished to organize the elements of the environment without introducing the overarching structure that unified and characterized the environment as a whole. As a result he was enabled to rationalize the assumptions of expressionism, since its feeling was in accord with his own oceanic temperament,[23] although its practice became increasingly alien to his rational sensibility.

Johannes Itten's principal concentration in his required half-semester Vorkurs was the stripping of student presupposition, the paring away of intellectual assumptions and historical prejudice. In itself this was a commendable enterprise, but Itten pursued it through a combination of psychological devices that amounted to

Painting: 1919 – 1982

little more than spiritual programming and emotional terrorization, since his approach was neither discursive nor dialectical but an appeal to the most coercive kind of intuitive emotionalism.[24] Itten succeeded in establishing student rapport with unfamiliar and presumably "unaesthetic" materials, obliging them to analyze paintings by means of a modified formalist analysis and compelling them to invent works of art with minimum technique, attending only to the characteristics of the materials at hand. At the same time he emboldened students to continue with an assumption that it was critical for the Bauhaus to undermine: That art is the rarefaction of emotion and hence of no industrial or public use.

Although this position continued to find its supporters, it was by 1922 consolidating in the Bauhaus an atmosphere that encouraged everyone to pursue his own aesthetic path, as long as it was one considered noble and sublime. Despite, therefore, the apparent communal character of the Bauhaus enterprise, little work was being produced that fulfilled the craft dimension of the original Bauhaus proclamation.[25] Undoubtedly, Gropius had begun to cavil with Itten's narrow transcription of the Vorkurs and, despite the efforts of Josef Albers to turn the direction of the Vorkurs (whose second part he had been appointed to teach) to a more technically rigorous examination of materials and methods of construction appropriate to their properties,[26] Itten's star began to wane. Even before Gropius's appointment of Moholy-Nagy, it was clear that Itten was no longer suitable and after a bitterly emotional letter of resignation, Itten departed in 1923. The heart of the controversy is stated by Gropius in a memorandum circulated to the Bauhaus masters on February 3, 1922: "Recently, Master Itten demanded from us a decision either to produce individual pieces of work in complete contrast to the economically oriented outside world or to seek contact with industry...I seek unity in the *fusion*, not in the separation, of these ways of life" (187:51).

Bayer at the Bauhaus: Painting and Other Projects

It was obviously not intended that young students should occupy themselves with their own artistic production during their formative years at the Bauhaus. Rather, it was assumed that most students would arrive with vague and inchoate aspirations to become artists of some kind and, through the process of their training at the Bauhaus, emerge as skilled practitioners in an economically viable craft that would yield handsome product, without necessitating official judgment on their ability to make paintings, sculpture, or other original works of art. The viable craft was never considered in any way inferior to painting and sculpture; the hope was rather that painting and sculpture would benefit from the Bauhäusler's grasp of materials, forms, and techniques of the various crafts that he studied.

Upon entrance at the Bauhaus, the student obliged himself for not less than six months to attend the Vorkurs established by Itten (with the assistance of his friends and disciples Georg Muche and Lothar Schreyer) and later expanded and revised by Josef Albers and Moholy-Nagy, who inherited the Vorkurs after Itten's departure in 1923. After completion of the Vorkurs and the regularization of the student's participation in the Bauhaus, he was expected to apprentice himself to one or another of the existing workshops,

presided over by a master of form and a master of craft, that is, by a theoretician of the fundamental forms and materials appropriate to the ceramic, metal, printing, binding, weaving, wall-painting workshops, and a technical master who commanded the historical methods of production and was skilled in the use of the tools and equipment of the craft. Although this formal master-apprentice relationship was eliminated when the Bauhaus moved to Dessau and the idea of the medieval guild (Bauhütte) was abandoned, the young Herbert Bayer came under the influence of the entire, unrevised scheme of Bauhaus education from 1921 to 1923.

It is no surprise that Bayer has insisted upon his uninstructed ignorance during his early Bauhaus years. How could it not be? At twenty-one, Bayer was in many ways far younger than the youth of the present, who assume knowledge of most things while failing to recognize that their information reflects the coded assumptions of their generation. During this early period, just after the conclusion of the First World War, in which he had served, it is credible that Bayer arrived at the Bauhaus a virtual *tabula rasa*. He had acquired bits and pieces of the history of modern art movements through his contact with Schmidthammer and Margold, through his boyhood friendship with the art historian Guggenbauer, who specialized in Bavarian church architecture but shared with Bayer the periodicals and books being published by the circles of expressionism and Jugendstil, through his participation in the Wandervogel that brought him into contact with other sympathetic and curious adolescents, but his eye was in no sense ordered by a formed aesthetic. Bayer's youthful drawings were talented, but not precocious; his early graphic design was no less talented, but clearly epigonic.[27] Moreover, Bayer was, by his own admission, neither pushy nor aggressive, but rather instinctively shy and introspective. It is hardly likely that his coming to the Bauhaus would compel him to visual partisanship or affiliation with any of the aesthetic and spiritual cliques that dominated the faculty of masters and the students. It is rather the case, as Bayer has testified, that he steered clear of Bauhaus factionalism. He admits to having enjoyed Itten's Vorkurs which he remembers attending "two or three times" (hardly assiduous or atypical class attendance). "Itten, of course, interested me. I liked him as a person very much and it was all new to me. I was much impressed by his way of teaching and by the importance of composition of black and white gradations, analysis of medieval paintings, the relaxation exercises before starting to draw—loosening up your hands and massaging your head. you relax your body and then do some rhythmic drawings after that."

Besides Itten, Bayer felt a particular affinity for Paul Klee, whose classes were based on a theoretical interpretation of his own paintings of the period, eliciting from them *après le fait* the logic of their development, structure, and color.[28] Everyone loved Klee, and Bayer was no different in this. Given Klee's inexperience as a teacher, his pedagogy was developed on the spot, working out through an analysis of his own paintings the orders of technical and metaphysical consideration that governed his visual language. Since, as Bayer acknowledged, "everybody liked his painting and I was particularly fond of his work," Klee's method of exposition was "a natural way of teaching" developed from its

foundations in his own work. Itten's Vorkurs, Klee's lectures on Paul Klee, Kandinsky's course in analytical drawing (in which, according to Bayer, "students put together or built a still life which they would then draw and abstract to the minimum, more and more, to the minimum, more meaning, until only the structure was left, so that the objects themselves could no longer be recognized") described the essential Bauhaus education in the foundations of visual sensibility. Gropius, Bayer acknowledges, hardly taught, although he gave an occasional lecture; nonetheless, it was Gropius's selection of architectonic artists—artists whose command of fundamental structure reverberated with the vocabulary of modern architecture—that defined the educational purview of the Bauhaus.

The principal influences on Bayer during these early years in Weimar were the architectonic visionaries—Itten, Klee, Kandinsky, artists whose work allowed no pragmatic incorporation. Although Klee and Kandinsky (and like them Feininger and Schlemmer) were not associated with such expressionists as Itten, Muche, or Schreyer, they were nonetheless painters who worked from an internal universe of feeling and vision, where objects were recognizable but not easily identifiable in the real world. As such, although they were highly disciplined in a way not characteristic of expressionism (certainly not like Peter Röhl, the young expressionist Bauhäusler who later joined De Stijl, who with his friends decorated the Weimar dining room by squirting paint on the wall),[29] they were nonetheless persuaded that painting was a spiritual act—an act that if not expressionist was still profoundly indebted to the assumptions of the German romantic tradition.

Not incorrectly has Otto Stelzer drawn attention to the propriety of Blaise Pascal's distinction between the two primary attitudes of mind, the one of geometry, the other of finesse.[30] In those early Weimar days of the Bauhaus, the lines of conflict between the expressionists (those for whom form is internal construction, color intuitive, space and time categories of perception) and the geometric constructivists propagandized by Theo van Doesburg and De Stijl supporters (who had set up shop in Peter Röhl's Weimar apartment and kept up a running dogfight with Gropius in general and the Bauhaus expressionist circle in particular) were quite explicit.

Herbert Bayer did not take sides in the conflict between expressionist romantics and geometric constructivists, but his painting and drawing of those early years reflect the interior discussion he conducted, siding here with the expressionists, there with De Stijl; producing collages moved by Dadaist informality and eccentricity and by their side studies for Itten's Vorkurs in which arrangements of color and materials articulated a highly personal fuzziness of form. The correct interpretation of Bayer's Bauhaus apprenticeship—the two years before the late fall of 1923, when he went on his Wanderjahr to Italy, returning in April 1925 to become a Bauhaus master—is that he pursued other styles in the absence of having defined one of his own; he worked through the implications and possibilities afforded him by the private transcriptions of the expressionists and at the same time undertook rigorous formal experiments in the neoplastic mode. In effect, as he had always done, Bayer educated himself through an experimental dialectic in

which he tried out the options available. He worked through the problems privately—not by discussing them with others (for he did not appear to be an expansive talker, although he was open to his friends Josef Albers, "Sepp" Maltan, Xanti Schawinsky, Marcel Breuer) but by working on single paintings, watercolors, collages, three-dimensional constructions, architectural drawings, typographic experiments, each projected as a problem in self-education and aesthetic clarification.

The experimentation of the visual autodidact describes accurately Bayer's early years at the Bauhaus. Since the Bauhaus was not an art school and had no library of art books, visual training was not through historical models or museum tours but through participation in a rare community of selected creators of modern art and contact with other artists who passed through the Bauhaus to visit, lecture, and show their work (Lissitzky, Schwitters, Max Burchartz, Walter Dexel, and van Doesburg were occasional visitors; some of them set up small exhibitions of their work for discussion and reaction). Moreover, since it was established practice at the Bauhaus that the students could execute no designs other than their own, it was mandatory that the student-artist become, if for no other audience than himself, an artist-producer. Bayer's production during his early student years was very small, but the break with his youthful academic drawings was virtually instantaneous and although he would later draw from nature again, his draftsmanship was to be wholly different, technically mature and extremely subtle. For the moment, however, Bayer's work reflected the insistent presence of his masters—Itten, Klee, Schlemmer—and to a lesser extent the impact of Dadaist collage.

At the same time as his painting and drawing responded to the presence of his Bauhaus masters and the free experimentation of Berlin Dada, Bayer's architectural drawing and graphic design combined a De Stijl rigor with a subject matter distilled from color theorems Kandinsky advanced in the wall-painting workshop to which Bayer belonged. One has only to examine *Architecture-Bauhaus* 1921/21, *Study in Various Media of Different Textures* 1921,[31] *Pflanze* 1922/7, an expressionist pastel of plant forms,[32] or the two versions of *Birthday Greeting "18 Jahre"* 1922/13, to recognize the influence of the expressionist-symbolic style on Bayer's early Bauhaus work. In these pictures, a wavering, indefinite line evokes the building forms or evinces, in Alexander Dorner's phrase, "the sleepwalking approach to material texture which—according to Itten—was to lead mystically to balanced composition" (68:131–133). Alongside these were two informal expositions of Itten's mystical imagery, devoted to the eighteenth birthday of a friend: architectonic imagery, Masonic eyes and pyramidal symbolism, and bright, celebratory colors are arranged in the romantic intimacy reminiscent of the symbolic works of Itten,[33] but accomplished with considerably greater playfulness. Clearly, Bayer learned from Itten's ability to organize a complex pictorial scene, but left off at the point at which Itten would require precise symbolic depiction. The glass rubbing Bayer had painted the previous year to celebrate the twentieth birthday of another friend rather more joyfully reflects Klee's presence in Bayer's imagination—the stick houses, rose heart, half-moon, the hieratic flower and minimal steamship all washed in shades of blue and

Architecture-Bauhaus 1921/21, charcoal, 19 x 13".
Collection Wilhelm-Lehmbruck-Museum der
Stadt Duisberg.

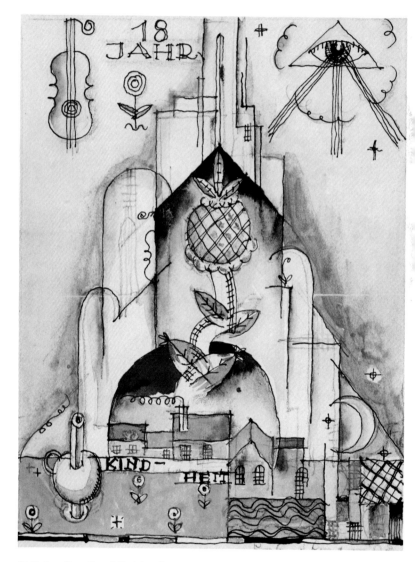

Birthday Greeting "18 Jahre" 1922/13, water-
color, 7 1/2 x 7 1/2".
Collection Joella Bayer.

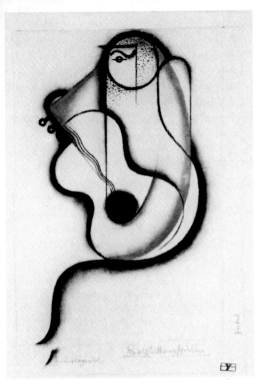

Guitar Player 1922/4, charcoal, 10½ x 15½".
Collection Wilhelm-Lehbruck-Museum der Stadt
Duisberg.

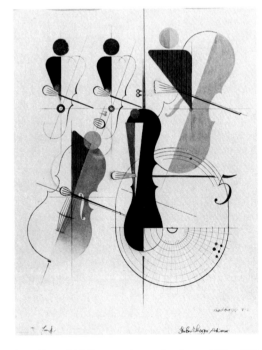

The Five 1922/8, gouache and collage, 14½ x 18".
Collection Joella Bayer.

pink with white panels upon which the flower, the heart, and the number 20 have been emplaced. Instead of the usual Klee title written at the bottom of the picture, Bayer's message to his friend is in scattered elaborate capitals around the central image.

Although Bayer has never acknowledged Oskar Schlemmer's influence on his early work at the Bauhaus, there is little question that the cubist exercises of his *Guitar Player* 1922/4 or *The Five* 1922/8 allude to Schlemmer's male figures in profile, since in both cases the abstraction of the figure playing the guitar and in the less successful *The Five*, a violin, refers to the drawings and theatrical figures that Schlemmer had begun formulating after 1914.[34] Clearly, however, Bayer was no more a disciple of Itten, Klee, or Schlemmer than he was a Dadaist. But his collage poster for a Bauhaus dance (1923), his Geschenkgraphik for Walter Gropius, *Prospekt der Mund*, in which real kisses of the student body are informally arranged and identified (1923), or his *Der Muster-Bauhäusler*, however much they reflect a passing familiarity with Dada play or, in the case of *Der Muster-Bauhäusler*, with George Grosz's portfolio of mechanical compositions, *Mit Pinsel und Schere* (1922),[35] indicate little more than an ability to respond in the appropriate context with an adaptation of Dadaist attitude. Bayer was no more a Dadaist than he was a disciple of his teaching masters. His wish to make pictures inspirited by the mood or devices of another artist or aesthetic ideology was a method of instruction consonant with the strategy of the autodidact.

Clearly, Bayer determined to call a halt to this eclectic experimentation with a small picture executed toward the end of his student years, in 1923. *With Head, Heart, and Hand* 1923/29, a picture employing collage, watercolor, and pen and ink, Bayer integrates distinctive elements suggested by Klee and Schlemmer, but goes beyond a mere commentary on their recognizable imagery in the direction of elaborating themes that would become uniquely his own—the architectural organization of space, the underpainting of neural circuitry leading from the blood vessels that feed the collaged brain, the formal draftsmanship with which the hand is analyzed through a geometric parsing of knuckles and joints, the caricature of a cubist body (half enlarged heart, half architectural space), the eye and mouth circulating upon a parabola inscribed on the perfectly round head, and more besides. With consummate drawing, implicit symbolism, witty legends written in Gothic script for head and increasingly personal calligraphy for heart and hand, Bayer has supplied in a single picture a summation and interpretation of his student years at the Bauhaus.

The production of Bayer's student years was not exhausted, however, by the making of a small number of pictures shaped by expressionism or even Dada. Abstraction as well competed with expressionism. The formulations of Kandinsky's theories of the proper relations of color and form, the neoplastic insistence on purification of form, and the pressing of construction toward its nonobjective basis were also recorded in Bayer's work, beginning in 1923.[36] Bayer's remarkable architectural drawings of 1923[37] and his imaginary kiosks and display stands of 1924[38] would not have been possible without the immediate impact of the De Stijl movement, which had established itself in Weimar from the summer of 1921 through 1924.[39] The insistence of partisan interpreters of

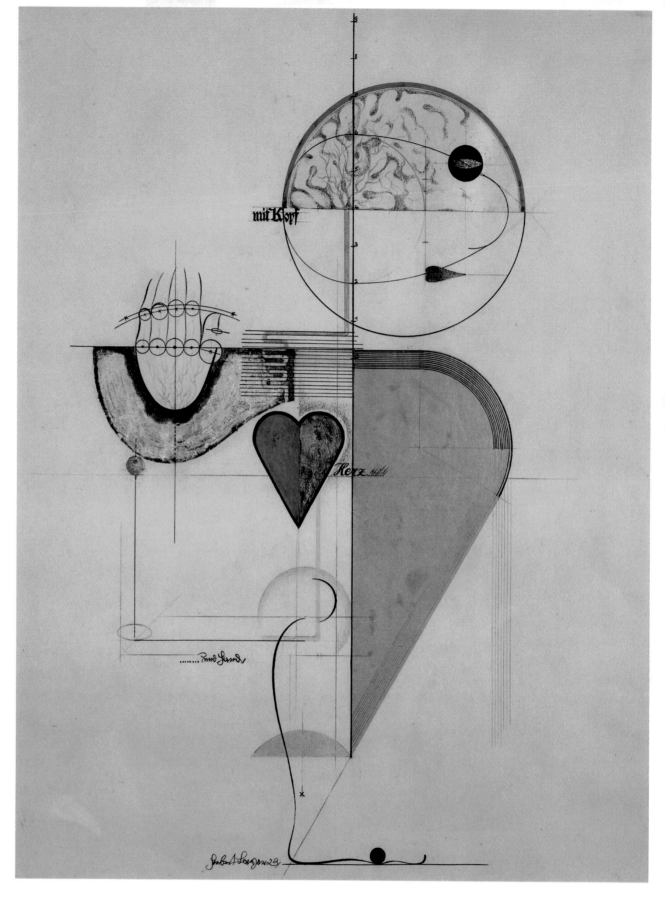

With Head, Heart and Hand 1923/29, collage and
mixed media on paper, 22 x 15³/₄″.
Private collection.

De Stijl that Gropius's formulation of Bauhaus objectives in his essay in *Staatliches Bauhaus in Weimar* derives from similar views expressed in the opening manifesto in *De Stijl* in 1918 may be questioned.[40] But there can be little doubt that van Doesburg's counter-program of education in neoplastic doctrine, which he asserted in Weimar and pressed with the aid of visiting De Stijl advocates such as the architects J.J.P. Oud and C. van Eesteren, managed to influence and alter the prevailing trend toward a medieval Einheitskunstwerk that had been heralded by Feininger's cathedral woodcut in 1919 and Gropius's romantic aspiration toward a Bauhütte in the initial phases of Bauhaus praxis. Van Doesburg wanted art to be turned toward concrete life and construction, not directed to the spirit, which he regarded as having no objective ground in the modern world. Because architecture was the common achievement of modernity celebrated by both Gropius and van Doesburg, the disagreement over the technical means of educating a sensibility capable of authenticating modern architecture was a decisive one. It cannot be doubted (although Gropius made no concession) that van Doesburg succeeded. To be sure, Gropius had the final and practical victory; the ideologist of neoplasticism was not invited to replace Itten at the Bauhaus, but rather László Moholy-Nagy, who could adopt neoplastic language or constructivist language whenever it suited his interest in bypassing all ideology toward the act of making useful objects. The departure of Itten, the appointment of Moholy, and the pragmatic reorientation of the Vorkurs, however, were indirect acknowledgments that van Doesburg's criticisms had been met.

Herbert Bayer has never expressed his views of van Doesburg (other than to remark that he was a divisive spokesman [47]) nor has he recalled whether he attended van Doesburg's lectures in Weimar or visited the exhibition of neoplastic architecture originally shown in Paris in 1923 and reconstituted in Weimar in 1924. Nonetheless Bayer must surely have heard from his Bauhaus friends and colleagues (notably Marcel Breuer, the Hungarian-born architect Alfred Forbat, Gropius's collaborator Adolf Meyer, or the artists and designers Walter Dexel, Max Burchartz, Peter Röhl, to name but a few) who frequented van Doesburg's Weimar circle what it was that van Doesburg objected to at the Bauhaus and what it was he was proposing as the basis of neoplastic art and architecture.

The murals Bayer designed for the secondary stairwell at the Weimar Bauhaus, employing a variety of geometric elements but centralizing Kandinsky's conviction that a circle was blue, a square red, and a triangle yellow,[41] and his experimental wall, executed in sgraffito and employing Fibonacci progressions, half-circles, and other primary and simple geometric shapes, were Bayer's earliest abstract formulations (146:plate 57); moreover much of his early graphic design during this period reflects impulses derived from his familiarity with Kandinsky's vocabulary of abstraction.[42] Bayer's work in the wall-painting workshop, conjoined with the neoplastic drive toward simplification of form and the architectural organization of space, supplied his early interpretation of functional design and architectural drawing with its indispensable vocabulary. It was not, as Dorner has suggested, a conflict produced by the split between artistic composition and practical employment that underlay the tension between expressionism and abstraction (68:67–68, 133–135); rather, the unification of aesthetic means and the concrete task obtained as vividly whether Bayer was composing a painting or designing a poster or executing his famous axonometric rendering of Gropius's design for his private study.

The conflict between expressionism in painting and neoplastic construction in graphic design and architecture was part of Bayer's trying-on of styles. What would come to be his mature style was latent in the vocabularies of this period, but the specific format and arrangement that his painting would acquire in the years ahead, the working beyond Bauhaus influences, through a quasi-surrealist mode, toward the geometric naturalism that would occupy the center of his painting for the next half-century cannot be reduced either to the determinants of the influence of Bauhaus masters or to the neoplastic theories of De Stijl.

From Bauhaus to Berlin

Herbert Bayer took his leave from the Bauhaus in late 1923 and, in the company of his fellow Bauhäusler Josef "Sepp" Maltan (who had assisted him by applying the cassein to the entrance sign Bayer designed for the Weimar exhibition of 1923), hiked from the Brenner Pass down through Italy, making his way slowly to Rome and across to Sicily for about nine months of leisurely travel. Without program or project, Bayer and Maltan supported themselves by painting flats for a priest's theater workshop in San Gimignano, house painting in Rome, where they camped out in an unfinished apartment block during the winter and early spring of 1924, and hiking throughout Sicily until they met an expatriate German baron whom Maltan had known, who gave them money to lease a car, which they drove back to Rome. During this period of uninhibited freedom and travel, Bayer drew constantly, filling many notebooks with impressions of Italy, but principally excited by the harbor of Palermo, the hill village of Bocca di Falco near Palermo, and the catacombs of the seventeenth-century Capuchin Pinde Monte monastery in Palermo. There Bayer sketched in charcoal and pencil some of the astonishing gallery of about 8,000 mummified bodies of clergy and nobility gathered there in the dry air to await their resurrection.

The drawings of this Wanderjahr were principally fine renditions of nature, typical travel notations, delicate, precise, warmly felt and recorded. Several works of this period, some of which allude to groups of pictures that would be developed later, should be singled out: the brilliant series of gouaches that evoke the brightly colored, quasi-historical legends of Sicilian heroes in the wars against the Moors that emblazon the peasant carts of the island. These drawings, executed as abstractions of elements of the Sicilian carts, freed from their utilitarian context as slats, panels, or side boards of the carretti, acquire in Bayer's representation a mysterious, totemic character. Bayer was fascinated as well by the brightly painted peasant fishing boats, treated by him like carretti as abstract geometric forms on which stripes of red, blue, and white, decorated with black birds and other graphic elements, are placed. Bayer's paintings of these carts and boats, represented as objects of peasant creation, prepare the way for the

Mummy Child 1924/45, pencil and charcoal,
15 x 10¾".
Collection Denver Art Museum (Herbert Bayer
Archive).

second major series of paintings that would be produced ten years later, paintings that depend for their austere power on the evocation of archaic peasant shapes cut in the walls of the farmhouses and barns of the Austrian mountain villages from which he came.[43] The Sicilian gouaches of 1924, although accurately observed and represented, possess a stark power made even more impressive and abstract by their being stripped of naturalistic context.

Bayer undertook a no less powerful group of paintings that resulted from his travels in Italy and Sicily during the half-year after he returned with Maltan to the latter's home in Berchesgarten, where they both painted houses for a living until Bayer went to Dessau at the end of 1924. These paintings (only four are documented) inaugurate a direction in Bayer's work that would become extremely important in the development of the highly abstract, formal, proto-surrealistic paintings that occupy the center of his attention from 1925 until his emigration to the United States in 1938. But these four oil paintings—a vignette of the Tuscan countryside (*Tuscany* 1924/83), a similar impression of a Sicilian village landscape (*Sicily* 1924/82), a vision of the unfinished Sicilian Greek temple (424–416 B.C.) at *Segesta* (1924/90), and the remarkable purist self-portrait of the artist as a fisherman sleeping beside his decorated boat (*Sleeping Fisherman* 1924/84)—marked by a kind of naturalistic fidelity and brilliant coloration, carry undertones of mystery and unease. The cacti that stand before the multicolored houses of the Sicilian hill village are so enormous that ordinary perspective is fractured, while in the impression of Tuscany, the tapered cypress trees throw contradicting shadows on the yellow wall of the house behind them and the denuded, skeletal pine trees set before bright walls and against green hills allude to a fantastical impression of the landscape. Both pictures are finished works, but as so few of them were made during these months and Bayer did not go on to make more, one can only surmise that he was beginning to do what he did more frequently throughout the remainder of the 1920s and well into the '30s: setting down single impressions, taking detailed notes, undertaking an occasional foray into a dense pictorial space where nature is made odd, uncertain, unpredictable.

The most perfect of these works, *Segesta* 1924/90,[44] in which the temple is floating just above the green earth in a serene blue sky interrupted by two puffs of cloud at either side of the picture, is surely surreal, but in what sense? Surreal in the conventional idiom of surrealism, since it is well known that buildings adhere to the earth when they are realistically portrayed? And floating temples, roofless and floorless as this unfinished temple might be assumed to be, one may correctly read as some kind of fantasy, unreality, or surreality? But it may be advanced against this view that Bayer is making the first of what would be many statements about the importance of classical imagery in his visual vocabulary. *Segesta* would be followed by many paintings and design projects making use of Greek imagery,[45] elaborated out of his admiration for classical sculpture and further documented in the photographs he took during his visit to the Greek islands with Marcel Breuer in 1934–35. The temple at Segesta is after all one of the most beautiful testimonies to the Greek presence in

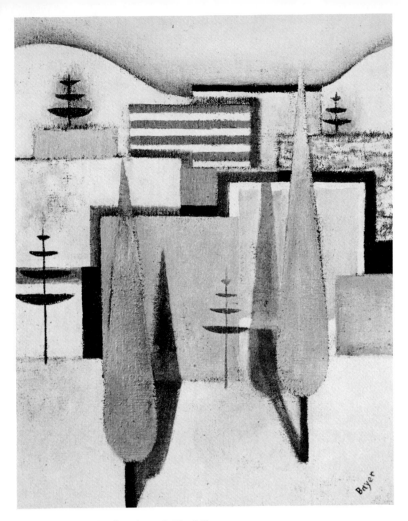

Tuscany 1924/83, oil on board, 17 x 21".
Collection Erich Vala.

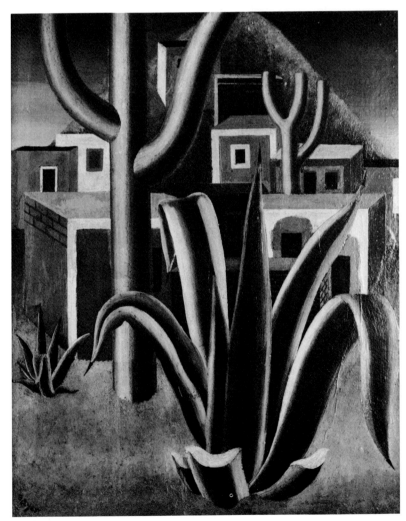

Sicily 1924/82, oil on board, 19¾ x 15¾".
Loan of Herbert Bayer to Bauhaus-Archiv, Berlin.

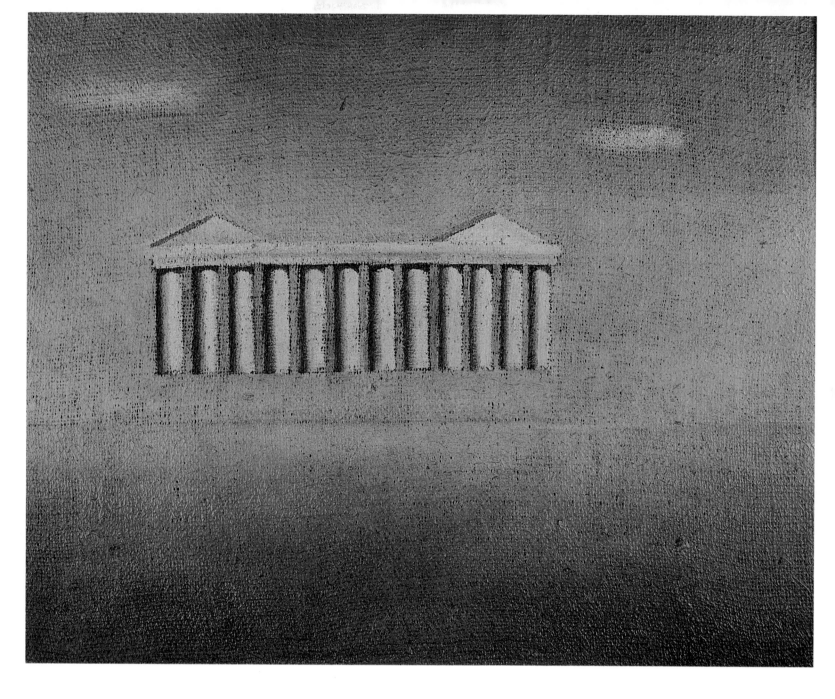

Segesta 1924/90, oil on canvas, 17³⁄₄ x 23″.
Collection Harry Glück, Vienna.

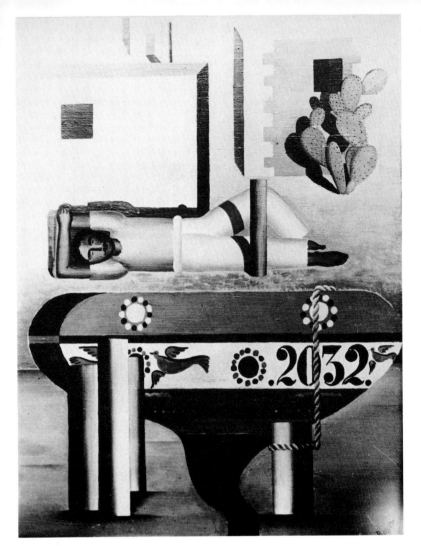

Sleeping Fisherman 1924/84, oil on canvas,
19 x 25¼".
Collection Guido Rossi, Milan.

Sicily—it is right that it float in a serene blue sky, above a verdant earth, marmoreal whiteness, timeless, spaceless, an emblem of the ancient world. Not surrealism but rather a portrait of ideality seems to be the issue here.

Bayer returned to the Bauhaus at the end of 1924, accompanying its move to Dessau and the immense building program and institutional transformation through which it passed during the next two years. The youthful painter and designer must have labored under considerable pressure. The years 1925 through 1926 were nonetheless crucial in the formation of Bayer's practical aesthetic, a time during which he began to work out the lines of separation and coalescence between the demands of modern functional graphic design and the obligations of free painting. Unlike other artists who early distanced themselves from the pressure to adapt their imaginative vision to commercial and practical necessities, much of Bayer's private aesthetic was shaped by the demands of his practical employment as the first master of the Bauhaus typographic workshop where, alongside the equipment of a modern printing shop, was the claim of constructive functionalism in design. It could not be otherwise. The other masters of form at the Bauhaus discoursed on the applicable principles of their painting aesthetic to the requirements of a craft whose fundamental discipline they avoided, whereas Bayer was obliged by the virtual simultaneity of form and craft in graphic design to introduce visual techniques into design that depended on pictorial assumptions.

It was unavoidable that several of his most important design projects made use of solutions that would have been as appropriate to painting, and his painting of the period reflected adaptations of research being carried on in technical workshops of the Bauhaus, including his own, where pictorial adaptation was not only possible but implied. For instance, Bayer's famous cover for the *bauhaus zeitschrift* (1928) could have yielded a painting no different in construction from his photomontage, but it was the case that photomontage was appropriate to design. The personal hand was saved for such works as *Suspended Architecture* 1925/2, painted with a precisionist clarity that might have been construed as photograph, or *Schwebende Plastik* 1925/8, where pictorial qualities predominate so powerfully that there is no confusion between the congerie of overlapping columns suspended in a blue field and the possible photoplastic that might have replicated it. In these cases Bayer understood perfectly the difference between painting and design, but since it was a relatively recent and novel discrimination, his sureness was not infallible.

A series of paintings that he undertook in 1928, evoking beach and bathing scenes, underwater life, and fishbowl existence does not succeed precisely because the paint quality is thin and weightless, the imagery commonplace, and the color lacking the density and richness that arrests and compels. Although Bayer's first interpreter, Alexander Dorner, praises these pictures for their appeal to common signs and their eschewal of the individualistic and eccentric, the real predicament is their literalness, their inability—despite the fact that these bathing beauties lack heads and legs—to evoke the classical model their bathing suits conceal. And precisely this, the bathing suits over the exquisite marmoreal torsos, allude to functions that would later become the clichés of

Suspended Architecture 1925/2, gouache,
14¹/₄ x 19¹/₂″.
Collection Museum Moderner Kunst, Vienna.

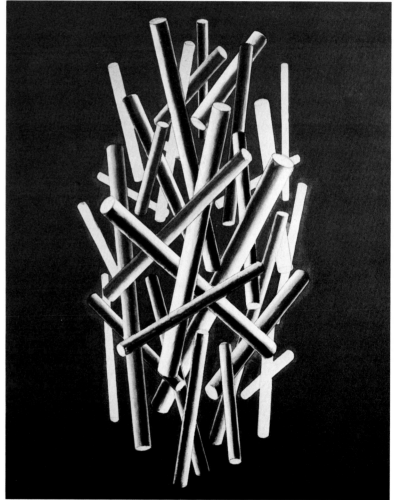

Schwebende Plastik 1925/8, gouache,
19¹/₂ x 15¹/₂″.
Collection Joella Bayer.

21

advertising rather than deepen the surreality of the framed beach (*Studio Beach* 1928/4) or the torsos before panels cut from the background of the sky (*Beach* 1928/6). It is not that Bayer created clichés (since his images were well in advance of the clichés such images would later become), but rather that he was working through distinctions between pictorial and realistic space, natural abstraction and the fantastic, dream signs and common signs, and had not yet settled his definitions.

Where Bayer fails in the series, he succeeds significantly in a larger group of pictures begun early in 1925 and resumed in 1928. The initial picture in the series, *Komposition in Raum* (*Composition in Space* 1925/5, also titled *Kulissenbild*), a tempera canvas of modest scale, is an incisive inquiry into theatrical space; that is, space filled by artifice. A horizontal format, foreshortened in perspective, reveals slablike shapes—large rectangles, floating boards, triangles, cloudlike formations—pallidly colored in bluish-white, ordered according to shape and lined up one behind each other like surreal stage flats stacked against a nonexistent wall—in this case, the wall of night, where sky, like the other shapes, is graded and recedes into the void. This layering of reality, each object cut as with a fretsaw, introduces for the first time in Bayer's work an order of frisson and amazement that would remain characteristic of his most profound painting.

Eberhard Roters, reading this group of paintings, observes that "the immeasurable has been squashed flat to make it measurable; an introvert has brought neatness and order into the absurd."[46] But a completely different interpretation based on an identical description of the painting's format and imagery is possible if one shifts the vector of the inquiry. Roters is, after all, inquiring into painting produced by Bauhaus masters and Bauhaus students. It is surely inappropriate to juxtapose Bayer's work of this period with the work of Feininger, Klee, Kandinsky, Schlemmer, and the rest. They were already formed in their vision by the time they arrived at the Bauhaus, whereas Bayer had just come to the point where he was formulating his own, moreover formulating it at a time when everything—art, culture, German society—was unsettled and turbulent. If anything, these pictures, beginning with *Komposition in Raum* and passing through the equally transnatural abstractions of 1928, are not about space as such or even abstraction as such. They are, however, clearly about the very definite problem of making pictures.

As many imaginative writers will take as the task of their first novel the problematic of creating an imaginary universe, of making literary art (a theme commonplace in Thomas and Heinrich Mann, for instance), in these important pictures Bayer set himself the question of how one organizes, renders, and frames the space against which nature and artifice devise the objects of the world. In some cases, as in *Komposition in Raum*, nature is composed theatrically, natural forms intermingling with forms cut from wood and stacked before the downstage drop of night. In others, such as *Park of Flat Trees* 1928/13 and its companion picture, *Flat Trees* 1928/15, the trees appear lush and full until one observes they are cut thin to a single plane while casting the shadows of a mid-afternoon sunlight, receding into beige and brown, the same fretsaw at work, devising a theater of mystery, almost mature, surely

artifice. There are a number of other versions and variations on this basic theme, some using trees delimited by the theatrical stage and others employing a literal picture frame to contain clouds or interpenetrating picture frames where clouds come forward and recede, casting shadows from one frame into the next, shifting color, density, volumes as they abrade each other and pass through. *Clouds and Frames* 1928/11, *Hovering Signs* 1928/14, *Abstraction-Blue* 1928/18, *World on Boards* 1928/25, and the final painting in this series, *Wood in the Forest* 1930/13, are the strongest formulations of the foundation format of *Komposition in Raum*, marred only by occasional lapses into a depictive literalness that was a notable weakness of Bayer's early painting. Nonetheless, the series is given a triumphant turn and conclusion during Bayer's month of holiday in Southern France immediately after his departure from the Bauhaus.

Beginning with *Portrait HB* 1928/12, a modest horizontal gouache, all of the themes and technical devices are crystallized. Five interpenetrating wooden picture frames (some painted with evenly spaced lines, others mottled with tiny white clouds) stand on a wooden stage, at the proscenium of which a large white capital *H* and *B* cast huge black shadows onto the frames behind them, reverberating through the frames to the final horizontal line. At the center of the picture a classically modeled but flatly painted head and torso, upon whose surface clouds float, rests before but not on a transparent white canvas (or glass) through which the frame behind it may be partially seen. The next painting in this group, *Zartes Bildnis E* (*Tender Picture E* 1928/22), is an essentially blue version of the same theme, simplified to two giant rectangles, one an empty frame containing real space, the other illusionary space stretched to an unframed edge that reflects the shadows cast upon the real. It is as though each half of the painting has been laid open to scrutiny, parsed in simultaneity, the giant *E* on the left (which casts a dark blue shadow on a cloud-filled sky) matched by a mirror-image reversed *Ǝ* on the right. The last painting, *BN* 1928/34, construing letters as the personae of a domestic interior, looking out through the window frame to a cloud-filled sky, is simply an extension and further exemplification of the same subject matter.

The World of Letters 1928/29, a gouache of the same month, to which Dorner pays particularly careful attention (68:142–145), is least successful in precisely the respects for which Dorner congratulates it. The mystery of self-portraiture in *Portrait HB*, the enigmatic *E* floating against a night sky, the metaphysical ambiguity in *BN* is aerated by the letter forms with which *The World of Letters* is populated. Although the same architectural space is alluded to, the same translucent frames and interpenetrable walls employed, the fact that now six letters of the alphabet are displayed, chosen only for their shapes, strips the space of its mystery. Where Dorner sees Bayer moving beyond surreality to a harmonic space, a picture such as this tends to crowd and, hence, to trivialize the composition. Dorner, it seems to me, is too involved with an ideology of reconciliation as the way beyond the rigidities of formalist painting and the celebration of the unconscious that he took to be the hallmark of surrealism, to read this period of Bayer's work with sufficient critical care.[47]

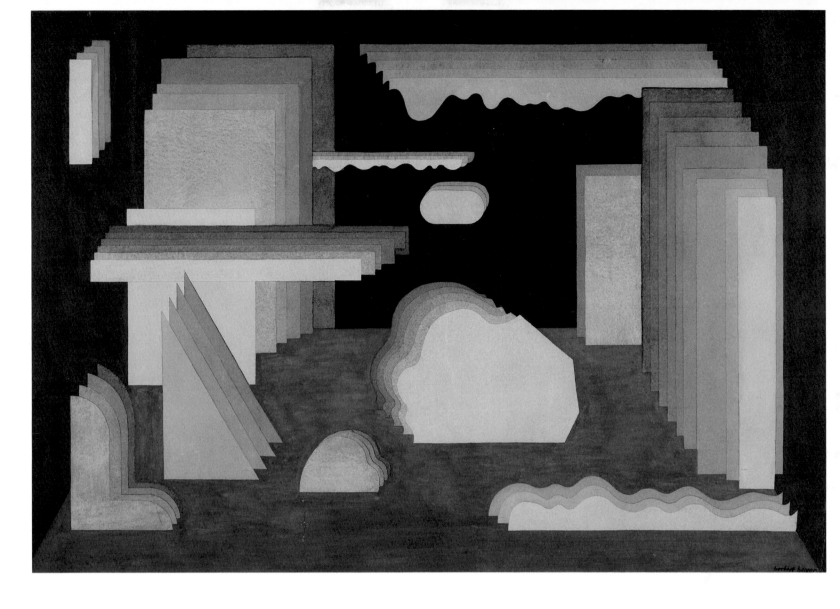

Kulissenbild (*Composition in Space*) 1925/5,
tempera, 18¹/₄ x 26″.
Collection Neue Galerie, Linz and Wolfgang
Gurlitt Museum, Linz.

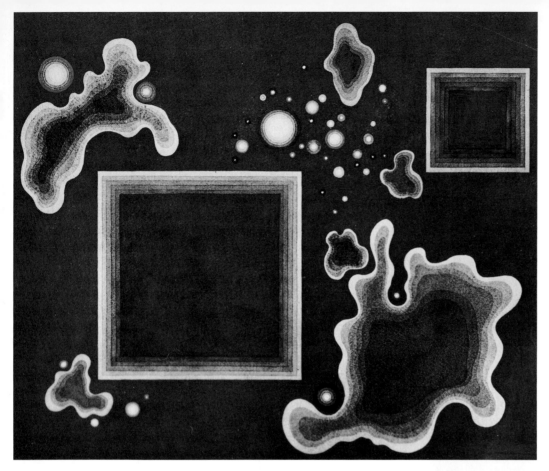

Blue Composition 1926/2, watercolor,
20¹⁄₄ x 24¹⁄₂″.
Collection Museum Moderner Kunst, Vienna.

Movement around a Spot 1926/3, watercolor,
18¹⁄₄ x 26³⁄₄″.
Collection Museum Ludwig, Cologne.

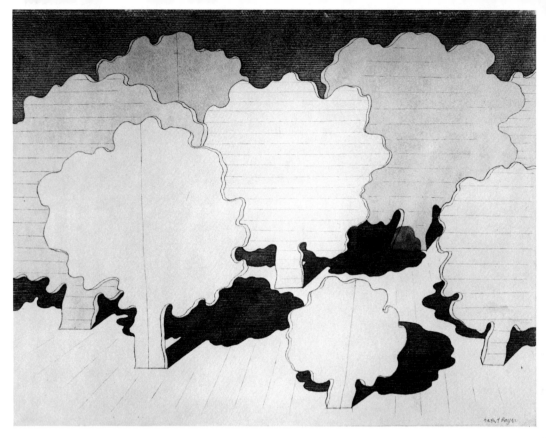

Park of Flat Trees 1928/13, watercolor, pen and
ink, 13 x 17".
Collection Herbert Bayer.

Flat Trees 1928/15, watercolor, 10¾ x 17".
Collection Joella Bayer.

Hovering Signs 1928/14, gouache, 10½ x 16¾".
Collection Freunde der Kunsthalle, Hamburg.

Abstraction-Blue 1928/18, watercolor,
10¾ x 17¼".
Collection Neue Galerie, Linz.

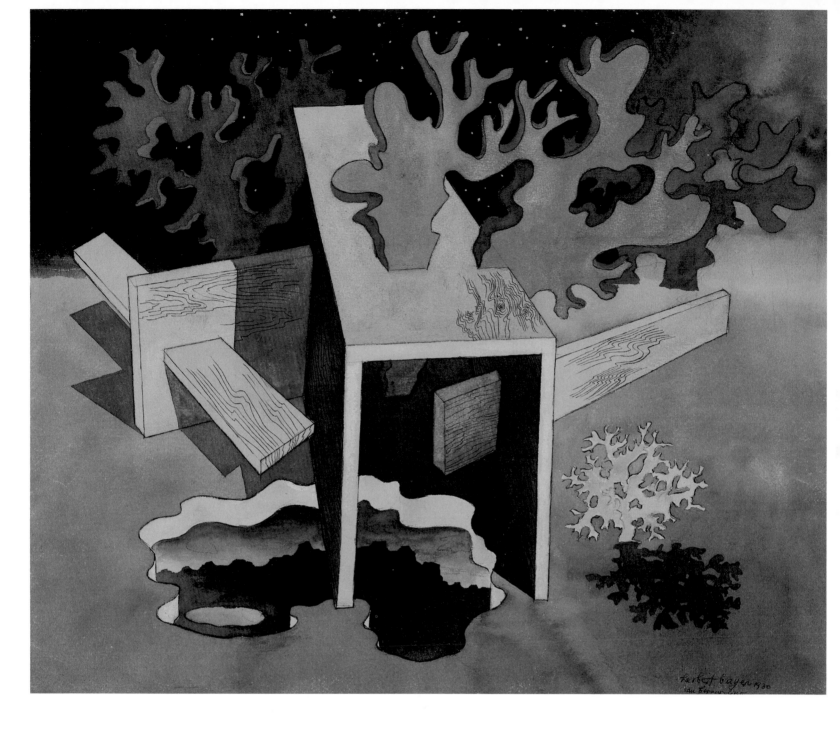

Wood in the Forest 1930/13, watercolor,
15¼ x 18½".
Collection Joella Bayer.

Portrait HB 1928/12, watercolor, 9 x 17¼".
Collection Joella Bayer.

Zartes Bildnis E (*Tender Picture E*) 1928/22,
gouache, pen and ink, 8½ x16½".
Collection Joella Bayer.

Yellow Guitar 1925/3, watercolor, 28¼ x 21″.
Collection Staatsgalerie, Stuttgart.

The World of Letters 1928/29, watercolor,
18 x 26″ (picture destroyed in Warsaw during
World War II).
Collection Lady Clifford Norton.

It is correct to contrast Bayer's painting of this time with the metaphysical paintings of de Chirico, which Bayer claims not to have seen, although he was in Rome shortly after de Chirico's participation in the Rome Biennale in late 1923 and might well have seen works by de Chirico reproduced in Paul Westheim's *Das Kunstblatt* or Herwarth Walden's *Der Sturm*. It is not possible to determine whether there is any causal connection between de Chirico's paintings of archetypal implements, mannequin heads, perspectival fractures, and painting easels and frames and the series of paintings Bayer began with *Komposition in Raum* and then advanced throughout 1928 to completion during his liberated month in Southern France. Bayer's interest does coalesce with de Chirico's and, although there may be no causal relation between their enterprise, the metaphor with which Bayer undertook to answer the issue of making paintings bears resemblance to that which de Chirico explored.

All of Bayer's paintings from his closing years at the Bauhaus, culminating in the letter paintings of 1928, are addressed to the question of the artist-architect (as any Bauhäusler would have interpreted the modern artist) before modern space. Space in our century is either natural space or constructed, either replete with natural forms (of which the clouds, trees, fruit abounding in Bayer's pictures of the period are emblematic) or else illusionary space, constructed as theater, whether framed with domestic practicality or displayed with nighttime mystery or the dead heat of midday. It doesn't matter whether the painter chooses to frame—that is, to pin down and hold—the real space that is endless and infinite by making its background wafting clouds and its foreground trees and foliage; the painter is finally alienated from his object, unable to master it, incapable of making its secrets public. In the end nature triumphs, forcing the artist back to the only mysterious signs that man can hold up to nature as mysterious as its own: language and speech. Letters are all that we can brandish before nature's space, letters that are finally as ambiguous as objects, throwing false shadows, interpenetrating like planes, translucent as light. These paintings, even if they grow out of the naked architectural spaces on which Kandinsky's wall-painting students were obliged to set down their color schemes[48] or employing letters as images derived from Hirschfeld-Mack's light experiments at the Bauhaus,[49] seen perhaps for the first time in the paintings of Paul Klee, are still original attempts to come to terms with an autobiographic question: How to become a painter and what is there real to paint?

One of the richest paintings of this period, small in scale but fully realized and elaborated, provides a kind of metaphoric reply to the question the earlier pictures have raised. Called simply *Bird with Egg* 1928/21, it was painted in the midst of the more schematic letter paintings; unlike them its palette is rich and varied and its employment of collage as a means of juxtaposing the painted bird with the real nest and enlarged egg suggested a way out of Bayer's autobiographic dilemma. The bird is guarded in an illusionist wooden cage whose interrupted lines appear both as cage bars at the front and as wall slatting at the rear, opening the cage and sealing it at the same time, revealing its contents but preventing the bird from escaping. The bird of remarkable

plumage, brilliantly red with layered brown and grey feathers, is perched on a floating piece of wood, its feet as unreal as the wood it grips. The entire cage, more realistic than the cloud-filled exterior before which it rests, is unconvincingly supported in the crook of a white tree. An oversized collaged nest holding a giant white egg floats in a blue sky rippled with clouds, touching the white tree, partly entering the cage. Passing through the blue sky is another irregular shape in brown, which emerges from beneath the sky at the left and rests before the sky to the right, coming forward from behind the birdcage, providing soil to its own rooted tree before which a leafy branch painted against a dark blue-gray ground has been framed in white wood. The whole—cage and bird, nest and egg, trees in white, blue shape with clouds, brown shape above and beneath the blue, framed leafy branch—is set against a blue-black night dotted with cumulus clouds.

What does this clearly symbolic picture signify—a picture unique in Bayer's oeuvre and one that appears at the point in his career when his Bauhaus youth was coming to a close and his advance into the world about to take place? Although enigmatic, it offers an appealing enigma, without foreboding and fright, despite the fact that formal perspective is arbitrarily violated, the picture planes ambulate, first frontal and then receding, the leaves appear within the frame and then curl from behind it, frame elements float, tree trunks are translucent, and clouds move everywhere. It is a delicious dream in which the movement of sequential time is alluded to in simultaneity, the clouds bearing time as a slow messenger, without haste or threat, the brown of soil against the blue sky of day, against the blue-black of night. This is the frame of the picture into which two dramas have been set, that of the leafy branch framed in white wood and the trapped bird facing the gray wall of its cage whose edge is penetrated by the oversized nest and egg. The bird should be with its egg, but instead is caged and cut off from its fecundity.

A more simple and direct metaphor of the creative predicament cannot be imagined. Were the picture leaner, less complex and rich, the metaphor would be lost in its insistent stridency, its claim to be symbol. Bayer's strategy in this painting has been sovereign: the picture is offered as a scene wrenched from time and the seasons, from barren stripped white trees and pictures of leafy branches, set into a sky that recedes to the edge of night. A magnificent bird contemplates through a gray wall the egg it has fashioned. The bird is trapped and cannot reach its creation. The cage seems insubstantial, evanescent as the clouds that float inside the cage and beyond. If one may venture to guess, Bayer was certainly preparing to leave the Bauhaus, to move beyond its claustral obligation toward an unsupervised world where creation can be brought to consummation, the shell broken, the image bird released, the narcissistic other vivified.

The dilemma of personal creativity evident in this simple metaphoric painting was soon to be resolved. During the early spring, Breuer and Bayer submitted their resignations from the Bauhaus to Gropius. Both felt the need to relinquish teaching for practice and determined to leave as soon as possible. Gropius asked that they postpone their resignation in order to permit him to resign first. This was accomplished during June when

Bird with Egg 1928/21, collage with gouache,
12 x 19".
Collection Joella Bayer.

Gropius resigned and virtually simultaneously Breuer and Bayer, now joined by Moholy-Nagy, left the Bauhaus. After an extended bicycle holiday in Southern France and Corsica, Bayer moved to Berlin.

Berlin Diversity: 1928–1935

Bayer's Berlin years afforded him precisely the kind of absorption in the real world that the Bauhaus had denied him. He had all along chafed at being placed in the awkward position of teaching while he continued to learn, instructing others while he lacked the praxis necessary to persuade himself that teaching was not in some measure subterfuge. His arrival in Berlin in the fall of 1928 was hardly noticed by the moiling society, its intellectuals, artists, ideologists, and émigrés who gave that society its inspiration and its vaunted decadence. Since he was poor, although by that point already married to his American-born first wife, the photographer Irene Hecht Bayer, whom he had met at the Bauhaus where she had come to attend lectures as a nonmatriculating student, he entered upon responsibility with a vengeance. By and large his financial needs were met by his becoming art director of German *Vogue* and shortly thereafter design and art director of the Dorland advertising agency,[50] but the problematic of his painting, significantly advanced by the work of 1928, lapsed for nearly a year and a half while he adapted himself to the demanding public life of Berlin.

When he returned to painting in 1930, virtually all of the problems posed by his earlier work had been resolved and would never recur, although fragments of their subject matter were retained and became emblematic in many later periods of his work. One cannot assume that his identity as a painter had clarified and achieved self-assurance, although the ambulatory ego-alphabet of his letter paintings do not reappear, any more than do his pictures about painting pictures. What is retained is no longer the issue of the artist's dilemma but rather elements that afford his later work an emblematic mystery or an atmosphere index. The paintings that resume in 1930 make use once again of clouds, but clouds are now established as a mark of cosmic weightlessness, the image hanging in a benign and unaggressive sky, clouds distant, graceful, pacific, inviting the viewer into the picture without threat or alienation as in *Cloud Picture* 1928/10, *Studio Beach* 1928/30, or *Blue Hour* 1928/25. Sometimes, however, the clouds darken and intervene in the picture's composition, acquiring a more naturalistic presence toned to the color of the painting, as in *Bone and Fruit Piece* 1930/12. But in the majority of the paintings of this period the clouds are patterned elements, indicating background and relief, pointing to infinitude, distance, the genial impassivity of the cosmos. Clouds do not yet register, as they will, a baleful, conflicted, violent universe.

Bayer, never a close observer of political events, was not yet recording (as he would by the end of the 1930s and during the '40s) the dreadful auguries of political catastrophe in Weimar Germany and the doom of its free institutions—and even when he would come to such reflections, the disorder and aggression of human society would be distanced and transformed into cosmic conflict. The human person is little in evidence in his work (other than for classical archetypes, bone forms, or the mummified dead of the Capuchin monastery in Palermo), cosmic nature being the principal *scenum* on which he would display his despair with the human order. The rendition of clouds was and would continue to be an accurate barometer of his mood, often joyful, sometimes tormented and buffeted by the winds of nature's outrage.

Following his kayak trip down the Danube during the summer of 1934 with Marcel Breuer, and their visit to the astonishing medieval city Skopje in Dalmatia and subsequent stay in the Greek islands, many of them virtually deserted, where he principally photographed and sketched, Bayer executed a group of transitional paintings dealing with classical Greek themes—renderings of Cretan wall motifs, Greek temples, friezes from Mykonos. It was to be the last time that such classical investigations were seriously to occupy his work. Later, when such depictive themes occur in response to his visits with his second wife, Joella, to Sicily in 1953–54, or his trip to Morocco and Ibiza in 1963, and later impressions of Tangier, where he acquired a house near the casbah in 1966, the drawings are personal, intimate, pleasurably annotative, without running the risk of the uncomfortable archness of the Greek series of 1934. By the late 1930s Bayer had succeeded in separating and maintaining the distinction between the function of drawing in graphic design and its use as a means of introducing the personal hand into commercial advertising (always used in conjunction with rigorously controlled photographic elements and typography) and drawing as the scaffolding of composition in painting. Cut loose from their moorings in design, where the composition is structured and held by mechanical elements, the watercolors produced out of his Greek holiday of 1934 are somewhat banal comments on their classical sources, too obviously derivative (*The Greek Profile* 1934/8), too studiously emblematic (*Mykonos* 1934/6), and too easily confused with the literalness of the contaminated classicism that had begun to sweep Germany after the advent of the Third Reich.[51]

Among the paintings of the middle 1930s, there are, however, several that prove to be decisive since they cast forward to themes that occupy Bayer for the coming decades. These paintings alert the attentive viewer to the onset of new motifs initially asserted simply as transformations of material already gathered and rehearsed. Although I will refer to them later when the groups to which they belong emerge full-blown, it is important to recognize that amid the incredible busyness of Bayer's Berlin years (years that saw his rise to celebrity as a designer, the birth of his only child, Julia, in 1929, and his separation from Irene Bayer in 1932, then the catastrophic accession of Hitler to power in 1933), he sustained an order of production that, although modest in quantity, secured critical notation of themes that would occupy the center of his career.

The three pictures *Whispering* 1931/4, *Mountain Picture* 1931/5, and the superb *Crystal Mountain* 1935/5 begin Bayer's inquiry into the convolution of natural forms, curiously conjoining two problematic themes: his desire to depict the agitation and dynamism of natural upheaval and transformation, adumbrated in the shock of sound distorting the undulating apparatus of the inner ear, and the flat depiction of mountains, which, by the late

Bone and Fruit Piece 1930/12, tempera,
9¹/₂ x 12¹/₄".
Collection Joella Bayer.

Mykonos 1934/6, gouache, 12¹/₂ x 18³/₄".
Collection Fabienne Cravan Benedict, Aspen.

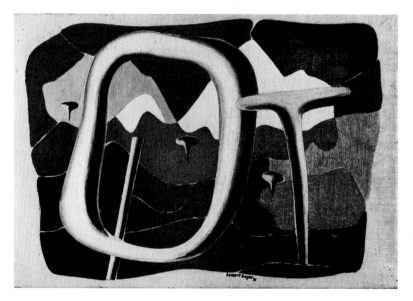

Mountain Picture 1931/5, oil on canvas,
16 x 23¹/₄".
Courtesy Galerie Thomas, Munich.

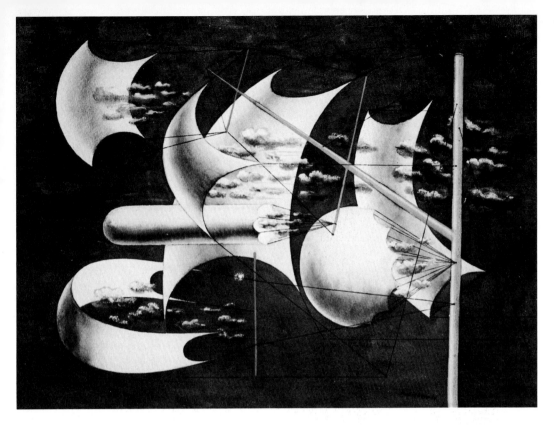

Wind 1934/2, watercolor, 16½ x 22″.
Collection Joella Bayer.

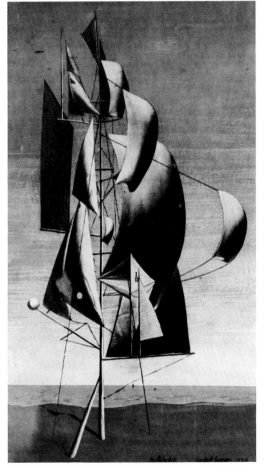

Segelplastik 1934/13, watercolor and collage,
20 x 15″.
Collection Joella Bayer.

1940s, will be utterly synthesized into the convolution of mountain ranges taking on the reverberating forms of the inner ear alluded to in *Whispering*, the flat mountain ranges represented in discrete patches of green, gray, and white before which the bone shapes and implements (which would become the principal elements of the "Dunstlöcher" series begun in late 1935) are statically displayed. In other words two pictures painted at the same time exchange technique and thematics, the flat natural literalness of the one acquiring the dynamic movement of the other, the inner ear becoming the upheaving mountain, an image of sound becoming the means of visualizing nature's transformations. The other two paintings, *Wind* 1934/2,[52] and *Segelplastik* (*Sail Sculpture* 1934/13), anticipate the weather signal paintings that predominate in the "Signs and Signals" series begun in 1939 and continued throughout the early 1940s.

The "Dunstlöcher" Paintings: Soft Form Paintings (1935-1937)

Beginning in the early 1950s, Bayer got into the habit of developing a brief statement to set forth the historical suggestion, autobiographic occasion, or aesthetic attitude implicit in each series of paintings upon which he was engaged. Such brief statements, never more than 750 words, served to recollect and interpret paintings done several decades earlier, but as the years have passed, they have enabled him as well to define the underlying intention of each group of paintings as a way of completing a series, and to develop a springboard for a series about to be inaugurated. Bayer thinks in an extremely orderly manner, his mind, like his desk, tidy, lineated, clean; and yet, despite such apparent fastidiousness, he is not always able to find what he's looking for, which is as healthy in painting as it is disconcerting in desk management. It is no wonder that the modest statement Bayer wrote in 1970 to recollect his thinking about the first coherent group of paintings that he annotated—the "Dunstlöcher" images of 1935-1937—as clearly as it elucidates their origin, remains enigmatic in explanation of the paintings themselves:

my fascination with and admiration for the old peasant houses dates back to my wandervogel days (1916-1919), when I hiked through the austrian countryside. of special interest to me were the barns and stables into which were cut windows of various and ornamental shapes, which are probably of baroque origin. these "windows" serve as vents for the hay stored in the barns and are called "dunstlöcher" (vapor or haze holes). against those barn walls, all sorts of implements for the peasant to use in agriculture were leaned or hung on hooks—shovels, rakes, harrows, threshing clubs, ladders, hook, poles to hang the hay to dry in the fields, ropes, etc.

it was later, during the thirties, that I remembered these barns and stables and painted a series of "dunstlöcher" paintings. their poetic and surreal conception is perhaps best represented by *barn windows*, (1926/11) painted in oil. I can understand why these paintings have less meaning for those who do not know the archaic nature of this subject, which is usually judged to have only sculptural interest. a three dimensional character is, of course, indigenous to these paintings, as my several attempts to make

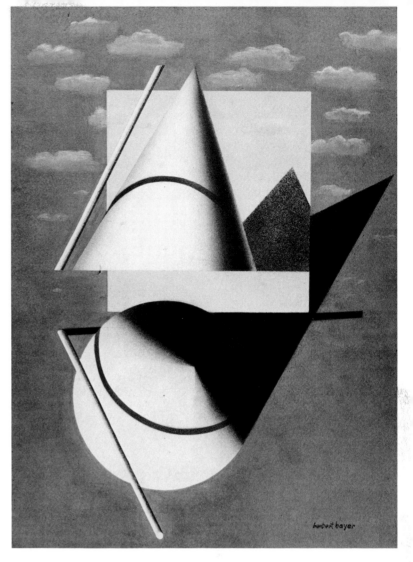

Shadow over Cone 1934/3, gouache, 14 x 11".
Collection Joella Bayer.

them into sculptural reliefs exemplify (for example, *wall sculpture* 1937/3 or *wall sculpture with two holes* 1937/4).

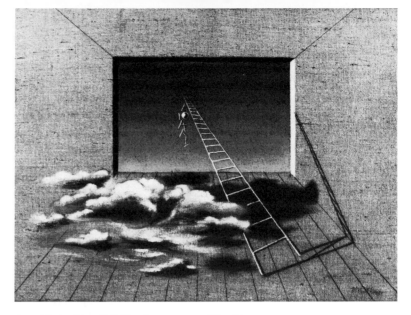

Jacob's Ladder 1935/6, oil on canvas, 50 x 40 cm. Collection Louise Pike.

Actually, Bayer anticipated the archaic forms embodied in the "Dunstlöcher" two years earlier with a small metaphysical painting. *Jacob's Ladder* 1935/6, although related in format to the tree and frame paintings discussed earlier, is more tantalizing precisely because it is unique in Bayer's oeuvre. Surely, it is related to the autobiographic inquiry described in the alphabetic self-portraits (*Portrait HB*) and the autobiographic commentaries (*Zartes Bildnis E* and *World of Letters*), but unlike them, *Jacob's Ladder* reverses an orderly universe, turning inward a vision that seems directed to the outside world. A simple format: a capacious room, perspectively marked, floor boards with receding perspective, a large window without frame or glass, through which can be seen a shadowed night; but strange, the night clouds, billowing, unsettled, hover just above the interior floor boards, casting dark shadows on the floor and the base of the right wall; and arising from the right, throwing an almost correct shadow on the wall, a ladder reaches out of the window into the night and at the point at which the eye limns the disappearance of the ladder into infinity, a disarticulated Jacob—small sphere and slat limbs with obscure resemblances to de Chirico's and Schlemmer's figures—loses its grip upon the ladder.

The wonderment of *Jacob's Ladder* is not only in its surreal disposition of elements, its simplification of a de Chirico subject matter seemingly rooted in the Biblical narrative, but rather in its relation to the "Dunstlöcher" paintings that were to emerge from it. Particularly notable is Bayer's wish to exchange the relation between inner and outer, domestic space and infinite space, to force the cloud forms inside and man outside, to reverse the human and the natural. This reversal is precisely what gives this small picture its uncanny atmosphere, making it in my view one of the finest of Bayer's metaphysical images. But in the context of the "Dunstlöcher" and the "Signs and Signals" pictures that follow it, it contains Bayer's first use of a standard farm implement—the ladder, which in *Jacob's Ladder* alludes to a hieratic, sacred tale of aspiration and blessing, aspiration blessed however with a recorded historical sense of endlessness, unfulfillment, ambiguity, itself an interesting transformation of the Biblical narrative into a metaphysical symbol of unease.

Jacob's Ladder, although not explicitly related by subject matter to the "Dunstlöcher" paintings, contains a psychological anticipation of their format, the reversal of interior and external space, the displacement of natural presentness, the creation of a surreal (or transnatural) cosmos in which what appears to be solid becomes evanescent and what is regarded as transitory and epiphenomenal becomes primary and fixed. The metaphysical and mythic explicitness of *Jacob's Ladder* finds its natural extension and rooting in the "Dunstlöcher" paintings. It is precisely here that Bayer's use of the term *archaic* in his description of this series in 1970 arrests us.

The archaic, a word given considerable psychological and religious enrichment by the investigations of Mircea Eliade,[53] is used by Bayer with ready ease and familiarity. It is a critical clue to the

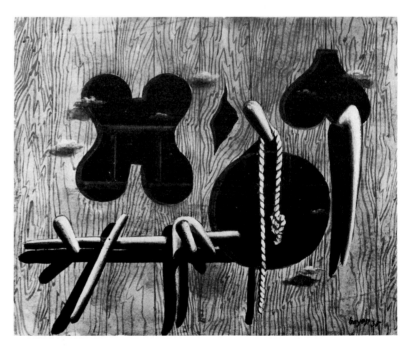

Nächtliche Dunstlöcher 1935/2, watercolor, 9½ x 11½". Collection Joella Bayer.

interpretation not only of this group of works but of Bayer's whole self-understanding as an artist. As the great communicator, the interpreter and translator of the sign language of the universe, the artist has a shamanic function. It is the artist who reaches into the deep regions of the universe and locates images that assist those whose sight is earth-bound to see connections otherwise obscure. The artist—at his most profound—is shamanic at precisely those moments when he takes the archaic foundations of culture (or even more precisely the archaic foundations of the psyche) and enables us to see them. The barn walls of the Austrian peasants, with the sign language of their rhythmic interaction with nature and cosmos, defy history and human event, illuminating not human time but cosmic time, not ornamental space (which architectural urban societies elaborate) but cosmic space, which hums in the seasons and turns according to the cycles of nature. Clearly, the artist in such usage is not visionary or prophet (although this, too, is relevant in the understanding of artists such as Paul Klee or of the Tantra art of India) but rather more modestly a deep perceiver who lifts the imagery out of an embedded context and enables us to see its meaning unconfined by local usage or convention. It is in this sense that we understand the "Dunstlöcher" series.

The earliest painting in this series, *Nächtliche Dunstlöcher* (*Nighttime Dunstlöcher* 1935/2), is typical, and incidentally confirmatory of the connection suggested between the series as a whole and *Jacob's Ladder*: a panel reproducing the green wall of a new, unweathered barn into which have been cut three apertures—inverted heart, circle, amorphic clover leaf—from which hang whitened, blasted implements. Through the major apertures can be seen a floating ladder, horizontally positioned against a black night dotted with tiny stars and gray clouds that shimmer in the darkness as well as on the green paneling. It is a congerie of objects and their shadows the source of whose light is behind the panel in the night. Whatever light is cast directly on the panel must emanate from an ineffable, universal source that is neither light nor dark, perhaps divine, but more likely the artist's clear sight. The series of paintings breaks off and resumes in 1936. Night disappears, the walls are weathered brown, the objects, no longer mimetic of the shapes and implements of the farm, have become the soft form images of ancient totems and devices, whose function can be guessed but not confirmed: clubs that seem made of rubbery substance, bone forms perforated with holes, sticks that are prehistoric weapons (although rounded and smoothed so that they appear to lack lethal potency), and again ladders that move between the frontal display through apertures to the unlimited space behind. Some of the barn walls are white, some beige; the apertures pierce through to night, the implements hanging on the wall or hooking into the openings become softer still, no longer implements but drapery or fleshy legs, prehistoric cookie cutouts, wheel hubs and spokes.

The "Dunstlöcher" paintings are superlative articulations of a transfigured imagination. First arrested by ancient Greece the year before, Bayer's imagination found an authentic substance in the imagery of his childhood landscape, as archaic as is a time that has no history, only calendrical sequence. There are two paintings—the last in the series—that point to this interpretation.

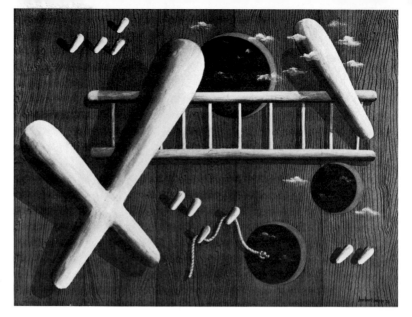

Barn Windows with Ladder 1932/3, tempera, 12¼ x 16¼".
Collection William P. R. Smith, Santa Barbara.

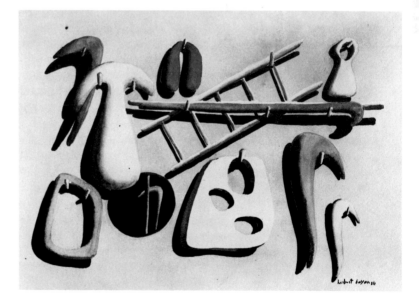

Stable Wall 1936/2, watercolor, 10 x 14".
Collection Joella Bayer.

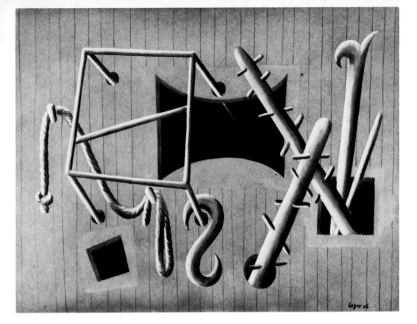

Stable Windows with Rope 1936/8, gouache,
13½ x 18″.
Collection Joella Bayer.

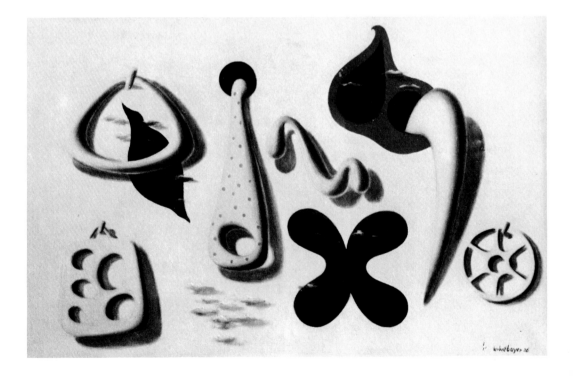

Dunstlöcher, Weiss 1936/12, oil on canvas,
24 x 37½″.
Collection Nationalgalerie, Berlin.

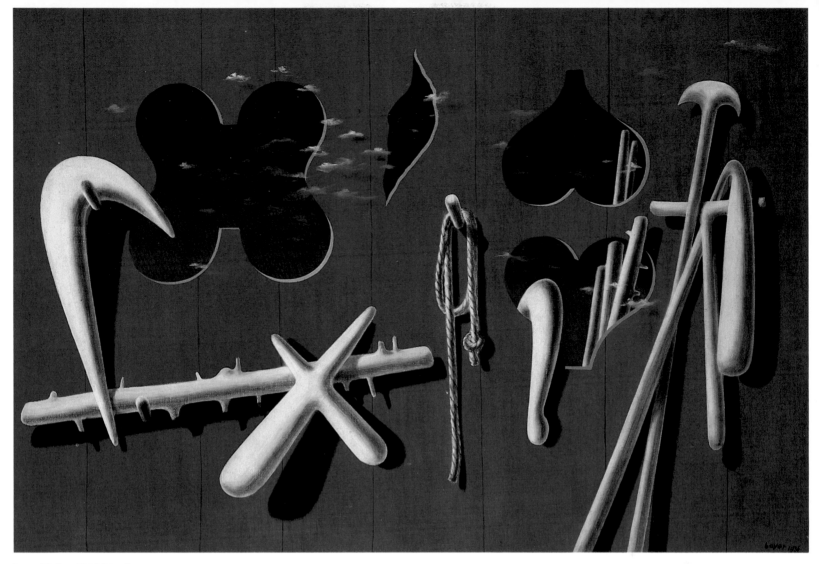

Dunstlöcher 1936/11, oil on canvas, 37½ x 47¼".
Collection Westfälisches Landesmuseum für
Kunst und Kulturgeschichte, Munster.

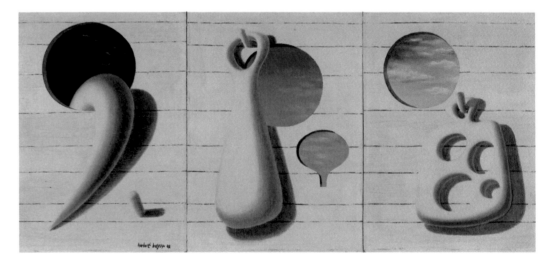

Times of Day 1937/1, oil on canvas, 11¾ x 15¾".
Collection Staatsgalerie Moderner Kunst,
Munich.

Deposition 1940/2, oil, 36 x 42″.
Collection Joella Bayer.

Times of Day 1937/1, a horizontal picture divided into three panels, contains three apertures through which are seen a beige, early morning sky with translucent clouds, a blue midday sky with white clouds, and a night sky with gray clouds; from each aperture or before each panel a soft form element, benign or elusive as the day's moods progress, calmly hangs. Unlike de Chirico's midday cityscapes where light and time seize and threaten, Bayer's painting has moved beyond psychic unrest and imbalance to the postulation of a rhythmic order and alarm, tied to nature, fixed by the seasons, beyond human control and hence both archetypal and archaic.

It is a short step from the implements of the barn wall to the flat panorama of deadly weapons by which Jesus of Nazareth is brutalized on the Cross. In *Deposition* 1940/2, painted shortly after the war had begun and Bayer had found refuge in New York, the archaic imagery has moved toward a religious intensification, a static distillation of themes being explored in other ways in the "Signs and Signals" pictures he was then making, a marking of clear separation between the archaic imagery that lent itself to soft form sculptures and the impending recrucifixion of the human race boded by a Nazi victory, which in 1940 seemed more than possible. Arranging the gray tableau much as he had arranged the implement of the blacksmith's forge in his Sicily drawing of 1924, Bayer pictorializes a synopsis of the agony of the Christ, the crown of thorns, the saw, the club, the hammer and nails, the ladder, the tunic, the legionnaire's spear arranged in linear succession so that the events leading up to Christ's death can be scanned and understood.[54]

Emigration and Despair: 1938–1942

It was no longer possible to keep clean of the Nazis much after 1936. A brilliant catalogue Bayer had designed for Das Wunder des Lebens exhibition organized by the Messenamt in Berlin in 1936 was stopped on press, and under pressure from the ministry of propaganda a small photograph of Adolf Hitler was inserted. The same had happened earlier in the year at the time of Bayer's design of the Deutschland Ausstellung catalogue; a double-spread montage celebrating National Socialist Germany was required.[55] Until 1936, the ministry of propaganda had generally left graphic designers alone, particularly those who were not Jewish and whose work was generally without political implications. Although Bayer confesses he later realized his own vulnerability to attack, given the party's animosity toward the trade-union movement, which he, Gropius, and Moholy-Nagy had served by their design of the major exhibition for the Building Workers Union in Berlin (1930–31), he felt that design work was not politically significant. By 1936, however, the Nazi bureaucracy had become sufficiently well organized to control every facet of German social and economic life. Although Bayer had remained incontestably loyal to his considerable Jewish clientele at the Dorland Studio, by the end of 1936 he had become aware that the conditions allowing productivity and freedom of artistic creation were being choked off. Like many other important German artists of the period, some of whom went into what came to be called "internal emigration," Bayer knew that the time to leave was fast arriving. Given that his wife and daughter were Jewish, it was no longer an option to stay put, to "tough" it out as did those who imagined that the madness would pass.

After long consideration, accelerated by the Anschluss, which drew Austria into the orbit of the Greater Reich and converted Bayer from a resident Austrian into a German national, he set his course on emigration. Bayer recognized that his work as a graphic designer was less threatened than his work as a painter. Although he had never exhibited in Germany, except for an occasional picture in a group exhibition, he was inextricably linked with the Bauhaus, and a number of his works in German museum collections were selected by the authorities for inclusion in the traveling exhibition of Entartete Kunst (Degenerate Art), which toured the museums of Germany and Austria in 1938.[56] Clearly, it was possible to ignore Herbert Bayer as a graphic designer, at most to compromise an occasional design, but as an artist he was considered "degenerate" and in time would be made to suffer for it.

During the spring of 1937, Bayer traveled with Carola Giedion and Lady Peter Norton to London to install an exhibition of his paintings and photoplastics, which opened on April 7 at the London Gallery. Bayer had met Lady Norton several years earlier while skiing in the Tyrol and had introduced her to the world of modern art. Subsequently, she founded the London Gallery on Cork Street, and she facilitated Bayer's introduction to the English-speaking art world. The exhibition, introduced by Herbert Read, achieved considerable notoriety as a result of the remarkable photomontage that Bayer prepared for the entrance doorway to the gallery and adapted for the invitation card to the exhibition.

After a brief return to Berlin during the late spring, Bayer visited the United States, in company with Marcel Breuer, from mid-July through mid-September 1937. He had come to the United States in order to see for himself if it was possible for him to emigrate and survive. Bayer recognized that he would be obliged to start over, to reestablish his credentials as a European graphic designer in an industrial community dominated by a completely different conception of advertising. It was fortunate, therefore, that he was invited to take part in a meeting held at the seashore near Providence, Rhode Island, where Walter Gropius, who had already arrived from England and taken up a teaching position at Harvard, had rented a summer home. At that meeting, Moholy-Nagy, who had come from Chicago, tendered an invitation to Bayer to teach at the New Bauhaus in Chicago.

In addition to reviewing the statutes proposed by Moholy for the New Bauhaus in Chicago, the meeting was convened to plan the major exhibition on the Bauhaus that the Museum of Modern Art wished to mount at the end of 1938. Also present were Alexander Dorner, former director of the Landesmuseum in Hannover and president of the Kestner Gesellschaft, who emigrated aboard the same ship that brought Bayer for his visit; Mary Cook (who was to become the wife of the American architect Edward Larrabee Barnes); and John McAndrew, who served as curator of architecture at the Museum of Modern Art. Bayer received the commission to design the exhibition and to organize the accompanying monograph *Bauhaus 1919–1928*. But more dangerous than the determination to mount such an exhibition (in itself a political act

of opposition to the Nazis) was the responsibility Bayer accepted for contacting the principal masters and students of the Bauhaus left in Germany, borrowing works from them for the exhibition and carrying them to the United States when he emigrated.

Returning to Berlin once more, he terminated his business associations, assembled the Bauhaus material, and began the long negotiation to complete his emigration documents before departing. The German tax authorities required that everything lent to the London Gallery be returned. Since the works were in a foreign country, Bayer was prevented from leaving until they were returned. Moreover, after his Austrian passport was lifted following the Anschluss and he was made a citizen of the German Reich, he found himself in the anomalous and exceedingly dangerous position of carrying a passport bearing both a visitor's visa and an emigration visa. As it turned out, a tax official who passed on his final application was sympathetic to his situation and validated his documents, stipulating only that the works shown at the London Gallery be returned to Germany for inspection, after which they would be shipped to New York. (They miraculously arrived in New York a few months later.) When the works arrived from London, Bayer sailed for the United States, arriving in New York on August 28 with less than twenty dollars in his pocket.

The work awaiting him on the Bauhaus exhibition for the Museum of Modern Art and a commission he received shortly after his arrival to design several advertising pages for the Container Corporation of America were auspicious beginnings for the second half of his life. Bayer had ceased to be an Austrian artist trained at the Bauhaus and had become first an American artist and, in July 1944, an American citizen. Of course, it has always been difficult to persuade the American art establishment that citizenship is what makes an artist American. In the absence of an aesthetic ideology that is pristinely American, it has been simpler for museums of American art (whose chauvinist narrow-mindedness is sometimes ill concealed) to regard Herbert Bayer as an Austrian artist, or a German artist, or a European artist, even though—as will be seen—the most important body of his creative work has been undertaken and accomplished in America.

It was not until after installation of the Bauhaus exhibition at the Museum of Modern Art was completed in December 1938 and the book detailing the history of the Bauhaus and its program was published that Bayer was able to return to painting.[57] He was by then settled in a small apartment on West 56th Street in Manhattan where he lived and worked, but the two groups of paintings that developed and interlocked reflected his agitation and sense of dislocation. The paintings, loosely grouped by him as images of "Signs and Signals" as well as atmospheric conditions and interaction in outer space, contain many elements that have appeared before (clouds and wind, the implements of agriculture previously displayed against barn walls); however they reemerge now, both separately and interconnectedly. They announce a forswearing of a pacific universe and propose a ferocity new to Bayer's work. The very first, untitled watercolor of the year (1939/1) displays the heavens and the earth passing through each other, the dark blue of the heavenly sphere, dotted with red meteoric fallout and floating planets, turns the cheerful yellow of the earth gray-green, and

surreal shapes, borrowed from the walls of his Austrian barns, disport themselves as totemic substitutes for man and his creations. What had previously been static and flat in the "Dunstlöcher" are now freestanding poles and amorphic forms which, along with geometric shapes, acquire a three-dimensional mass capable of throwing red shadows on the yellow landscape. A superb picture, bright, appealing, but resolutely fantastic, it joins with other pictures that will follow during the year in making an assertion about Bayer's surrealism that his first interpreter, Alexander Dorner, has seen as a benignant introduction of common signs and symbols, shared dreams, conscious reflections that repel association with either de Chirico's metaphysical voids and alienating nightmares or the surrealist introduction of unconscious automatic creation.

This first picture of 1939 (one of the few in Bayer's oeuvre to remain untitled) lacks a name for what may be the most significant of reasons: none of the signs or signals he employs is yet recognized by him as either *signs* or *signals*. When these implements and constructions first appeared in the "Dunstlöcher" paintings four years earlier, they were clearly allusions to possibilities lodged deep in the natural psyche of the peasant world—everything alluded to a vast, tumultuous but finally manageable and productive nature. The peasants survived: year after year, they filled their granaries, used their tools, scythed and threshed their grain. The transformation of real into imaginary implements, actual nature into dream nature, still maintained connection with archaic rhythms that ordered and held natural forces in check. Nature was plenitude and mystery, abundance and wonder. Bayer was able to examine these archaic shapes and transform them, flatten and soften them like putty and clay, blunting sharp edges and points into soft forms, which lay inert upon the surface of the barn walls or oozed over the edge of their openings.

The year of the new interpretation and extension of his gentle surrealism from meditations on nature and the self into cosmic investigations that no longer shied from the tragic dramas of the human race—murder and war—or the immensity of natural upheaval—cyclone, cosmic winds of immense heat and cold, heaving planets and galaxies—was also the first year of emigration and the first year of world war. The untitled picture of 1939 begins the drama of the year's painting in slow motion, heavens abrading the surface of the earth and charging it with darkness, the symbol system of poles and triangles, balls and soft amorphic creatures displayed at rest on a summer landscape. Only the overwhelming brightness of the yellow—blindingly yellow against the blue heavens—and the red shadows thrown presumably by the small meteors that dot the sky suggest an ominousness, an unstabilizing atmosphere in which these seemingly serene forms could become, with just the slightest shift, the weaponry that will shortly appear in his painting.

The early part of the year is filled with uncertainty and ambivalence in Bayer's rendering of his increasingly personal and premonitory subject matter. The experimental play that dominated his paintings of the 1920s and the early '30s has disappeared. The hesitancy that attended his separation of painting vocabulary from the common sign imagery of his graphic design has vanished. The issues are no longer technical. What occupied Bayer

during this most critical year of his painting was the settlement of the primary issue of intention and subject. He had retained from his work of the previous two decades certain signature images that had come to be identified with his visual vocabulary—clouds, amorphic human bodies, animate geometry. Classicism, however, was finished for him as a painting metaphor. (Moreover, it didn't work in America, which possessed no traditional obeisance toward classical culture.) As a device, classical allusion could be used for the creation of resonance and reverberation in consumer communication (where Bayer occasionally used it during the early 1940s)[58] but no longer in the more subtle, adumbrative vocabulary of painting. Moreover, Bayer now found himself classified with the surrealists, although he regarded the connection as virtually meaningless.

The surrealists were intent on the rendering of the unconscious, the dream life of the disjunct, the automatic, the anecdotal, the poetic concatenation of impossible elements, whereas everything in Bayer's painting was recognizable, in a sense, clear and unmistakable. What was difficult in Bayer's paintings was the insistence that such perfectly clear elements could exist in a cosmic atmosphere that nobody had ever experienced. The atmospheric paintings in which winds whoosh through perforated panels in an infernal climate (*Wind* 1939/13) or vast cumulonimbus clouds, floating beneath an overhanging roof and toward an interior wooden wall (*Descending Clouds* 1939/8), are pictorializations of a cosmic aerodynamics. Infinite nature was now housed in the human mind and represented by the imagination: the clouds were always real clouds of astonishing shape, variety, density, and mass; the winds were no less powerful and irrational. What was unknown was the imaginary field on which these natural forces played and there, legitimately, Bayer was free to imagine. He had no interest in organizing the reconciliation of contradictories as did the painting of René Magritte or the biomorphic inventions of Yves Tanguy or Mattá, or the hieratic episodes of Max Ernst.

Bayer's surrealism was always an excogitation of possibility, a conscious fabrication of supraterrestrial forces and polarities, sometimes juxtaposed to designed elements as in another untitled oil painting (1939/19), where a realistic globe counterpoises a startling moonscape covered with lunar cones interrupted by a wall before which the dominant shape of a cumulonimbus cloud reflecting its shadow can be seen. These paintings of the fluidity of wind and cloud, recollecting the two earlier *Sail Sculpture* pictures, have moved decisively beyond the gay and winning machinery of wind before a linen sail. The winds have now become trumpets of nature, warnings of apocalyptic terror, and although partly realistic in their depiction, no less surreal as they move out of a baroque sky in which unseen wind-swept archangels blast toward the floating panels that diffuse their power and channel it from the gray, black, brown, blue swirl of the nether heavens toward the light blue and pastel yellow of a redeemed heaven. This picture, *Wind* 1939/13, had grown out of an earlier and more simply formulated picture in which two white, freestanding baffle walls receive through their respective circular apertures the press of the highest cirrus clouds pushing through the first hole from a white aerated sky, accumulating near the first wall, a stream of whose powerful

cloud shape passes through a second dominant wall situated before a yellow skyscape where it separates into two streams of clouds, like the trumpets of heaven. Called *Annunciation* 1939/4, it may well allude to the Holy Ghost at the Incarnation or it may announce the apocalypse to which the Archangel Michael seems called in *Wind*.

The two pictures, related in format and presentation, are essentially ruminative, religious pictures, the latter ecstatic and terrifying, the earlier serene and hopeful. Both pictures give way, however, by late 1939, to a more controlled and impersonal representation of explosion and transaction in space. "around 1940," Bayer has written, commenting on these pictures, "the paintings explode with diagrammatic arrows, flying receptors and activities in space. they reflect a vision of cosmic intervals and exchange inspired by the sciences probing into the universe. meteorology, the weather and other happenings are part of the subjects" (117:22).

Before Bayer could arrive at *Tensity in Universe* 1941/1, *Interstellar Exchange* 1941/2, *Fata Morgana* 1942/3, *Celestial Spaces* 1942/5, *Atmospheric Conditions* 1942/8, or *Messages Through Atmospheres* 1942/9, all invested with a swirl of colored directional vectors and moving arrows documenting the forces of the weather, he had to pass through the extremely complex and brilliantly realized series of paintings he has called "Signs and Signals." This series, interjected into the baroque cloud pictures discussed above, adopts the vocabulary of the "Dunstlöcher," but introduces into that environment of soft implements, inert forms, and moody colors a symbolic violence, indeed a madness unique in Bayer's work. The universe might moil with wind and bluster, but atmospheric conditions, the riot of weather signals, the meteorological imponderables were far out in space, plotted by whirling balls, thermometers, wind tunnels in those presatellite days, and in consequence fit subject for the imagination fascinated, as Bayer's has always been, with the instrumentation of scientific measurement and prognostication.

The artist could always divine what the meteorologist attempted to understand; yet, however much divining might fail in precise forecasting, it could still devise in vivid imagery. On earth, however, alone and rootless in New York City (his apartment robbed three times during his first six months in the city), in the early days of war, struggling to master a new language, to support himself, to give assistance to his growing child and his separated wife, Bayer found a much more immediate visual language for describing, indeed objectifying his sense of the collapsing human order. Naming the more than score of pictures after the title of a few, "Signs and Signals" reflects an enlargement of the archaic vocabulary he had used in the "Dunstlöcher" as a means of fixing the iconography of his childhood memories—happy memories—of the peasant alpine world of upper Austria.[59] Those same implements of conservation, agriculture, production out of the earth now became weapons, which the peasant armies of humanity used against each other (as several hundred years earlier the peasants of the Salzkammergut took up their implements during the bitter religious wars and turned their scythes, flails, axes against each other) to threaten and to destroy. The pictures express their

Annunciation 1939/4, oil, 11¹/₂ x 15¹/₂".
Collection Joella Bayer.

Tensity in Universe 1941/1, oil on canvas, 37 x 60".
Collection Herbert Bayer.

Interstellar Exchange 1941/2. oil on canvas,
66 x 37".
Collection Joella Bayer.

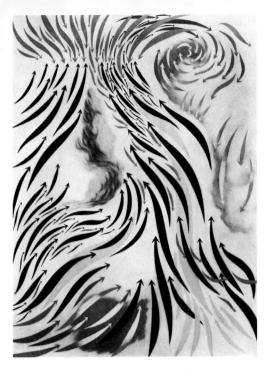

Atmospheric Conditions 1942/8, oil on canvas,
55¹/₂ x 42″.
The Breakers Collection. Atlantic Richfield
Company.

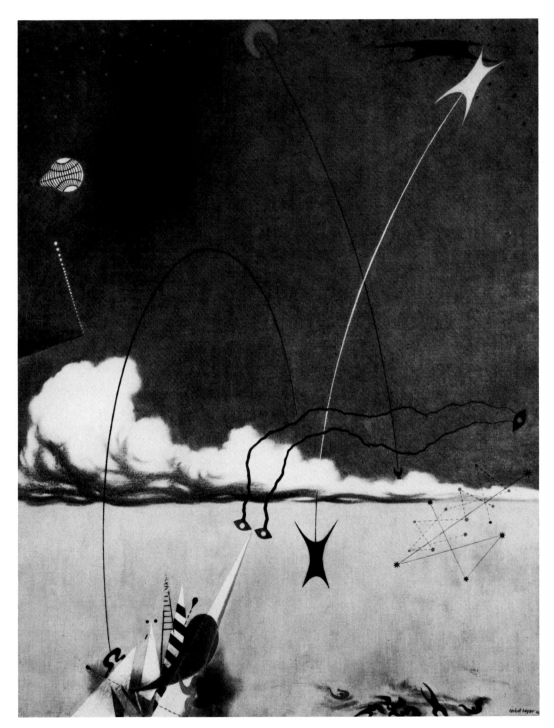

Messages Through Atmospheres 1942/9, oil on
canvas, 40 x 30″.
Collection Ingeborg ten Haeff Wiener, New York.

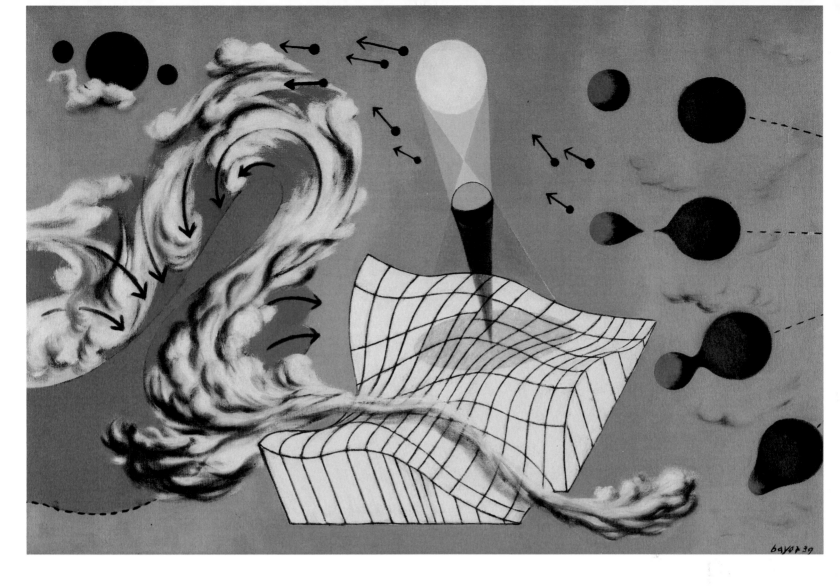

Clouds Wandering through a Valley 1939/15, oil
on canvas, 20 x 30″.
Collection Herbert Bayer.

indebtedness to the fanciful toys, gaming boards, marble geometric shapes that often appear in the metaphysical paintings of de Chirico (which Bayer surely knew by the late 1930s) and introduce such elements into a more architecturally balanced and perspectively rigorous pictorial space.

Detailed coloring, bright, almost garish in tone, inverted human shapes and human shadows (respectively from Picasso and the surrealists), and Miró-like biomorphic shapes invest the paintings with a magical quality, sometimes gay, sometimes macabre. Despite all these manipulations of elements drawn from the glossary of modern painting, the syntax of the elements, their conjuration and disposition, are uniquely Bayer's. Whether he has arranged the vertical implements and weapons (borne aloft by unseen hands and "photographed" by the artist from above) against a yellow earth or a rock-strewn terrain or envisaged them as an army moving behind a rocky wall, the paintings are incredibly ominous. The skies are black or deep blue or filled with ghostly shapes that conduct the armies across the horizon of the picture. The implements themselves, all peasant weapons, are either displayed on a checkered wall, stationary as in an armory awaiting the soldiery in *Signs & Signals* 1939/18, or activated and borne aloft at an angle beneath a ghost-ridden sky in *Call to Arms* 1939/16, or displayed on walls and floor before a fiery hearth in *Archaic Chamber* 1940/3.

Obviously, the most loaded and impressively iconographic pictures of the series—in which signs and signals are always both literal as well as symbolic—are *Crucifixion* 1940/1 and *Second Deposition* 1939/17. *Crucifixion* disposes within a cubistically deformed space brightly colored elements of the Crucifixion, symbolically animated against a cloud-filled baroque sky. *Second Deposition*, quite flat by contrast to *Crucifixion* (although even here a cubist revision of perspective is employed) is dominated by an absolutely realistic wooden cross, set off-center but in the midst of a congerie of ladders, spears, steel-studded poles, and other deadly weapons assaulting the Cross, imparting violence to the only element that hangs on the Cross, the Sacred Heart of Jesus pierced by a lance. Again employing an architectural element (perhaps suggested by de Chirico's painting *The Jewish Angel*, 1916) as an observing bystander to the event, the painting is a complex abstraction of the dramatis personae of the Crucifixion. Although modest in scale, this watercolor and gouache is among the most complex and commanding assertions of Bayer's control of a mythological language. *Second Deposition* and the more elaborate *Crucifixion* mark the middle and the last painting respectively in the series of "Signs and Signals"; they make clear that Bayer has employed all of his storehouse of symbolic language to draw an emotional and pictorial continuum from his Catholic peasant childhood in Austria to the Crucifixion of twentieth-century man, to the brutality of the regime he had left behind in Germany, to the destruction of his own past and, at least by portent and foreboding, the destruction of Western man.

Deeply persuaded and persuasive as these pictures are, they conclude Bayer's preoccupation with the fabulist reading of his personal vocabulary—the symbolism of his own archaic depths, his humanistic rendering of nature as strife and human conflict as

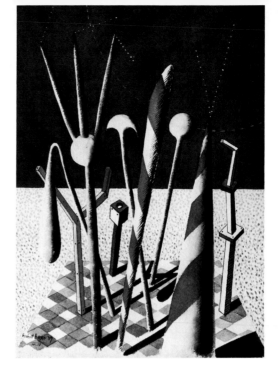

Signs and Signals 1939/18, gouache, 17 1/2 x 23". Collection Joella Bayer.

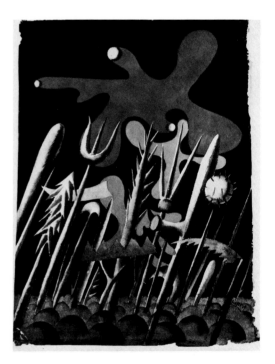

Call to Arms 1939/16, gouache and watercolor, 23 x 17" Collection Joella Bayer.

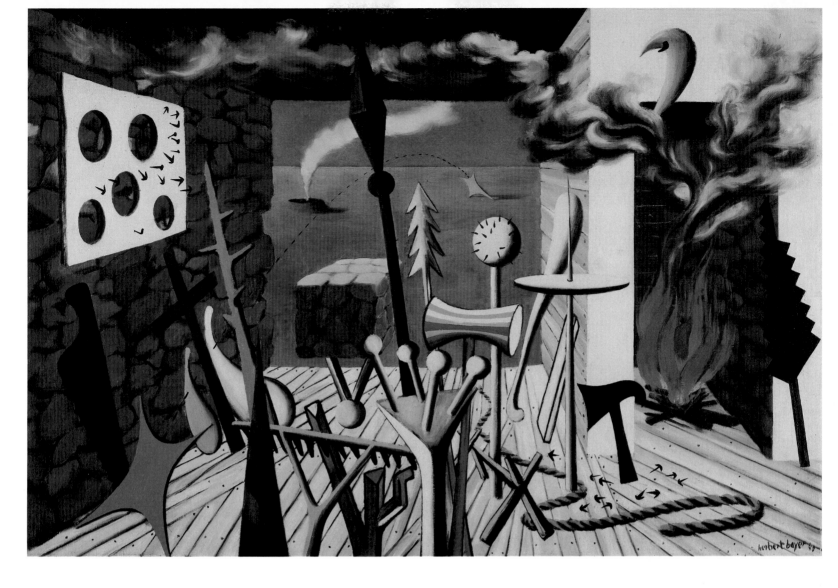

Archaic Chamber 1940/3, oil on canvas,
24 x 36".
Collection Herbert Bayer.

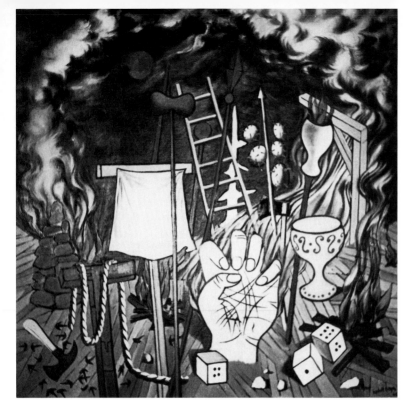

Crucifixion 1940/1, oil on canvas, 36 x 36".
Collection Herbert Bayer.

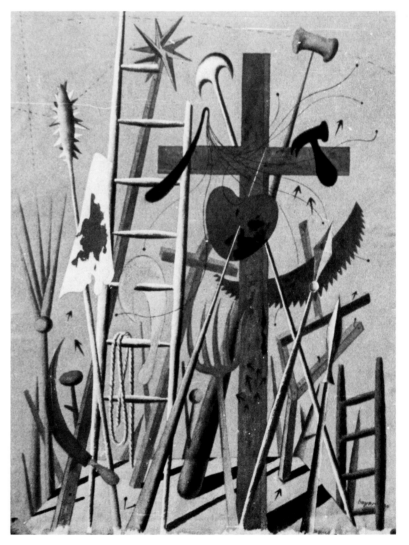

Deposition 1939/17, gouache and watercolor,
24 x 18".
Collection Robert O. Anderson.

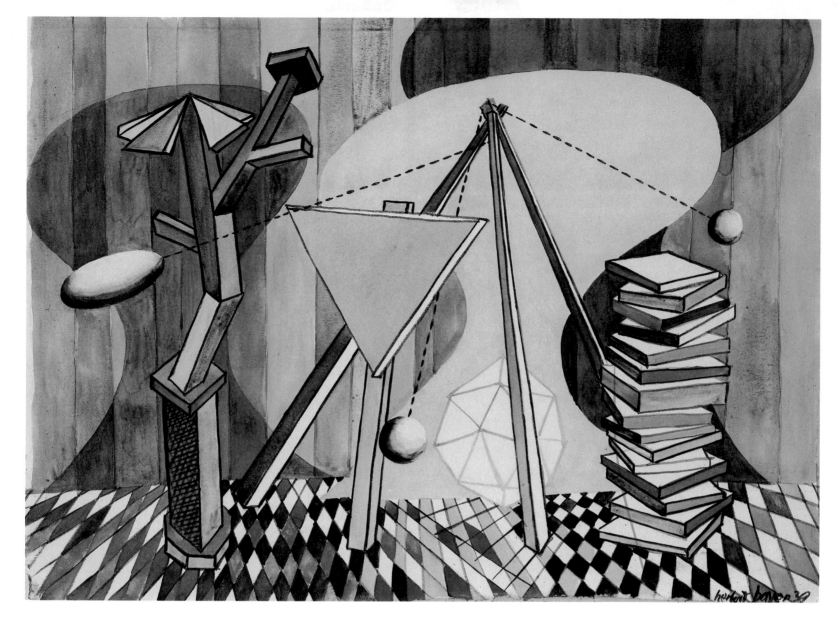

Experimental Geometry 1939/19, watercolor,
13½ x 18½".
Courtesy Galerie Thomas, Munich.

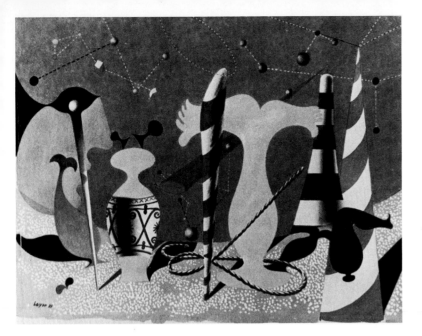

A Set for a Magician 1939/15, gouache,
20¾ x 27½".
Collection Joella Bayer.

natural. Bayer's artistic renderings of the despair of this century will shortly turn in a different direction, setting forth themes that will be resolutely out of nature but no less passionately imagined.

One instinctive principle of order should be underscored, which has dominated all the paintings from 1935 until these symbolic paintings come to an end in 1942: they are all cogently and carefully balanced, elements of weight offset and ordered, the horizon line either imagined or rigorously examined, holding the picture axis and sustaining a dynamic, but palpable tension among the elements. Although the order is somewhat more methodical and static in the "Dunstlöcher" paintings where the predominance of softness and pallor enforce a simpler format, where balance is more easily articulated, the "Signs and Signals" paintings sustain an order even more geometrically precise. This is most obvious in *Experimental Geometry* 1939/19, a superbly vibrant and intense picture in which a sculptural construction on the left, an easel holding an inverted triangle at the center, and an irregularly stacked pile of white rectangles, their exposed sides brightly colored, at the right, set on a floor patterned like Renaissance marble and against a wildly striped wall with large transparent shapes out of Calder sculpture (which Bayer had come to know shortly after his arrival, when the artist became one of his earliest and best American friends) establish a blazing but still architectural and sculpturally frontal ordering of space.

These paintings conclude a major period in Bayer's oeuvre. From the earliest Bauhaus pictures of 1921 to 1923, Bayer had explored his own symbolic language, defining personal shapes and preferred forms, developing (as Dorner has correctly said) a vocabulary of public imagery counterpoised by a vocabulary deeply rooted in his own biography and atavistic preference. Nature was first stage and altar, perceived as interpenetrating with the letter icons of a typographer's symbolism. It then became the issue of the artist and the *objectivum*, the frames and windows both selecting space and enclosing it, balanced with perspectives, shadows without apparent sources of light and light upon objects that produce no shadows. And finally, having worked through these primary subject matters, he returned to the symbolism of deep nature, his beloved mountain landscape, its people, and their archaic language of implements that are silent in repose and in wartime become instruments of violence and thereafter remain keepsakes of the arcanum of magic, mystery, and hope.

The pictures of Bayer's early days, although rarely depictive, invariably contained figures. They are pictures about recognizable elements in obtuse and baffling relationships. They were never surrealist pictures per se, although they sometimes employed (or at least mimed) surrealist strategies of insubstantialism and purposeful deformations of the expected. They were frequently witty, commenting pictures, making statements about the excessive seriousness with which other artists took themselves (indeed a fruitful direction in which further discussion of Bayer's early paintings might go) and the making of art and the artist's ego. Whatever their success—and their success was considerable—it has been possible to see at close hand the growth and maturing of an artist whose full and powerful work was still ahead.

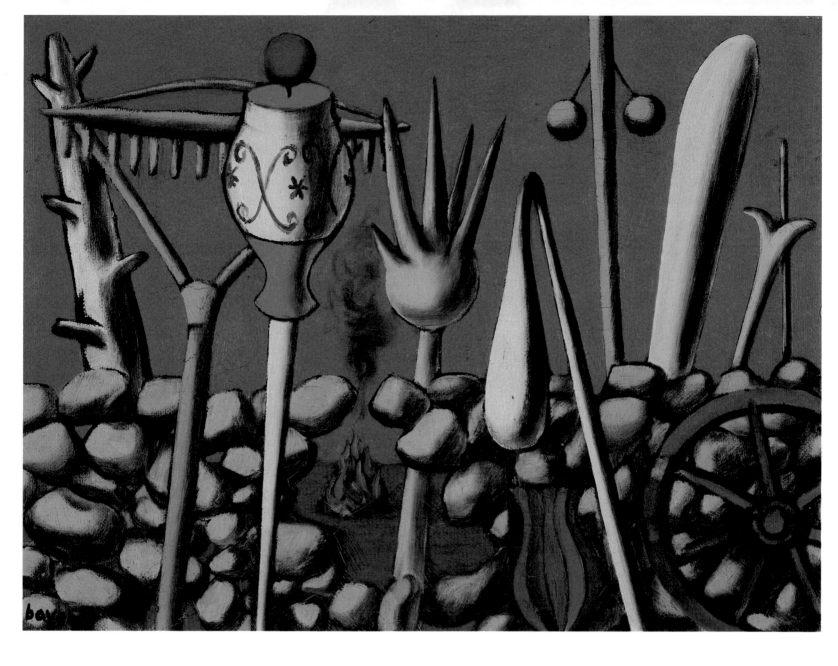

Sticks and Stones 1939/10, oil on board,
11¹/₂ x 15¹/₂″.
Collection Joella Bayer.

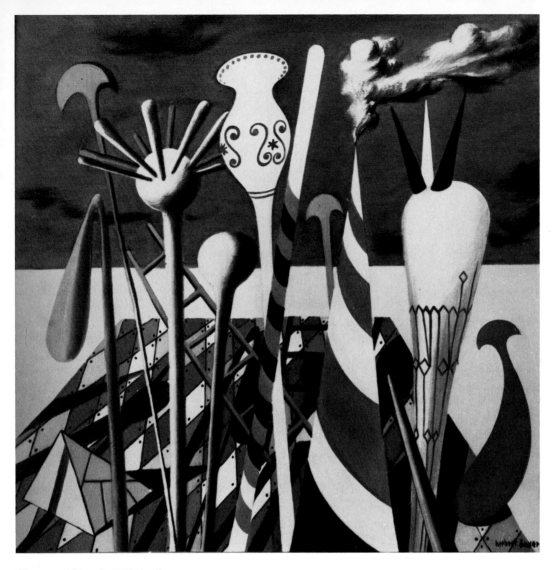

Signs and Signals 1940/4, oil on canvas,
24 x 24".
Courtesy Galerie Thomas, Munich.

"Mountains and Convolutions": After Vermont, 1944

The fury and repose of nature, in its concreteness and particularity no less than in its remote and cosmic abstractness, is the critical subject matter of Bayer's painting both before the series of pictures known as "Mountains and Convolutions" and thereafter, when his work moves resolutely and without reversion toward geometric abstraction. As I have noted, the figure appears early in Bayer's work and disappears early, being replaced by totemic forms that allude to the human but do not document it. Figuration as symbol of the archaic as well as sign of a correlative in the natural order occupied the center of his work just before his emigration from Germany and just after his arrival in the United States. But clearly, even in those pictures of the late 1930s and early '40s, nature was the scene on which the signs and signals of premonition and doom are displayed. Virtually no picture of Bayer's is without its natural element–the clouds, wind, greenery, stones, plant life, biomorphic shapes, shadow formations sustain the structure and supply the relief imagery of the archaic implements, which are themselves but one level removed from the natural, being the ambiguous tools of peasant agrarians and peasant warriors. Nature is Bayer's home and his imagination has worked throughout his career among the elements of nature, with both playfulness and cool dispassion.

It is no wonder that in the winter of 1944, recollecting the cue of incompletion offered him by *Crystal Mountain* 1935/5, Bayer confronted in Vermont the most awesome phenomenon of his childhood in Austria: the mystery of mountains. The earlier painting, *Crystal Mountain*, is a serene evocation of a partially abstracted mountain range rising behind a cold blue lake. The composition, although edging back toward sharp, crystalline, glacial heights, is inventive in its shapes but conventional in its frontal organization. The mountains are seen head-on with the traditional sense of equality between painter and object characteristic of outdoor easel painting; the artist is the companion of his mountain range and insofar as its painter, its creator as well. All this was to change radically during 1944. Commenting on the "Mountains and Convolutions" series in 1970, Bayer wrote:

these paintings were first started during a stay in vermont. as an alpinist I have experienced mountains in many ways, but I had not attempted to paint them as I had not thought of transforming them into a personal expression.

in 1944 I suddenly saw them as simplified forms, reduced to sculptural surface motion. with their positive and negative relief of mountains and hills, depressions and valleys, they were not seen frozen as in a time-lapse film but rather in a motion which human perception cannot recognize.[60]

The essential format of this remarkable and lengthy series of paintings (begun in 1944 and concluded during the early 1950s after Bayer had moved from the East Coast to Aspen, Colorado, in 1946, where the series was reinvigorated and extended) consists in the examination of topography in motion. Whether seen close-up, the scrutiny attending to details of geological evolution, or viewed from a point far out in space, looking straight down, or seen from within, at the depth of a valley where all the mountains rise and tower above the eye, these relatively small pictures

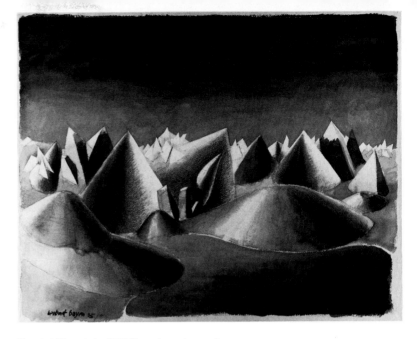

Crystal Mountain 1935/5, watercolor and crayon, 15½ x 19".
Collection Joella Bayer.

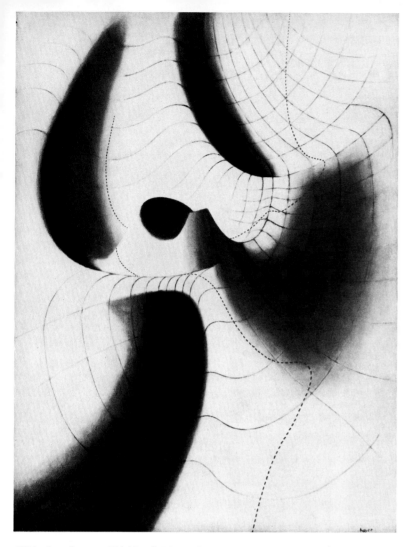

White Landscape 1944/1, oil, 22 x 29".
Collection Herbert Bayer.

assert a view of tectonic unfolding and movement.[61] Making use of his earlier mastery of architectural drawing at the Bauhaus, where the method of representing an architectural space by means of single-perspective drawing produced vistas otherwise unavailable to normal perception of architecture in space, Bayer has established a variety of points of entrance into the flow of mountain surfaces. The mountains and their movements are rendered in such a way that surfaces at moments fold into foreshortening, doubling and condensing, while at other reaches attenuate and move beyond sight into an indefinite outer space. This method of condensation and extension, arising from his experience of architectural drawing, is present throughout the series but in its opening phase is less pronounced as the issue of treatment and attitude is tentatively explored.

Some of the earlier pictures tend toward a more cubistic presentation of the volcanic mountains, indented with caverns, ornamented by paper-thin overhangs and abutments that seem caricaturally surreal and indefinite, or topographic mappings of mountain surfaces with undulant gray lines and blue shadows, occasionally contrasted with red or yellow reflections and spiky glacial needles. Although there are a number of these pictures at the beginning of the series and occasional forays for counterpoint into the same, somewhat inconsequential organization, most of the paintings are severe and arresting explorations of a fascinating pictorial problem. Three-dimensional picture space, traditionally frontal, with illusions of depth created by the perspectival arrangement of figure, ground, and horizon, give way to a slow-motion transformation of geological surfaces, sometimes orderly and quasi-realistic, but for the most part rhythmically agitated, as though, to use Bayer's striking photographic reference, a time-lapse film of millions of years of tectonic motion were caught in a single frame that unites in simultaneity phases of the entire evolutionary process.

In every picture it is clearly affirmed where the eye is positioned—above, beneath, to one side of the mountain surface it examines. No less is the artist's eye engaged in a procedure not merely of abstracting the natural forces at work but of assimilating its findings to a pictorial scheme that permits an intense, slow-motion, million-year process to be arrested and annotated. What is at issue is not scientific description; whatever Bayer's considerable knowledge of geology, biology, and meteorology, his curiosity about these disciplines was never for their own sake, but for what they could yield in definitions that would enable the pictorial imagination to achieve a wider frame of reference. Indeed, even in these early pictures of 1944, a number of years before he set to work on the technical triumph of his *World Geo-Graphic Atlas* (20), his general scientific inquiry was subordinate to a primary perception: nature only appears to be static, occasionally ruffled into exaggerated explosiveness, but on the whole generally sedate and calm. Bayer's perception, contrary to appearance, is that nature is never at rest.

As Bayer has put it, the issue is, how to express the dynamism? Clearly the winter in Vermont, with long mountain walks and explorations, provided the pictorial clue, but one also sus-

pects that by this time all of the accumulated technical mastery of photography, architectural draftsmanship, and free drawing came together to define the procedure he would adopt. Motion can be alluded to by line and shadow—parallel lines moving along a surface made tremorous and vibrant by their perspectival positioning and the astute placement of contrasting light and dark shadow. Color enforces line and shadow, defining the mood of the picture (glacial blue and white or summer yellow and azure), but the essential underpinning, its anatomy, is line. All this is present in *Folding Landscape* 1944/32, in which ribbons of surface motion, concavities, promontories, and depths unfold just beneath eye level toward a vanishing point to the right of the painting. In *Undulating Landscape* 1944/34, the forms in gray and purple are enlarged and focused more precisely; Bayer seems to have made a closer inspection of *Folding Landscape* and in the process moved the vision from a general recognition of nature's large rhythms to the more precise perception of its specific undulancy.[62]

Most discussants of Herbert Bayer's work correctly single our *Exfoliation* 1944/39 and its several variants of the same name (1945/4, 14, 1946/7, 1947/59), as well as *Convexing Concavities* 1945/13, *Scars of Time* 1945/30, and *Impress of Time* 1945/34 as full expressions of the considerable visual possibilities of his subject matter. These pictures make clear that the issues of pictorialization have been solved. The line is subtle and superbly drawn, the shadows used in modulation and delicate gradation, a large scene condensed and held with telescopic precision. Each a rhythmic, virtually monochromatic abstraction, in which a single dominant color (earth brown or gray-green) is modulated with white and black to express the penetration or evacuation of light, these are among the finest abstract landscapes in the modern movement. Ludwig Grote is correct, of course, in observing that "these are not mountain landscapes" but rather studies of the "swell of waves, that rising and falling of slopes" that implies a kinesthetic response of the ski-borne body physically absorbing the traumatic motion of the earth's surface on a downward descent (106:5). Quite probably so, since Bayer was in these years a passionate skier, renewing in Vermont and later in Aspen his youthful enthusiasm for cross-country treks and downhill skiing. But translation from a body memory of motion to pictorial depiction is certainly a different order of perception, and it is here that Bayer's command of architectural rendition and description supplied him with a draftsman's shorthand that facilitated the enterprise.

The ability of these remarkable pictures to transmit within a small scale an astonishing concurrency of immense motions that hug the surface of the picture, alluding to depths of crevasse and valleys while demanding no sense of spatial distance and reach, suggests part of the dramatic effectiveness of the image. One has no idea whether the picture is reflecting a vast space in miniature or a small vista of what is, even in its smallness, immense and dwarfing of the human. The paradox of spaces in simultaneity alludes to the collapse of time into space, the folding of time into the bland substance of ancient space. Mountains as such (the early *Crystal Mountain* of 1935, for instance) are therefore frontal, blue, glacial, serene, for in those mountains time is only a moment

in the presentness of geological space. This is not to be the case in "Mountains and Convolutions." There Bayer has undertaken to compel space to give up the secrets of time, to condense into a single frame of time the millions of years of diastrophic evolution.

The analytic phase of Bayer's "Mountains and Convolutions" series came to an end in response to his moving to Aspen. Thereafter, obviously relieved and invigorated by the challenge of his new situation, Bayer celebrated in his paintings his first real homecoming since his emigration in 1938.[63] Though he had by no means concluded his tectonic paintings, their spirit and presentation lightened considerably, the muted tones of earth and rock formations beginning to give way to a lyrical use of color, the introduction of natural sources of light, the presence of insect and animal life as well as plants and foliage alongside the familiar formations of Vermont. Although Bayer would paint several more pictures grounded in the format of *Exfoliation* 1944/39, the shadow areas were now to be orange-red, pink, or azure blue; their linear structure, no less rigorously defined than before, would be set down more delicately, the lines closer together, their atmosphere more benign and seductive. The early Aspen years were filled for Bayer with a rediscovery of the natural *in situ*, the remembered emblems of his youth now redocumented and enjoyed. The mural *Colorado* 1948/67 and its earlier small-scale version, *Wings over Mountains* 1948/16, integrate a surreal vision of enormous butterflies, their wings resplendent with dots of red and tipped with deep blue spots on a lighter blue field, fluttering over a mountain valley whose convex folds move toward the edge of the picture. The mural, an eight-by-ten-foot picture, transmutes the day vision of the study into a convolution under moonlight, the valley lake silvery, the tones of blue, gray, and brown darkened but glowing beneath the unseen moon.

During 1949 Bayer adapted the mural technique of sgraffito that he had mastered in Kandinsky's Bauhaus wall-painting workshop to the next development of his convolutionary series of paintings. Although he would use the sgraffito technique as such for the exterior mural he executed in 1953 for the Seminar Building of the Aspen Institute, the pictures he undertook, beginning with *Foliage* 1949/3 and continuing with multiple modifications through the early 1950s, might be called illusionistic sgraffito, since he did not set down an underlayer of dark paint over which a light shade was laid in order to then scratch out the desired lines and reveal the dark color beneath.[64] In *Foliage*, for instance, where resemblances to Klee landscapes are palpable, Bayer has indicated the forest covering of a mountain by interlacing forms made up of densely packed colored lines in motion, closely valuing their greens and yellows in such a way that the lines appear to have a depth and elevation intended in sgraffito mural. The same technique, with even more richly contrasting blues and orange-reds, appears in *Metamorphosis* 1949/26 and its variants, *Weaving Nature* 1949/22, *Making of a Rock* 1953/17, and the various pictures called *Veil* 1951/2 where the illusion of sgraffito enables the color to move continuously, creating the sense of additional dynamic spaces normally prohibited to a two-dimensional surface where laws of formal perspective have not been observed.

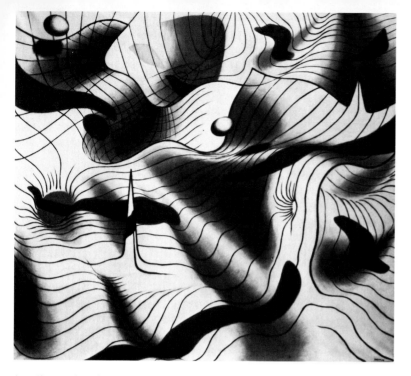

Lamiferous Landscape 1944/5, oil, 46 x 51".
Collection Joella Bayer.

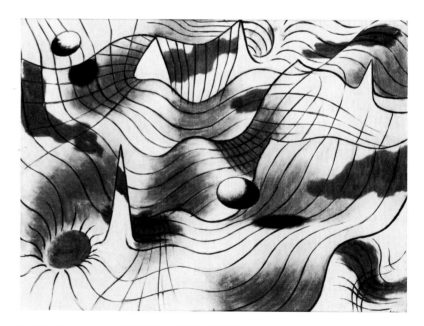

Folding Landscape 1944/32, oil, 20 x 26¾".
Courtesy Galerie Thomas, Munich.

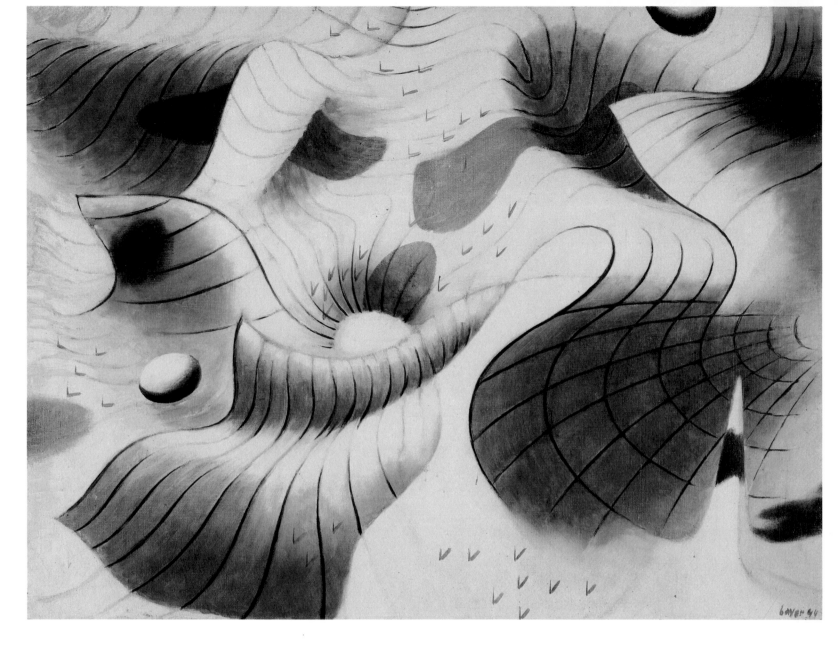

Undulating Landscape 1944/13, oil, 20 x 26¾".
Collection Joella Bayer.

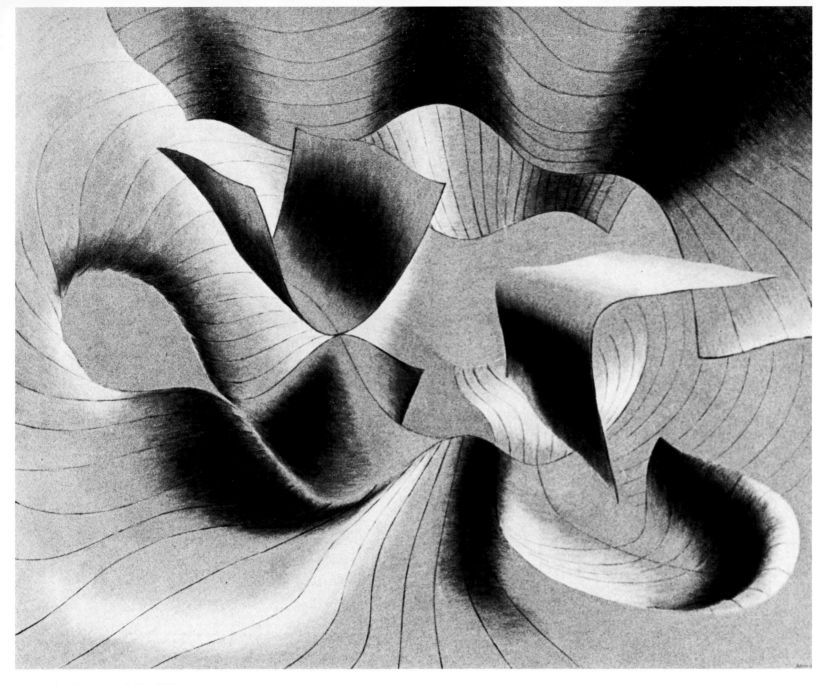

Exfoliation 1944/39, oil, 40 x 50″.
Collection Busch-Reisinger Museum,
Cambridge, Massachusetts.

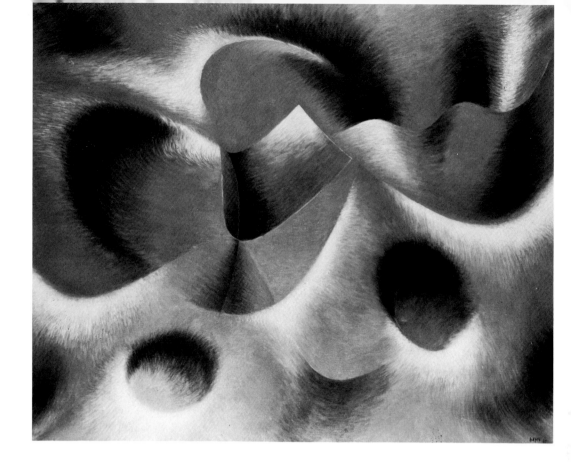

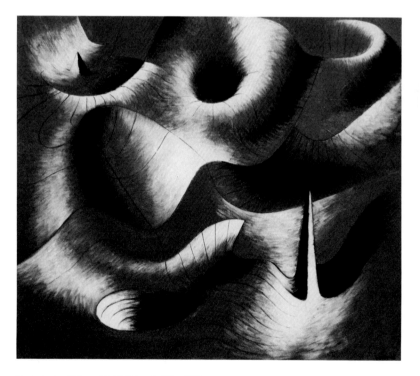

Impress of Time 1945/34, oil, 23 x 27".
Collection Joella Bayer.

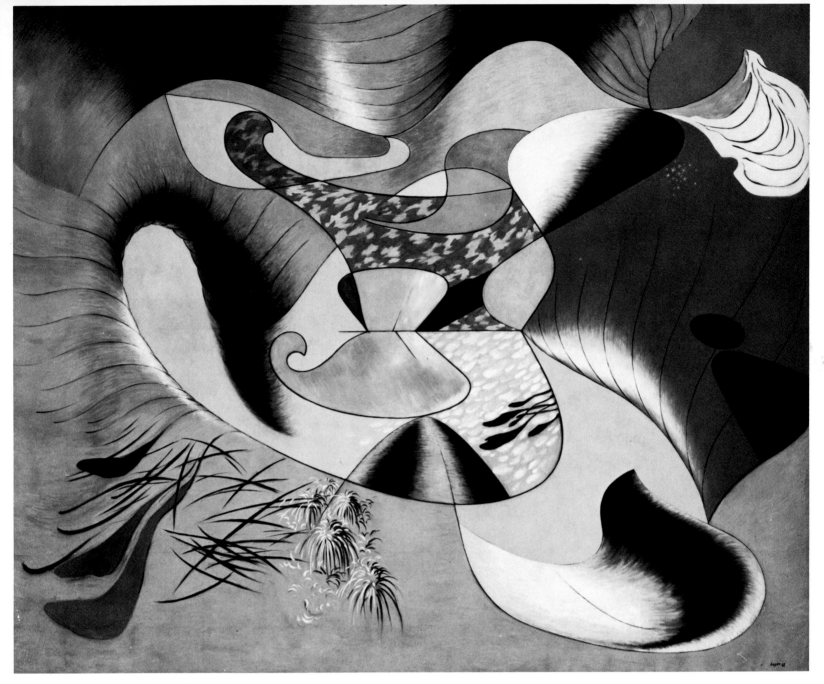

Colorado 1948/67, oil mural, 8½ x 10'.
Denver Art Museum (Herbert Bayer Archive).

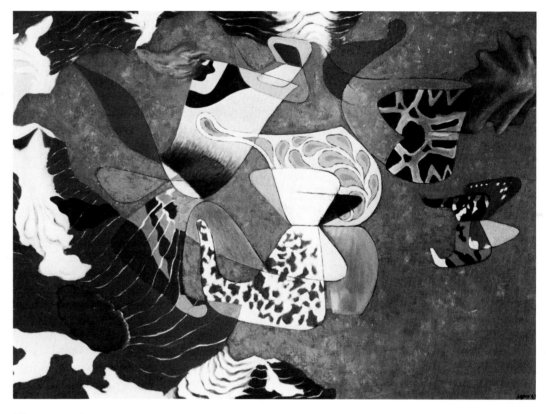

Wings over Mountains 1947/6, oil, 30 x 42".
Collection Joella Bayer.

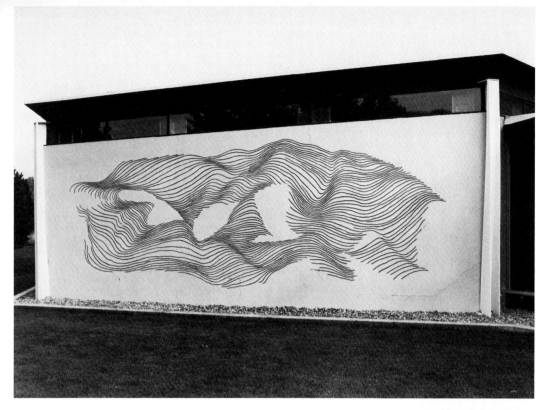

Sgraffito Mural 1953, sgraffito, 10 x 26′.
Seminar Building, Aspen Institute.

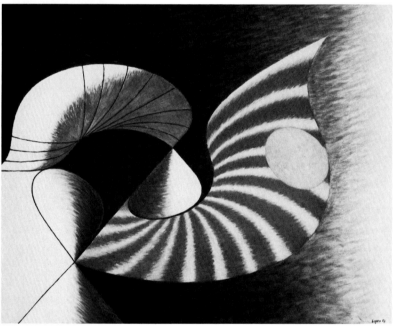

Night Flower 1953/19, oil on canvas, 24 x 30″.
Collection Mrs. Robert M. Hutchins, Santa
Barbara.

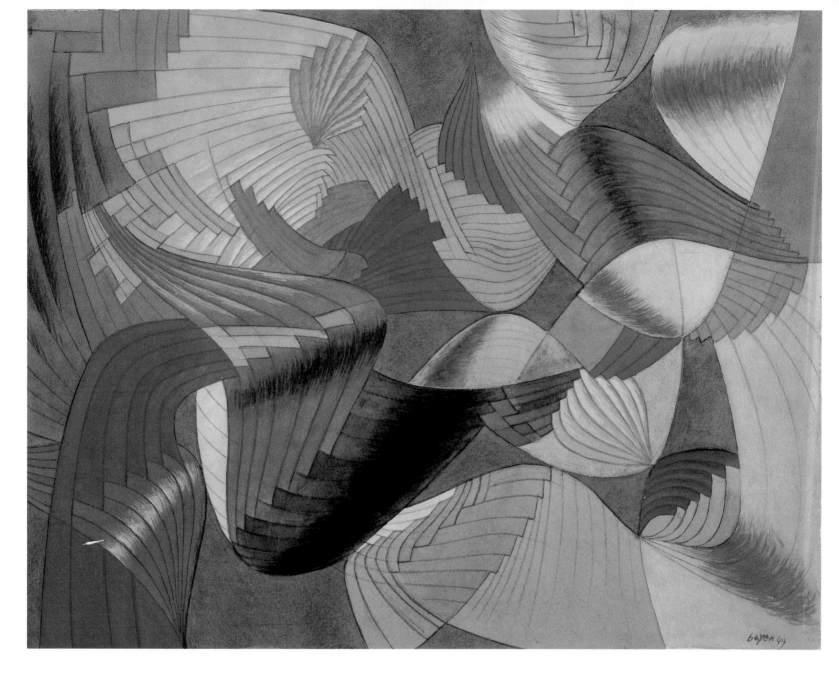

Weaving Nature 1949/22, watercolor, 13¾ x 18".
Collection Joella Bayer.

In Bayer's estimation, the commission he received from Walter Gropius in 1950 to execute a mural painting for the intimate faculty dining room in the Harkness Commons Building, which Gropius had just completed at Harvard University, was a significant event. He admits he had no wish to undertake a purely abstract design, which he recognized would not sustain visual interest for long. He wanted something that would interact with the faculty who dined there, neither aggressive nor inconsequentially passive. Fascinated with the process by which nature rejuvenates itself in springtime, he explained in a letter to the Harvard *Crimson*, he determined that the subject matter of the painting should be "sprouting, glaucous verdure, an image of the idea of growing." The horizontal picture, appropriately named *Verdure* 1950/41, 7½′ × 20′, set beneath a strip of frosted glass (Bayer would have preferred transparent glass so that the motion of the trees outside could shadow the variations of vivid yellow shading toward "cooler-bluish tints") was dominated overall by "*green*, as rich and juicy as possible." Bayer also would have preferred to have called this picture *Entfaltung*, because the German signifies a process movement of unfolding and becoming, whereas *Verdure* describes a realized stasis at odds with the evolving covering of green foliage and forest trees that begins to move in springtime over the naked brown soil of the mountain. The rhythm of the picture, its build-up of surface supporting the clearly indicated linearity of the convoluting foliage, again employs the sgraffito illusion to enable the figurative spaces of the picture to move across its large surface.

The "Mountains and Convolutions" series was completed during 1953, the subject matter exhausted, the abstract phenomenon of tectonic motion analyzed, its bare abstraction fully swathed with the product of the seasons—foliage of spring, density of summer, nudity of winter—examined under all conditions of light and shadow, concentrated and exploded, and now returned to the background and environment in which Bayer happily lived, no longer interested in establishing rapport with beloved mountains. The beginning of a return to a rigorous geometric abstraction that would be virtually uninterrupted over the next three decades was signaled by a group of pictures in which for the first time color created form unstructured and settled by line. As in virtually all of Bayer's painting series, this new group of pictures (though small and evidently not regarded by him as having a sufficiently discrete identity to require a series name) was anticipated two years earlier by the substantial oil *Formation* 1951/6. Geometric forms, principally balloon-shaped cones and elliptical planes built up of evenly spaced segments in brown and blue move forward and recede, passing over and dipping behind shapes in white, red, gray, and blue. This picture, a very original alternative to the planar spaces used by Otto Freundlich and other German geometric abstractionists, depends for its power on the mystery of color describing form and eliciting by asymmetrical contrast a pictorial balance independent of traditional notions of staged proportion. A liberated geometry, no longer tied to natural figure or drawn line, that had first appeared in *Formation*, begins to predominate during 1953.

The simplest picture in this small group of paintings, although

making reference to its title, *Bird* 1953/2, need not be construed, however, as figure, nor the green leaf shape beside it described as organic. Bayer could as well have avoided a figurative title, for the watercolor displays a curvilinear green shape (built up of lines that follow its contour) balancing on a white solid with visible sides in beige and gray, positioned against a blue field that forms a right-angle triangle. The amorphous curvilinear shapes that appear in this group of transitional pictures (most of which are untitled) are imaginary shell and leaf constructions in green, red, and dark brown positioned primarily against a blue field. The series is climaxed by two superb horizontal pictures, *Wintry Afternoon* 1953/10 and *Winter Afternoon* 1953/34, in both of which looming black mountain forms are depicted upside down penetrating an inverted blue-green sky. The picture is dominated by a red oval sinking beneath the black horizon at the lower left. Again, the image can be read as abstract geometry of forms or, cued by Bayer's title, an impression of ominous cloud shapes and approaching night as the sun sets.

Sicily and the Succeeding Years of Plenty

Fortuity of place has always played a significant role in the development of Bayer's pictorial ideas. Classical remains and peasant artifacts of the Mediterranean world suggested motifs and figurative elements for his paintings and graphic design of the middle and late 1920s (as well as during the mid-1930s); the archaic implements of his native Austria and their suspension from the "vapor holes" of mountain barns provided the incentive to the "Dunstlöcher" images of the late 1930s; the winter mountains of Vermont in 1944, and the winter and summer aspect of the Colorado mountain ranges throughout the late 1940s and early '50s, reinforced by images of the Mexican volcanoes he saw during a trip in the 1940s, display natural forces and evolutions he had always sought to understand. It is worthy of note, however, that place became increasingly natural and its inspiration abstract, moving from the remains of culture and the implements of millennial peasant tradition toward the situated phenomena of tectonic nature, the uniqueness no longer one of place as such but of universal natural phenomena seen, quite by chance, in Vermont or Colorado or Mexico.

This is also true of the remarkable series of pictures occasioned by the months he and his wife, Joella, spent during the late fall and winter of 1953–54 in Taormina, Sicily. Bayer had visited Sicily in 1924, but that trip had produced impressions of carretti, Capuchin mummies, decorated fishing ships, alongside surreal renderings of mountains and villages. By 1953, however, Bayer had exhausted his interest in figurational symbolism and sign language, and his curiosity had moved beyond surreal allusion or even cataclysmic nature and atmospherics toward an interpretation of natural phenomena whose fundamental structure could be read as abstract geometry. Although Bayer was to make one brief and extremely compelling foray into imagery of temporality (the "Forces of Time" series) that would collateralize the interpretation of space he had offered in the "Mountains and Convolutions" picture,[65] the principal group of paintings—those he has called

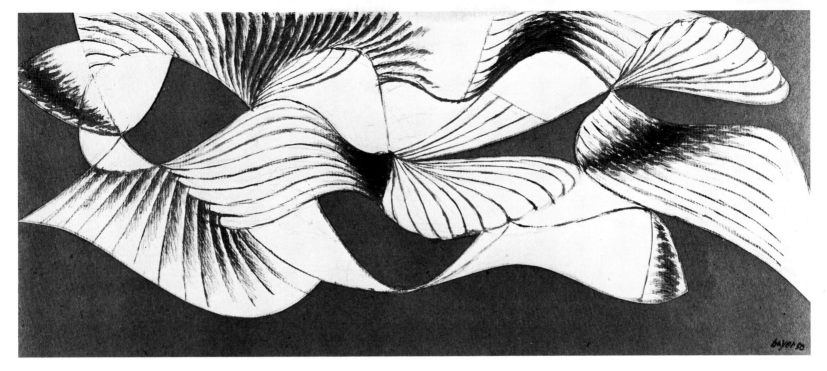

Convolutions in White #1 1950/4, oil and collage,
10 x 23″.
Collection Joella Bayer.

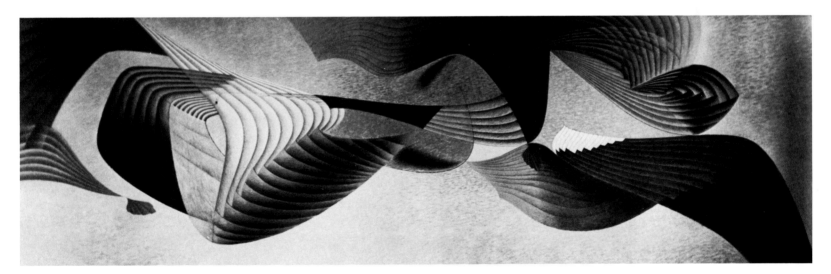

Verdure 1950/41, oil, 7½ x 20′.
Collection Harvard Law School.

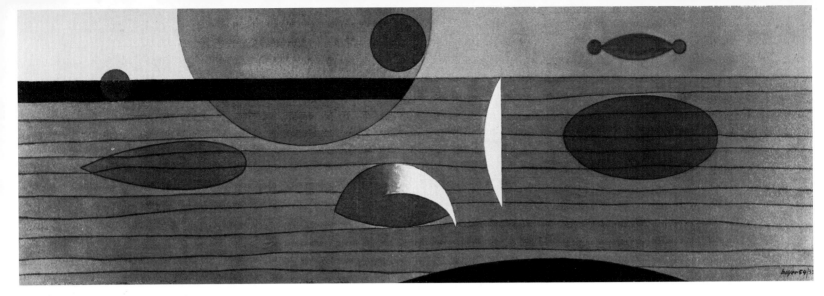

In Other Waters 1954/32, watercolor, 7 1/2 x 21 1/4".
Collection Joella Bayer.

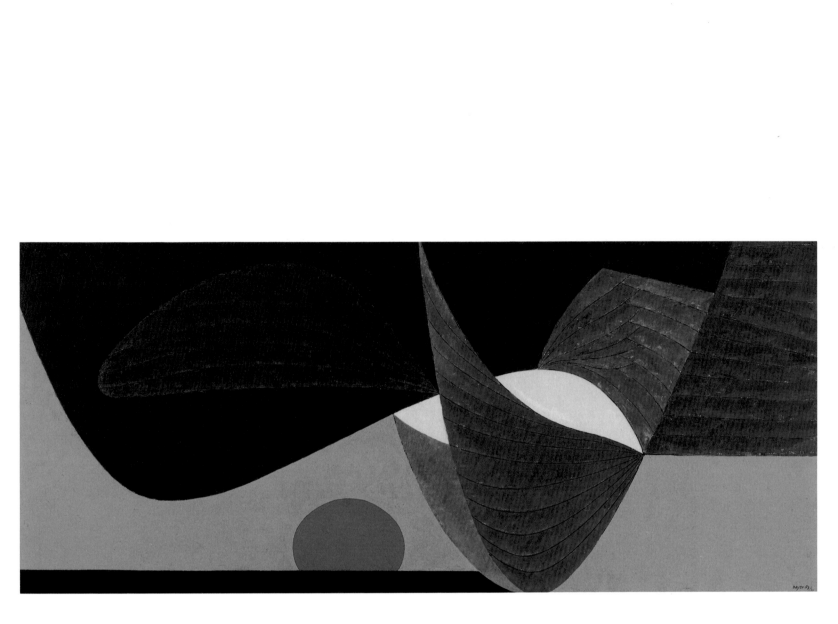

Wintry Afternoon 1953/10, watercolor, 6 x 12".
Collection Herbert Bayer.

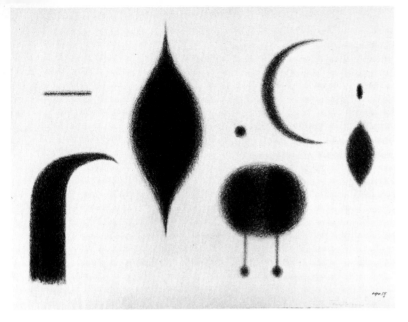

Homage to Kairouan 1955/4, oil crayon,
18 x 24½".
Collection Joella Bayer.

"Linear Structures" (which, in turn, yields place to "Moon and Structures")—emerged from impressions and interpretations garnered during a holiday in Taormina.

The Sicilian landscape—hard brown earth, fruit trees in bloom (lemon, orange, lime), Mount Aetna in the background, colorfully washed houses, waving palm fronds—European in position but North African in atmosphere and texture, allowed Bayer a resurgence of romantic expression. This is much present in the first painting of 1954, a richly colorful impression of a Sicilian *Sunrise 1954/1*—brilliant sun over a pink horizon balancing a hemisphere into which have been set architectural abstractions of red- and orange-roofed white houses. These Sicilian paintings, wrought over a period of perhaps four months, supplied Bayer with pictorial ideas that would last him the next decade, enabling him to work from a primary impression of nature, through degrees of abstraction, until the structures cease to be examinations of nature and light and become iconic altars to the mystery of planets and ultimate sources of light. He began slowly, however, the paintings accumulating through scores of modulations and reconceptions, defined side by side, clarifying each other by contrast and implication, natural abstraction alongside geometric abstraction, experiments with color and light accurately observed alongside interpretations of light emerging from color itself.

The "Linear Structures" series of paintings, as well as those developed at the same time, the "Architectural" pictures and the later series begun in Mexico in 1959 called "Moon and Structures," have their formal origins in the pictures developed in Sicily in 1954. The "Linear Structures" pictures, marked by rigorously and precisely balanced format, richly colored (but still color supported by geometry), were preceded and interrupted by the remarkable group of expressionist abstractions the "Forces of Time," which explores the temporal dimension of nature's seasonal moulting and transformation with an automatism of gesture. Although clearly marked by certain formal and coloristic devices adapted from Joan Miró (the fuzzy red and yellow ovals that accent an otherwise tight composition in india ink, as well as frequent appearances of colorful amorphous shapes and biomorphic forms), the "Forces of Time" paintings are fundamentally cut-ups of the mountains, valleys, skies, and rivers that supplied the tectonic rigor of "Mountains and Convolutions."

The series was obviously begun as an extension of spatial inquiries; Bayer had undertaken to see space from the perspective of time, the movement of the eye supplying the temporal faculty for the reception and rescription of space, eyes operating together, eyes seeing separately, breaking up and uniting, scrutinizing under the laws of an unending cosmic circularity (time moving in cycles, in vortices, repeating and revising) and, in consequence, both relative in its view of space and absolute in its capacity to be aware of all simultaneously. Those remarkable pictures entailed (as do the best pictures) a philosophic point of departure, in which issues of space, time, knowledge, and the representation of appearances are pursued without dogmatism or finality. The riddle of these pictures encodes an answer, as do all riddles, but with each picture the riddle offered is answered differ-

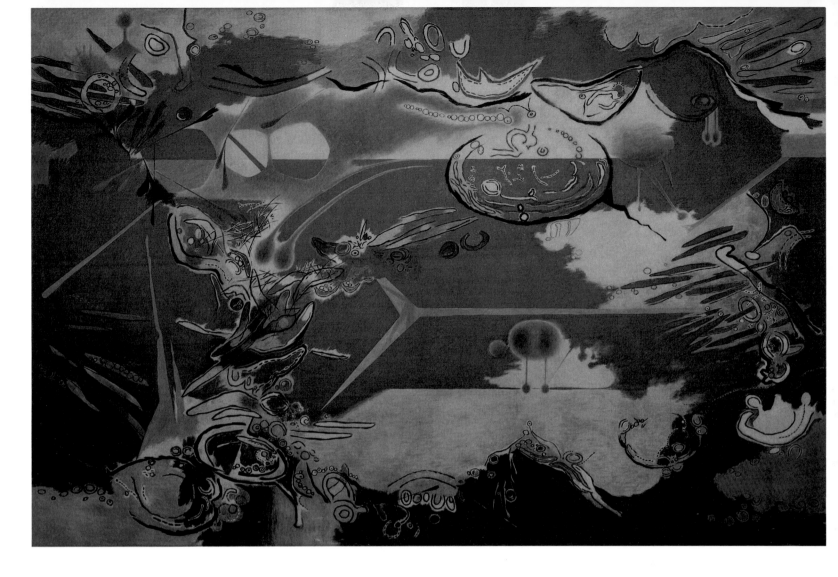

Far Back in Time 1954/105, oil, 78 x 120".
The Breakers Collection. Atlantic Richfield
Company.

ently. The spatial shapes that predominated in "Mountains and Convolutions" are split apart by time–the onslaughts of time being vivid reds, yellows, splotches of black interrupting strong angular shapes in beige, olive green, and shadowed white, exploding, abrading, firing the rugged contour of things. Some of the pictures cope with mountains; others are aqueous, beneath the sea (itself a primary source of life). But clearly the pictures are about spontaneous creation, not the "big bang" but the endless sequence of little bangs in the evolving order of the natural.

The two superlatively painted pictures, central to the series, are *Far Back in Time* 1954/105 and *Blue Evolution*, the first predominated by red, the abridged yellow starfish of insemination, and the blue-white irregular bursts where life is slowly unfolding; the second, a painterly ground in highly textured blue and white, beneath whose horizon line a triangulated yellow biomorph, outlined in red, pushes upward into the atmosphere through which a green spear shape has already passed. The pictures composing the "Forces of Time" are clearly visual approaches to the evolution of organic, chemical, vitalist reality, while "Mountains and Convolutions" were explorations of the diastrophic dynamism of the inorganic, where life is symbolized as motion, push, press, violence, transformation. Space, in Bayer's philosophic vocabulary, is about the inorganic universe; time, however, is about the living.

Close inspection of the sequence of pictures that Bayer made in Sicily confirms an insight into his working procedure. Until critical observation that leads to a new series of paintings is formulated, Bayer begins with a reprise of well-developed formats. Two pictures (*Horizon* and *Toward the Horizon*) play with Mondrian's use of variously weighted short black lines on a white field to construct a village scene, but this technique, virtually patented by Mondrian, was not pursued. There followed several images (*Horizontal Flow* 1954/31 and *In Other Waters* 1954/32) that recapitulate the arrangement of elements he had treated in *Winter Afternoon*, although now the locus has shifted from a Colorado winter to the effect of sun and moon beneath the water. Certainly serious pictures, but still continuations of compositions already fully mastered. Several weeks into his holiday in Sicily, Bayer began to experiment with the pictorial implications of an observation that he had already made several times. In 1970, he recollected this simple natural episode and commented:

during a few month's stay during the winter of 1953–54 in sicily, I often observed palm leaves and the play of light and motion on their thin, light-reflecting surfaces. (they appear to me as kinetic structures, the changes of which are unpredictable and not like most mechanical kinetic structures would be.)

the first designs in which the palm leaves became lines or "sticks," were still structured like multi-colored palm leaves (*horizontal ascent*, 1954/61).[66]

The interaction of light and motion on tough, fibrous palm leaves, which receive and diffuse light rather than absorbing and mixing it with their own green or greenish-yellow surfaces, constitutes the basic observation. The palm fronds refracted the light, becoming orange, red, purple, black under the shifting power of Sicilian dawns, brilliant noons, and effulgent sunsets. Moreover,

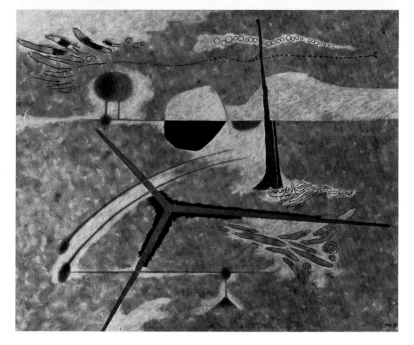

Blue Evolution 1955/7, oil on canvas, 32 x 40".
Collection Joella Bayer.

in addition to throwing color, the palms moved, shifting the color, repositioning it against other surfaces. It was easy for Bayer who had, after all, made a whole group of interpretive pictures of mountains and their convolutions built up of undulant parallel lines and had earlier devised magical interiors defined by floor boards and slatted scenery, to turn his observation to an abstraction generated by the play of light and surface movement.

From the very outset of the "Linear Structure" paintings, the palm fronds were never depicted. They were the natural sources of Bayer's vision, but the issue was never one of representation. Having established a ground color–cocoa brown, green, blue, yellow–a thick tracery of colored stick shapes, flat with no suggestion of curvature, bent and flexible as though strippings of palm fronds, were interlaced to develop patterns of colored movement. In the early phases of the series the "stick" strippings were stacked in disorderly order (one margin justified, the other ragged) over a stippled monochromatic field as in *Horizontal Ascent* 1954/61 and *Diverted Progress* 1954/53 or a dense foliage of pink, orange, beige, strippings, some straight, some curved, some laced and entangled, others distinct and individually trackable, rose up before an oval reveal filled with vertical blue, green, beige bands of light as in *Afterglow* 1954/34. In *Disorder into Order* 1954/36 and the similar *Hidden Squares* 1954/39, a series of horizontal and irregular blue, green, orange, and thin pink lines are interrupted by small rectangles placed randomly on the field, some receding into the ground where they are aligned with the striped surface beneath, while others abrade and contrast with the ground. The interest is in the interplay of lighter and darker shades of color, their vibrancy and absorptiveness, their ability to resonate and sound movement by virtue of tone and hue. Such curiosity is less about kinesis than it is about chromatic brilliance and subtlety, a curiosity that is not optical–since the colors are not bidden to dance–but concerned with creating a psychological tension of considerable power.

Gradually, the sticks of color, abstractions stripped from the palm leaves, are left behind; even sticks of color realized with painterly intimacy were regarded by Bayer as being too closely tied to naturalism. The sticks of color become, as Bayer has noted, "abstract linear motifs in which the 'lines' are arranged either horizontally or vertically to give the illusion of depth or the suggestion of receding into the far distance of space (*on the way to order* 1954/69, oil)."[67] What is important, however, is not the elimination of reference to the palm leaf (since the actual palm leaf had never appeared, and would have remained an unknown source of imagery had Bayer not noted it). Rather Bayer has passed beyond an awareness of his sources and founded the imagery that would succeed it on the earlier paintings in the series rather than on their origins in an observation of actual light and motion on a palm. The linear motifs that occur for the first time in his study in shades of blue (*Distant Solution* 1954/68) and continue with *On the Way to Order* 1954/69, a tracery of orange over recessive yellow lines laid upon a dark green ground, do not forego painterly touch and intimacy.

Only a few pictures in the series may be belabored, as Bayer has done, with the accusation of being more graphic than painterly.

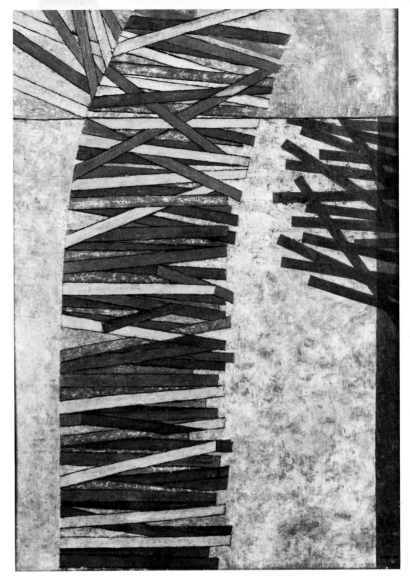

Horizontal Ascent 1954/61, oil, 18¼ x 25".
Courtesy Galerie Thomas, Munich.

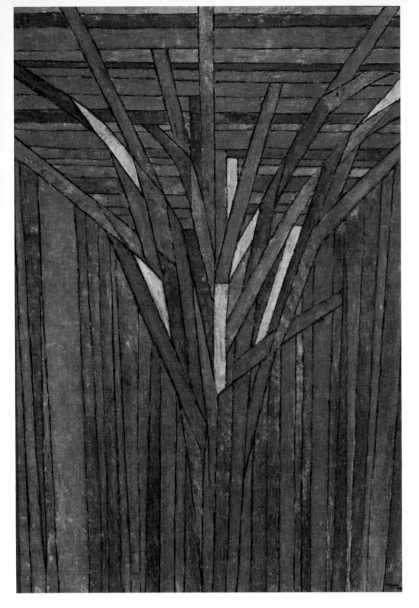

Ramification 1954/37, oil, 17½ x 25¼".
Collection Joella Bayer.

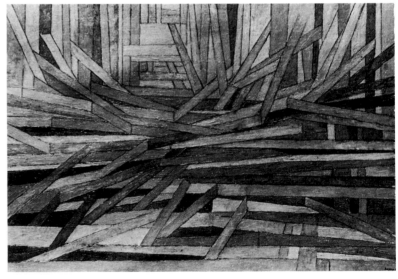

Landscape of the Mind 1954/61, oil on canvas,
17¼ x 25¼".
Collection Mrs. Morris Erskine.

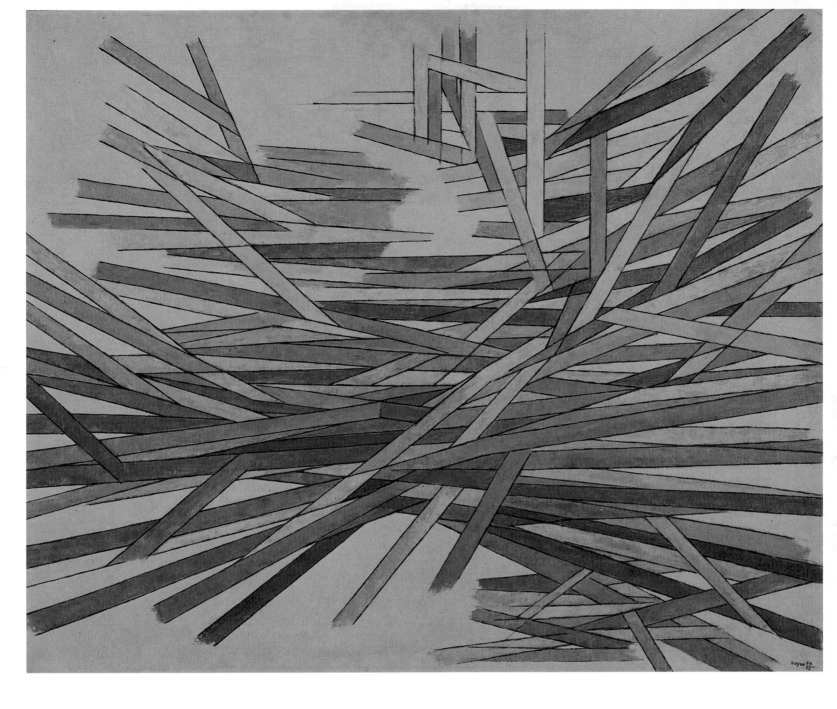

Distant Solution 1954/68, oil, 32 x 40″.
Collection Evansville Museum of Arts and
Sciences, Evansville, Indiana.

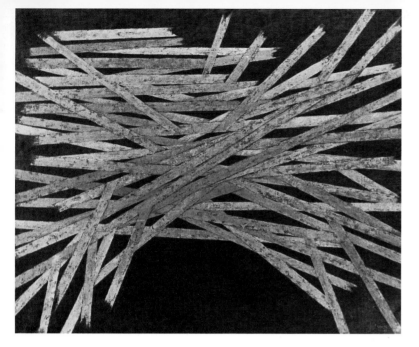

On the Way to Order 1954/67, oil, 32 x 40".
Collection Robert O. Anderson.

Bayer makes clear that for him the charge of being graphic has more truth than for most, since his work has been from its inception filled with an often preemptive interest in line as the anatomical underpinning of his art.[68] Nonetheless, I believe, he has not been fair to himself. The pictures that he might accuse—*Ascending Elements* 1954/71 and *Aurora Stellae* 1955/9—are those in which line becomes literary, pointing and indicating a half-expressed thematics that addresses the visual more than the intellectual, but for the most part this series of pictures with linear motifs, at least at this juncture of its unfolding, does not suffer from graphic explicitness that compromises the imbrication of colored elements dominating each composition. At its finest, in such pictures as *Towards Order* 1955/38, *Conflict of Invention & Simplicity* 1955/22, and *Ramification in Brown* 1955/45, there is an overall treatment of the canvas, a complex interweaving of thin bands of color that change as they connect or shadow each other, usually set down against a pale blue ground visible through the weaving of the bands, either building in the vertical canvases from planned helter-skelter toward layered order or forming tight knots of random interlacing over subtly concealed but strong geometric structure, or balanced by a distinctly formal, architectural resolution of the colored bands.

In all these pictures, the tension derives from the meshing of the bunched bands of continuously modulated colors, lightened and darkened as they pass over or behind each other, sometimes massed as constructions against a painterly ground of dark blue, brown, or green or else contrasted with the same elements reperceived as building elements of an orderly universe (*Ramification in Brown* 1955/45). The pictures maintain their painterly surface, each strip of color marked by definite boundary lines and set down without any concealment of hand. Beginning in 1949, and principally advanced during the late 1950s until 1961, when the series acquires the formal iconic arrangement of the "Moon and Structures" paintings, the stick lines had become "a medium to build on the canvas 'structures' combining many lines to form bundles of straight lines overlapping, transparent, and interweaving horizontally and vertically to the effect of a linear structure."[69] Having dispensed with the issue of the objective light source and its play on a waving surface, which had supplied the original impulse for the series as a whole, Bayer now turned his attention to a graphic problem pictorialized: how to make a system of densely packed colored lines, each individually displayed and delineated, group to form color and space patterns against a unitary ground or so densely packed as to reveal only glimmerings of the ground behind the linear figuration?

A further variation of the paintings, introduced in 1959, shifts the format in the direction of a more rigorous symbolic ordering that would culminate in the "Moon and Structures" image. Here, as Bayer has described it, "a single color area or two areas are sometimes incorporated within the linear composition giving the impression of a window."[70] The pictures are now constructed with meticulous symmetry and balance, vertical and horizontal bunches of lines in black and white (sometimes mixed with other colors) frame and overlay one or two rectangles in blue, black,

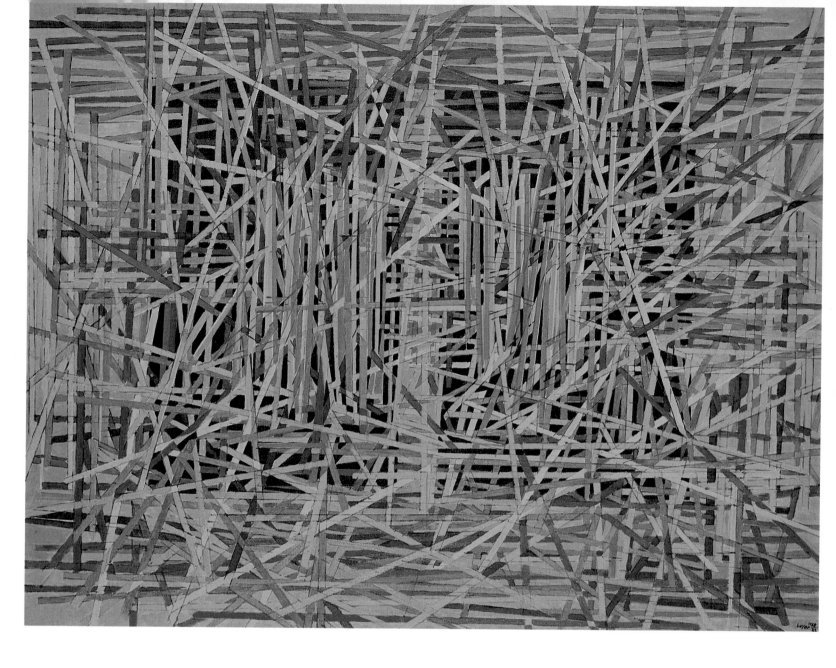

Conflict of Invention and Simplicity 1955/22, oil,
32 x 42".
Collection Saarland Museum, Saarbrucken.

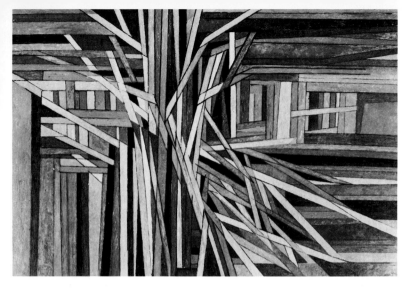

Ramification in Brown 1955/45, oil, 40 x 60".
Collection Mr. and Mrs. Nicholas F. Wilder.

Heated Calm 1955/49, oil on canvas, 40 x 32".
Collection Whitney Museum of American Art
(Gift of Mr. and Mrs. Marcel Breuer).

yellow, or orange set down on a strong blue, ruby, or brown field (*New Year's Picture* 1957/1, *Linear Structure with Orange Field* 1959/48, and the various pictures titled *Linear Structure*). The framed color drives forward, while the carefully emplaced bands of black, gray, white lines pull the eye back into the dark surrounding ground. These pictures tend to be much larger than earlier pictures in the series, their heightened power deriving from their role as emblems, pennants of structure in which the symmetry of the linear verticals and horizontals on which the color window rests make an assertion about monumental space.

The beginning of enlarged pictures in Bayer's oeuvre (that is to say, pictures measuring between three or four feet by up to five feet) marks the emergence of a different sense of format. With composition reduced and balanced, the power of symmetry becomes tied to scale, thereby permitting the reduction of complex pictorial action to more simple formal assertions. Enlarged scale begins to replace a raising of the voice by means of color. At the same time, the personal hand so evident in Bayer's smaller pictures begins to yield place to a smoother, flatter delineation of color, hand disappearing as scale enlarges.

As I have noted, the press of new creative ideas has several times compelled Bayer to strike out in a different (or seemingly different) direction while apparently fully engaged in working through another idea. The "Linear Structure" series was interrupted on several occasions between 1954 and 1958 for the investigation of a variant of the issue of linearity. These pictures, designated by Bayer as "Architectural," are precisely that—about architectural space, but not about architecture as such, except in the widest sense of pictorializing the agglomeration of linear solid shapes that are the building blocks of architecture. Abstract pictures of the highest order with some casual, but not causal echoes in Francis Picabia's *Procession Seville* (1912), and *New York, 1913,*[71] as well as associations with Léger's early cubist compositions that centralize closely valued cylinders and planes, Bayer's "Architectural" pictures are original in their conception and development. They arise out of a perception of space that is nominally post-cubist, but quite commonplace among practicing architects (which Bayer was during this period)[72] who are obliged to treat space as the rationalization of volumes. Although these "Architectural" pictures are anticipated in the layering of gray-blue triangulated slabs in *Strange Worlds* 1954/13, painted while Bayer was in Sicily, this earlier picture positions the architectural elements horizontally, which contradicts their employment as elements of true building. What is immediately recognizable in this subgroup of pictures embedded within the series of linear studies is that line has frozen into solid.

The "Architectural" pictures deal with vertical alternations of densely packed rectangular triangular shapes, that rise up to meet an irregular horizon line from which descends a background that inexactly mirrors the identical structures and coloration. The vertical solids rising in shafts of blue, black, gray, dark green, beige—muted colors all—terminate in white. Their flat, angled tops, similar to hilltop villages or the packed skyscrapers of New York seen in photographs by Stieglitz, Steichen, or Sheeler, all glaring white

Constellation of Six Squares with Linear Structure 1960/3, acrylic on canvas, 86 x 77".
Collection Robert O. Anderson.

Acropolis 1954/42, oil, 17 x 25½".
Collection Frank Porter, Cleveland.

and shadow, monumental acropoles on the mountain plains (a frequent subject), marble slabs encountered in the abandoned quarry of Aspen where Bayer gathered his found sculptures, are essentially all solids under light, reflecting earth, sky, seasons, their intrinsic whiteness absorbing and shadowing nature's quiet earth and calendrical palette. Sometimes the pictures are brilliant with color, the solids orange, mauve, blue, their faceted tops pink and pale blue, as in *House of a Geometrist* 1957/14 or an untitled picture (1958/1), but overall the pictures are consolidations of linearity on the path to chromatic space.

Precisely because the coloration in most of these pictures is closely valued and often nearly transparent, the solids transmit a rippling vibrancy; some colors move forward, others recede from the picture plane. It is interesting to note that the series was never pressed further, some forty works being completed during the four years from 1954 to 1958. One explanation (and perhaps the sufficient explanation) is that the problem posed by the pictures—that of expressing the mutations of color and light on massed architectural solids—was readily perceived and mastered. Although the series could have been pursued with the obsessional interest in variants that marks Bayer's explicitly chromatic paintings, the method of abstraction in the "Architectural" pictures was not conceptual but actual, the visual source being an awareness of the mutability of light on real architectural surfaces rather than the behavior of colors on pure geometric shapes.[73]

"Moon and Structures"

The paintings with linear motifs were all dense pictures. They absorbed the eyes, obliging them to work exceedingly hard to track the linear forms and catch the modulations of color as the lines passed through different sources of illumination. Only occasionally were the lines arranged over iconic, colored surfaces, and these pictures, precisely because their lineation was so rational, tended to suffer from an excessively balanced precision. The pictures with linear motifs were always obliged to resolve the problem of a conception that was essentially vague—namely, how to record the impression of bands of colored light upon a field, either massed and meandering or rigorously positioned according to the symmetrical division of the canvas? The center of these pictures—their fundamental structure—sometimes held the elements, as in *The Conflict between Invention and Simplicity* 1955/22 or *Ramification* 1954/37, where a horizontal or a vertical construction allowed the agglomeration of colored bands or a brilliant array of magenta complemented by violet and yellow bands to sustain the composition. The structure was either built up out of a massing of colored elements or else reduced to simplicity. In general, however, the series acquires its power from a structure that is coeval with the color, colored light determining the movement of the bands and the formal arrangement that results. In these pictures color elicited a structure from the intrinsically fragile and limited line.

During 1954, in the midst of Bayer's preoccupation with his linear pictures, he completed a small watercolor, *Mexican Evening* 1954/79, that served him as an *aide-mémoire* five years later when he began the lunar structure pictures that were to interest

House of a Geometrist 1957/14, oil, 50 x 60".
Museum Moderner Kunst, Vienna.

Image with Green Moon 1961/19, liquitex on
canvas, 16½ x 17".
Collection the Museum of Modern Art, New York.

him into the 1960s and beyond. Dividing the canvas into horizontal panels of varying width, Bayer arranged a color scale, proceeding from a green base through modulations of yellow to orange, orange-red surmounted by gray, dark gray, and black. The apparently academic organization of color value suggested, however, a metaphor of green earth and black night. Upon this surface he placed at the left of the composition a thin rectangular chart of color notations overlaying the light gray, orange-red down to the brilliant yellow above the base green. The color chart sometimes disappears in the ground, sometimes contrasts with it or effects a transparency. The remainder of the composition, its compelling forms, are ovals, balloons, hemispheres of brilliant yellow, orange, violet that excite and contrast with their respective grounds of gray, dark gray, orange, becoming gray-green and dark brown as they merge with the black of night.

Mexican Evening, a study of the colored effects of moons and planets on the progression of space (from green earth rising to the highest atmosphere) and clock time (from light through darkness) is, as well, an illustration of the principal premise (somewhat modified) of Wilhelm Ostwald's visualization of the harmonics of color. Given Ostwald's definition of these harmonics as a double cone, one of whose bases is black, the other white, with all hues running around its equator, the pale yellow in *Mexican Evening*, surmounting the lush green (with yellow), is a simulacrum of the admixed white that moves through the atmosphere toward black. Bayer had been responsible for inviting Wilhelm Ostwald to lecture at the Bauhaus during the spring of 1927, and although he learned from Ostwald—as well as from Goethe's *Farbenlehre* (*Doctrine of Colors*) and Goethe's contemporary Philip Otto Runge's *Die Farbenkugel* (*The Color Sphere*), both of which he had read—as a painter Bayer had little interest in color theory; his decisions were intuitive modifications of theoretically prescribed color arrangements.[74]

Mexican Evening is a precursor to the "Moon and Structures" series and like those pictures, readdresses the fundamental issue of formal construction as the underpinning for the elaboration of color variations and transformations. Whether dividing the image into horizontal panels, or introducing rectangles or gates formed of rectangular columns and a surmounting lintel—whatever the formal pictorial scaffold—Bayer was in the process of returning to a constructed, architectural form as the prime initiatory element of his painting.

Clearly, the pictorial power of the "Moon and Structures" pictures derives from their nonspecific allusion to a ceremonial initiation into the universe of space. Instead of treating these paintings' monochromatic ground, which is in fact their proper space, as simply an undifferentiated colored void before which the figuration rests, space itself is the subject of the pictures. But how make space—immense, invariant, abstract—a subject of painting without overwhelming it with the figuration that supplies interest and contrast? Bayer accomplishes this by putting near the bottom of the vertical ascending images a processional gateway of columns and lintels, which draw the eye up and into additional rectangles of transparent colors that limn the void. Sometimes the columnar planes pass through the lintel, changing color as they ascend into

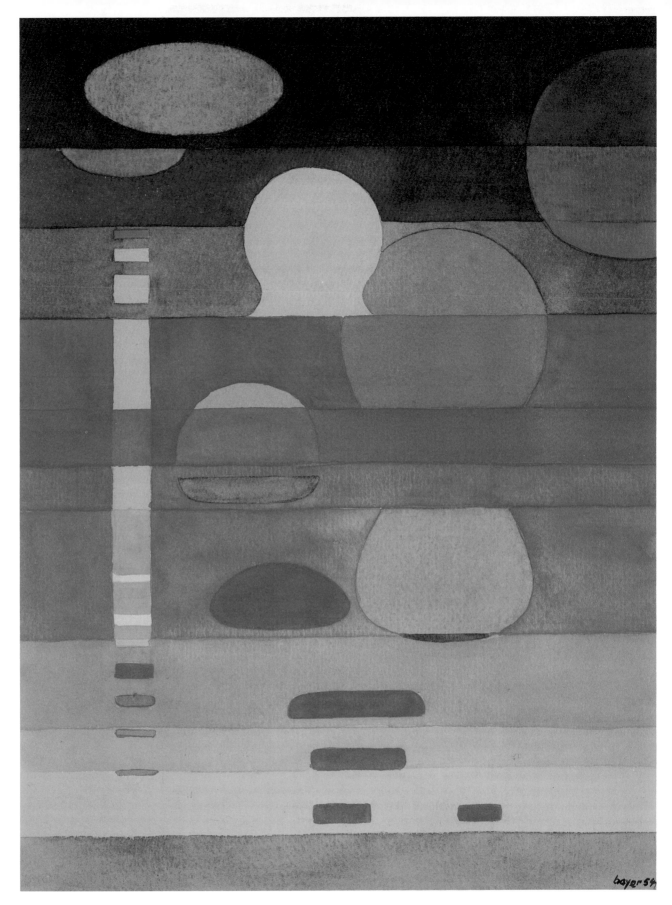

Mexican Evening 1954/79, watercolor,
10¼ x 13½".
Collection Joella Bayer.

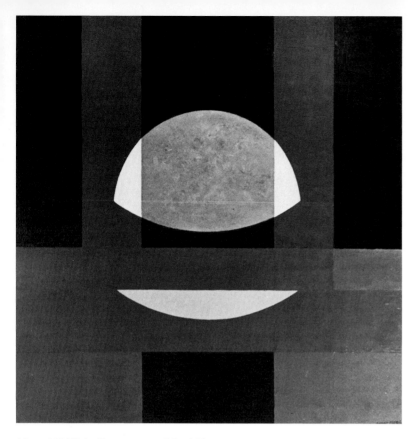

Moon 1959/24, oil on canvas, 30 x 30″.
Private collection.

the void; at other times an oval, a circle, or a hemisphere with two half-hemispheres, positioned in the upper center of the spatial monochrome, will survey the ground below, compelling the eye to focus the void beneath the moon and above the gateway through which it has gained entrance. Although architecturally abstract in their delineation, these pictures are profoundly hieratic and initiatory, acquiring in their serenity a quality commonplace in the architecture of classical Japan, where often one does step up through formal porticoes and porchways into a flat expanse where what is to be viewed is pure space. Bayer keeps a photograph from his five-week visit to Japan in 1960 of an austere porch in the Katsura Palace where the aristocracy gathered to view the night.[75] Throughout these allusive paintings, the gateway is sometimes brilliantly colored but the expanse of space is dark (*Moon and Structure* 1959/44); or the dark gateway is set immediately beneath a lowering pink moon (*Untitled* 1959/19); or the gateway is centered in the composition, the moon is absent, but the moon-light irradiates transparencies of space (*Untitled* 1960/7).

Bayer's interpretation of his painting *Eye* 1962/48 confirms the reading I propose, although he underscores even more than is necessary the symbolic contrast between the architectural passageway to space and its luminary. The eye of the moon seems to overwhelm the human eye reflected in the segment rising through the gate. But Bayer's exegesis makes clear that the architecture in his painting (no less than in the architectural environments he was executing at Aspen) is dominated by notions of pictorializing an attitude of introduction, initiation, and passage into cosmic space. These pictures are pacific and benign, and at their best mysteriously glowing. If one sees afresh, however, several of the variations in the series, although continuous with the image of the gate, may be read as rectangular painted canvases on a raised easel positioned beneath the moon (*Untitled* 1961/7, *Moon & Structure/Purple* 1961/35, *Structural on Blue* 1962/32). As Bayer always worked at an easel, the organization of the pictures alludes to a self-reflective awareness of the artist as painting hierophant, depicting the mysteries as well as being initiated into them. The gateways sometimes even acquire the aspect of altars, as in *Invocation* 1962/46, where excessively literal handprints mark the aspiring ascension of the humanly finite toward the moon.

In short, the "Moon and Structures" pictures, spanning a decade and concluding only in 1972 (when Bayer was already engaged in painting his chromatic images), pass through very softly painted, intimate renditions of cosmological rites of initiation to the concluding images, painted with hard-edge exactness, the moon having become circle, the gateway having been retracted to a hard-edge bar line with rigorously proportioned rectangular ascendant bands of color, the light shadowed and geometrical forms and proportions predominating (*Two Red Squares with Two Black Segments* 1971/144, *Structure with Two Gold Squares* 1972/27, *Curvature around Gold Disc* 1972/111). Notwithstanding the diminishment of intimacy and wit, what was acquired along the way was a sovereign command of an iconic vocabulary that could soften into spatial landscape or toughen into analyses of abstract geometries of space.

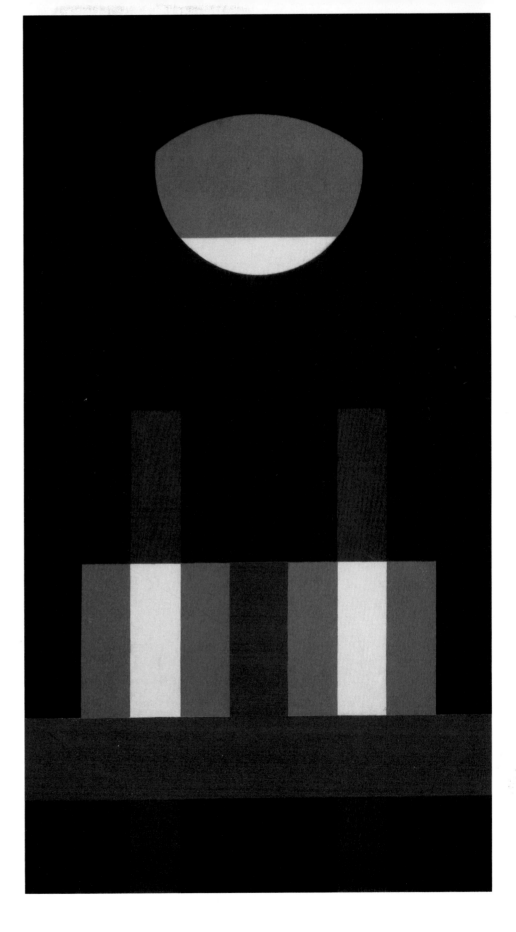

Moon and Structure 1959/44, oil on canvas,
72 x 40".
Collection Ingeborg ten Haeff Wiener, New York.

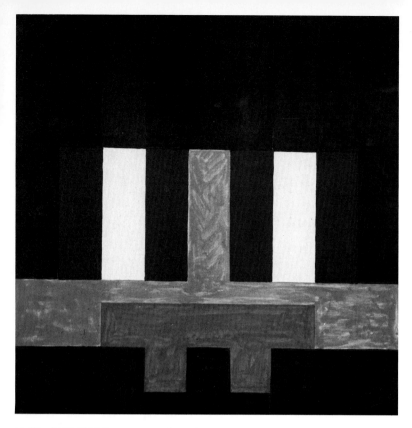

Untitled 1960/7, tritec on paperboard,
10¹/₄ x 9¹/₂".
Collection Herbert Bayer.

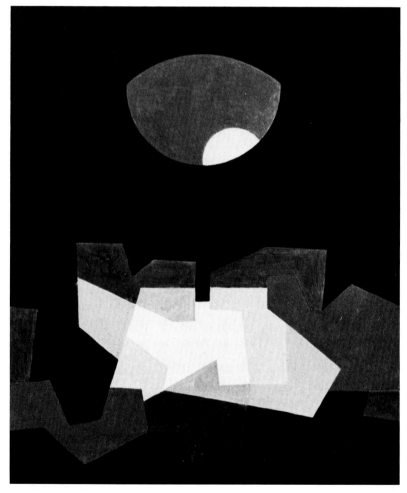

Green Night 1961/25, liquitex on paperboard,
14¹/₂ x 11³/₄".
Private collection.

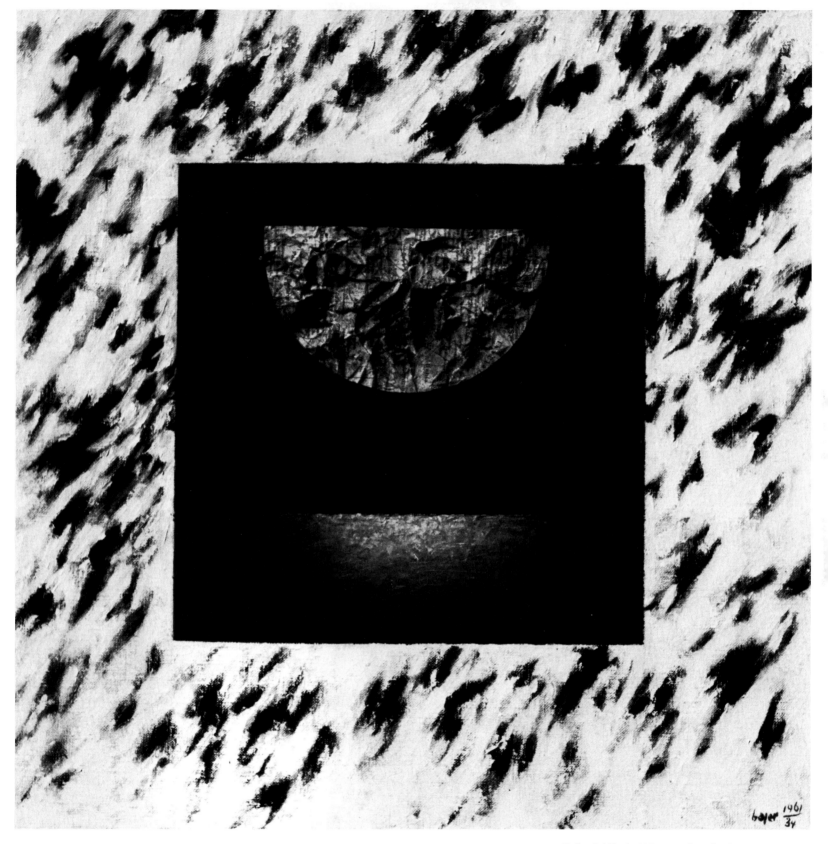

Celestial Body 1961/34, oil and collage on
canvas, 22 x 20″.
Collection J.H. Smith Jr., Aspen, Colorado.

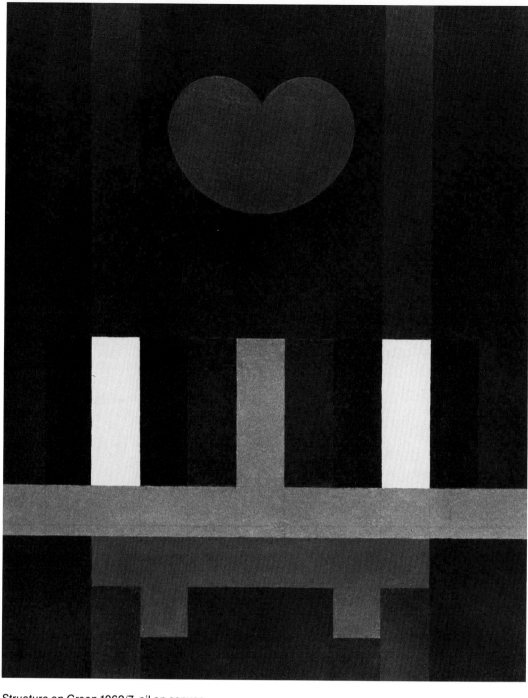

Structure on Green 1962/7, oil on canvas,
40 x 32".
Collection Joella Bayer.

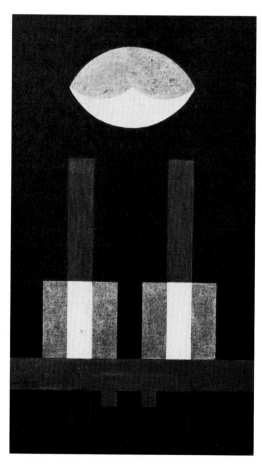

Moon and Structure 1961/35, liquitex, 18 x 10½".
Collection Robert O. Anderson.

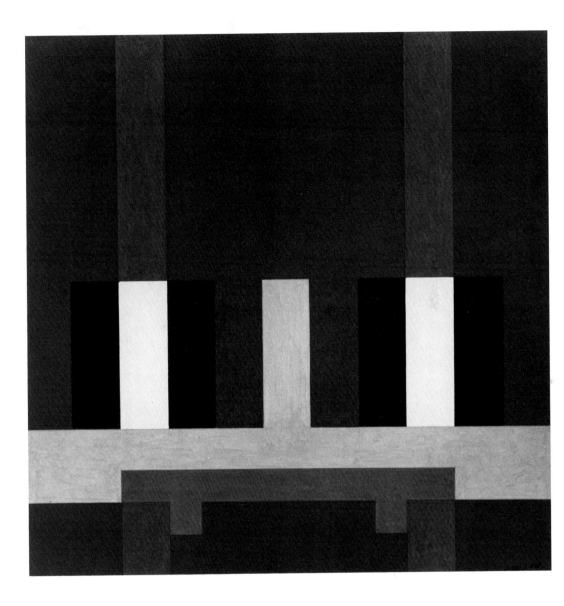

Structure on Green 1968/3, acrylic on paper,
13 x 13″.
Collection Herbert Bayer.

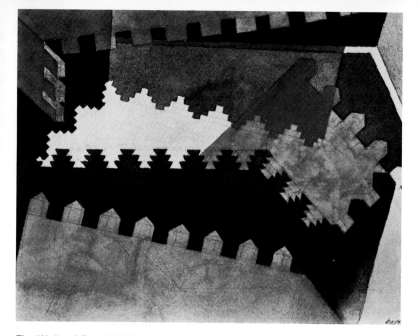

The Walls of Fez 1966/62, watercolor, 8 x 10".
Collection Robert O. Anderson.

Moroccan Punctuation: Tangier (1963–1974)

The Bayers first encountered North Africa during a brief foray to Tunisia during their Sicilian idyll in 1954. It had been, Bayer recalls, an extremely cold winter in Sicily and, seeking sun, he and his wife crossed over to Tunisia. Unfortunately snow had already fallen there and, although they loved the Tunisian souks and "the holy city of Kairuwan which had inspired Paul Klee fundamentally," they returned to Sicily until May 1954.

In 1966 the Bayers acquired a house on the New Mountain overlooking the old city, the bay of Tangier, and the Atlas Mountains. They visited Tangier at least once, sometimes twice a year, until 1976. Throughout Bayer's visits, rarely longer than six or seven weeks, he continued to work on the painting series that were underway at the time (principally "Moon & Structures" and the "Gates" and "Chromatics"), but he produced to one side a variety of collages, pencil drawings of exquisite delicacy, impressions of Arabic life and cultural artifacts, brilliantly colorful and decorative, and one remarkable small series of pictures that return to a principal and abiding preoccupation—the investigation of perspective and flat space.

Beginning with *The Walls of Fez* 1966/62, a picture with explicit allusions to the fretted and crenellated walls of medieval Fez, Bayer has created a tension between wall, ground, and transparency that makes it visually exciting to determine which is architectural and which reflected space, which figure and which ground. The orange, citron yellow, pure blue, and brown walls set in an organized jumble before the fractured perspective of the distant brown wall at the upper rear of the picture, which looks out toward an orange desert, make it difficult to know whether one is above, before, or within the composition. Several areas, not marked by crenellation, are clearly ground—blue, brown, yellow. These become the suggestion to the series of thoroughly abstract images that follow, several a year for each year of Bayer's visits to Tangier. In this series Bayer has set down an abstract architectural plan, painted flat in primary colors, but creating by the presence or absence of color the illusion of three dimensions. Architectural spaces are fractured, broken, displayed from above, viewed from inside, all the while compelling the viewer to determine where the eye is looking and which space is near, which far.

In the most daring pictures (*Tangier 2* 1969/33, *Tangier V* 1975/12, and *Tangier* 1976/35), Bayer has dropped color from critical areas, right up to the margin of the image, fixing the edge by setting a fragmented element apart from the rest of the composition but rigorously proportioned to its dominant color so that this fragment (yellow, blue, gray) remains integrated with the whole. These remarkable small watercolors and acrylics sustain their fascination by Bayer's sovereign command of architectural space, its jigsaw puzzle character, its susceptibility to interpretation as the play of planes or the presence or absence of color, as though a city plan were being devised without all the spaces being explicitly delineated. The dazzling, bright light of North Africa makes white a powerful component in these pictures, counterbalancing the primary colors and making of black and gray less negations of color than means of asserting and confirming their power. The pictures

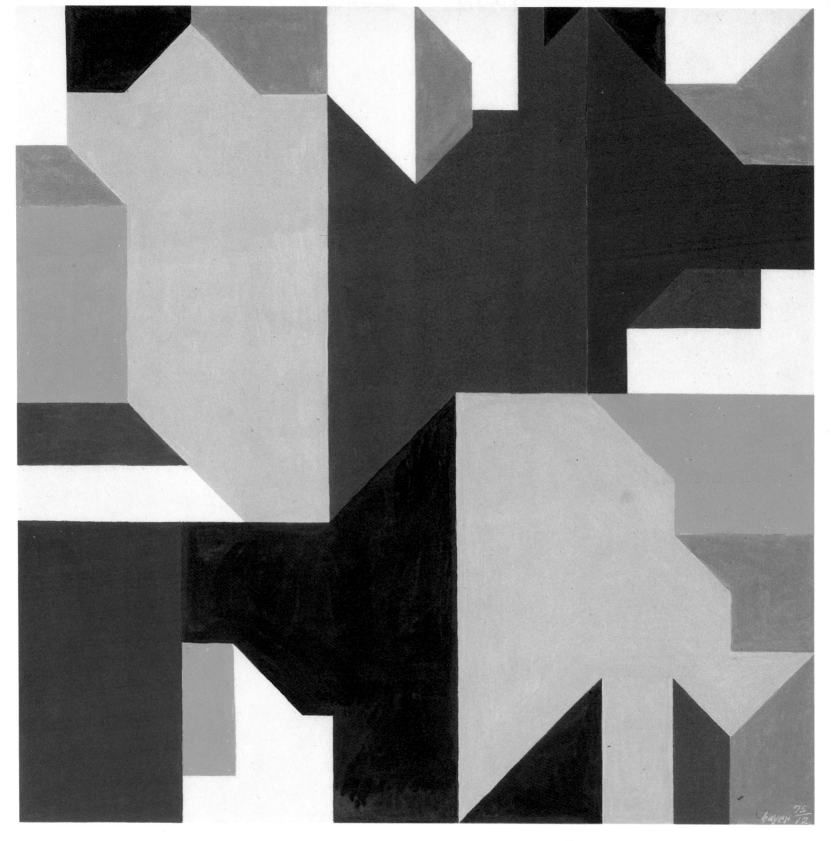

Tangier V 1975/12, acrylic, 14 x 14".
Collection Herbert Bayer.

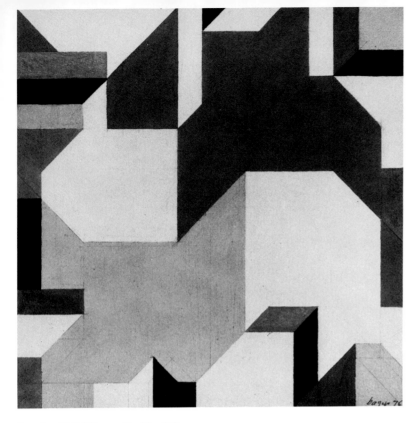

Tangier 1976/35, acrylic, 12 x 12".
Collection Dr. & Mrs. Simon Jameson.

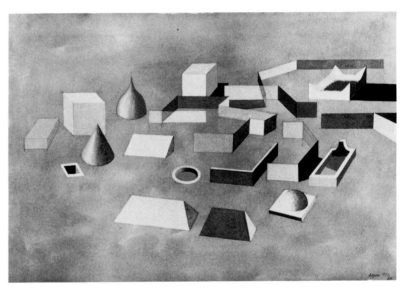

Arab Village 1970/80, acrylic, 14³/₄ x 22".
Collection Joella Bayer.

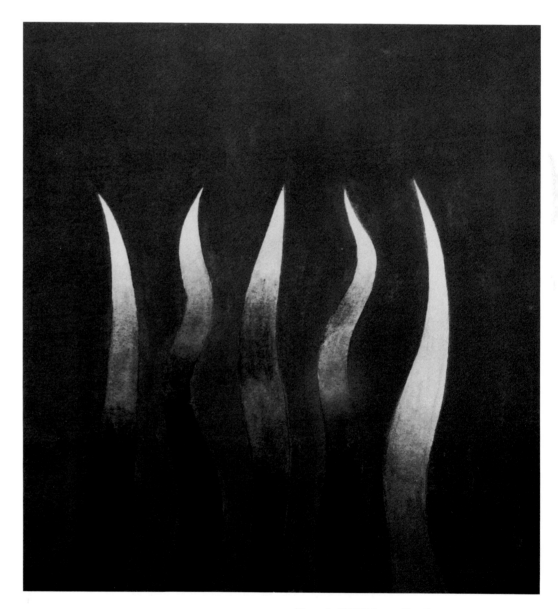

Phoenix 1976/23, acrylic, 13 x 13".
Bambi Collection, Mexico City.

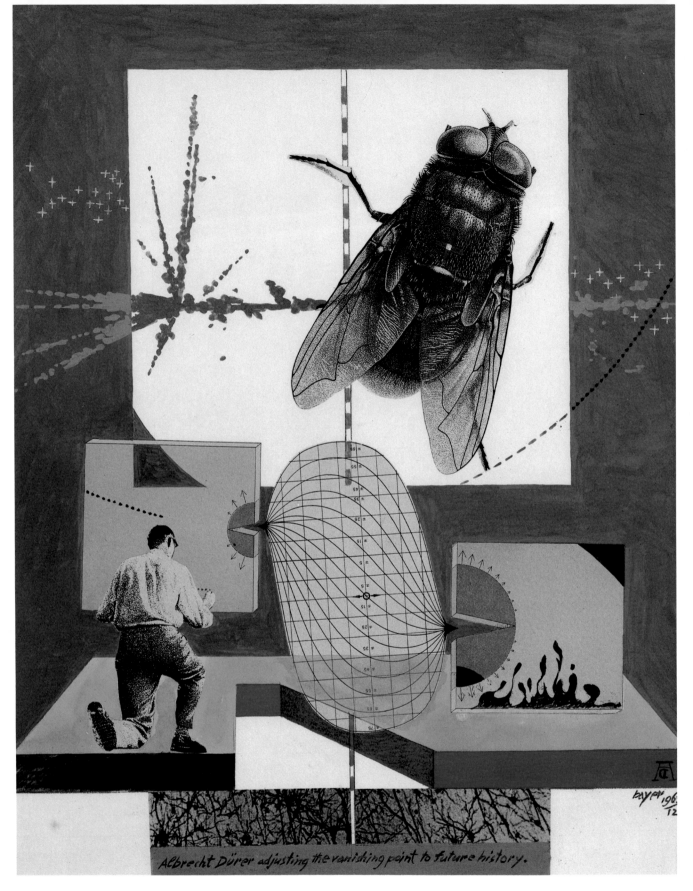

Albrecht Dürer Adjusting the Vanishing Point to Future History 1963/12, collage with liquitex on paperboard, 15½ x 12″.
Collection Joella Bayer.

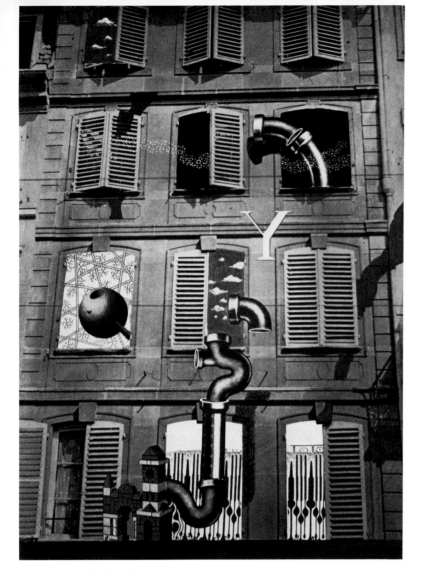

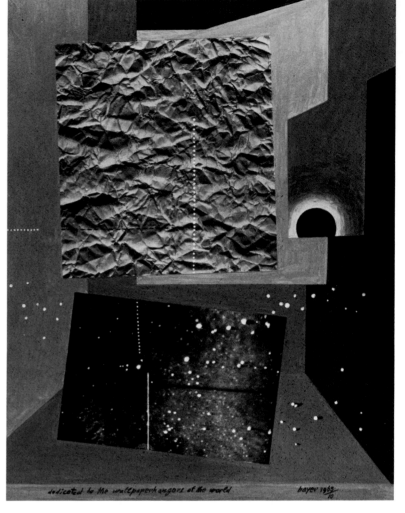

Dedicated to the Wallpaper Hangers of the World 1963/10, collage and liquitex on paperboard, 16¼ x 13″.
Collection Joella Bayer.

Denkmal für die Gefühle eines sentimentalen Klempners in Salzburg 1963/11, collage and liquitex on paperboard, 15½ x 11¼″.
Collection Joella Bayer.

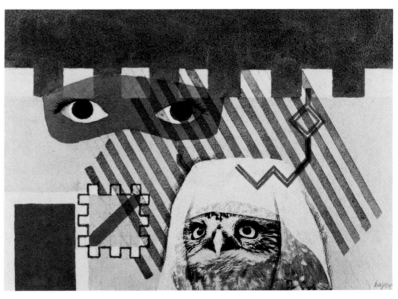

Anti-Atlas 1972/84, acrylic and collage, 9 x 12¾″.
Collection Joella Bayer.

range from those in which one can diagram an abstract architectural composition to the last images in the series, *Tangier* 1976/34, 35, where architectural reference is all but obliterated by the sheer power of the abstract spatial arrangement of color. The issue ceases to be about space as such and becomes an exploration of the way color creates space and successfully expresses it.

From Monochrome to Polychrome: The Chromatic Paintings

Although the years from 1964 to 1976 mark a significant departure from Bayer's sometimes romantic, sometimes symbolic, intensely passionate interpretations of landscape and atmospherics, architectural space and linear motifs, they are nonetheless continuous with these concerns. There appear to be breaks in Bayer's paintings—separations between allusive figuration and hard abstraction, soft tonalities with intimate hand and cool, distant, flat spaces colored with aloof precision—but these breaks reflect less the truth about his growth as an artist than they do conspicuous gaps in the awareness and reception of his work. For many years, Bayer hardly exhibited. As a result the continuity and development of his work is incompletely known. Given the range of formats and media, consistently high quality, and immense productivity of the previous forty years of his work, the paucity of significant retrospectives is surprising.[76] More than depriving the public of a considerable pleasure, this skews the perception of Bayer's work. Sometimes the work has been viewed as that of the designer who paints, or more precisely the Bauhäusler who continues to enact as artist the ideological solemnities of the Bauhaus without understanding either the Bauhaus or its aftermath. Sometimes, in reference to the more widely disseminated "Chromatics" of the 1960s and '70s Bayer is seen as the painter who was too readily assimilated to the school of painting dominated by such artists as Max Bill, Richard Lohse, Karl Gerstner, or the more exploitative Victor Vasarely, without appreciation for the common source from which all these artists, including Bayer, derive.

It is appropriate to recall the starting place for these chromatic painters, namely their indebtedness to the Vorkurs and its aftermath, established at the Bauhaus by Johannes Itten but extended and enlarged by the contributions of Josef Albers and László Moholy-Nagy. As Bayer has written in private response to a critical assessment by Jacques Leenhardt in the *Journal de Génève"* about the differences between his paintings and those of Vasarely: "learning in the workshops (of the bauhaus) was preceded by a course designed to instill in the student a fundamental objective understanding of the physical and psychological facts of vision, materials and construction. this became visual research and free association experimentation by design without applied function. it was the beginning of those explorations of optics in art which in later art movements, such as op and hard-edge painting, became fundamental." This is not to say that all the chromatic painters mentioned (and many others besides) were themselves involved in the Bauhaus, although Max Bill was at the Bauhaus in Dessau from 1927 to 1929, and Victor Vasarely studied at the Budapest Bauhaus (founded by Sandor Bortnyick), with Fred Forbat, Gyula Pap, and Farkas Molnar. Like Herbert Bayer, they had all been exposed through the Vorkurs to experiment with materials, spatial arrangements, and color as abstract alignments and compositions.

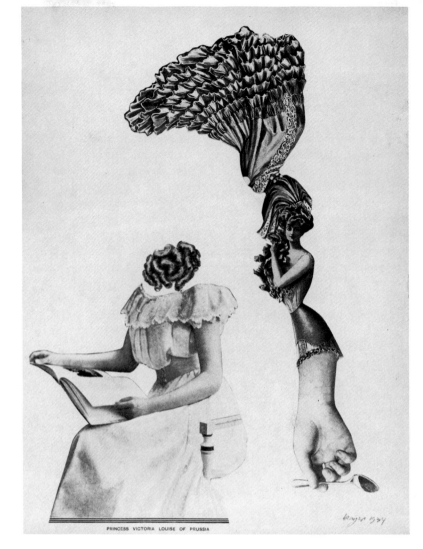

PRINCESS VICTORIA LOUISE OF PRUSSIA

Untitled 1934/12, collage, 14 x 11".
Collection Joella Bayer.

To trace the movement from Albers's early experimentation with the optical properties of colors and Moholy's interest in the relation between color and materials to the emergence of what Karl Gerstner has called "kalte kunst"[78] would go too far afield and would entail consideration of the whole devolution of constructive art and De Stijl in the 1920s, their passage through architecture and its renovation toward a conception of pure abstraction grounded in the adaptation of geometric space and form to a palette dominated by the rigorous separation and counterpoint of the warm and cold color scales. But even more significant than considerations of space and color is the fundamental mathematical substratum on which this art depends. For Piet Mondrian and Kasimir Malevich the mathematical properties of space involved quasi-metaphysical assertions about the fundament of the universe, but such theosophical underpinnings are not evident in the modern chromatic painters, although their sense of the underlying mathematical of the universe is preeminent. Max Bill has written passionately about "The Mathematical Approach in Contemporary Art" in which he affirms that, far from being impersonal and impassive, mathematics allows for an art that builds up "significant patterns from the ever-changing relations, rhythms, and proportions of abstract forms, each one of which, having its own causality, is tantamount to a law unto itself."[79] Bill stresses the ability of the mathematically knowledgeable artist to opt for the theorem of his choice and establish the parameters of its experimental possibilities, so that the only thing removed from the feeling of the artist is the arbitrariness of the geometric form.

The artist is finally in control of his mathematical options, but he no longer allows the hand to move independent of reason. The domain of feeling to which the expressionist tradition assigns the origins of artistic creation is not sufficiently construed by notions of automatism or the unconscious, much less by dreams or impulse. Mathematics is a rigor, but not a straitjacket, since mathematics allows for multiple decisions regarding the placement of the form, the sequence of its unfolding, and the fixing of colors with which to run the permutations. Nor is the resulting art simply the working out of established rules of order already implicit in the mathematical formula. The misconception of mathematics by the nonmathematician and even more by the nonmetaphysician (who cares nothing and knows less about the classical Greek tradition where philosophy was grounded in mathematics, specifically in Pythagorean mysticism of numbers and in Euclidean geometry) is that they are unaware that the simplest mathematical formulation is capable of implying a much broader universe in which to make visible the classical harmonics.

It is in this context that Bayer's ongoing involvement with mathematical proportion and, from the middle 1960s through the '70s, with chromatic geometric painting may be viewed. For Bayer, as for Bill, mathematics represented neither limitation nor loss of creative energy and imagination. Quite the contrary, it was the next step in the movement of art from the discernment of abstract figuration in nature and the cosmos toward the implicit structure of all things. As Bayer has often remarked, his earliest and sustaining intellectual enthusiasm was for descriptive geometry. A school exercise notebook given to him in later years by his fellow student Karl Pichler contains solutions to the problems posed by his teacher in Darstellende Geometrie in the Real Gymnasium of Linz; to this day Bayer refers to these notebooks of his youth as an *aide-mémoire* in his pursuit of the fundamental geometrical forms he has elaborated in his work. But as with every aspect of Bayer's mature work, the intellectual problem–the mathematical proportion under consideration–is only the point of departure for the inquiry.

What is constantly at stake is not the preservation of the mathematical theorem for its own sake but rather the elaboration of its implicit possibilities. The theorem appears to the unsophisticated as an invariant formula, unsusceptible of variation. It appears precisely the opposite to the mathematically gifted artist. For Bayer as for Max Bill, the theorem is the occasion, not the finality. It supplies the initial form but does not delimit its mutations; the settlement of scale, coloration, or the complementarity or opposition that certain colors set up to the harmonics of the mathematical solution remain open and depend only on the artist's choice.

During the early 1960s, principally during 1964 and 1965, Bayer began his investigations of the interactive relationship between light and color. With a darkening palette (ascribed by Bayer to his grief over the sudden death of his daughter in 1963) in which the transparency of light itself became a critical element in the development of the series, his simple format traced the gradations from darkness to light in a number of monochromatic paintings that examined the passage from black to white, with subtle tonalities of gray the principal gradual. "I was concerned," he wrote in 1970, ". . . with the phenomena of the monochromatic. . . this series of monochromatic paintings became gray space illusions through the shading of geometric forms. space illusions, however, were not my primary intention. they happened to be a side effect of the process of shading dark areas to light areas."[80] Employing either horizontal bands of irregular length and width that phased from gray to dark gray to white, forming a pattern of illumination that maintained geometric balance, or triangular dark shapes repeating graduations or contrasting with horizontal bands of fuzzy white light cutting across vertically poised triangles, or yet again dividing the field into four rectangles that are enlargements or reductions of similar themes of progressive exfoliations of light and dark, Bayer created meticulously painted (never air-brushed as some have thought) tonal compositions. Occasionally, the light field was interrupted by a serpentine line (reminiscent of Kandinsky or Miró),[81] which Bayer had also used as an element in several of the iconic motifs in "Moon and Structures," but used here principally to relieve the experimental monotony of the enterprise.

Although the series has its echos in *Suspended Architecture* 1925/2, where the play of light on floating architectural elements was briefly essayed, Bayer was clearly setting the groundwork in the "Monochromatics" for an extended examination of color and geometry. Beginning with the Ostwaldian essentials–black and white, blended and graded, but free from any mixture of hue– Bayer explored, perhaps at too great length, the permutations that were possible. Although he tried on several occasions to see what would happen if the paint were applied to metal, notably in an

Positive-Negative 1963/35, liquitex, 14 x 14".
Courtesy Saidenberg Gallery, New York.

Line at Dawn 1964/4, oil on canvas, 32 x 25".
Collection Museum Tamayo, Mexico City.

Monochrome Exfoliation 1965/8, oil,
50 x 50″. Collection Mr. and Mrs. Moses Lasky,
San Francisco.

Blue Bird 1968/21, oil on canvas, 40 x 40″.
Collection Herbert Bayer.

untitled work (1964/44) where he put acrylic on aluminum to realize the natural reflectiveness of metal, he denied that he was trying to create through his monochromes any illusion of "sheets of metal gleaming with light reflections" (117:34). Bayer has never shown any interest in securing representational illusion; simulation, even imitation in its aesthetic significance, is not part of his intention. It would have been no triumph to have created a metallic trompe l'oeil. If such occurs for the viewer, despite the fact that the composition of the paintings defies anything but a microscopic trompe l'oeil of a diamond-point drill head, for example, it is because the viewer is not as knowledgeably interested in the kind of theoretical problem that Bayer had posed himself.

The monochromatics yielded place in 1966 to Bayer's long research into pure color and geometry. Writing in 1970, Bayer annotated the chromatic paintings, their origins and intentions, as follows:

It must have been the power of the sudden character of morocco with its isolated accents of bright colors against the purifying background of white in the buildings and the peoples' dress, the strong contrasts of sun and dark shadows, which opened again my eyes to the world of pure color.

I had the clear feeling and the strong urge to forget all my previous work and thought and to start again fresh and new at zero, on a clear table, beginning at the bottom and to learn again. out of the gray I was again in the sun, like a child who does not know and has not yet been mistaught. I am getting on in years and have gray hair, and I am still and again among the searching.

the pure colorfulness of the spectrum is the starting point. I recognized two psychological qualities of the primary colors: warm and cool. I divided the warm scale into divisions going from yellow through red to purple and in the cool scale leading from yellow through green to blue. placing the scales opposite each other or running in opposite directions or the two scales running parallel produced unexpected results. the neighboring opposites testifying to the relativity of color in nearly endless vistas of variations opened up a long view. when seen in detail, there appears less emphasis on harmony and more evidence of contrast and vibrations because complementary effects appear naturally from the positioning of opposites.

the proportions of the compositional structure is in some of these works determined by mathematical progressions, a motif which has interested me for some years. impressed by morocco's carpet culture, I also have left aside the conventions of the pictorial in order to develop color concepts and to bring forward the self-expressive reality of pure color.

The chromatic paintings begin in 1966 with a brilliantly original extrusion of an element that first appears as one of the primary structures in the "Moon and Structures" series of the early 1960s. An emblematic forecourt to the spatial plane that rises upward toward the moon describes the essential format of these pictures. Influenced by the sensitivity of Japanese architecture toward nature and the cosmos as well as by the even more vivid naturalism of Moroccan architecture and the severity of its landscape, Bayer's gateway to the heavens defined a hieratic and reverential attitude toward space. The early chromatic paintings, which Bayer called "Gates" whatever their atmospheric indebtedness to

his visit to Japan in 1960, were specifically suggested to him by the commonplace phenomenon of the *axis mundi*—that is the freestanding gateway, coming from nowhere, leading to nowhere, standing solitary in the desert wastes of North Africa, sometimes elaborated into a double gate, sometimes presented with smaller arches to shade travelers, but always marking a place, celebrating an event in space.

Rightly suspecting their mysterious character, Bayer has referred to such gates (which became the subject of a group of his important sculptures) as fata morganas, mirages that alluded to vistas to be approached through the gate, although in fact nothing eventuates in the beyond. Such gates mark moments in space, crossroads of divine-human encounter or avenues where space and time intermingle, heaven and earth intersect. As *axis mundi*, the gate is a freestanding structure whose power resides not in what it marks but in its actuality as marker. It marks itself, and the celebration of such an object is a celebration of its essential geometry, its lawfulness, its order, its proportion. Bayer's gates are powered by a majestic command of the chromatic scale, the subtleties of complementarity, and the force of noncolors such as white when situated between yellows that ascend to deep blue and disappear into blackness and condense into deep purple and disappear into blackness. A superb example of such close-valued chromatism is *Spectral Gate* 1966/50 or the similar *Spectral Gate* 1967/23. In a similar gate painting, *Spectral Gate in Yellow* 1966/5, the chromatic progression moves from a closely valued yellow through green, blue, purple, red, orange, orange-yellow, disappearing finally into the yellow field again. In an alternate format, the gate dominates the edge of the picture, turning with regularity until through the rhythm of the spectrum the regular gate of yellow has passed through the scale of cool and warm colors, turning and receding in measured intervals until by the final color in the succession of rectangular passageways, the left side of the gate has condensed and receded and the right side of the gate has expanded and moved forward (*Leaning Gate* 1966/91).

The essential format of these pictures is rendered more complex by arranging the elements of the gate as segmented planes and lintels, each element fashioned from complementary and contrary hues set into a black, white, or monochromatic field; the sequence and width of each planar segment intensifies the sense of both depth and frontality. Where the pictures maintain their chromatic calm, avoiding busy invention or novel overlays and abutments, they are immensely successful. Even where Bayer thinks he is deriving something from Frank Stella (*A la Stella* 1973/52), his interest is quite different. The processional emplacement of a receding sequence of blue gates, each separated by a narrow band of white (or unpainted canvas), the whole set into a yellow field, reveals that Bayer's fascination is with the power of color to allude an architectural space, whereas Stella was defining a minimalist conception of color—color making space infinite or obliterating it entirely.

Bayer's "Gates" yield up their considerable richness, whether received in their essential simplicity as exercises in the chromatic scale or presented as complex geometries of color where double gates, leaning gates, prismatic gates, repeat, angle, or refract the color scale. When the ground colors are sombre and severe and

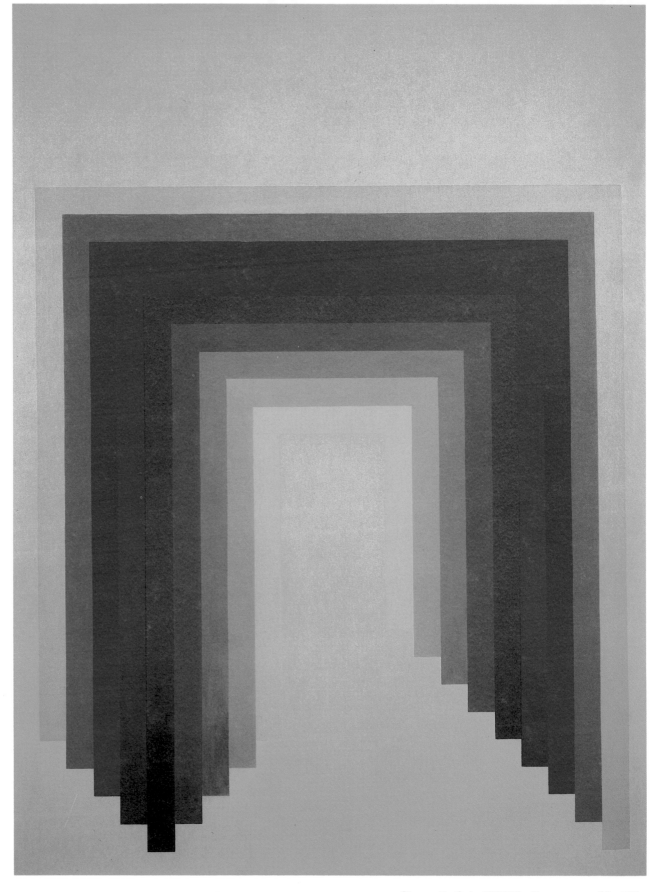

Chromatic Gate 1969/20, oil on canvas, 80 x 60".
Collection Denver Art Museum (Herbert Bayer
Archive).

Leaning Gate 1970/60, acrylic on canvas,
80 x 80".
Collection Neue Galerie, Linz.

Irregular Gate 1973/90, acrylic, 12 x 12".
Collection Joella Bayer.

the chromatic harmonies are composed of grays, greens, and blues (*Passage to a Cemetery* 1973/51, *Double Gate in Green* 1976/45), there is an echo of Josef Albers's studies in the optical qualities of closely valued colors, but the mathematical precision of Albers's repetitive inquiry satisfies curiosity with a few examples, whereas Bayer's research deals with the establishment of imaginary structures in real space and employs a color sense that, whatever its knowledge of theory, is deeply intuitive, always surprising, and virtually inexhaustible.

The Progressions of Fibonacci

Bayer's lifelong fascination with geometry and geometric forms was not merely an enthusiasm stimulated by his considerable facility as a young student in mastering the theorems and representations of Darstellende Geometrie. Since those early days, many other factors have come into play in his intellectual and artistic development, suggesting that a more profound premise was involved in his growing preoccupation with geometry. By the early 1960s, the period transcribed by his "Chromatic" paintings, one feels increasingly that the shift of Bayer's interest toward an apparent concentration on chromatic scales, values, and interactions may actually be a concealment of his real intention.

Bayer may not have known much classical philosophy or medieval and Renaissance speculative mathematics, but he was—by the time of his acquaintance with Greek and Roman sculpture and architecture after his trip to Italy and Sicily in 1924—fully conversant with the rules and regulations governing descriptive and projective geometry. He was familiar with the underlying algebra of the Golden Section and quite capable of applying its algebraic and geometrical properties to the development of proportionate curves or the formation of divided rectangles that would yield analogous and balanced elements. Bayer's architectural isometric drawings of 1923 illustrated application of principles of proportion to the envisagement of architectural space and by the time he had digested his travels in Italy and Sicily, he had undoubtedly annotated the familiar relationships between classical sculpture and architecture and the application of ancient geometrical principles to the documentation of Renaissance perspective and architecture. Moreover, he used the Doryphoros a number of times in his graphic design of the 1930s, an example of Greek sculpture acknowledged to have exhibited the canon of Polyclitos, which was based on the geometrical principle of the Golden Section used to establish the proportions of the human body.[82]

Not that Bayer was proposing a secret subtext to his explicit work, an arcanum where the postulations of Pythagoras, Plato, Euclid, Vitruvius were worked out in painting and design. I am suggesting that he possessed an intelligence acutely responsive to the proportion and mathematical balance implicit in descriptive geometry, that he pursued a harmony of elements in his architectural drawing and design, that he admired the classical articulation of such harmonics, and that as his work became more resolutely abstract and distant from literal figuration, his ideal forms and their relations quite normally returned to fundamental geometrical proportions and analogies. It could be argued that such premises were already fully articulated by Kandinsky, whose theoretical notions of color and form harmonics were available to Bayer in *Über das Geistige in der Kunst* (*Concerning the Spiritual in Art*), but Bayer has made clear that after his initial reading of the work he never looked at it again, that the impression of Kandinsky's ardor and ethical seriousness were much more important to him than the actual doctrine.

These reflections are appropriate as we turn toward the first major group of paintings that are linked to the larger body of Bayer's chromatic investigations. Entitled "Fibonacci," they refer, of course, to the two-beat additive series identified by Leonardo of Pisa (known as Fibonacci, that is, Filius Bonacci, the son of Bonacci).[83] Known in classical mathematics and rediscovered by Leonardo of Pisa in 1202, the Fibonacci series describes a progression in which each additional numerical term is the sum of the preceding two terms (1, 1, 2, 3, 5, 8, 13, 21, 34, 55, etc.). Luca Pacioli, a friend of Leonardo da Vinci, observed that the elaboration of the series tends asymptotically to the Golden Section or the "Divine Proportion."[84] Many botanical species exhibit the Fibonacci progression in the positioning of their leaves and petals, and it has been suggested that the same proportion obtains in the relation between the first finger joint and the next two,[85] as well as in the pentagonal symmetry of many marine animals, in which the intimate connection between the Fibonacci progression, the Golden Section, and "gnomonic growth" (in the phrase of Sir D'Arcy Thompson) may be observed.[86]

There are virtually no other commonplace additive series that lend themselves as brilliantly to pictorial transcription as that of Fibonacci. Other proportions could be derived (indeed many others do appear in Bayer's work) where proportional curvature or the relation between rectangles of color are examined, but Fibonacci progression is the most fundamental and flexible; moreover, because it only approaches the Golden Section (although it is always a mathematically close approximation), the Fibonacci maintains an incompleteness and visual uncertainty particularly congenial to an imagination like Bayer's, which prefers that the mystery endure even after scrupulous examination. I suggest, then, that Bayer's return in the 1960s to a full and unconditional involvement with chromatics is only the inevitable surface manifestation of a primary occupation with the implications of geometry for the description of the fundamental forms of all life.

Bayer leads the Fibonacci series through considerable permutations; however, in all of them the use and determination of color is conditioned by the nature of the geometrical forms that exhibit them. The most subtle and gracious compatibility of two curves meeting back to back at the center of the canvas, segmented according to Fibonacci in a scale from white to black, leaves a large spherical shape that is itself segmented from yellow through orange to red (*Two Curves Back to Back* 1973/85, 86). Serene, calm, almost too settled in its atmosphere of balance and complementarity, the format turns to the next logical development in a series of images in which the meeting points of vertical and horizontal progressions produce an upsweeping curve of immense expressiveness. Since the vertical progression yields a curve of such swift and precarious ascent, the coloration of the vertical entails reasonably small segments relative to the bands descend-

ing downward through the horizontal unfolding. This allows for a considerable range and contrast in the scale of colors, from the already familiar white through black, working off large swathes of yellow descending to red (*Curve from Two Progressions* 1973/60, 68), as well as the combat of warm and cool colors, dark blue descending horizontally through green to yellow, while the upsweeping curve passes from very dark red through orange to yellow once more (*Curve from Two Progressive Scales* 1974/35, or a variant with two curves, *Two Curves with Progressive Colors* 1977/31).

These formats, which entail a rigorous employment of the Fibonacci series to produce color abutments and subrectangles whose metaphoric diagonal is a segment of the rising curve, are also bypassed for much freer experiments where the issue of color becomes more intrinsic to the determination and exposition of the geometric shapes. In *Two Untitled Curves* 1974/40, a voluptuous spherical shape in grades of blue, green, and yellow is placed next to a down-sweeping needlepoint curve in yellow, orange, red, blue-purple, and blue, leaving beneath both shapes their counter images in unpainted canvas.

Early in the "Fibonacci" series, when the vocabulary is young, Bayer begins with a simple, non-Fibonacci additive series in which a horizontal in complementary colors or identical scales works off a vertical series to produce a simple curve (*1, 2, 3, 4 … Making a Curve* 1973/20, 21), becoming later more complex as a two-tier double curve ascends to break up the symmetry of horizontal descending stripes (*Two Geometric Curves* 1973/76 and *Two Curves with Progressive Colors* 1973/77). Two years into his experimentation with the Fibonacci progressions, with *variora* of the chromatic paintings having been accomplished at the same time, it is apparent that his careful, somewhat stoic, adhesion to the rules of complementarity begins to give way to a more instinctive application of color and a considerably freer, in several cases, even riotous, fracturing of the measured Fibonacci progressions.

The premise of this brilliant subgroup of "Fibonacci" paintings turns on a basic intuition—the curve need not be the only shape extruded by the meeting of vertical and horizontal progressions. If indeed the meeting of the bands is fractured, either by starting the progression at other than the extremity of the canvas or by situating the progression as a triangle that cuts downward into the canvas or rises as a body in its center, everything that comes off the hypotenuse or the long side of the triangle will dictate unscheduled areas that require original and intuitive coloring. From dealing with two principal areas where coloring will be proportional and rigorous in exposition, the format shifts to three (even four) areas in angular combat, where the color harmony is not dictated by the gradual of complementarity but will evoke frequently daring and unpredictable alterations of regulated coloration.

In *Progression into Triangles* 1974/30, a thin lozenge of pink defines the base of an inverted right-triangle progression through blue, yellow, black, white, and red to the bottom of the canvas. This offers the possibility of a pyramid coming off the hypotenuse, repeating the pink, black, white of the principal form, but toning the powerful pyramidal expanse by the use of red, dark blue, and gray for the larger segments. But there is still more to be done: the side of the inverted right triangle throws off a small pyramid fashioned

of stripes of mixed and distinctly eccentric colors that touch a black right triangle abutting the back of the powerful red segment of the dominant form. The empty spaces left over (themselves triangles) are painted Bayer's favorite sky blue. This remarkably effective picture skews the formal geometry and allows an eclecticism of color that holds the form as much as creates it. The tension between image and color is powerful precisely because the rational solutions that tend to dominate the series have all collapsed. Bayer is faced with building up the canvas to resolution a step at a time, a color at a time, an evoked shape at a time. Nothing is predetermined and, hence, this picture enjoys a spontaneity and brilliancy sometimes lacking earlier in the series.

This phenomenon of eccentric fortuity occurs in virtually identical compositional circumstance in *Prismatic* 1970/86, a picture where the Fibonacci progression is absent, but triangulation within an internal rectangle throws off a series of color progressions that are both unpredictable and marvelous. Even the success of studies in warm complementaries, such as *Reversed Progression* 1973/7, or the use of a powerful pink form to complete the space left over from two or three series that meet and commingle (*Two Curves with Pink* 1973/88 or *Connected Progressions B* 1974/4) defer to the logic of forms that allows little room for the precarious generation of the odd triangle, the unused space, the irrational color. The series, immensely elegant in all its permutations, leaves too little to chance. A few pictures employing the Fibonacci formula refer to Bayer's ongoing preoccupation with architectural space and turn the format toward the investigations of perspectives and flat space he had undertaken periodically in Tangier. Using the same palette as he did in the *Tangier* studies, white once again predominates, the Fibonacci curve establishes an angled relation to the diagonally descending horizontal progression, the space is somewhat revolved, and the picture acquires an almost constructivist purity (*Curve from Diagonal Progressions I and II* 1975/24, 25).

Finally, there are several incomplete explorations of what would happen if the progression of colors were according to enlarging rectangles throwing off incrementally elongated stripes of extremely intense red, green, orange, yellow, purple, and blue. In *Verticals into Horizontals I* 1975/30, this alternative application of the Fibonacci additives allowed a more inventive series of color options while breaking out of the geometric formulas assiduously pursued earlier in the series.

What emerges in this small group of pictures (not more than eighty paintings from the *Two Progressions* 1964/7 through the last pictures in 1976) is a description of the speculative curiosity underlying Bayer's entire series of "Chromatic" paintings: Bayer had adopted color as the means of expressing fundamental geometry. There is to be sure a temptation to apply color with such a coolness and dispassion, flat and impassive, that the subtle hand present throughout most of his earlier work virtually disappears in favor of a clinical display of color. This strategy, however it may have served the precise and elegant constructions in the Fibonacci series, detracted from the experimental caprice in those works where color genuinely took off, splitting away forms from a skewed geometry and encouraging color to find its own way.

Curve from Two Progressions 1973/68, acrylic,
60 x 60".
The Breakers Collection. Atlantic Richfield
Company.

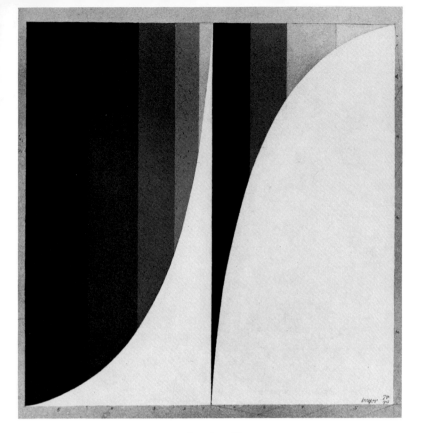

Two Untitled Curves 1974/40, acrylic, 18 x 18".
Collection Herbert Bayer.

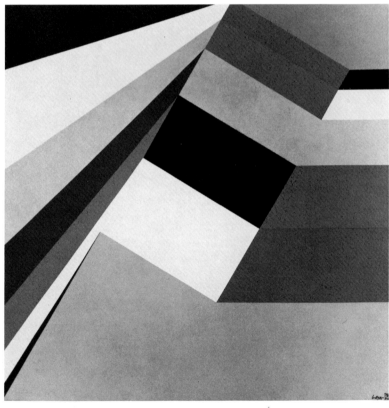

Connected Progressions B 1974/29, acrylic,
30 x 30".
Collection Herbert Bayer.

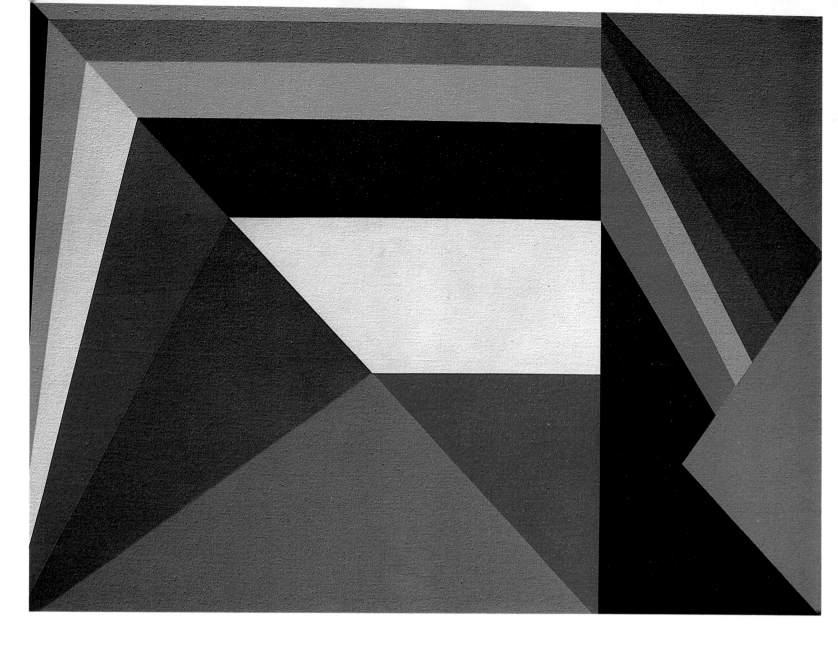

Progression into Triangles 1974/30, acrylic,
30 x 40".
Collection Joella Bayer.

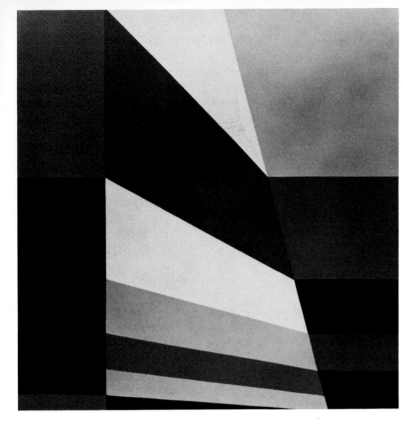

Reversed Progression 1973/7, acrylic on canvas,
20 x 20″.
Collection Herbert Bayer.

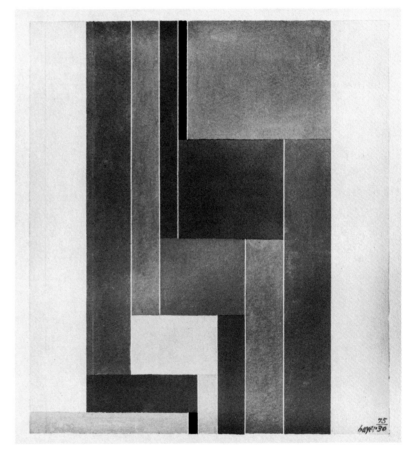

Verticals into Horizontals I 1975/30, acrylic,
11 x 9³/₈″.
Collection Herbert Bayer.

Chromatic Paintings and Celestial Bodies: 1964–1976

My ambivalence toward the precursor series to the chromatic paintings and the pictures devised out of the Fibonacci progressions has been noted. On the one hand, I admire Bayer's turn toward mathematical structure as a strategy that eliminates the predicament of mimesis, allowing him to confirm an unyielding commitment to abstraction and focusing the issue of rhythm and harmony on the interaction of formal structure and color. On the other hand, I prefer those pictures in which the placement of form within the composition introduced an irrational factor that could only be resolved by the description of logically optional forms and free color. Although the formal relationships between shapes remained logical, the logic was not necessary; it became possible to select between implied forms, to expose those that were not implicitly predictable and, having fixed an optional possibility, to develop a coloration that abandoned the regulations of a formal scheme. Having acknowledged my prejudice against (or at least resistance to) the limitations imposed by an all too rigorous consecration to mathematical balance (note as well that all pictures from this time forward are square), I find it necessary to reopen the whole issue as I turn to the immense body of paintings that enfolds Bayer's "Chromatics" and the smaller series of "Celestial Bodies," which begins somewhat later and concludes at the same time.

By the middle 1960s chromatic painting had achieved an unanticipated eminence. The exhibition The Responsive Eye, mounted at the Museum of Modern Art in 1965, constituted a kind of institutionalization of the mode.[87] Although Bayer's work was not in the exhibition, since it was generally unknown (his first New York exhibition of any consequence took place at the Byron Gallery the same year, although a modest retrospective had traveled in the United States and Europe during 1962–63). By and large Bayer had admittedly not been aggressive (until 1963)[88] about exhibiting his paintings, and the chromatic experiments he had been making since the early 1960s would have accorded with the definition advanced by William C. Seitz for that landmark exhibition.

Identifying as "perceptual abstraction" work by everyone from Josef Albers, Max Bill, Kenneth Noland, Ellsworth Kelly, Paul Feeley, and Morris Louis to Karl Gerstner, Victor Vasarely, Brigit Riley, and many others, Seitz took his point of departure from the variations wrought in the fundamental argument of the De Stijl movement. Citing Alfred Barr's dictum that De Stijl was based on three elements ("in form the rectangle; in color the 'primary hues,' red, blue, and yellow; in composition the asymmetric balance"),[89] Seitz might easily have gone on to cite passages from van Doesburg's manifesto of 1930, to which Max Bill makes frequent reference, in which twentieth-century abstraction is asserted to be one in which intellectual decision obliterates the necessity of hand and heart, style and feeling.[90] In such a view, painting becomes the objectification of judgment, decisions of color rational rules, the certitudes of the object eliminating all reference to a reality beyond or a subject matter external to the means of making. The new chromatic painters, however, ignoring, or at least violating, the docta of De Stijl, replace asymmetry with symmetry, complexity with simplicity, variety of means and media with economy, and spare color with considerable variety of color. In this order of painting, form becomes minimal or serially repetitive in order to enhance perceptual responsiveness; color areas are simplified and reduced to achieve rhythm and movement; while the fundamental geometry of shapes, throwing off, as they do, metaphysical associations, are restored to literal immediacy by the general flatness and asymbolic neutrality of color application.

All these criteria, *mutatis mutandis*, are fufilled by the several hundred paintings and drawings made by Bayer during these years. And yet, although it seems appropriate and convenient to assimilate his work of these years to the broad category of perceptual abstraction (which assembles a variety and ostensible contrariety of painters whose visible intentions and means are often at war with each other), a reservation asserts itself.

Some of the painters Seitz congregated in his exhibition sustained an orientation to the mathematical matrix and its permutations through the discipline of color, but not many. By and large the American-born painters in the group were dealing with considerably more limited chromatic problems, and issues of retinal saturation or effects of the afterimage (both of which Albers had condemned as "legitimate painting aspirations" and Bayer had eschewed) cropped up in some of their work.[91] Moreover, by the time of his chromatic paintings, Bayer had nearly a half-century of work behind him, work in which the mark of personal style, individuality, distinctive image and hand were in his view already satisfactorily defined.

The issue of coherence and cohesiveness—which occurs in Bayer's discussion of his chromatic paintings as well as in Max Bill's definition of his own art—makes an appearance; this suggests a genuine distinction between Bayer and the other perceptual abstractionists. With the exception of Le Corbusier, Bill, and the younger artist Gerstner, no other artists of the contemporary period had maintained an artistic practice that included painting, sculpture, environments, and design. Coherence and cohesiveness of the creative undertaking are critical for such artists. This is not to deny that each discipline entails different technical skill, but to affirm that the handling of form as "beautiful" form is implicit to each, that there is never any escape from the fundamental intuition of form. If form is always distinctive to every artist, however much each artist may adapt his specific vocabulary from the general universe of forms, the internal logic and implicativeness of the artist's own language of forms is critical. Bayer is certainly addressing this issue when he wrote, in "Vasarely's Paintings Compared with My Own," "my paintings are indivisible from the rest of my work in the sense of complete coherence." He was referring in this context to his chromatic paintings, but it is also true of earlier periods in his work, where the vocabulary of his painting is adapted and transmitted in his design work as well.

It is relevant that Bayer's images are unique to him, as for that matter are those of Bill, Vasarely, Gerstner, and the rest. There is a universal vocabulary upon which each draws—circles, squares, curves, triangles, and so forth—and mathematic regulations govern their disposition and implication, but selection from the common stock of geometric forms is personal, even if not idiosyncratic.

Bayer organizes a principal body of his chromatic paintings about the positioning of a circle at the center of the canvas; the circle is reduced in even bands of color moving through the warm or cool spectrum; entering the circle from right and left or top and bottom are two eccentric hemispheres also marked in receding stripes of the contrasting complementary. The colors are brilliant, but do not cause any optical illusion or conflict; rather they afford a rationally simple pleasure, the pleasure of perfect form and generous coloration. This basic format is pressed through all modulations and permutations; from four circles with hemispheric interference and progression, reading through each circle to a final reversal, or shifting the coloration within the spectrum of the primary circle and its insurgent hemispheres, or attenuating the shape of the warm color interruption to that of a soft pyramid so that the background becomes the hemisphere. These shifts in the working of the primary circle and its permutations begin to elicit figure-ground relationships, surface and depth comparisons that pull forward or draw away as the colors require. It is theoretically predictable. The schema is limited, but even in the absence of intellectual surprise, there is immense pleasure in the sheer succulence of color.

The effect of color transparencies occasioned by passing yellow or orange over a blue stripe, although present in the investigation of chromatic circles, becomes one of the major considerations in the series of paintings that deal with the division of a square format into thirteen identical units. In these luminous pictures, the checkerboard organization into thirteen lines of squares (based either on a thirteen-by-thirteen-inch format in the acrylic on paper drawings or a forty-by-forty-inch format in the acrylic on canvas paintings) permits Bayer the magic center where colors finally meet and are dissolved or consummated. Using the thirteen-by-thirteen unit organization invariantly, he is always permitted a locus, either centered or placed beneath the center, for an area three units by three units square, or for a cruciform consisting of three intersecting colored horizontals and verticals. The coloration either floods outward from the cool center, emphasized by black or blue surroundings, to the warm perimeters of the canvas or a staccato variation of reverse progressions; or the ambiguously warm-cool yellow dominates the center or defines the route of a reversed progression from the periphery of the painting inward (*Polychrome I, Warm and Cool* 1970/41; *Polychrome II, Green Center* 1970/42; *Polychrome IV, Diagonal Progression* 1970/51; *Polychrome V, Diagonal Progression* 1970/53). Sometimes within a structure organized of yellow and blue squares, an overlay of orange and red bands will sufficiently alter the yellow and blue underpainting as to create a glowing internal square moving about a white or yellow center (*Polychrome to Double Progression Warm* 1970/93 or *Double Progression Warm* 1971/2). *Double Progression, Cool* 1971/3 is a study of interlocking cool squares, which proceed from purple and green or tonal weights of blue or dark blue and green moving inward from the peripheries, exchange weights, pass over each other, and finally resolve in a cruciform where the white center borrows the optical strength of the surrounding yellows and greens.

The final principal format in the "Chromatics" consists in setting down on a neutral and essentially passive ground (light gray, beige, blue) or painting up to the edge and filling the leftover areas with shades of color that complement the composition, a series of circles that lie over each other, like perfectly scalloped fish scales. The circles begin at the edge as abutting hemispheres and unfold through the canvas, implying their hemispheric circumferences or touching the edge; this leaves a cycloidal shape that needs to be relieved, or else is situated as a pattern within an unpainted ground (principally in drawings or studies for larger paintings), or completed as a constructed shape requiring a complementary ground color that baffles, without constraining, the dominant form. Although the circles offer the possibility of a shimmering light that alters the prevailing squareness of the format, these paintings—though their titles are variants of words for accumulation and agglomeration, notably, *Chromatic Amassment* 1975/111, *Chromatic Pile* 1971/37, *Chromatic Aggregation* 1971/76, 80, *Spectral Accumulation* 1971/78, *Chromatic Accruement* 1971/102, *Diagonal Accession* 1971/103—become curiously methodical and undemanding when viewed serially.

It is only when the rhythm is broken that the pictures become visually tense and agitant, as in *Chromatic Accruement* 1971/102, where the picture's blue border surprisingly reappears at the blue center of a progression of extremely warm colors; or in *Reversal* 1971/33, where two inverted triangles of circular colors share a side of purple, all set into a field of blue. Similarly, in *Nimbus* 1971/36, which alludes to elements of both the earlier hieratic "Moons and Structures" series and the "Celestial Bodies" series on which Bayer was working concurrently with the "Chromatics," there suddenly appears, amid a patterned arrangement of scalloped blue and white circles surmounted by a field of red, a single green form—no longer circle, but a cycloid (rather like an inverted parachute)—breaking serial rank and beginning to fall. *Nimbus* acquires by this inspired gesture an order of humor that seems at odds with the rigors of geometric chromaticism. It is as if, periodically, Bayer had had enough and took leave of the gravity invested in the series as a whole to permit a luxurious frivolity.

This would be a permissible reading of this picture were it unique in the body of his chromatic investigations. But it is not. It occurs many, many times, effects being wrung from order but extended into chance; color avowals that when joined to eccentric geometric shapes introduce a kind of invention and play often lacking in astringent chromaticism. Bayer's goal was never to achieve the mathematical routinization of his options—telephoning the painting to the craftsman in the manner of Moholy-Nagy's famous experiment or devising a box where a series of cubes could be rearranged by the owner to produce new geometric and color constellations as did Karl Gerstner.[92] The point was that the three formats described supplied a basic vocabulary of circle, square, and overlaying circles and cycloids with which to investigate the effects of serialized color progressions that yield, within the mathematical limits of the divided forms, a gradual of perceptual impressions. But once Bayer had defined these changes and recorded the possibilities, he struck off beyond the regulations of the problem.

It may be objected that some of the pictures I cite are not specifically chromatic inquiries at all, that they turn the issue of chromaticism toward Bayer's familiar preoccupation with architecture,

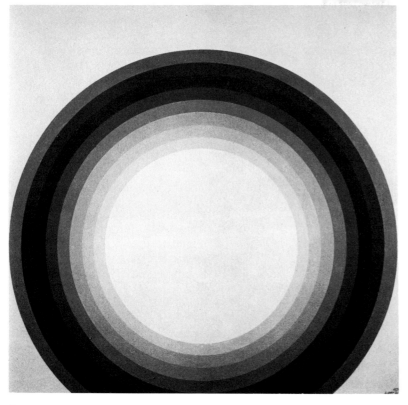

Chromatic Disc 1970/61, acrylic on canvas,
40 x 40".
Collection Herbert Bayer.

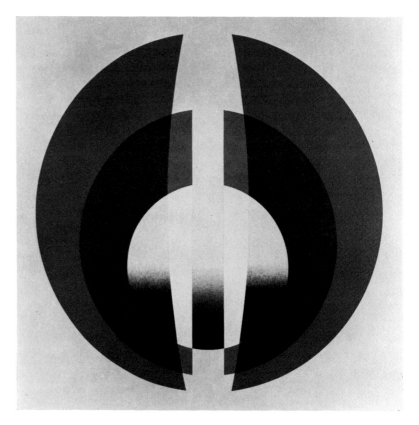

Double Transparency 1976/66, acrylic, 50 x 50".
Collection Herbert Bayer.

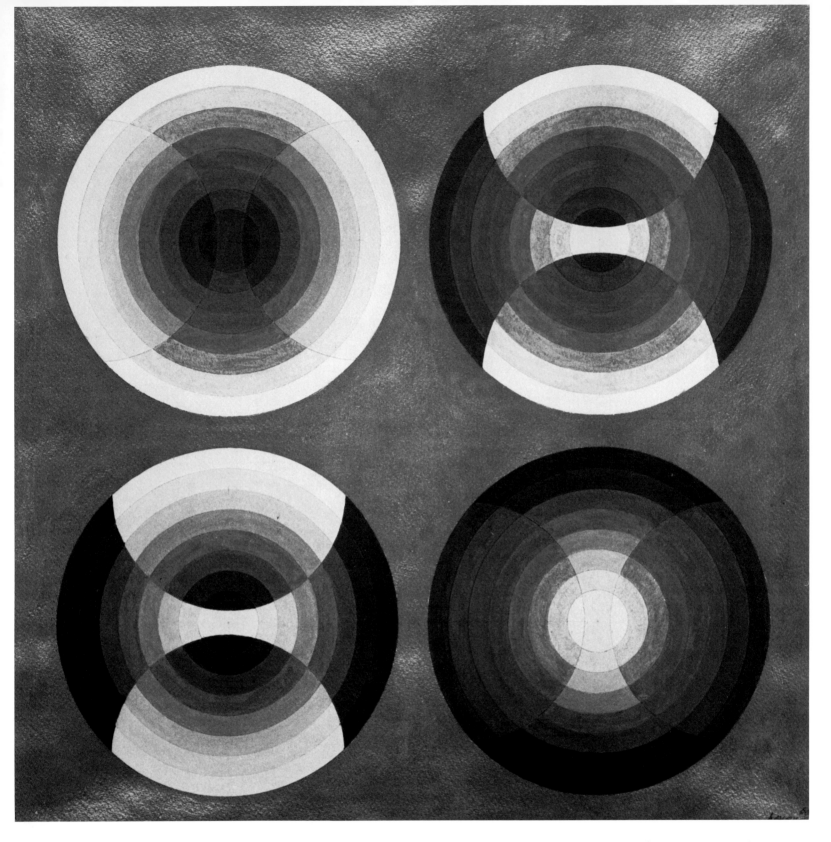

Four Chromatic Objects 1969/8, acrylic,
20 x 20".
Collection Joella Bayer.

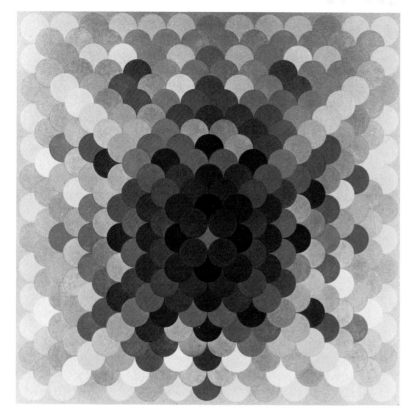

Centralization 1975/93, acrylic, 60 x 60″.
Collection Joella Bayer.

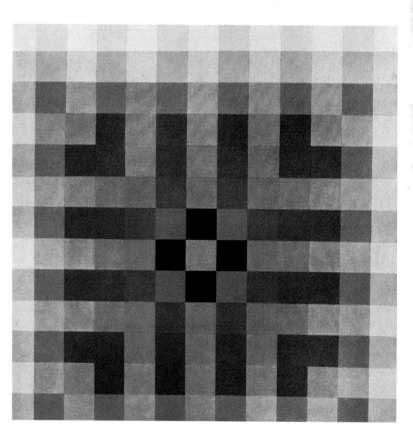

Polychrome 2 (Green Center) 1970/42, acrylic on
canvas, 40 x 40″.
Owner unknown.

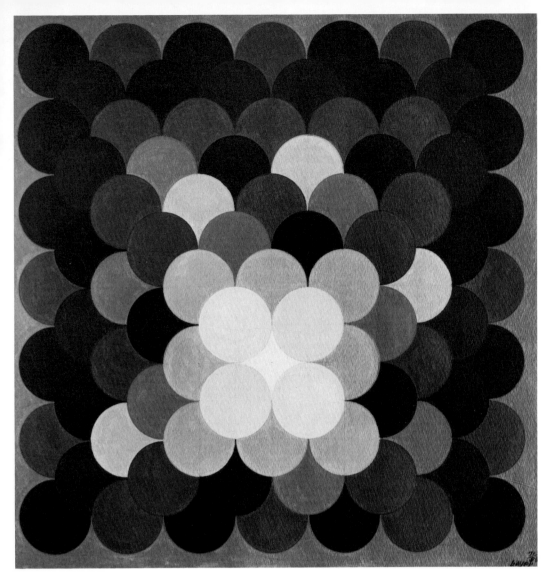

Accumulation 1971/83, acrylic, 15 x 15".
Collection Mr. and Mrs. Henry T. Chandler,
Lake Forest, Illinois.

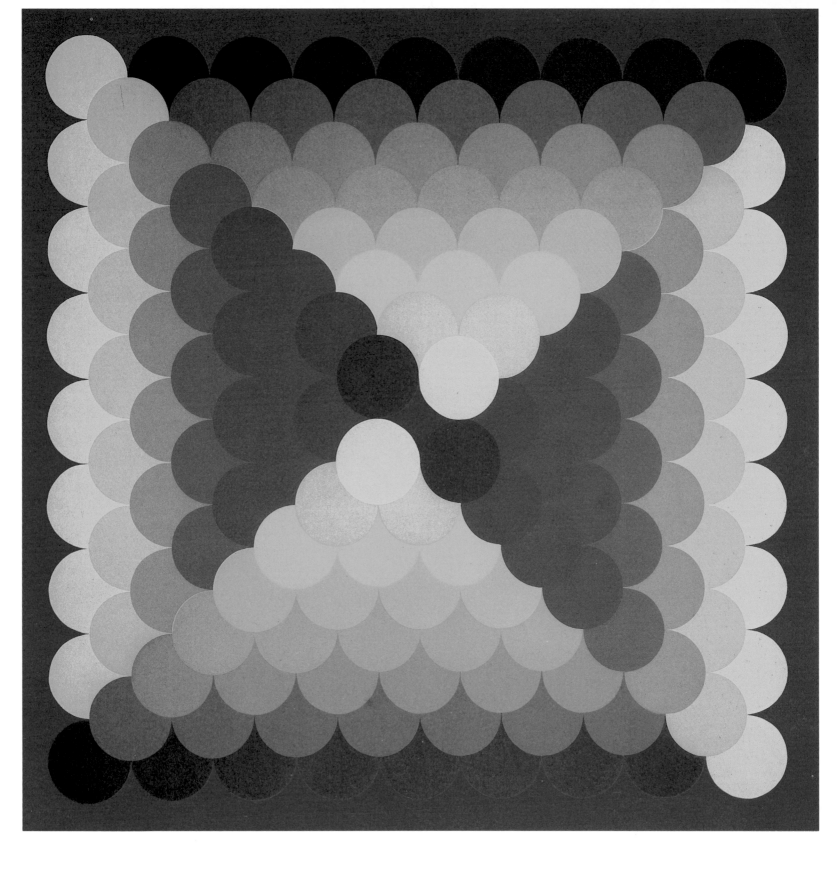

Spectral Accumulation 1971/78, acrylic,
60 x 60".
The Breakers Collection. Atlantic Richfield
Company.

spatial arrangements, perspective, cubist byplays, and playful comment on himself, his history in the arts, and his relation to other artists. But why should these issues not reassert themselves? They are entirely appropriate and (but for the fact that Bayer has organized his paintings according to broadly defined groups) the paintings need not be considered studies in chromatic progressions as such, even though they work through modulations and reconsiderations of the value and power of primary colors and their relationships.

The diamond shape set as an acrylic on paper in *Chromatic Structure* 1967/12 is no longer involved with formal chromatic progressions but with linear structures meeting and parting. The fact that the structures are displayed in primary colors, with considerable personal modulation of hue and intensity, does not really force them to the chromatist's Procrustean bed. Although they adopt the diamond format propagated by Mondrian, there is no indebtedness to him in the organization of space; moreover, Bayer does not play to particular advantage Mondrian's involvement with the edge in his use of the diamond, since in most of the chromatic studies where it appears, Bayer has floated a central form, using the surrounding area only to supply glow and totemic mystery to the composition (*Two Corners* 1966/72, *Divided Center* 1967/38, and *Two Chromatic Corners* 1967/39).

The acrylics on paper, *Five Progressions* 1969/41, *Kandinsky Exercise in Progressions* 1969/42, *Homage to Moholy-Nagy* 1970/5, and *Phoenix* 1976/23, are extremely strong, inventive images set as totemic elements into a deep blue or black ground—serpentine shapes, spherical solids, segmented cones, receding rectangles arranged like chips of glass, circles painted like eyeballs. Only *Homage to Moholy-Nagy*, a rather straightforward display of hemispheres and ellipsoids in blue, red, green, yellow, black, and white, overlaying each other and producing separations of the spectrum, is relieved of this mysterious ambience. Like Moholy himself, it is an homage in straightforwardness, whereas the other pictures are all indebted to Kandinsky, Kandinsky celebrated and Kandinsky rectified. It is noteworthy that the constructed elements in these images will occur again in Bayer's major contemporary paintings, the "Anthology" series.

Nor are responses to cubism ignored in Bayer's rehearsal of the eccentric opportunities of color investigation. Frankly called *Resembling a Table* 1971/42, a frontally presented rectangle, rising from brown legs, tilts toward the viewer. On its upturned face are two adjacent parallelograms colored in complementaries, along with a red cube, mostly absorbed into the lowermost parallelogram (however with one identifying side in brown) and a point of the red parallelogram tipped in yellow jutting off the table. One is compelled to the conclusion that Bayer has presented a *nature morte géométrique*, in which the shapes are celebrated as a cubist might have described the fractured perspectives of a bowl of fruit. Another approach to rectangular shapes appears in *Squares Changing Position* 1971/39, where a fan of white squares set into a brown ground unfurls in progression through grades of brown until the squares disappear into the background; however, above the image, as though counterpoint and comment, are four horizontal stripes moving from white through grades of blue to dark blue. The play with illusion, with figure-ground relationships and their reversals, seems at the heart of this lovely image. And finally, *Square Divided Into Fifteen* 1975/83, a picture that is not about chromatism at all, however much it uses rich and powerful colors, centers about a draftsman's scheme in which shapes are drawn on a black sheet of paper. Floating above the drawing, whose elements are clearly visible, are the same shapes in green, blue, red, orange, ruby, purple, and so forth. The draftsman has cut up his drawing, painted its elements, and displayed them above the negative image of their pristine spaces.

Two acrylics on the theme of the *Hidden Circle* 1972/78; 113, one extremely small (10 x 10″), the other quite large (80 x 80″), are superb chromatic articulations of a problem put by Paul Klee numerous times throughout his career. The patterning of the world, in its will to conceal, actually discloses by indirection. Bayer has divided the entire, square area of the composition into an equal number of rows of smaller squares, each one painted according to a rhythmic system of intervals and repetitions. There are no forcing colors, no compelling progressions, nothing to reveal the secret; however, a small shift occurs, a minor seismic dislocation and a hidden circle emerges. Since the colors are generally pallid and closely valued, a small shift in the coloration of certain squares reveals a circumference and the hidden circle, at first view unseen, is quietly and circumstantially disclosed.

Bayer's inventive forays beyond the strict requirements of format and color progression and complementaries also include a remarkable suite of pictures involved in the fracturing and recomposition of circles (*Making of a Circle* 1968/16; the segmenting and transparency of circles (*Fractured Moon* 1969/13); the passage of circular elements over each other as though an homage in circles to Moholy-Nagy (*Circular Progression in Size and Color* 1970/43); the use of gold leaf to counterpoint the descent of two brilliant orbs, colored in complementary spectrums, into a blue sea, the descending hemispheres of each orb becoming black as they pass into the blue water of *Afterglow* 1971/66; and finally the simple circle, cut with a carpenter's saw into quadrants and triangles, cycloids and cones, each painted in primary brilliance, rising up and away from their underlying dark circle (*Triaded Circles* 1975/64).

It is astonishing that through the long, disciplined research into chromatic progressions in which the images were dominated by rigorous mathematical proportion and balance, analogy of elements, progression and reversal of color, Bayer should simultaneously have been producing the smaller series of pictures called "Celestial Bodies." Although these images do entail the precise placement of circular shapes or shapes triangulated by the ethereal fracturing of light within a field exactly described, they are not bound by any regimentation of color. Clearly, Bayer was able to paint with imaginative unconstraint while at the same time pursuing rigorous chromatic inquiry. During the twelve years that compassed the chromatic paintings and the nearly fifteen years during which he moved from the monotone and duotone paintings through the "Moon and Structures" images, the "Gates," and the chromatic geometry with which I have been dealing, he was never far from his primary preoccupation as a celestial architect. In the

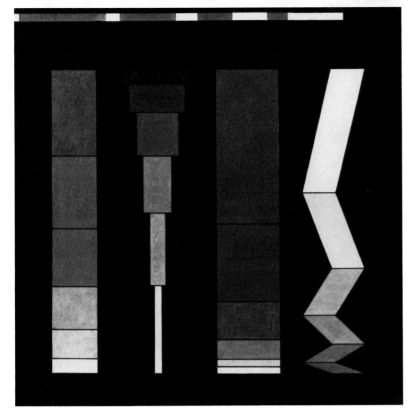

Five Progressions 1969/41, acrylic, 14 x 14″.
Private collection.

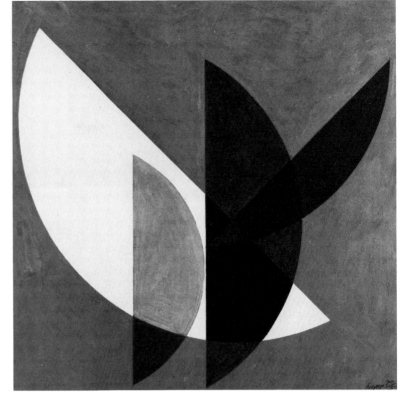

Homage to Moholy-Nagy 1970/5, acrylic,
10 x 10″.
Collection Ulla and Peter Nowack, Tegernsee.

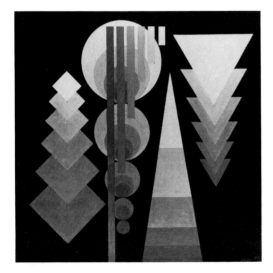

Kandinsky Exercise in Progressions 1969/42,
acrylic, 14 x 14″.
Collection Joella Bayer.

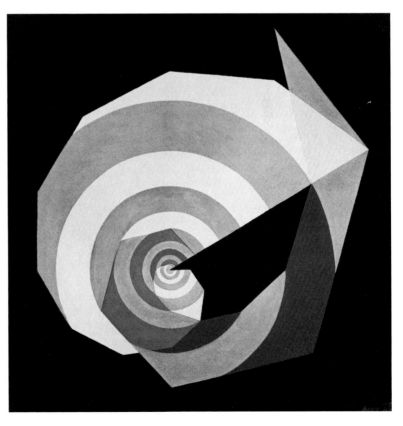

Twin Gyration 1973/98, acrylic, 12¾ x 12¾″.
Collection Herbert Bayer.

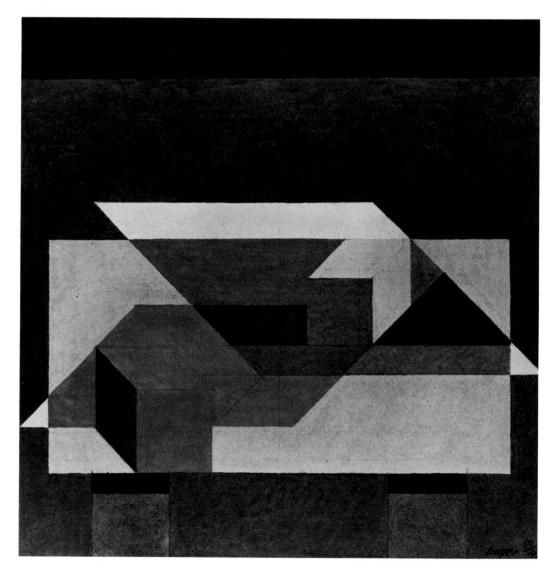

Resembling a Table 1971/42, acrylic 12 x 12".
Collection Joella Bayer.

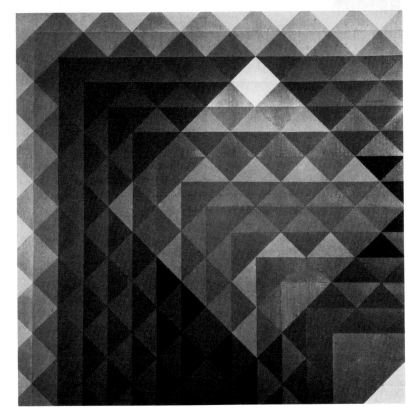

Triangulation (With Hidden Square) 1970/17,
acrylic, 50 x 50".
Collection Mr. and Mrs. Robert B. Eicholz.

Four White Corners 1976/68, acrylic, 60 x 60".
Collection Joella Bayer.

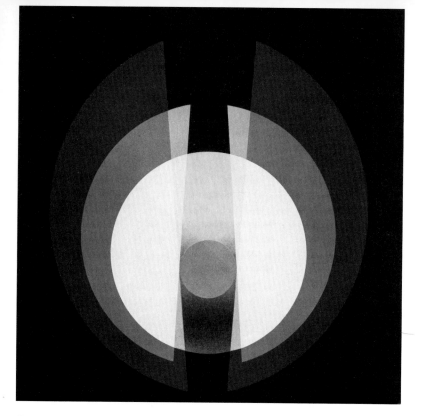

Segmentation 1976/65, acrylic, 40 x 40".
Collection Joella Bayer.

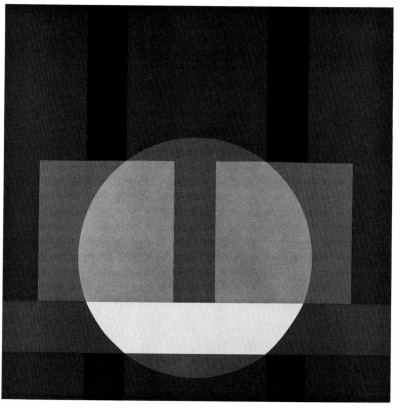

Structure with Circle in Three Pairs of Complementary Colors 1969/10, silkscreen, 16 x 16".
Collection Herbert Bayer.

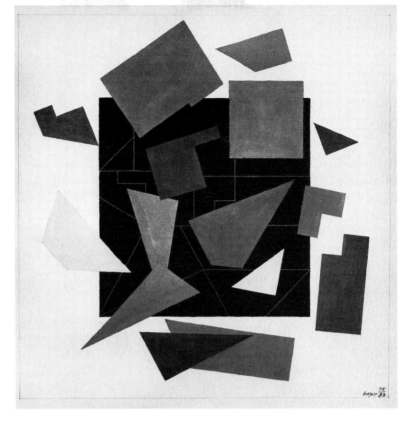

Square Divided into Fifteen 1975/83, acrylic
14 x 14".
Collection Joella Bayer.

Triaded Circles 1975/64, silkscreen, 14 x 14".
Collection Helmuth Gsöllpointner, Linz.

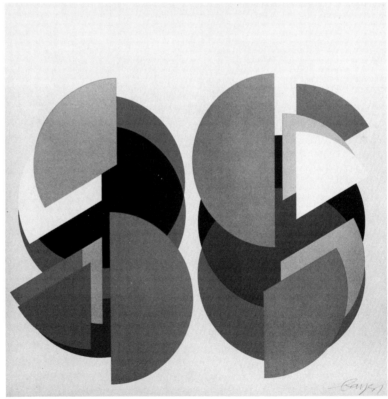

chromatic paintings the stellar reaches, the atmosphere of outer space, the representation of the primary geometry of the universe were not far from view. Even the eccentric pictures in the chromatic series turn about issues of hieratic assertion and dislocation, the emblemata of geometry as both essential building blocks of the universe and allusion to the distorting schemas of outer space. Light bends, color is erratically diffused; light distorts, and celestial bodies are not what they seem to be when viewed through telescopes.

Obviously, this description of the "Celestial Bodies" within the general schema of Bayer's "Chromatics" is not without its analogue in his earlier series. But as the others had used geometry as a schematic and orienting device to direct the vectors of the paintings (most notably in *Atmospheric Conditions*) or geometric structure had been employed as the formal (but inexplicit) basis for outlining the hieratic and processional character of "Moon and Structures," the geometry evoked in "Celestial Bodies" is more rigorously situated. Although the painterly hand reappears in this subseries, particularly as the content of the pictures—although unliteral—alludes to the immense magnification of mythic imagery, the refusal to distantiate in these pictures is in vivid contrast to the often frozen quality of the paint in the "Chromatics." This not only testifies to Bayer's intuitive unification of subject matter and technique, it explicates an aspect of his work noted earlier but now significantly underscored as the paintings verge on the powerful body of work that has occupied him for the last ten years.

The celestial universe is for Bayer the ultimate arcanum, the highest and the most noble scene of the modern imagination. The world beyond unaided sight—sight that endlessly requires technological magnification (as though if we could see more sharply, more perspicaciously into outer space we would uncover confirmation of our most ancient myths about the origins and unfolding of the universe)—is endlessly attractive and fascinating. No wonder that several of the most beautiful images in this series are named after the great astronomers of the late Renaissance: *Galileo* 1971/133 and *Tycho Brahe I, II, III* 1971/132, 1973/13, 1973/14. In these remarkable geometric abstractions, a celestial orb is parsed by light, light diffracting aspects of the orb, faceting its surface, and eliciting from it perspectives glowing with subtle color. The principal power of these small acrylics on paper comes from their cubist analysis of an unconventional subject matter, unhuman, thoroughly undomestic and inaccessible, and yet in Bayer's treatment immensely warm, unforbidding, and deeply satisfying.

The same attitude prevails in the mythological group of pictures that turn about the archetypal view of the universe as a giant egg—an egg of oval purity, gestating internal spheres and layers organized according to the spectrum (*Spectral Egg* 1971/64, 128; *Cosmic Egg* 1971/126; *Sectioned Ovoid* 1973/6). A further turn, familiar from the late paintings in the "Mountains and Convolutions" series attaches to the heavens the significance of the seasons, shifting the attitude of light and color in the universe as the seasons alter. This is particularly dramatic in *September Geometry* 1973/83 and *Fall Geometry II* 1973/100, where the cooling of light alters the planar reflections cast into the atmosphere by the interaction of sun and earth. The schema of both the astronomer's pictures—the cool analysis of the spherical planes elicited by an

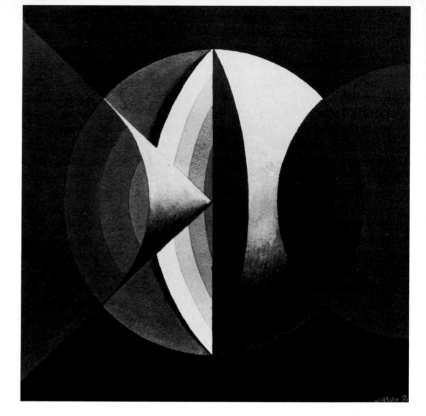

Galileo 1971/133, acrylic, 10 x 10".
Collection Joella Bayer.

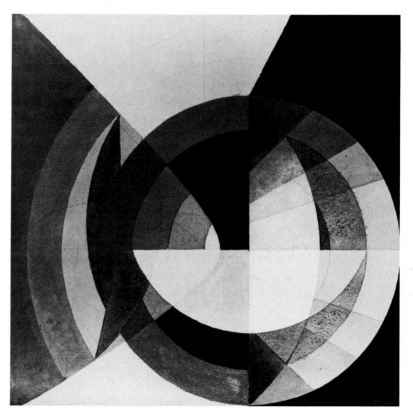

Tycho Brahe I 1971/132, acrylic, 10 x 10".
Collection Joella Bayer.

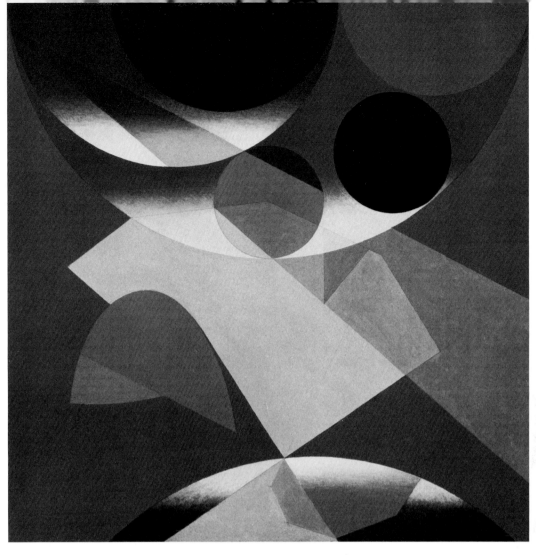

Fall Geometry II 1973/100, acrylic 20 x 20".
Collection Mr. and Mrs. Allan S. Ghitterman, Paris.

orbiting earth and a turning sun—and the brilliant alteration of color produced by the changing seasons are integrated in *Permeation of Circular Planes and Bodies* 1972/116, where the conjunction of earth, sun, and moon yield a quintessential radiance, an imaginary body striped in yellow and pink.

The "Anthology" Paintings: 1976 to the Present

At this juncture Herbert Bayer had completed a body of work covering more than a half-century. Certain tentative summations could be essayed, feints in the direction of definition and cloture. However, it seems more appropriate, since a significant and contemporary body of work is still ahead, to attempt something of a balance sheet, a reckoning without undertaking to add up the columns and settle a final sum. Certain characteristics are evident in Bayer's work, although a number of them appear in contradiction or at least irresolution when placed side by side. Throughout his life, Bayer has managed an astonishing intellectual complexity and curiosity without being an intellectual or even a technical adept in the disciplines that have fed his imaginative vocabulary. From the very earliest of his mature and self-assured period—the "Dunstlöcher" paintings of 1935 where for the first time the gifted guesses and genius of immaturity were put behind him—his paintings maintain an engagement with the mystery of the natural that has never wavered. The human figure virtually disappears from his work and at first a symbolic language replaces it with signs and signals of the appalling human condition, to be supplanted by sustained investigations of the means by which intimate nature, monumental nature, and ultimately celestial nature can be made the apposite to human finitude. Bayer struggles to make nature give up the secret of its estranging and alienating presence—not its majesty or immensity or nobility but its aspect of frightening destroyer.

The body of his work turns on the humanization of nature—whether interpreting its emblematic mystery, of describing its indifferent violence and combativeness, or releasing its astonishing structural complexity and unspeakable richness of color, or devising architectures that concentrate its light and lead its proud avatars to contemplation. Nature is never cozened into friendship or compatibility with man. Bayer is not naïve. Nature is regarded with the constructive eyes of the imaginer as a reality to be acknowledged, described, and wondered at. This latter seems the most consistent and felt aspect of Bayer's work: nature is the object of wonder and if honored long enough and profoundly enough, beyond a certain point it ceases to be inert, impassive, unfeeling and is invested in private anthropomorphic theologies with a kind of intelligence, presence, intimacy that inspires worship as a divinity.

There is nothing sentimental in Bayer's view of nature, nothing mawkish or stupid; rather there is an affection and mutual acknowledgment absolutely coherent with the experience of the lonely child walking in the mountains of Austria, observing, responding, pacifying, obliging himself to make of rock and glacier sunlight parsing ice crystals into bands of color, jagged cliffs and yawning abysses, all the while devising schemas for transforming the human predisposition to be in terror before such immensity into fundamental accord.

In the order of precedence, one might suspect that even if Bayer were no sentimentalist about nature, he could be liable to romanticism. In his early, untutored drawings from life there is a temptation to the romantic, transforming landscapes into personal feeling, implying that nature has as much anguish as man. And even early in the "Mountains and Convolutions" series, although the application of paint is radically different, nature is invested with the colors of melancholy familiar from Caspar David Friedrich. And yet, Bayer's romanticism is not involved in man's turning away from the social toward the attractive, self-infatuated aloneness of classic romanticism. It is a working away from his original involvement with an experimental autobiographic inquiry into the subject matter of painting and toward the location of the subject matter that has become the authentic content of his work.

The issues of geometry, mathematics, atmospherics, and geography make few appearances in his work prior to the 1940s. Although the work from the Bauhaus period and immediately afterward make frequent comment—often ironic, sometimes caricatural—on matters of architectural perspective and delineation of space, the vocabulary was principally derived from a personal adaptation of Amedée Ozenfant's and Le Corbusier's purism projected with a distancing of personal humanism in the style of de Chirico and Carlo Carra's metaphysical painting (obviously interconnected with the cool straight photographs that Bayer began making in 1928).

The attribution of surrealist intentions to Bayer's painting of this period is a casual and unserious assumption that the use of time-space disjunctions, unreal concatenations, and interpenetrating shapes propose a surrealist framework. Bayer may well have adopted certain surrealist conventions, but these conceal an intention that is quite other than surrealist. Alexander Dorner is correct in surmising that Bayer's use of surreal devices during the late 1920s and early '30s collateralized his pursuit of a vocabulary of common visual signs that could sustain his work as painter, photographer, designer. Bayer's wish to define a vocabulary that could be homologous, subject to variations of technique and usage required by the three disciplines of painting, photography, and graphic design, proved to be impossible. Just because classical imagery, for example, could become the subject for photography or the idiom of graphic design did not make it necessarily useful for painting. In several pictures it worked, notably in *Segesta* 1924/90, where the architectural mass floats in a mysterious blue-green void, but the image becomes mired in graphic connotation when the subject is depictive amphora or renditions of classical wall painting.

The problem of literalness and illusion—a problem that has never particularly fascinated Bayer—is settled by eschewal after the late 1930s. The only romanticism that remains beyond the war years proves to be more the predicament of the viewer's convention than the artist's creation. There are so few painters in the contemporary world who undertook to treat the issue of nature as a problem for abstract painting that work such as Bayer's comes up against a viewer's unfamiliarity and consequent prejudice.

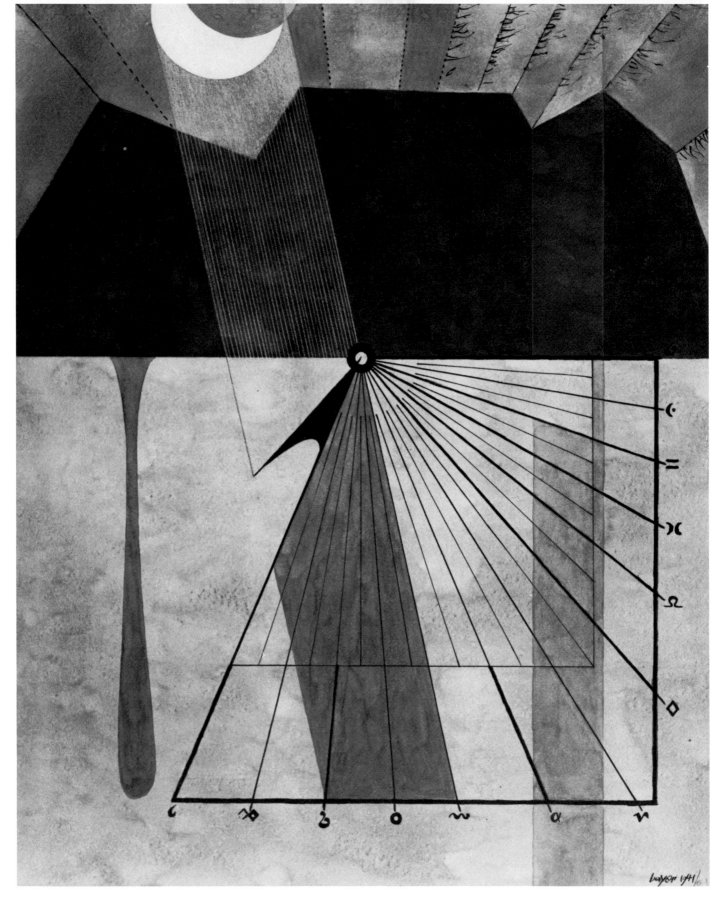

Time and Shadow 1941/6, watercolor, gouache,
and ink, 17 x 14".
Collection Joella Bayer.

Bayer undertook to visualize the fundamental underpinnings of the natural without retracting the problem to a consideration of space as such, light as such, or geometry as such. Space, light, color, proportion were alternative vocabularies for the abstract interpretation of the natural scene, to be used together, to be interpreted separately, to be interrelated in a painting vocabulary that was always and finally examining what was before sight—mountains and valleys, terrain and landscape, sun and moon, clouds and wind, celestial ethers, planets, nebulae. And the painter before them was a Prometheus seeking the secrets of fire.

Last, the underlying discipline of architecture and architectural drawing is critical to an understanding of the course Bayer's painting has taken. Bayer never studied architecture as such. He had learned how to visualize and conceptualize architectural forms early in his career—as apprentice with Schmidthammer and assistant to Margold—but he never acquired technical training. His knowledge of building construction and engineering were mastered by happenstance, but his command of architectural form was solid and well defined from an early period of his career. Indeed, among the students at the Bauhaus he was virtually alone in having previous sophisticated training in the conceptualization of spatial volumes and the logic of spatial forms. This is clear as early as the famous axonometric drawing he executed for the miscellany, *Staatliches Bauhaus in Weimar 1919–1923*, as well as for the kiosks and display stands of 1924. After 1928, however, the many exhibitions that Bayer designed with others or on his own confirmed a command of architectural space that has been an essential component of all his topographic drawing and painting. The presentation of space—a complex philosophic and scientific problem—as a visual projection that commands and leads the eye, instructs in the perception of the priority and succession of presented elements as well as cues interpretation of his work to a literal perspective or a metaphysical trajectory. Bayer knows exactly when he intends his spaces to be literal or metaphoric, frequently wishing that we employ both reference systems in reading one picture. The picture is often an iconic event, which, at the same time as it holds the bounds of commonplace perception, requires us to move beyond its limits to limnings of a metaphysical beyond.

There is no evidence of Bayer's having a religious or theological doctrine to which his work is tied; rather, his use of symbols and emblems of mythical archetypes defines an open universe where metaphysical gravity is prudent policy. The viewer is instructed by a painting of an immense universe to adopt an attitude of wonder and attentiveness. He may not know what beliefs to hold, what obeisances to perform, what rituals are appropriate, but he knows perfectly well that he is up against a universe far more subtle and mysterious than he had previously suspected.

These observations are all preliminary to an assessment of the astonishingly original "Anthology" series of paintings. Anticipated by the modest acrylic *Potpourri Géométrique* 1973/84, the series unfolded within groups of graduals elaborating an imagery that not only recapitulates the vocabulary of a lifetime but augments it with several remarkable and unprecedented formulations. Moreover, color is no longer applied impersonally as it was

throughout the chromatic series. Bayer clearly wished to be liberated from the dogmatics of optical color. The hand returns in regency; the image now demands its presence. As Bayer has said, the chromatics could have been executed by mechanical means or at least aided by a hand other than the artist's; but in the "Anthology" series the personal hand is palpable, a hand of extraordinary delicacy and subtlety, where brush movement is visible but not aggressively assertive.

The series is controlled with a sovereignty and sureness not as much in evidence earlier, where the ferocious energy necessary to sustain a large group of paintings over a significant period of time was sometimes lacking, and paintings of undue literalness or occasional obviousness obtruded. In the "Anthology" paintings there is no question of describing failures or missed opportunities. Every painting is of a coherent piece and portion to the whole, the vocabulary elaborating slowly and commanding the resource on which its imagery draws with such assurance that at most one is obliged to select preferred paintings rather than to reject some. Occasionally, the image will overflow, too abundant, reaching for too much at one time as in *Carpet of Symbols* 1980/8, but the correction will be speedily installed as the succeeding pictures reconsider the mass and refine it. This series, on which Bayer is still at work, is the most comprehensive, total, and sovereign body of work in his oeuvre—a remarkable accomplishment given the considerable range of work I have already surveyed.

The earliest paintings of 1976 outline the basic format of the series. The images are clustered at the edge of the canvas, soft forms abrading the edge, indenting it with curves and pockets of color, forms that allude to, but never quite assert, symbols gathering at the periphery. In contrast to these forms a brooding monochromatic emptiness predominates, compelling the eye to invent its seas and stratospheres, around which hover the forms. Occasionally, within the red or blue void, a green circle or yellow diamond, a white balloon or articulated white rhombus will disport themselves. *Event* 1976/12, *Event C (on Green)* 1976/53, *Event E (with Pink)* 1976/62, and *Black Border* 1979/8 establish the fundamental schema of the series, the formal invention moving quietly from the borders of the canvas into the textured ground color of the uninhabited center.

Having established the pull of the empty center, compelling the peripheral forms toward the gravitational void of color, Bayer devises a fascinating scheme for investing the emptiness with visual interest. Every painting in the series is preceded by a drawing and virtually every drawing or painting is diagramed in pencil drawings where the scale of the picture is reduced to analysis in millimeters. For example, see the construction drawings 1976/22 or *Double Spiral Structure* 1978/28, pencil and crayon on tracing paper; and the construction drawings for *Belle Nuit Géométrique* 1978/69 and the *Large Anthology* 1978/77. In the course of devising the content that congregates at the painting's edge and identifying the shapes he will use, Bayer drew them in detail, sometimes employing divider lines to position the edge, marking the distance in millimeters between an exfoliated circle or a curved geometric stairway or a rectangle subdivided into equal colored units, so that when the picture is translated from pencil drawing to large painting,

the basic proportions will be sustained. Undoubtedly, in the course of doing this he discovered that such lines could be preserved in the final canvas, the division of a picture into grid patterns or curvilinear underscoring preserved beneath the gray, beige, of charcoal surface enhancing the visual fascination, modulating the power of persuasive forms, as in *Night Map* 1977/40, where a star-shaped collection of acute-angled triangles colored in pink, purple, yellow, orange, and white dominate a charcoal ground divided into a grid of rectangles.

Of course, there are other elements in *Night Map*, but clearly the grid division reinforces the cartographic image. The virtual twin of this picture, also named *Night Map* 1977/32, shifts the imagery from maps to cosmological vectors, although everything else remains the same. The use of such diagrammatic markings serves to hold the imagery, defining abstract perspectives, obliging the eye to travel according to predetermined routes. The lines sometimes appear before the ground, at other times beneath it, supplying the picture plane with a tracery that complements and reinforces the authority of Bayer's figurative imagery.

Even more than a resonation of Bayer's use of pencil drawing as the original matrix for each canvas is the allusion and suggestion of maps. In 1953, Bayer originated, designed, and wrote the innovative *World Geo-Graphic Atlas* (20) as a presentation of the total human environment. Unlike most atlases that had preceded it, Bayer's atlas suggested that maps did more than read space and identify place. The map of the earth was also a record of time, time evolving not only land formations, rivers, and mountains but also climatic conditions, atmospheric implications, organic life, the movement of large forces that have over millions of years affected the alteration of the earth. At the very outset of the project Bayer visited the major cartographic centers in the United States and Europe,[93] acquiring detailed information not only about the charting and graphing of the natural elements of the earth's atmosphere—water, rainfall, thermal conditions, natural wealth, food production—but all the types and styles of map visualization, which entailed conical projections, plane projections, cylindrical projections, and the various distortionary formations that follow from equal-area world projections (20:22–23). These cartographic conventions are efforts toward an abstract visualization that allows each continent to be centered or reconciles longitudinal and latitudinal distances.

After Bayer had put this extraordinary enterprise to one side, he was left with a vocabulary of visualization that effected a permanent link between his primary commitment to nature and its expressive articulation. This visual language acquires considerable importance in "Anthology" paintings such as *Descriptus Quadratus* 1977/38; 1978/48, 92, 93, 94. Here the diagrammatic structure is either derived from basic geometrical projections of planes where lines, moving out from a colored plane, limn the shadow image of the plane and point to the plane reconceived as an architectural space; or the structure defines a grid in the style of a Mercator conformal projection (in which the longitudinal distances are increased in proportion to latitudinal accretions) or Miller projections, where accuracy of shapes is sacrificed while their exaggeration is avoided, or perspective projections (in which

the projection is made on a tangent cylinder, maximizing distortion as areas become distanced from the tangent). All of these projections—and others besides—having entered an imaginary topography, are not excluded because of their distortion of real spaces on the earth. On the contrary, since Bayer can diagram in any topography he chooses and is not constrained to approximate literal distances, the geometric shapes that he exposes on the grid, the organic forms that occasionally naturalize the vocabulary, or the symbolic references to images from the repertoire of his language (gates, linear structures, signs and signals) need not be corrected to supply cartographic verisimilitude. He can invent and imagine. The grid holds the painting imagery but never imitates nature.

In his "Statement on Anthology Paintings," Bayer has written, "by grouping iconographs and symbols at the periphery, the contrasting emptiness in which they float invites the imagination of the observer to read his own thoughts into the void." What he is really proposing is that the viewer become responsible for documenting his own interpretation. Such a posture tends to contradict the almost axiomatic assumption of abstract geometric painting in this century where not the viewer but the artist prescribes the absolute reading of the work. The artist, not the observer, defines the *scenum* of the image. This was certainly true in such ideologizing doctrines as neoplasticism or suprematism, where minimal painted structure implied absolute painting values. In such movements, the metaphysics of the painting was virtual with its constructed surface, and what the image implied carried not only significance for a reading of a new definition of the vocation of painting but salvational significance for painting as a whole.

Bayer's view of the "Anthology" series is diametrically counter to such attitudes. For Bayer, the process of conversion to his vision of the total aesthetic environment is much slower and ultimately libertarian. The viewer has eyes with which to see; the periphery defines the content and the diagrammatic linear structure incised in each painting suggests routes of travel, but the unfilled center (which obtains to a lesser or greater degree in virtually every painting in the series) invites the viewer to become the unifier, the system builder, the synthesizer of the images. Bayer suggests the reading, even leads the viewer to the right reading, but refuses to make his own reading mandatory. There is, of course, the strategy of naming pictures—a verbal gambit that will neither make nor break an image, but does assist in conducting the viewer to one location of interpretation rather than another. Bayer's titles are invariably inspired, affording us precisely that nuance of suggestion which opens his own mind to us, allowing us to consider his proposal before adopting our own. But as in all superlative titling, the function of the title is not to gloss the work but to describe something of the painting's mood or the artist's intentions.

Few painting titles in the series employ the word *anthology*. But this is as it should be. After all, *anthology* has a curious origin. It derives from the Greek for flower (*anthos*) and *logia* does not allude to *logos*, but the verb for collecting (*legein*). An anthology is thus a collection of flowers or, in its literal usage, a collection of literary maxims and epigrams, presumably selected from a wider

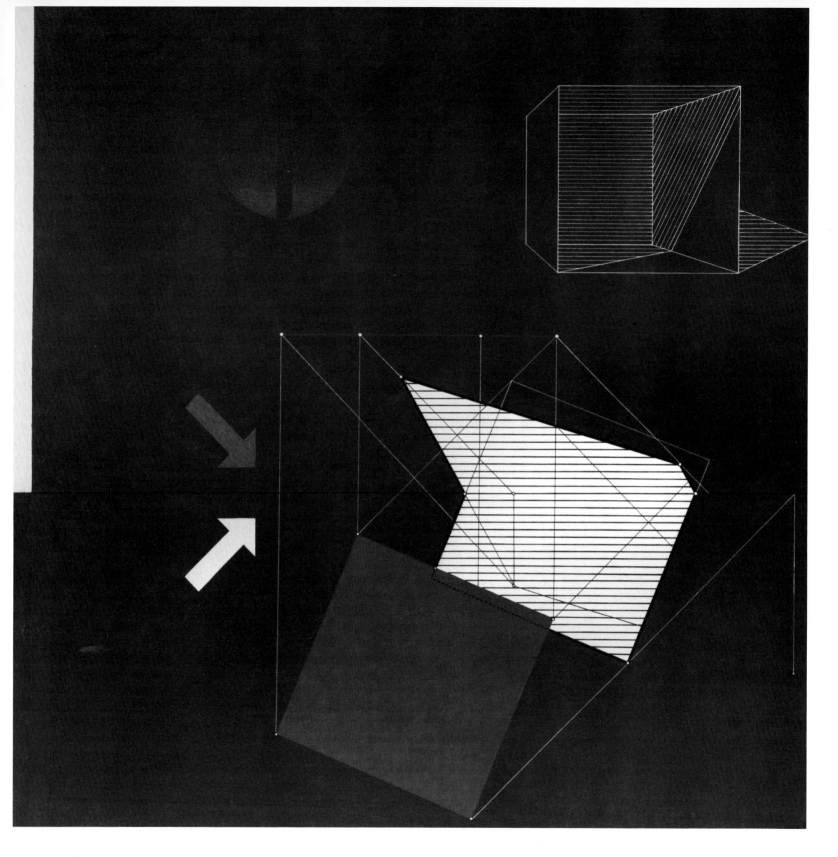

Descriptus Quadratus 1978/48, 40 x 40".
Collection Atlantic Richfield Company.

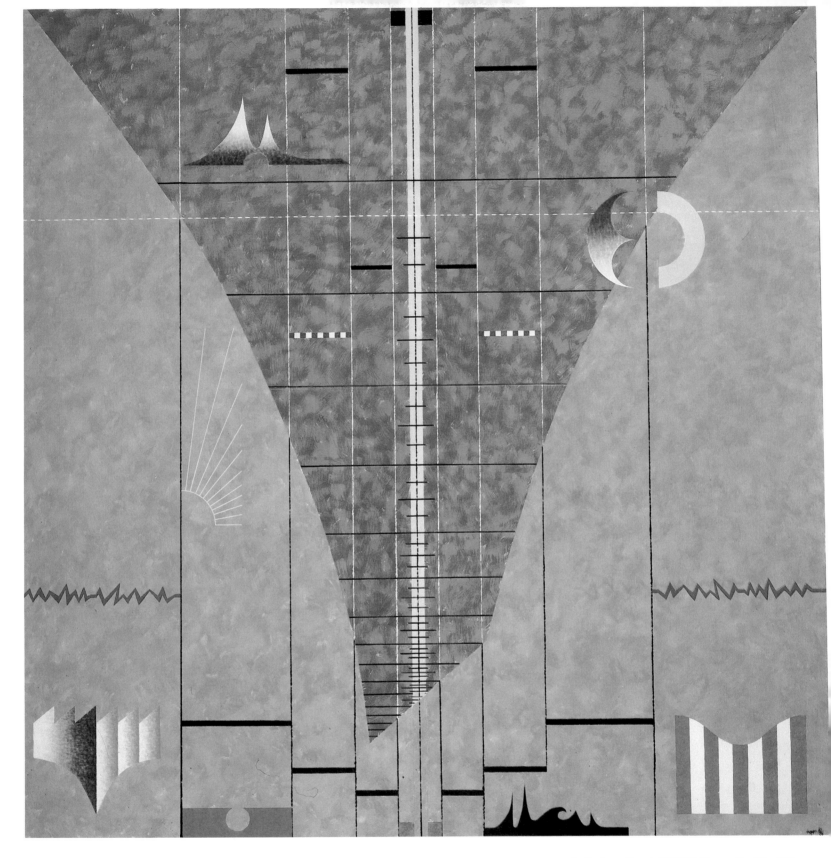

Anthology Graph III 1981/36, acrylic, 80 x 80″.
Courtesy Marlborough Gallery, New York.

treasury of literary sources. Bayer intends his "Anthology" paintings as a winnowed harvest of visual images, choice formations that balance and complement each other, however much they may be structurally diverse in origin. It is thus possible to aggregate either a complexity of geometric forms (logorhythmic shell, a suite of rhomboid shapes, a french curve, a series of scalloped arches, a procession of acute-angled triangles), each element distinctly colored, set into a topographic field of textured white, as in *Large Anthology* 1978/5, or to employ a richly colored ground, in the case of *Anthology II* 1978/23, one of densely textured blue, and use only three powerfully colored elements—a circular stairwell of perfectly balanced steps in a spectrum of warm colors, a suite of folded rhomboids whose sides are white, gray, black, and a complex architectural solid delineated in black.

Shifts from immense activity to simplicity (as from *Anthology with Ladder* 1980/52 to *References in Space* 1977/33, 34), varying the ground plane according to the intensity and power of the prevailing images, dramatize the extremities through which the series as a whole works. In some paintings the periphery becomes excessively busy with burgeoning shapes detracting from the larger forms that veer off from the diagonal or rectilinear division of the canvas, as evidenced in both versions of *Charting Space* 1976/63, 72, or *Composite* 1976/30, in which the predicament of arbitrariness obtrudes, the edge and the fill being unconvincingly interactive. But these occasional lapses disappear before the persuasive success of such ravishing images as *Belle Nuit Géométrique* 1978/69, 76, *Map* 1978/30, *Geometric-Organic* 1981/8, *Spectacle for a Naturalist* 1977/62, *Iconographic* 1978/22, or the untitled anthology 1981/28. In all of these—and there are others besides—the color is exquisitely balanced with the ground, the plane holds the congerie without setting up warfares of stridency and contention, the forms are subtle and allusive, and the whole arouses curiosity, fascination, and mystery, qualities that are always the most insistent when Bayer's work is most profound.

There are, of course, significant *variora* in the format and subject matter of the "Anthology" pictures and, although these reflect alternative options, they do not compromise the anthological character of the series. Obviously, there came a point in the unfolding of the group when Bayer became aware of the essential meaning of the anthological principle; rather than determining the series by its format, he luxuriated in the possibilities implicit in the "anthology" as such. The idea of repertoire and selection emerged at the forefront. *Two Gates I* 1981/10, *Two Gates* 1981/23, and *Two Gates II* 1981/11 make use of gates as modest graphic elements in an otherwise lightened color field. *Geometry Homework I* 1981/1, *Geometry Homework II* 1981/2, *Shadow Play* 1978/6, and *Colori Romani* 1978/4 fracture architectural drawing into geometric planes that refer to the flatter topographic architectural plans of an earlier series, the Tangier paintings, and the axonometric architectural drawing of his youth. Revisions of the relation of line, cone, and circle refer back to his earliest photomontage for the *bauhaus zeitschrift* (1928) and comment on the academic uses to which this relation was put by his successor at the Bauhaus, Joost Schmidt. *Nocturnal* 1979/13A, *Nocturnal with "N"* 1979/13C,

References in Space 1977/34, acrylic on canvas, 50 x 50″.
Collection Elizabeth Paepcke.

Charting Space 1975/63, acrylic, 16 x 16".
Collection Joella Bayer.

Two Gates 1981/23, acrylic on canvas, 40 x 40".
Collection Herbert Bayer.

Nocturnal with "7" 1981/30 are brilliant Klee-like excursions into nighttime light and geometry.

Fibonacci progressions make a brilliant satiric appearance as commentary on the Pop artist's use of garish color to celebrate the ebullience of American popular culture in *Fibonacci in Las Vegas* 1979/19 as well as extremely subtle scale progressions in diagrammatic lineation of *According to Fibonacci II* 1980/17, 21. Chromatic analysis of circles as was employed in a whole group of works in the "Chromatics" becomes one striking element in *Semilunar* 1977/21, as does the color segmentation of a curve in *Divisions into a Curve* 1978/5; contrasting semicircular rings formed of color circlets in a color wheel of warm and cool hues dominate an untitled picture, 1980/56, and *Interspace III* 1981/9. The serpentine form, sign of eternity, which occurred in Kandinsky's paintings as well as Klee's, assumes cosmic significance in *Curvilinear II* 1977/68 and *Curvilinear* 1978/2. In *Spiral and Free Curve* 1976/86, *Distant Happening on Green* 1976/79, *Curve Linear #1 on Blue* 1976/80, and *Objects in Blue Void* 1976/81, the serpentine is always identified as a geometric form, which tends to neutralize its mythic implications.

And, of course, virtually throughout the series and, hence, too numerous to cite, are chromatic checkerboards, sectional graphs indicating mountain ranges of a galactic world (which appear as literal devices in the *World Geo-Graphic Atlas*), measuring rulers for color intensity, each unit inscribed according to chromatic scales, and every imaginable primary geometric shape, articulated, solidified, planar, in all expressible dimensions, shadowed and highlighted by gradations of color. In short, Bayer devised a suite of paintings that winnowed his predominant imagery, miniaturized it, and set it on a calm field marked by lines and directions that chart his whole magical universe. The map lines are the underpinning of the mythological adventure, the images of his painting oeuvre define the formal content; geometry identifies the method of proportion and balance; the color receives, holds, emphasizes, and underscores the surface plane.

In 1978, Bayer undertook to write about the intention and meaning of his "Anthology" paintings. His "statement on anthology paintings" is remarkable both for what it asserts and what it withholds about this body of work:

the language of forms used has been derived to some extent, but not exclusively, from previously used elements of my visual alphabet. other romantic-geometric forms are introduced into a lyrical world with scientific undertones and metaphysical fantasies of a personal universe. some elements resembling natural phenomena, as well as possible and impossible geometric constructions, descriptive geometry, cosmogony, appear. they may be called anthologies of my images.

the rationality of the earlier "hard edged" paintings has been replaced by fantasies and intuitive imagination without having a concrete aim, purpose, or content. they derive from a creative process springing from subjective, personal prepossessions and imaginings developed through preoccupation with science translated into visual imagery.

this description can only be a hint which perhaps should not be given at all. a deeper meaning comes to the sensitive viewer from beyond the ambiguous titles which sometimes are arbitrary, or on purpose, misleading. there is more than what meets the eye. as in writing, where the essence is often to be found between the words, the meaning in these paintings is found beyond the images.

Although the principal repertoire of images in the series results from a sharper, focused selection and revision of formal devices Bayer had previously used in contexts defined by other and variant considerations, their appearance now is under different auspices. The artist is fully grown, past middle age, approaching old age; the weakening body, battered from a severe heart attack in 1979 that had obliged him to leave his mountain home in Aspen and return to the sedentary and presumably more salubrious climate of Santa Barbara, California, where he now lives, is no longer able to wage efficient combat. Although he has had to battle through lowering depressions in which he sometimes felt all his energy drained, what emerges in "Anthologies" is a lightness and gaiety of spirit that approaches serenity and wisdom. Ultimate questions begin to replace transitory preoccupations. Issues of fame and notoriety seem behind him, although he strives for greater visibility and understanding of his work.

He now undertakes to ensure that the creative enterprise of a lifetime be perceived as a unity, that images parsed discretely and in separateness be finally recognized as elements of an imaginative unity. The synoptic undertaking of the "Anthology" series is pursued as a vehicle of synthesis, painting overriding graphic design, sculpture, and architecture. Painting, it now appears, becomes primary because the vision is to be made integral and the means of effecting the unity can be only artistic. Despite the cynicism with which such notions are inevitably greeted, Bayer asserts "all I do and all I live for is art–for things that I can do with my hands: to create. but even people who are not active artists, I believe, could not live human lives without a touch of this metaphysical quality. in some people religion takes its place. but almost everybody has a contact with and a concept of things that exist not purely for functional reasons, things that also have about them some element of pleasure, satisfaction. even simple people who have nothing, perhaps only three pots, will like one or two of those pots better than the others, and those pots have artistic qualities (139:66)."

Given such a frame of mind, it is no surprise that there appears for the first time as an element in *Geometry of an Illusionist* 1978/55, then fully asserted in *Ancient Secrets* 1978/39, and in a score of remarkable synoptic paintings in the series, a familiar symbol of cosmic integration–reversed triangles intersecting each other bestriding a circle inscribed within a square. This symbol is instantly recognizable as the device of the Rosicrucians, a sectarian movement of personal enlightenment and self-understanding founded in the fifteenth century by Christian Rosenkreuz and still flourishing. Based on notions of self-clarification through the nullification of the demands of flesh and the impostures of the ego, Rosicrucian doctrine seeks, through disciplines of meditation, to unify the highest aspirations of human intelligence with the cosmic intelligence. What matters finally is that a scheme in nature be identified through which the adept can learn, a meditative mark left in history that points the adept toward the ultimate intelligence

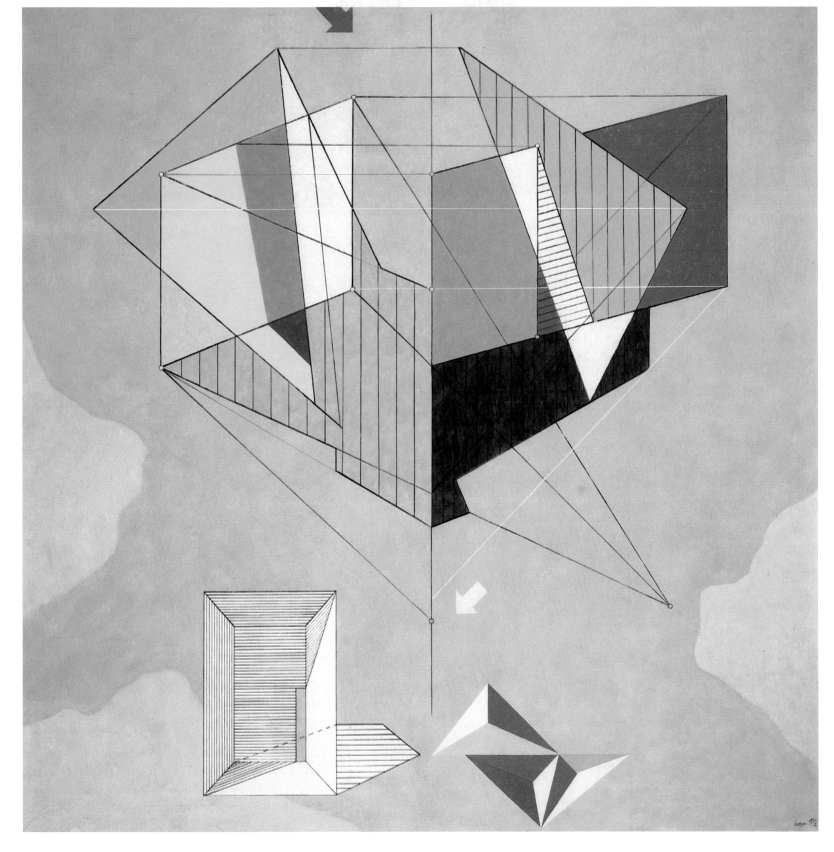

Geometry Homework II 1981/2, acrylic, 70 x 70".
Courtesy Marlborough Gallery, New York.

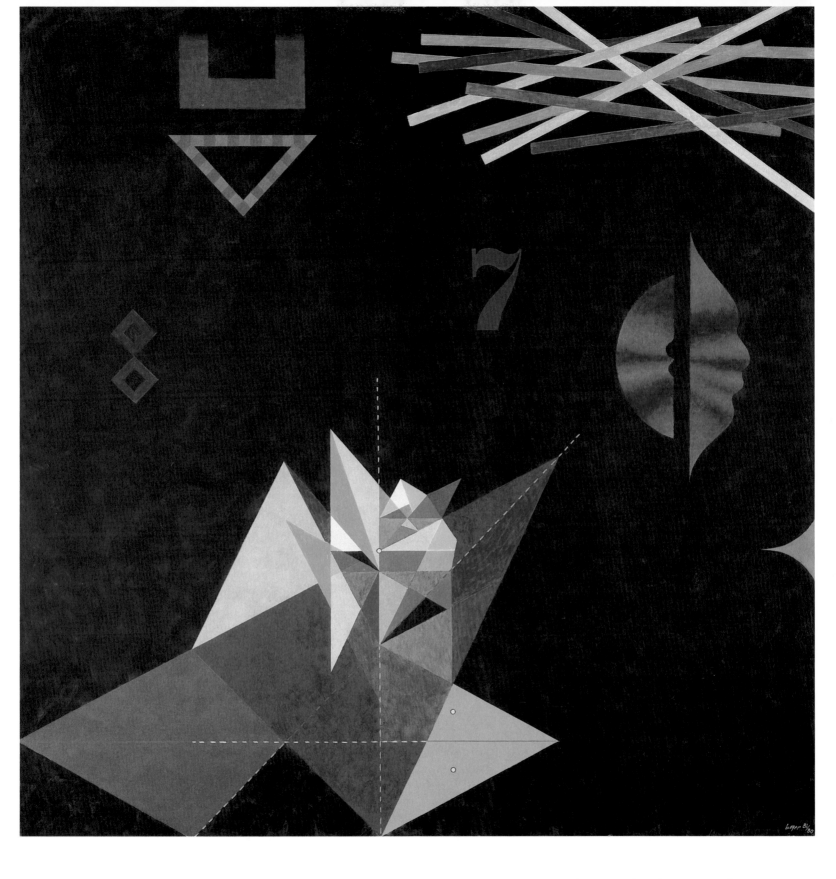

Nocturnal with '7' 1981/30, acrylic on canvas, 60 x 60".
Collection Mr. and Mrs. Barry Berkus.

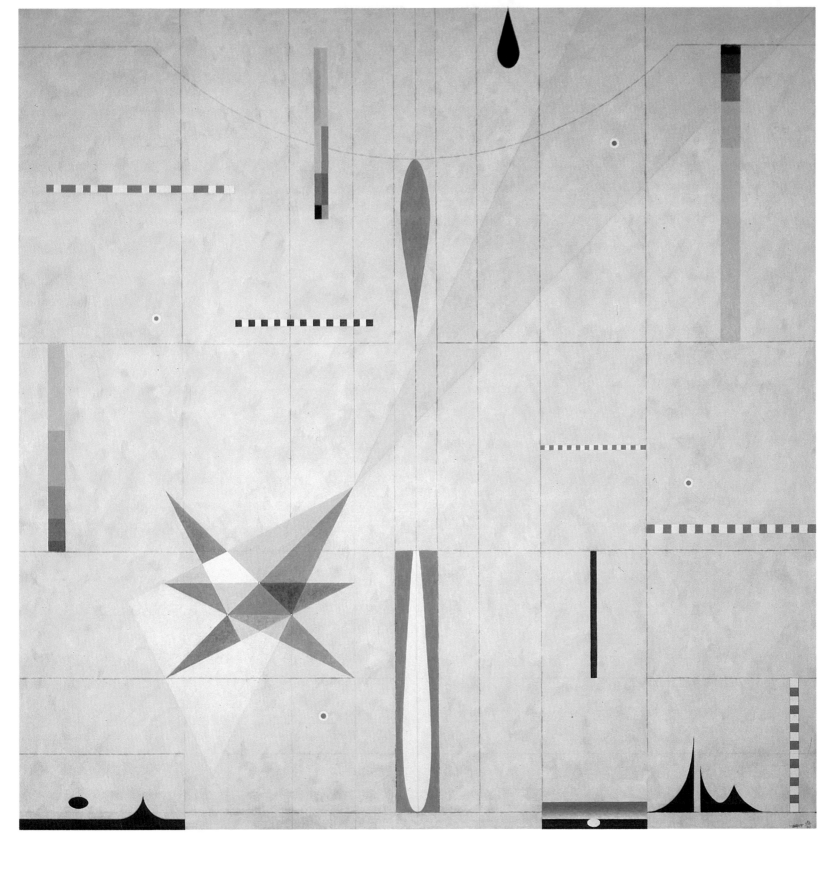

According to Fibonacci II 1980/21, acrylic,
70 x 70".
The Breakers Collection. Atlantic Richfield
Company.

Triangular Progressions 1981/15, acrylic on
canvas, 40 x 40".
Courtesy Marlborough Gallery, New York.

Al Aqsa II 1979, lithograph, 22½ x 20″.
Collection Herbert Bayer.

Ancient Secrets 1978/39, acrylic, 20 x 20″.
Collection Santa Barbara Museum of Art,
Santa Barbara.

he desires. For the Rosicrucians that meditative mark, that ancient secret, that geometric scheme was the pyramids of ancient Egypt. The pyramids, an unexplained marvel of ancient architecture and building, disposed to receive the sun at precise angles, constructed according to a mathematics as rigorous as it is mysterious, fashioned by an engineering that was regarded through millennia as wondrous, became the explicit metaphor of Rosicrucian intelligence. The precise measurement by which the pyramids were formulated resulted in the Rosicrucian sign. The third painting of Bayer's in which the Roscrucian sign is inscribed, *Geometric Scheme* 1976/70, was first called *Shadows at the Pyramids*, but the earlier title was crossed out and replaced by the more exoteric version.

The primary Rosicrucian symbol, first asserted in *Geometry of an Illusionist* 1978/55, was preceded by an earlier version of *Ancient Secrets* 1978/70. The earlier *Ancient Secrets* 1978/39—a purposeful and risky obfuscation on Bayer's part—totally omits the Rosicrucian sign. It is a witty aggregation of a child's toy room of geometric solids, in pinks, yellows, and greens with thin chromatic lines and borders set against a warm beige ground. Nothing threatening, nothing revealed. What is omitted is a premise of unification. The painted elements hold the surface; they are proportional, but they are not unified. In the full-scale *Ancient Secrets* 1978/70, the first presentation of the pyramidal emblem dominates the whole picture, filling it completely, ignoring Bayer's own description of the format of the ''Anthology'' series, as paintings where everything hugs the periphery and the center is left empty. In the full-scale *Ancient Secrets* there are no peripheries. Following this claimant image, the Rosicrucian sign is once more emblazoned on a vast blue cosmic heaven, otherwise populated by a sectional oval of earth, stars, and other celestial bodies (*Sketch for a Large Painting* 1978/60, 66, 91 and the fully realized mural *Suspended Secrets* 1979/5).

The Rosicrucian sign makes its next appearance as a subtext, the diagrammatic structure of triangles that lies beneath an oval fashioned of colored squares that build up to a Klee-like human head through which one can see sky beyond and before which obscuring gray cloud forms hover. The clear imagery of human head and its invisible sempiternal intelligence is purposely obscured (as Bayer warned it might be) by the obfuscating titles *Proportions of an Amphora I* 1979/1 and *Proportions of an Amphora II* 1979/2, which the image superficially resembles. It is as though the esoteric adept wishes to obscure from the unenlightened the wisdom he has gained, so he employs a visual and verbal device to hide the path of true interpretation. There are, indeed, two later versions of the same image, no less subtle and meticulously devised although the image is cleft, a jagged break fracturing *Amphora* 1980/60, *Amphora (Blue)* 1981/20, and its untitled companion, 1980/61. In *Construction* 1981/38 the Rosicrucian sign is upside down and in two versions of *Color Concentration* 1982/58, highly abstracted renderings of the emblem are emplaced in a celestial map, textured with distant clouds and amorphous forms that could be land masses of earth or planets. The Rosicrucian sign is split into two portions, the first construed as a planar image within the circle and adjacent to it an ambiguous congerie of partially painted triangles, which can be confused with the suite of rhomboids Bayer had used earlier in the series. And, most recently, the sign appears in *Yellow N* 1982/26, construed as elements and contrasts of an architectural portal and fractured into stars in *Three Stars* 1982/25.

What does all this mean—this use of the Rosicrucian symbol of triangles, circles, squares? Is it metaphysical usage, the transformation of the picture into an icon of higher instruction, a system of symbolic allusion? Or is Bayer identifying a visual metaphor that effectively constellates the basic geometric vocabulary with which he has worked throughout his career? Or could Bayer be asserting that the Rosicrucian symbol, with its link to an ancient architectural triumph that endures as a powerful example of unexplicated mystery, instructs us regarding the fundamental connection between the architecture and the geometry of the universe? Is it perhaps a metaphor for his own biographic excursion through modern art—an assertion of his indifference to the theoretical issues of painting that occupied the center of the art world throughout the 1970s, and made bold to make the content of painting equivalent to its means? Finally, could this image be the effective coda of sixty years of work, from his youth at the Bauhaus to the present—a symbol, heretofore not used in painting, that integrates the basic elements Kandinsky employed at the Bauhaus, around which Bayer's earliest wall mural turned, that underlay his first great photomontage for the *bauhaus zeitschrift*, that legitimated his earliest commitment to descriptive geometry as the building language of the universe? For what is the Rosicrucian emblem but a constellation of triangle, circle, and square? And what are they other than fundamental geometry?

Bayer's comments on his use of the Rosicrucian symbol certainly confirm the direction I have taken in interpreting its appearance in his late ''Anthology'' paintings. ''it is,'' he asserts, ''merely a coincidence that a design in the 'anthology' series resembles the rosicrucian symbol. there is no factual connection other than the mystery of the design and content which interested me. the design in the painting has probably been freely created by myself. I am neither mason nor rosicrucian and am only superficially interested in their doctrines . . . the rosicrucian symbol would be my personal interpretation, suggesting cosmic order and geometric rightness . . . in recent years I have seen graphs of so-called ancient secret geometry used by the egyptians and in greece. this interested me very much in relation to the compositional analysis of medieval paintings practiced in johannes itten's course at the bauhaus. they are comparable in nature to the concept of the golden section or other geometric configurations.'' Bayer's intentions are always visual. The symbol, whatever its meaning for the Rosicrucian, is an accidental discovery for Bayer: an iconograph that integrates his own biography and an arcane image of the essential geometry of nature and architecture.

The least fashionable, but perhaps the most profound, fidelity in the painting career of Herbert Bayer has been his insistent perpetuation of an optimistic geometry, a geometry that not only articulates form but argues that geometric form is clarity and that only clarity ennobles. The fact that he has maintained such an optimistic reading of geometry in the face of a present-day return to

expressionist realism, and has managed it at such a consistently high level of imaginative production, is the moral power of his work. I speak of the moral authority of Bayer's work now, at the very end of my narration of his painting achievement, to affirm it as part of his immense gift. Bayer has said that the principal virtue an artist requires is "humility" (139:66). He might have wished for many gifts of personality and passion by which to stamp the contemporary art scene with his authority. Bayer, however, takes it for granted that all these are assumed if one has worked relentlessly and without relaxation for more than six decades. The achievement is there whether the world acknowledges it or not. The artist finally must worry about his own achievement, for it is he—not the public—who made it. Hence, the wish for humility (he undoubtedly said this with a shy laugh). But having wished for modesty, he leaves to others the seeing of his oeuvre and the recognition of its unfailing gravity, its lightness and risk in the employment of color, its fecundity of form, its pursuit of clarification and understanding, and its immense respect for sheer work.

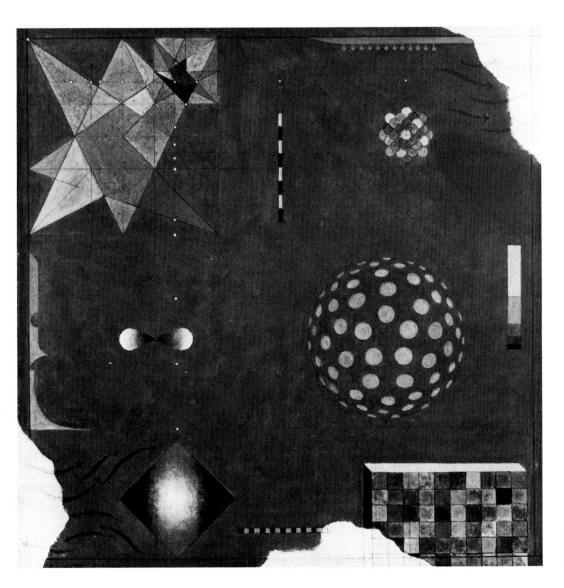

Geometry of an Illusionist 1978/55, acrylic, 20 x 20".
Collection Joella Bayer.

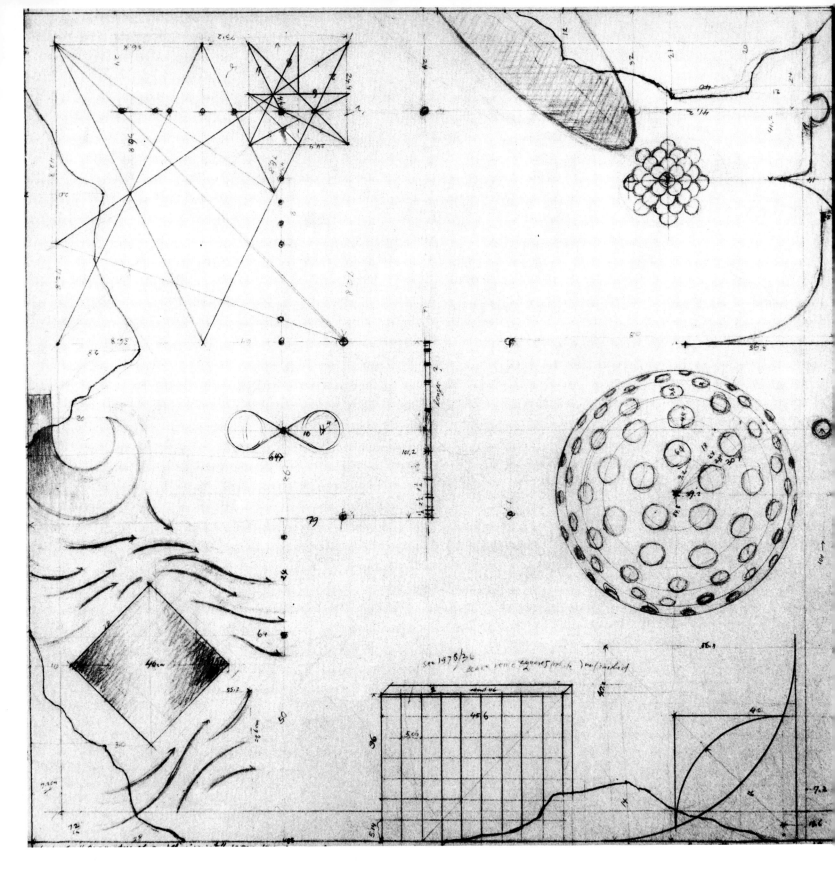

Study for *Geometry of an Illusionist* 1978/75,
acrylic, 20½ x 20½".
Collection Herbert Bayer.

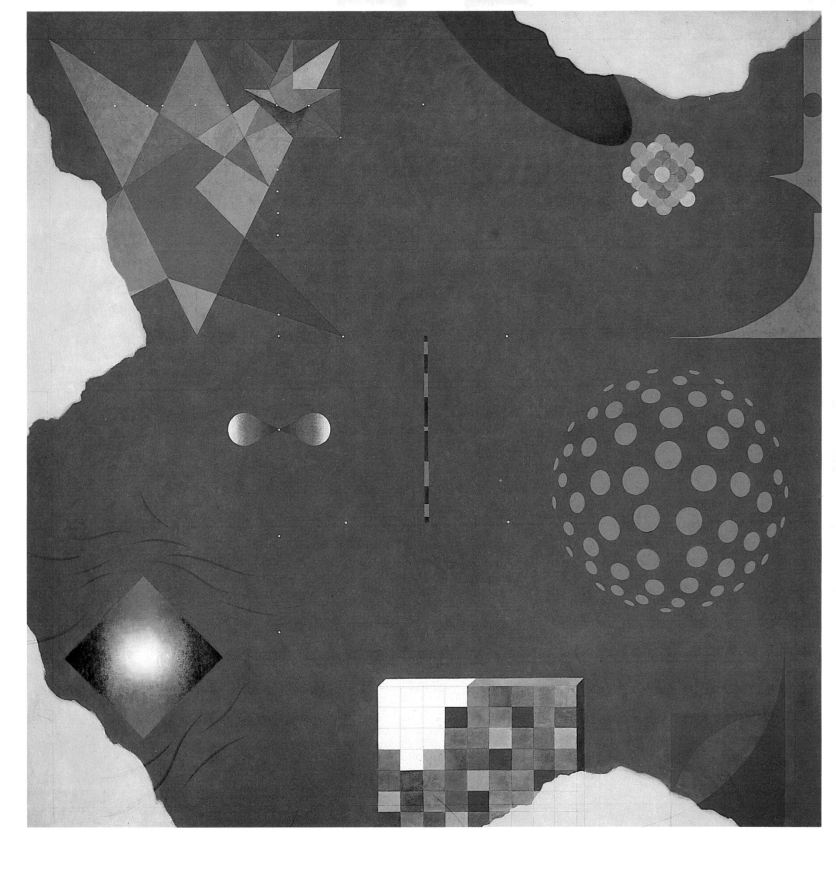

Geometry of an Illusionist 1978/75, acrylic on canvas, 80 x 80″.
Collection Atlantic Richfield Company.

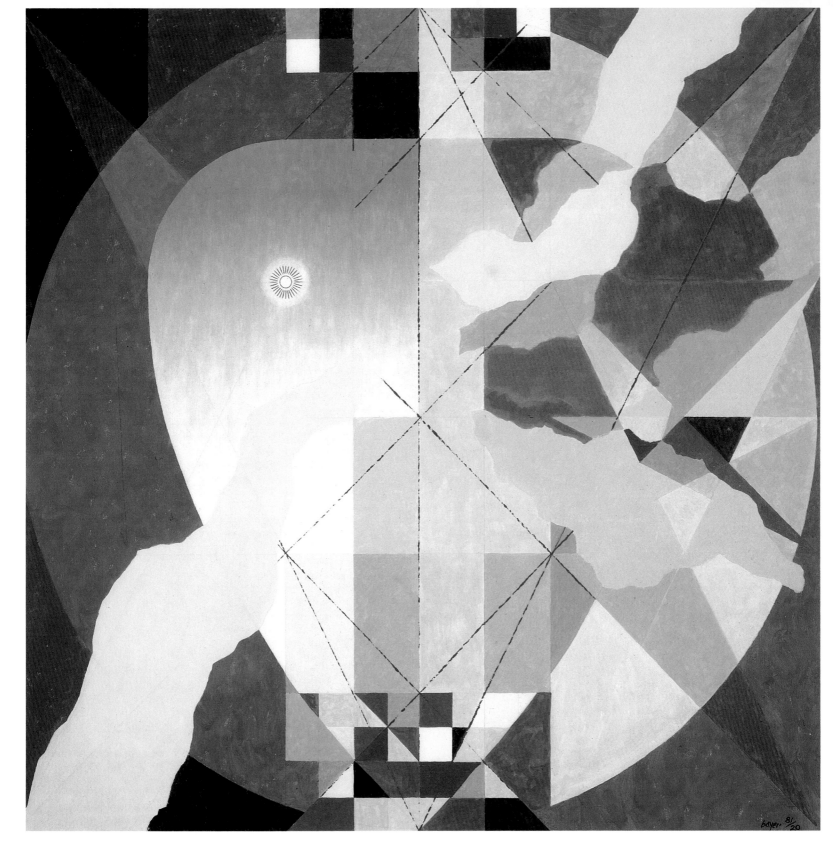

Amphora, Blue 1981/20, acrylic, 40 x 40".
Courtesy Marlborough Gallery, New York.

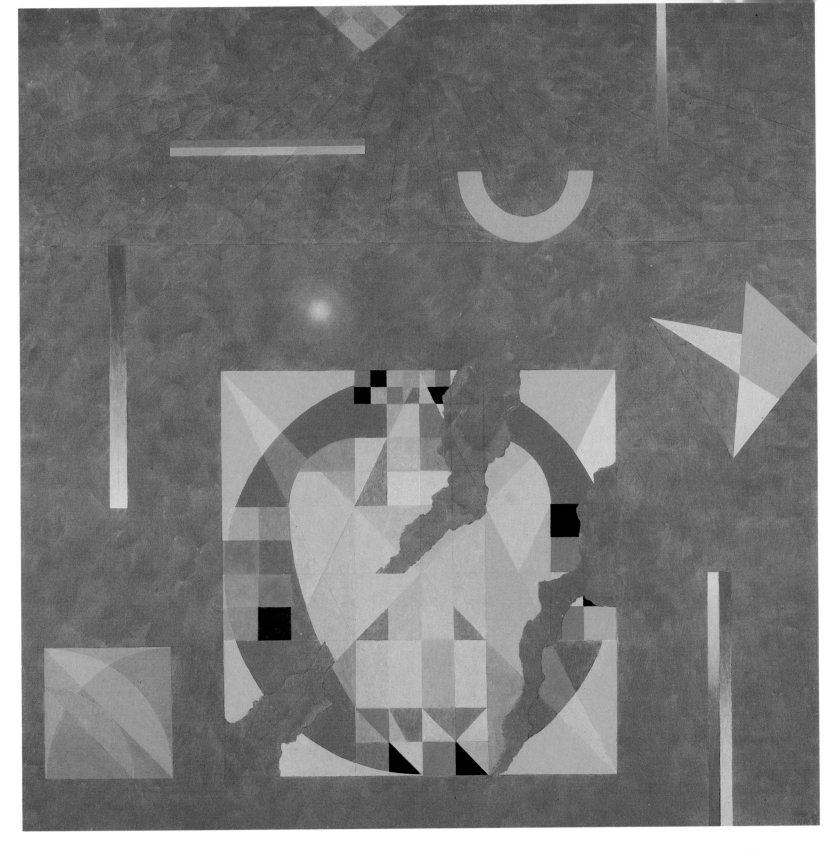

Fragments II 1983/5, acrylic, 50 x 50″.
Collection Herbert Bayer.

From his Bauhaus days to the present, Herbert Bayer has refused to distinguish between painting and sculpture, architecture and design. It is not that he ignores the considerable differentiation in the use of materials, the articulation of form, or the varieties of surface entailed by each medium; rather, it is that he wishes to promote a commingling and interpenetration of media that ensures a fundamental obeisance to the natural and the human environment. But there is one distinction—and only one—that he has consistently enforced in his description of his work and in his attitude toward all his creative activity: the fundamental difference between the natural and the human. "the artist," Bayer has written, "does not imitate nature but creates a spiritual world alongside nature. The structures that man erects do not rival nature nor assert themselves against it. both the natural and the human environment can exist side by side, if their boundaries are understood."[1]

Nature is always presence in Bayer's work, not simply material to be manipulated and transformed; nature possesses a claimant presence that insists on its own geological and climatic prerogatives. Nature is a given, but its reality as presence does not imply for Bayer that its minimality as factual *donnée* strips it of power, movement, meaning, intensity. These qualities of affect reside in the human transcription of nature's authority. Nature before man is nothing other than the content of human affect. But this is, in itself, extraordinary—nature as a domain of presentness to the spirit. If it is betrayed, polluted, depleted—issues Bayer addressed in his remarks of 1962 on the environment (34)—it is not easily regenerated. The relation between man and nature is consequently precarious and the role of the artist, never simply one of depiction or rendition, is in the most profound sense custodial and enhancing.

In giving expression to these values, Bayer is only continuing the tradition of the Bauhaus. As he affirmed in 1972, "the bauhaus already saw the function of the artist not only in the shaping of particular objects and issues, but in the totality of all design for an all-inclusive environment (117:44)." The new artist envisioned by Walter Gropius reflected the unity of "art and technics."[2] The intention (although it was anathematized by many of the senior masters at the Bauhaus) was that art make use of every available innovation of modern science and technology, bypassing the preciosity of the handmade in the interest of effecting a more efficient and spontaneous connection between conception and realization. Gropius's notion had its analogues in both Soviet productivism of the 1920s, where the end point of the creative process was the object produced for public use, and neoplasticism, in which the utopian vision of a world harmonized by beauty would result, in Mondrian's words, from "the unification of architecture, sculpture and painting."[3] This unification, or at least their compatible interaction, is a principal assumption from which Bayer's multifaceted creative activity proceeds. Although he has never spoken exactly like Piet Mondrian, he would hardly demur from the oft-quoted conclusion to Mondrian's *Plastic Art and Pure Plastic Art*: "By the unification of architecture, sculpture and painting, a new plastic reality will be created. Painting and sculpture will not manifest themselves as separate objects, nor as 'mural art' which destroys

architecture itself, nor as 'applied' art, but *being purely constructive* will aid the creation of an environment not merely utilitarian or rational but also pure and complete in its beauty."[4]

Architecture becomes plastic, painting approaches sculpture, all the arts share a community of intent—that the human environment become a unity of means and purpose that makes it difficult to separate surface and interior, facade and structure, form and texture, the two-dimensional from the sculptural third, the parameters of the environment from its constitutive elements. All art is turned then to the making of a total plastic environment. If there is a building, it calls for more than intrinsic beauty of form; its "sculptural" structure must be counterpointed with actual sculpture that elaborates and complements the architecture's explicit plasticity; if it has a mural wall, the mural should interact not only with other walls but with the outside environment;[5] color should be utilized in furnishings, tapestries, wall hangings that play off architectural values and intensify visual richness; paintings should be hung in order to extend the surface of architecture; trees should be planted, gates installed, sculptural reclamations of the earth introduced in order to provide maximum excitement and fascination. In such a view, architecture is never simply architecture, painting painting, sculpture sculpture. They are interactive elements in a total scheme that is the environment.

Since the environment is the most universal term of social interaction, the environment in all its natural and man-made components is the substratum of the modern arts. As Bayer has observed, supplying a coda and transition to this discussion, "my projects dealing with environments are not merely imaginative ideas such as the designs and symbols which today's earth artists scratch into the surface of the desert . . . my aim with environmental designs is to carry art and design from the privacy of the museum to the public realm (117:44)." Whatever the accuracy of Bayer's distinction of himself from the artists of earthworks (and we shall address this issue shortly), what emerges as the visionary insistence of his whole art—not simply in "earthworks" but in all domains of his activity—is that the artist is the form giver who elevates as he unifies. It is the ethical insistence of the Bauhaus and neoplasticism that culture is enhanced and man ennobled as the arts become commingled in the formation of pure and integral beauty. The corollary of such an ethical usage is the belief that the aesthetic unity has salvational value, that art "redeems" if its means are honest and truthful.

I shall not address the epistemological and moral difficulties that such a position entails. What is palpable is its moral optimism and enthusiasm, its conviction that artists form a sacred tribe within culture, capable of transforming the pedestrian and elevating it. That a nonpolitical artist like Bayer holds such a view in the face of the grim evidence of twentieth-century misuse of all utopian ideologies does not of itself condemn him to naïveté. Bayer would argue, with considerable force, that the environment has *never* been transformed by art, that the experiment has *never* been tried, that the artists do not believe such a vision and the public does not clamor for it, that it is, finally, an untested position. True and not true, certainly arguable. What is clear, however, is that Bayer has for more than six decades held to the view that art

and technology enjoy a unity, that both have as their objective the *reforming* of the environment in which man and nature must abide together.

I shall make no distinction between sculpture and environment as such. They are not separable subject matters. All of Bayer's sculptures were created and fabricated for a particular environment. The environment was given; the sculptural ideas followed. On the other hand, the environmental presence—the fields around the Aspen Institute or the oil refinery of the Atlantic Richfield Corporation outside Philadelphia—presented Bayer with a physical reality that proposed sculptural transformations of the environment. Sculpture and environment were portions of the same rhythmic continuum, the environment evoking sculpture further moderating the environment.

Bayer made very little sculpture deriving from the tradition that antedates machine fabrication and environmental installation—sculpture that is carved or forged for domestic installation. The small pieces that exist are all reductions from the enormous scale for which they were conceived or replications of the maquette for larger works. They are modest and minor, and Bayer does not advance any particular claim on their behalf. Early in his career, Bayer adapted several of the "Dunstlöcher" soft form paintings for wall reliefs, using wood and wood cement. Whatever their sculptural allusion, however, the three soft form "Dunstlöcher" were essentially relief paintings. He had "envisioned building a large wall with moveable *dunstlöcher* objects to place in variable compositions, but I never had the opportunity to execute a large wall."[6] He made three sculpture reliefs, one of which, *Wall Sculpture with Two Holes* 1977/48, was cast in white marble in 1977 for distribution in a limited edition. They hugged the wall, and although not flat like his mural paintings for the Bauhaus stairwell or *Verdure* 1950, installed in Gropius's Harkness Graduate Center at Harvard Law School, they were not sculpture either. Bayer was never confused about this point. Sculpture meant freestanding objects situated in the context of an architecturally formulated landscape or else described as a reclamation of land and its plastic reconstruction. An environment entailed tectonic plastic surgery or the establishment of a rhythm between the modification of nature's contours and the installation of found or formed elements in marble, wood, or metal. Although the proposition is not logically convertible (for sculpture is not identical with environment nor environment with sculpture), the relation between sculpture and environment is very close. The imponderable third term in any discussion of sculpture and environment is architecture and the linking between building site, surrounding landscape, and the placement of the sculptured environment in its midst.

Gardens and Earthworks

The interaction of sculpture, architecture, and environments is most clearly asserted in the complex of projects that grew up around Bayer's design and building of the Aspen Institute for Humanistic Studies and the redevelopment of Aspen, Colorado, following his move there in 1946. Remember that in 1944, following a winter visit to Vermont, Bayer began his remarkable "Mountains and Convolutions" series, which centered about the

pictorialization of tectonic motion, the undulancy of landscape, the incredible dynamism of the earth's surface reflecting movements deep within the earth and far back in time. "in 1944, I suddenly saw the (the mountains) as simplified forms, reduced to sculptural surface motion (128:32)."

Although the pictures in this series alluded to sculptural formation, they were, as pictures, two-dimensional, flat and small. The sense of scale was all but obliterated by their modest format. Yet, the pictures were formulated as though the artist were positioned above or within the mountains themselves, observing from a point in space or peering up through the volcano to the configurations that formed above and below. The perspective was sculptural, but sculpture was beyond reach. In 1947, however, a number of months after Bayer had been retained by Walter P. Paepcke, chairman of the Container Corporation of America, to become the design consultant for the development of Aspen from a moribund mining town into a "combination ski resort and 'mind spa' (128:32)," Bayer completed a small, visionary drawing, *Aspen Valley Redesigned for Technical Purposes* 1947/9. Using a felt-tip pen, Bayer sketched a landscape in which many of the surreal devices of "Mountains and Convolutions" appear as elements in a complex drafting of the new environment of Aspen. Underground conduits surmounted by small circular vents, Mayan pyramids in ceramic (or hydroelectric plants artfully concealed), leaf-shaped declivations, mountains with sculptural guy wires, and circular troughs of water cover a terrain otherwise unmarked by human presence. This small drawing (not one, as Jan Van der Marck wittily observes, likely to be whipped out of his portfolio at a planning session of the Aspen Institute [128:32]), formulated a visionary impetus that would be implemented later in a modest scale as the *Marble Garden* 1955 and the *Grass Mound* 1955 and more fully realized in 1973–74 as *Anderson Park*.

The scheme of the *Marble Garden*, as with virtually every significant development in Bayer's work, was anticipated in 1949 by a project drawing for *Marble Platform with Sculptural Marble Elements*. As van der Marck points out, this drawing lacked an essential orientation to water and surrounding landscape, features Bayer has asserted are essential to all his environmental and sculptural projects.[7] Indeed, the drawing seems somewhat artificial in its formalism, particularly compared to the *Marble Garden* realized six years later.

The *Marble Garden* was executed in 1955, several weeks before the *Grass Mound* was formed. Set on the lawn in front of the reception building of the Aspen Institute (in the distance is the small geodesic dome Buckminster Fuller made for the outdoor swimming pool), the *Marble Garden* is of modest scale. A concrete platform (36 x 36') is divided into a grid of nine squares (each 4 x 4'). The various elements of the *Marble Garden* reflect the complementarity and interaction of unaggressive, eloquent, primary, and classical geometric shapes—rectangles, broken columns, fractured arches, right-angle triangles, cylinders. The objects are placed on the platform in a carefully devised pattern of accident and irregularity, the tall columns (none of which is higher than twelve feet) clustered to one side of a rectangular pool of water. Three of the squares of the platform are green lawn, as

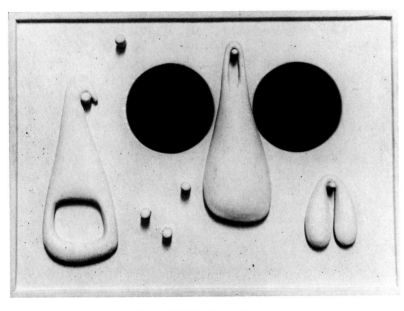

Wall Sculpture with Two Holes 1937/4. Maquette for the edition cast in 1977 was executed in 1937. The edition of 37 numbered sculptures (and 7 each for artist and collaborators) was executed in white marble.

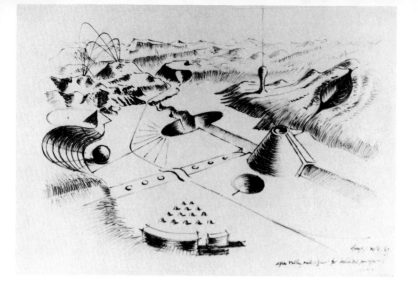

Aspen Valley Redesigned for Technical Purposes
1947/9, felt pen, 21 x 29 1/2".
Collection Herbert Bayer.

Isometric design of *Marble Garden* 1955, Aspen,
Colorado. 36 x 36".
Collection Herbert Bayer.

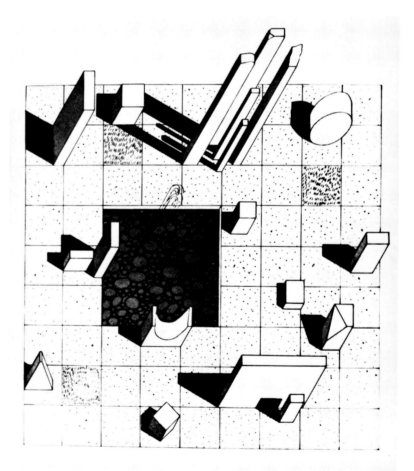

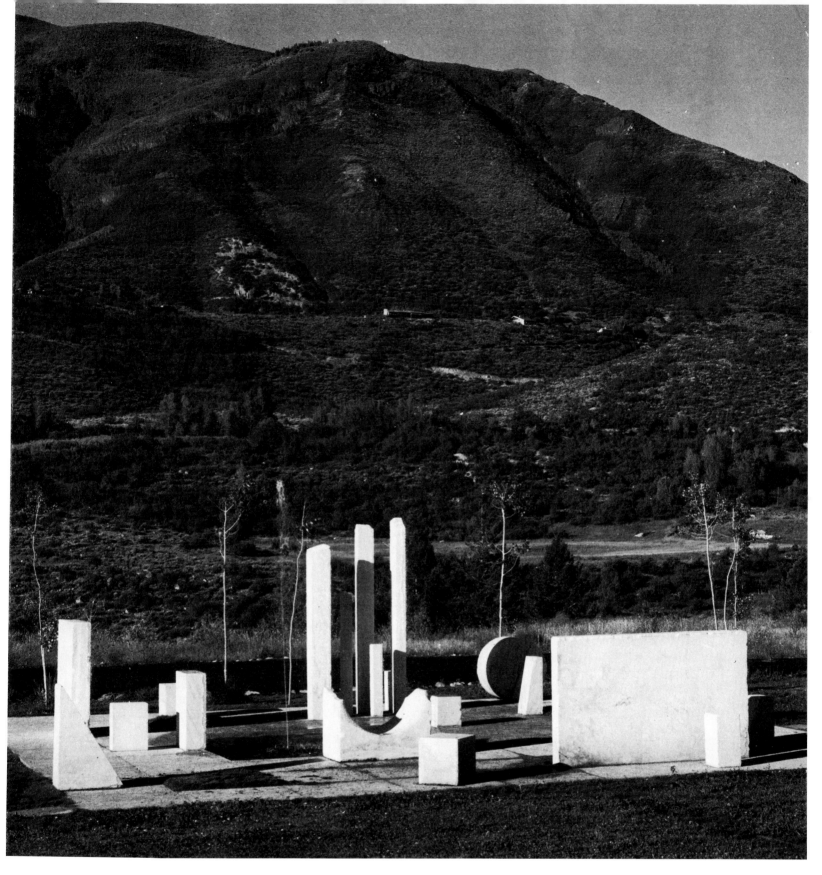

The *Marble Garden* 1955, Aspen, Colorado. 36′
x 36′ concrete platform: 4′ x 4′ linear grid; 12′
height of tallest element. Aspen Meadows Hotel
Development. View to the northeast.

though nature had burgeoned through the stone. The material is white marble from an abandoned quarry in the vicinity of Aspen, where once large marble forms had been cut for shipment to Washington for the Lincoln Memorial and other monuments. The discovery of the rough-hewn marble forms, unused and unwanted, seems to have provided Bayer with the cue for this exquisite exercise in surreal landscaping, but whatever its origin, this table of forms strikes the mood of a de Chirico piazza. But the scheme, in its relative diminutiveness, possesses an intimacy that aborts any specific analogy to de Chirico, although under Aspen's hot sun, the light and shadows can be distinctly disorienting. The *Marble Garden* is finally a play of forms, classical in mood, fundamentally harmonious, and only provocative of anxiety when approached from a distance and seen against the background of the craggy Rocky Mountains, which rise behind it. In the winter, when the platform is obscured, the forms capped with snow, the ensemble acquires a kind of archaeological aura, rather more spare, severe, and unsettling. One wishes that the trees now growing behind it were gone and the *Marble Garden* left as a small desert of marble in the lawn surrounding it, stark and unrelieved by humane landscaping dignities that soften this garden of Greek geometry.

The *Marble Garden* was one means of punctuating the architecture of the Aspen Institute. A contemporary irony, setting down upon the lawn of a resuscitated Western mining town a classical tableau, the *Marble Garden* would have been an anachronistic *beau geste* if its classicism had not been counterpointed by the prehistoric allusion of the *Grass Mound* (called *Earth Mound* as well, although Bayer has favored *Grass Mound*, probably to forestall the inevitable link to "earthworks," of which it was a unique and influential progenitor).[8] In the course of designing the Health Center in Aspen, which was completed in 1955, Bayer sought to economize by making use of the *Grass Mound*.

The formulation of the *Grass Mound* was not a fortuity, however much it proved useful in reducing expense; moreover it had a functional propriety since it was construed as a space where one could read, hidden away from the surrounding public space, or could contemplate the sky. The visualization of movement of the earth's surface had occupied Bayer from 1944 to 1953 in the "Mountains and Convolutions" paintings; the *World Geo-Graphic Atlas* (20), which he executed for Container Corporation of America in 1953, showed advanced and sophisticated knowledge of the impact of environment on the earth's surface. Bayer had responded enthusiastically to the ideas of Buckminster Fuller (although their points of view were certainly different), who had built a geodesic dome for the outdoor circular swimming pool installed in the Aspen complex,[9] and he had executed a mural in sgraffito for the exterior of the Aspen Institute of Humanistic Studies which alludes a three-dimensional rendering of mountain undulations (see *Veil* 1951/2). The enterprise of actually interpreting the interaction of the earth and its surface with the surrounding environment of air, light, and architecture was the "earthwork" itself. Bayer offered *Grass Mound* as an expression of the attitude he later described as "an inquiry into the reality of space rather than painting the illusion of space on a two-dimensional plane" (40:12, 139–143).

The *Grass Mound*, which measures forty feet in diameter, presents a gentle ring of molded earth defining the perimeter of the circle. Opened at one point where a stone footpath enters its confines, the circlet of earth guards a negative and positive earth mound (recalling two versions of the *Grass Mound* that Bayer had sketched in 1954, each showing a positive mound and ridge of earth offset by a negative hole and trench from which the earth has been removed),[10] flattened at the top like the Mayan pyramids that Bayer admired, and a circular depression whose earth has been used to form a portion of the pyramid. To one side of the pyramidal mound and directly facing the declivity several feet away is a rough granite plinth, found *in situ* but resited and sunk at an angle into the earth. It was *trouvé*, but also sculptural, a glyphic stone like the Easter Island monuments of prehistoric times.[11]

The circular arrangement of the *Table of Silence* at Tirgu-Jiu, where Brancusi placed twelve sculpted seats fashioned of marble hemispheres some distance from a ritual circular stone table,[12] is as nonutilitarian as Bayer's grass ridge surrounding the miniature grass mound, its partially filled hole and its marking stone. Bayer's mound does not appeal to Druidic antecedents or the notion of the Western "tribal meeting place" or corral, as some interpreters suggest (128:40); rather, it is a perfect compatible extension of the mythic imagination that functions in Bayer's work. Always permitting himself a retreat to purely formal interpretations (since he dislikes symbolic readings of his work), Bayer has allowed an ambiguity generous enough to encourage an association with the mythic. The most striking aspect of this remarkable project is not the creation of the first earthwork but the introduction of the rough granite shape into the complex, the first element of which, in distant times, will be read as man-shaped, while grass-covered rises and hollows will be construed as a memorial of an archaeological site where human beings congregated for their worship. Weathered as it now is, the grass grown, the rocks worn, the surfaces of the formation made smooth and undulant by the seasons, the *Grass Mound* is already self-mythologized. The human imagination, the human hand can be construed as the imagination and hand of early times—Mound Builder culture of prehistoric America, which favored the mound as burial site—rather than a work of contemporary conception. Only the granite rock, throwing its anthropomorphic shadow,[13] appears to collateralize a mythic reason, another *axis mundi*, a monument whose asymmetric placement proposes something ambiguous in a setting that can otherwise be read as minimalist geometric play.

The impulse to form the earth in contravention of the conventions of urban art was one of the impulses behind the emergence in the mid-1960s of the important artists of earthworks. Jan van der Marck is correct to suggest that the *Grass Mound* "cannot be passed off as a curious but essentially unrelated parallel to the works of Robert Morris, Robert Smithson and Michael Heizer twelve or more years later" (128:40). One of the few articles to mention Bayer in the context of "earth art" speaks of the *Grass Mound*'s influence on a number of young artists. Robert Smithson clearly acknowledged its significance for him by including a photograph of it in the historic exhibition "Earthworks" at the Dwan Gallery in 1968 (128:40, 114); Robert Morris had seen the work in

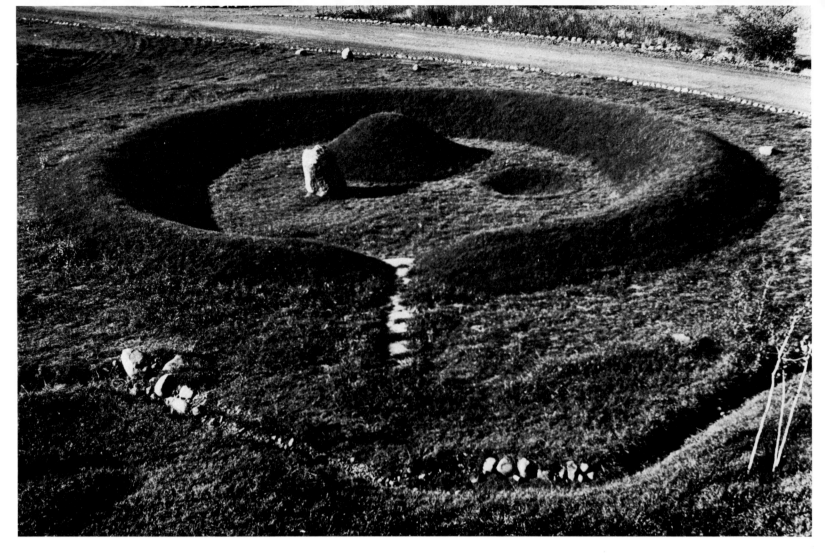

Grass Mound 1955, Aspen, Colorado.
Diameter: 40′.

Aspen and had been impressed by it.[14] Bayer, as usual, is uninterested in either claiming for himself the paternity of earth art or, more seriously, in having *Grass Mound* incorporated into an aesthetic canon that turns upon what are, to his view, more limited intellectual and aesthetic supposition.

The earthwork artists were not only transforming site topography by the introduction of semiotic devices and devising an art that denied the presence of the object, depending principally upon effected process and the documentation of process, but were also engaged in intellectual guerrilla warfare with the gallery and museum procedure of institutionalizing creative activity. Richard Long made use of the negative form of Bayer's grass mound, indenting a grass-covered trench that could be viewed as a self-contained emblem (*Sculpture Summer* 1967).[15] Michael Heizer indited into the earth vast amorphous geometric shapes that were best viewed from airplane or documented by photograph (the series of photographs of the Nine Nevada Depressions that ends with the return of the Black Rock desert to its original state).[16] And one of the most impressive earthworks, Robert Smithson's *Spiral Jetty*, depended, as did much of his work, on site photographs and drawings to bear the image away from the earth to the gallery and museum where it could serve as an iconic reference for a creation already in the process of erosion.[17]

Unlike the earth artists, Bayer was engaged in something considerably different. He did not make marks on the earth to formulate an antiobjective strategy of sculpture nor did he place his earthworks so far from habitation that there would be little or no human interaction with the created environment; finally his work was not about the subversion of traditional sculpture.

Clearly, the earth artists' decision to ignore Bayer's antecedence and Bayer's decision to distance himself from their enterprise a decade later resulted from the fact that they were about different things, despite the similarity in their work. The *Grass Mound* (as well as Bayer's earthworks in Anderson Park and in Kent, Washington) centered about the employment of landscape, other than as sited planting for the selective revelation and concealment of architecture. The earth was not romantically reformulated, as was commonplace in Robert Smithson's ideological defense of the vulnerable earth.[18] Rather, the earth became a medium—grass, soil, and rock the materials—for articulating forms already explicit in Bayer's vocabulary. Bayer had no particular investment in the originality of *Grass Mound*. It was simply another dimension of architectural design, an extension of that spatial language to the modeling of nature's raw materials. *Grass Mound* was neither decoration nor ornament to any contiguous architecture. It related to the architecture of the Aspen Center (as well as to Fuller's geodesic dome and later to *Anderson Park*), but only as the eye synthesizes connections, reducing spatial separateness by describing abstract relations and context. The *Grass Mound* was finally self-subsistent, relating to the total environment only insofar as it was an element in an abstract plan that unified many diverse and separate elements. It was earthwork as emblem—allusive and suggestive to the extent of the viewer's sensible equipment. Literally, it was grassy ridge, stone, mound of earth, and shallow hole. Beyond that, Bayer was content to let the viewer invent.

The *Marble Garden* was partially synthesized with the planned invention of *Grass Mound* in a small group of studies that proved preliminary to *Anderson Park* 1973. *Geometry Lost in an Undulated Landscape* 1958/50 undertakes a preparatory synthesis, liberating the tight structure of *Marble Garden* and submitting a larger terrain to the formation of undulant landscapes, knolls, rises, and footpaths, all of which reflect the subtle, unaggressive alteration of the existing earth. As van der Marck has surmised, the impulse was "to turn the Aspen meadows into a walk-through sculpture.... If *Aspen Valley Redesigned for Technical Purposes* looked like a center for space communications, *Geometry Lost in an Undulated Landscape* has the appearance of a graveyard for the abandoned hopes of a Euclidean world" (128:43). The gently flowing topography of Bayer's drawing is dotted with figures wearing 1920s dress, moving along worn footpaths beside which are a toppled cone, a stone cube and diminutive ball, a smaller cube in the distance, a giant ball, and a disused column beside an overturned stone gate. No classical city this, no surrealist mortuary, rather another version of a familiar Bayer image—the vivification and animacy of geometric shapes, serving no apparent purpose, *personae* in a marble necropolis.

These fundamental geometric shapes first appeared as an implicit homage to Kandinsky's mural workshop in the hieratic mural in the Bauhaus stairwell (1923), later as the elements of design in the 1928 photomontage for the *bauhaus zeitschrift;* again as the migrating shapes rushing from the cave to the sunlight in the *fotoplastik Metamorphosis* 1934, and finally in the present drawing finishing their days as elements of a classicism come to ruin. But none of the geometric forms are damaged by time, none broken or betrayed by carelessness. They are placed at random, with no apparent logic of display or encounter, no formal sequence, no scheme of revelation and disclosure. One is obliged to return to the surreality of the landscape and consider the significance of Bayer's description of this geometry as being "lost." And "lost" is quite accurate, as is the wording of all Bayer's titles: the geometry is lost, but certainly not dead or destroyed (or another way of regarding it: geometry may be ignored, but it is always present, inviolate, inviolable).

If *Geometry Lost in an Undulated Landscape* sets down sculptured elements in a prepared landscape, the *Sculptured Garden* project, 1962, proposes a less rigidly fixed and logical *Marble Garden*, one flowing with soft forms (borrowed from the "Dunstlöcher" wall reliefs but displayed as elements in an earth relief). Bayer annotated his photograph of the plaster model of this project as follows: "undulating platform within large flat lawn area 45' x 45'. when walking through 'valleys' of white concrete forms, rising to 6' height, visitor feels he is *inside* world of forms. Vertical areas, risers of steps, 'cut away' surface, of mounds and some sunken areas colored tile. three foundations move water through several basins and along valleys. plastic forms seen while moving through make sculpture garden an experience in amorphous space" (128:46).

In my discussion of Bayer's "Mountains and Convolutions" paintings I noted that a number of them position the eye in the depths of the mountain observing the slopes rise around it. The only way the *Sculptured Garden* proposed by Bayer in 1962

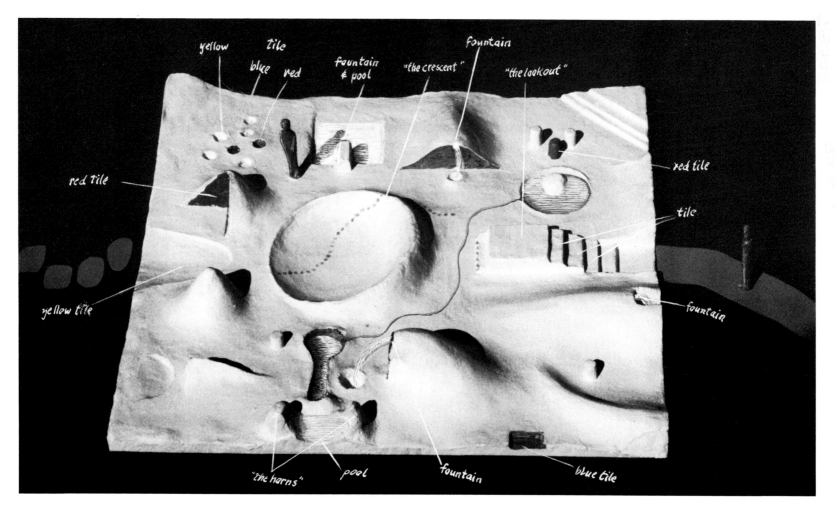

Geometry Lost in an Undulated Landscape
1958/50, crayon, 12 x 20½". Unexecuted project
for the Aspen Meadows in Aspen, Colorado.

Sculptured Garden project, 1965, Roswell,
New Mexico.

159

(and at this date unfortunately unrealized) could achieve the same effect—that of feeling "*inside* world of forms"—would be if the platform were significantly raised off the lawn area, severing the viewer from orientation to the landscape; otherwise it is unlikely that the six-foot height of the tallest elements would be sufficiently estranging. For such a project to succeed, the bystander must be passed into another world, a world fabricated of unfamiliar surfaces and textures, disorienting forms, color areas, vistas, and positions; the psychic wrenching indispensable to its effectiveness must be wrought. The man-made quality of some of the elements must be removed more than the model indicates in order to bring the work closer to the truly ambiguous character of *Grass Mound*. The artificial color called for by the model may not be effective, whereas the tonalities of those odd pinks and bisters that turn up in celestial photography would intensify the unearthly quality of the celestial tableau. The stairway—as in the processionals of the "Moon and Structures" paintings—is absolutely right, however, as the effect of this *Sculptured Garden* is to endorse once more an initiatory attitude toward the heavenly orders, whose only analogue in the terrestrial arts is, as van der Marck suggests, Frederick Kiesler's *Endless House*. "Both artists," van der Marck continues, "have dealt with organic form in a baroque, yet tectonic fashion. Bayer is unrivaled among his contemporaries in his understanding of the physiognomy of landscape. He draws such powers of imagination from that understanding that, in his three-dimensional renderings of landscapes, the surface literally burgeons with subterranean vitality" (128:46).

Some years later, in 1967, Bayer presented several schemes for the development of an urban landscape for the South Flower Street location of the international headquaters of the Atlantic Richfield Company and the Bank of America in Los Angeles. The scheme entailed installing on the plaza before the two setback buildings a series of soft form horizontal sculptures that recalled the celestial mood of *Project for Sculptured Garden*. The ten elements, among which was a biomorphic shape set into water (an obligatory feature of Bayer's environments),[19] included gently undulant rises, shapes that alluded to parts of the body (usually female), and other eccentric sculptural forms. The project was never executed, undoubtedly because it seemed too intimate, suggestive, and unconventional for a public space, and too daringly abstract without at the same time being monumental in scale (as was the *Double Ascension* Bayer subsequently developed for the same space). Nonetheless this modest sculptural landscape carried to its logical extreme Bayer's effort to translate the spirit of his paintings into sculptural fantasy.

The only fulfilled consequence of this project was *Primary Landscape (Fountain in Ten Parts)*, which he completed the same year. Fashioned in bronze (in two casts, one of which actually pumps water through its central fountain), *Primary Landscape* envisages the transfer of the *Sculptured Garden* to a rigorously proportioned grid (10 x 10'). The free shapes of *Sculptured Garden* and *Project for a Garden* 1965 for the Roswell Museum and Art Center in Roswell, New Mexico,[20] are now precisely fixed, the elements choreographed and balanced to each other, creating an environment through which the viewer may pass, liberated

from the sense of amorphous space and estranging uncertainty that was a critical aspect of *Sculptured Garden*. Precisely because of its bronzed and burnished frozenness, the *Landscape* acquires the surreal mood that puts it in the canon of sculpture that includes Man Ray's chess sets, Max Ernst's bronze tableaus, and the sculptures that Giacometti realized between 1932 and 1934 (128:47).

The sculptured landscapes and marble gardens that Bayer drew from 1947 until the end of the 1960s are, with the exception of *Marble Garden*, unrealized; however, *Grass Mound* received a broadening and extension in *Anderson Park*, a large-scale earthwork he executed for the Aspen Institute with the support of his principal patron of those years, Robert O. Anderson.[21]

Bayer was given an area set around a bend in the road leading from the complex of buildings that form the Aspen Meadows Guest Chalets. This was flat land in a natural state, marked only by a giant white boulder, which was used in the composition of the park without physical alteration or resiting. Bayer adapted the premise of *Grass Mound* and his drawings for *Project for Positive-Negative Grass Sculpture* 1954/111 and elaborated it on a somewhat grander scale. The scheme envelops the formation of four artificially fashioned grass-covered mounds of varying height, circumference, and gradient (oriented in its large plan to the viewing of the North Star) and complemented by a swirled circular grass ring (much like the surrounding shape of *Grass Mound*) and a kidney-shaped artificial body of water into which is set a small doughnut-form grass mound that breaks the water's surface. Inconspicuous footpaths thread through the earth shapes, blocks of irregularly cut white marble are positioned at the perimeter to serve as benches, and a bridge of trimmed beams picks up the main road and extends it over the body of water. The sizable boulder several feet from the water is an axial center for the composition, defining a visual radius to a sculptural composition interpreting the sign of the Big Dipper, by the Mexican sculptor Mathias Goeritz, which functions as the introductory element to *Anderson Park*.

Bayer's involvement with environmental earth art continued over the ensuing years principally in the development of large-scale visionary projects for the reconception of the role of sculpture in motorways, industrial transformation, and seaside sculpture, all of which require separate and intensive scrutiny. The most recent project to attract his attention as an earth sculptor was the invitation to develop and reclaim for the purposes of water retention and control the Mill Creek Canyon Park for the city of Kent, Washington. The actual Bayer earthwork covered two and a half acres of the ninety-six-acre park, which threaded between a residential and commercial area in Kent. With a grant from the King County Arts Commission, the King County Department of Public Works, and other civic organizations, a large-scale, statewide project involving eight artists (Iain Baxter, Richard Fleischner, Lawrence Hanson, Mary Miss, Robert Morris, Dennis Oppenheim, Beverly Pepper, and Herbert Bayer) was projected for the reclamation of disused or eroded land sites throughout the county. Extending the basic module developed out of the *Grass Mound* and *Anderson Park*, Bayer proposed a scheme entailing

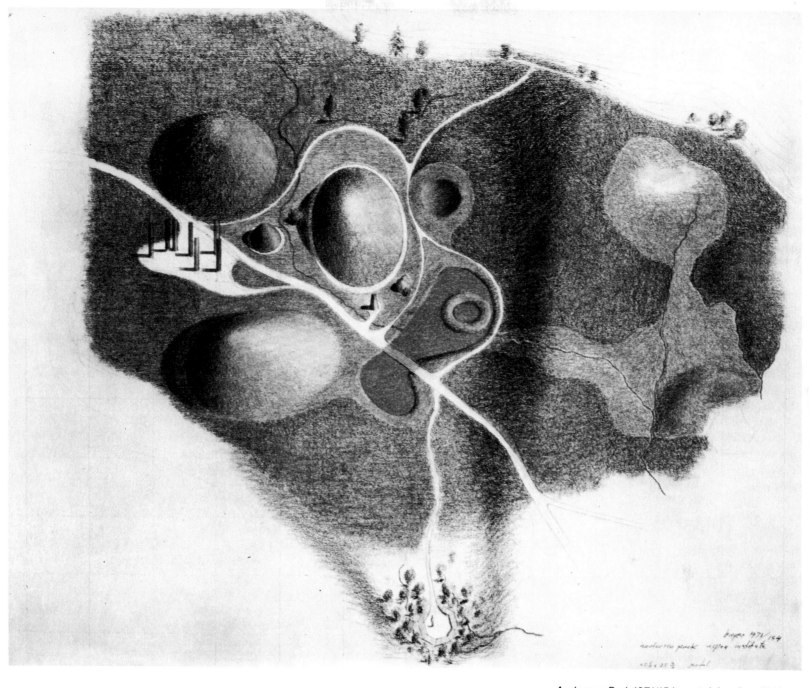

Anderson Park 1971/154, pastel drawing, 20¼ x
25¾". The path shown leads from the Aspen
Institute over the pond past the *Big Dipper*
sculpture of Mathias Goeritz to the Aspen
Meadows buildings.

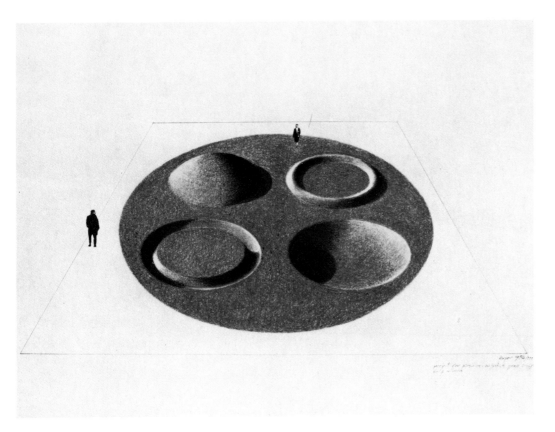

Project for Positive-Negative Grass Sculpture
1954/111, pastel on paper, 19 1/2 x 25 1/2".
Collection Herbert Bayer.

Anderson Park 1973, Aspen, Colorado.

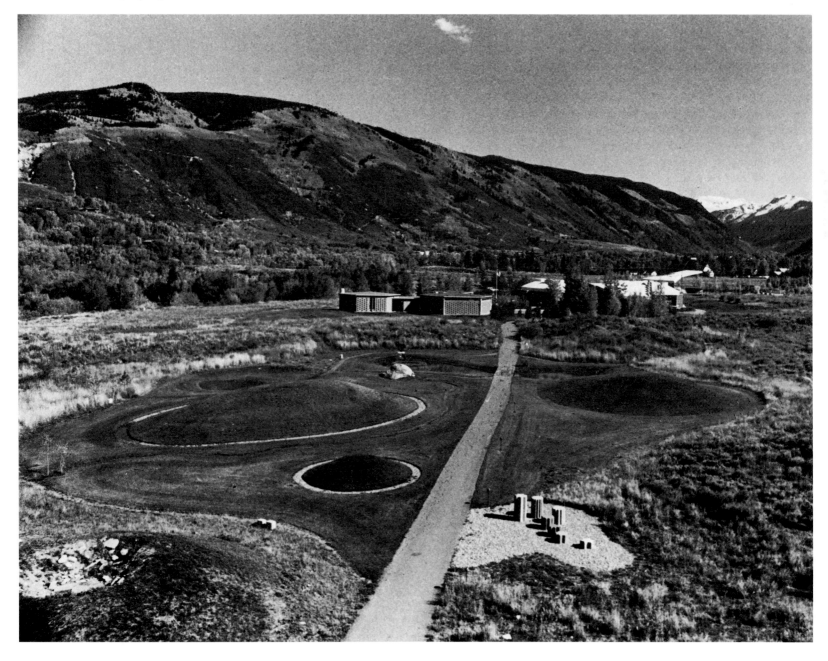

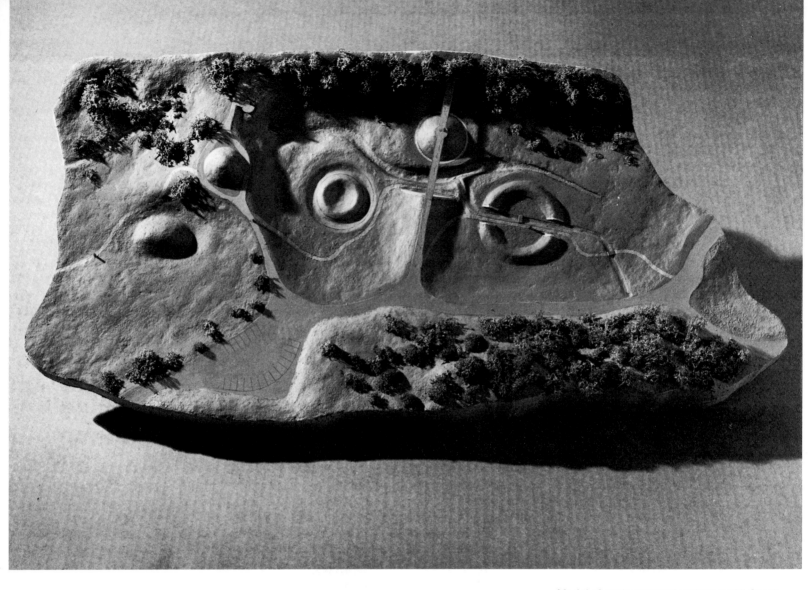

Model of environmental project at Mill Creek
Canyon, Kent, Washington, 1982/19, cardboard
and model compound, 30 x 14 1/2".
Collection Herbert Bayer.

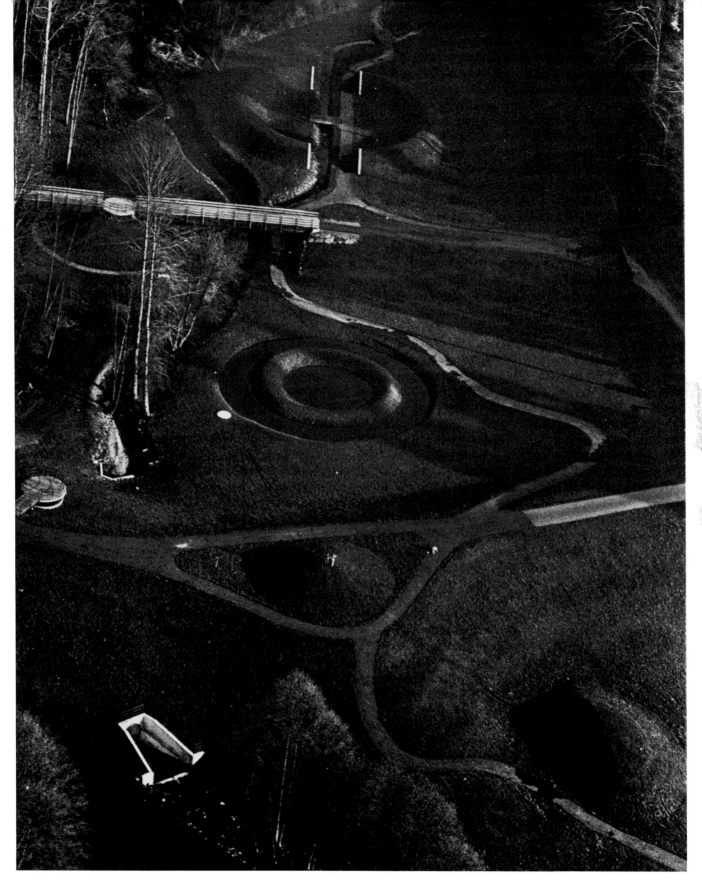

Mill Creek Canyon Earthworks. Kent, Washington, 1982. Aerial view from the south.

cone that helps support a circular cement pediment linking two portions of a conduit over Mill Creek; a ring pond surrounding a circular mound bisected by the creek. Not all features of the site can be seen at once and only one mound is visible from the road. Bayer sited it beyond a grassy berm that shields the project from idle curiosity, while at the same time, as Bayer observed, planting "the seed of curiosity in passers-by, and making them wonder what's on the other side."[22]

Bayer developed a suite of variant drawings for the siting of this earthwork, one proposing a linear unfolding of the five elements, the other (the one accepted for realization) covering a slightly larger terrain, involving the placement of the variously scaled mounds in a more dramatic counterpoint. Once again Bayer's interest was not in the conceptualist aesthetic mode nor in the employment of earth as a simulacrum of the architectural, but rather—as adumbrated in the original *Grass Mound* and reformulated in *Anderson Park*—the transformation of existing land mass by the introduction of foci of visual interest. The classical garden introduced real sculpture as a means of orchestrating the response to patterns of topiary gardening; Bayer assumes the earth itself can be translated into sculpture that can be enjoyed as object, man-made but still ambiguously natural. The earth can become an instrument of nature's architecture; the artist's hand intervenes merely to site and reformulate, unassisted by the materials of industrial fabrication.

In this respect Bayer's fascination with environmental earth art is a shift away from the Bauhaus ideology that underlies much of his work. The Bauhaus considered architecture a siting that reconstrued the ecological balance between nature and man, giving pride of place to the formal invention of modern architecture in effecting nature's new presentation. Bayer's interest in environmental art moves in the direction of making nature the medium of the building arts and compelling the technics of modern architecture to become an instrument of enhancing and *representing* the forces of the natural. Bayer's earth art (and his environmental projects) are principally media for enabling us to see again what we neglect or take for granted: the natural convolution and dynamism of the earth. If the *Grass Mound* or *Anderson Park* or Mill Creek Canyon Park reclaims the earth from erosion and depletion, and becomes as well an object that compels aesthetic response, Bayer has actually extended the Bauhaus maxim to the new horizon: not only art and technics are the new unity, but rather art *is* technics and nature. Only when nature is added to the complex is there a unity capable of saving the earth by making it more attractive and habitable.

Murals to Screens to Sculpture

Sculpture has never occupied a critical place in Bayer's oeuvre. He has made scores of models, many drawings, maquettes in insubstantial materials, of large sculptures that might come into existence, but sculpture as such—the obsession with volume in space—has always been linked with issues in his aesthetic that entailed other, more broadly defined notions of environmental form. Sculpture for its own sake is rare in his enterprise. Graphic

design had focused the vocational consequence of his Bauhaus years; photography enabled him to describe a kind of objective narrative that complemented and nourished his early activity as designer; and later, after his arrival in the United States, when architecture and environmental planning extended the range of his interest in visual communication, he identified a new and relevant role for sculpture. Describe a site, situate a building, and sculpture became a means of effecting visual contrast and counterpoint. Sculpture was always for place, never an end in itself.

This should not surprise anyone familiar with the development of Bayer's conception of environmental design. Architecture, the surrounding urban or rural terrain, the nature of appropriate materials, the prevailing climate and atmospheric conditions are all weighted factors in his formulation of sited sculpture. Sculpture then, rather than being absolute form (whatever its internal requirements for clarity and integrity) is the crossroads of several relative factors. Unlike the makers of most contemporary monumental sculpture, such as Kenneth Snelson, Mark de Suvero, or Alexander Liberman, none of whom are architects or environmental designers, Bayer is usually involved in the whole project as architect or consultant to the architects, as designer or consultant to the designers. The Gesamtkunstwerk is truly Bayer's; he has formulated the entire scheme. Sculpture is usually only an element in the complex.

It will be immediately clear that divergencies occur, usually in the case of the odd commission from a client not otherwise engaging Bayer's services as overall architecture and design consultant. But all this developed more slowly, over many years, from the making of two-dimensional murals to relief murals, to freestanding screens that modulated into sculptures, to sculptures themselves. It is this progression of enterprise to which I now turn.

Bayer's apprenticeship in Vassily Kandinsky's wall-painting and mural workshop at the Bauhaus in Weimar turned upon the mastery of all the techniques of applying paint to wall surfaces. Collaborating with his friend "Sepp" Maltan (who knew better the method of cassein painting, having been a house painter before he came to the Bauhaus), Bayer executed the entrance sign mural for the Bauhaus Ausstellung (1923), which Bayer had designed. He also realized the three-panel mural for the stairwells of the Bauhaus (1923); designed a mural in sgraffito for the Bauhaus Ausstellung (146: illustration 57), and earlier worked on the canvas for Kandinsky's entry in the 1922 Juryfrei exhibition in Berlin,[23] as well as working on various assignments contracted for by the wall-painting workshop in Weimar.

Wall painting and mural painting have no explicit connection with sculpture, other than the significant alteration of scale involved and the absence of the frame as a convention for sealing the edge. And yet, precisely here, in the recognition that both edge and scale were significantly modified, large color areas compelled to perform graphic as well as plastic functions, are the beginnings of an aesthetic logic whose path can be charted as follows. From flat mural painting installed in a public space (as was *Verdure* for Harvard University or the sgraffito mural in Aspen) and the curved wall mural executed in brown, white, beige, and yellow tiles of equal size for the ramp of Gropius's Harkness

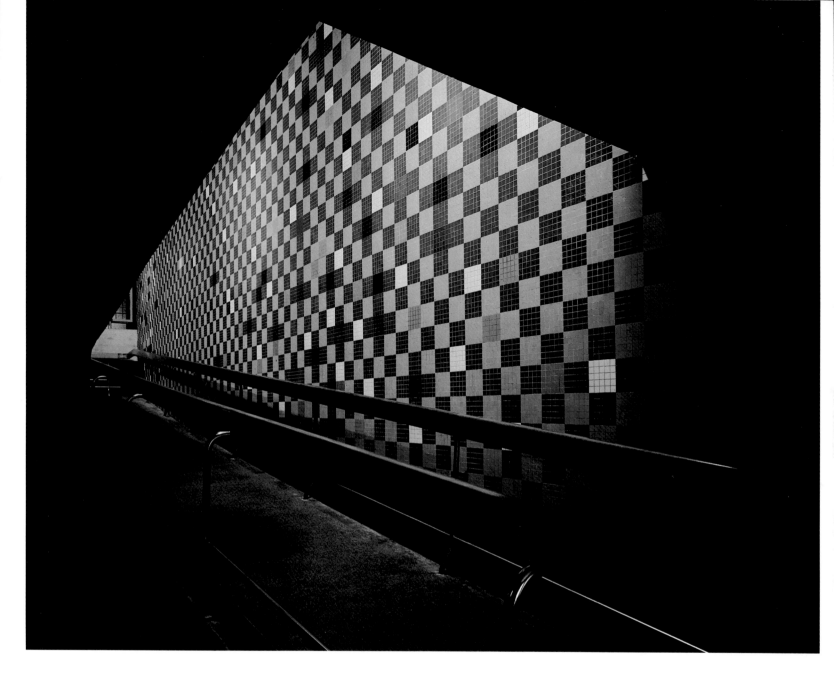

Tile Mural 1950, glazed tile, 93′ x 18′ 6″. Extending over two floors along ramp to restaurant. Harkness Graduate Center, Harvard Law School.

Graduate Center at Harvard (1950),[24] and the inset tile painting (*Beyond the Wall*) installed by Bayer in wall apertures facing a mini-park at the Philadelphia College of Art (1977)[25] to the experimentation with freestanding perforated louvered screens (*Kaleidoscreen* 1957), whose panels rotated to form different plastic relations of form and color, to the final articulation of colored sculptural elements forming walk-in tableaus, which Bayer called *Walk in Space* paintings (1962–1981). These were originally proposed for the Roswell Museum and Art Center in Roswell, New Mexico, later redevised for ARCO Plaza in Los Angeles, and finally executed in the garden entrance to the Breakers, an Atlantic Richfield executive seminar center in Santa Barbara, California.[26]

The sculptural panels—*Kaleidoscreen* 1957—that Bayer devised as a space divider for installation near a swimming pool on the Aspen meadows in the Aspen Institute complex was realized from a set of prefabricated aluminum panels (undertaken for the Aluminum Corporation of America as an experimental project). One side of the panel structure was textured, while the other proposed designs in primary colors. The entire arrangement was geared to a cranking device that permitted the seven louvers to turn ninety degrees, to intersect and form a continuous plane in which the panels would recompose like the elements of a jigsaw puzzle. They could then turn a further ninety degrees to a position that would be a mirror image of the original composition. Such freestanding dividers defy definition. Neither sculpture, nor painting, nor architecture, they nonetheless make clear reference to discoveries Bayer had elaborated from the earliest of his paintings (those that entailed fret-work cutouts, such as *Kulissenbild* 1925, *Violin & Frames* 1928/7, *Hand & Frames* 1928/8, and *World on Boards* 1928/33), where planes passed through each other, creating a translucent space that would be responsive, as was the *Kaleidoscreen's* aluminum surface, to reflections of the sun, mutations of the seasons, and intensities of light and heat. The painted side of the screen interacting with the landscape relieves dull days and responds correspondingly to solar brilliance. Unlike monumental sculpture, as van der Marck notes (128:42), the *Kaleidoscreen* (whose overall dimensions are 7 x 12') must be sited so as to take advantage of the shifting light in order that it can enjoy optimal kinetic intensity. Bayer made a number of other models of the *Kaleidoscreen* (including a multiple issued by the Marlborough Gallery, New York), utilizing themes from his "Linear Structure" paintings, as well as bold color forms reminiscent of the "Architectural" series, but these have not been sited.

The premise of *Kaleidoscreen*—in which two-dimensional colored panels acquired (through their ability to turn) a third dimension and ultimately (through surface interaction with the environment) a fourth as well—was extended in Bayer's *Walk in Space* projects (1962–1981). The various *Walk in Space* projects (only one of which, the *Walk in Space Painting*, was executed), retaining the flat, mural character of *Kaleidoscreen*, accomplish the articulation and movement that was *Kaleidoscreen's* essential appeal by creating an architectural environment through which the viewer passes. The panels, set into a circular pool of water, are reached by a footpath of stepping-stones that leads to a square concrete platform around which the panels are positioned.

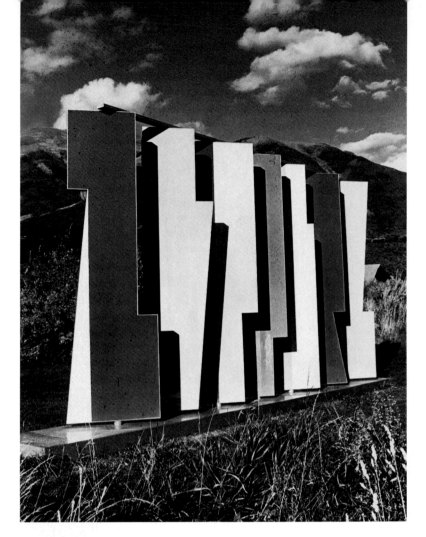

ALCOA *Kaleidoscreen* 1957, 7' x 12'. Aspen Meadows Hotel Development. Aspen, Colorado.

Each of the concrete panels is faced with vitreous tile that form various chromatic constructions. The viewer enters, in effect, a perforated sculptural room, with vistas extending beyond the boundaries of the composition; color moves over the water, reflecting intensities of light and temperature, throwing shadows on the terrain beyond.

The original conception of the *Walk in Space Painting*—proposed for the courtyard of the museum in Roswell, New Mexico (1962)—suffered from an excess of individuation; each element was designed and positioned to effect changes of relation to the viewer without achieving an effective compositional integration. It appears this is what Bayer intended, for he described it as "a series of open spaces related to the proportions and to the location of the panels,"[27] but unfortunately the project was, to my view, insufficient. Some of the problem was resolved in the subsequent reworking of the scheme (1969) for situation in a round pool of water on ARCO Plaza in Los Angeles. There, the step-up walk over the pool (whose diameter was to be twenty-two feet) passed through panels chromatically more intense, with contrasts of primary colors and black-and-white checkerboard patterns marked by strong chromatic-constructivist designs. The difficulty of this proposal was that the work was to have been sited on a plaza paved in polished granite before twin fifty-two-story highrise buildings faced in the same stone. The pool and its mural dynamic would have created an environmental playground that might have relieved the site's overpowering gravity, but its own statement appeared sufficiently arbitrary as to become a minuscule *beau geste*. This scheme was abandoned in favor of Bayer's sculpture fountain, *Double Ascension* 1972–73, which I will examine later.

The most successful model for the *Walk in Space Painting* (1980) was realized in the intimate, private environment of the Breakers, the ARCO seminar center in Santa Barbara that houses a large collection of Bayer's work. A visitor standing on the rich lawn in front of the unpretentious one-story traditional building that dominates the grounds is delighted by the vista of a pool, forty feet in diameter, surrounded by a concrete lip, out of which arise freestanding concrete panels faced on both sides with glazed tile forming chromatic scales and progressions. Eight concrete circular steps conduct the viewer from the lip into the compositional structure that rises from a modest concrete platform and out through a large oval opening in a square panel. The elements are grouped intimately, positioned subtly; and although one is passing through an architecture of freestanding chromatic murals, one's pleasure derives from the ensemble, trees at the perimeter of the property, rich green lawns, shimmering water, and the bright, sun-laden atmosphere. The *Walk in Space Painting*, a modest exercise in realizing the integration of architectural, plastic, and chromatic values, comes off precisely because it has not pressed too hard. It lacks the elegance of *Marble Garden* or the originality of *Grass Mound* and *Anderson*, but it is an example of a garden of aesthetic delights that would be immensely welcome in virtually any public space of reasonable size and informality.

The prefabricated element is at the heart of these Bayer projects for constructed mural architecture. Faithful to the impulse of the Bauhaus, Bayer has formulated the task of public sculpture as the integration of architecture and environment, employing the most modern materials and establishing the use of prefabricated modules, which can be joined together and erected at the site. In this respect his notions do not differ markedly from contemporary sculptors (one thinks immediately of Kenneth Snelson's remarkable stressed constructions), whose elements are machined in the factory and delivered to the site for assembly.

The difference between Bayer and Snelson is that Snelson's tension constructions depend more on the possibilities of engineering, each sculpture acquiring different authority from the continuous shifting of its gravitational center and field, whereas Bayer's are all based on the definition of a geometric shape and a mathematical plotting of its stepped arrangement. The tension wires that hold and elaborate the steel elements of Snelson's sculptures become part of the sculpture, while remaining intrinsic to its engineering; in Bayer's sculptural constructions, as he notes in "Sculptures with Prefabricated Elements," "they are composed with predetermined elements and because these elements are identical in shape and size they must be assembled or stacked or otherwise connected to result in the planned concept."

There is an unavoidable indebtedness in all vertical module sculpture to Brancusi's *Endless Column*, the primal *axis mundi*, constructed in Tirgu-Jiu, Rumania, in 1937. There Brancusi erected a sculpture of 98.5 feet, whose bottom was sunk into the earth and whose truncated top pressed toward the sky. Each module, fashioned of gilded steel, was identically repeated. The several earlier versions of *Endless Column*, carved in wood (the first from "heavy tree trunk, in 1916, in three days")[28] had a limited number of modules, rarely more than eight or ten. Their scale was modest, their reach constrained. At Tirgu-Jiu, Brancusi asserted the fullness of his conception, pressing it to a reach where its mythic intentions could not be avoided. Brancusi could not carve the great *Endless Column*. The steel casings were cast, although not under industrial auspices. It is but a short step to the formation of sculpture whose prefabrication establishes modular forms that can be endlessly repeated, endlessly rescaled and arranged, variously colored (either by saturating the concrete with color, which has many problems, spraying color to achieve maximum impersonality, or applying paint by hand before the work is assembled at the site), and achieve sometimes brilliantly, at other times less dramatically, the kind of mythic resonation that is at the heart of Brancusi's sculptural vision. The success of monumental sculpture—any sculpture that makes claim by scale and presence to holding gravity in place—depends on where it is situated. A monumental sculpture in an urban space already deformed by its architectural environment can do little more than "stamp its feet" to gain attention and such clamor results in defeating its intention; whereas, in Brancusi's case (remote as Tirgu-Jiu may be to most of us), the siting of the *Gate of the Kiss*, the *Table of Silence*, and the *Endless Column* in a park memorializing the dead, surrounded by a peasant architecture rich with the sculptural vocabulary upon which Brancusi drew, cannot fail to evoke precisely the sensations of sublimity to which he aspired.

The variety of preparatory models that Bayer developed during the 1960s for a series of large-scale sculptures fashioned from

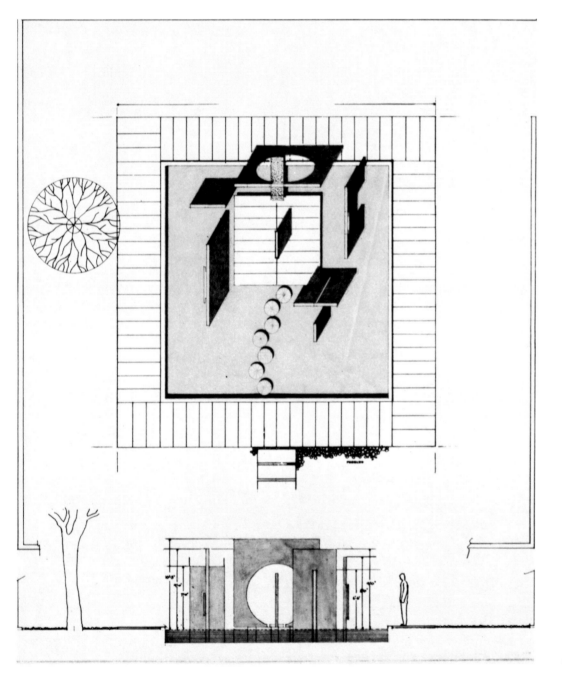

Space Painting project, 1962, Roswell Museum of Art. Roswell, New Mexico.

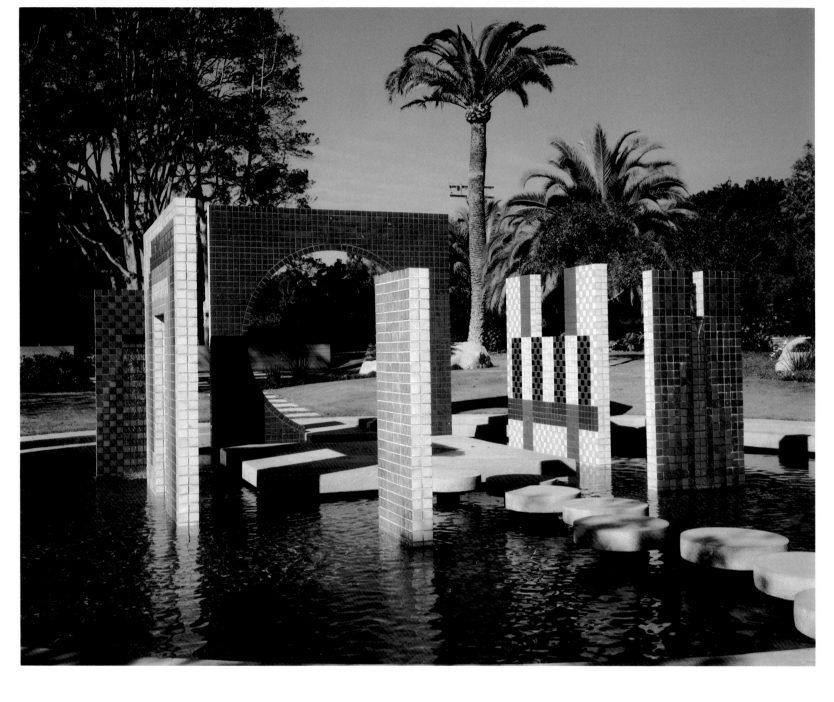

Walk in Space Painting 1981, concrete faced with
glazed brick (maximum height: 10′; pool diameter
40′). ARCO Breakers. Santa Barbara, California.

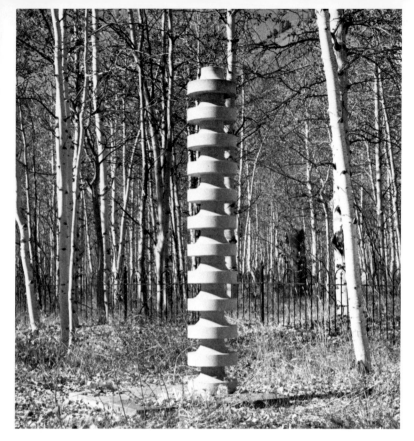

Walter Paepcke Monument 1960, gray granite,
9' high. Aspen, Colorado.

prefabricated elements substantiates these preliminary observations. The earliest and the most complete assertion of Bayer's affinity with Brancusi's *Endless Column* is the monument he designed to commemorate his great friend and first significant American patron, Walter Paepcke, who died in 1960. Standing on a simple stone plate flush with the earth, the structure consists of twelve modules fashioned from a single piece of light gray granite that has been turned on a lathe. The sculpture, each of whose modules are formed like inverted Japanese urns (or broadbrimmed flattened sampans), rises up a modest nine feet and is situated in a clearing surrounded by white birch trees.[29] Here it is not the scale but the arresting forms ascending among the trees that underscores the compelling presence of this work.

However much the pure geometry in painting to which Bayer turned in the 1960s was linked to chromatic progressions, it was nonetheless independently focused as the implicit armature of his exploration of form. It is not surprising that the sculpture he began to formulate after the free figuration of the louvered space dividers of the *Kaleidoscreen* and the planned happenstance of the *Marble Garden* should turn upon the measured articulation of geometric progressions and unfolding spatial volumes. None of his sculptures defines volume by the presentation of a single carved or fabricated form; possible exceptions are *Leaning Pyramids* 1967/52s, which presented three related triangular solids on a rectangular base forming a spatial tableau or the geometric gardens he produced by the situation of a series of columns (*Forest of Columns* 1973/73s) or cones (*Forest of Cones* 1969/73s), graduated in scale or identical, related to a cruciform flow of water or forming a field of form. In virtually every other instance, Bayer has organized conjugations of prefabricated monochromatic elements, stacked with progressive turns at precise intervals (*Column of Random Stacked Squares* 1967; *Spiral Tower* 1967/57s; *Articulated Wall*, 1968 Mexico). In *Stacked Tower with Short Twist* 1967/65s, where he wished to introduce color variants, he maintained the rectangular symmetry of one element and incorporated a series of stepped revolutions in a differently colored element at a certain juncture in the vertical construction.

The premise of all of these works was the minimal visual means implicit in the use of a single geometric form, mounting upward or creating a horizontal sequence (*Domino* 1971/101s). The appeal of such sculptures is intellectually quintessential, since they derive their authority from their relative massiveness, their domination of the surrounding terrain, and the economy of their principal device. Whether that is stacks of turned lengths of wood or flat tablets of concrete or assembled pyramids of cubes (*Cubic Tower* 1970, *Maya* 1971/91s) or clusters of cubes composed like the bonding of atomic structures (*Pueblo* 1971/95s), the delight is less with their tension or the awesomeness of their engineering than with the spatial volumes that can be accomplished with an elemental geometric principle.

The sculpture of these years, formulated as small models, was for the most part unrealized as sited work. In several cases, small editions—rarely exceeding three examples—were executed in polished aluminum or, in the case of *Tubular Structure 1* 1969/51s,

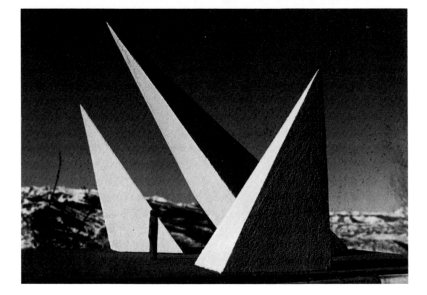

Leaning Pyramids 1967/52s, concrete, about 36' high. Project.

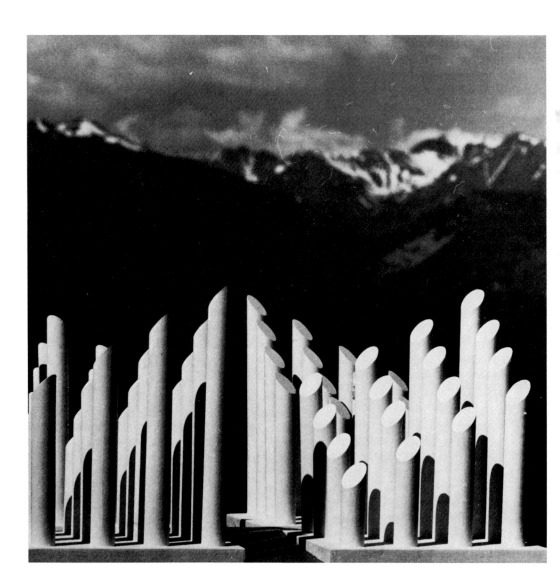

Forest of Columns 1973/73s. "Walk through sculpture," 9½' high x 19' x 19'.

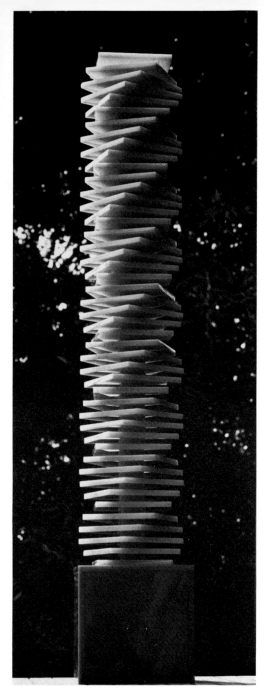

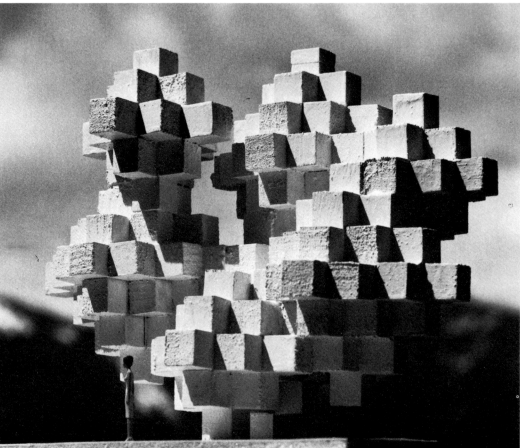

Spiral Tower 1969/60s, yellow Plexiglas on orange Plexiglas base, 25″ high x 4½ x 4½.

Pueblo 1971/95s, model for sculpture in prefabricated elements, painted wood, total height 6¼″, width 8″, with 8 x 8″ base.

in chromium-plated tubes, but only four major works were constructed for installation and siting. Bayer's first major public commission, for the Route of Friendship abutting the highway leading from Mexico City to the Azteca Stadium where the Olympic Games of 1968 were held, resulted in *Articulated Wall* 1968. The *Articulated Wall* was fabricated by a Mexican building contractor in concrete elements, each of which was 26′ x 39″ x 19½″. The concrete elements, painted chrome yellow, were built up to a height of 53′6″, stacked over a structural core in a forward and backward progressive ascent. *Articulated Wall* (one of eighteen sculptures commissioned by sculptor Mathias Goeritz, art director for the Olympics) was situated in a perpendicular juxtaposition to the highway in a "north-south position in order to benefit from the full range of light and shadow effects from sunrise to sunset and in order that the driver sees the full width of the structure first and, when passing, the thin undulated appearance of the elements. at night it is lighted with floodlights placed close to the structure to get light and shadow effects which reverse those of daylight."[30] This piece, like those before it, and the several that would succeed it, were correctly described by Bayer as "environmental art"—in this case, more properly as environmental sculpture.

The willingness to prefabricate and assemble, to experiment on the site with appropriate color and its method of application, make clear that for Bayer the object is constructed as an element interposed between traveler (in this case) and the surrounding terrain. Like the other sculptures commissioned for the Route of Friendship (notably those by Jacques Moeschal), *Articulated Wall* was intended to delight and distract without being hazardous to the passing motorist. Bayer's sculpture, the most severe and pristine in its formulation, avoids the narrative and "designed" quality that often afflicts public sculpture ordered to fit and measure. Delight in form and space first, curiosity about its mathematical intervals second, define the range and satisfaction of *Articulated Wall*.

The spacious plaza formed of fitted granite slabs fronting twin fifty-two-story skyscrapers (corporate headquarters for the Atlantic Richfield Company and the Bank of America) is situated at South Flower Street in downtown Los Angeles. Although separated from the street by trees planted in small rectangular beds protected by low concrete pediments, this plaza was without visual interest, an unrelieved expanse of gray granite. Undoubtedly, Bayer envisaged the necessity of water first—something with water, over water, water moving and circulating in a receptacle, providing cool diversion, relaxing the formidable gravity of the site. In his memorandum on the *Double Ascension* sculpture, he notes that initially, he had several ideas for "sculptural treatment of the plaza." A *Walk in Space* project was considered during 1968, as well as a *Chromatic Gate* (for which several models were developed during 1969) in which a sculptural spatialization of colored volumes, similar to those of the "Gate" and "Chromatics" paintings, are given volumetric articulation, the continuous form receding in size as the chromatic scale unfolds from blue through red, orange-yellow, and white, and expands again to the other side. He then conceived of a fountain that was to have consisted of ten sculptural elements of "stylized geologic formations with water fountain incorporated."

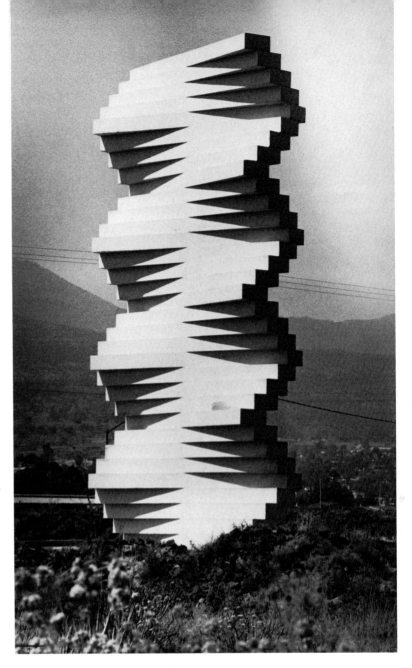

Articulated Wall 1968, prefabricated concrete painted chrome yellow, 53′6″. Situated on highway between Mexico City and Azteca Stadium.

All of these were rejected, probably because their atmosphere was too personal, individual, and assertive. They did not exude the monumental illegibility and neutrality that seems to be the requirement of corporate sculpture. Although the *Double Ascension* 1972–73, certainly derives fully from Bayer's familiar vocabulary, it seems—in light of the available options—a relatively tame decision. It derives from the sculptural notions Bayer used in the *Articulated Wall*, two flights of heavy-gauge aluminum slabs (laid over steel framing) rising from opposite ends above a round granite pool overflowing with water gathered and recycled in a trough below. The double ascent of stairs (each unit of which measures 11′ x 2′1″ x 9″) rises up approximately fourteen feet and covers an expanse of thirty-three feet within a pool sixty feet in diameter. The aluminum slabs, fabricated by William G. Zimmerman Architectural Metals, in Denver, were shipped individually, spray-painted with orange-red epoxy paint, and assembled on site.[31] The geometric formulation of *Double Ascension*, indebted to Bayer's early model for *Stairs to Nowhere* 1968/75s, in which the form is more leisured in its curvature, and *Double Twist* 1971/94s, in which the curve of both ascending stairways opens an expansive aperture between the curved ascents, is more condensed in its interval and progression than either of its antecedents. My only reservation is about Bayer's use of an orange-red color that imparts a somewhat theatrical effect, reinforced by the sculpture's placement in the circular pool of water. One would have wished for a rougher quality to the piece, less harmonious and formally contrapuntal to the site and its architecture. The rough quality of the *Articulated Wall*, whose concrete elements suffer continuous weathering, and the occasional faults in the lathed granite urns of the *Paepcke Monument*, guarantee to those pieces a jarring discordance that fascinates and rewards. *Double Ascension* surrenders a portion of its intrinsic lyricism and mystery to its surroundings.

The sculpture mural *Anaconda*, which Bayer developed for the interior foyer of the Anaconda Building in Denver in 1978, presents a varied display of solid geometry in marble, a takeoff from the more casual and hieratic *Marble Garden* 1955. The seven pieces of marble, cut from the Carrara quarry in north central Italy under Bayer's supervision, repeat Bayer's favorite geometric shapes—hemisphere, right triangle, elongated rectangle, and square, diamond (minus a forward triangle), and circle without quarter—positioned in a shallow reflecting pool (9 x 35′) that is the sculpture's pedestal. Around the pool runs a trough (shallower than that of *Double Ascension*), which receives and circulates the water. Behind the sculpture platform Mathias Goeritz, who collaborated with Bayer on this project, has devised a mural fashioned of eight-by-eight-inch, twenty-two-gauge brass squares, fifty-two horizontal rows by twenty-two vertical rows. Each brass square was burnished by intensive preparatory pounding, with approximately two hundred nail holes per square, resulting in a textured dynamism that contrasts with the eloquent simplicity of the marble geometry. The geometric shapes are choreographed both frontally and sideways, hidden behind another and fully revealed, as though frozen space immobilized before the sun-swept glitter of the polished brass mural.

Though *Anaconda* is successful as pictorial sculpture, it misses real grandeur precisely because such a variety of means have been required to produce the whole, and the means—each offsetting to the next (marble geometry, reflecting pool, burnished mural, which, incidentally, should have run from floor to ceiling)—tend to cancel each other out. It is an instance of the problem Bayer has often faced: knowing too much about all aspects of the problem and sympathetic to the complexity of devising sculpture that is integrated as a presence within the architecture (rather than combatively unnerving as sculpture indifferent to the permissions granted by the architecture often are), Bayer has been too understanding. The framed sculpture fails to be fully sculpture, much less pictorial sculpture, and the frame dilutes the total experience by setting off the work as a pictorial interruption of the architectural space.

These criticisms cannot be leveled against *Organ Fountain* 1977/50s, which was commissioned for the City of Linz, Austria, within the sculpture program described by the Forum Metal held in Linz during 1977. In front of the modern but unpretentious architecture of the Bruckner Concert Hall, surrounded by tall chestnut trees, Bayer positioned in a raised granite-framed basin (twenty-five feet in diameter) a series of seventeen matte-finished steel cylinders forming a serpentine of mathematical progressions from thin to thick and back again, each cylinder circulating water through an appropriately graded aperture that shimmers the water down into the pool. The mathematics of the progression offers a horizontal movement in handsome contrast to the vertical descent of the water. *Organ Fountain*, positioned on a granite octagonal walkway, is a lovely, intimate work, which obviously pleases spectators, who are delighted by its graded gush of water during summer and fascinated by its mute music during winter, when the fountain is silent. Bayer also devised a scheme some years earlier (out of which *Organ Fountain* emerged), which is splendid, wholly convincing, and unrealized. The *Two Groups of Columns* 1967/56s positions the same constellation of cylinders (either in marble or in the matte-finish steel of *Organ Fountain*) on a raised rectangular black granite platform that rests in turn on a larger checkerboard of brown stone slabs. The entire work is unframed by basin or contrasting circularity; the serpentine of columnar progression from extreme thin to thick, high to low, creates a mood of ascendency and exaltation that, were it situated free of the constraints of architectural *arriérè-pensées*, would command an excellent beauty.

Throughout the late 1960s and '70s, when Bayer was completing his chromatic investigations and commencing his summary "Anthology" series, he continued to develop sculptural projects that took off from the suggestion of his painting. Notable among these were a number of projects interpreting the chromatic "Gate" paintings of the 1960s (*White & Red Gate* 1969/58s, *Chromatic Gate* 1975/100s), but extending their vocabulary by introducing sculptural values that significantly alter and intensify their plastic energy. The gate was reconceived in more fluid forms: as turning volumes (*Turning Gates* 1977/2s); as leaning chromatic structures (*Leaning Gate* 1969/66s); as receding circular forms punched into

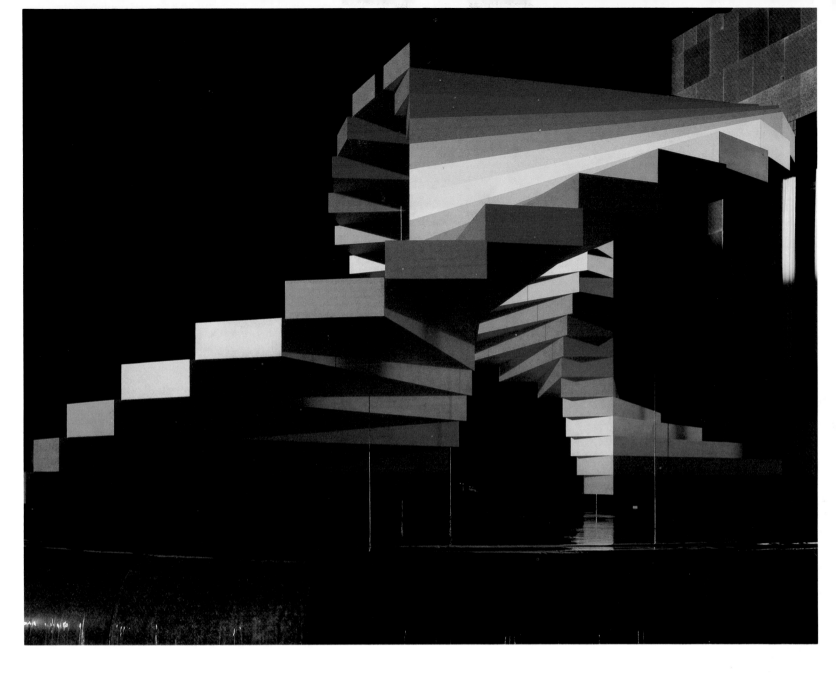

Double Ascension 1972–73, painted aluminum
(14'3" height; maximum length 33'; pool diameter
60'). ARCO Plaza. Los Angeles.

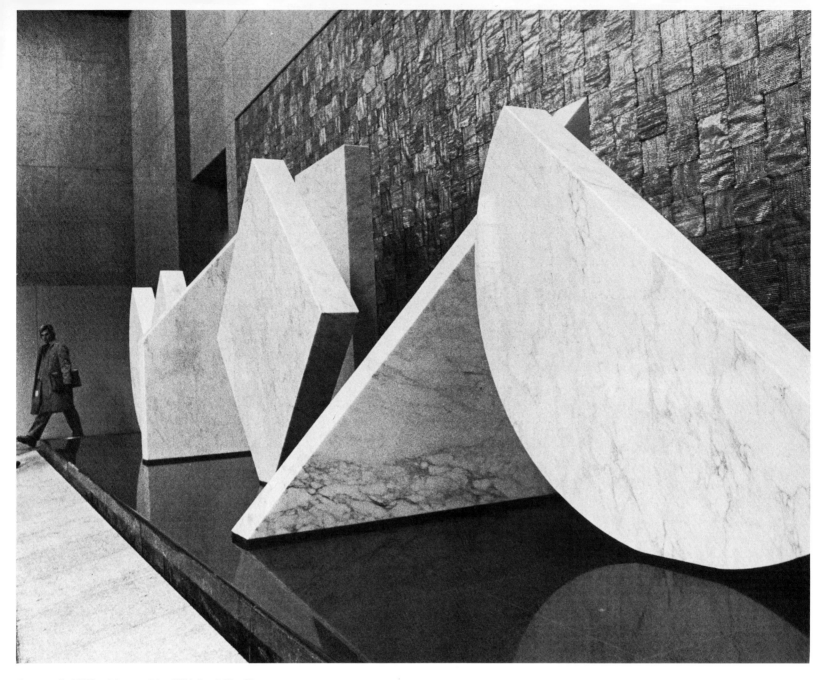

Anaconda 1978, white marble, 8' high x 30' x 8',
placed in shallow reflecting pool. Background
mural of perforated brass squares designed by
Mathias Goeritz. Main lobby, Anaconda Building,
Denver, Colorado.

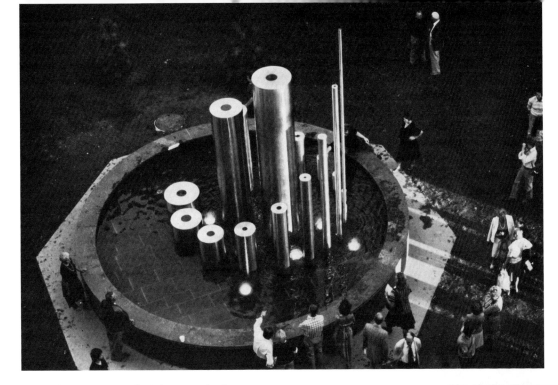

Organ Fountain 1977. Stainless steel columns, maximum height 21′, stone basin 25′ diameter. Linz, Austria.

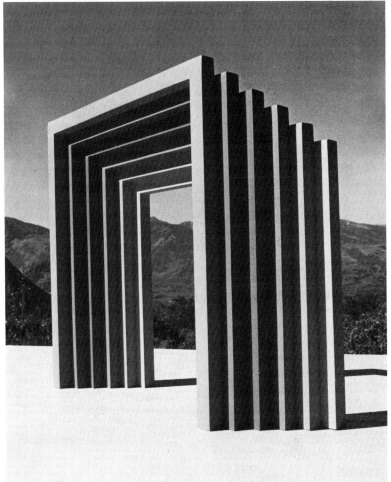

Chromatic Gate 1975/100s, 16″ high x 18½″ wide x 4½″ deep. Project in painted wood for Philadelphia office of Atlantic Richfield Company.

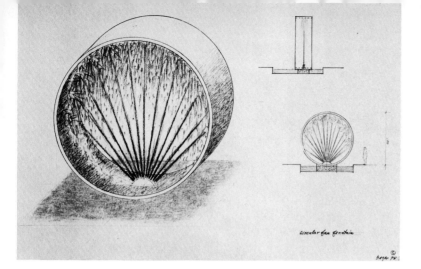

Circular Fan Fountain for Jerusalem, 1978/61,
pencil and pastel drawing, 12 x 18″.
Collection Herbert Bayer.

the traditional rectangular doorway (*Gate with Receding Circles* 1970/62s); as freestanding chromatic gates in varying sizes and asymmetric relations (*Gate in Four Parts* 1977), conceived for positioning at an entrance walkway to the Bauhaus-Archiv in Berlin; and as fractured elements of the gate, massively construed, with solid color areas, deriving in part from the sculptural notions Bayer was developing at the same time for his brilliant project of highway sculpture.

A remarkable series of drawings for a freestanding sculptural fountain, where control of water flow and pattern is essential to visual pleasure, was proposed by Bayer for construction in Jerusalem in 1978 through his friend the Mexican sculptor Mathias Goeritz (one of Mayor Teddy Kollek's Jerusalem art advisers), but no decision has been made; the official reservation suggested has been the scarcity of water in the city, but this is hardly a consideration, as the water would be recycled with minimum loss through evaporation.[32] Bayer is now completing work on two relief sculptures, consisting of free-form colored sculptural elements fabricated in metal, to be set into the lobby walls of the Atlantic Richfield offices in Los Angeles and Dallas. These brightly colored elements, which seem disarticulated from a Calder mobile, actually owe their principal inspiration to Bayer's vocabulary of geometric forms. They form a wall garden of found and cherished angles, circles, curves, squares, to be fashioned of spray-painted aluminum elements, some lying flat on the wall, others extending from it, producing a rhythmic flow and patterning as one passes before it. Of course, the success of such a work depends on achieving and maintaining the visual interaction when transposed to scale. The existing models (*Wall Relief* 1979/24, 26), however, are immensely appealing.

Environmental Sculpture: Visionary Projects

Too often the most fascinating creations of the artistic imagination are those that remain unrealized. The artist works in pure conditions, fabulating the site, construing its hypothetical conditions, conceiving within the canon of his prevailing visual vocabulary, unhampered by the limits imposed by nature or the restrictions devised by clients, whose financial reservations may be presented as aesthetic objections. Bayer's visionary schemes for a series of sculptural highway landscapes, the beautification of the Atlantic Richfield Refinery outside Philadelphia, Pennsylvania, and his congerie of surf sculptures inspired by water breaking over a rough mole in the small harbor of Las Cruces in Baja, California, are the principal examples of this predicament and because of their palpable excellence deserve extended attention. They are visionary, not merely in the obvious sense that they remain unrealized but also because they defy the prejudice of the public sector, which historically regards art as a medium of cosmetic beautification without utility or practical value. The art object is thought to be simply and sufficiently beautiful. If it proposes itself as having a function that alters prevailing relationships between the private and the public sector—not merely masking the product of technology or channeling the forces of nature but transforming them, re-presenting them as something other than they are, at the same time that their intrinsic reality is maintained—the art object

becomes doubly suspect. Most people do not know how to think about the art object or the aesthetically transformed environment.

Art must be beautiful, but it must also be cheap and manageable. If it is represented as having functional value by reason of being contextually beautiful, aesthetic criteria are immediately masked by considerations of practicality and cost. But such considerations, it becomes clearer and clearer, dissimulate confusions that are more obscure and critical. Guardians of corporate and government space are habituated to guard art as something beyond the ordinary, intrinsically irrelevant to the mundane issues of land reclamation and conservation, so proposals to formulate aesthetic answers to practical questions are deemed specious. The artist *must* be impractical and improvident if he is to be artist; the managers *must* be practical-minded and hard-headed to be managers. Both roles are conventional fictions. It would be well if such assumptions could be rethought, since many of the most imaginative projects devised by the architects of this century (the Weissenhofsiedlung architectural complex sponsored by the Deutscher Werkbund in 1927 in Stuttgart and the Dammerstock exhibition in Karlsruhe, 1927–28 are remarkable examples)[33] marked beginnings that later became the common coin of architectural and environmental modernism.

Bayer's earliest environment reconception (leaving aside numerous projects in his career as industrial designer and architect that introduced fresh possibilities into the familiar procedures of exhibition design, billboard display, and commercial kiosks) was his series of sculptural designs for the relief of highway ennui and landscape disfigurement, undertaken in the aftermath of his highway sculpture the *Articulated Wall* 1968. Bayer was aware that quite often the approaches to cities with medieval and Renaissance foundations offered exquisite battlements and landscaped escarpments to invite the oncoming traveler, enlivening his attention and distracting him from otherwise wearying highway travel. Such vistas are common throughout Europe, although the principal arterial systems of most European countries are today succumbing to the same deadly vulgarity and barrenness to which Americans have been inured since the 1930s.

American highways are constructed with engineering brilliance, lacing the approaches to major metropolises with dazzling overpasses and trunk highways, offering signage of indifferent quality and a startling lack of uniformity; America's intercontinental routes (those that bear the major traffic of the nation through the expanses of the Midwest and the desert areas of the Southwest) are monotonous, unrelieved by nature's invention, and inevitably dangerous because there is no distraction.

The conceptions Bayer developed during 1971–72, responding to this problem, function differently from sculptural diversions in an urban space. The object is not situated to focus prolonged attention, but to relieve the eye and enliven the psyche as the driver rushes past. Their situation at the side of the highway or use as sculptural, but nonpedestrian, overpasses, allows the speeding eye to give a kinetic value to these static structural forms. Chromatic stabilities are transformed into progressions and objects stationed at considerable intervals become part of an unfolding dynamic. Even objects staggered at intervals of a

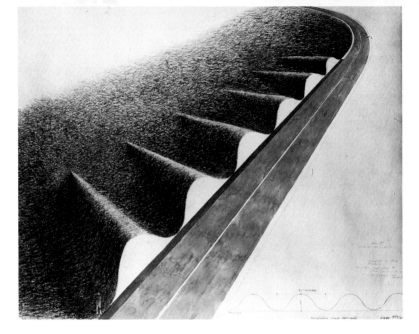

Undulating Grass Mounds 1971/150. pastel, 20 x 25½".
Collection Herbert Bayer.

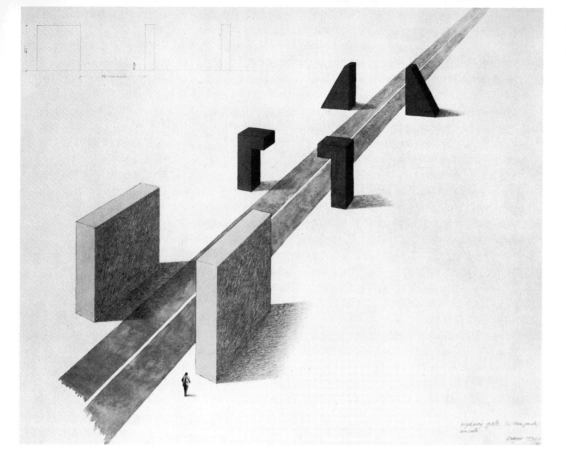

Highway Gate in Three Parts 1971/147, water-color, 20 x 25". 50' high, with spacing of elements at 75'.
Collection Herbert Bayer.

Four Gates 1972/60, acrylic and pencil, 15¼ x 22¼". To be fabricated in painted concrete. The driver would leave the main highway in order to pass through the gates and would then return to the highway.

quarter to a half mile become portions of the same continuum if the automobile is traveling at the legal limit of little less than a mile a minute.

Some of Bayer's conceptions involved forming earthworks in which an undulance of earth unfolded rhythmically at the roadside, with a painted red band marking the highway edge that delimits and alludes the earth sculpture; or a sequence of massive concrete pyramids leaning toward the highway, defining a series down one side of the highway, counterpointed by a single pyramid on the opposite side (*Road of the Leaning Pyramids* 1972/3, 9) or a highway gate (*Highway Gate in Three Parts* 1971/47), visually underscoring the implication of the leaning pyramids, in which three pairs of elements—slabbed rectangles of massive proportions, followed by inverted L shapes, completed by right-angled solid triangles, painted in various colors—allude another sculptural passage. Other conceptions were of curved formations of earth supported by rock-filled concrete forms planted with grass, coming from two directions and meeting to form a crested abstract gate (*Gently Rising* 1972/4, 5); or a road tunnel fashioned of steel (perhaps polychromed) tubes—reminiscent of the same element used in Bayer's very early drawing of *Aspen Valley Redesigned for Technical Purposes* 1947/9—providing the effect of the steel tracery of a suspension bridge becoming an overhead landscape (*Road Tunnel in Steel Tubes* 1972, *Wire Sculpture at Intersection* 1972/28); or finally the brilliant notion of a motorway punctuated by an immense hole and its positive counterpart, the highway passing over a bridge that traverses the hemispheric hole and proceeds through an open cutting that forms a hemispheric construction in relief (1971).

There has been no limit to the fertility of Bayer's imagination in this project. The number of his conceptions is virtually limitless, with sculptural fans, polychrome tunnels, road markings devised out of sculptural vocabulary, wire sculptures, and many more. But despite the necessity of repairing and redefining the highway network of the United States and environmentalists' enthusiasm for new schemes to enhance the public spaces through which America's highway system passes, not one of Bayer's notions has to date been realized.

Realization seemed more likely in the case of Bayer's 1972 proposal for the beautification of the ARCO refinery outside Philadelphia. The acreage covered by the petrochemical storage and refining complex situated between the airport and the city first comes into view from the Penrose Bridge. Spread out before the traveler is a vast sprawl, clearly identified as belonging to the Atlantic Richfield Company, but agglomerated without integrated design or standardized signage. The corporate complex was visible, but remained an unsightly accumulation of buildings, service areas, giant drums, refinery equipment poised like spaceships at their launch docks. Initially, Bayer's proposal documented the situation, establishing short-term and immediate priorities for cleaning up the clutter and clarifying the immediately achievable goal of removing sprawl and disorder. Bayer suggested tearing down some ugly structures, and rebuilding or relocating others to achieve an immediately coherent organization of movement and flow through the area; the introduction of a system of consistent

visual identification would enhance existing and permanent structures. At this juncture of the project, Bayer's role was consistent with his responsibilities as design consultant to ARCO. It was a task he had performed many times before.

Following cleaning up the site, Bayer went on, however, to describe a program of painting "which will unify the total appearance of the refinery and set it off from the surrounding areas as an entity. the purpose of painting is not to paint it in such a manner that the entire complex will be less visible and blend with the generally disagreeable atmosphere of this industrial environment. it must receive a crisp, neat look and be turned into a development of which nobody needs to be ashamed."[34] Bayer recognized that many elements of the complex (by virtue of their technological function) would need to remain black or in their raw-material color. He continued, "there is no need to be afraid of monotony as there will be many instances which will 'break the rule' of the basic color." Bayer's drawings show drum storage tanks rimmed with a fifteen-foot-high red band for distillate, blue for gasoline, yellow for lube oil, crimson for heavy oil, their predominant mass painted off-white, with trim, or parts demanding emphasis or subject to unsightly spills to be painted the standard ARCO blue. A large program of landscaping involving graded trees and bushes was developed to provide natural screens and apertures through which the passing motorist could see and not see at the same time. This green belt, varying in depth, would be girdled by a tightly woven chain-link fence, also appropriately painted.

All these proposals were coherent with a coordinated program of industrial housecleaning and design clarification, but did not yet pass over into environmental sculpture. That transition, representing the long view of Bayer's proposal, was reached at the point that Bayer envisaged the introduction of massive sculptural forms as means of heightening and intensifying the public reconception of the industrial complex. The naked drums and refining towers, however cleaned, decorated, and identified, were still drums and towers, rising above the landscaping when seen from a distance. Bayer proposed a series of sculptures—two curved concrete walls moving sinuously around a refinery tower; a massive version of his sculpture *Two Pyramids* fabricated out of stacked oil drums painted red dominating one access road to the complex; and *Three Triangles*, a sculpture fabricated of standing steel or painted concrete columns, dominating another. The effect in Bayer's rendering of these projects is quite literally staggering, as though the conflict of art and technology were resolved by the introduction of immense structures prefabricated and installed on site, behind which rises the color-emblazoned industrial complex. Particularly moving in Bayer's proposal is the recognition that prefabricated monumentality, however much it may owe to the single artist, is stripped of the egocentrism normally associated with artistic creation, achieving vitality and presence by the simplicity of its geometric assemblage of elements, its monochromatic assertiveness, and its overwhelming scale.

Although the ARCO refinery was cleaned up, so to speak, some essential features of Bayer's proposal, notably those relating to environmental sculpture, were never accomplished. The drawings for these sculptures now hang in a hallway adjacent to

Project for visual improvement of ARCO Phila-
delphia refinery, 1972. Monumental sculpture of
two standing curved walls composed of yellow
square concrete columns.

Project for visual improvement of ARCO Phila-
delphia refinery, 1972. View of road leading
through the refinery area, distinguished by color-
ful panels screening the unsightly areas along
the road.

Project for visual improvement of ARCO Refinery (Philadelphia, 1972). Proposal for monumental sculpture, *Three Triangles*, of standing steel or painted concrete.

the lounge of the ARCO Breakers conference center in Santa Barbara. The costs of fabrication during the early 1970s were estimated at $1 million, a considerable amount for those years. Today, it would be a pittance, but the opportunity is lost.

Bayer's fascination with the movement of water as an element in the intensification of kinetic play and counterpoint to sculptural mass has been evident in the siting of virtually every one of his public sculptures. Fountains, pools of water, water receptacles and troughs, streams, and artificial ponds have appeared in most Bayer sculptural tableaus. It is no wonder then that during a brief stay in Baja California, in the small fishing village of Las Cruces, Bayer should have been moved by his observation of sea water crashing upon a mole that served as a breakwater protecting the harbor of the village to devise a surf sculpture that would employ and control the conduit and breaking of the waves. Devising a series of sculptures positioned in the water near the shoreline, Bayer utilized the force and motion of the waves against "a massive concrete barrier."

"the various sculptured forms are designed to make the water conform to their curved surfaces and thereby produce a kinetic design, rhythmically changing with the oncoming breakers. the power of the waves under the overhang of the sculpture forces the water through the channels appearing on the platform of the sculpture as jets, their size changing with the strength of the surf."[35] A massive concrete quay with differentiated sculptured rises and fountain apertures forces the breaking water against the screen and through the walls so that it rushes upward in planned forms, breaking over and flowing down graded steps into a channel, where it runs out. Situated behind the quay is a T-shaped structure from which visitors can watch the action of the surf fountain at high tide; during low tide the fountain would be inactive.

Two versions of the drawings show the sculptural barrier as an elongated rectangle, although the drawing that treats it as a concrete curve permits greater grading and differentiation as the water both mounts and cascades (*Surf Sculpture I* 1972/17, *Small Harbor with Surf Sculpture II* 1972/16, *Surf Sculpture I* 1972/121). This project, unlike those for highway sculpture or the ARCO Refinery in Philadelphia, is purely visionary and visual. Whatever value the surf sculpture might have as a breakfront, the cost of transforming the water into a medium of aesthetic delight certainly exceeds the cost of the conventional mole, usually only a massive agglomeration of masonry and stones. Nonetheless, these drawings propose an alternative, which one hopes will someday find its enthusiasts.

With study, several elements of Bayer's sculptural work emerge clearly. All of the works that he has conceived and installed were the consequence of the sophisticated technology of prefabrication. He has had little or no interest in the appearance of the personal hand in his sculpture, however critical precise articulation of form and the quality of its execution remained. He was quite able to describe his sculptural requirements over the telephone–to order it long distance, so to speak and in fact. The sculptural work was always conceived for the public space, an environment element, softening or intensifying the experience of an urban or a pastoral

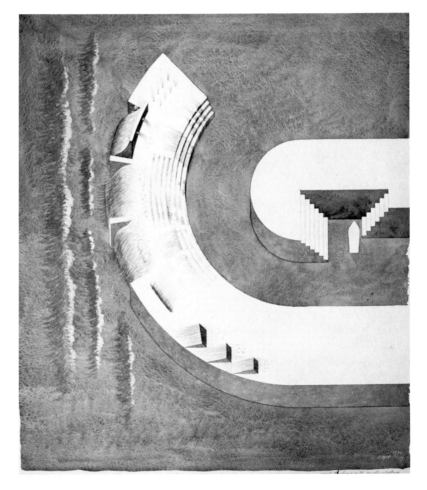

Surf Sculpture 1972/121, acrylic and pencil, 31¾ x 22½". Collection Herbert Bayer.

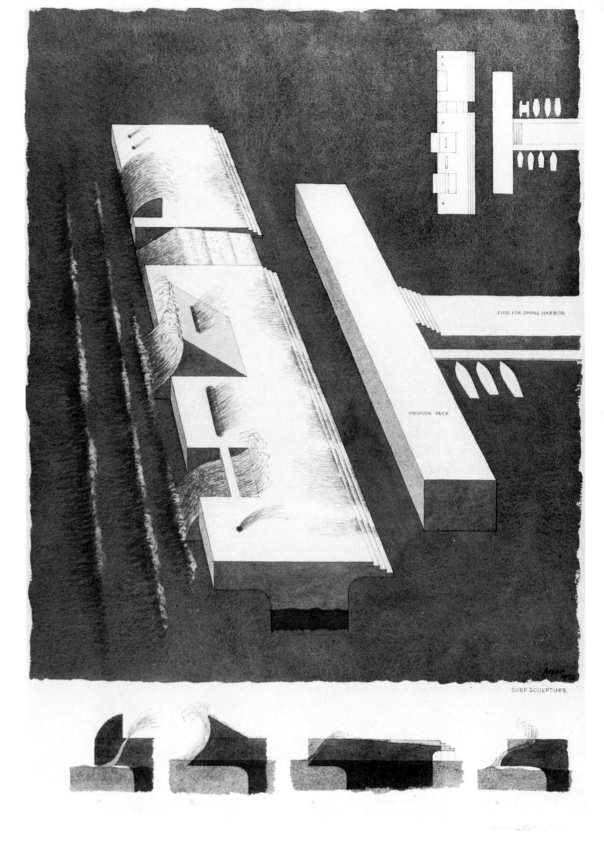

Within the image: PIER FOR SMALL HARBOR

VIEWING DECK

SURF SCULPTURE

Small Harbor with Surf Sculpture II 1972/16,
watercolor and gouache, 25 x 22″.
Collection Herbert Bayer.

setting, supplying rhythm or enforcing counterpoint to the architectural or natural scene. Sculpture was still an art object, but not in the sense in which Rodin's *Balzac* is an art object. Walking around a Bayer sculpture will, of course, confirm its volumetric scale; in the case of sculptures like *Shinto* 1971/98s or *Maya* 1971/91s, which, despite being built up of prefabricated elements, introduce real consideration of surface variation and differentiated angles, the spectator is afforded a sense of formal variety. For the most part, however, Bayer's sculpture is monolithic and invariant, presenting a single face regardless of the point of access.

Viewed from the highway speeding toward Azteca Stadium, the *Articulated Wall* overwhelms by its virtually limitless ascent, scale enforcing a perception of its formal accomplishment (a stacked progression of human scale would be trivialized and lost), while the *Organ Fountain* in Linz, Austria, transmits in steel the same pleasure that the Aspen garden does in marble: a congregation of elemental geometric forms, interwoven with natural water movement and light. But in no traditional sense are these objects of contemplation and reflection. Lacking all mimesis, while at the same time undercutting the rigorous assumptions of abstraction in which sculpture is intended to be torn out of its natural environment and severed from any connotative and referential context, Bayer's work has occupied the middle terrain.

His sculptures are not representations and interpretations of the human order nor are they intended to be treated as biomorphic analogues. They are all grounded in fundamental geometry and the engineering of geometric proportions. They are all executed in reasonably large scale, situated to be caught by an eye that is moving elsewhere (across ARCO Plaza toward one of the twin skyscrapers, passing *Double Ascension* at an axial crossroads, speeding down a highway and fleetingly encountering *Articulated Wall*, meeting *Anaconda* while going toward the elevators in the corporate headquarters in Denver, or seeing *Organ Fountain* while entering the Bruckner Concert Hall) and is briefly delighted or relieved to meet a sculpture that commands by being unexpected and proposes—as do all Bayer's sculptures—a sense of the limitless, the aspirant ascent of the human, the *axis mundi*, the mystery of the geometric, the fundamental forms and materials of ancient and modern man.

II. Graphic Design, Photography, and
Exhibition and Architectural Design

The premise of Herbert Bayer's graphic design is identical with that of his painting. The accommodation of appropriate means to the solution of any visual problem underlies the rational solution; however, given Bayer's emotional constitution—essentially intuitive and nonintellectual—dangerous risks, surreal juxtapositions, witty *gestes*, jocular comment, and aside, abound. And yet, whatever the situation and solution, Bayer approaches the problem of the poster or the letterhead with the same preconditions as he does his painting. The solution must be rigorously proportioned; a balance and internal harmony must be established among otherwise diverse and incompatible elements; form must be thoroughly investigated, colors direct and evocative; the text must be situated within the composition as a typographic element no less definitely positioned and balanced than are other more explicitly visual elements. Graphic design requires as much concentration, precision, clarity, rhythm, and allusiveness as the well-wrought painting. The difference is not in the armamentarium of means but in the nature of the problem posed and the audience addressed.

The Bauhaus Years: Elegance through Severity

Whatever Herbert Bayer accomplished during his apprenticeship with Georg Schmidthammer in Linz and his several months with Emmanuel Margold in Darmstadt, his design work during those apprentice years, although distinctly talented, remained in the tradition of ornamental design described as Jugendstil. Design was still the pleasing arrangement of the surface, typography was conventional and elaborate, illustration was manual, color dominating vast areas of the format. Bayer's posters of those years were virtually indistinguishable from those of Ludwig Hohlwein, then the master commercial-poster artist in Germany,[1] and his package design organized triangulated color bars in much the same manner as was common among artists of the Vienna Secession (40:18–19, 143:19–22). Influenced by the idiom of prevailing styles of design, Bayer's work before he arrived at the Bauhaus in 1921 consisted in balanced and centered symmetries, recapitulating, however excellently, commonplace solutions.

When Bayer arrived at the Bauhaus in Weimar, he discovered that it had no typographic workshop. Its printing facilities were devoted exclusively to the production of portfolios of etchings and lithographs reflecting the accomplishments of the Bauhaus masters (Klee, Kandinsky, Marcks, Muche, Itten, Feininger) and the propagation of newer tendencies in painting.[2] The *necessary* printed matter required by the Bauhaus for its faculty and students and for the education of the public was executed off the premises and was, by and large, undistinguished. Graphic design during those early years reflected at best a cleaning-up of the past, according to the requirements but not the explicit intentions of Georg Muche, Lothar Schreyer, and Johannes Itten. For instance, Itten's typography for his book *Utopia* was imaginatively fresh, but remained locked in conventions of design defined by expressionism,[3] and Peter Röll's signet for the Bauhaus (1919) gave no hint that Röll would shortly become a disciple of van Doesburg and De Stijl (204:117, figure 301).

Undoubtedly, the appointment of László Moholy-Nagy to the Bauhaus and the decision of Walter Gropius to put the Bauhaus

Poster for American Gerwürz Curri (1920).
Executed while in the atelier of Georg
Schmidthammer, Linz.

While in the studio of Emmanuel Margold
(Darmstadt 1921), sketch for a cigarette package.

Cigarette package (1920) while with Margold.

Cigarette package (1920) while with Margold.

on display in the famous Ausstellung of 1923 were the principal catalytic forces that transformed the attitude of the Bauhaus in general and Bayer in particular toward graphic design. Clearly, the technical training in Kandinsky's wall-painting workshop had moved Bayer to the disciplined organization of form and color that shows up in the geometry of his painting and also reinforced assumptions that were to be made explicit in functional typography—clarity and unclutter.

Moholy-Nagy arrived at the Bauhaus during the spring of 1923, flushed with the success of his exhibition of constructivist painting at Der Sturm Galerie in Berlin. He carried with him as well the exhilaration of his meetings with El Lissitzky,[4] who had settled in Berlin and was in the process of seeing through press his seminal work The Story of Two Squares (which redefined the construction of the book)[5] and working on the design of pages for his celebrated For the Voice,[6] a work that influenced Bayer's early thinking about problems of design.[7] Moholy-Nagy was, as I have suggested earlier, a brilliant halfway house between the ideological demands of van Doesburg's De Stijl and the increasingly persuasive representatives of Russian constructivism. Unlike his predecessors, Moholy was not involved in the metaphysical implications of art or in polemicizing the social uniqueness of the artist. Moholy was first and foremost a communicator. Art was made in order to speak in the here and now, to employ every technical achievement of the modern world in order to facilitate the making and communication of concrete visual language. Shortly after Moholy took over the Vorkurs (preliminary course), the issue of Bauhaus education shifted from inquiry into the nature of materials to their immediate application to technical uses and industrial employment. It is no wonder that Gropius, evidently delighted with the ferment produced by Moholy's managerial energy and ideological directness, would take as his slogan for the Bauhaus Ausstellung of 1923: "Art and technology, a new unity."

Bayer, by his own admission, was undecided about Moholy during those early years. He seemed too aggressive, but he undoubtedly energized Bayer to the reconception of his work at the Bauhaus. Until that time, Bayer had restricted his activities to that of a learner, working in the Kandinsky wall-painting workshop, executing painting jobs at the Sommerfeld House in Berlin, decorating a theater in Weimar, conducting tours at the Goethe Haus, and trying to make ends meet (a familiar activity for all impoverished Bauhaus students). The occasion of the Bauhaus Ausstellung obliged everyone, however, to redefine their enterprise. The Bauhaus was going on view to the world, and, in a certain sense, everyone had to work freshly and imaginatively in order to secure not only its future but his own as well.

The projects Bayer executed during 1923 would themselves have been sufficient to earn him a niche in any history of functional design. Although few, they were brilliantly defined and executed; moreover, designed and executed at a time when there were still comparatively few examples from which to learn and few practitioners to emulate. The breakout from the traditional modes of balanced, symmetrical, fussy design that characterized the early twentieth century's dependence on the nineteenth had already been accomplished by Marinetti's parole in libertá (where

the typecase was ransacked and, like Pandora's box, opened to view and its contents released with wild abandon)[8] and the typographic experiments of Tristan Tzara's periodical, Dada, as well as those of Richard Huelsenbeck, Raoul Hausmann, John Heartfield, and Max Ernst of the Berlin and Cologne Dada enclaves.[9] The combination and interdependence of futurist and Dadaist experiments made clear that typography was not sedation, a gentle seduction of the eye or a rendering of the receptor passive and indolent by pleasant and innocuous arrangements of the message. Type was a medium of agitation and the typecase was the storehouse of possibility.

Herbert Bayer's new typography, although it would make occasional ingenious forays into Dadaist abandon (notably for Geschenkgraphik, those typographic beau gestes many Bauhaus members designed as presents for each other and as publicity for Bauhaus festivities), found its essential structure during 1923, and although it was later to acquire a complementary tool in photography and a variety of images from his increasingly transnatural vocabulary (what some call Bayer's surrealism), it remained essentially invariant throughout his long career.

Several examples from Bayer's work of 1923 will serve to illustrate this: his versions of a Bauhaus Ausstellung poster, which were entered in the poster competition that he and others lost to Joost Schmidt, and the several Bauhaus postcards he produced to disseminate word of the exhibition; his design of the cover for the Bauhaus exhibition almanac, Staatliches Bauhaus in Weimar 1919–1923, edited by Gropius and Moholy-Nagy, and the banknotes he executed for use by the Thuringian state government in Weimar, during October 1923. Particularly after seeing earlier versions of Bayer's approach to the problem of the Bauhaus poster[10] one realizes that these works demonstrate a drive toward simplification—reducing the language of the message to clear essentials and, in the process of reduction, paring the requirements for differentiated type weights and color areas. At least one of Bayer's Bauhaus postcards, which shows three cubes of decreasing size, is indebted to a Klee course exercise (142:32, figures 18, 19, 21), and another is a witty comment on Kandinsky's inquiry into the appropriate primary color for square, triangle, and circle (a motif that Bayer also used for his three directional murals placed in the auxiliary stairwell at the Weimar Bauhaus [142:30, figure 17]).

In these, as well as in his two versions of the Bauhaus poster and the name sign for the entrance to the Bauhaus building, executed in casein together with "Sepp" Maltan,[11] the vertical placement of the lettering for the word Ausstellung either balances with a red square in the poster or runs the length of the sign, dividing two solid color areas. The lettering for Staatliches Bauhaus was hand-drawn since there were no sans-serif display faces available at the time and no means for photographic blow-up and printing. Even if such had been available, it would never have occurred to Bayer to employ them. Bayer used the same hand-drawn alphabet, lightened and simplified, for his famous cover for the almanac of the exhibition. There, maintaining the abstraction of a medium axis, he shattered the traditional balance by alternating the color of portions of the cover text, splitting words into blocks of red and

Poster for Bauhaus dance (1923), collage.

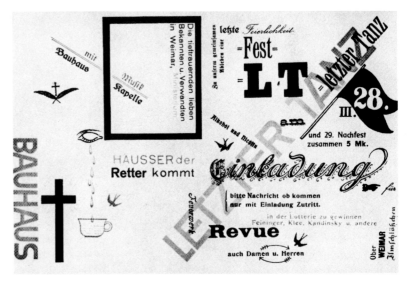

Invitation to last Bauhaus dance in Weimar
(1925).

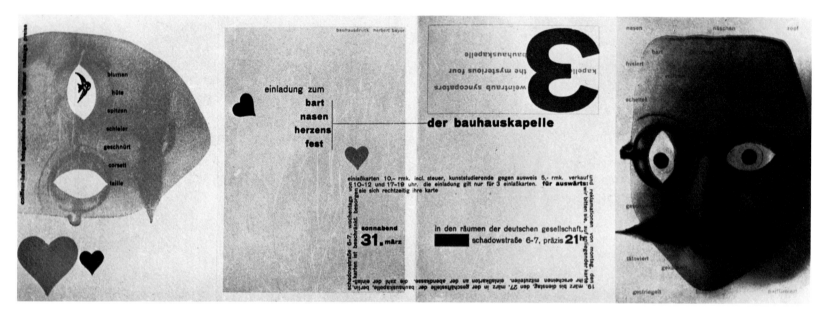

Invitation to Bauhaus "Beards, Noses, & Hearts" festival in Berlin (1929).

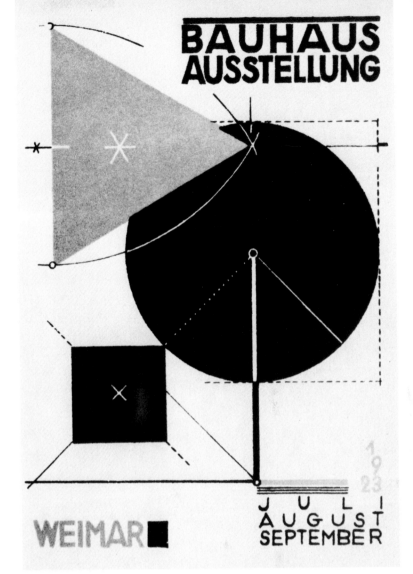

Two postcards announcing the Bauhaus
Exhibition of 1923 in Weimar.

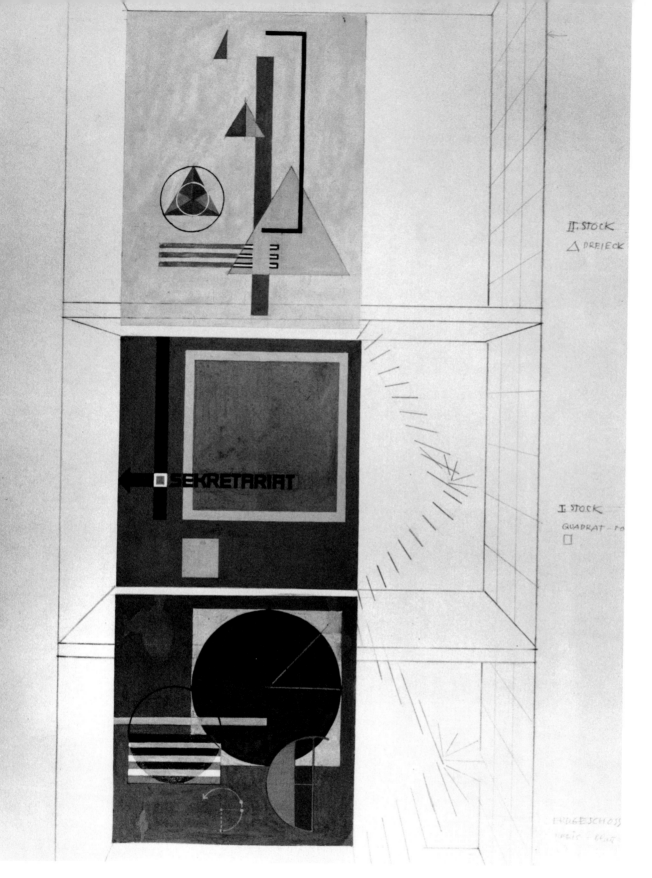

II. STOCK

△ DREIECK

I. STOCK

QUADRAT - ro

ERDGESCHOSS

Bauhaus stairwell mural. Three stair landings
from blue through red to yellow. Bauhaus build-
ing in Weimar (1923).

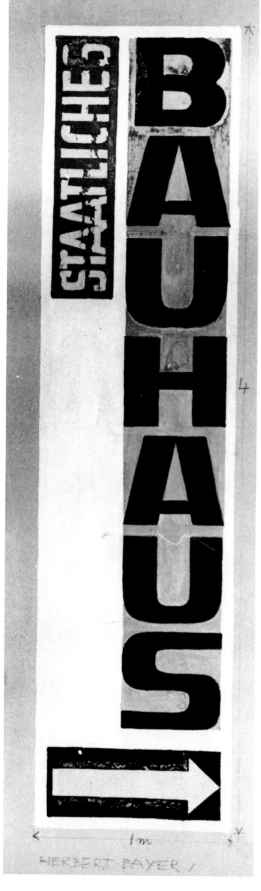

Design for Bauhaus Exhibition sign (1923),
gouache.
Collection Busch-Reisinger Museum,
Cambridge.

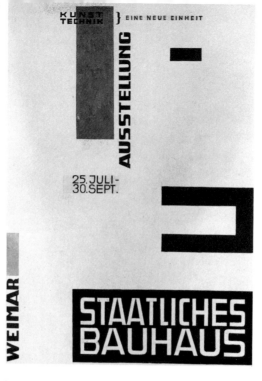

Design for billboard poster (1923), gouache,
17 x 12½".
Collection Busch-Reisinger Museum,
Cambridge.

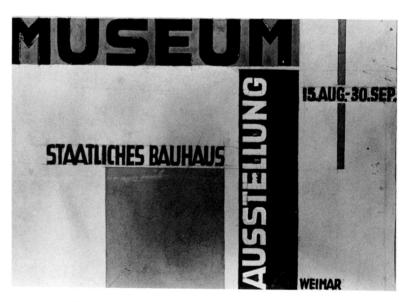

Design for billboard poster (1923), gouache,
9½ x 6½".
Collection Busch-Reisinger Museum,
Cambridge.

blue letters, in some cases condensing letters, in others (where space was not at a premium) allowing them to breathe. Bayer's cover was as much praised and attacked in the press as were the contents of the volume.[12] Clearly, however, Bayer was working from an intuitive denial of his previous Jugendstil training toward a new vocabulary of type. The lettering was rough, even crude, the splitting of the words unconventional and jarring, the stamped printing of red and blue upon the black binding paper imparted to each letter an unfamiliar architectural weight. And yet the cover for *Staatliches Bauhaus in Weimar 1919–1923* achieves by the greatest economy of means ideological assertions about the Bauhaus that were incontrovertible: the Bauhaus *was* unconventional, demanding, jarring, original, architectural.

Late in 1923, after the Bauhaus exhibition had closed, Bayer was commissioned by the Thuringian state government in Weimar to design new paper money for use during the wild inflation sweeping over Germany. The design had to be prepared in tremendous haste and make use of an available printer's typecase. Bayer executed the commission in two days and, printed overnight, the money was in circulation the following morning. The notes, in varying denominations ranging from one to ten million marks, signified by different colors, are probably the first—and one suspects the only—paper money ever designed that eschews the vanity of flourish and curlicue by which the state banks of the world impose their seriousness. Rejecting all such trivializing conventions, Bayer organizes the material so that it remains indisputably significant, while putting to one side, so to speak, in a perpendicular block of type all information that describes the legal and banking provisions of the note. Bayer's banknotes are of such elegance and simplicity, one would like to imagine that, unassisted, they stemmed Germany's inflation and restored confidence in its benighted currency.[13]

When Bayer returned to the Bauhaus in 1925 after a Wanderjahr in Italy and Sicily, he found his situation completely changed. Forced by an increasingly repressive city government to abandon Weimar, the Bauhaus had found a new Maecenas in Fritz Hesse, the mayor of Dessau, who, in addition to inviting the Bauhaus to transplant itself, supplied the necessary funds for the construction of buildings for workshops, faculty housing, and ateliers for students. Gropius, determined to take full advantage of the new situation, abandoned the guild structure of the old Bauhaus, assimilated his faculty to normal academic procedures and titles, and identified the Bauhaus as an institute for design (187:121). Among his first decisions was to appoint young masters from the ranks of the students, notably Marcel Breuer, Joost Schmidt, Josef Albers, and Herbert Bayer. Responding to the challenge with considerable ambivalence (for Bayer has never been delighted by the requirements of supervising others or wielding political power), Bayer nonetheless ordered and installed a fully equipped typographic workshop on his return to Dessau in April 1925. Henceforth, the typographic workshop of the Bauhaus would not only be responsible for the design of materials needed by the Bauhaus itself but would actively seek clients in the industrial community, for whom it would supply an integrated service, printing letter-heads, brochures, inserts, booklets, and posters on the large flat-bed press and two small platen presses that it housed.[14]

During this period, from 1925 until Bayer's departure from the Bauhaus in 1928, the basic course of Bayer's graphic design, already adumbrated in the works of 1923 and 1924, is fluently elaborated and the development of his characteristic approach to the handling of typographic problems projected. Never an ideologist or a spokesman, Bayer had accepted functional design, whose parameters were set forth by Moholy's essay "The New Typography"[15] and codified later by Jan Tschichold's "Elements of Typography," an insert in the German printing trades periodical, *Typographische Mitteilungen* (147), for which Bayer helped select representative examples.

Bayer was a quiet midwife to the new typography, receiving its premises, attending to its argument, but delivering the child in a manner more fastidious and careful than Moholy had advocated. In his role as ideologist, Moholy would argue that all rules should be broken—type should play free, no axes to be observed, no regulations regarding type size and weight to be enforced. In practice Moholy was more rigid and more clumsy. Despite Moholy's protestations that typographical compositions should be unconstricted by any *a priori* aesthetics,[16] it was Bayer, not Moholy, who was indifferent to issues of typography as art. Bayer insisted that typography and its various means was a service discipline, subordinate always to the requirements of the problem and the client's assertion of his need. This is not to imply a slavish interest in pleasing the client but rather a pragmatic recognition of the cultural situation and social requirements of a producer in a consumer society. Bayer's most notable assertion on this point was his brief essay in the issue of the *bauhaus zeitschrift* that carried his remarkable abstract photocollage cover (1928). "Typography and Creative Advertising" (3:10) makes clear that the designer is a sinuous and subtle smuggler, whose principal task is to understand the needs defined by the culture represented through industry and commerce and to devise practicable and immediately understandable solutions.

The designer has the task of awakening the public from its visual slumber by the use of vivid imagery, situated with clarity and precision. The typographic assertion, given the presupposition of a modern typographic vocabulary, must eschew the idiosyncratic and private hand, the manual image, the personal style, in favor of one so rigorous in its legibility and intelligence that it would seem to be universal. This implicit philosophic paradox (which Moholy tended to avoid by introducing moral and aesthetic criteria into the development of legitimate typographic means and volumes) was for Bayer irrelevant. The fundamental problem—the only problem—was how to develop a style that would appear as though it were no style, that would be so universal in its cognitive value that no hand, no persona, no characteristic gesture would be discerned. By the time of this essay of 1928, not long before his departure from the Bauhaus, Bayer was already acknowledging the failure of his aspiration. He recognized that the Bauhaus possessed a style; he admitted—citing the evidence of a printing house in Frankfurt am Main, which acknowledged that during the previous

Binding design for *Staatliches Bauhaus in Weimar 1919–1923*, published by the Bauhaus Weimar for its first exhibition.

Front and back of the 1,000,000 DM banknote (one among a series of denominations) designed overnight during the German inflation of 1923.

year some fifty percent of its job clients had asked that their work be executed in the Bauhaus style—that "it was back to square one again."[17]

An anonymous, universal style—a style that communicates instantly by means of its freshness, clarity, and concision—could be accomplished, but its hand would be known. And that hand, in the case of the Bauhaus during that three-year period, was Herbert Bayer's. The hand, not governed by the laws of functional typography, however guided it might be by its attitude, was still under the principal and undemonstrable grace of intuition. In speaking of intuition, Bayer had returned as well to square one.

The typographic work of those years included a series of letterheads (standarized according to the DIN format promulgated in 1924)[18] and announcements for Bauhaus activities, dominated by a lowercase assertion of type elements set within or beneath a narrow red rectangle, as well as invitations to Bauhaus functions and the astonishingly difficult organization of the first trade catalogue of Bauhaus products, employing photographs of the manufactured objects, red circles and rectangles into which critical information is set, and a neatly regularized listing of product features emphasized by black bar lines of varying weights.[19] Beyond these most famous objects, Bayer executed a brochure for the furniture of his friend Marcel Breuer, printing on the cover a reverse photograph of a woman (Breuer's wife) seated in the famous tubular armchair, her shadowed presence turning attention to the black and white values of the furniture itself.

During this period Bayer assimilated and extended the range of application of the novel premise set forth by Moholy in his essay "The New Typography." Moholy had asserted, "the most important aspect of contemporary typography is the use of zincographic techniques, meaning the mechanical production of photoprints in all sizes. . . ." This was the earliest formulation of the origin of the "typophoto"—the integration of photographic elements with typography as the most efficient and direct means of laying hold of the concrete situation of contemporary man. Modern man (Moholy presumed and modern design followed) no longer enshrouds the handmade with any distinctive aura and mystery. Quite the opposite, the mystery imputed to art during former ages is dispelled by the associated judgment of fantasy and unreality. In the service of the public, the real claim on the objective world is made by the photograph, and hence the use of photography—however scissored, apportioned, divided, emplaced—reinforces the legible typographic message with a visual image that serves as allusion or icon, referring to the real world or sufficient in itself.

Although during this period Bayer's interest in the camera was just asserting itself and he had not begun to take the photographs that established his excellence in the medium, he began to employ photographs in the elaboration of typographic solutions, notably in his poster for Kandinsky's sixtieth-birthday exhibition (1926), where a bust photograph of Kandinsky is tipped at an angle and accented by a characteristically strong red rectangle defining the left border of the poster, which is printed on yellow stock. No less explicit a "typophoto" composition is Bayer's use of a photograph for the 1927 cover of a prospectus for a washable wallpaper (142:163) or his famous emplacement of Klaus Hertig's photograph of the Bauhaus building in Dessau, shot from below, which gives to the simple legend "bauhaus dessau" a power and dynamism appropriate for a catalogue describing the Bauhaus and its program (1928). But the most original employment of a photograph was Bayer's photocollage for the cover of the *bauhaus zeitschrift* (no. 1, 1928), where he has disposed over the surface of a partially folded copy of the periodical a sharpened pencil and a sixty-degree transparent triangle pointing downward, and has then arranged to their right a white cone (which throws a shadow that intersects the point of the triangle), and above it a white sphere, a white cube, and a white rectangle (each of whose shadows abrade and darken the triangle's transparency). The title of the magazine, *bauhaus*, moves through the composition and is partly covered by the white cube. Not only has the periodical and its subject matter been identified, virtually without words, but the entire message—the Bauhaus and its educational program—has been communicated.[20]

In singling out specific examples of Bayer's design during the period of his directorship of the Bauhaus typographic workshop, it is not my intention to slight his numerous letterheads (which are of a special brilliance for their reconception of the problem of public identification and personal statement that every letterhead entails), nor the important poster he executed for the *Europäisches Kunstgewerbe* exhibition in Leipzig in 1927 (204:113, figure 358). My interest is to describe the range and sensibility Bayer brought to his design during the Bauhaus years and to establish the frame of aesthetic and ideological reference that defined its parameters.

During those early years when Bayer asserted his sovereignty as a designer, there were some who disputed his eminence. As Franz Roh, an enthusiast of Bayer's achievement, noted, there were "those in Germany who were narrow partisans of Expressionism (who) called him 'the dandy of design.' "[21] In the climate of the twenties, this meant that Bayer had taken his stand against the handmade, the personal, and the private and had turned resolutely toward an unrhetorical mode of public communication. Graphic design was obliged to serve the public interest and it could do so most authentically only with the means first made available by a technological age. Nothing new was to be spurned because it was new, but rather analyzed and investigated to clarify its proper function and to establish its propriety to the problem. In those days, without photolettering or transfer type or all the other utilitarian gadgetry developed later, the designer had to be a master of simple means. Above all he had to be able to handle volumes, color, and type. These required an individual standpoint, but did not demand a metaphysics or a comprehensive Weltanschauung, themselves the hallmark of expressionism. In this respect Bayer's design was always elegant, but his means were elemental, simple, and severe.

The contemporary Swiss typographer and graphic designer Josef Müller-Brockmann has summarized the essential stylistic principles of Bayer's design—principles that originated during his Bauhaus tenureship but continue, *mutatis mutandis*, to define his design sensibility:

Slogan-like emphasis on individual words by means of large point sizes.

Series of letterheads and business stationery
(1925–26) designed according to the DIN norm
established in 1924.

FAGUS-SCHAFTMODELLE
werden von erstklassigen, durchaus erfahrenen Fachleuten nach Leistenkopien entworfen. Ein Nichtpassen ist ausgeschlossen.

FAGUS-SCHAFTMODELLE
berücksichtigen raffiniert alle Möglichkeiten der Ledererersparnis.

FAGUS-SCHAFTMODELLE
sind geschmackvoll in Linienführung und Einteilung. Sie werden der Leistenform gerecht.

FAGUS-SCHAFTMODELLE
sind auf der Höhe der Zeit.
Ich bekomme Anregungen aus allen Teilen der Welt und verwerte sie im Interesse meiner Kundschaft.

Fagus

FAGUS-SCHAFTMODELLE sind in jeder Beziehung richtig; ob Sie feine Modestiefel anfertigen oder derbe Arbeiterschuhe oder Pantoffel, in jedem Falle bekommen Sie die richtigen Schaftmodelle beim

FAGUS-WERK
KARL BENSCHEIDT
ALFELD·LEINE (PROV. HANNOVER)

Auch zu bereits bestehenden Schaft-Modellen liefere ich sauber gearbeitete Schablonen aus Hartpappe mit Metalleinfassung.

?

WIE BESTELLT MAN FAGUS-SCHAFTMODELLE

1.
Geben Sie mir die Modellnummer der gewünschten Leistenform an.
Wenn die Leisten nicht von mir geliefert sind, so senden Sie mir einen RECHTEN Leisten der gewünschten Länge. Wünschen Sie ganze Sätze Schablonen, so senden Sie mir 3 RECHTE Leisten, und zwar einen der kleinsten, einen der größten und einen der mittleren Größe.

2.
Geben Sie mir Ihre Wünsche an bezüglich:
a Schnittart
b Schafthöhe
c kurzen oder gewöhnlichen Blattes
d Ausführung mit oder ohne Bug.

3.
Ferner bitte ich um Mitteilung
a mit welcher Überholmaschine Sie arbeiten
b welche Ledersorten Sie verwenden, leicht, mittel oder schwer
c ob Sie Absätze verwenden, die der Leistensprengung nicht entsprechen.

Prospectus for Fagus Werke (1925), manufacturer of shoe products.

Invitation to the Bauhaus Weiss-Grun-Club dance in Leipzig (1926).

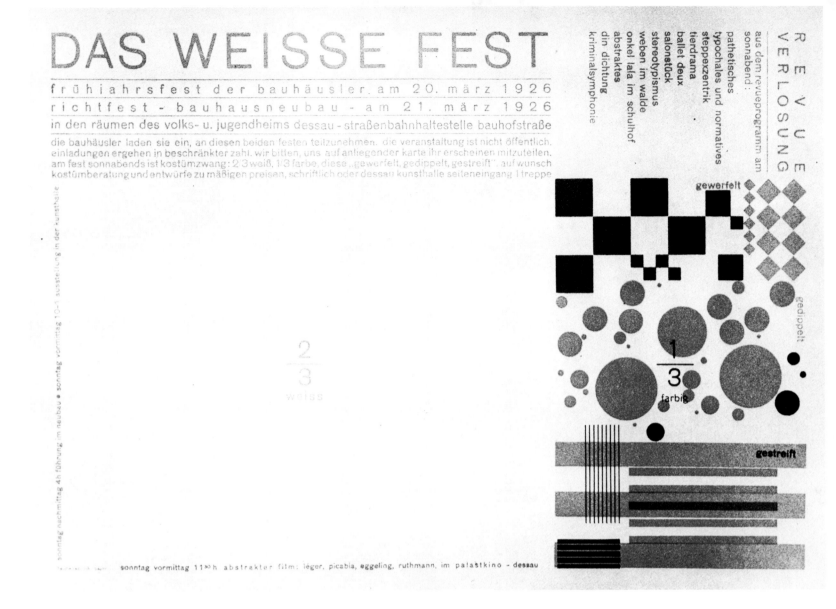

DAS WEISSE FEST

frühjahrsfest der bauhäusler. am 20. märz 1926
richtfest - bauhausneubau - am 21. märz 1926

in den räumen des volks- u. jugendheims dessau - straßenbahnhaltestelle bauhofstraße

die bauhäusler laden sie ein, an diesen beiden festen teilzunehmen. die veranstaltung ist nicht öffentlich. einladungen ergehen in beschränkter zahl. wir bitten, uns auf anliegender karte ihr erscheinen mitzuteilen. am fest sonnabends ist kostümzwang: 2/3 weiß, 1/3 farbe, diese „gewerfelt, gedippelt, gestreift". auf wunsch kostümberatung und entwürfe zu mäßigen preisen, schriftlich oder dessau kunsthalle seiteneingang 1 treppe

REVUE VERLOSUNG

aus dem revueprogramm am sonnabend:
pathetisches
typochales und normatives
steppexzentrik
tierdrama
ballet deux
salonstück
stereotypismus
weben im walde
onkel lala im schulhof
abstraktes
din dichtung
kriminalsymphonie

gewerfelt

gedippelt

$\frac{2}{3}$ weiss

$\frac{1}{3}$ farbig

gestreift

sonntag nachmittag 4h führung im neubau ● sonntag vormittag 10-1 ausstellung in der kunsthalle

sonntag vormittag 11³⁰ h abstrakter film: léger, picabia, eggeling, ruthmann, im palastkino - dessau

Typographic invitation to Bauhaus dance (1925).

Design of book jacket for Bauhaus Book 9, Kandinsky's *Punkt und Linie zu Fläche* (1926).

Advertising card for Oskar Schlemmer's stage workshop at Bauhaus Dessau (1928).

DAS BAUHAUS IN DESSAU

Dessau, Mauerstraße 36 Fernruf 2696 Diskontogesellschaft Filiale Dessau

KATALOG
DER
MUSTER

VERTRIEB
durch die

BAUHAUS
GmbH

gesch.
Höhe ca. 35 cm
AUSFÜHRUNG

Messing vernickelt, Glasschirm, Zugfassung

ME
2

TISCHLAMPE AUS METALL

VORTEILE

1 beste Lichtzerstreuung (genau erprobt) mit Jenaer Schottglas
2 sehr stabil
3 einfachste, gefällige Form
4 praktisch für Schreibtisch, Nachttisch usw.
5 Glocke festgeschraubt, bleibt in jeder Lage unbeweglich

bauhausdruck bayer
din a4 11. 25. 1000

Cover and interior page for product catalogue of
the Bauhaus (1925).

207

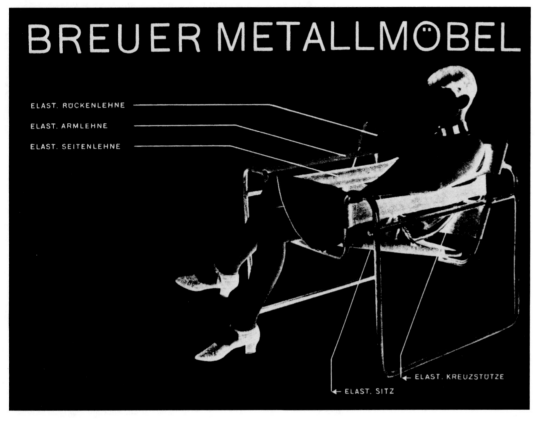

Cover for catalogue of furniture designed by
Marcel Breuer, featuring photograph of Breuer's
wife in reverse (1927).

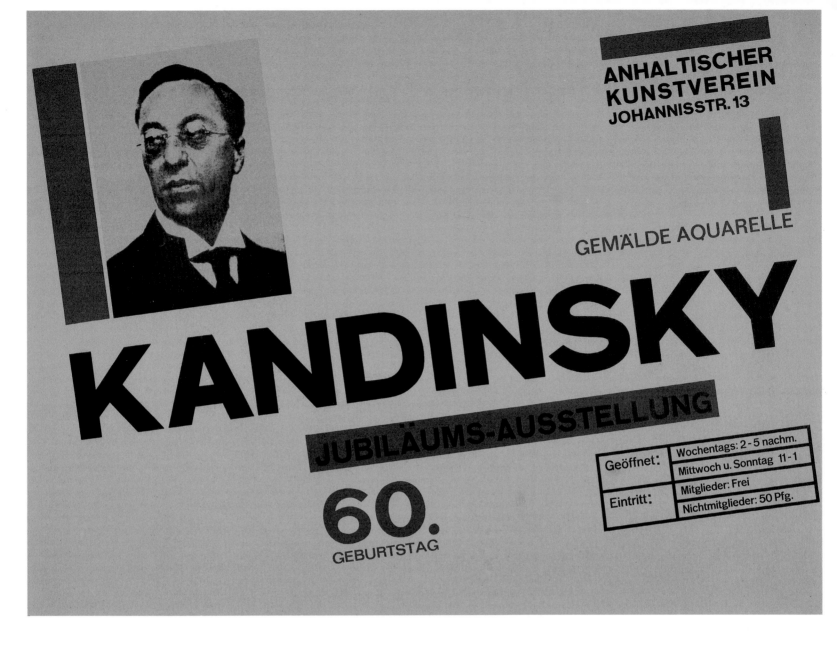

Poster for Sixtieth-Birthday Exhibition of Kandinsky (1926).

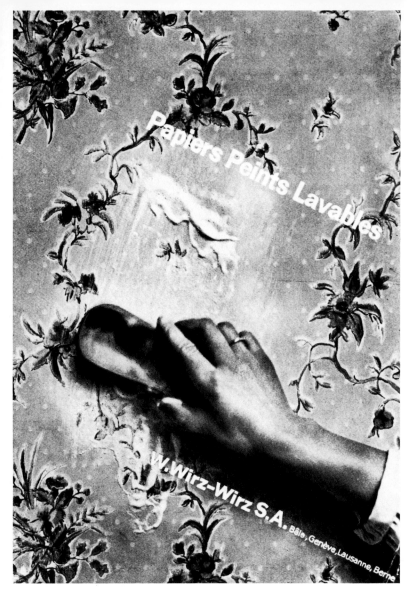

Cover for brochure for washable wallpapers
printed in red and black (1926).

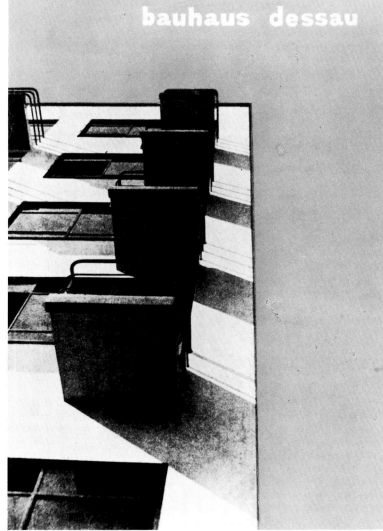

Cover for booklet *bauhaus dessau* using photo-
graph by Klaus Hertig (1926).

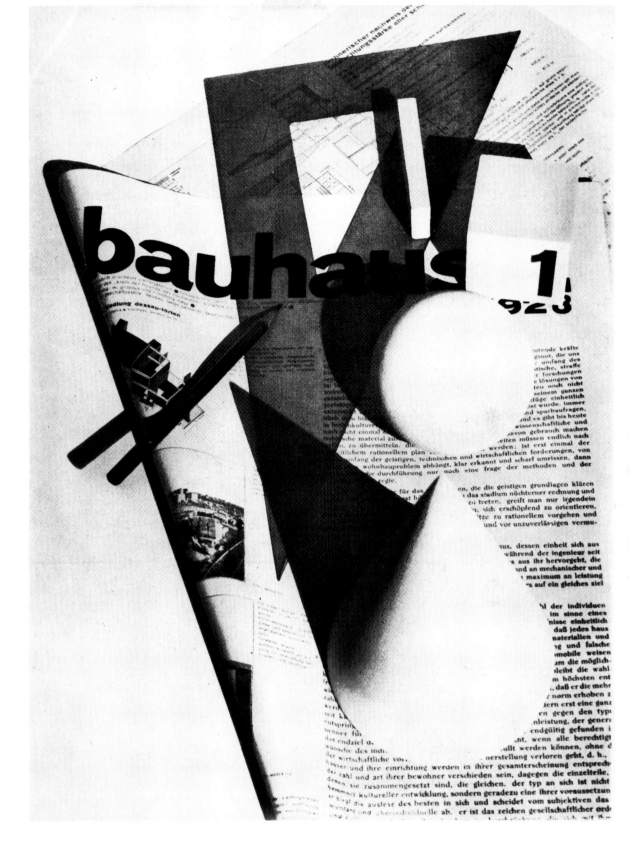

Photomontage cover for *bauhaus zeitschrift*
(1928).

Letterhead for glove manufacturer; one of the
earliest to use photographic element (1927).

Letterhead for Adler typewriters (1930).

Poster for exhibition of European arts and crafts
in Leipzig (1927).

Concert poster (1928).

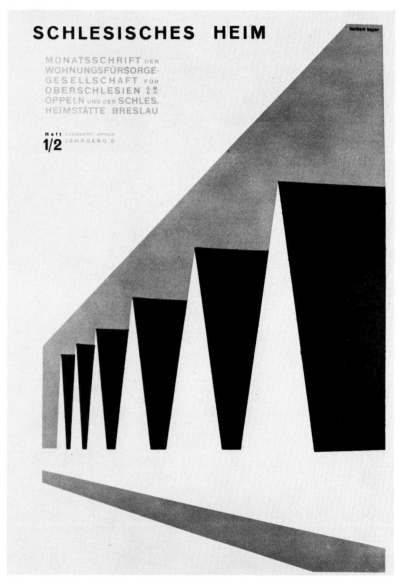

Magazine cover for *Schlesisches Heim* (1927).

words pulled out of horizontal alignment into slants of up to 90 degrees. This was still a strikingly novel idea in 1926. Since then it has universally triumphed.
Achieving psychologically suggestive effects by the use of red type.
Running a band of color beneath words that are to be emphasized.
Accentuating the surface space through the use of geometric shapes.
"Disorientation" through inclusion of photographs, often reproduced in unnatural colors. Using demi-bold (viz. bold) and bold (viz. extra-bold) type to emphasize words. (110)

Bayer's Alphabets: Simple Functionalism, Functional Simplicity

In 1925, at Bayer's suggestion, Gropius abolished the use of majuscules in all printed matter and correspondence at the Bauhaus. Henceforth, only the lowercase would be used. Bayer argued—and his view seems persuasive even if custom is engrained—that the use of a double alphabet is anachronistic. The voice does not make capital sounds. Why then should the eye require them? Moreover, in the interest of speed and efficiency it is more economical to employ a single lowercase alphabet. This is even more true and applicable to the tradition of German orthography, which requires capitalization of all nouns, but Bayer allowed for no exceptions other than the personal pronoun I. He still maintains his eccentric innovation and, by his example, has encouraged its usage in many media—book jackets, posters, announcements—where previously capital letters or mixed alphabets would have been used.

The premise behind Bayer's insistence on the lowercase is a refusal of any recidivism in the advocacy of functional design through the elimination of all calligraphic influence on letter forms. It could not be persuasively argued that design was functional if it continued to insist on an orthographic convention that emerged out of medieval calligraphy into the early history of type. No less Bayer's insistence that all Bauhaus type be sans serif (what is called Grotesk in Germany and Gothic in England and America). Rejecting the typographer's traditional affection for fussy and ornamental typefaces and returning to a simplified Roman face, Bayer's advocacy of sans serif (whether Futura, Berthold *Grotesk*, Bauer *Grotesk*, and latterly Helvetica) reflects a logical continuity that extends the principles of functional design to the simplification of a classical Roman face and the adoption of a preferred lowercase idiom. Bayer has been not only rigorous but consistent in his position (12).

At about the same time as Bayer persuaded Gropius to eliminate capital letters and imposed the use of sans serif on the typographic workshop, he also undertook the design of a new typeface, one that would express as perfectly as he could realize it the intention of a modern functional type. Known as universal type, it was characterized by a double intention that perhaps obscured its drive to simplification. Influenced by discussion already well advanced by the time of its creation, Bayer sought to design a sans-serif face constructed out of a minimum of geometric elements—several arcs, three angles, and a vertical and horizontal line. At the same time he hoped (although several preliminary examples show his initial interest in analysis of majuscules) to provide a vivid exemplification of his advocacy of a single lowercase alphabet. Indeed, as Bayer has indicated, his universal type was not intended to become a typeface, but was the first of his investigations in the direction of developing a new alphabet. The geometrical basis of the alphabet already forces certain forms and transforms the final solution into an argument rather than a fully resolved visual vocabulary, but Bayer did succeed in creating a machine alphabet that would meet the four criteria he had set: simplification in the interest of legibility; clean proportions grounded on basic geometric elements; renunciation of serifs; and adaptation to typewriter or machine print.[22] The universal type had a limited success, but it established Bayer as one of the few of his generation who addressed the problem of a machine type from the vantage point of the new functional typography.

In 1933, after Bayer had established himself in Berlin, he designed for the H. Berthold type foundry company a successful face known simply as Bayer-type,[23] which more modestly than universal type was based on a simplified version of a classical serif Antiqua. Although universal type was and remained the ideal typeface, Bayer always lived in the real world, and if the real world preferred a serif face, better that it should employ one that had been reperceived and drawn anew. The result was Bayer-type, a constructed alphabet in light, bold, and extra-bold weights that was well received and widely used throughout the 1930s in Germany and Scandinavia.

The imaginative impetus given Bayer by his creation of universal type in 1925–26 was never lost. Characteristically, he does not let go of an idea but in all his work continues his reflections on its implications long beyond the point that others, having made their mark, pass on to something else. The creative impulse, as can be seen from my discussion of his painting, describes an initial vocabulary that over the years is continually reinvestigated and restated. No less the case with the more general issue of the Western Phoenician alphabet, which has occupied Bayer since the 1920s. The practical achievement of a new simplified constructed alphabet was no victory if only the Bauhaus and its adherents adopted the strictures against majuscules. The war on capital letters was an initial skirmish, not the major confrontation. That would come nearly thirty years later, from 1958 to 1960, when Bayer devised a new orthography that would eliminate the immense oral-aural confusions provoked by the English language, as well as by every other Western language where spelling and speech were not synchronized. In his essay "basic alfabet" (40) Bayer advanced beyond universal type to the assertion of a computer face that would reflect his rules for a new orthography to eliminate all discrepancy between spelling and pronunciation.

The difficulties English orthography presents to the foreigner are notorious. Perhaps these, combined with Bayer's avowal that in the United States he would not speak German unless compelled to do so by his friends (like Siegfried Giedion, who Bayer

Universal Type (narrow face bold, 1925).

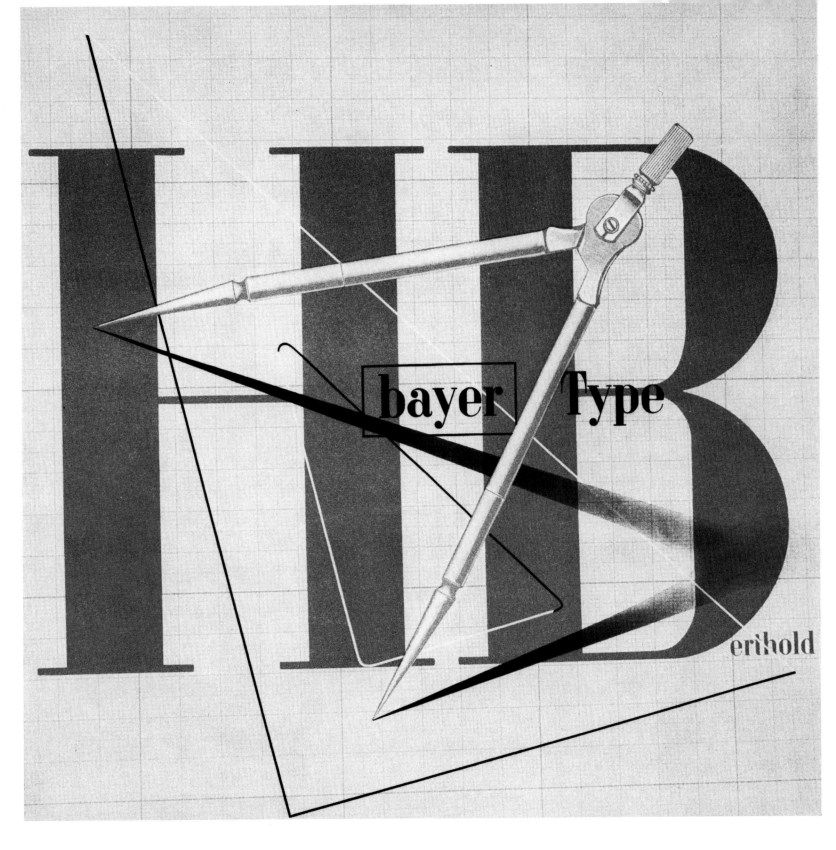

Berthold Type Foundry prospectus for Bayer-type
(1933).

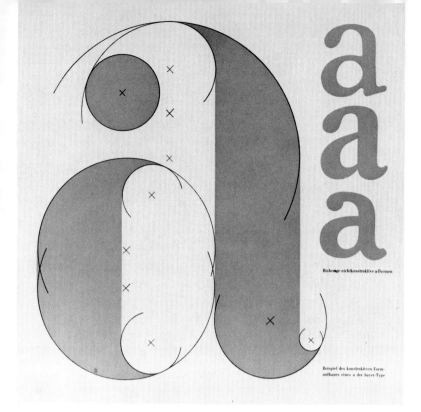

Page from Berthold prospectus for Bayer-type
(1933).

Double page from Berthold prospectus for
Bayer-type (1933).

Annual calendar cover for Berthold Type
Foundry (1935).

Display advertisement for Berthold Grotesk
(1930).

IMPRIMEURS
de METIER

Le texte **moderne**
demande un
caractère moderne
Sans employer
des caractères d'un autre style,
vos travaux
auront un succès durable
par l'emploi exclusif de la

Berthold Grotesque
qui répond dans ses différentes
formes et graisses à toutes
les adaptations que
vous
pouvez lui demander.

**Fonderie
H. Berthold S. A.
Berlin
Représentants généraux
Edouard Edler & Cie.
30 Rue de Montbrillant
Genève**

reported did everything possible to avoid speaking English), made vivid the contradictions between English spelling and pronunciation. Be that as it may, the underlying principle of Bayer's basic alfabet was the conviction that as a medium of communication English lacked "a more organized relationship of the written word to the spoken language." Although he alludes in this essay to earlier attempts to correlate majuscules and minuscules (by Stefan George and A. M. Cassandre) and to eliminate majuscules in favor of a single alphabet (by W. Porstmann, Jan Tschichold, and Bayer himself), such polemics were of limited value since the basic alphabet was still inefficiently correlated to speech. The substance of the essay "basic alfabet," genially developed and modestly argued, presses toward the "principles for the concept of a new alfabet, not the design of a new typeface." The aesthetics of design, Bayer acknowledged, would entail a free play of diversity, where trial and error in compliance with the implied flexibility of the computer would at the right time devise appropriate type styles.

Typography and orthography have been continuous themes of interest since Bayer's early days. Although he has held with his early rejection of capital letters, his design has been undogmatic. He has been able to use many typefaces without feeling obliged to pronounce upon their ideality or deficiency. In this, as in all phases of his applied activity, he has been a pragmatist. The only rule that held firm was his insistence that whatever style is used must be consistent, clear, and legible.

Beyond the Bauhaus: Berlin (1928–1938)

Bayer's decision to leave the Bauhaus in 1928 after Gropius's resignation was in part an ideological decision but also, as his letter of resignation made clear, he thought himself too young to remain a teacher without more intense experience of the world (40:11). The Berlin to which he went was the center of industrial, commercial, and artistic Germany. Thriving and teeming, Berlin was to become for Bayer the scene of his most total and intense fulfillment as a graphic designer; during the course of a mere decade he not only mastered the basic visual vocabulary that supplies the imagery of his painting but allowed himself an openness and freedom that virtually revolutionized exhibition design and the application of photography to commercial design, and brought about the development of a pragmatic individualism that transformed modern advertising.

Soon after his arrival in Berlin, he was invited by Walter Matthess, the young director of the German branch of the international advertising agency Dorland (founded in New York in 1890 with immensely successful branches in London and Paris),[24] to act as autonomous art director of the Dorland Studio, responsible for all design solutions for such German clients as Blendax, Blaupunkt, Schaub-Radio, and Olympia Typewriters, and such foreign accounts as Elizabeth Arden, Kellogg Company, Packard, and Nash (142:105–109).

Modern advertising was in those days in its infancy. An outgrowth of the increasing need for product differentiation and marketing, advertising had previously been an adjunct service of newspapers and print shops. By the late 1920s, however, advertising had ceased to be mere product announcement and had assumed—with the emergence of specialized magazines, large department stores, and international distribution of foreign products and services—the characteristics recognized today: individualized style, advertising budgets and campaigns, mass diffusion.

It is remarkable that the essentially shy and modest Bayer, trained in the rarefied environment of the Bauhaus, should have taken over the design studio of what was to become the major advertising agency in Germany and placed upon it the inimitable mark of his genius. In virtually no time, Dorland Studio was besought by an ever-increasing range of clients and Bayer's personal attention was required by most of them. Although the sophisticated procedures of market research and product testing were unknown at the time, Bayer equipped Dorland with a modern photographic laboratory, facilities for type experimentation, and all of the necessary accoutrements for visual research.[25] During the years that followed, what came to be recognized as Bayer advertising was established: the integration of photography and typography; compositions with elements in surreal juxtapositions in terms of their size, placement, and color; the employment of his own preferred pictorial devices—classical statuary, cloud formations, climatic and weather indicators—to establish appeal, attraction, and immediate communication. It was a design style based not on assault or aggressivity but rather on the establishment of assumptions regarding a voluntaristic public. What marked this phase of Bayer's graphic design, in contrast with his Bauhaus years, was its almost total absence of *parti pris*, of ideological posturing or any dogmatizing about the principles and program of functional design and the new typography.

Virtually no other typographic and design innovator of the 1920s became involved in large-scale advertising. By the 1930s, most of the revolutionary figures in modern design either returned to painting and architecture or, like Tschichold, were principally involved with book, letterhead, and poster design. Granted, Bayer had not invented his opportunity or pursued its achievement; he had come to the right place at the right time and had been fortunate. But surely had he tried to set upon the free marketplace the rigid requirements of a functional typography, he would have failed. Rather, having mastered his own presuppositions and having already devised a motile and fluid connection between the doctrine of clarity and legibility in type and the open world of signs and symbols (which the collaged photographic element invited), he was armored for a more realistic engagement with the market. For want of a more technically accurate formulation, Bayer invented a graphic design that was open, free, and endlessly adaptable. Foregoing dogmatism and doctrine, the issue of design became one of establishing an instantly comprehensible visual communication.

Since it is one of the most thoroughly documented periods in the history of Bayer's oeuvre, it is impossible to do justice in brief compass to this period of Bayer's work as graphic designer.[26] Seeking one image that combines the essential ingredients of his

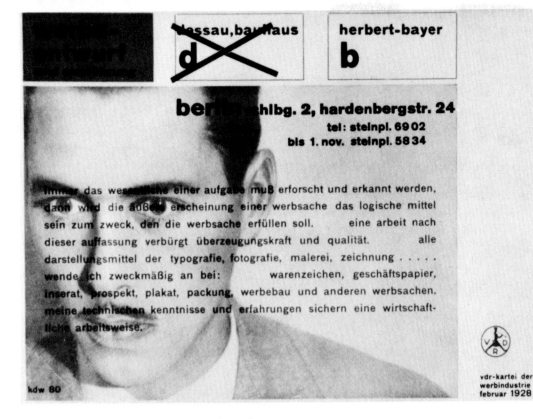

One of series of change-of-address cards mark-
ing Bayer's departure from the Bauhaus for
Berlin (1928).

Annual meeting program for the German
Werkbund (1929).

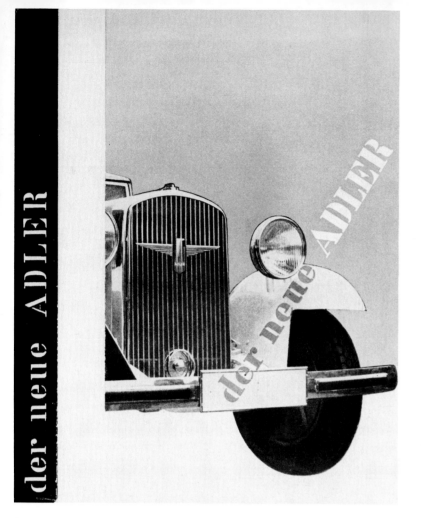

Prospectus for the Adler automobile designed by
Walter Gropius (1929).

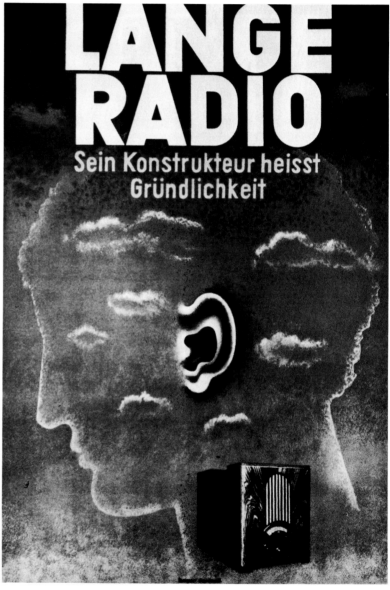

Advertising poster for Lange Radio (1931).

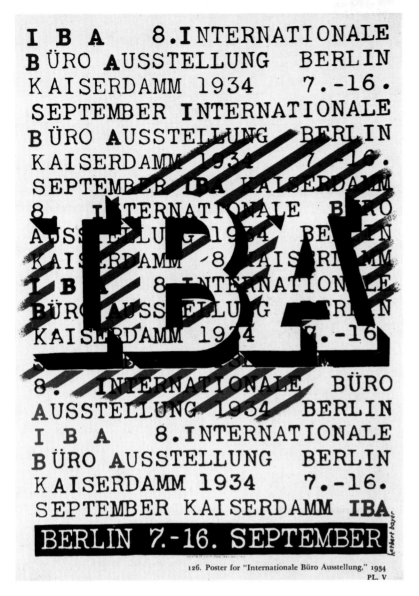

126. Poster for "Internationale Büro Ausstellung," 1934
PL. V

Poster for International Office Exhibition (1934).

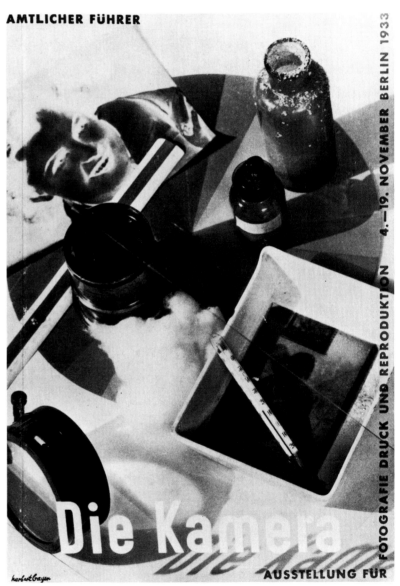

Catalogue cover for Die Kamera, an exhibition of
techniques of photographic printing and repro-
duction in Berlin (1934).

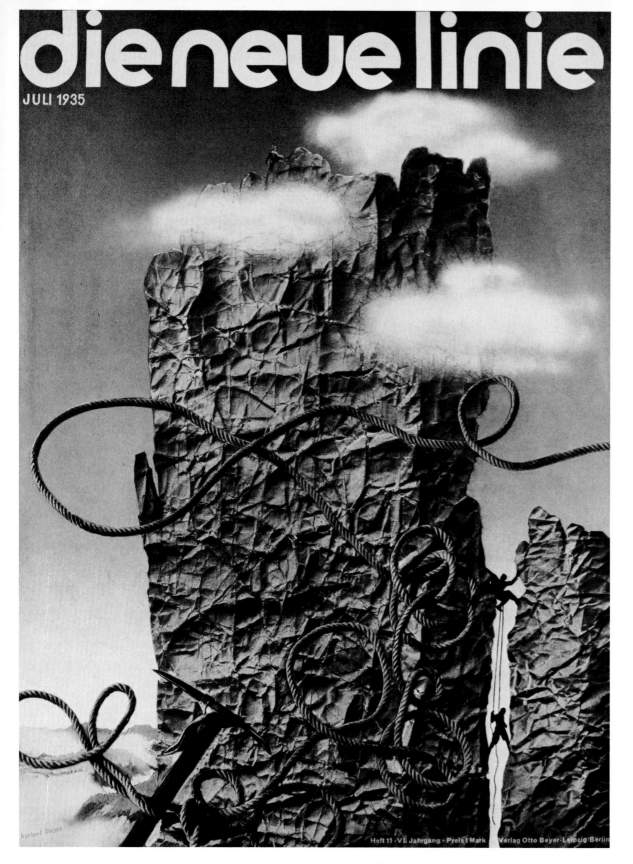

die neue linie

JULI 1935

Heft 11 · VII Jahrgang · Preis 1 Mark Verlag Otto Beyer · Leipzig/Berlin

Photomontage cover for the monthly periodical
die neue linie (1935).

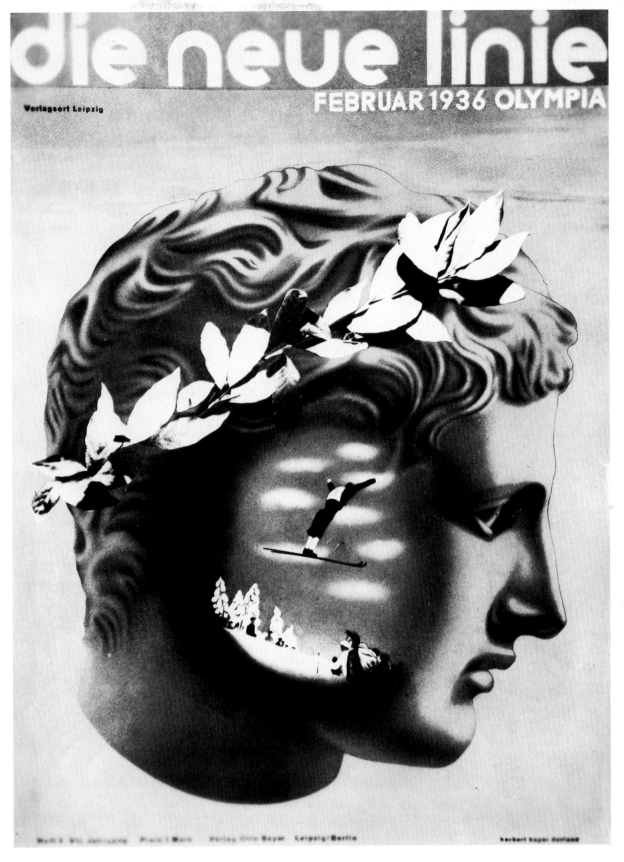

Photomontage with classical head for *die neue linie* (1936).

Poster for Adrianol nose drops (1935).

Poster for Adrianol Emulsion (1935).

DAS WUNDER DES LEBENS
AUSSTELLUNG
BERLIN 1935
23. MÄRZ
bis 5. MAI

Cover for booklet accompanying Das Wunder
des Lebens exhibition in Berlin (1936).

design during this period, however, I have selected his 1936 adver-
tisement for Adrianol-Emulsion. This four-color, offset magazine
advertisement is, as Dorner notes, "even more daring" than the
photographic juxtapositions Bayer used to such great effect the
year before in his brochure for the exhibition Das Wunder des
Lebens.[27] There, in the earlier example, employing his favorite
classical statuary—the Doryphoros of Praxiteles—Bayer extended
its recognizable meaning and application so that it became a
device for clarifying concepts in modern medical anatomy. In the
process the hieratic sculpture lost its aesthetic estrangement and
became an instrument of scientific pedagogy. This technique is
even more pronounced and concentrated in the Adrianol adver-
tisement, where the head of Praxiteles' Hermes is collaged with a
human hand holding a poised nose dropper set against the back-
ground of a photograph of a rainy pavement strewn with autumn
leaves. The lone bottle of Adrianol is the only realistic element in
the composition, whereas the overlay in red of respiratory ducts
and passages collaged on the classical head (in order to avoid
naturalistic familiarity) displays a medical procedure, in fact,
invites it.

Reaching into antiquity for symbols and allusions of classical
formality and beauty, then placing them in visual contexts that
integrate them into modern life, is a frequent Bayer device, one on
which he commented with great wit in his visual essay "Undress
and You Are Greek," which he prepared for a popular magazine in
1930.[28] There classical statues are shown with male and female
undergarments and robing—socks and garters, corsets, and beach
hats. These photographs, retouched as though to appear in con-
temporary clothing, "reveal" in Bayer's words, "that modern man
is as classic as Greek man was when undressed (7:28)." But,
more than making witty comment, Bayer makes clear an aspect of
his personality as designer and artist: art and design need not be
laden with heavy meaning and significance. Even contemporary
art, even design, he seems to indicate, can use the greatest
achievements of Western art—the art of classical antiquity—with
lightness and gesture. "Undress and You Are Greek" was a
means of demythologizing the German romance with classicism,
stripping it of its Olympian Entfremdung and making it, along with
everything else that is available in the repertoire of man's culture,
accessible and usable. If there are sacred things—mysteries—
Bayer reserves them for nature and painting.

The American Experience: From Advertising to Corporation

Shortly after his arrival in the United States in 1938 Bayer made
contact with the American corporation. Although he was involved
for several years with the N. W. Ayers advertising agency (whose
art director C. T. Coiner had commissioned Bayer's first designs
for the Container Corporation) and later, as consultant art director,
with the J. Walter Thompson agency and with Dorland Interna-
tional in New York, where he was director of Art and Design, Bayer
recognized that the scope of design as the medium of visual com-
munication could be most imaginatively explored and developed
under the aegis of a sympathetic and companionable corporate
sponsorship. It is no wonder then that (aside from numerous com-
missions for book jackets and book design and isolated projects

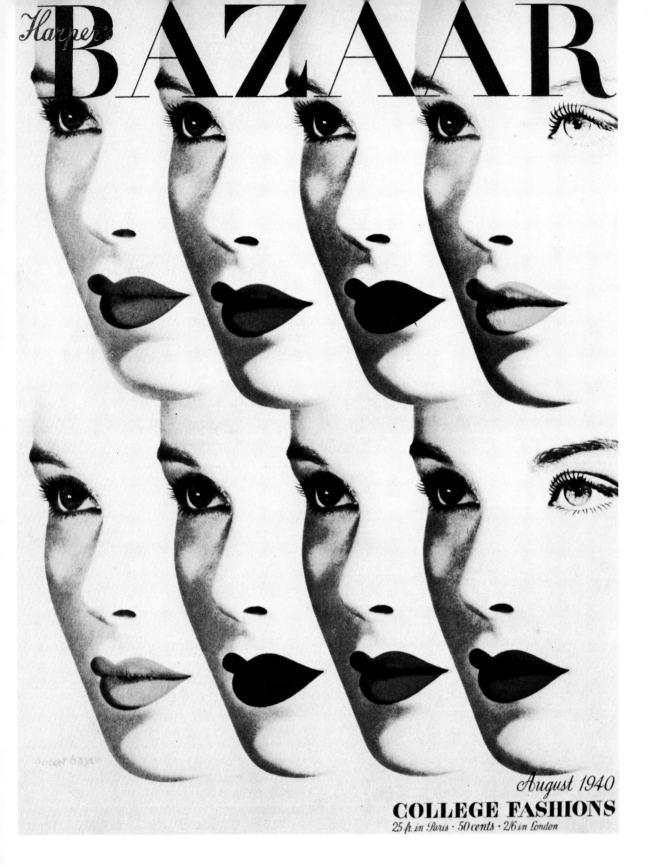

Magazine cover (1940).

Vogue page using theme from "Communications
in Space" paintings (1944).

Spread from booklet on electronics for the
General Electric Company (1942).

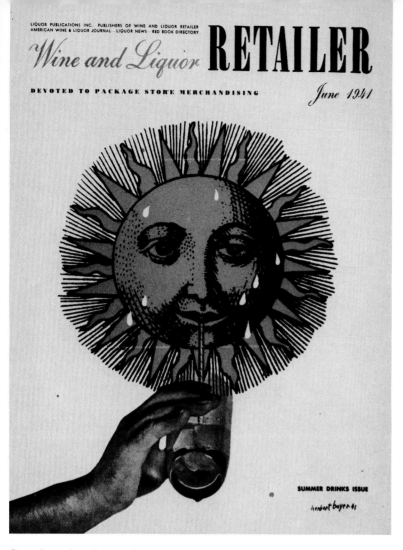

LIQUOR PUBLICATIONS INC. PUBLISHERS OF WINE AND LIQUOR RETAILER
AMERICAN WINE & LIQUOR JOURNAL · LIQUOR NEWS · RED BOOK DIRECTORY

Wine and Liquor **RETAILER**

DEVOTED TO PACKAGE STORE MERCHANDISING

June 1941

SUMMER DRINKS ISSUE

herbert bayer 41

One of a series of magazine covers for the
Wine and Liquor Retailer (1944).

for a variety of American magazines and products),[29] since 1946, Bayer's work as a designer has been with two corporations: Walter Paepcke's Container Corporation of America and Robert O. Anderson's Atlantic Richfield Corporation.

The corporation is the fundamental substratum of American commercial enterprise. Bayer already understood this in Germany, where it was possible to execute brilliant advertisements for companies whose internal structure was still mired in outmoded conventions. There, the public image might acquire a fresh and modern presentation in Bayer's design, while the self-image remained stuffy, staid, and untouched by the modern world. Moholy-Nagy, who had become design consultant to the Parker Pen Company shortly after the collapse of the New Bauhaus in Chicago, construed his function as that of not only dressing up the packaging of product but investigating the design of its elements and the organization of the assembly line that produced it.[30] In the same way, Bayer extended his vocabulary from visual communication to total design.

In the interest of total design he moved from being design consultant to the Container Corporation of America (1946–1956) to chairman of its department of design from 1956 to 1965. Of course, such a program requires a sympathetic curiosity and an efficient passion to become effective. In Walter Paepcke, Bayer acquired his first profound American collaborative friendship.[31] Their relationship, more than addressing the formal assertion of problem and the search for solution, entailed a wider curiosity about the situation of modern man functioning within a capitalist system—a system defined by the free market, where products compete and consumers choose.[32]

It was because of Walter Paepcke that Bayer left New York in 1946 to settle in Aspen, Colorado, where he undertook, under Paepcke's aegis, the transformation of that sleepy Western mining town into a thriving center—too thriving as it turned out—of winter resort recreations and year-round cultural activity. It was, however, at the Container Corporation of America that Bayer continued the scheme of integrated design started by the art director Egbert Jacobson; it affected every aspect of the corporation's marketing and communal environment; it covered low key, design-intensive, image advertising for the company; standardized design for everything from its logotype and business stationery to the color modules employed in its packaging and corporate interiors; Bayer developed architectural schemes used in factories and headquarters during the more than twenty years he was involved with it.

What was gained in clarification and integration of the design image of Container Corporation of America was probably lost in brilliance and original *éclat*. It was a successful program—but its high points were fortuitous by-products of the unglamorous nature of the company's basic product. Little can be done to make the advertising of paper packaging products dramatic. What could be done, Bayer did, designing institutional advertisements. Growing out of the activities of the Aspen Institute for Humanistic Studies, Container Corporation launched a series of full-page magazine advertisements realized by the world's leading designers and artists, pictorializing or giving visual emphasis to a salient

Photomontage book jacket for J. L. Sert's
Can Our Cities Survive?

Poster for Sibyl Moholy-Nagy's biography
Experiment in Totality (1948).

SPACE, TIME AND ARCHITECTURE

S. GIEDION

the Growth of a new Tradition

Book jacket for Siegfried Giedion's *Space, Time and Architecture* (1942).

The series must be regarded as innocuous popular education, but the assumption that it would permit many middle Americans to acquire their favorite quotation from Plato, Goethe, or Melville guided the intellectual elitism of the founders of the Great Books program who supplied its impetus. Much more to the point was that Bayer commissioned work by Paul Rand, Alvin Lustig, Louis Danziger, E. McKnight Kauffer, René Magritte, Joseph Cornell, Philip Guston, Gyorgy Kepes, Herbert Matter, Richard Lindner, Willem de Kooning, Leo Lionni, Ben Shahn, and many others to implement the visually distinctive context of epigrams of world culture. The series of advertisements continued over a number of years, were published separately as a series of annual portfolios, and acquired for CCA its deserved reputation as one of the most visually sensitive and progressive corporations in America.[33]

In the early 1950s, with CCA's sponsorship, Bayer undertook the research and preparation of what became one of the most complex design projects of his career, the *World Geo-graphic Atlas* (20), published by the corporation to celebrate the twenty-fifth anniversary of the company in 1953. In proposing to prepare a new atlas, Bayer was fulfilling a personal curiosity that was by then deeply embedded in his painting, for his interest in natural forms, climatic conditions, stratospheric movement within and beyond the ozone layer of the earth, as well as in mountains, seas, and volcanic dynamism, had contributed to his pictorial vocabulary since the early 1930s. The Container Corporation was giving Bayer more than the opportunity of providing a visualization for an existing body of information; here was an opportunity to reconceive the traditional atlas, to make of it a visual dictionary of the earth's environments and peoples. Bayer traveled to cartographic institutes throughout Europe in search of suitable maps, accumulating the relevant data, but more significantly devising a visual system that would permit the maximum amount of scientifically accurate information to be transmitted with concision and clarity. Although some facts may be out of date, the resulting atlas, published privately by CCA in 1953, remains a masterpiece of cartographic clarity. It achieved a brilliant integration of diffuse and complex information through a precisely conceived iconography unparalleled in a work of such scope. Working with a team of three associate designers, Bayer produced this immense and difficult project in less than four years, while continuing his architectural work for the Aspen Institute and producing a substantial body of paintings and drawings as well. However, surprise gives way to comprehension when one examines the *Atlas*.

The rigor with which the visual iconography has been defined, its color key established, its typographic organization systematized, demonstrates a quality that has all along been one of the hallmarks of Bayer's finest design. There is no caprice in Bayer's work; rationality (or better yet, reasonableness) is its hallmark. This does not mean that intuition and play are eliminated or imagination set to one side in favor of imperial analysis but rather that the problem is first scrupulously investigated in order to define its parameters and priorities. Once these are set down (eccentricities and special difficulties assimilated to general rules), intuition and play are liberated within the broad field settled by reason's

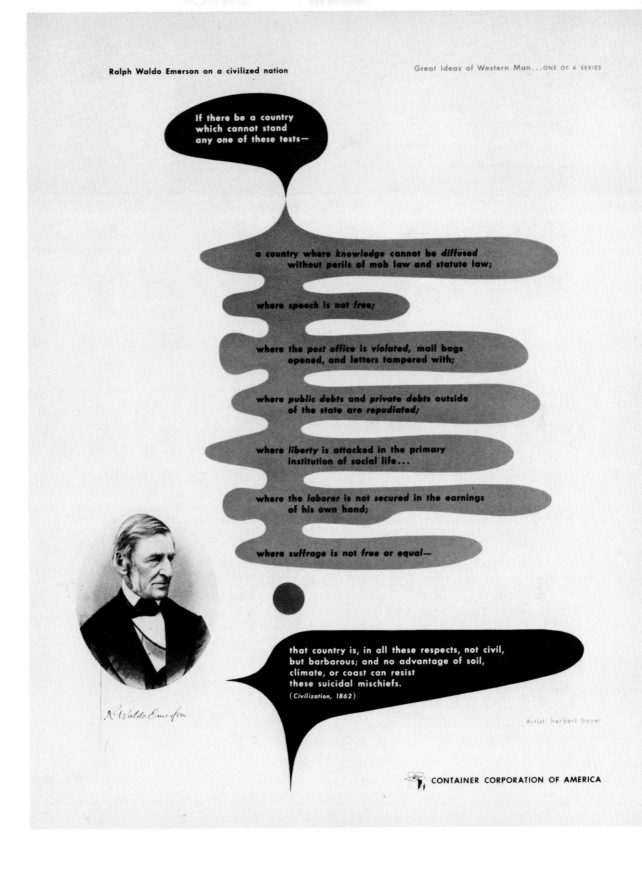

One of Bayer's contributions to the series of Great Ideas of Western Man institutional advertisements, which he pioneered for Container Corporation of America (1952).

every individual is co...
exerting himself to fi...
the most advantageo...
for whatever capital h...

...is own advantage, indeed,
...d not that of society,
which he has in view.

but the study of his o...
naturally, or rather nec...
leads him to prefer
that employment whic...
most advantageous to...

great ideas of weste...

container corporation of...

Experiment for typographic solution to one of the
Container Corporation Great Ideas of Western
Man series (1962).

CUMULONIMBUS

VERTICAL UPDRAFT
500 MILES PER HOUR

after C. W. Barber

Radar view of typhoon moving from
Philippine Sea to Korea.

HIGH CLOUDS

MIDDLE CLOUDS

LOW CLOUDS

Vertical moist currents, caused
by terrain, form clouds

CIRRUS **Ci**

CIRROSTRATUS **Cs**

CIRROCUMULUS **Cc**

ALTOSTRATUS **As**

ALTOCUMULUS **Ac**

STRATOCUMULUS **Sc**
right STRATUS **St**

NIMBOSTRATUS **Ns**
right CUMULUS **Cu**

THOUSANDS OF FEET

40,000'

35,000'

AVERAGE HEIGHT 35,000'
MAY RISE TO 50,000'

MOVEMENT OF CLOUD

30,000'

25,000'

20,000'

15,000'

10,000'

5,000'

ICE CRYSTALS

SNOW

RAIN
WITHIN CLOUD

GROUND
LEVEL

3 MILES WIDE

CLOUDS are formed by condensation of vapor in
the air. Knowledge of cloud types is useful
to the meteorologist as they indicate conditions
of air masses. They are also visible indications
of weather trends to pilots and forecasters.
Changes in their structure and appearance suggest
reactions taking place between various air
conditions. In winter, clouds are usually lower
and travel faster. Over land, cloudiness is greater
at night than by day. Cloudiness is greater in
winter than in summer.
There are four families of clouds with many
additional varieties and special forms.
HIGH CLOUDS
CIRRUS Silky, white threads. Barometric
depression, attended by rain and wind, on the way.

CIRRO-STRATUS Thin veil of pale, milky sheet.
Sign of approaching storm.
CIRRO-CUMULUS Small white globular flakes.
Dappled sky.
MIDDLE CLOUDS
ALTO-STRATUS Dense sheet of grey or bluish
color; sometimes of fibrous structure. Precedes
precipitation.
ALTO-CUMULUS "Mackerel Sky" of waves or
layer of globular masses.
LOWER CLOUDS
STRATO-CUMULUS Curtain of rounded, notably
winter clouds. May indicate dry weather.
STRATUS Uniform layer of fog-like cloud.
NIMBO-STRATUS Low and dark rain cloud.
CUMULUS Upper surface dome shaped. Base
mostly horizontal.

Page on clouds for *World Geo-Graphic Atlas*,
which Bayer designed and edited for Container
Corporation of America (1953).

Industrial design project for Wilshire Gas & Oil Company (1957).

constraints. Free drawing, renderings, photography, montage, all are used in the *Atlas*. The strictures and rules of Bayer's Bauhaus inheritance are not foresworn but are rather reexamined. What is relevant is retained, and much that he considered in his youth to be the formal conventions of nineteenth-century book production is cleaned up and restored to use. A new atlas could not be designed with dogmas but only within the framework of reason that has an end in view.

Prior to Walter Paepcke's death in 1960, Bayer had met Robert O. Anderson, who was later to build the Atlantic Richfield Corporation into one of the largest and most energetic of America's major oil-refining companies. Like Paepcke, a man of restless imagination and enthusiasm, Anderson was active in the Aspen Institute for Humanistic Studies and had been instrumental in supplying the financial resources for many of Aspen's development projects. Attracted to Bayer's vision of total design and his no less forthright disinterest in corporate power and influence, Anderson began an association with Bayer that has proved immensely fruitful for both. Since 1966, as corporate art and design consultant to the Atlantic Richfield Corporation, Bayer has been occupied less with specific issues of graphic design than with the more difficult and subtle demands of supplying the worldwide program of the corporation with a comprehensive visual articulation.

It is already clear from Bayer's work over the past decade and a half that the obligation of design, as he sees it, is to keep pace with the multifaceted self-image and public face of the corporation. The obligation is not simply one of supplying rationalization or beautification to the aggressively competitive enterprise of American business. Bayer has no such view; moreover, given the extent of his commitment to making certain that everything he designs is correctly executed, it would be sheer hypocrisy were such his view. Quite the contrary. Although popularly conceived to be faceless and indifferent to the public's interest, it is precisely such corporations as those with which Bayer has been associated who define themselves differently. The Atlantic Richfield Corporation, under Anderson's spirited direction, has been a leading respondent to the social, educational, environmental, and aesthetic needs of the community. Fierceness of competition is the hallmark of business, but the corporation of massive wealth can, without injury, regard the community with benign philanthropy, transforming the personal enthusiasms of its managers into a consistent policy of benefaction. It cannot harm the corporation to be generous. Bayer's task as overall design consultant to Atlantic Richfield has been, in addition to projecting a coherent program of visual identification, to be among its cultural advisers and planners, devising ways to extend the range of its support for the arts and education.

Summation: Commercial Art or Fine Art?
A Rhetoric of Confusion

Bayer's work as graphic designer reflects a continuous transaction—oscillation and tension—between a visual vocabulary functionally displayed in the graphic arts and that same vocabulary condensed by abstraction and imaginative rigor to reflect a

visionary nature and geometry. It is not that his vocabulary as designer is different from his vocabulary as painter; it is rather that when the vocabulary must address a large, anonymous, consumer public the disposition of elements is more simple, elegant, and direct, playing on arousing contrasts and juxtapositions, bold color, and finite implications. This formulation is utterly reversed when the universal mysteries must be dealt with in painting and sculpture. There, finitude is avoided in the interest of implying an unbounded space and an unlimited universe, the format is made obedient to imaginative imperatives, nature becomes symbolic and allusive, the answers required by design become the questions with which art begins.

It is important in understanding the body of Bayer's work to address squarely the issue of the designer's art and the artist's design. They are not the same. Proficiency and excellence in one are no guarantee of sovereignty in the other. Yet, it would be equally mistaken and unjust to assume that what the public has absorbed as the received perception of an artist's designing skill in any way compromises *ipso facto* the richness and profundity of the same artist's power to construct a pictorial geometry. The difficulty of being both painter and designer did not restrict the reception of the work of El Lissitzky, Kurt Schwitters, or Moholy-Nagy, although all three were not only proficient but committed during significant periods of their career to the development of a new vocabulary for graphic design, which adapted premises already elaborated in their conception of painting. In Bayer's case, the predicament has been exaggerated by the fact that (unlike Lissitzky, Schwitters, or Moholy-Nagy) he was initially recognized for his innovative adaptation of functional typography and design to the needs of consumer advertising. It was one thing, apparently, for Lissitzky to design books or Schwitters to offer, through his Merzgewerbecentrale, schemes and layouts for posters, brochures, and letterheads, and quite another to become director of the international Dorland Studio in Berlin or design director of the Container Corporation of America or the Atlantic Richfield Corporation. Bayer's willingness to adapt his visual vocabulary to the requirements of mass communication, to apply a rigorous aesthetic to the needs of a consumer culture—even if accomplished with a rhetoric of elegance and simplicity—was held against him by those with purist, indeed puritan, assumptions, who thought themselves only artists.

Implicit in such polemical disdain of the "commercial" application of a univocal aesthetic is a modicum of jealousy for which both the purist and the universalist are bound to pay: the one by rationalizing his indifference to commerce (and, by implication, to money) and the other by reconciliation to comparative neglect amid presumed security. The truth of the matter is that whatever recognition one receives as an artist is never enough: if security, one also wants appreciation; if the honor of one's peers, one wants success. The world, of course, refuses to be forced. It plays its hand cautiously and slowly.

It is the case—as I have suggested in this brief review of the principal attitudes and achievements of Bayer's work as a graphic designer—that his contribution has been nothing short of revolu-

tionary. Where Lissitzky, Schwitters, Moholy-Nagy were only provisionally engaged in graphic design and at different junctures in their careers terminated their interest or succumbed to other forces,[34] Bayer matured with the movement, contributing to the adaptation of the premises of functional design, enlarging the scope of their application and, in the process, setting higher and more sophisticated standards for the use of design as an instrument of reason, play, and lucidity in modern culture.

The distinction between commercial art and fine art I regard as a rhetoric of confusion, a verbal flourish that is uninstructive and morally disastrous. It seems to imply that if an artist turns his hand to making a living other than through his art he has succumbed to some species of capitulation or, worse, to hypocrisy. The only question, the critical question, is to what extent and in what respects is the language of the applied craft employed without transformation in the expression of the solitary art. It would certainly damage the poet's art if, unawares, he imported into verse the commonplace sloganeering and shortcuts of his journalism. How much more obvious if the painter were simply to use the easily reproducible images of advertising and design in his works of imagination, transcribing them to canvas, omitting only product identity and tagline. This, however, is always a temptation of the unconscious. Bayer came close to this transgression in his early work of the 1930s, but clearly in the work that has followed—the past forty years—the visual vocabulary of his art has kept its distance from that of his design, only occasionally and helpfully instructing his design to become as wide and free as his private imagination.[35]

2. *Photography: 1925–1938*

Herber Bayer's involvement with photography, like his activity as painter and graphic designer, was as an enthusiastic practitioner, often eclectic and happenstance, never theoretical or ideological. As in other domains of his expertise, Bayer may have been inspired by the enthusiasm of others, but their passion did not become his own until he had tried it on for himself. Bayer acknowledges that the enthusiasm of Moholy-Nagy about the creative possibilities of photography "rubbed off" on him as well as on others like Umbo and Finsler, but Moholy had far less to teach about the technical aspects of photography as such than did his more reticent but gifted wife, Lucia,[1] who during the Bauhaus years did not teach photography at all.

It would be more to the point to say that by the early 1920s, photography had finally come to Germany. Photography had of course been practiced in Germany for many decades, but its practice had been confined to soft-focus replication of domestic and pastoral environments, portraiture veneered with sentiment and romanticism, yielding nothing to the undertakings of Charles Sheeler, Paul Strand, or Alfred Stieglitz, who by 1921 were engaged in a "straight" photography that varnished nothing and made no concession to the acceptably benign and saccharine. Germany, prior to the 1920s, was a photographic desert. As Beaumont Newhall has observed, "as late as 1926, an exhibition billed in Frankfurt as the first large-scale exhibition of German photography since World War I, showed the weakest backwash of the pictorial movement of the turn of the century" (126:11).

But all this was to change within a few years, years that saw the genuine internationalism of the Film und Foto Ausstellung of 1929 in Stuttgart, where fourteen rooms were hung with many hundreds of the most advanced photographs, photomontages, and photograms, selected from the works of American and European pioneers of photographic modernism.[2] During those years Germany learned the lessons of its resident foreigners, paying attention to the innovative experimentation of Alexander Rodshenko, László Moholy-Nagy, El Lissitzky, the neoplastic innovators, and their design and photography collaborators (such as Piet Zwart, who had been using his own photograms in conjunction with graphic design since 1924).[3] But more than influences and causalities, photography was in the air. It had finally come to be acknowledged as a technological extension of the eye whose inevitable link to the objective and real tied it to movements of Die Neue Sachlichkeit, which compelled painting toward an exaggerated, sometimes sleek, sometimes decadent, reportage of a German social milieu in crisis. The camera was that incredible *neutrum*, an instrumentality that could be whatever its exponent required—passive, receptive, objective or personal, passionate, and surreal.

For Moholy-Nagy, who began to propagate the uses of photography almost immediately upon his arrival at the Bauhaus in 1923 (accompanied by his philosophically inclined wife, Lucia, who acquired considerable technical knowledge of photography and the printing arts in order to assist him),[4] photography was the medium for the modern art of light, and the photograph was the exemplary product of controlling light's focus and exposure.[5]

Moholy's *Painting Photography Film*, which appeared as the eighth volume in the series of Bauhausbücher in 1925,[6] reads as an almost "futurist" manifesto of the new art of light, defining an aesthetic that not only renounces the nimbus of traditional art and its aura of uniqueness but affirms the revelational value of photography as the dispensation of modernity that allows a redefinition of man's creative relationship to himself and his environment.

But all this ideological passion did not really affect the Bauhaus and its attitudes toward photography. There was to be no photography workshop until Hannes Meyer became director of the Bauhaus in 1928 and appointed Walter Peterhans to establish a department of photography at Dessau in 1929.[7] With the departure of Gropius and his intimate colleagues in 1928, and installation of Meyer as director, a move toward art education as education for social production was formalized. Prior to that time, photography was an instrumentality subservient to other objectives, and the Bauhaus, despite Moholy's advocacy, treated photography as a server of other crafts, not an art and craft in its own right.

Photography and Design: 1923–1938

Herbert Bayer, the most eminent graphic designer nurtured by the Bauhaus, had used photography as an element in graphic design before he began to take photographs himself. Indeed, he had early accepted Moholy's conception of "typophoto," which he had defined in these terms: "Typography is communication composed in type. Photography is the visual presentation of what can be optically apprehended. *Typophoto is the visually most exact rendering of communication.*"[8] Moholy understood that the traditional linearity of type has been radically altered by the new dimension inserted by photography into its traditional procedures. Photography permits for the first time a "flexibility and elasticity" that encourages a more optically dynamic exchange between text and imagery.

These insights confirmed procedures already employed by Dadaist collage, which had set down found images alongside asymmetrical typographic arrangements and reproduced them photographically, as in the photomontages John Heartfield devised for *Die neue Jugend*, published by his brother Wieland Herzfelde in 1919, as well as in the amazing book jackets he later prepared for the publications of Die Malik Verlag. But photographic elements did not begin to assert their claim on graphic design until the mid-1920s, with such works as El Lissitzky's advertisements for Pelikan Inks (1924) and his 1924 photocollage *The Constructor*;[9] Alexander Rodshenko's photomontage covers for LEF;[10] covers for the *Bauhausbücherei*, notably those by Moholy-Nagy for *Painting Photography Film* and *Von Material zu Architectur* (204:331). Bayer's manipulation of photographic elements included in 1924 drawings for unrealized kiosks and exhibition stands (204:127, figures 370–373), his covers for various Bauhaus product catalogues and bulletins, and the 1926 posters for Kandinsky's Jubiläums Ausstellung (sixtieth-birthday exhibition) and Teutoburger Wald (40:46–47).

Bayer claims not to have done much photography at the Bauhaus, being content to use the photographs of others and elements clipped from magazines and newspapers for purposes of photomontage. Coincidentally with his departure from the Bauhaus, he wrote for the periodical *Wirtschaftlichkeit* what was in effect a summary of his views of the relationship between photography and design. In that essay, "Werbephoto," Bayer set forth his views of the aesthetic and technical advantages that accrue to advertising by the uses of the photograph. The illusionistic employment of drawing, which had dominated the poster arts and advertising until the 1920s, effected an artificial connection between industry and the public, seducing the viewer without enlightening him, sustaining a fanciful, essentially unreal, re-creation of the commercial object and winning the approval of the public by subtle appeals to identification with the graceful hand of the artist rather than with the actual uses of the product. The photograph, however, "reproduces the basic appearance of something without personal contact or intervention. as a result, the precision of technique is superior to that of the manual thereby presenting a recorded document as reliably as an eye witness. . . . the image in a particular advertisement is an exact replication of the object. in short: a direct ersatz of the original."

The value of the straight photographic image lies in its documentary clarity, whereas the use of photomontage in advertising permits the juxtaposition of hand-drawn elements, type, and a mix of photographic units, which together describe an abstract image that both arrests and involves the viewer. Bayer used this device of photomontage repeatedly, for advertisements he designed at the Dorland Studio after 1928, for the series of covers he executed for the monthly *die neue linie*,[11] and in his posters and publicity throughout the late 1920s and '30s, until his emigration. Combining elements from photographs of classical sculpture, photographs of parts of his own body, and file photos manipulated in the darkroom he had established as part of the equipment of Dorland, Bayer created some of the most effective advertising of the period and established the uses of photomontage in advertising for decades to come.

Straight Photographs: 1925–1934

In 1928, following his departure from the Bauhaus, Bayer went for a three-month holiday in company with Marcel Breuer and Xanti Schawinsky to Southern France and Corsica, before coming to Berlin. It was during his visit to Marseilles on this vacation that Bayer began his systematic experiments with straight photography (despite several Parisian street scenes dating from 1925).[12] Perhaps inspired by Siegfried Giedion, who in 1927 had published in the periodical *Cicerone* several of his own photographs of the Pont Transbordeur in Marseilles and included discussion of that astonishing bridge complex in his 1928 book *Bauen in Frankreich, Bauen in Eisen, Eisenbeton*,[13] Bayer produced a series of remarkable photographs of the Pont Transbordeur. Using a small bellows camera (3 x 4″), whose make he no longer recalls,[14] he established a series of vantage points overlooking the bridge, vantage points where the diagonal interaction of the guy wires of the bridge produced the most delicate tracery and intersection. Writing of this phenomenon in *Das illustrierte Blatt*, Bayer commented that the

Bayer's photograph of the Doryphoros of Prax-
iteles (one of several he made) was used by him
frequently in photomontages for advertising
(1930).

Morgen in Paris (1925), the first straight photo-
graph Bayer preserved.

Two Eggs (1926), exhibited in the Werkbund
exhibition Film und Foto in Stuttgart (1929).

Shooting down from the Pont Transbordeur over Marseilles. (1928).

Shooting up from the Pont Transbordeur over
Marseilles (1928).

Der Stuhl (*The Chair*, 1928).

Mein Fuss (*My Foot*, 1928), one of several photographs in which Bayer used parts of his own body as subject.

Radpanne (*Blowout*, 1928).

Arm of the Mannequin (1928).

"fixed and tangible parts seem to be alive in their connection . . . like a fantasy of wire and air." The images he produced, although he replicated angles Giedion had already photographed, were taken from a higher elevation, the whole framed as though a floating, disengaged abstraction.[15]

Bayer's photographs in this period were principally one-shot decisions, the small camera positioned to record a single composition. One might suppose that he would have been interested in the procedures of printing and development, but he avers that it was primarily his first wife, Irene Hecht Bayer, who developed and printed his early photographs.[16] The photograph was taken by Bayer, but determination of cropping and intensity of print quality fell to the technically equipped Irene. During this period of modern photography the photographer as artist often restricted himself to the composition of the image and decisions about the degree of light exposure. All the rest—the procedure of printing that the present generation increasingly feels is essential to the making and control of the print—was left to a different hand.

Bayer had admittedly little interest in the technical aspects of photography, its history and development. His fascination was with the camera as a means of framing reality and, having selected the appropriate angle and focus, locking the image as an extension of personal vision. Given such a view of the photograph, particularly given his notions of photography as the adjunct of design, it was inevitable that Bayer's interest in the straight photograph would be limited. Although he and Moholy often took their cameras with them when they went somewhere together, Bayer did not think of such forays as "photo expeditions."[17] Rather, the camera went along as an appendage, which could be called into play if the right subject proposed itself. It was surely in such unplanned contexts such as these that his remarkable photograph *Wannsee Beach, Berlin* (126:38, plate 24), the various photographs of *Pebble Beach* (printed in both a negative and a positive version), *Legs in Sand* (126:31, plate 17), or *On the Beach* (126:30, plate 16) were taken. His interest in these and many others besides—those dating from the Marseilles trip of 1928, or his photographs of the Piazza del Duomo in Milan during the same trip (126:16–17, plates 2, 3), or the Castello Sforza in 1930—was a reflection of delight in the austere geometry of public spaces, dotted with occasional passersby, viewed from remote heights, creating the illusion of immense tapestries or constructed shadows counterpointing the flying buttresses of Milan's Gothic cathedral. In these photographs Bayer's eye was focused on abstract structure or the detailing of sculptural qualities that would be more fully explored in his Fotoplastiken.

The straight photographs do not involve people, with rare exceptions (like that of the man asleep in the street, *Siesta* 1934, a subject that, like the Pont Transbordeur, was undertaken by other photographers, such as Moholy-Nagy, using virtually the same composition; Bayer's photograph was taken at closer range and does not transmit the same loneliness and estrangement as those of Moholy or Emile Strassburg).[18] Hardly any of them express curiosity about face or body as such, nor did they record incidents or episodes that are narrative in character, nor make comment on the social milieu. Bayer's straight—that is, unmanipulated and unmontaged photographs—of 1928-29 were principally means of recording arresting form, providing a permanent device for selecting and storing images, even if these did not directly serve his painting or become collage elements in graphic design. Such photographs as the box of glass eyes (*Glasaugen* 1929) or the mélange of children's dolls hung up in the flea market (*Flohmarkt* 1928) or stacks of cut wood (*Sägemühle* 1929) or the shadows cast by an ornamental iron balustrade (*Schatten auf der Treppe* 1928)[19] provoke an awareness of unsettling arrangements in the real world that can only serve to agitate and jar the visual imagination and to confirm that these things—only imagined by the surrealist painters—are both beautiful and alarmingly concrete.

During 1934, when Bayer was traveling with Marcel Breuer through Yugoslavia into Greece and the Greek islands, the curious genre of travel photographs made a brief appearance in his work. By then using a Rolleiflex (5½ x 5½) and a Contax 35mm, Bayer began to take photographs as a means not only of recording remarkable images but of documenting autobiography. Although there continued to be images like *Stairs to Santorin* 1934 (126:55, plate 41), in which a serpentine tracery of steps down to the sea is recorded from above or the differing values of black and white are indicated by a photograph of volcanic ash, many of the photographs from this trip are conventional compositions in which the odd creature, the mysterious beggar, the wall filled with garish posters, the curiosity of the natives is documented.[20] Greek light—that bleaching whiteness, which before and ever since has fascinated photographers who come under the pressure of fixing the camera at a time of day when there is the most startling contrast between shadow and blinding light, predominates as the real subject of these photographs. All these—robed priests, whitewashed buildings, classical sites—attracted Bayer, and the repertoire of images he retained from that trip, although never reproduced in edition form, have been exhibited several times,[21] since they constitute the last sustained period of straight photography in his oeuvre. Thereafter, although Bayer has taken photographs in Tangier and elsewhere, his interest has been increasingly personal and documentary and he has correctly suppressed them as being irrelevant to his photographic activity.

It is understandable that Bayer would lose interest in narrative photography. He had no interest in photojournalism or in using the camera as a means of determining judgments of history, or even in recording amazing and curious episodes from his everyday life. Unlike such great photojournalists of that early period as Erich Salomon or the younger Tim Gidal, Bayer lacked the participatory ideology such an employment of the camera as historical witness entails. Soon after he had established himself successfully in Berlin, he turned his curiosity to the more intimate, private, autonomous world of photomontage, where the object is fabulated, treated, and only then photographed and printed.

Pebble Beach, Negative Image (1928).

Xanti Headstand (1928). The surreal conse-
quence of Xanti Schawinsky at the beach.

Castello Sforza, Milan (1930).

Glasaugen (*Glass Eyes*, 1929). This photograph, like *Flohmarkt*, depends for its power on the surreality of the real, aggregated.

Sägemühle (*Sawmill*, 1929).

Knight with Bicycle (1930). Commenting on this photograph and the others in the series, Bayer has written: "in 1930, I was with a group of european artists invited by madame de mandrot to her 11th century castle, la sarraz, in the french part of switzerland. she used to invite every year a group of artists—once a group of film people, another time, sculptors, etc. in the castle was armor dating back to the early history of the castle. we were allowed to play with it and dress up. this is one of several in which the knight appears in a surrealist (or contradictory) situation. in another pose the knight is smelling flowers through a closed helmet. the artist vordemberge-gildewart posed as the knight."

Schatten auf der Treppe (*Shadows on the Steps*, 1928), a subject Bayer investigated several times.

Schatten (*Shadows*, 1931)

Ober Bayern (1931).

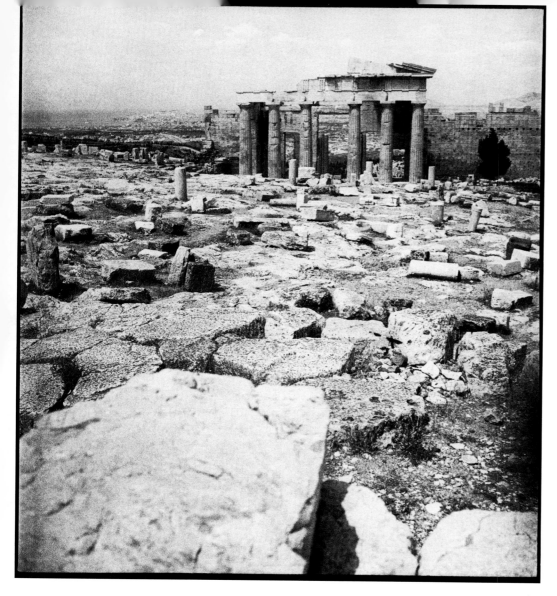

At the Acropolis (1934).

Crater in Santorin (1934).

The Lions in Delos (1934).

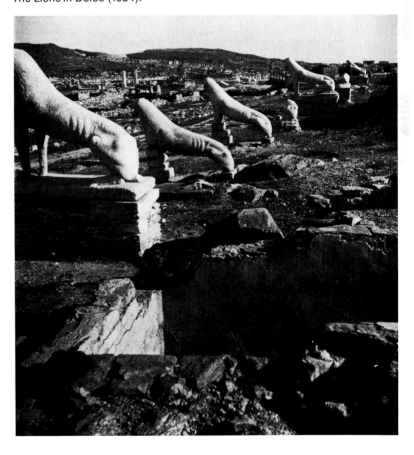

The Dream Montages: 1931–1932

The photomontage has been most acutely employed by photographers who were often, even principally, painters. The interest in colligating elements drawn from diverse sources, bits of printed matter, fabric of various textures, manufactured and natural elements had been energetically pursued by the Dadaists well before the advent of the photographer as *photomonteur*. The proper distinction between photomontage and collage is that the final product of the monteur is a photograph of pasted elements among which are one or more photographic elements. The photomontage is a photograph of photographs, whereas the photocollage is a photograph of juxtaposed elements, none of which need be photographs. Max Ernst's books *La Femme sans 100 têtes* or *La Jeune Fille qui voulut entrer au Carmel* are narrative works involving the collage of elements cut from steel-plate books of the nineteenth century. Clearly Ernst's books are collage, but are they photomontage? Another discrimination might well be that the photomontage involves photography of an assemblage of photographed elements, all of which are flat, without illusion of three-dimensionality except to the extent that the montaged photograph might be of a scene alluding depth. The photocollage, on the other hand, is a photograph of elements that have depth—as a piece of fabric or a machine element would possess when set alongside flat surfaces.

Be all this as it may, it has become commonplace for many writers to use photomontage and photocollage virtually interchangeably without assisting the reader to any distinction between them. Since Bayer tends to use the terms interchangeably, but has determined to call his dream sequence of 1931–32 photomontage, we are left with no choice, but also with no clear understanding of the difference, if any, between them. Indeed, the most fruitful avenue is that proposed by Lucia Moholy when she writes ". . . photomontage (collage) is a different category, making use of existing photographs and/or prints to serve a new pictorial entity which, in itself, is not subject to the technical or aesthetical laws governing photography."[22] The photomontage, in this view, derives its elemental structure not from the real world in which objects are spatially arranged at a specific moment, but from an interior association of elements drawn from different times and different spaces and conjoined by an imaginative decision. The photograph and photography itself are tertiary to the process of conceptual association and the location and juxtaposition of the elements in photomontage. Photography in this case only records what has been composed in the imagination. Subjectivity does not require the Kantian epistemology of Otto Steinert (173) to assert itself. The composition is subjective and its very subjectivity of association makes the photomontage different from simple collage. The *photomonteur* can ransack a history of photographed images for those that embody his dream-vision, whereas the collagist is limited to what he finds, saves, tears, and emplaces. It is no wonder that photomontage at its finest—those by Rodshenko, Lissitzky, Domela, Zwart, Citroën, Moholy-Nagy, Bayer—have the effect of estranging the viewer, inspiring either a shudder of light or a frisson of terror.

The series Bayer undertook in 1931 to document the fragments of what he termed a dream was never finished, either because the dream initiated the process but the imagination could not complete it or because the dream, alas, did not continue. The eleven photomontages that composed the series he called "Man and Dream" (the last of which, *In Search of Times Past* 1959, was completed many years later and constitutes a speculative overview of the sequence) are fragmentary assertions of the relation between the artist and his life and loves, begun shortly after his separation from his first wife and after the conclusion of those paintings I described at length as dealing with the issue of the artist's subject in painting.

The photomontages begin with an adaptation of the same chromolithograph Marcel Duchamp had used for his readymade of 1914, *Pharmacie*, which shows the sun breaking through the clouds overlooking a stagnant pond.[23] Over the center of this pedestrian image Bayer has suspended from a rope anchored in infinite space an elaborate gilt frame that isolates a portion of the scene. After photographing each element and pasting them together, "the string was painted in" and the whole photographed again.[24] This photomontage, *Blick ins Leben* (*Look into Life*), although the third made by Bayer, was installed by him as the opening of the series when it was published in a minuscule edition in 1930 and republished in an edition of forty by Galerie Klihm in Munich in 1968.[25] This first image is clearly an ironic answer to the question: what makes art? Art is precisely anything that is framed and asserted to be valuable, even if it is vulgar and pedestrian.

To the task of art comes the *Einsamer Grossstädter* (*The Lonely Metropolitan* 1932/13)—one of the most famous of Bayer's photomontages—in which a photograph of his own hands extending from a suit jacket are collaged to a photograph of a commonplace, anonymous Berlin apartment facade, and into the palms of the beseeching hands are collaged the artist's eyes, airbrushed so that they seem to peer out from the palms. This haunting image of alienation is followed by the extremely funny portrait of a Wagnerian *Heldentenor* posed with a monstrous shield to which has been collaged one of Bayer's sculptural bones (an image that becomes central to the Fotoplastiken and appears as a critical element in his "Dunstlöcher" paintings of 1936). The *Knochenbrecher* (*Bone Breaker* 1931/1), his vast shadow airbrushed to the background, may be the ridiculous lover of the celestial, turn-of-the-century beauty in the clouds who clutches a love letter to her breast in the next montage of the series, *Sprache des Briefes* (*The Language of Letters* 1931/3). It is a bit too simple and direct in its irony to be wholly successful. The next image is the mordant *Monument* 1932/12, which exhibits a gowned woman of quality, her rose-holding hand resting on a fin-de-siècle flower stand, her head lost in mincing clouds, while at her feet the toppling legs of her classical statuary suitor fall off into the void. Not even the most classical suitor, it seems to say, can stand on the same pedestal with such a monumental woman.

Schöpfung (*Creation* 1932/3), the middle image in the series, sets forth a theme Bayer had previously alluded to in his painting *Bird with Egg*. His own divine hand extends the egg of creation from an airbrush background suggesting chaos. A few drops of

Blick ins Leben (*Look into Life*, 1931).

Einsamer Grossstädter (*The Lonely Metropolitan*, 1932).

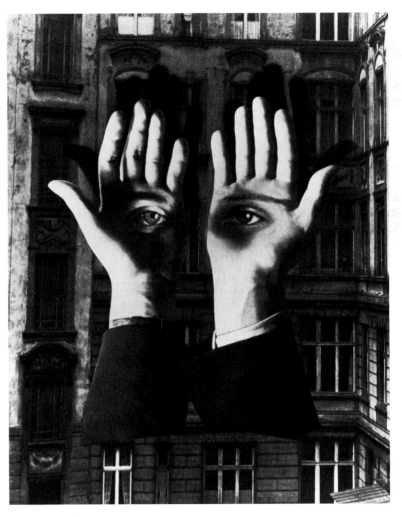

the egg's albumen are sufficient to gestate plants, woman, and the crenellated battlements of a typical German fortress tower. Somehow too complex while at the same time strangely literal-minded in its symbolism, *Schöpfung* is followed by *Profil en face* (*Frontal Profile* 1929/1), actually the first photomontage executed in this suite. Extremely painterly in its construction, it is closely related to the series of paintings Bayer made during his last years at the Bauhaus, in which an autobiographic use of majuscules—in this one a reversed *R*—serve as *dramatis personae*.[26] The curiosity of *Profil en face* is its technical identity with a painting of the same period, *Atelierstrand* (*Studio Beach* 1928/30), which sets a photograph of a bathing beauty into a painted frame alongside an abstracted drawing of the same woman seated at the beach, her head, like the head in *Monument*, vanishing in the clouds above the sea.

Profil en face contains only three photographic elements: a skyscraper within a drawn frame; a portion of a woman's face shot straight on but cut so as to appear in profile; and a fringe of framed leafless trees, rising behind a crudely drawn inset of clouds upon which a shadow profile of a man's face, not unlike Bayer's, has been airbrushed. Why is one photomontage and the other collage? It is because *Profil en face* has been photographed, while the other has merely employed a collaged photographic element without reproducing it. But in substance and treatment, the images are identical in feeling and technique; indeed, to my mind, *Atelierstrand* would have made the more powerful image to have been retained as a photomontage.[27] The two images, both about eros and sensuality, are infected by caricatural drawing that inhibits their power as montage. This defect is corrected by the lethal revision of *Blick ins Leben* (*Look into Life*), which had inaugurated the series. *Der Mensch gewinnt* (*The Man Wins*; otherwise titled by Bayer as *The Kiss* 1932/9) collages over the same cheap chromolithograph of the sun breaking over a stream, cut-up and framed portions of a photograph of romantic embrace (the kind common in postcards of the period). In *Der Mensch gewinnt* the cut-up postcard replaces the gilt frame of *Blick ins Leben*—the gilt frame makes one kind of art valuable, while cheap sentiment enshrines another. In either case, the artist is cynical about these totems of culture, art, and romance.

This ironic pastiche is followed by one of the most famous and alarming of Bayer's photomontages, his *Selbst-Porträt* (*Self-Portrait* 1932/5). Jan van der Marck has observed that *Selbst-Porträt* "has entered the annals of photography as an example of the influence of surrealism on the photographic medium (128:22, plate 19c)." With only his naked torso visible, the artist stands before a mirror holding a sponge in his left hand. The mirror image metamorphoses the familiar narcissistic episode of self-regard by transforming the artist's double into marble. The innocent sponge in the left hand has become a marble section from the artist's shoulder and the imaged arm raised above his head reveals a smooth break, as if a Greek statue had been shattered. Needless to say, the artist's face—immoderately handsome—is distorted with horror. As van der Marck has proposed, one can argue that Bayer had been aware, by the time he made this montage, of Jean Cocteau's *The Blood of a Poet*, which had its first

showing in Paris in January 1932 (128:22); however, Bayer says he rarely went to films and was unaware of filmic surrealism before he came to the United States. Nonetheless, Cocteau's film, with its images of narcissistic transformation, offers a superb gloss on Bayer's montage, both terrifying and honest in its self-characterization. By the time he made this self-portrait, Bayer was incorporating in his graphic design and painting the classical imagery of male and female beauty as devices of attraction and repulsion, idealization and critique. Its context as a single montage in a suite that ostensibly had its origins in Bayer's wish to narrate the sequence of an undoubtedly erotic dream gives the image an added power.

The concluding image of the suite, *Gute Nacht, Marie* (*Good Night, Marie* 1932/2), shows the artist's hand on a baroque door handle, behind which the naked Marie kneels on her bed beneath a starlit night. Presumably love is done and the smiling Marie is left by her withdrawing lover to sleep in satiation. It should be noted that all the images of woman used in these montages (including those shown in *Among Odalisques* [126:75, plate 60], a montage of 1931 not included in the series published by Klihm) are slightly vulgar, erotic photographs commonplace in turn-of-the-century romantic postcards—the women fleshy, redundant in sensuality, either gowned in filmy dress, wearing pearls or beads, or naked in rolling flesh; either innocent with big eyes and winsome smiles or assertively sexual. In only one montage does the romantic male appear, evenly matched to his sweetheart (*Der Mensch gewinnt*); for the rest, where male elements appear they are the petitioning hands of the artist (*Einsamer Grossstädter*), the creative hand of the artist (*Schöpfung*), the artist's hand on the door handle bidding his love goodnight (*Gute Nacht, Marie*)[28], or in *Selbst-Porträt*, the artist as shattered Narcissus.

This remarkable series of photomontages, which was concluded many years later when he collaged multiple images of eyes peering from a forest of birch trees (*In Search of Times Past* 1959), did more than any other body of Bayer's work to transmit the impression of him as a surrealist artist. However, I believe I have shown persuasively that the use of so-called surrealist elements in his painting did not arise from surrealist impulses, but from questions regarding the nature of the artistic enterprise, which called forth techniques and juxtapositions that are always firmly anchored in the conscious life of perception and interpretation. Not so, however, in these photomontages. Eduard Jaguer does well to propose that Bayer—"the most important photographer of the Bauhaus—along with Moholy-Nagy and Umbo"—is "equally the nearest to the surrealist mentality in his photographic investigations."[29] And yet, even here, the scheme is not generalizable as surrealist in its impulse. Most of the images in the series of photomontages are proposed as gestures of wit and irony, comment on commonplace vulgarizations of romantic love. Only the *Einsamer Grossstädter*, *Selbst-Porträt*, and the much later *In Search of Times Past* (in which surrealist conventions are employed *après le fait*) seem to have surrealist content. These, however, strike me as isolated interpretations of the narcissistic predicament—the estrangement from self and body that, had Bayer indulged them, might well have led in the direction of

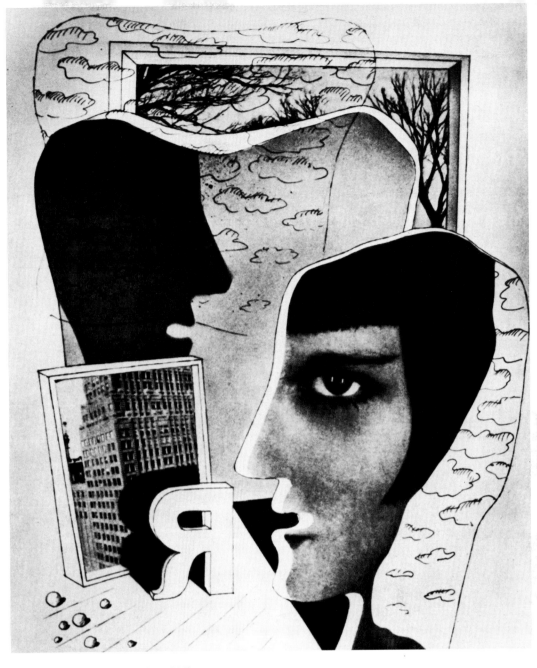

Profil en Face (*Frontal Profile*, 1929).

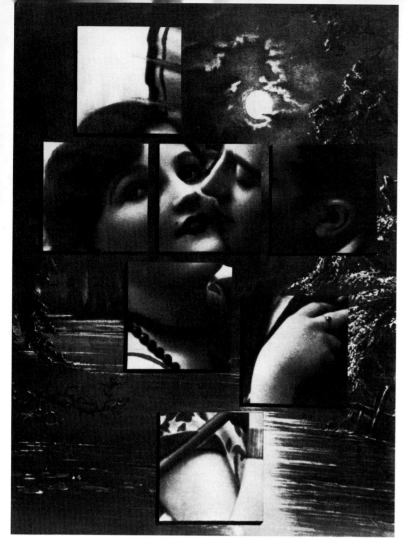

The Kiss (1932).

the neurotic exaggeration of the erotic that was worked out one way by Hans Bellmer and another by Bayer's friend Richard Lindner. For all Bayer's life difficulties, however, those of flight, exile, estrangement from place of birth, language, and culture, and the requirements of adaptation and renewal in a country that continues to treat him as a European artist, his work appears to be remarkably healthy in its concerns.

Sculptural Fotoplastiken: 1936

The last major series of photographs Bayer undertook in 1936, following a visit to his native Austria, he has called Fotoplastiken, after Moholy-Nagy. But Moholy's term Fotoplastiken and Bayer's use of the same word to describe his compositions of 1936 have different sources and meanings. Lucia Moholy traces her husband's use of Fotoplastik to its roots in neoplasticism, which fascinated and arrested his aesthetic curiosity at precisely the time he was beginning his montaged compositions.[30] Irene-Charlotte Lusk has documented the resemblance a number of Moholy's montages have to the angled structure of paintings among the Russian constructivists and De Stijl,[31] but Lucia Moholy is prepared to see the term only as the expression of a "fascination which finally materialized in a similar-sounding name, even though no identity of meaning was thereby implied."[32] The term Fotoplastik, or photoplastic, was rapidly used up and by the time of *Photo-Auge* (*Photo-Eye*), which Franz Roh and Jan Tschichold published in 1929,[33] and the anthology of Moholy's photographs introduced by Roh in 1930,[34] the term had disappeared, giving way to photomontage and photocollage.

Only Herbert Bayer has continued to use photoplastic.[35] Granted that photoplastic was a word invented by Moholy-Nagy, what meaning does it have for Bayer? This question is answered in Bayer's reply to an inquiry from Tim Gidal in 1977, asking Bayer to distinguish between his Fotoplastiken and his Fotomontagen. Addressing himself to the definition of the Fotoplastik, Bayer wrote: I use this term to signify the plastic quality which dominates in these images. I made sculptural elements like frames, rings, or wheels, and placed them in spatial arrangements with the proper lighting. this was then photographed. the print obtained was worked over with brush and airbrush and then rephotographed. the prints were then made from the negatives obtained. there are, of course, variations within this technique, as for instance in *hands act*.[36] here actual hands (my own hands) were photographed, cut out and montaged over the image of a map, and shadows added to the map."

The series of Fotoplastiken (except for two images, which will be dealt with separately) consists of ten compositions that are related to the "Dunstlöcher" paintings of the same year. These images of archetypal forms derived from Bayer's interpretation of farm and domestic implements that hung from the "vapor holes" (Dunstlöcher) punched into the walls of Austrian mountain farms. The question about the five Fotoplastiken that relate to the "Dunstlöcher" paintings is this: Does the arrangement of these fabricated sculptural elements and their manufactured (rope and ladders) and natural (shells and leaves) components on a section

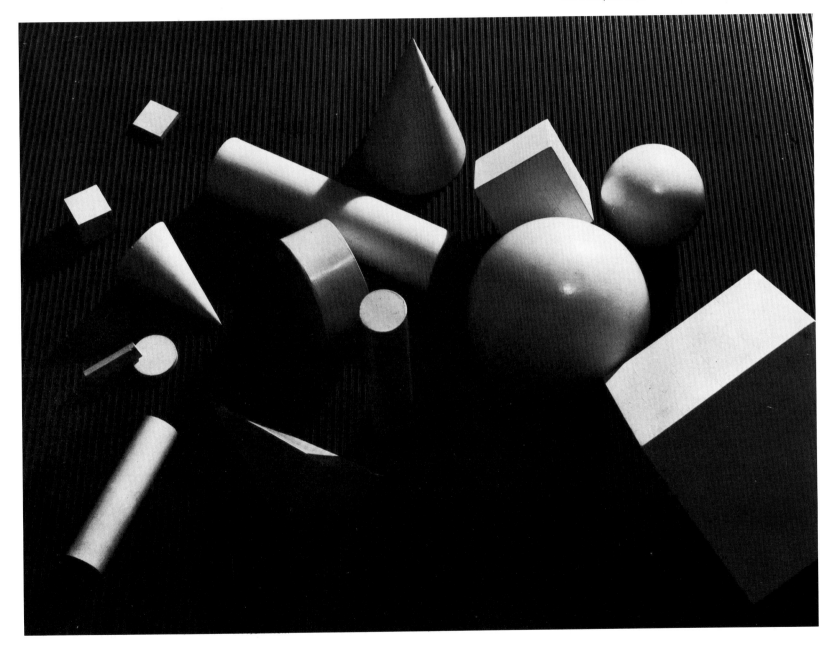

Primary Sculpture I (1935), one of a series of exercise studies with plaster forms anticipating the Fotoplastiken.

Hands Act (1932), using bare and rubber-gloved hands forming a midpoint between photomontage and the Fotoplastik.

Stable Wall (1936).

Nature Morte (1936).

Stehende Objekte (*Standing Objects*, 1936).

Metamorphose (*Metamorphosis*, 1936), a
Fotoplastik animating the elements of *Primary
Sculpture I* (1935).

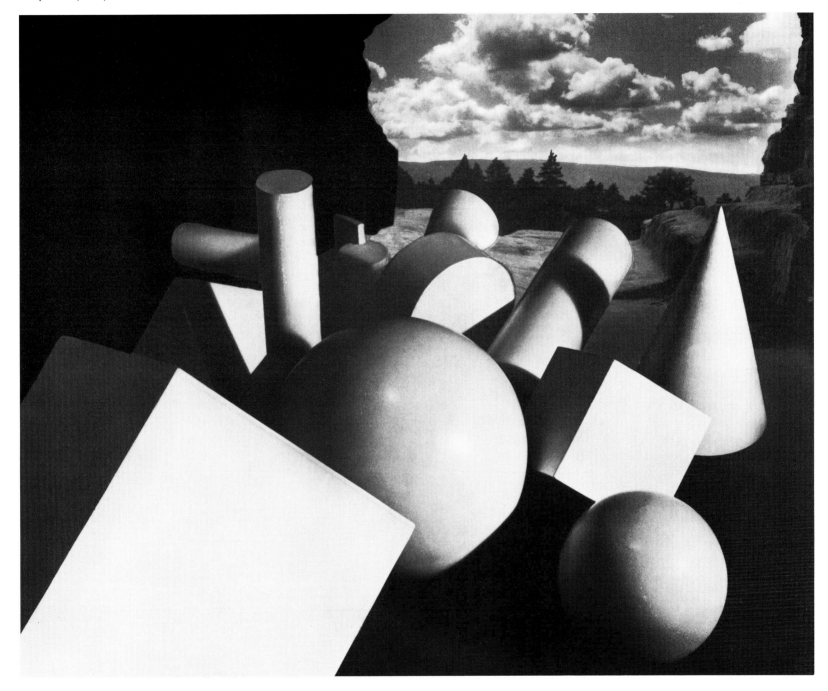

Spoon Sale (1936).

Skyscraper (1937), taken by Bayer in New York during summer visit.

Optics Notations I (about 1943).

Piazza San Marco, Venice (1952).

Stairs in Italy (1954).

of planked wall or shingled roofing transmit, in a photograph, an impact comparable to that of the paintings of the same subject matter? Bayer has not neglected in several of the images to airbrush clouds into the background or promote shadow effects as means of elaborating texture. He has tried, in effect, to impose a painterly arrangement on his subject, to enforce, so to speak, on an imagined universe a verisimilitude of the real. The straight photograph announces the real. Even in photomontage the elements are real; the imagination functions as the faculty in photomontage of congregating from diverse sources a variety of elements, each of which shares a portion of the real.

In his Fotoplastiken, however, Bayer has moved away from the real to the fabulation and construction of sculptural elements—bones, wheels, frames, boomerang shapes, ovals—which, set before the vapor holes of actual farm buildings, allude unintentionally not the real that has been photographed but the imagined that might have been painted. This is particularly noticeable in *Wand mit Schindeln* (*Wall with Shingles* 1936/6) and *Stadelwand* (*Stable Wall* 1936/3), where the device of holding the objects to a vertical surface (by means of string and putty, which were airbrushed away when the first photograph was taken) compels an absolutely frontal display as in relief sculpture (which Bayer also made from the same subject matter).[37] In the "Dunstlöcher" paintings the objects suspended before the walls exude a biomorphic quality that is intensified by their absence of wood grain and texture, which the photograph underscores. The objects in the photographs can only allude to fantastical imagined shapes and creatures oozing from the vapor holes. They can allude them, whereas the paintings can make that allusion palpable and felt. Indeed, the paintings of the "Dunstlöcher" series, precisely because they are tied to the real only in the imagination, succeed more significantly than the composed tableaus that make up the five Fotoplastiken directly related to them. Leave aside *Winter* 1936/8, which is wholly derivative of a kind of realistic advertising convention, and the two still lifes (*Nature Morte* 1936/9, and *Stilleben* 1936/4), which are serene and elegant compositions, simple and effective without being exceptionally demanding, and we are left with the two images that to my mind are the most successful and most disturbing photoplastics in the series.

Stehende Objekte (*Standing Objects* 1936/2) makes use, as do none of the other photoplastics, of a severe angle in which the eleven precariously balanced elements seem pressed toward a diagonal that suggests a receding and asymptotic perspective. Moreover, the ladder, cone, frame, pencil, bones, and wooden rod (as though the elements and sinew of artistic creation) suggest a scheme of meanings that enrich the viewing without settling an interpretation. It is a photograph of symbols disposed with such tension of relation and subtlety of shadow as to arouse more questions than it can possibly resolve. It sustains fascination without abusing it. In these respects it succeeds as a constructed atmospheric tableau in persuading us to forget the devices that produced it and the artificial lighting and airbrushing that perfected its mood.

Even more successful—indeed perfect in its assertion—is *Metamorphose* (*Metamorphosis* 1936/7). Recall Bayer's cover for the 1928 *bauhaus zeitschrift*, a photomontage making use of a cube, ball, and cone (solidifications of Kandinsky's square, circle, and triangle) along with sharpened pencil and transparent triangle disposed on the surface of a rolled cover of the magazine. This image, classically simple and evocative, was one of the most widely reproduced examples of Bayer's graphic design. Moreover, the cube, ball, and cone became his personal shorthand for the Bauhaus aesthetic. In *Metamorphose* Bayer has arranged a processional of these elements, moving out of an airbrushed cave of darkness toward a vista of trees, ocean, and cloud-filled sky. The marble creatures of geometry, the building blocks of nature, are on the move from darkness to their transformation by sunlight into the materials of creation. This Fotoplastik is an integral metaphor: nothing needs to be added or removed for it to suggest a wealth of meanings abundant beyond its simplicity of means.

Photography was always a byway for Herbert Bayer, relief from the pressure of the graphic-design practice that occupied him from 1928 until his departure from Germany. It was a technology that complemented the eye but could not replicate the imagination. When he strove to achieve in photography values that were obtained more subtly with brush, the images he created were less successful. However, when he succumbed to the limitations of the medium and submitted to its terms, he produced some of the most remarkable and enduring photographs, photomontages, and photoplastics of the modern movement. In 1937, the last full year he spent in Germany, he photographed his hand holding a sharpened pencil poised over a sheet of blank paper. *Selbst-Porträt* (*Self-Portrait* 1937), as he called it, is the insignia photograph of his photographic oeuvre. It makes clear that Bayer—for all his gifts as a photographer—is not a photographer. He is a man who draws.[38]

3. Exhibition Design and Architectural Design: 1928-1968

Exhibition Design

Herbert Bayer broke with conventional exhibition design on the occasion of his first commission to undertake the presentation of the new functional typography (Elementare Buchtechnik) on behalf of the Deutsche Buchkünstler Verein, which mounted the Europäische Buchkunst der Gegenwart exhibition, otherwise known as the Press Exhibition (Pressa Ausstellung) in Cologne in May 1928. Although Bayer has no archival documentation of his display design and no installation photographs to annotate his selection and presentation of materials, he has sketched from memory the basic scheme he designed. Having first painted the interior exhibition spaces of the German pavilion pure white, Bayer broke up the essentially uninteresting architectural space by fixing wooden slats before the walls in patterned intervals. The graphic examples of functional typography—drawn from the Typographic Workshop at the Bauhaus but including examples from all the practitioners of the new typography, including Tschichold, Schwitters, Burchartz, and Johannes Molzahn—were fixed under unframed glass and hung on the slats, sometimes overhanging the slats, at other times hinged to the wall behind and protruding at angles. The display was a success, but quite tame when compared to the Soviet pavilion designed by El Lissitzky for the same exhibition.

More than any other practitioner of exhibition design, El Lissitzky provoked Bayer to rethink the conventional approaches that had established decorative motifs as the prevailing historical style of design for exhibition spaces. Bayer's exhibition design at the Pressa Exhibition in Cologne was admittedly "very purist and very formal," whereas, in his words, "when I saw lissitzky's experimentation with large photomurals and the use of cellophane—which had just been invented—the general mixture of techniques—new techniques—produced an overall impression that was rather chaotic. it was the throwing together of a great many ideas. but that made it interesting for me. (47)"

Undoubtedly, the concatenation of ceiling-high, moving press sheets to which propaganda leaflets were attached, immense photomurals designed by Lissitzky and Syenkin[1] to celebrate the "task of the press in the education of the masses," the giant illuminated red star bidding the workers of the world to unite, the application of display material to the ceiling of the pavilion, seemed an excessive exercise in propaganda to Bayer, but nonetheless, in all its riot of activity, disorder, jumble of messages, it was extremely effective. For the first time, the inert materials of exhibition display became alive and agitant and the viewer— normally circulating about formal displays, passing in and out in unplanned flow—was compelled to pay attention.[2]

Bayer did not attend the Film und Foto Ausstellung the following year in Stuttgart, despite the exhibition of a number of his own photographs. It cannot be assumed therefore that he was aware of Lissitzky's use of freestanding display stands of painted wood with connecting panel areas creating the illusion of depth and perspective, as well as cubby-hole intimacy for the viewing of particular images mounted in various sizes, nor of Lissitzky's use of serial

photographic stills.[3] However, the press and magazine coverage of Lissitzky's subsequent exhibitions for the Soviet pavilions at the International Hygiene Exhibition in Dresden in 1930 and the International Fur Trade Exhibition in Leipzig the same year permit one to suppose that Bayer may have read reports of them and seen the catalogues for the latter exhibitions, which reproduce photographs of the actual displays Lissitzky designed. Moreover, given the general enthusiasm among functional designers for Lissitzky's exhibition work, at the very least Bayer must have heard descriptions of Lissitzky's exhibitions from the many artists, historians, and designers who attended them.

Although Bayer recalls meeting Lissitzky twice at the Bauhaus during the early 1920s, when he visited Moholy-Nagy, there was no memorable contact between them.[4] The impact of the work remained, however, and although Bayer went on to develop an extremely original and innovative approach to exhibition design, it will readily be seen that the impasto energy of Lissitzky's mixed-media approach to exhibition design made an enduring impression on Bayer (68:199).

Exhibition Design: Sources and Experimentation

Bayer's exposure to the formulations of De Stijl, even more than to Lissitzky, had a subtle and persuasive effect on his understanding of the relation between architecture, typography, and display. Lissitzky's work entered the consciousness of German plastic theory several years after De Stijl had cleared room for it. Lissitzky may have extended the technical possibilities of asymmetric construction in exhibition design by using inexpensive materials, prefabricated elements, novel integrations of photomontage, typography, display fixtures, and devices, but De Stijl had altered the fundamental understanding of architectural space, introducing into its reconception organization around the spatial grid that virtually destroyed perspectival imagining in terms of front and back, right and left, top and bottom. The absolute formulations of architectural space, which had held virtually unbreached from the Renaissance until the twentieth century, were rethought in more fluid terms, space increasingly tied to function and flow, since its point of fixity and delineation (particularly in the axonometric drawings, revived by Lissitzky and van Doesburg) was no longer "the geometrical representation of depth on a two-dimensional medium" but, henceforward, would be to make infinity "thinkable by placing the center of geometric projection into infinity."[5]

These considerations first appear as significant elements in Bayer's thinking when he executed a series of drawings for imaginary, and unrealized, exhibition and sales kiosks in 1924. These remarkable De Stijl constructions, employing volumes delineated with planes of red, yellow, blue, and black and white, were fabulated by Bayer as stands, kiosks, stations where products could be advertised, offered, and sold. The basic architectural unit was the box, whose colored sides allowed for loudspeakers declaiming the product and its uses, motion-picture projection, roof apertures emitting smoke in the form of letters, flashing electric lights (project for exhibition pavilion at an industrial fair, 1924, advertising Regina toothpaste), assuring a simultaneity of sound, speech,

and various kinds of moving images. Bayer's kiosk for selling cigarettes (brand P) was a small rectangular unit on whose yellow wall CIGARETTEN appears in green majuscules; rising against an enormous red vertical plane a giant cigarette, emitting smoke, counterpoints a vast display P (for P brand) whose bulb lights illuminate the trademark. An open-air streetcar station with newsstand is conceived by Bayer as a synthetic De Stijl architectural project with intersecting planes of red, white, and blue passing each other atop a unit constructed like a Rietveld table.[6] Finally, a pillbox kiosk, outlined in blue, with a montage of newspaper and periodical elements on one wall, above which rises, for two stories, a structure of linear rectangular volumes formed of yellow, blue, and red surfaces, cut by a white arrow that points downward toward the sales window of the kiosk; running from bottom to top in the distinctive Bauhaus lineation is JOURNALE in hand-drawn white letters set against a pink plane.[7]

These architectural displays to be fashioned of prefabricated elements—augmented by several display units employing a phased lighting system for a revolving advertising sign for the electric industry and a freestanding display tower advertising electrical products—all date from 1924. However, it is unlikely that Bayer had seen the pavilion drawing of Lajos Kasak (1923) or even the display stand for the sale of the De Stijl periodical (1923), both of which exemplify the intimate scale of his own projects (142:36–37, figures 25, 26). Clearly, Bayer's were a perfectly reasonable application of the De Stijl architectural module and employment of planes of primary color to create offsetting volumes. These projects were never realized nor is there evidence that they were even intended to be realized. It was another example in Bayer's oeuvre of an experimental curiosity about new solutions to old problems, adapting the most immediately innovative design vocabulary to the treatment of a familiar problem that had been theretofore conventionally resolved.

The twenty-four-year-old artist who made these drawings was still a student at the Bauhaus—albeit one of its most gifted and sophisticated. He had behind him the jerry-built atmosphere that had reigned at the Bauhaus Ausstellung of 1923 and had undoubtedly been appalled by the prevailing clutter and rigidity that had defined industrial and state exhibitions in Germany. Indeed, as Bayer's essays on exhibition design make clear (12; 30; 40:26–51), he was well aware of the history of exhibition design in the nineteenth and early twentieth century. The formalistic immensity of the International Exhibition at the Crystal Palace in London in 1851, where there was "an orderly arrangement of many small displays within the elegant architectural structure," and the palpable pomposity of the Gewerbe Ausstellung in Berlin in 1896, where the environment supressed the exhibited material as a means of lifting "the exhibited products on to a higher plane of beauty" exemplified the prevailing atmosphere of "superficial beautification and historical eclecticism" that dominated exhibition design until the 1920s (30:266–267).

By the second decade of the twentieth century, industrial and trade fairs had multiplied, frequently traveling within the country of origin, attracting millions of visitors, covering vast acreage and using considerable amounts of public funds, all in order to inflate

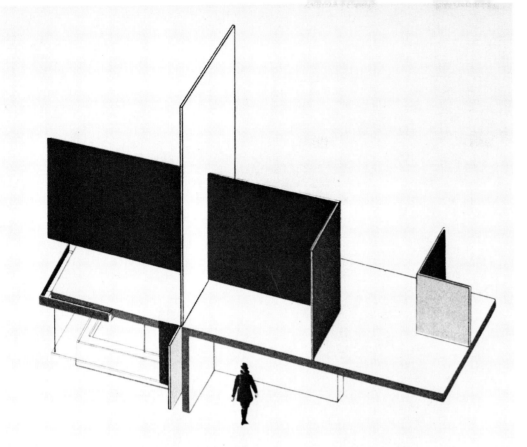

Open streetcar station with newsstand. Project
(1924). Advertising displays and posters to be
mounted on roof. Construction of prefabricated
elements suitable for mass production.
Gouache, 20⅝ x 19″.
Collection Herbert Bayer.

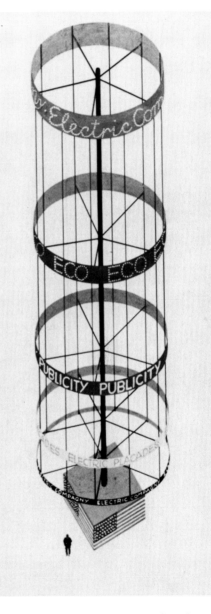

Exhibition tower advertising electrical products
(1924), gouache, 26 x 15″. Project.
Collection Herbert Bayer.

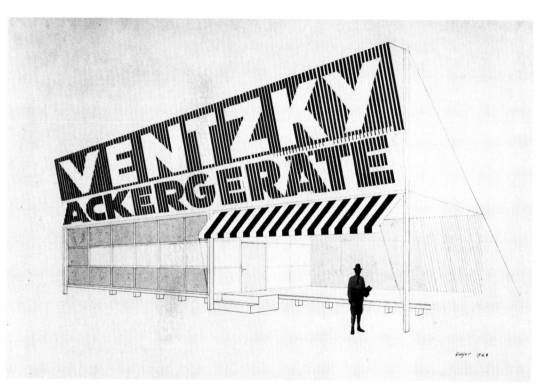

Demountable exhibition stand for agricultural fair (1928), gouache, 19 1/2 x 27".
Collection Herbert Bayer.

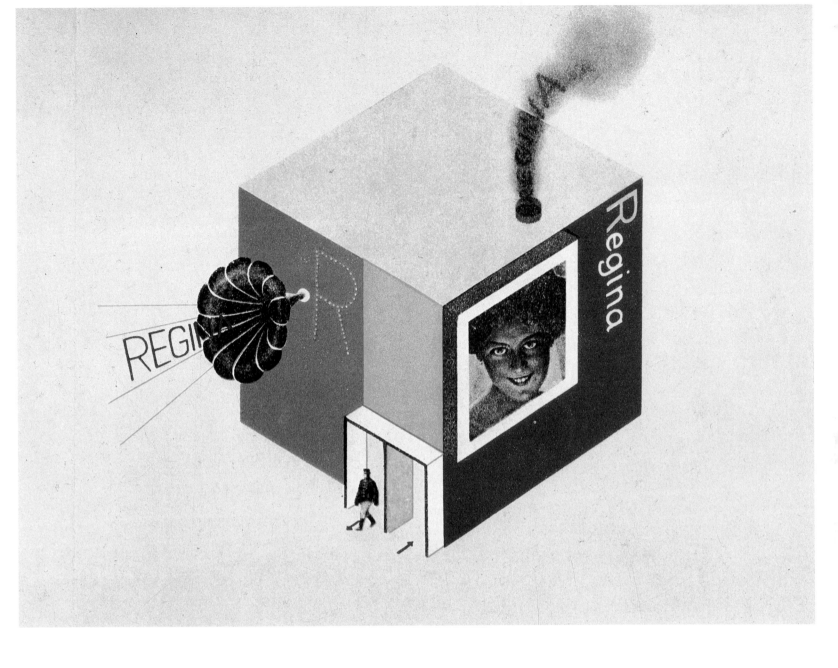

Project for exhibition pavilion at an industrial fair
(1924). Gouache, 22 1/2 x 17 1/4".
Collection Herbert Bayer.

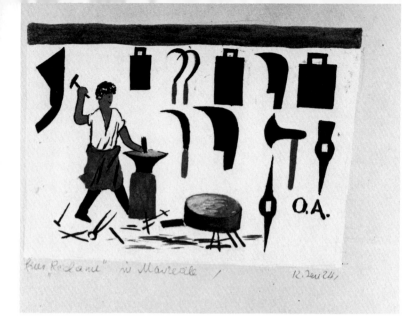

Advertising for a Blacksmith 1924/95, gouache,
8¼ x 7¼".
Collection Herbert Bayer.

the national ego and generate trade. The purpose of the fair was to introduce and represent product within the context of a benignly overpowering architectural *neutrum*, which superficially covered, integrated, and organized the public flow. The exhibition was rarely scrutinized in terms of its intent, its premise of coherence, its historical origins and promise, its associative context. As a result the movement of the public through its space was either haphazard or rigorously disciplined irrespective of any notion of the flow of meanings implicit in the materials displayed. Indeed, Lissitzky, genius though he was at impasto presentation, was fortunate in having one exportable commodity whose virtues constituted the single premise of his enterprise—Soviet political and economic ideology. Bayer, on the other hand, forming his design ethos within the combative aggressivity of Weimar democracy, was engaged in the presentation of many products and diverse sensibilities. The devices of inquiry were not as efficiently monolithic as were those of Lissitzky. Indeed, the problem could only be addressed by a calm, intuitive, balanced design aesthetic that began with analytic scrutiny.

As Bayer has made clear (referring to his pen and ink transcription of the sign of a Sicilian blacksmith's workshop [30:272]), the craftsman makes absolutely clear what he does, the forms he employs, and the quality he will produce by displaying on his walls the emblems of his craft and the finished product. He has no need of language, no need of crying address, no need of stentorian architecture to make his point. It can be done by visual iconography. This became the starting point of Bayer's understanding of exhibition display. The display could be effective if it made use of a synoptic visual language that was instantly intelligible, that integrated dramatic placement of materials along with appropriate visual implementation, moving through the exhibition space with narrative intention. The exhibition must narrate—whether it tells the story of German postwar product in Paris (1930) or the involvement of the building trades in the construction of housing and factories in Berlin (1931), or the moral unity of the American people committed to fighting a war (1943). In each situation Bayer located the narrative line and devised a system of disclosure that enabled the viewer to pass through the exhibition space keyed by appropriate diagrams of exposition (and inhibited from circumventing the narrative by impedimenta—walls, plastic interventions) to assimilate beginnings, middles, and ends. The intent of an exhibition was to transmit a few critical ideas—excellence, quality, moral clarity—regarding the subject matter. The designer must work with economy of means, counterpoint of message, and grading of impacts and effects (by use of color, lighting, signage to establish stress and focus), various techniques of drawing attention and achieving drama, until the viewer is sure to have gotten what the exhibitor intends to transmit. Within the analytic frame, the means are virtually endless, but the origin and the goal remain as always simple and direct.

Section Allemande: Deutscher Werkbund and Display of German Products (1930)

Prior to the exhibition of the Deutscher Werkbund (known as the Section Allemande) within the large exposition mounted by

the 20e Salon des Artistes Décorateurs Français at the Grand Palais during the early summer of 1930, Walter Gropius had been responsible for only the Bauhaus Ausstellung (1923) and the remarkable Open-Air Life Exhibition set up in a Berlin suburb in collaboration with Moholy-Nagy shortly after they both left the Bauhaus in 1928. Moholy had been explicit about the application of Bauhaus methods to the domain of exhibition design: "moveable walls lettered with new slogans, rotating color filters, light projectors, signal demonstrations and reflectors: transparency, light and movement all in the service of the public. Everything so arranged that it can be handled and understood by the simplest individual. Then also the exciting use of new materials: huge sheets of celluloid, lattice work, enlargements, with lettering suspended in space, everywhere clear and brilliant colors."[8] The effectiveness of their collaborative exhibition flowed from Gropius's willingness to allow Moholy "to paint with light—both natural and artificial, to employ demountable stands, which were alternately open to the street or the interior courtyard of the Berlin suburb where it was situated. The intent of the exhibition was to demonstrate the relation between old and new housing, old and new interiors, old and new ways of living, all moving toward and being consummated in the presentation of a final, completed building. The exhibition was both pedagogic and ideological. Gropius wished to propagate his views and Moholy-Nagy devised the techniques of achieving this. The scale of the exhibition was modest, the intent narrow. What was undertaken the following year in Paris was, by comparison, monumental. To this project commissioner Gropius called Marcel Breuer and Herbert Bayer, as well as Moholy-Nagy, to form a collaborative unit reinforced by preparatory work undertaken by a considerable body of eminent German architects, industrial designers, and curators.[9]

The Section Allemande under the direction of this unusual team was in itself a remarkable phenomenon, an unparalleled phenomenon, since never before (and never since) had a nation called upon its unfashionable best to represent its new achievement to a frosty, even hostile, audience—as was France a decade after the close of the First World War. Indeed, this was the first time since the war that Germany had been asked to participate in this exposition. Writing of this occasion Siegfried Giedion commented: "This was, as I wrote at the time 'certainly a matter of no small political importance; but the thing that struck one most was how it had come about that the Foreign Ministry, instead of taking on the job itself, handed it over to the German *Werkbund*.' The procedure of the *Werkbund* was then typical: instead of nominating a many-headed committee, they appointed one man to take over responsibility, and that man was no irresolute, compromising type, but: Walter Gropius."[10]

Gropius organized the space situated at the farthest end of the Grand Palais into the reproduction of a community center for "one of the unbuilt slab-like apartment houses which Gropius and his companions were then actively engaged in working out."[11] A viewer was first struck by the glass walls of a swimming pool and gymnasium which was, as Giedion observed, absolutely right since it was a startling confrontation for the habituated visitors who expected something more tame and conventional. The

exhibit was presented as a single entity, which was to be the community services of a ten-story apartment house; Breuer organized the actual apartment and its furnishings, Moholy-Nagy devised its lighting effects, and Bayer saw to the arrangement of the mass-produced objects that were displayed. The entrance area, designed by Gropius, contained a swimming pool, gymnasium, bar, dance floor, reading and recreation corners, library, and other facilities. A ramp with an open latticelike construction of galvanized steel rose over the pool, conducting the visitor to the exhibits above and leading through the exhibition hall, where Moholy had incorporated discrete wall displays of new lighting fixtures along a straight wall leading to a flow of photographic images on demountable stands and display of Gropius's design for his Total Theater (1927), as well as models for Moholy's stage sets and Schlemmer's Triadic Ballet (1916).[12] The visitor then proceeded to Marcel Breuer's installation of the rooms constituting the new "boarding house," where clean space, efficient built-in units, and Breuer furniture were displayed with characteristic asymmetric interaction.[13]

The last major display rooms of the Section Allemande were designed by Herbert Bayer. In a sense these were the most difficult spaces to work out because they were not characterized by a single theme or integrated by an architectural frame. Bayer had to create an atmosphere for the new German craft industry, in which everything from fabrics, mass-produced chairs, porcelain table settings, glassware, silver, household objects of diverse materials and uses, to jewelry, his own universal alphabet (1926), and much besides were to be presented. In the amazing catalogue that Bayer designed for the exhibit (itself as Giedion remarked, "a minor typographical masterpiece"[14]), the analytic procedures he employed in the preliminary investigation of the problem were set forth.

For the first time Bayer presented his famous drawing of the exhibition viewer whose head has been replaced by an immense surreal eye tracking lines of vision to panels moving from the floor to forty-five-degree angles off the floor, standing before the wall, tilted at angles extending downward from the wall, indeed looking down from the ceiling. Never before had an exhibition-space designer recognized that the line of vision was not limited to the horizontal plane and determined to utilize the immense motility of the eye to focus angles that encouraged the eye to swivel, to rise, and to lower. This drawing became Bayer's exhibition design signature, expanded later to interpret the placement of displays at the Bauhaus: 1919–1928 exhibition in New York in 1938 as well as to explicate his views on exhibition design set forth in numerous articles following his seminal "fundamentals of exhibition design" (12;14;30). Bayer had succeeded in totally shifting the emphasis from the display to the viewer. Since it had always been assumed that displays required flat frontality, constraining space to its two-dimensional wall surface in the service of that dumb, lazy, immobile viewer who stands grimly uncomprehending before the display-covered wall, nobody had undertaken to systematically break the plane.

De Stijl had made clear that architecture could break the plane; it was now the exhibition designer's turn to extend the

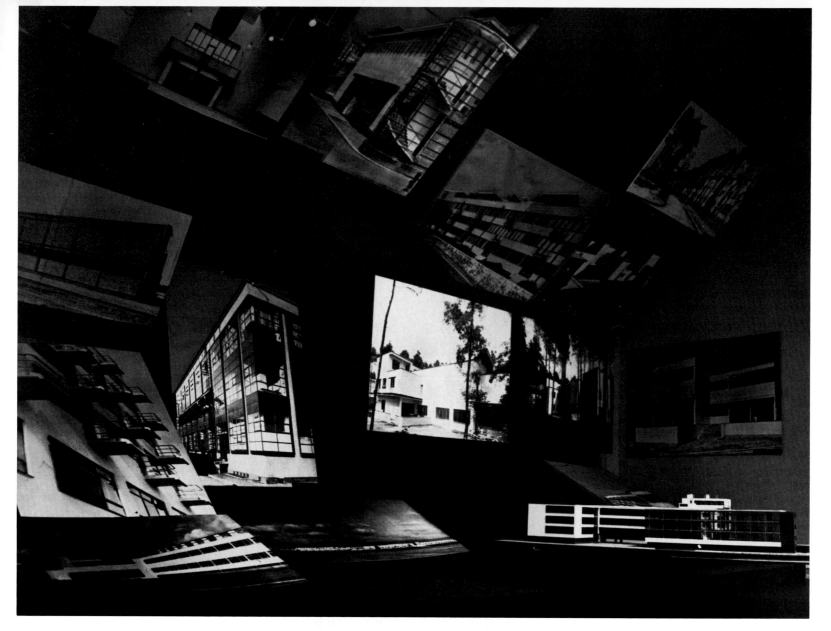

Section Allemande of the Deutscher Werkbund
exhibition of German architecture and furniture in
Paris (1930).

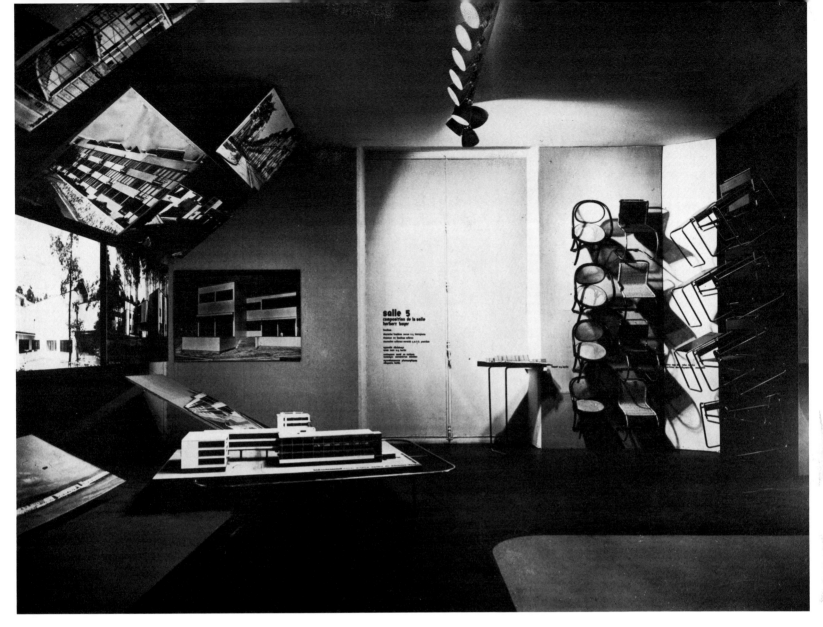

Architectural photographs and models raised
off floor demonstrating Bayer's conception of
the field of vision. Section Allemande of the
Deutscher Werkbund, Paris (1930).

Display of upholstery material. Section Allemande of the Deutscher Werkbund, Paris (1930).

Diagram of the field of vision from Bayer's catalogue for the Section Allemande of the Deutscher Werkbund, Paris (1930).

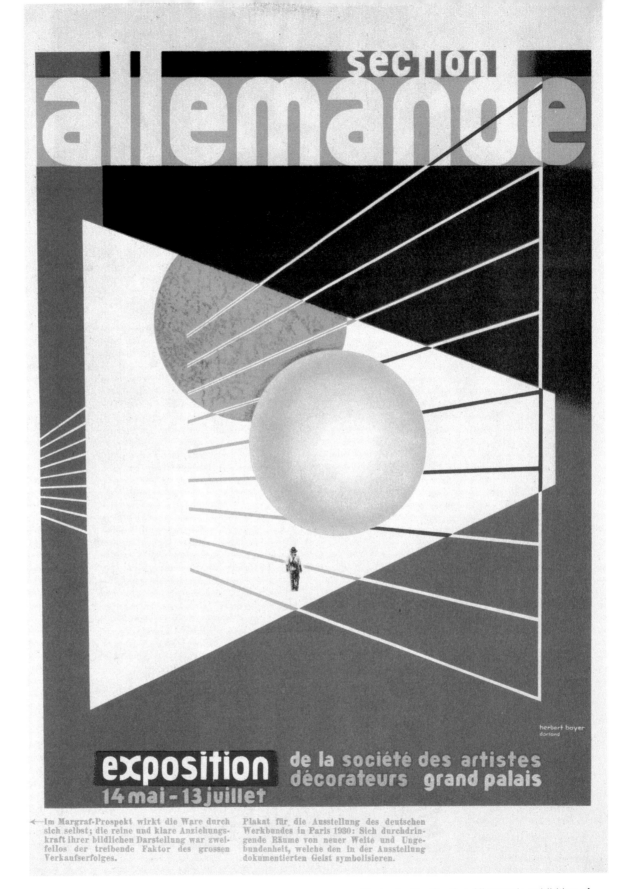

Poster for the Section Allemande exhibition of
the Deutscher Werkbund, Paris (1930).

Plastic covers with raised lettering over printed outline type for catalogue of the Section Allemande exhibition of the Deutscher Werkbund, Paris (1930).

insight of architecture to the materials displayed in the interior space. Architectural photographs (of buildings by Scharoun, Haesler, Mendelsohn, Mies van der Rohe, Gropius, May, the Tauts) were shown in dynamic, flowing placement off the wall, suspended from wires, and counterpointed to each other at angles that obliged the eye to move and connect, while architectural models (of buildings by Gropius, Mies, and Breuer with Hassenpflug) stood out from raised platforms on small low tables with tubular guardrails behind which the photographs rose. All these were, as Bayer explained, "bodiless displays," their mode of suspension or attachment hidden or rendered indistinct. Chairs and small tables were attached to the walls and rose up in frontal columns, seat out as well as in profile; china, glassware, and other household items in mass aggregations transmitted not only a sense of their machined elegance but of their abundance and availability.

In Bayer-designed vitrines whose interior divisions were asymmetric and detailed for objects of different quality and weight, the intention was to subtly command the viewer to think about household objects differently, to value them independently, and to see them in a manner that emphasized their modernity while insisting on their individuality.[15] New textiles, linoleums, curtain and rug fabrics were mounted in square segments, some rolled against a cardboard form, some vertical, others horizontal, some seen as though stuffed, others flat, all creating an allusion to use and function, the entire tableau framed in metal as though an enormous textile mural. Next to it Bayer's universal alphabet was displayed as cast elements against a flat metal surface forming a type mural.[16] Finally, at the extreme right abutting the staircase, flat metal ovals hung from the wall and a display of segments of new metals and alloys were splayed in star formation. Bayer had succeeded in detaching the exhibition displays from the static wall surface and dissolving the conventional space by creating fresh relations between the elements by the use of divisions, penetrations, and interactions of textures, surfaces, lines, and volumes. The traditional rigidity had been overcome and the small, tight space available to exhibition design had broken out of its constriction.

The Section Allemande—complemented by Bayer's brilliant exhibition poster and catalogue (employing plastic covers impressed with the exhibition's title over a printed cover using the exhibition's name in Bayer's open-face shadow type, Konturlose Schattenschrift)—proved to be a triumph. It was the sensation of the Grand Palais exposition, receiving enthusiastic endorsement from the normally hostile French press.[17] The German ambassador to Paris was persuaded by its success to venture a large party in honor of the commissioner and his associates. As Giedion described the reception in the Empire mansion formerly owned by Prince Beauharnais, "the *'chef de reception'* in his red livery, banged his tall staff upon the floor each time as he announced: 'Monsieur Perret; Monsieur Mondrian (in a borrowed frock coat and cravat); Monsieur Le Corbusier; Monsieur et Madame Delaunay; Monsieur et Madame Arp; Monsieur Vantongerloo; Monsieur Léger; etc.' All people who would not normally be found

in this environment. And it was a superb party! This Paris exhibit was a beginning and at the same time an end."[18]

An end in many senses, but no less a beginning. Every German exhibition thereafter, whether mounted by Gropius and his team or by Bayer alone, and exhibitions in the United States, would be constructed with the same dazzling originality and analytic cleverness. Gropius had seen to it that the Section Allemande was understood as a triumph not only of his own architectural vision but of the integral pedagogy of the Bauhaus. At the same time, however, it marked the end, for never again would Weimar Germany sponsor an exhibition abroad fashioned by the Werkbund nor permit the most ingenious and gifted representatives of young Germany to be reflected in an international exposition. From 1930 until Gropius emigrated to London in 1934 and Bayer emigrated to New York in 1938, their exhibition activities would be confined to Germany and, as the years unfolded under the Nazis, their efforts, most particularly Bayer's efforts, retained their freshness of technique while their scale and content became progressively narrower and in several cases nationalistically constrained.

There was, however, one last great collaboration among Gropius, Moholy-Nagy, and Bayer in 1931, on the occasion of the Baugewerkschafts Ausstellung (Exhibition of the German Building Workers Unions) in Berlin. This exhibition, which constituted an affirmative support to one of the major trade-union organizations in Germany, was, in Bayer's opinion, an association that would have finally compromised his artistic neutrality in Nazi Germany. Not only was he continuously linked with the Bauhaus and its egalitarian and intellectual founder, but all of them had joined together to celebrate a German trade union, itself anathema to the Nazis.

The Baugewerkschafts Ausstellung, unlike the Section Allemande, was a statistical celebration of the revival and growth of the building trades in Germany and was regarded by Gropius's collaborative as a Schlüsselgewerbe (key craft) since all the other crafts producing household objects depended on new home construction for their growth and expansion. It was an exhibition that did not require close inspection of each display, but rather a mode of circulating that would insure a synoptic grasp of the significance of all the facts. Consequently, Gropius designed the space so that the display areas would be unified by a surmounting bridge, accessible from a ramp below, which enabled one to survey the entire exhibition and then descend to examine its parts. The exposition was divided according to new techniques of building and construction, statistical presentation of the growth of housing, employment and trade-union expansion and services. Since the material was not visually dramatic, Bayer and Moholy used huge photomontage displays (in the Lissitzky manner) that opened and changed on louvers, animation, peepholes, montage murals with relief signage, giant maps with magnification, devices that could be initiated by the viewer—all manner of techniques to engage the viewer's active participation and sustain and guide his intellectual curiosity and judgment. The clean assembly of architectural compartments and connective bridges and freestanding curved railings counterpointing the dramatic use of display volumes—machinery, models, panels, murals, suspended montages—created the effect of the orderly vigor that was so effectively and recognizably German industry.

Until his emigration in 1938, Bayer designed at least eight other exhibitions in Germany, fixed as well as traveling exhibitions that depended on demountable display elements. In all of these—for the cork industry (executed with Marcel Breuer, 1931), the Rundfunkausstellung (Radio Exhibition, Berlin, 1936), Wanderausstellung für die Tapetenindustrie (Traveling Exhibition for the Wallpaper Industry, Hamburg, 1936), and the Gas und Wasser Ausstellung for Junkers Industries (Gas and Water Exhibition in Leipzig, 1937), concluding with the Berlin exhibition Die Gemeinschaft (The Community)—Bayer's emphasis was consistent: make use of all available display techniques to reveal the message and compel the viewer to an active, creative role in its understanding.

One last accomplishment of Bayer's innovative display and exhibition design should be noted precisely because it reflected his own ability to synthesize painting, design, and exhibition techniques in a completely fresh manner. In 1932, several years after he had already established the visual success of the periodical die neue linie (the new line), Bayer situated in an empty lot adjacent to the surrounding apartment houses in the Ollendorf suburb of Berlin a freestanding outdoor billboard advertising die neue linie. This immense wood and brick billboard, facing the railway tracks of a commuter train, with amorphous painted areas in red and blue to which was affixed an androgynous woman's face over which the periodical's name was set in large cutout white relief letters, was probably thirty feet high and fifty feet long. Portions of the composition extended over the top of the supporting wooden frame, the whole presenting an attitude of simplicity and visual directness that accorded perfectly with its only descriptive tagline—"das blatt des menschen von geschmack" (the periodical for men of taste). The die neue linie billboard, one of the first of its kind in Europe, was unique in Bayer's design oeuvre, but reflected once again his complete openness to every available technical means of effecting visual communication.

Bauhaus: 1919–1938 and Exhibitions Beyond

In a 1969 lecture on "total design" at the University of California, Santa Barbara, Bayer crystallized attitudes he had defined much earlier in the Section Allemande exhibition in Paris for the Deutscher Werkbund and in the 1936 Radio Exhibition. In his display designs for Section Allemande, he detailed the application of his analysis of the field of vision to the dynamics of exhibition, while in the Radio Exhibition he demonstrated how the actual floor plan of the exhibit—in this case, passage along a spiral walk to the center of the exhibition under large display panels—determined its essential design motif. Both elements, the organization of the floor plan to lead and guide the visitor to view the exhibits and the viewer's optimal field of vision, became the essential ingredients of the exhibition design.

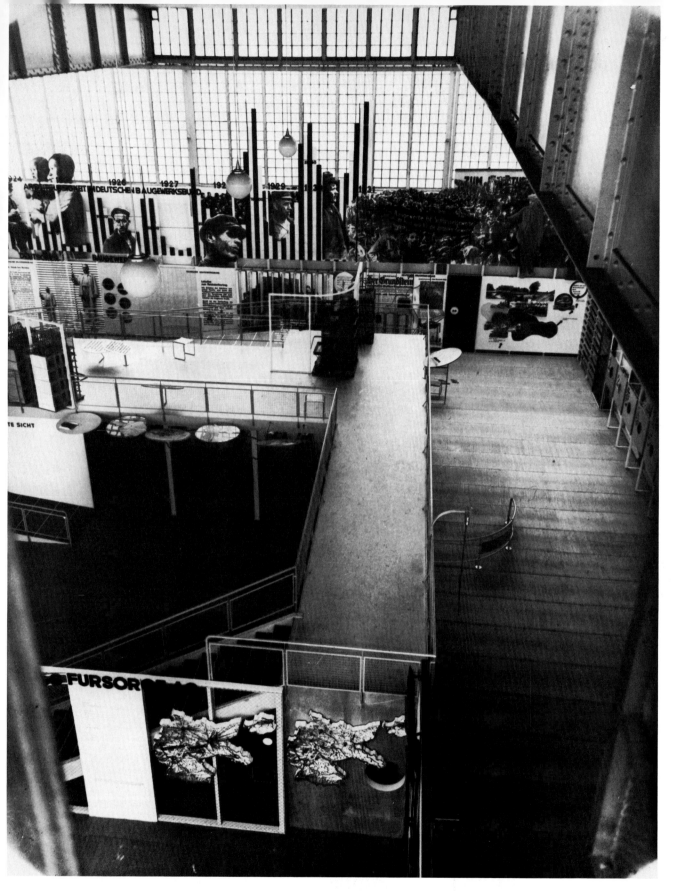

Gropius structure with ramp for Baugewerk-
schafts Ausstellung (Building Workers Unions
Exhibition, Berlin, 1931). Displays, Herbert Bayer
and Moholy-Nagy; ramp and structures, Walter
Gropius. Note Bayer montage displays resem-
bling those of Lissitzky at the Pressa Exhibition
Cologne (1928).

Exhibition Design and Architectural Design: 1928–1968

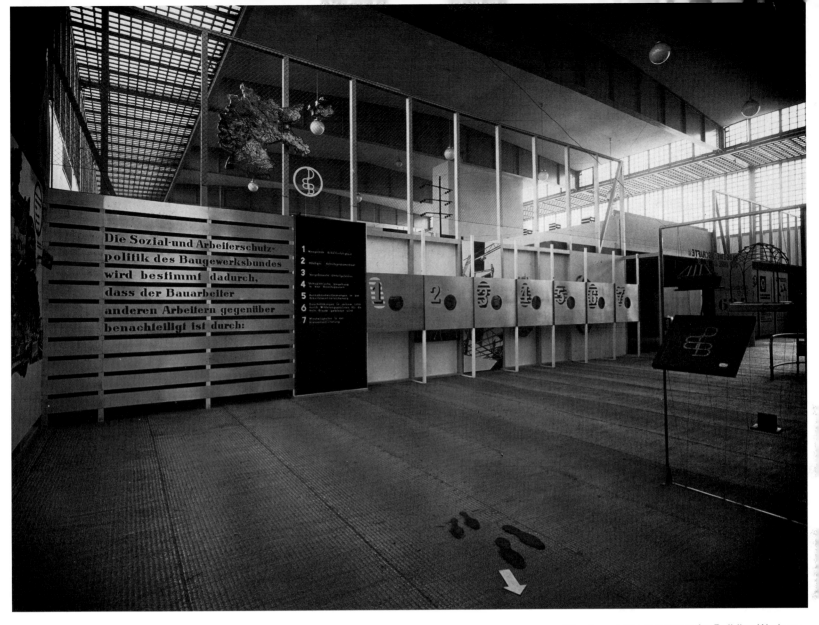

Simple wooden structures for Building Workers
Unions Exhibition. Note use of large panel
printed in reverse as well as the directional foot
markings, later used at the Bauhaus Exhibition at
the Museum of Modern Art, New York (1938).

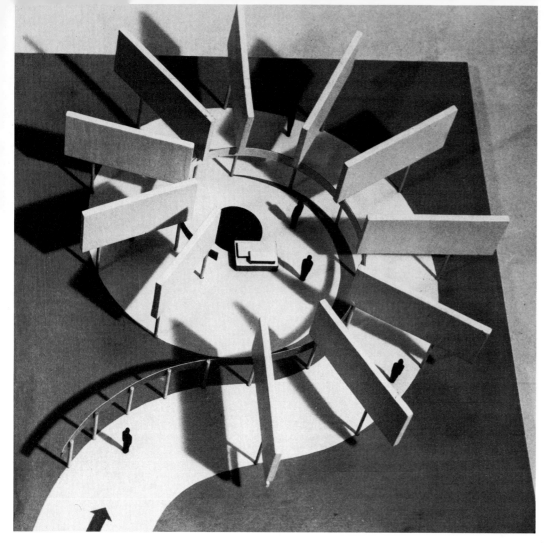

Rundfund Ausstellung, Berlin (1936), Radio Exhibition. Model. All Bayer exhibition models center about viewer flow through the exhibition space.

Outdoor advertising billboard for the magazine
die neue linie, Berlin (1932).

Sketch for book jacket for a bauhaus exhibition
(1938).

The Bauhaus exhibition at the Museum of Modern Art in New York in 1938 realized in effective unity everything Bayer had been exploring, in some cases partitively, in Germany. Moreover, given the available floor space of the museum, broken up into numerous little rooms, there was no opportunity for creating a new architectural space. Instead, it became necessary for Bayer to employ every device of visual communication to effect a flow and integration of meanings, which, had the plan been rigid or architectonic, would have been diffused into chaos and unclarity. Having first prepared a model of the space and determined where the clusters of Bauhaus material would be situated—moving from origins and beginnings through Itten's Vorkurs, to the various workshops of the Bauhaus, including Schlemmer's theater and ballet projects to the painting of the great Bauhaus masters and the design product of its artists and crafts people—Bayer was able to detail a smooth flow of the public through all the exhibits, using false walls and blocked areas to both focus and screen the viewer from what was up ahead or just around a bend.

Bayer accomplished this by using a device he had first suggested in the Section Allemande, where the cut and placement of the carpet conducted traffic, and at the Baugewerkschafts Ausstellung in 1931, where footprints indicated where the viewer should stand. In the Bauhaus exhibition the entire floor was painted with directional shapes, lines, and footprints, which assisted the attentive visitor to move through the exhibition in the order that its pedagogy required. Using a minimum of material display devices, concealing support wires, and hinges, Bayer effected the integration of walls and space by employing two-dimensional panels with photographs, textiles, paintings tilted from the walls or stretched between ceiling and floor at angles. Some rooms—those showing Schlemmer's masks and his painting *The Dancer*—were extremely spare and pristine, while others played with dark walls and spotlights to create visual tension. Those rooms showing serial photographs of furniture before which a single example was placed were counterpointed to two sealed vitrines containing craft objects, one vitrine placed atop the other at a forty-five-degree angle.

Exhibitions like the Bauhaus exhibition had been seen in Europe for nearly a decade before 1938–39, but nothing like it had ever been presented in the United States. Bayer had succeeded in creating through the subdivision and plotting of his four small rooms so many areas of dramatic focus and contrast that, despite its cabinet scale, the exhibition became a landmark for the American design world and immediately established Bayer's preeminence among American exhibition designers.

Four years later, Bayer returned to the Museum of Modern Art to mount an exhibition of photographs selected by Edward Steichen (with text by Carl Sandburg) to chronicle the unity of the American people in the war effort. As Bayer was limited to the use of 150 carefully selected photographs in black and white, the effectiveness of the mounting consisted in determining the scale and abutments of the photographs, their flow and curvature, and the emphasis of certain dramatically large and elemental images next to suites of smaller images that correlated the same themes.

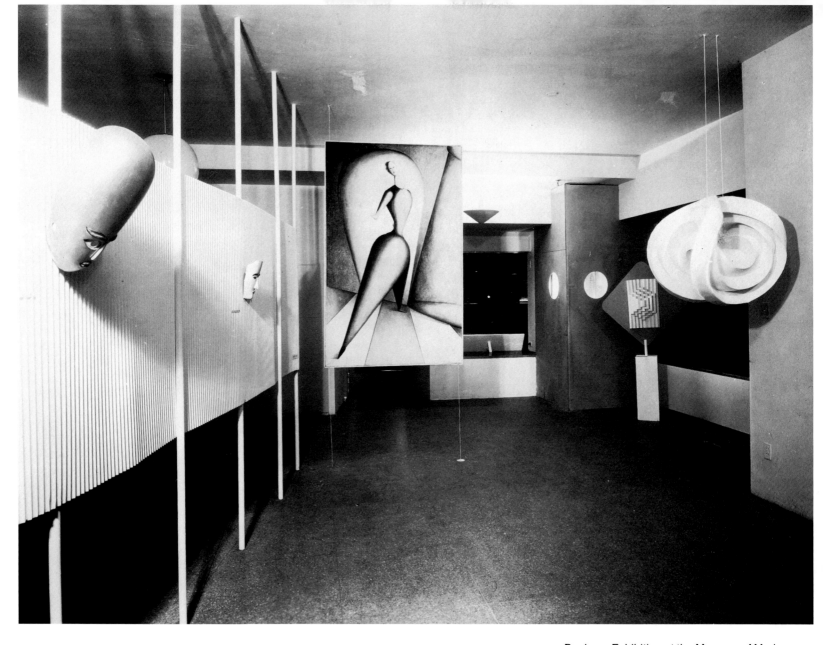

Bauhaus Exhibition at the Museum of Modern
Art, New York (1938). View of entrance; at the left
are two masks from Oskar Schlemmer's course
in stagecraft; in the center Schlemmer's painting
The Dancer; and on the right two sculptural
paper constructions.

Bauhaus 1919–1921 exhibition at the Museum of Modern Art, New York (1938). Exhibition of Bauhaus stage, with Schlemmer's revolving dance figures seen through peephole. Note projecting information panel at left and freeform movement directions painted on the floor. Herbert Bayer views the Schlemmer processional.

The entrance to the 1942 exhibition Road to Victory confronted the viewer with a vast photograph of the Rocky Mountains, a text panel surmounting a smaller photograph of a buffalo, to the right, three large photographs of American Indians, and next to that, hanging from the ceiling, a panel showing virgin forest. The theme of American origins had been struck. From there the viewer passed through nature to agriculture, to the American farm and its indigenous culture, to the power of American natural resources, industry, to giant pictures of battleships in construction, American troops in training, toward an axial counterpoint of a resolute American farmer against a brilliant sky set in isolation on one wall, while on the adjacent wall a giant blowup of the bombing of Pearl Harbor hung above a smaller image of Japanese diplomats relaxing in laughter. The exhibition then shifted from origins, materials, resources to panels of combat troops in action in the South Pacific, moving toward the concluding enlargement of marching troops interspersed with a small progression of photographs of parents, lovers, domestic scenes defining the hopes and longings of return. The entire second floor of the museum had been turned over to the exhibition and the photographs were detailed in their interactions with such restrained eloquence that despite the patriotism of Sandburg's accompanying text and the often indifferent quality of the photographs as photographs, the narrative visual power of Road to Victory proved overwhelming.[19]

The following year, Bayer was once again called upon by the Museum of Modern Art, this time to enact Airways to Peace: An Exhibition of Geography for the Future, planned by Monroe Wheeler to demonstrate the altered conception of the geography of the world as exemplified by the transformation of cartography and the history of air flight (interpreted as the modern technology that contracted the world and, looking beyond the war and the strategic power of the airplane, to the uncharted meteorological atmosphere beyond the confines of our planet).[20] As in Road to Victory, Bayer was working with material not usually situated in a museum context. Although no longer limited to the narrative exposition of photographs, the emphasis had to fall on didactic presentation in which exempla—diagrams, charts, maps (material generally unfamiliar to general audience)—had to be integrated as a visual unity.

The principal invention Bayer devised as a means of counteracting map distortion was an inside-out, freestanding demountable globe, fifteen feet in diameter and suspended from the ceiling. Since it is virtually impossible except through intense visual projection to conceive the position of the great land and sea masses on a large convex globe, Bayer designed a globe into which one could enter and see the land masses placed on its concave inner surface, with various of the continental masses falling below the cutoff line of the equator. Around this impressive sphere other smaller, freestanding illuminated hemispheres (or half-globes) had been constructed that showed the principles of map distortions when compared to the accuracy of the large globe. A ramp, similar to the device Gropius used in Paris and Berlin as well as to the bridge Gropius and Breuer constructed for the Pennsylvania State exhibit at the World's Fair Exposition of 1939 (for which Bayer and Xanti Schawinsky had executed the displays), enabled the viewer to look down on aerial photographs.

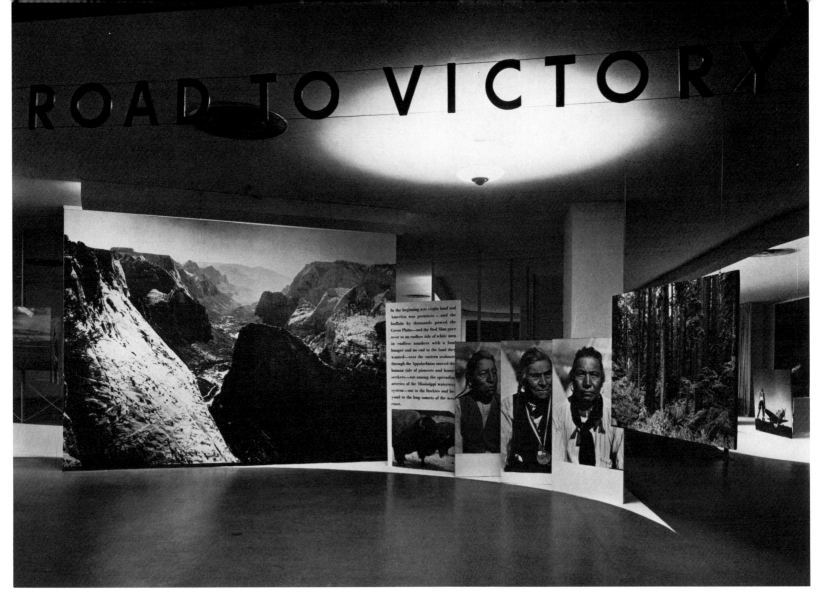

Entrance to Road to Victory exhibition at the Museum of Modern Art, New York (1942).

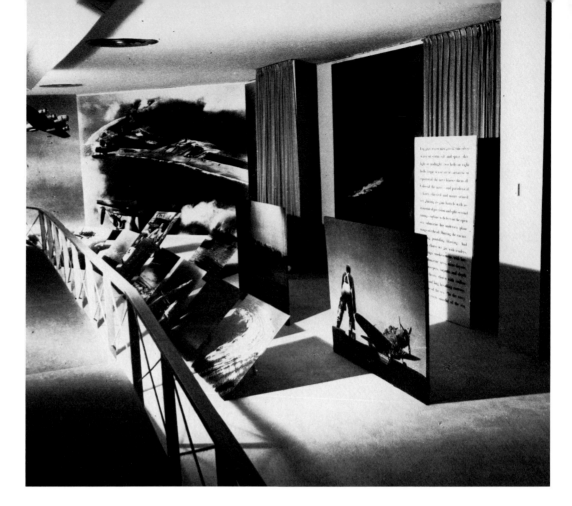

Specially constructed ramp passing through photographic display at Road to Victory exhibition, New York (1942).

Installation model for Road to Victory exhibition,
New York (1942).

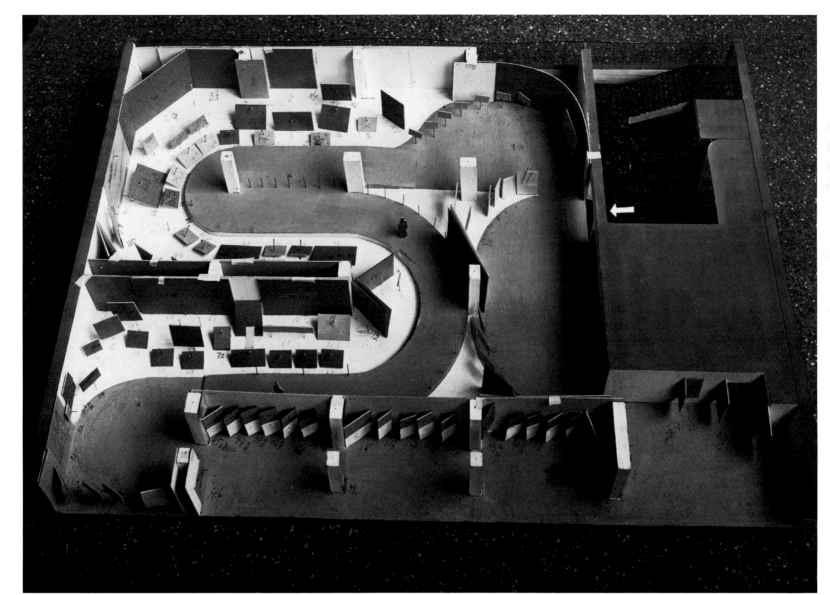

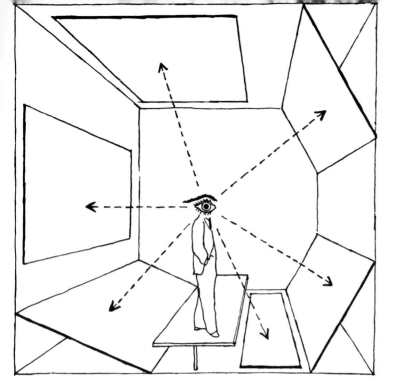

360° field-of-vision diagram, used in Road to Victory exhibition principles established for the Section Allemande exhibition of 1930.

Project drawing 1943/31, pen and pencil, 9 x 12″. Trompe l'oeil backdrop to create illusion of visual depth. Developed, but unexecuted, for Theater Exhibition to have been mounted by the Museum of Modern Art.
Collection Joella Bayer.

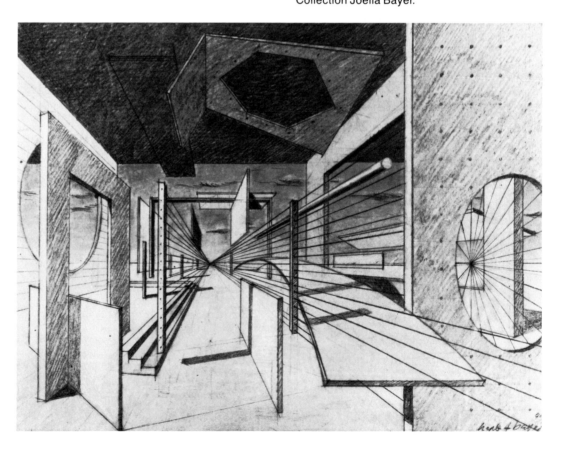

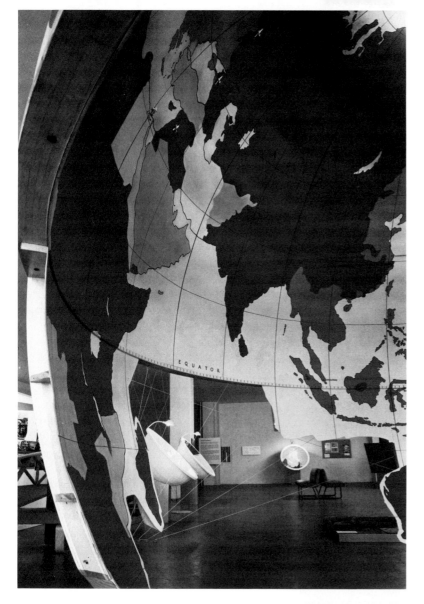

From within the demountable globe (fifteen feet in diameter) constructed for Airways to Peace exhibition at the Museum of Modern Art, New York (1943).

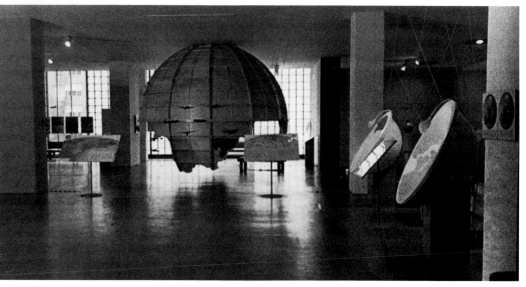

Freestanding hemispheres that surround globe demonstrate principles of cartographic distortion at Airways to Peace exhibition, New York (1943).

As Alexander Dorner described this exhibition, a "network of ropes, screens of poles and patterns of geographical altitude lines brought things together in a new kind of causal relation" (68:212–213). Since Bayer was working at the time on his small group of paintings dealing with "Communication in Space," the series of meteorological paintings that he executed for the exhibition to explain fundamental relations between the atmosphere, troposphere, stratosphere, and ionosphere in relation to the water mass of the earth proved particularly effective.

As Bayer understood it, the mystery of maps and map projections and the geometry of globes in their relation to air travel was both the content and the form of exhibition. For this reason, he wished to achieve as light and unencumbered an exhibition space as possible. He removed many of the optional space dividers on the museum's second floor in order, in Dorner's words, to ensure that the "exhibition appear as light and bodiless as possible" (68:212–213). As in all of Bayer's exhibitions, architectural volumes become unimportant and the creation of artificial architectural elements in order to force design is avoided in favor of lighting flat and curved planes (made with latticework, demountable displays, curtains, "anything," in fact, as Dorner continues, "that gives an atmosphere of lightness, bodilessness and hence spacelessness").

During the war Bayer devised a series of demountable freestanding display units whose stability depended on their zigzag installation. Posters and other propaganda materials were mounted on them for inexpensive traveling exhibitions sent to South America by the commissioner for Inter-American Affairs in 1941, and they also provided a graphic display mural for the Film Library of the Museum of Modern Art during its fifteenth-anniversary exhibition Art in Progress (1943). In 1943, Egbert Jacobson, art director of Container Corporation of America, invited him to develop a traveling exhibition of considerable scale, Modern Art in Advertising, which was to open at the Art Institute in Chicago and travel to some forty-eight other museums. Working in collaboration with his friend Stamo Papadaki, Bayer devised demountable standardized units of maple-wood struts, easily erected and fastened with nuts and bolts. Counterpointing the installation of original drawings and their printed realization as advertisements by such artists as A. M. Cassandre, Miguel Covarrubias, Gyorgy Kepes, Fernand Léger, Jean Helion, Willem de Kooning, Ben Shahn, Ruffino Tamayo, Richard Lindner, Bayer, and many others (167) were panels painted in bright colors as organizing devices. The very flexibility of the structure permitted easy demounting and reinstallation with different combinations of the panels and the use of photographic enlargements of some of the designs as optional space dividers.

As in most Bayer exhibitions, the entrance to Modern Art in Advertising was converted into a primary assertion about the nature of the exhibition itself, a visual synopsis and précis. In this case, Bayer converted the foyer before the actual exhibition entrance into symbolic crystallization of the idea of sight transforming an art object into an advertisement. He first reconstructed the doorway to the foyer, attaching to the door frame a series of wires that converged at a point in midair where they then passed through holes in a wooden frame loom attached to the ceiling, in the center of which was suspended a brightly striped white cube (alluding to the trademark of the Container Corporation of America); the wires gathered once more and splayed out to penetrate holes in an identical door frame, which was the entrance to the exhibition itself. This dramatic wire sculpture suspended above the sight line of the viewer was a visual homily about sight, imagination, and transformation—and prepared the viewer to acknowledge that many masters of modern art could adapt their visual vocabulary to the language of public communication.

Volk aus Vielen Völkern Ausstellung (Nation of Nations), Bayer's first exhibition in Germany after the war, was mounted by the United States Information Agency at the Kongresshalle in Berlin in 1957. An easy exhibition, it was a photographic elaboration of the incredible variety of native and ethnic communities that form the united people of the United States. Using basically the same technique he had established for Road to Victory, Bayer—working with Nancy Newhall and Ansel Adams—used contrapuntal demountable white display panels to which, in addition to enlarged thematic photographs and smaller suites of reinforcing images, an occasional example of native-American textile, weaving, or rug making was added for textured color; also used were unobtrusive cylindrical or rectangular stands on which American craft antiques (a wooden eagle, a statue of Columbia, native-American artifacts, and other emblemata of America) were situated, and closed vitrines with curved plastic tops in which detailed scale models of indigenous American communities were displayed.

The last great exhibition of Bayer's career as exhibition designer was the enormous retrospective, 50 Jahre Bauhaus (50 Years Bauhaus), first installed in Stuttgart, Germany, during 1968 and traveling thereafter to museums throughout the world. It was drawn from the extensive holdings of the Bauhaus-Archiv (then located in Darmstadt) and supplemented by the private collections of surviving members of the Bauhaus and public and private collections throughout Europe and the United States. Bayer first entered into complex negotiations with the City of Stuttgart and the foreign office of the Bundesrepublik to ensure that all preliminary details regarding financing, intention, installation, coordination between himself and the German committee headed by Dr. Ludwig Grote, the distinguished art historian and museum director, were clearly formulated.

The 50 Years Bauhaus exhibition had resulted from the interest of the Royal Academy of London to mount a major exhibition of the art treasures of Dresden, located in East Germany. The West German ambassador to London, getting wind of this, proposed through the foreign office in Bonn that the Royal Academy be offered instead an exhibition of West German provenance. Having consulted with Grote, an old friend of the Bauhaus, for advice, the ambassador proposed that a large retrospective about the Bauhaus—certainly a movement of international consequence and interest—be funded and produced, and offered it to the Royal Academy as soon as its tour of Germany had been completed.

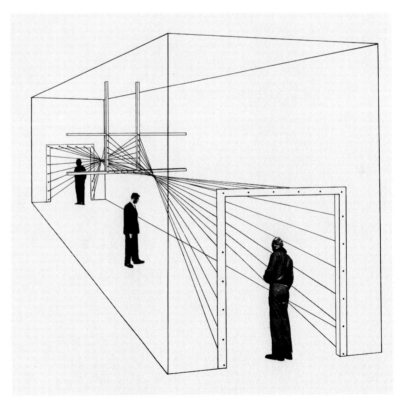

Drawing of entrance area to Modern Art in
Advertising exhibition at the Art Institute, Chicago
(1945). Ropes, twisted from a central frame
to the doors, formed an open tunnel to attract
visitors to pass through long corridor towards
the exhibition entrance.

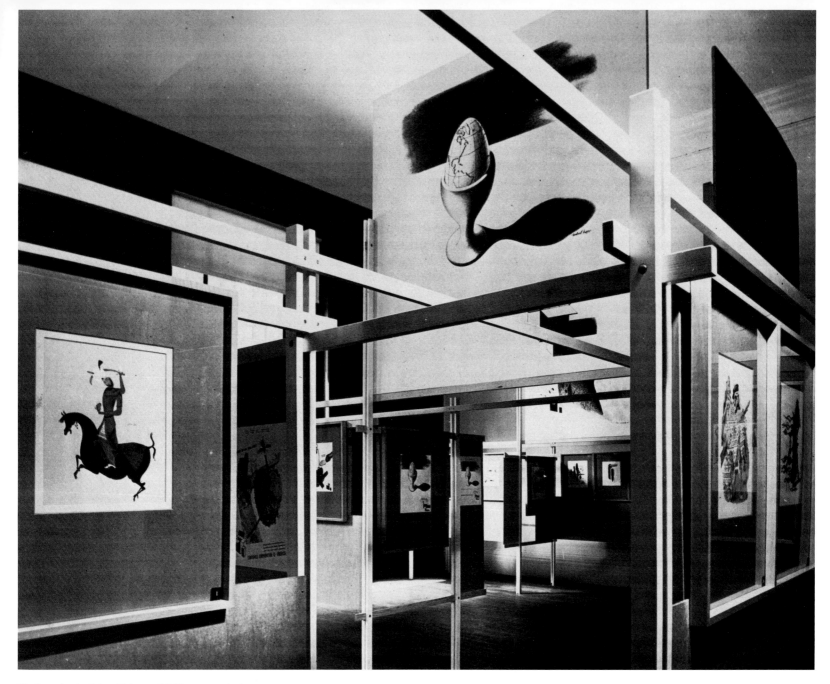

Modern Art in Advertising exhibition mounted
by Container Corporation of America, Chicago
(1945).

Grote, in turn, contacted Bayer, inviting him to design the exhibition. Bayer hesitated before agreeing because he felt that he "did not want to spend time looking backward into history instead of concerning myself with new production, and secondly, I thought it might be interesting for a younger designer or architect to demonstrate the bauhaus by means of an exhibition."[21] Bayer proposed as an alternative designer a younger colleague and friend from his Bauhaus days, Xanti Schawinsky, but the official German intermediaries insisted on Bayer and only Bayer. Although energetic cooperation had been promised by other members of the organizing committee, prior obligations and protestations of work inhibited their active participation, and the essential work of selection and design were left to Grote and Bayer.

The exhibition opened with enormous success in Stuttgart during the spring of 1968. It was later reinstalled in London under Bayer's supervision in the "stylish large 18th century rooms of the royal academy with its ornamented ceilings and very good skylights. the entire academy was painted white at my suggestion. (the director of the academy said to me that I have changed the character of the academy and that she will never be the same.) it was a great success here as well."[22] However, transporting and reinstalling the exhibition at its subsequent locations proved to be extremely taxing. Beyond Stuttgart, installation record photographs had not been taken and no drawings were made of the exhibition as finally built, so there was no point of reference for subsequent installations. Moreover, due to poor coordination, the greatest exhibition of the Bauhaus was never shown in New York City. Characteristically, the Museum of Modern Art declined the exhibition because it had mounted a Bauhaus exhibition thirty years before; the Guggenheim Museum wanted the art without the design and crafts; while the Metropolitan would have been willing to divide the exhibition with the Guggenheim had the former made a binding commitment; and the Whitney Museum insisted that the Bauhaus was not American (although a substantial body of its representative artists and architects were by then longtime American citizens and its future home would be designed by an early Bauhäusler, Marcel Breuer). New York City proved hopeless and, although the Brooklyn Museum was willing, the German Foreign Office considered Brooklyn too far off the beaten track to justify the expense. Negotiations for sites outside New York City, although continually snarled by poor communication and flaccid cooperation, went forward, the bulk of responsibility falling on Bayer to make certain that installation was properly realized. In some cases it was; in others, due to cramped quarters and lost time, the installation was haphazard. Nonetheless, the exhibition proved an international success.

Bayer's design for 50 Years Bauhaus represented his quintessential contemporaneity as an exhibition designer. The early years of the jerry-built and makeshift, forced on him by narrow budgets and lack of space, were completely behind him. An immensity of space was available in the Württembergischer Kunstverein in Stuttgart. There, spacious rooms, high ceilings, and marble floors carried the Bauhaus forward with an atmosphere of opulence quite uncharacteristic of its true history. No effort was made to conceal or deny the luxury that history had

bestowed upon Stuttgart. The first encounter with 50 Years Bauhaus was an entrance display in which three characteristic Bayer proposals were asserted: a tilted white stage on which a giant white cube, pyramid, and globe rested—the geometric signs that Bayer had long identified as the symbolic vocabulary of Bauhaus pedagogy. To the right of the stage stood Bayer's poster for the exhibition, adapting the same elements in a reworked presentation of the famous photomontage cover for the bauhaus zeitschrift of 1928. Where these elements had previously been the portion of the working hand, designing within its limits and possibilities, they were presented in Stuttgart as accomplished realities, affiliated permanently with the colors Kandinsky had assigned to them (a motif repeated on the catalogue cover Bayer designed). To the left, behind the table of solid elements, Bayer presented a Schlemmerlike figure standing in a theatrical box (recalling the device he had used for the entranceway to the Modern Art in Advertising exhibition), surrounded by a tracery of perspectival wires reaching out from all positions before, behind, above and, at a point, alluding infinity in the beyond.

Three pictorial means—drawing, sculpture, graphic design—were used as mutually collateralizing interpretations of the Bauhaus—no longer the Bauhaus of the living but the received Bauhaus of history and the future. A central rotunda contained elegant display cases holding numerous examples of the rough student work in the Vorkurs of Itten, Albers, and Moholy-Nagy; examples of poster and graphic design held simply between plastic sheets were situated on elegant, demountable standing panels; Bauhaus furniture stood on rectangular white pedestals; Schlemmer ballet sculpture protruded from the walls, paintings hung from wires, pedagogic documents and manifestoes were enlarged, architectural drawings, models, Bauhaus graphic work and postcards marched down the length of rooms; one panel attached to a wall and beneath, another tilted outward, resting on running wooden benches with a raised protective lip. White was everywhere. With space abundant, spaciousness triumphed and the Bauhaus had been transmitted into the world of the received, the acceptable, and, ever so faintly, the passé.

Herbert Bayer, along with El Lissitzky, is surely one of the greatest and most influential exhibition designers of the modern period. He rationalized the spontaneous innovations of Lissitzky, turning them from sheer exuberance to calculated planning, maintaining clarity of intention and explicitness of meaning by the use of premeditated tensions and counterpoints. Although he never worked with budgets that might have enabled him to provide the multimedia productions that mark the genius of Charles Eames's technological expositions, Bayer extended the vocabulary and conception of thematic and movement exhibitions; to a considerable extent, Eames picked up where Bayer left off, extending already defined formulations into new dimensions of sound and film. Clearly, however, the proposition Bayer and Lissitzky formulated in the 1920s has held. In the same manner as Lissitzky insisted that the book would be transcended by "living movement"[23] and Moholy-Nagy, working from Lissitzky's presuppositions, argued for a light-controlled environment, Bayer presented the exhibition as the constellation of all available means. No

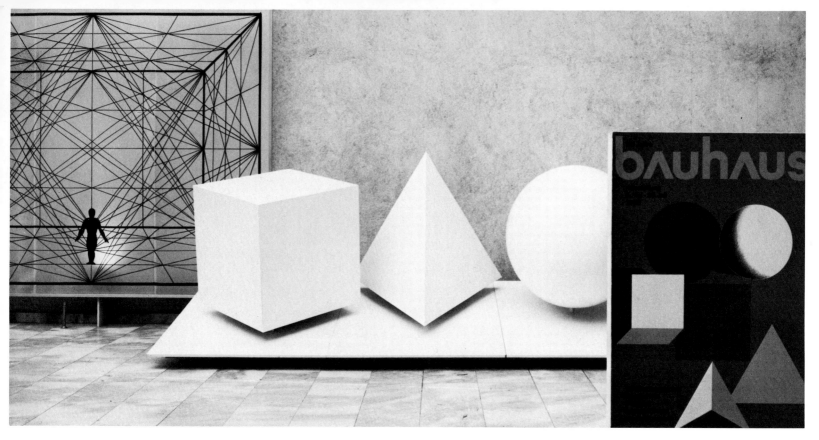

Entrance to the 50 Jahre Bauhaus Exhibition at the Württembergischer Kunstverein, Stuttgart (1968).

Reconstruction of giant Schlemmer theater figures used in the Triadic Ballet for 50 Jahre bauhaus exhibition, Stuttgart (1968).

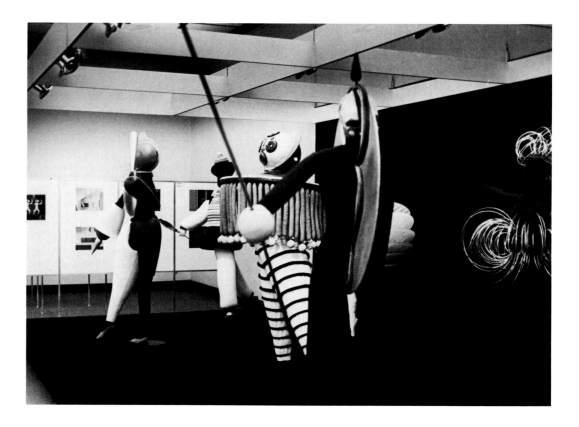

Exhibition Design and Architectural Design: 1928 – 1968

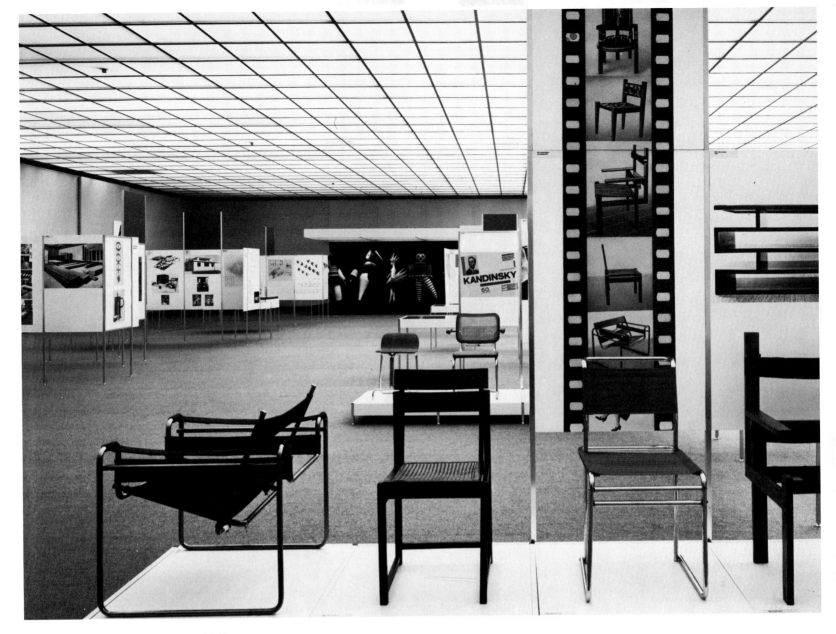

Interior of the 50 Jahre Bauhaus Exhibition,
Stuttgart (1968).

longer would Bayer allow the exhibition to be read as frontal narrative lineation. The exhibition–most successfully realized–would require no direct, explanatory text. The exhibition would be the text (and all additional tagging would serve only to identify, not explain), as it was in Road to Victory, Airways to Peace, and Volk aus Vielen Völkern.

The function of the texts provided by Carl Sandburg, Wendell Wilkie, and Walt Whitman to these three photographic exhibitions is lyric counterpoint, neither explaining nor even interpreting but supplying a verbal tape complementary to the visual narrative. Everything else that Bayer invented or used to new advantage by way of technical devices–novel means of clamping and bolting, unusual panels and demountable struts–was secondary, even tertiary, in importance. The revolution in his method of installation was that, for the first time, he had asked the questions: how does the viewer see? how does the viewer receive impressions? how will the viewer think? Having posed these questions, the determination of the obligatory preliminary model, the installation photographs, the enacted drawings provided him with an ever-expanding vocabulary of form with which to go on producing innovative exhibitions. For Bayer, the exhibition is the place where painting, sculpture, and graphic design (with architectural space) converge. The exhibition is the primary testing ground for their interaction, where all the means of visual communication are present and must play their part in expressing a complex form.

Architectural Design: 1946–1965

The concentrated period of Bayer's architectural design does not much exceed a decade. Although he had been involved with architectural drawing since his youth, with schematic reflections on the transformation of geometrical forms into building materials,[24] with isometric drawing, and projects for De Stijl-like kiosks and display stands, he had not actually executed an architectural commission prior to the Sun Deck Ski Restaurant, a simple octagonal wooden structure (with an inverted roof to retain water for heating purposes atop Ajax Mountain in the Aspen complex (1946). Even that project was not succeeded by others for several years, although he was involved by Container Corporation of America in numerous architectural projects for their various corporate offices and factories during the years before he began to design the Aspen environment in the early 1950s.

Bayer was licensed on April 1, 1960 (without examination), to practice architecture in Colorado. As he had had no formal architectural training, he generally associated with an architectural firm to see through dealings with contractors and other technical professionals. In 1959, in conjunction with various architects, Bayer had undertaken for the Container Corporation of America the construction of a series of factories, papermills, and folding plants entailing module construction, requiring considerable density of space use for the large machinery involved in the paper fabrication industry, and leaving little room for the elegancies of architectural imagination. Clearly, the most engaging of Bayer's buildings for CCA was the Valley Forge Research Center in Oaks, Pennsylvania (executed in conjunction with Don Harms, the staff architect

of Bayer's department of design, and Norman de Haar). Built of precast, prestressed concrete posts and horizontal concrete channels that projected beyond the curtain wall to enhance its formal and plastic distinction, with exterior walls of blue glazed brick and gray tinted glass, the center's agreeable facade was complemented by a single generous interior feature, the lobby, which is two stories high and provides circulation to the upper offices by means of a bridge on the second floor. No space was left over for fantasy.

What Bayer lost in the interior was made up by his landscaping of the circular garden outside, involving rings of trees, one earthwork resembling Grass Mound, and another with negative and positive depressions. Moreover planted stairs lead from the garden to a sunken terrace that opens into a basement cafeteria in the main building. In all the detailing of the relation of building to grounds, Bayer has maintained his tutelage to the spirit of the Bauhaus where the notion of gardens amid architecture, the avoidance of applied decoration, the planned disorder and heterogeneity of the architectural environment is realized.[25] The Valley Forge Research Center, Bayer's most inventive corporate architecture, had the tightest budget, and if this was prohibitive of any architectural beau geste, one can imagine what other buildings for that corporation demanded by way of efficiency, in the ratio of space for machinery to space for movement and fluidity. All of the other buildings throughout the United States and Europe are marked by maximum use of brick walls or an aluminum skin over a steel and concrete structure in order to achieve cleanness of line at minimum cost.

Bayer could not have been significantly challenged by the problems he addressed for CCA. The evolving architecture of the Aspen Institute for Humanistic Studies was a quite different situation. There the need was for nothing less than total visual integration; articulation not only of solutions to problems he had not contributed to defining but engagement in the entire process of identifying the environment, describing its condition (virtually unaltered since the late nineteenth century), projecting the image of Aspen's future, locating the terrain where its cultural hub would be situated, and producing the architectural scheme for its clarification and expression. Unfortunately, Walter Paepcke, under whose auspices Bayer had come to Aspen in 1946, was opposed to the idea of a master plan for Aspen. Bayer, trained by the experience of the Weissenhofsiedlung in Stuttgart (1927), the various programmatic communities of the Deutscher Werkbund, and Gropius's Dämmerstocksiedlung (1927–28), was all for an overall plan–not necessarily a plan that inhibited free expression but one that took account of possible alternatives, anticipated them, and set forth standards for building, maintenance, and growth. The difference in their approaches was finally between democratic planning and consultation and the chaos that has now overtaken Aspen. Then–during the mid-1940s–it would have been possible to establish an overall program for controlled growth and development not only of the grounds occupied by the buildings of the Aspen Institute but for the whole community as well; however, opposition and the resulting absence of a master plan (although it did not forestall Bayer's conceptual organization of the projects of

Valley Forge Marketing & Research Center
for Container Corporation of America, Oaks,
Pennsylvania (1959); supervising architects
and engineers, Pace Associates.

View of lobby, open stairwell, and bridge leading from second floor to folding carton plant at Valley Forge Marketing & Research Center of Container Corporation of America, Oaks, Pennsylvania (1959).

the Aspen Institute, what he has termed his "secret concept of a master plan"[26]) permitted the rest of Aspen to succumb by the 1970s to a spiraling of real-estate investment values, commercialization, and the triumph of sheer tourism.

Nonetheless, the achievements of Bayer's architectural scheme for the Aspen Institute are impressive, despite small budgets and the lack of trained workmen and skilled contractors in the Aspen area. Walter Paepcke early acquired a substantial tract of land outside the city proper, which was subsequently acquired by Robert O. Anderson and donated to the Aspen Institute. It was intended that this land be developed as an integral community of buildings to serve as a meeting place for educators, philosophers, scientists, and artists, and as an annual site for the Aspen Music Festival and the International Design Conference. It was and remains the interest of the Aspen Institute to encourage leaders in business, government, the professions, and academia to gather for the exploration of fundamental philosophic and moral ideas that supply structure to the social and intellectual programs of twentieth-century life. The first building completed in the Aspen complex was the Seminar Building (1952), intended for large and small discussion meetings; a hexagonal room design facilitates direct encounter between all seminarists and avoids, by its shape (and the interior furniture designed to express it), any formal distinction between teacher and learner. Using basically simple and readily available prefabricated materials, Bayer designed a steel structure, without supporting posts within the rooms. The walls were of double thickness with cinderblock on the outside and masonite panels within, ceiling surfaces broken by geometric designs intended to afford "a sculptural effect and improve acoustics."[27] The cinderblock of the exterior walls employs a repeat-pattern, in which some of the blocks are allowed to protrude, creating a light-shadow contrast complementary to the sgraffito mural Bayer designed to reflect the movement of the surrounding mountains and valleys.

There followed a series of guest accommodations incorporated in the Aspen Meadows guest chalets (1954), which were oriented to various sun exposures, with balcony dividers in blue, red, and yellow and based principally on wood construction with transite or concrete block walls. These chalets were all easily accessible to the Central Building (1954), which contained the restaurant, lounges, offices of the institute, built from cinderblock with local stone, with a roof fashioned of precast concrete channels whose openings were glazed for clerestory light. The Health Center (1955), designed with Frederic Benedict (as were the earlier Aspen Institute buildings), was the first building to break from the basic utilitarian functionalism of the meeting center, chalets, and central office building and restaurant. Employing identical prefabricated concrete elements for walls and roof, Bayer designed a building distinguished by its essential Gropius-style concrete shell with frontal glass facade. However, the use of prestressed concrete forms for roof and wall with bolted connections allowed a rhythm that was intensified by the numerous graphic elements Bayer introduced into the mural signage and the circular steel stairs (suspended from a central post) leading to the solarium.

In 1962, Bayer designed the Walter Paepcke Memorial Building, which consists of a series of hexagonal volumes integrated by means of a white neoprene roof with the existing hexagonal structure of the seminar buildings. Three main areas–for offices, auditorium, and library-gallery–are unified by a centrally positioned lobby. The white neoprene roof, which settles low upon the concrete and cinderblock structure, expresses a sculptural quality common in Japanese pottery and appropriate to Bayer's essentially sculptural interpretation of architectural form. In the same year he designed an engaging, simple structure, utilizing redwood over cinderblock for the Institute for Theoretical Physics.

The most original and formally engaging of Bayer's architectural program in Aspen is undoubtedly the Music Tent designed for the Music Associates of Aspen in 1964. To provide seating for about 1,400 people, Bayer developed a canvas tent adhered to a suspension system from steel columns and cables and opened and retracted along conductor cables from a tension ring at the center. Walls in pleated plywood and graduated concrete floor surround the stage, which is sheltered by a cantilevered acoustical roof resting on beams between two columns and suspended by cables. A musician's building economically fashioned from cinderblock with a white neoprene roof connects to the stage entrance at the rear. Seating is capacious, canvas colorful, air circulation through the canvas aperture salubrious, and the stage and its baffle system acoustically sound, making this modestly built tent one of the most attractive and efficient in the country.

Bayer's house (1959) and studio (1950) are among the more intimate personal residences he designed in Aspen. Located among glacial builders, scrub oak, sagebrush, Aspen trees, and meadows, they were designed for solitary work, distant from any other dwelling except on the other side of the valley, overlooking the Roaring Fork River and the city of Aspen hidden in the meadow below. Using rectangular box format, with convergent walls to enhance the working area along the north wall, Bayer contrasted the flat open space of the studio with a sunken area at the south wall where the view of the mountains was extraordinary. The house, with its cantilevered terrace, was carefully positioned to catch maximum light, while the colors on the north wall were situated to avoid snow reflection during winter. Fashioned with natural pine or pine stained dark brown, the house has a rustic simplicity, distinctly related to the boxlike construction already developed by the California architects Neutra, Soriano, and others.

If Bayer's home of 1950 is simplicity on modest means, the private chapel he built in Hondo Valley, New Mexico, on Robert O. Anderson's Circle Diamond Ranch can only be described as opulent simplicity. Originally formulated as a structure that would resemble the familiar, quasi-baroque seventeenth-century churches in the Mexican countryside, it was modified by Bayer to reflect the use of local adobe sculpturally fashioned "to shape the architecture in contrast to the existing stone elements. I wanted to combine the traditional elements with a contemporary sculptural design concept. this contrast is also carried out in the white coloring of all the adobe work in contrast with the pink brown sand-

stone. the red brick of the patio floor and the dark gray stone of the north terrace correspond to this concept."[28] Bayer utilized two baroque architectural features from Mexico–the bell tower and a sandstone portal from Guanajuato that was incorporated into a modern sculptural structure of four concave walls. The walls, bending outward and unjoined at the corners, were only connected by the floor-to-ceiling windows; the roof was hyperbolically shaped as well and contains one round skylight. One enters the chapel through a walled-in brick-paved yard of flowering crabapple trees. An elegant combination of sensuously curved adobe and baroque elements from seventeenth-century Mexico, the interior furnishings were either designed by Bayer (principally, the fitted carpet originally to have been woven in India, but subsequently woven in this country) or were selected antiques (a Romanesque baptismal font, a twelfth-century Flemish madonna set on a tenth-century Italian capital, a fifteenth-century Spanish iron gate).

Architecture was always a tributary activity in Bayer's total design practice. It was a secondary consideration, serving prior formal interests that were either graphic or sculptural in nature. His most successful buildings were those that employed an eccentric geometric shape or relied for their effectiveness upon starkness of color coupled with sensuosity of form. Bayer had relatively few opportunities to practice architecture, and those were always subservient to his occupation as overall design consultant and coordinator; he was continuously hampered as well by constricted budgets and demanding schedules for completion. It is for this reason that he originally demurred at the inclusion of architecture in this book, regarding it as an activity in which his work was outstripped by the rapid developments in both the technology and the direction of contemporary architectural practice.

Wheeler Opera House restoration, Aspen, Colorado (1950–1960).

Overall view of the Aspen Institute for Humanistic
Studies, Aspen, Colorado (1964).

The Seminar Building for the Aspen Institute
for Humanistic Studies, Aspen, Colorado (1953);
associate architect, Frederic Benedict. Sgrafitto
mural by Herbert Bayer.

Health Center, Aspen Institute, exterior gymnasium wall (1955). Associate architect, Frederic Benedict.

Health Center at the Aspen Institute for Human-
istic Studies (1955).

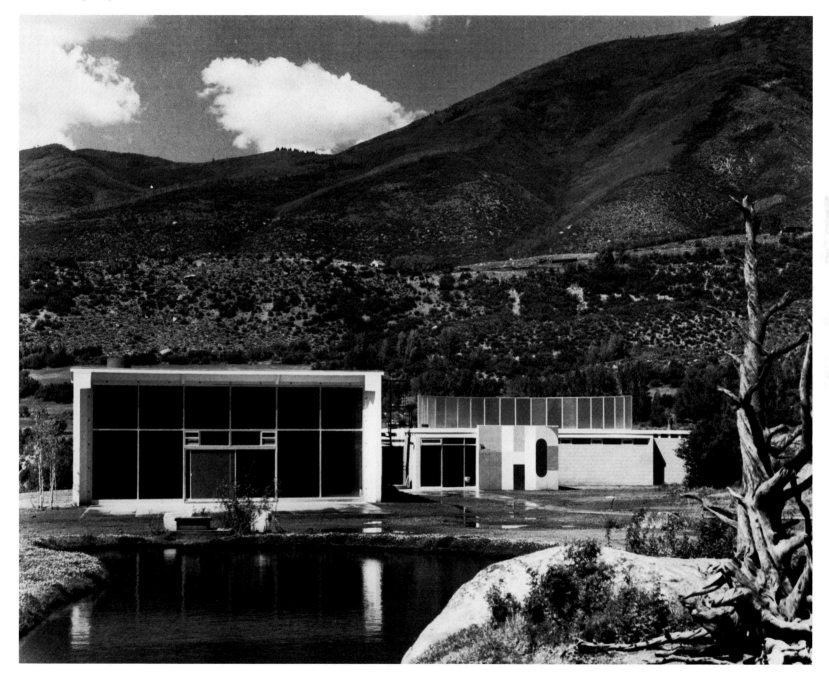

Walter Paepcke Memorial Building, Aspen
Institute for Humanistic Studies (1963), Aspen,
Colorado.

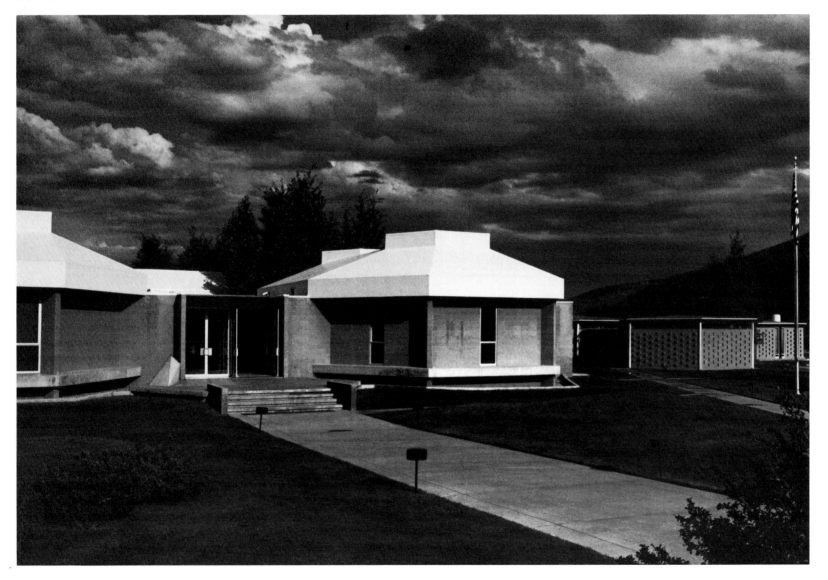

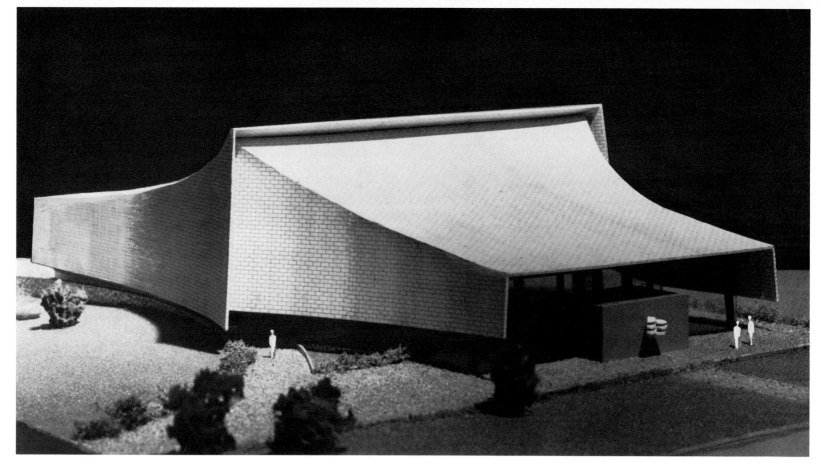

Photograph of model of Music Hall for the Music Associates of Aspen (1964).

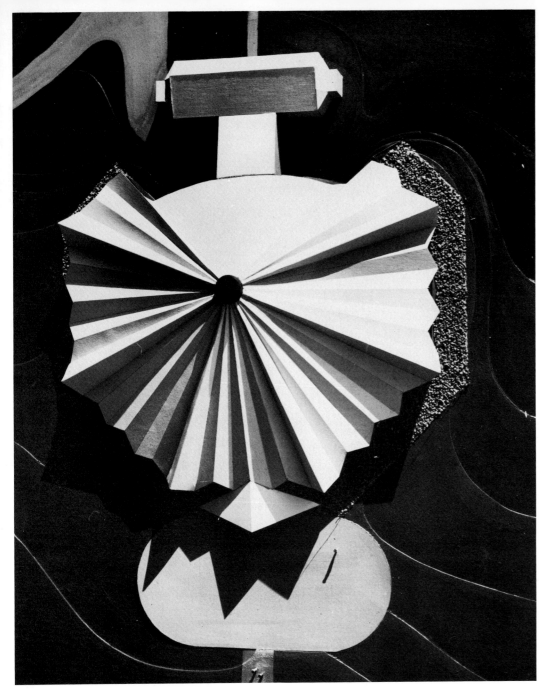

Photograph of model for Music Tent, Aspen,
Colorado (1964).

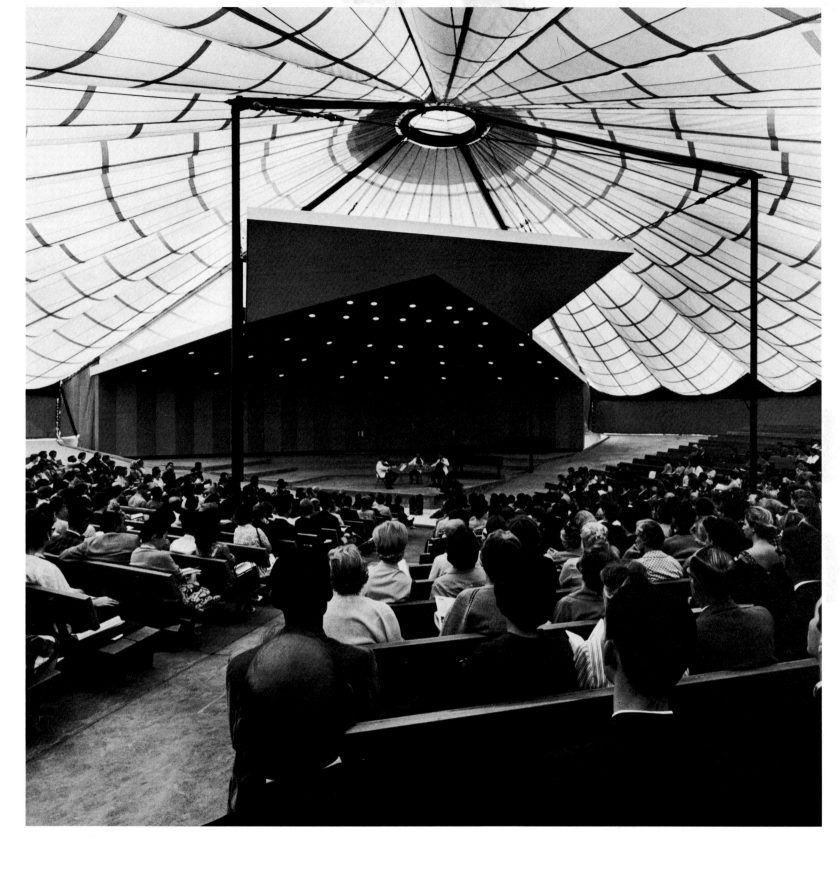

Interior of Music Tent, Aspen, Colorado (1964).

Bayer studio on Red Mountain, Aspen, Colorado
(1950).

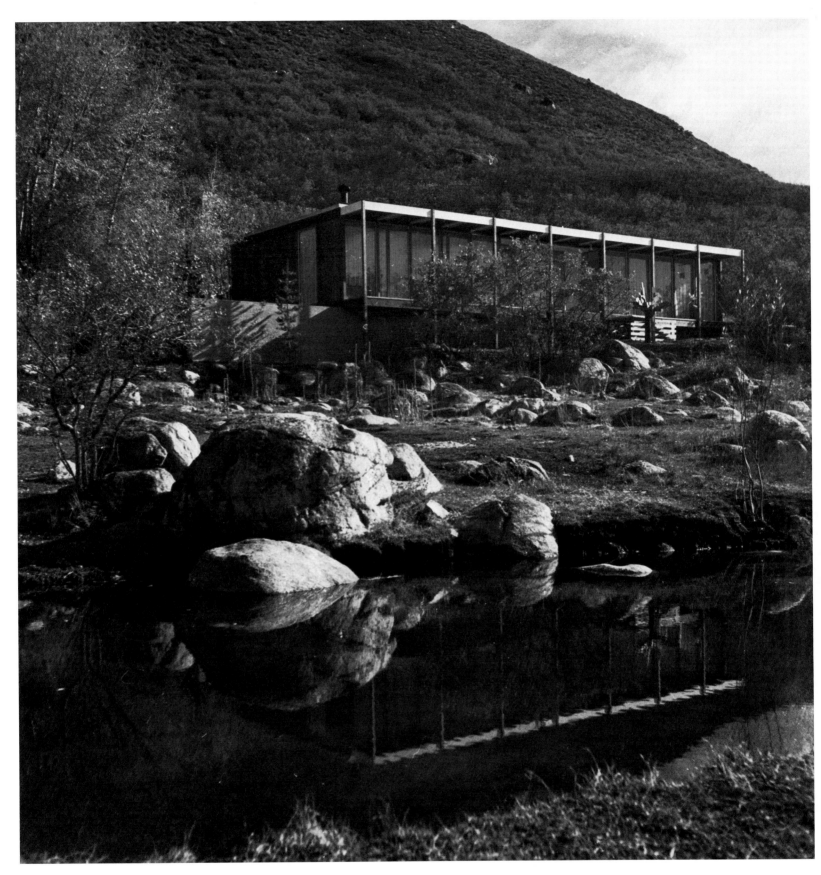

Bayer house in Aspen, Colorado (1959).

Floor plan of chapel for Robert O. Anderson,
Hondo Valley, New Mexico (1962).

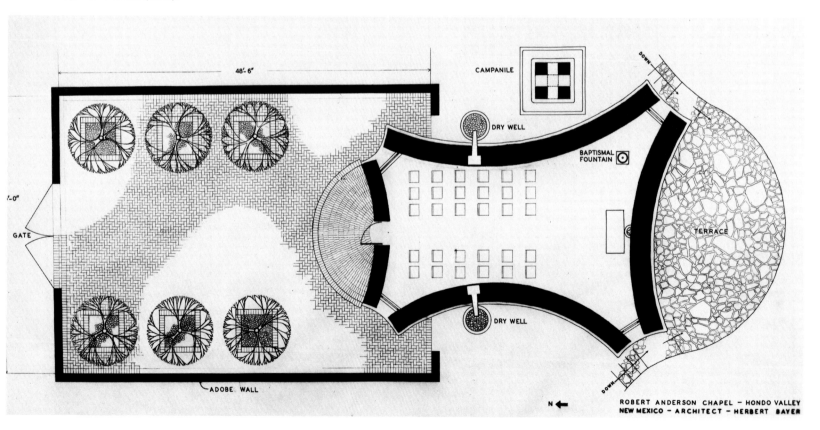

CAMPANILE

DRY WELL

BAPTISMAL
FOUNTAIN

48'- 6"

TERRACE

GATE

DRY WELL

ADOBE WALL

DOWN

DOWN

N

ROBERT ANDERSON CHAPEL — HONDO VALLEY
NEW MEXICO — ARCHITECT — HERBERT BAYER

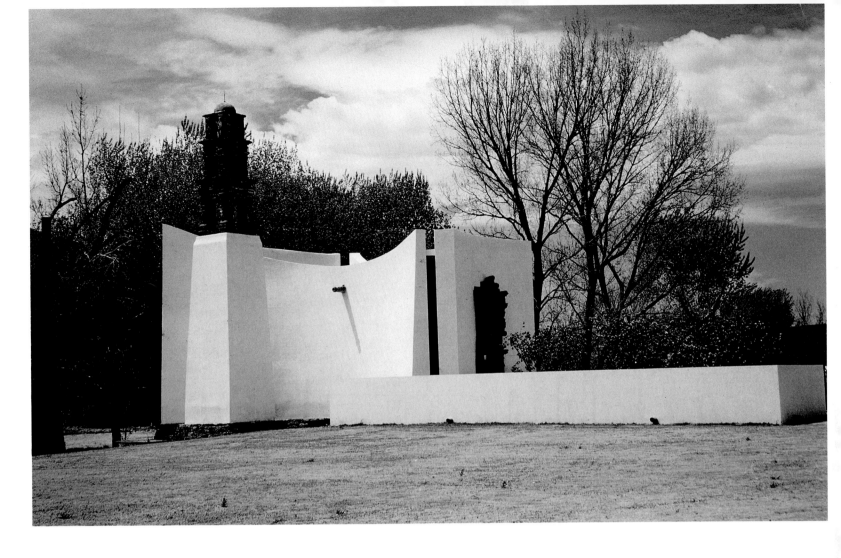

Robert O. Anderson Chapel, Hondo Valley,
New Mexico, 1962.

III. *Selected Writings by Herbert Bayer*

Over the years, beginning with his earliest essay in the special number of *Offset* (1) devoted to the Bauhaus, Herbert Bayer has been commenting on his activity as a visual communicator. His published writings have dealt principally with the range of applied arts to which he has devoted considerable professional time, although his activity as painter, sculptor, and maker of environments has been addressed in his private writings with no less significant comment.

In this anthology of his writings, I have tried to avoid repetition of well-known essays or aspects of his work that are now part of the common property of contemporary artists and designers. His work as a type designer has been covered by numerous essays, no less his activity as a graphic and exhibition designer. Instead I have chosen to bring forward brief essays and longer annotations of his work as painter and sculptor, since both the work and his annotation of it is less familiar to the large audience that already knows his activity as a designer. Similarly, although his work as a photographer played a considerable role in the formation of the avant-garde of the 1920s and '30s, his writing about photography is generally unknown. The interested reader will find some fascinating documentation of his work in the appropriate section of the anthology that follows. Generally, I have followed the structure of the book; a body of reflective and general statements that set forth Bayer's personal attitudes and values serves as an introduction.

In 1967, Reinhold Publishing Corporation, New York, published Herbert Bayer's own visual narrative of his career as painter, designer, and architect (*herbert bayer: painter, designer, architect*). Bayer wrote several brief essays to introduce the various domains of his work. In addition, essays, comments, and annotation that were drawn from previously published writings have been included, sometimes in edited and amended versions. Since I do not wish to repeat any of the previously published materials in this selection of Bayer's writings, there follows a sequential listing of materials published in the Reinhold volume. Materials original to that publication are so indicated by an *O* following the title; materials republished in the same or amended form from earlier publications are supplied with their source, keyed to the bibliography and the page on which they appear in the Reinhold volume. preface (autobiographical document; *O*), pp. 9–13; "toward a new alfabet: the 'universal' type" is an original essay based on three earlier versions of Bayer's discussion of "Versuch einer neuen Schrift," which originally appeared in *offset* (1), "folgender versuch einer neuen schrift bezweckt" (1927), which was not published, and "towards a universal type," written in 1935 and, according to Bayer, poorly translated for publication in *PM Magazine* (12:27–32), p. 4; "design analysis of five posters" (an amended version of "contribution toward rules of advertising design," *PM Magazine* (12:6–11), pp. 46–47; "on typography" (an edited version of "On Typography," which was published in *Print* [24:7]), pp. 75–77; "basic alfabet" (appeared first as "basic alfabet" in *Print* [37]), pp. 78–80; "design as an expression of industry" originally appeared under the same title in an issue of *Gebrauchsgraphik* (19) dealing with the activities of the Container Corporation of America, pp. 86–95: preface to *World Geo-Graphic Atlas* (20),

pp. 96-103; "aspen" (*O*; followed by illustrations and comments), pp. 112-113; "on environment" (edited version of original text delivered at the International Design Conference in Aspen, Colorado, 1962, and published subsequently in *New Mexico Architect* [34]), pp. 142-150.

Source information will be found at the conclusion of each selection. The writings are keyed to the bibliography for fuller documentation. Material appearing in this volume for the first time is drawn from Herbert Bayer's private archive in Santa Barbara.

goethe and the contemporary artist (1949)

if this celebration is to be a genuine reconsideration of goethe, it means discovering a connection between his work and our experience, actual or desired, and today we speak in particular of esthetics and art, painting, sculpture, architecture as experience.

goethe, as we know, was poet, playwright, critic, man of letters. he studied art and exercised it to some degree. a considerable part of his life was devoted to observation and experiments of all types of life, of "higher" plants and animals. in physics his best known work is on color, "optical," as he calls it. he held important posts in the court of saxon-weimar as minister of state, superintendent of mines, director of the theater.

great genius that he was, I believe that goethe's talents as a painter have been vastly overrated. moreover, I cannot trace any connection to speak of from his art directly to contemporary art. it is a curious fact that, with his deep interests and extensive work on the physiological aspects of color, there is no traceable relationship between him as a practicing artist and as a theorist on color. neither did he seem to have had any exchange of ideas on that subject with the painters of his day.

but if we investigate some of the other great interests in his life, I believe we see several points of immediate concern and exemplary value to artists today. one of them is his approach to nature. in his scientific studies of living nature goethe was first of all attracted by the outer appearance of natural form. it was the study of the living shape as assumed by nature that fascinated him all his life, and it was he who gave this science the name of morphology. the abstract, detached thinking of the scientist, pursuing experiments and details for the sake of knowledge only, was foreign to the mind of the artist of his time. a basically visual approach is evident in his work as a naturalist. from his italian travels we know his exciting experiences with the variety of shapes of plants and leaves which the rich vegetation offered his eyes. whenever he speaks of memories and fantasies they are an imagined pictorial order. in the animal world it was individual form that interested him. that he even classified the shapes of clouds is another proof of his extraordinary visual sensitivity. in short, he would be characterized as the "visual" type by a psychologist today. from scientific observation he expected *anschaulichkeit*—obviousness, evocativeness. but he dispensed entirely with the abstract of mathematics. in conversation he once said: "we talk too much, we should talk less and draw more. as for me, I should like to renounce the word, and, like plastic nature, speak only in images. this fig tree, this serpent, this cocoon exposed to the sun before this window—all these are profound seals; and he who can decipher their true sense, can in the future do without spoken or written language. . . ."

it should be significant to us that this quotation was used by the surrealist painter, andré masson, in place of a foreword to his book, *anatomy of my universe*. and it sounds as though spoken by a modern painter when goethe says: "all that we perceive around us is merely raw material; it happens rarely enough that an artist attains the beautiful exterior to penetrate into the depth of things as well as into the depths of his own soul, in order to produce not

only something effective. . . but, as a rival of nature, to produce something spiritually organic. . . ." the predominance of the visual sense in his interpretation of nature strikes me as being in direct relation to the psycho-visual trend in modern art—surrealism.

the second factor is goethe's concept of classicism. the antique world was for goethe the most humane expression of man's aspirations. to give visible form to it he believed to be the highest problem of art. he insisted that all true culture should be based on that of greece, and that classic languages should be the backbone of education. greek sculpture was to him the ultimate in perfection, as he believed the human body to be the last word in organized form. the greek ideas of the harmony of the universe and the importance of form were ever present. for goethe's contemporaries, the imaginable world was considerably smaller than ours and its conceptions still closer to the greeks. since then discoveries, transforming our cosmos, made the established laws of physics tumble in their very foundations, and enlarged our universe a million times. space has been expanded and, with relativity, a fourth dimension has been added.

I do not contend that these new conceptions are generally understood by the man in the street, but they embody something new whose visual documentation the artists are searching for. it is understandable that in this search our thoughts go back to similar situations in the past. in the history of art we observe a periodical rebirth or renaissance of the antique. even contemporary revolutionaries like picasso have passed through periods of the revival of greek ideals of beauty and monumentality. the hellenistic inclinations will always be of certain importance to the artist because of the established ideals of beauty, but, although such revivals have temporarily been in the foreground, they obscured basic forward-moving cultural tendencies.

every period, if true to itself, must create its own cultural expression out of its specific place in time and history. no nostalgia for bygone established entities like the antique can help us to discover where our problems are. this is an ever-changing world.

a third aspect is goethe himself as a genuinely "universal man." we may say that goethe was the last of the aristotelian geniuses to span with equal enthusiasm all fields of human activity. but there is a tendency to regard him with reservations in respect to his manifold interests. we may wonder whether goethe, the artist-genius of letters, had suffered dilettantism by his divided sympathies as statesman, philosopher, student of art, etc. great art is conceived, not only instinctively, but from the common experiences of life as well, and goethe's great strength was his ability to transform the realistic into art. I would rather say that his greatness benefited by these practical experiences. his divided attentions are evidently responsible for some delays or incompleteness in a few of his works. he might have been dissatisfied with the entanglements of court life in weimar. his journey to italy evidently was a flight away from his burdensome duties to the freedom of the artist.

there was much suffering in his life, but it was transformed into productive experience. he said once: "I have always been praised as one who was especially favored by fortune. . . but at bottom it has been nothing but toil and trouble, and I think I may say that in all my seventy-five years I have never known four weeks of well-being."

it is this fact in his life that should be of interest to the contemporary artist. a creative person must be drawn into the problems of his time. why should an artist be spared and separated from realities and be made escapist? would not art end as pure self-expression if it does not participate in our life on common grounds? art has become quite removed by such isolation, and a new integration must be effected.

goethe as a man still stands as an example. as a poet and thinker he still speaks with the greatest force to the individual, since individual life has remained much the same. as artists we may remember that he looked at everything not only with his mind but with his senses and his heart. to miss this would be to miss the meaning of goethe.

(Delivered at the Goethe Bicentennial Convocation, Goethe and Art Today, in Aspen, Colorado, on June 23, 1949. Published in *College Art Journal* [17] and reproduced here with slight alterations, restoring Bayer's original introduction to his delivered text.)

credo (1962)

my work seen in its totality is a statement about the integration of the contemporary artist into an industrial society. I believe that the artist must achieve creative control over the whole of his environment.

my image, varied by the diversity of subjects in which I am interested and the many techniques I employ, stems from the realization of an intensified and extended language of vision. its wide range includes the examination of our alphabet, the shorthand language of symbols and posters, communication with most visual media, including techniques for three-dimensional exhibition design and the shaping of architectural spaces for man's use.

while the art producing process differs in some ways from that of giving form to useful things, the motive remains the same.

basically, I have always been a painter, and for me it does not mean crossing a boundary from design to art when I paint. the difference is only that in art, function is within the painting, while in design function is external.

for many years I have been attempting—by means of observation and contemplation of nature—to portray the world as transformation, as change and dynamism.

sensing man in his undefined relationship to powers beyond himself, I have now come to a more formal and serene conception. a symbolism of the round form above, towards and of the geometric structure below has evolved an expression of man's metaphysical aspirations. these juxtapositions are emotional, but they are also expressions of a desire to reduce the elements of a picture to their essentials in form and color.

concern with the pure elements of design is exemplified in the "linear structures" where ambiguous spaces are manipulated to form structured images of an architectural character. these illusions of space are pictures of a world which I like to view as an ordered entity.

(Bayer prepared various versions of his credo, employing elements of it in a variety of statements that appear in his manuscripts at a later date, but this version of 1962 seems the clearest, although it does make specific reference in the concluding paragraph to the "linear structures" paintings that he had begun in the early 1950s. It is published here for the first time.)

walter paepcke: prose poem (1960)

I speak of walter paepcke
as of my great friend

it is hard to realize that I do not
see him any more at his desk
with a warm and friendly greeting
a teasing remark a cynical beginning
not any more
at the entrance of the hotel jerome
with open shirt and baggy pants
greeting guests which he loved to do

no more in conversations
turning from music to musicians
to production of packages
to civic developments in aspen

we talked in airplanes in sleeping cars
of the california zephyr at picnics under trees
at the bank of a mountain stream in crystal
anywhere

he loved to talk
not about past or established things
not about news always about projects
new ideas analyzing and probing
into new areas exploring
unknown fields

his mind untiringly on the go
active brilliant daring
there was nothing he took for granted

when in preparation for the goethe bicentennial
it was thought that the presence of albert schweitzer
would be appropriate
but that he had refused an invitation
he did not accept this statement
and brought schweitzer to aspen
everybody has a weakness or a price he used to say

his thoughts
always followed a clear and personal logic
no mere fantasies they were founded on reason
argument and documentation rejecting
anything believed to be immutable
listening to opinions and their opposites he would

argue against his own beliefs to hear
what others had to say
then drawing conclusions making his decisions

his mind never worked in ordinary ways
entirely independent (sometimes seemed removed)
often going in loops and somersaults
once made up
he pursued an idea relentlessly

his great sense of humor drew him
to humerous people

a great teaser he called me schnooky
to my embarrassment even
in business meetings

not that there were no differences of opinion
when there were diverging or
opposing beliefs he would
pat me on the shoulder
and say that *it wouldn't be fun
if all people would think alike*

he respected independence of thought
discarded the conformist

ready at any time
to catch one off guard to trap one
unawares in the webs of his schemes

hard on the surface
admitting of no weakness
not showing any softness
he had a warm heart radiated affection

praise left his lips only indirectly
and admiration was not shown in words
but in acts of confidence

like a child clings to its toys
he held on to objects he was attached to

in his old office he sat elegant and confident
at a double roll top desk which
had belonged to his father
the desk a shapeless relic but
to him a cherished piece with memories

only extended manoeuvers when I designed his new office
could pry him loose from it
this attachment to tradition rather
endeared him to me

how much his heart was in aspen I perceived
when he discussed in a meeting
a summer folder for aspen
a small expenditure

on the same day at container there was
in a meeting in record time
a very large budget approved
for the world geo-graphic atlas

next day he asked
didn't it go well yesterday?
and I expressed appreciation
of this unanimous and important decision

he brushed this aside and said
oh I didn't mean that
I meant the aspen folder

a business man with
too much imagination to be satisfied to solve
problems of what he called the profanity of boxes
he turned to design to answer his
aesthetic cravings in a world of industrialization
but it would be wrong to think that
he would ever forget himself to
accept design or art for art's sake only

there had to be purpose and reason
it would have to be justified within
the context of a business plan

one of his qualities was that
in most instances he knew to choose well
a collaborator and when he was certain
of a good choice he relied upon
the person's abilities without
interference on his part

relentlessly driven by his imagination
the demands upon him and
the stresses and strains of aspen's projects
reflected on his composure made him
at times unreasonable and difficult

only those who faced with him
the lack of understanding
the petty oppositions
know the magnitude of his efforts
the tensions he suffered by lack of sympathy

not well enough known and still not
believed here the sacrifices he personally made
to cover unselfishly financial losses
still more a privation as he was not a rich man

witty and often cynical
he was a formidable opponent
respected feared and loved

an extremely hard worker

he would not understand when others
did not follow with his same devotion and energy

not that his pace diminished in later years
but he mellowed towards the tasks
he had set himself and looked
upon life with philosophical smile

his plans to improve on life were
not so much material
as idealistic himself being
a frugal man who often said
what would I need more money for
I can only sleep in one bed

can only eat three meals a day

he was not an easy spender unless
he was certain of the good of it

with restrained enthusiasm he liked to
speak of his projective thinking

once at his ranch in larkspur
he talked on a long evening
about creating many aspens
to develop the natural springs of colorado
a day's drive from each other
into spas with bathhouses and all
I would do the designs
he had all figured out
down to the rentals of towels

courageous
he would face anything in life
he could have walked into a room full of devils
and not batted an eye

the most courageous
when he was facing the end

it is hard to realize that he is
no more walking among us because
everything here
reflected from him
or came through him
or reverted to him
who made so many decisions
took on so many cares

walter's ashes
are now in an aspen grove
looking over the valley
where his imagination roamed
where his dreams took form
where he was often misunderstood

to his strong convictions
to his independence

I pay tribute
I think of him
seeing the community of man
aspire to higher planes
to deeper understanding
improving human relations
and useful goods
towards a more complete life

I think of his concern with education
with the morals and ethics of man

I acknowledge what he has done for many
I thank him for what he has meant to me
his plans far from completed
are here for his friends to continue

(Herbert Bayer's close friend and earliest American patron, Walter Paepcke, died suddenly in May 1960. This poem of homage and grief was written during the early summer of 1960 and was published in *Print* [29] in September 1960.)

about moholy-nagy (1965)

moholy-nagy was already an established painter when he came to the bauhaus. as a constructivist he brought an individual and new orientation to the bauhaus.

seen today from a distant perspective, he was already one of the most forceful agents of the formulation of new ideas, in the exploration of new areas, toward the molding of the bauhaus as a school, and particularly in the dissemination of the bauhaus philosophy and of new concepts of art in general (mention only his editorship of the series of bauhausbücherei).

it was moholy who opened the eyes of a generation to the new aspects and possibilities of photography and film. he inspired many with his interests and his concern with typographic communication was equally influential.

as an educator, he made a fundamental imprint on design education in the united states. one of his great contributions, as a thinker and writer ahead of the times, is the brilliant chapter on space in his book *vision in motion*.

the lack of direction in art today obscures temporarily the recognition of his contributions to art in a new context. the arts of the world have suffered a great loss in his untimely death, but future history will reestablish him as one of the moving forces in the concept of a new vision of this century.

(László Moholy-Nagy died in Chicago of leukemia on November 24, 1946. On October 6, 1965, Bayer wrote this brief testamentary homage, which is published here for the first time.)

homage to gropius: prose poem (1961)

he was in his office
at the van de velde-bauhaus building in weimar
when I first met him
presenting my work
to become a student at the bauhaus.

above his desk in the spacious high ceilinged room
hung a cubist léger.
there was also a medieval architectural drawing.

gropius wore black trousers, white shirt, slim black bow tie
and a short natural colored leather jacket
which squeaked with each movement.
his short mustache, trim figure and swift movements
gave him the air of a soldier
(which in fact he had been until recently).
gropius's manner of dress was in contrast

to the generally fantastic individualistic appearances
around the bauhaus.
it was a statement of his opinion
that the new artist need not oppose his society
by wearing dress which, to begin with,
would set him apart from the world he lives in,
that the first step toward common understanding
would be acceptance of such standards
as would not infringe on a free spirit.
when I recall those years
I first think of a community of highly eccentric individuals
some of them strange or just funny with vague notions
about their purpose for being there,
attracted mainly by the promise of the unknown,
bohemian, poor, defying weimar's bourgeoisie.
I also think of the scent of roses and lilac,
and of nightingales in goethe's moonflooded park.

my background lay in the viennese design tradition
of art nouveau and sezession.
dissatisfied with the role of the designer
as a mere beautifier,
I was drawn to the bauhaus by its first proclamation
with feininger's symbolic romantic woodcut—a revelation.
at the time I was deeply impressed by kandinsky's book
"about the spiritual in art," which I read by chance.

if even in retrospect I cannot express exactly
what brought us all together,
in gropius's mind it must have been clear,
as preceding the bauhaus he had already opened the doors
to new perspectives with his crystal clear buildings.

and he steadfastly guided us
through yet undefined concepts
to a distinct consummation.
outside currents and inside trends contributed
to an atmosphere of explosive evolution.
most of us were stricken with romantic expressionism.
dadaism paralleled our rejection of any sanctioned order.
the work of the stijl-group, attractive by its purity
had a short lived, formalistic influence.
constructivism added its share to the artistic turmoil
but the world of machine production
with its innate facts and functions
was already coloring the future.

more evident still becomes the greatness of his vision
if we understand the utter confusion of those times.

as a student of the bauhaus I honor gropius
for he was always drawn to youth—
and youth is always attracted to him.
a prerequisite for the great educator he is,
dedication to the younger generation
gave him strength in the face of hostility
to deal with unending personal, artistic, internal, financial issues.

his interest in man is at the core
of his belief in the working team.
and it is here that I had the privilege
to be associated with him in later years
in collaboration on design projects.
this I learned from him:
to give and take, to live and let live.
by exchange of thought to contribute parts to the whole
making teamwork a great and successful experience.

whether the aims were vague or clear to the bauhaus
there was a unifying air—the spirit of a group,

making each member
an active part in the explorations of the new.
friction of thought against thought
or harmony of ideas
inspired the individual.
group spirit carried feeling and thinking, living and working.

for the future
the bauhaus gave us assurance
in facing the perplexities of work;
it gave us the know-how to work,
a foundation in the crafts,
an invaluable heritage of timeless principles
as applied to the creative process.
it expressed again that we are not to impose aesthetics
on the things we use, to the structures we live in,
but that purpose and form must be seen as one.
that they seldom can stand alone.
that direction emerges when one begins to consider
concrete demands, special conditions, inherent character.
but never losing perspective
that one is after all an artist.
whereas the painter can only be guided from within.

the bauhaus existed for a short span of time
but the potentials,
intrinsic in its principles
have only begun to be realized.
its sources of design remain forever full
of changing possibilities.
the bauhaus is dead.
long live the bauhaus.

I pay homage to gropius
for his creative intuition.
for his relentless perseverance in the advancement of life.
for his strength of mind and character
in standing firm against opposition and slander.
for his inspired leadership.
for his deep concern with man and his community.
for his search for a common basis of all understanding
beyond the mastery of material and physical things.
for his belief in personality
as the ultimate decisive value.

(Written by Bayer, undoubtedly about the time of Walter Gropius's seventy-eighth birthday on May 18, 1961.)

reason is language, logos (1966)

logos is the rational principle in the universe. it is the moving and regulating principle in things and is the element in man by which he perceives this order of things.

my painting represents various symbols in relation to the meaning of this formulation. there are the square-root rectangles as they are constructed within a square. the rational principle in this visual language symbol is supported by the coloring of prismatic chroma.

furthermore, there is a concept of our universe that differs greatly from that of the greeks who perceived the idea of logos. the circular design with dots is, according to the astronomer george gamow, a symbol of the expanding universe—visualized as dots representing galaxies of worlds, painted on a balloon. the distance between the galaxies increases in an outward direction when the balloon is being inflated. (earlier, pascal described human knowledge as a sphere of a balloon, continually expanding.)

while reason prevails over human aspirations, the image of the ethereal sky leads us to look, as if through a window, into the transcendent realm.

(This formulation, written by Bayer in September 1966, is an extension of his various personal credos. It is published here for the first time.)

general statement (1967)

although I am primarily a painter, I have been profoundly interested in all forms of visual communication, from typography to exhibition design.

the search for the improvement of our alphabet and for a visual language in general has been persistent.

believing that the separation of the "fine arts" and the "applied arts" is arbitrary and unfortunate, I have been living and practicing the integration of art and life through design. for this reason, I have also become an architect and environmental artist.

however much I am concerned with the individual work of art, I am always trying to see it in relation to the total human scene.

my paintings are the connecting links in the chain of interests within this totality.

the significance of this idea does not lie in the ability to master more than one discipline or to create artistic form in all of them, but that the congruity of thought and principle unites them in a coherent image.

(An interesting variant of Bayer's personal statement, prepared on the occasion of an opening of an exhibition of his graphic art at the Art Alliance, Philadelphia, on August 3, 1967. It is published here for the first time.)

back to basics (1979)

1. the creative process is not performed by the skilled hand alone, or by intellect alone, but must be a unified process in which "head, heart and hand" play a simultaneous role.

2. I quote the japanese saying "first acquire an infallible technique and then open yourself to inspiration."

3. the human being as a manifestation of the supreme spirit or the source of life "performs what is given him to do." in the consciousness of "I of myself can do nothing," the artist becomes a transparency through which the creative principle operates.

(Bayer received an inquiry from Peter Schneider, associate professor in the Department of Architecture at Louisiana Tech University in Ruston, Louisiana, requesting a statement for his workshop Back to Basics. On March 14, 1979, Bayer replied with this brief text, which is published here for the first time.)

murals at the bauhaus building in weimar (1923): a statement about the wall-painting workshop at the bauhaus (1978)

in preparation for the first exhibition at the bauhaus in 1923, the bauhaus ventured to show what it had produced and accomplished since its founding in 1919, to exhibit its teaching methods and to account, especially to the opposition, for its creative spirit.

in preparing for the exhibition, the van de velde bauhaus building itself was to be "decorated" and to receive both art and design. as a student in the wall-painting workshop, I was given to the task of designing besides posters on the exterior, the murals in the small staircase.

wassily kandinsky was the form master of this workshop. his theories of the primary forms, circle, square, triangle and their relationship to the primary colors, blue, red, and yellow, were predominant in discussions and influenced the students. it was accepted that red was the color of the square, yellow the color of the triangle. there were different opinions whether the blue was the color of the circle or of the square. I personally believed in blue as the most esoteric color to correspond with the form symbolic of infinity, of the innermost and mystery. I was also considering qualities of lightness, brightness, depth and weight in the three colors.

I dedicated each floor to one of the colors, rising from the deeper blue color on the first floor through the powerful, aggressive red to the light and floating yellow composition with triangles on the third floor. variations in the surface were added by treating some areas with a glossy finish.

I am very happy that these murals were recently recovered. I greatly admired the schlemmer murals in the workshop building and very much regret that they do not exist anymore.

the work in the "wall-painting" workshop consisted of:

1. experimenting in many techniques on the walls of the workshop under the guidance of the master of technique (werkmeister). experimental designs for painting houses and walls, super graphics, outdoor advertising, etc., some of them executed on the walls of the workshop.

2. theoretical teaching consisting mostly in discussions with the form master on color organizations, color systems, psychology of color as propounded in kandinsky's book *concerning the spiritual in art*. (being personally very interested in color theories, I studied the systems of goethe, philip otto runge, and ostwald. unexpectedly, I had to tell about my knowledge in this area during the verbal examination before the board of the guild in order to receive my journeyman's document.) later in dessau, I had the pleasure of inviting wilhelm ostwald to give a lecture and introduce his color system.

3. practical work, painting exteriors and interiors. among them sommerfeld house, berlin, designed by gropius. this was a way of earning an income for a minimal existence.

(In response to an inquiry, Bayer wrote this brief account of the Wandmalerei Abteilung whose Formmeister was Wassily Kandinsky and whose Werkmeister was Carl Schlemmer, brother of Oskar Schlemmer, who left the Bauhaus in 1923 after the famous "Yellow Brochure" episode, which compelled Walter Gropius to

file suit against him. Bayer wrote this memorandum in 1978; it is published here for the first time.)

statement on "soft form" paintings (1970)

my fascination with and admiration for the old peasant houses dates back to my wandervogel days (1916–1919), when I hiked through the austrian countryside. of special interest to me were the barns and stables into which were cut windows of various and ornamental shapes, which are probably of baroque origin. these "windows" serve as vents for the hay stored in the barns and are called dunstlöcher (vapour or haze holes). against those barn walls, all sorts of implements for the peasant to use in agriculture were leaned or hung from hooks. shovels, rakes, harrows, threshing clubs, ladders, hooks, poles to hang the hay to dry in the fields, ropes, etc. it was later, during the thirties, that I remembered these barns and stables and painted the series of "dunstlöcher" paintings. their poetic and surreal conception is perhaps best represented by *barn windows* 1936/11, painted in oil. I can understand why these paintings have less meaning for those who do not know the archaic nature of this subject which is usually judged to have only sculptural interest. a three-dimensional character is, of course, indigenous to these paintings, as my several attempts to make them in sculptural reliefs exemplify (for example, *wall sculpture* 1937/3 or *wall sculpture with two holes* 1937/4).

an additional idea became part of this series: the concept of the soft form. I had perhaps seen cloth or sacks hanging on those walls. those hanging, soft forms were executed in hard materials. I had planned to build a wall on which such large soft forms might hang. they would not be permanently fastened but could be exchanged in order to vary the composition. I never had the opportunity of making this wall. the idea of sculptures of soft forms made in soft materials has in the meantime become a preoccupation of some contemporary artists.

my interest in soft forms reappeared in the '50s, perhaps suggested by the cloud formations seen from airplanes. skies with lyrical clouds had appeared in many of my early works. *during my years in germany they had been accepted as a sort of bayer trademark and have become known largely through my graphic designs and posters. the soft forms of the "cosmic" paintings (1956–1958) became strong black shapes fading out to silhouette.* in view of space explorations and sputnik events, they were forms in motion and were sometimes joined with other symbols of space phenomena.

simultaneously with these works I was engaged with the opposite of soft forms, with sharply defined flat, geometric areas, a group of paintings which may be seen as architecturally defined spaces.

(During 1970 Bayer began to provide himself with a series of *aides-mémoire* about groups of paintings executed during the previous decades. Some of these were brief and virtually shorthand, but a number were expository and autobiographic in character. This is the first of several reproduced here for the first time, slightly amended by the author. The "Dunstlöcher" and "soft form" paintings were begun in 1935–36, following a visit to the scenes of his childhood in Austria.)

statement about "mountains and convolutions" paintings (1970)

alexander dorner has given the "mountains and convolutions" paintings the name "moving mountains" and has written about them in *the way beyond "art"*: *the work of herbert bayer*, published in 1947. I would like to make an additional comment. these paintings were begun during a stay in vermont in 1944. as an alpinist I have experienced mountains in many ways: their rugged forms, their size, the direct touch of the rock while climbing. I have admired the realistic watercolors of english mountaineers, but I had not attempted to paint them as I had not thought of transforming them into a personal expression.

in 1944 I suddenly saw them as simplified forms, reduced to sculptural surface motion. with their positive and negative relief of mountains and hills, depressions and valleys, they were not seen frozen, but as in a time-lapse film, in a movement which human perception cannot recognize. man is too transitory a creature, with his life span of only seventy or eighty years as compared to that of two billion years for mountains, and yet we know through geology that mountains are in constant motion, so slow, however, that within our short span of life we cannot register it.

my mountains were seen in constant motion, heaving and settling, surfaces peeling off, undulating and convoluting, renewing themselves with this process.

in painting these images I was considering their relation to the observer for whom they were to maintain prolonged interest through their self-changing dynamics as compared to a static image which would be forever fixed. see *exfoliation* 1944/39, oil; *lamiferous landscape* 1944/21, charcoal.

the coloring of these paintings was generally in earth tones. it later changed to bright colors, when the mountain subject was extended to nature's movement in plants. see *weaving nature* 1949/22 or *metamorphosis* 1949/21.

since the mountains were formed by the creator, I was also tempted and assumed the boldness of shaping earth surfaces myself, producing the first drawings of "earthworks" (*work with earth* 1947/41). later, it led me to the shaping of mounds in aspen and valley forge.

(This statement, also written in 1970, deals with the "Mountains and Convolutions" paintings begun in 1944 and carried to completion during the early 1950s. It is published here for the first time.)

on the mural painting *verdure* (1950)

for a modern painter the commission to paint a mural in a given space does not come too often. to be given a wall in an architecturally outstanding building is rare, especially as in this case my painting will not be the only "piece of art," but will be in company with creations of some of the leading modernists in sculpture and painting.

I suppose that, given such opportunity, any "fine arts artist" will go ahead and paint to his heart's desire.

for me it was, first of all, a question of choice of subject matter. a purely abstract design I thought would not suffice nor survive to be lived with for a considerable length of time. the painting should have a meaning that would help it to retain the interest of the faculty which was to dine in that room. so the theme became a sprouting, glaucous verdure, an image of the idea of growing. green, as a soothing, quieting, and appetizing color. moreover, the green should contain enough variations towards more exciting yellow shades as well as towards cooler bluish tints. but *green*, as rich and juicy as possible without becoming aggressive.

it is a small room, the picture taking an entire wall. thus, the picture will *make* the room, and I could not share the opinion, according to which the composition of a mural should rather conform with the architectural elements—emphasis on horizontal-vertical directions and flat color areas. I wanted the convolution-like movement of the painting to counterpoint the architecture, to "open up" the wall, to extend the three-dimensional enclosure, to break the wall.

one joining wall is a large window and above the picture, between it and the ceiling, is to be placed a long, narrow strip of frosted glass. I wanted the glass to be clear, transparent, in order to see some trees moving their branches in the wind *together* with the picture: the indoors and outdoors to become one.

another consideration was the scale of the design elements. planning a *large* form, more or less one structure over the entire length of the mural, I believed it necessary to compose it in a way that parts of it (when one is sitting close to it) can still be recognized and identified.

the slight movement of the surface texture, obtained by applying the pigment in short brush strokes, was to give it a certain luminosity and lightness, as well as transmitting an impression of dynamic suspension, rather than static solidity.

having the opportunity to suggest the electrical illumination, I believe that an even mixture of white and regular yellow incandescent lamps will support the coloring.

the "background" of the painting on which the convolution is set is no real background because it is in some places "foreground" as well. thus, it participates equally in the functions of all areas of the painting. this may be one means, I hope, to keep this picture "alive."

(A memorandum written in late 1950 regarding his mural painting *Verdure*, which was installed in the faculty cafeteria of the Harkness Graduate Center designed by Walter Gropius and The Architects Collaborative for Harvard University. It is published here for the first time.)

on titling the mural painting *verdure* (1950)

the title of this mural has been of great concern to me all along. when I choose a title for a painting of mine, I do not want it to be too definite a description or definition of the picture. the title should merely support what is visually expressed. the origin of the design which you see on the wall now and of a series of similar recent paintings was the phenomenon of plant growth in spring. the mysterious appearance of plant forms and flowers in a new green world. a process that can be registered only in time intervals and for which we have no true understanding although we may have a feeling for it as for all life processes. the movement in the painting and the attempt to keep it moving may be a translation of the time element of growth. the green color is an allusion to new plant life.

although some of the titles that were suggested come quite close to an interpretation of the painting, I'm not very happy about the choice of the title *the garden of eden*. this title suggests something different and in any case adam and eve are missing.

when I chose the title *verdure*, I knew that this was not the best, but it was the best I could find. I was searching for a verb to suggest a state of becoming rather than a static substantive. there is one word in the german language, *entfaltung*, which would be a perfect word for this picture. it incorporates all the aspects of unfolding and growing.

(This is an extract from a letter that Herbert Bayer wrote to the Harvard *Crimson* in November 1950, interpreting the title he gave to his painting.)

statement on chromatic paintings (1970)

my particular color experiences of recent years go back to a visit to morocco. during the preceding years I was concerned and occupied with the phenomenon of the monochromatic and its gradations from dark to light. this series of monochrome paintings became gray space illusions through the shading of geometric forms. space illusions, however, were not my primary intention. they happened to be a side effect of the process of shading from dark areas to light areas. these paintings have been taken to represent sheets of metal gleaming with light reflections. but I would never think of imitating by the use of color pigment metallic qualities. the choice of gray as the only color was, as I see it now, the declaration of a serious and somber state of mind.

it must have been the power of the sudden character of morocco with its isolated accents of bright colors against the purifying background of white in the buildings and the peoples' dress, the strong contrasts of sun and dark shadows, which opened again my eyes to the world of pure color.

I had the clear feeling and the strong urge to forget all my previous work and thought to start again fresh and new at zero, on a clear table, beginning at the bottom and to learn again. out of the gray I was again in the sun, like a child who does not know and has not yet been mistaught. I am getting on in years and have gray hair, and I am still and again among the searching.

the pure colorfulness of the spectrum is the starting point. I recognized two psychological qualities of the primary colors: warm and cool. I divided the warm scale into divisions going from yellow through red to purple and in the cool scale leading from yellow through green to blue. placing the scales opposite each other or running in opposite directions or the two scales running parallel

produced unexpected results. the neighboring opposites testifying to the relativity of color in nearly endless vistas of variations opened up a long view. when seen in detail, there appears less emphasis on harmony and more evidence of contrast and vibrations because complementary effects appear naturally from the positioning of opposites.

the proportions of the compositional structure is in some of these works determined by mathematical progressions, a motif which has interested me for some years. impressed by morocco's carpet culture, I also have left aside the conventions of the pictorial in order to develop color concepts and to bring forward the self-expressive reality of pure color.

(The statement on the "Chromatics" was written on October 12, 1970, and is published here for the first time.)

on vasarely's paintings (1970)

with this statement I want to respond to the comparison which is sometimes made between my paintings and those of victor vasarely. in order to do this, I must go back to the bauhaus of the early twenties.

the bauhaus conceived an aesthetic of the machine age and of mass production. accordingly, products constructed in this sense were to be useful, functional, and pleasing, and would find their place in a society dominated by science and technology. the bauhaus slogan of 1923, "art and technology, a new unity," testifies to this idea.

designers of the bauhaus devoted themselves to the produce of everyday objects—chairs, lighting fixtures, typography and graphic design for communication, weaving, architecture, and design.

learning in the workshops was preceded by a course designed to instill in the student a fundamental objective understanding of the physical and psychological facts of vision, materials, and construction. this became visual research and free association-experimentation by design without applied function. it was the beginning of those explorations of optics in art which in later art movements, such as op and hard edge painting, became fundamental.

I find the recent article by jacques leenhardt in *journal de génève*, "pas d'accord avec vasarely," interesting and illuminating in relation to my own work and, therefore, I quote a few paragraphs.

one knows that one of vasarely's principal merits consists in having assimilated the teaching of the bauhaus and to have systematically reproduced the exercises (*unterrichten*) . . . this in itself has no interest since anybody has the right to exploit the ideas of others. if only vasarely would not promote so pompously his pretentions to originality.
. . . he is concerned with the phenomena of optical illusions . . .
. . . his work of 1970 has infinitely less sensibility than gunta stölzl's work of 1927 . . .

. . . at the bauhaus of budapest, vasarely learned from his teacher bortnyik that art has from now on entered an industrial era. this tendency which asserted itself at the bauhaus in dessau had its great representatives—moholy-nagy, albers, and bayer . . .

the author continues to say that "vasarely retained only the exercise-research ideas of bauhaus teaching and expanded on them, turning these school exercises into art pour l'art. he thereby reintroduced into traditional concepts of art what had heretofore been abandoned. the function of vasarely's multiples is not different from the traditional easel painting except that they are not produced as individual unique works of art but more or less mechanically in quantities. only herein lies the difference—in the merchandising of art for a larger public." it is appropriate to remember that the idea of art in multiple editions had already been projected in the twenties by moholy-nagy as a method to make art available to a larger public.

some of the students' exercises done in moholy-nagy's course in wood and metal were reproduced for the exhibition 50 years bauhaus in 1968. seeing these works from a perspective of nearly fifty years, they compare favorably indeed with the best of today's constructivist art. although they were created not as an end in themselves but as school exercises, they are today easily seen as art because the definition of what art is and what it is not has in the meantime become less fixed. a further illustration may be the paintings of joseph albers's exercises in theories of color, visual statements from which the attribute art is withheld by some.

I find, therefore, mr. leenhardt's critique somewhat harsh because vasarely is not devoid of talent, invention, and conviction, and his contribution to today's art scene is considerable. in a time when the limits of art have been exploded, exercises in optics and vision cannot be excluded from the wide range of search for an art of our time. it is perhaps in the nature of these works that they become decorative through their lack of content which, to make a comparison, the impressionists could retain in spite of scientific painting methods. however, vasarely's optical illusions are not always conceived as steps of research on the way towards an art of humanistic technology but are meant to be high art.

perhaps six years ago I first saw some vasarely prints which impressed me by their intelligence. I cannot deny that this reassured me about the flat treatment of the canvas in my own and more recent works.

the bauhaus aimed at the concept of a total environment. the extension of my work into many areas of space, using all available media, as I have done in my exhibition designs since the twenties, was pursued in the search for an aesthetic totality and a unity of life. I have included on my way also architecture and landscape design.

to be accounted for are the deviations and fluctuations in my painting—sideways into the imaginative and fantastic in image making is natural with me and has in no way obscured my total image. even during periods of involvement in romantic concepts in my paintings, my typographic-graphic work has been produced with the aim of creating a more humanistic environment.

I am interested in multiple issues of some of my works for the same reasons as moholy-nagy was. they are for me one of the ways to disseminate art. nonetheless the unique, original painting retains its validity.

my paintings are indivisible from the rest of my work in the sense of complete coherence. my more recent paintings, although necessarily done in sizes of easel paintings, are all conceived as works to be placed in larger dimensions to make an environment of color in space and have a firm and logical place within my total work.

(This frank and informative interpretation was written for Bayer's own clarification during 1970, following the appearance of Jacques Leenhardt's essay in the *Journal de Génève* on October 10/11, 1970. Leenhardt's internal references to Gunta Stölzl and Sandor Bortnyik are clarified in Bayer's footnotes to his own comment. Gunta Stölzl is identified as a Bauhaus student in Weimar and later a teacher of weaving at the Bauhaus in Dessau. Sandor Bortnyik, who had come to the Bauhaus in Weimar in 1920 with other Hungarians (Gyula Pap and Farkas Molnar) returned in the early twenties to Budapest and opened his own Hungarian "Bauhaus" at which Vasarely later became a student. Vasarely apparently wanted to be included in the exhibition 50 Years Bauhaus [1968], acknowledging thereby his affinity with and discipleship to the Bauhaus. He was not invited, Bayer notes, because only works by members of the original Bauhaus or products of their teaching were to be included. This document is published here for the first time.)

in honor of albrecht dürer: an interpretation of *adjusting the vanishing point* (1971)

I was fortunate as a young man in getting to know the works of albrecht dürer through the writings of an art historian who happened to be a friend of mine. it was my interest in typography and in the alphabet which eventually led me to the block-designs of dürer's alphabet. I could only marvel at their perfect fusion of form and idea. early on, the bauhaus defended the concept of the artisan's workshop and as a result introduced a contemporary parallel to the circumstances under which dürer himself had worked. his "theory of perspective" and his practical application of geometry to both design and typography were not without their influence and I can see a strong affinity between dürer's studies in proportion and oskar schlemmer's print *man in space*. what impresses me about the body of dürer's work is his pursuit of absolute authenticity of expression and his rejection of any surface gloss in order to achieve a purely formal beauty. particularly striking is the innate sureness of his composition, the secret of a true artist. the collage *albrecht dürer adjusting the vanishing point of future history* (*albrecht dürer beim visieren des fluchtpunktes der zukünftigen geschichte*) is on a different artistic level. my piece pits two simultaneous and reciprocally stimulated opposites against each other: the rational-constructive versus the romantic-instinctive, both of which are a part of this montage. the method which I used

here is an automatic instinctive one which originates in the subconscious and in certain mental associations. different kinds of visual stimuli, *objets trouvés*, are seen in a fresh context and acquire a brand-new meaning. the use of the kneeling figure, whatever hidden significance it might have, has given rise to comparisons with dürer's *introduction to perspective*. it has been suggested that by uniting an extraordinarily realistic vision with the scientific detail of the present, albrecht dürer, preoccupied with the future, will become symbolic of a new way of perceiving space. this modest attempt at analysis was written for the present catalogue many years after the creation of the montage itself.

(Bayer contributed to an exhibition Albrecht Dürer zu Ehren at the Dürer Stiftung in Nuremberg, May 1971, an essay dealing with his collage *albrecht dürer beim visieren des fluchtpunktes der zukunfitgen geschichte* [*albrecht dürer adjusting the vanishing point of future history*], which was exhibited and reproduced in the exhibition catalogue. The text of Bayer's note appears here in English for the first time, translated by Elliot Junger.)

statement on "anthology" paintings (since 1976) (1978)

in my paintings of the last ten to fifteen years, I was concerned with designs and constructions of a geometric nature, with rules and principles of numbers, proportions, primary colors underlying them. exploration of the many possibilities and the optical surprises of these geometric images grew from rational thinking and careful planning. the two-dimensional space was filled to its edges with the compositions. the exploration of mathematical numbers-progressions were often supported and enforced by chromatic color scales. fibonacci's was the progression most prominently used and preferred because of its inherent power of expression.

in my recent paintings, I have abandoned the impersonal, flat application of paint versus a more painterly treatment of the surface by introducing brush textures. there is no point in denying the individuality of a handmade object if it is made by hand and not by machine. while some of the previous images could have been executed by mechanical methods, the new works demonstrate a handmade character and its individual, subjective treatment.

after previously filling the canvas spaces with bold nonobjective designs, I now make evident empty space by grouping elements primarily along the edges, the outer confines of the painting. the visual events, or happenings, are sometimes being placed at the rim of the picture to emphasize the void in the rest of the painting area. by grouping iconographs and symbols at the periphery, the contrasting emptiness in which they float invites the imagination of the observer to read his own thoughts into the void.

primary, bright colors are used sparingly in certain of the small forms and ideograms to give way to generally subtle and subdued coloring in grays, tans, browns, and much white.

the language of forms used has been derived to some extent, but not exclusively, from previously used elements of my visual alphabet. other romantic-geometric forms are introduced into a

lyrical world with scientific undertones and metaphysical fantasies of a personal universe. some elements resembling natural phenomena, as well as possible and impossible geometric constructions, descriptive geometry, cosmogony, appear. they may be called anthologies of my images.

the rationality of the earlier "hard edged" paintings has been replaced by fantasies and intuitive imagination without having a concrete aim, purpose, or content. they derive from a creative process springing from subjective, personal prepossessions and imaginings developed through preoccupation with science translated into visual imagery.

this description can only be a hint, which perhaps should not be given at all. a deeper meaning comes to the sensitive viewer from beyond the ambiguous titles which sometimes are arbitrary, or on purpose misleading. there is more than what meets the eye. as in writing, the essence is often to be found between words, the meaning in these paintings is found beyond the images.

let the season's avant-garde, the fashion of the moment, discard the continuation of visual documentation and communication and leave the wide world of nonclassified art production open to the astringent questions that theories and principles alone cannot answer.

(Written in 1978, after the "Anthology" series was well under way, this statement is published here for the first time.)

sculptures with prefabricated elements (1972)

when I was commissioned with a large sculpture a few years ago, it was stipulated that it should be built in concrete. before developing design ideas it was necessary to understand the nature of this material and the possibilities of creating form with it.

concrete is not clay which can be molded and from which casts can be produced. in any case, the project referred to was too large for this technique and certainly too costly, even if it would have been practical in small dimensions. it would have been foreign to the nature of concrete to force it to look like hand-molded sculpture. it would have needed a strong structural framework of steel to which elaborate armatures would be attached which would then be coated with a skin of concrete, sprayed or troweled on.

in architecture concrete is formed. that is to say, forms are manufactured, usually of wooden boards with backings for strength. a simple wall or slab must have boards an all sides containing within the volume and shape of the slab. concrete is then poured into this space. the emballage can be taken off when the concrete is dry. this building of forms can require quite elaborate preparations necessary if the shapes to be cast are at all complex, if different shapes join or intersect each other and if roundness must be produced. curved forms can be round only in one direction if the emballage (verschalung) is made of straight boards. this dictates certain sculptural forms, which have become typical of concrete architecture. any deviation toward freer form expression is very expensive and can look forced. this technique poses

definite limitations within which the artist must work. the surface texture of the material of the emballage is imprinted in the surface of the cast concrete. if it is wood, its grain will be negatively expressed in the concrete. this makes it possible to create patterns with the sizes of boards or panels used in the emballage. this is a legitimate technique indigenous to concrete. le corbusier's later works, to mention only one artist, is representative of this use of concrete.

the problem of repetition and uniformity is a subject that is of concern to many who must cope with mass production, with the often drab environment of long rows of identical houses, with the standardization of life in general. that uniformity need not be an aesthetic problem. examine those southern cities that are composed basically of one type of flat roofed, cubic building all in white. yet there is no dead monotony in this unity because of the multiplicity of variations within the typical.

a similar principle is observed in my sculptures with prefabricated elements; I prefer to call them constructions. they are composed with predetermined elements and because these elements are identical in shape and size they must be assembled or stacked or otherwise connected to result in the planned concept. preliminary models are already produced in this manner. drawings of plan and elevations and, if needed, sections are made simultaneously. methods of making them structurally sound and safe are projected at the same time. the idea of achieving uniformity by repeating one identical element in a composition that yet effects diversity can produce successful plastic concepts.

such ideas call for prefabrication of the elements as the logical and economic method of execution. prefabrication simplifies the building process as it is necessary to build only one form to cast the elements. it can be built precise and with smooth surfaces and sharp edges if metal forms are used. it depends on the design and differs with each. solid foundations and firm anchorage of the structure against windloads and earthquakes are, of course, required beyond the solidity which its own weight may provide.

to treat concrete with color is to my knowledge not yet satisfactory. to integrate it through mixing color dyes with the wet concrete should be the answer. but such colors are not brilliant or lightfast and often appear spotty when dry. the only way to make concrete colorful is by painting its surface, however to such an option it may be objected that it is not material gerecht to cover up a material. besides sealing concrete against waterstains with silicone or with any such transparent liquid, acrylic paints or masonry paints are the most durable.

with the years concrete becomes unsightly, especially in humid climates. to give it a richer surface texture, brushing, combing, or hammering can be applied.

(Bayer's *Articulated Wall*, executed on the highway from Mexico City to Azteca Stadium in 1968, provided the occasion for these reflections on the use of concrete for prefabricated elements in sculpture. Written in January 1982, it is published here for the first time.)

statement about the gate (1972)

when I first saw the countryside in the new england area of the united states, I was impressed by the democratic idea of abandoning fences around private houses and opening one's front lawn to everybody's view. this, however, invites a lack of privacy which indeed is not much respected here. anybody can intrude at any time. the walls which surround properties as they do in mediterranean countries preserve and maintain the concept of a private home, the intimacy and shelteredness within one's own walls. if the exterior of the walls suggests unfriendliness or enmity to the outsider, it is offset by the mystery of what lies behind them, by the benefits of protection, and by the architectural character which they impart to an environment.

walls make gates necessary and as the gate is the first contact with another man's house, it has naturally offered opportunities for special treatment and design (color and plastic design). my interest goes back to the yellow walls and ornate iron gates of monasteries, palaces, and country mansions in countries where the baroque is seen. a gate receives the visitor. it prepares him for what he may find upon entering the house itself. it conveys to him something of the nature of the place he is about to visit and puts him in a visiting frame of mind. it can provide his entrée with a festive quality and can induce the feeling of being privileged to enter the place.

the gate need not be confined to be an opening in a wall; and I am thinking of gates not only to a house within a garden, but to any building: a government building or a business skyscraper. now that large structures in cities are more often built with a setback from the street, a freestanding gate away from the building would have more raison d'être than, for want of a better idea, a sculpture, just any modern sculpture. the *gate* can be the sculpture and it need not be an arch or doorway. it can be a freestanding opening, a form suggesting a passage. it can be a succession of different plastic forms; it could be of linear elements or of glass. its possibilities are many if we open our minds to a ''preparatory'' passage to a building, to a square, or to a park. the setback expresses itself something of the nature of the gate. not only because of the distance from the building and the open space in front of the facade, but of the emotional transition when walking through it from the street to the door instead of the abrupt change. an intermediate experience would soften the act of moving from the hostile traffic lane into the architectural shelter.

I see a gate's function in the experience of ''walking through'' a form or forms, in the perception of its plastic forms and in the activation of a sequence of various forms and colors as one passes through them. an example may be a narrow walkway through ''arched forms'' which progressively change in size, shape, and color, all placed over a large pool of water. the views would be reversed when returning on the walkway. the purpose of this sculpture, besides the varying views from all sides around and from within, is the act of walking through, thereby vivifying it as a gate. the aim is not to go somewhere.

in the arid region of the *haut atlas* of morocco one sees many gates. there are gates without walls marking the entrance to a town. there are gates out in the semidesert where no human being can be seen—colorful structures, usually a large arch and on either side small arches for people. there is nothing before or after the gate. it is like a fata morgana or a lonely symbol which man imprints for himself upon the endless and stark landscape. perhaps it marks some otherwise not visible boundary.

the desert of our modern cities cries for these symbols of human thought and feelings so that the poverty of a material life can be enriched again.

(In addition to painting a series of pictures thematically united as ''Gates,'' Bayer devised a group of sculptures whose principal form was the gate in chromatic progression. This statement, written in January 1972, was occasioned by his reflections about the gate as cultural and spiritual phenomenon. It is published here for the first time.)

statement on the kent mill creek park canyon earthworks (1982)

some years ago I conceived the idea that large outdoor sculptures organic with the surroundings could be built with earth. this led to various applications for undulating landscapes and gardens, mounds and sculptures.

while my previous earthworks are primarily concerned with the issues of sculpture as art alone, the mill creek earthworks have a decided purpose and function. as integral parts of the water retention basin, they control the flow of water. they are abstract forms of geometric delineation. their roundness and angles of inclines are conditioned by rules of water flow and maintenance. they express a play of positive and negative three-dimensional bodies, light and shadow, surface textures, water, motion and sound, in short all the qualities of sculptural art, to make a walk through it an enjoyable experience of diverse facets of tranquility and serenity. in particular, it is an experience of contrast of geometry and harmony with nature.

the entire site is shaped with natural materials and natural elements (earth and water), maintaining organic relationships between them. it is designed for the aesthetic enjoyment of people looking at them, moving through them, and using them for limited recreation.

footpaths provide for pedestrian circulation throughout the park.

the bed of the creek feeding the basin and emptying it is part of the total design (integrated with it). there is a ring mound 100 ft. in diameter and 5 ft. high. it is open on two sides for a small creek and footpath.

a principal *large berm* (previously a dam superimposed on nature) conforms in its configuration to the natural character of the valley.

a *secondary berm* roughly dividing the catch basin continues with a bridge over the creek to the top of the *cone mound* widening there into a viewing platform. the bridge, about 12 ft. from

ground level, continues to the north side of the valley. the cone mound is 64 ft. in diameter.

a *circular pond* containing an *inner grass ring* is located in the secondary catch basin. it contains water part of the year, but remains a sculptural form when water has drained out. (85 ft. in diameter.)

another mound is located at the top of the main berm with another viewing platform nearby above the main outflow of the creek. an *oval mound* extends the total design towards the city and will add design articulation to the west face and vegetation of the large berm.

while the site which needs water control is about 100 acres, the actual controlling and designed area is approximately 2.5 acres.

(Written in August 1982, on the occasion of the completion and inauguration of the Kent Mill Creek Park Canyon earthworks, Washington, which Bayer was commissioned to execute following a competition in 1980. The statement was published in *Kent Arts*.)

3. *Graphic Design*

a great deal has already been said about the necessity of using printed matter as advertising media in business transactions. therefore, I predict that such a necessity will eventually be recognized.

in order to conserve material by means of standardized paper sizes and to facilitate the processing and filing of all correspondence and printed matter, a standard format was created by the *deutscher industrie-normenausschub*–din (the german bureau of standards) for stationery and later for printed business forms. the principal advantage of such standardization lies in the fact that all letters are the same size and that specific recurring information such as the date, name of the sender, etc., will always be in the same place, thereby saving time spent searching for it and permitting greater clarity. at this point a few examples should be given,

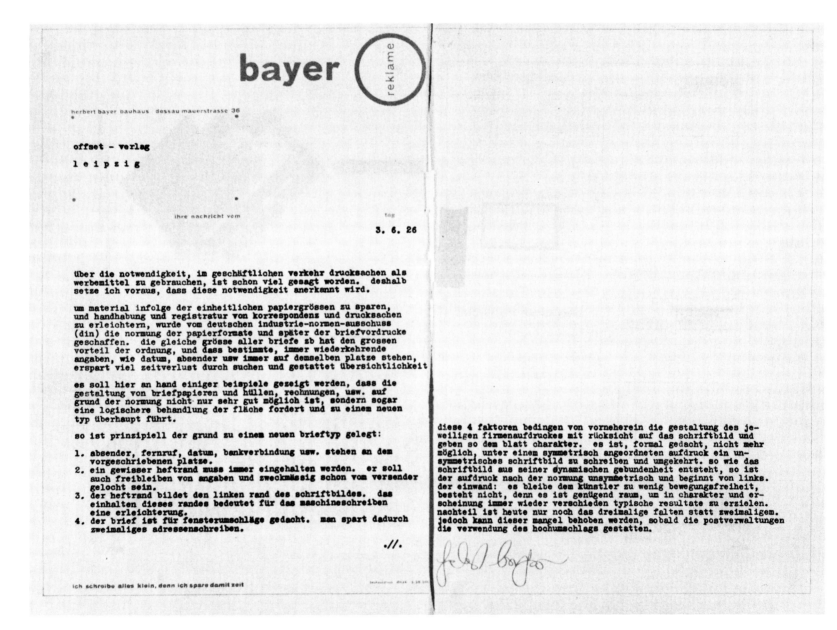

indicating not only that the design of stationery, envelopes, invoices, etc., has excellent potential by reason of standardization, but promises an even more economical use of space, leading towards a completely new style. this is the format for a new type of stationery:

1. sender, telephone number, date, firm contact, etc., appear in their designated spot.

2. a justified margin must be maintained at all times. it should also depend upon the information to be transmitted and should be spaced accordingly by the sender.

3. the margin will form the left edge of the type. by justifying the margin, typing will be facilitated.

4. the letter is intended for window envelopes, thereby eliminating having to write the address twice.

these four elements predetermine the design of various letterheads with regard to typeface, thus lending the page its character. from a technical point of view it was no longer thought possible to use an asymmetrical type page below a symmetrically arranged letterhead or vice versa because the lettering is bound by certain formal constraints, and the letterhead, according to the din-standard, is asymmetrical and starts from the left. the one objection that too little freedom of movement would remain for the artist, does not apply here, for there is ample space in which to achieve an ongoing variety of results both in character and outward appearance. the only disadvantage is the three-way fold rather than the two-way. however, this problem can be remedied as soon as the postal authorites permit the implementation of din-format envelopes.

(The 1926 issue of *Offset* [1] devoted to the Bauhaus reproduced Bayer's personal letterhead for his design practice at the Bauhaus in Dessau. The text of this note on the new style of executing business letters was published within the letterhead as reproduced in the illustration. The German is translated by Elliot Junger.)

on typography

typography is a service art, not a fine art, however pure and elemental the discipline may be.

the graphic designer today seems to feel that the typographic means at his disposal have been exhausted. accelerated by the speed of our time, a wish for new excitement is in the air. "new styles" are hopefully expected to appear.

nothing is more constructive than to look the facts in the face. what are they? the fact that nothing new has developed in recent decades? the boredom of the dead end without signs for a renewal? or is it the realization that a forced change in search of a "new style" can only bring superficial gain?

it seems appropriate at this point to recall the essence of statements made by progressive typographers of the 1920s:

previously used largely as a medium for making language visible, typographic material was discovered to have distinctive optical properties of its own, pointing toward specifically typographic expression. typographers envisioned possibilities of deeper visual experiences from a new exploitation of the typographic material itself.

they called for clarity, conciseness, precision; for more articulation, contrast, tension in the color and black and white values of the typographic page.

typography was for the first time seen not as an isolated discipline and technique, but in context with the ever-widening visual experiences that the picture symbol, photo, film, and television brought.

they recognized that in all human endeavors a technology had adjusted to man's demands; while no marked change or improvement had taken place in man's most profound invention, printing-writing, since gutenberg.

the manual skill and approach of the craftsman was seen to be inevitably replaced by mechanical techniques.

once more it became clear that typography is not self-expression within predetermined aesthetics, but that it is conditioned by the message it visualizes.

that typographic aesthetics were not stressed in these statements does not mean a lack of concern with them. but it appears that the searching went beyond surface effects into underlying strata.

it is a fallacy to believe that styles can be created as easily and as often as fashions change. more is involved than trends of taste devoid of inner substance and structure, applied as cultural sugar-coating.

moreover, the typographic revolution was not an isolated event but went hand in hand with a new social, political consciousness and consequently, with the building of new cultural foundations.

the artist's acceptance of the machine as a tool for mass production has had its impression on aestheic concepts. since then an age of science has come upon us, and the artist has been motivated more than ever, to open his mind to the new forces that shape our lives.

new concepts will not grow on mere design variations of long-established forms such as the book. the aesthetic restraint that limits the development of the book must finally be overcome, and new ideas must logically be deduced from the function of typography and its carriers. although I realize how deeply anchored in tradition and how petrified the subject of writing and spelling is, a new typography will be bound to an alphabet that corresponds to the demands of an age of science. it must, unfortunately, be remembered that we live in a time of great ignorance and lack of concern with the alphabet, writing, and typography. with nostalgia we hear of times when literate people had knowledge, respect, and understanding of the subject. common man today has no opinion at all in such matters. it has come to a state where even the typesetter, the original typographer, as well as the printer, has lost this culture. responsibility has been shifted onto the shoulders of the designer almost exclusively.

in the united states the art of typography, book design, visual communication at large, in its many aspects, is being shelved as a

minor art. it has no adequate place of recognition in our institutions of culture. the graphic designer is designated with the minimizing term "commercial," and is generally ignored as compared to the prominence accorded by the press to architecture and the "fine arts." visual communication has made revolutionary strides and real contributions to the contemporary world picture. yet, the artist-typographer represents a small number of typography producers compared to the output of the nation. their efforts must be valued as they keep the aesthetic standards from falling, and because they alone set the pace in taste.

there can be no doubt that our writing-printing-reading methods are antiquated and inefficient as compared to the perfection attained in other areas of human endeavor.

the history of our alphabet and any probing into its optical effectiveness expose a lack of principle and structure, precision and efficiency which should be evidenced in this important tool.

attempts have been made to design visually (to distinguish from aesthetically) improved alphabets. but redesigning will result in just another typeface unless the design is primarily guided by optics as well as by a revision of spelling. this, in turn, reveals the need for a clearer relation of writing-printing to the spoken word, a reorganization of the alphabetic sound-symbols, the creation of new symbols. the type designer is not usually a language reformer, but a systematic approach will inevitably carry him to a point where he will ask for nothing less than a complete overhaul of communication with visual sound.

however unlikely the possibilities for the adoption of such far-reaching renovation appears at the moment, revitalization of typography will come:
a. from the increased demands made on the psychophysiological apparatus of our perceptive senses;
b. from a new alphabet;
c. from the different physical forms that the carriers of typography will take.
the more we read, the less we see. constant exposure to visual materials has dulled our sense of seeing. overfed with reading as we are, the practice of reading must be activated. a new effort is needed to recapture and retain freshness. little known is the fact that the act of seeing is work, that it demands more than a quarter of the nervous energy the human body burns up. during waking hours your eyes almost never rest. in reading this article you must refocus as you skip from word to word. much energy is required for blinking and turning the eyeballs. more is needed by the tiny ciliary muscles to alter the shape of the crystalline lens for focusing. the effort of seeing contributes a large share to physical tiredness.

taking a closer look at present-day typographic customs, I make the following suggestions, believing that they offer immediate possibilities for both improvement and change.

visual research

"the eye seldom focuses for long on one point in a design. it flits back and forth from one element to another in haphazard sequence, unless the design is skillfully arranged to force its orderly progress from one idea to the next. it is a vital part of the designer's job to make sure that the eye sees first things first and that it is made to dwell as long as possible on areas of special importance, such as the name of a product."*

graphic design will more than ever be determined by its purpose. the designer-typographer can find new impetuses from research in vision such as the above exemplifies.

universal communication

for a long time to come we will accept the existence of the different languages now in use. this will continue to pose barriers to communication, even after improved (possibly phonetic) writing methods have been adopted within all the languages. therefore, a more universal visual medium to bridge the gap between them must eventually evolve. first steps in this direction have, strangely enough, been made by the artist. now science must become a teammate and give him support with precise methods for a more purposeful handling of visual problems.

the book has been a standard form for a long time. a new spirit invaded the stagnant field of rigidity with the adoption of the dynamic page composition. an important extension was introduced with the recognition of supranational pictorial communication. with its combination of text and pictures, today's magazine already represents a new standard meduim. while pictorial communication in a new sense has lived through a short but inspiring childhood, typography has hardly aspired to become an integrated element.

exploration of the potentialities of the book of true text-picture integration has only begun and will, by itself, become of utmost importance to universal understanding.

communication of selling

recently certain american national advertising pages have expressed a remarkable trend to planning. these pages contain and operate with a conglomeration of ugly, differently styled, contrasting or conflicting alphabets. the advertising agencies (no artist-designer's reasoning or taste could produce these pages) that produced this concept clearly must have been motivated by attention-getting-by-all-means aggressiveness and provocation. the result is irritation to the reader, who, therefore, reacts. this ignoring of aesthetics, in fact this twisting of unaesthetics into a function, provides a lesson to be learned. here is bad taste under the disguise of functionalism par excellence.

but new typographic life may come from such a ruthless technique, as is exemplified in many of america's "hard-sell" advertising pages. the reason for this speculation is that here typography clearly serves an intended purpose. the means by which the purpose is obtained are wrong and bear none of the aesthetic restraint that dominates much typographic thinking.

*from a booklet "an approach to packaging," container corporation of america, design laboratory, which makes extensive use of an ocular camera to check this aspect of the designer's work.

sizes of typefaces must be proportionate to the length of the line. the smaller the type, the shorter the line (for a standard measurement, 10 point typeface should not be set wider than 20 to 25 pica). adoption of the narrow column, which has proven itself to be considerably easier and faster to read, as newspaper readers can testify, would change the shape of the book. a "one column" book would be high and narrow, would not lend itself to binding on the long side, but might be divided into separate chapters in accordion folds collected in binders or boxes.

square span

tradition requires that sentences follow each other in a horizontal continuous sequence. paragraphs are used to ease perception by a slight break. there is no reason for this to be the only method to transmit language to the eye. sentences could as well follow each other vertically or otherwise, if it would facilitate reading.

following is an excerpt of a letter from "the reporter of direct mail advertising": "square span" is putting words into thought groups of two or three short lines, such as

| after a short time | you will begin thinking | in easily understood | groups of words |
| you will automatically stop | confusing your sentences | with complicated phrases | and unnecessary words* |

typewriters and typesetting machines would have to be adjusted to this method. text written in logical, short thought groups lends itself best. the advantages of grouping words support the theory that we do not read individual letters, but words or phrases. this poses a new challenge for the typographer.

text in color

black printing on white stock, because of its extreme opposites, is not entirely satisfactory. the eye forms complementary images. flickering and optical illusions occur, however minimized they may be in a small typeface. they can be reduced if the contrast of black on white is softened by gray printing on white stock; black printing on gray, yellow, light blue, or light green stock; brown, dark green, or dark blue printing on light colored stock. the colors of printing in relation to the colors of stock need not necessarily be chosen for harmonies; it is the power of controlled contrast that must be retained.

change of impact

furthermore, a great easing of reading is effected and freshness of perception is prolonged if a book is made up with a sequence of pages of different colored stock printed in various colors. which color follows another is less important than that the hues be approximately of equal value to safeguard continuity.

**"square span" writing was developed by robert b. andrews, dallas, texas.*

dr. w. h. bates has recommended a frequent shifting to aid in refocusing a fixed stare caused by the eye-tiring monotony of reading matter. the typographer can support this recommendation by the above change of impact through color.

new slaves

speculation into the future (perhaps not so distant) leads me to assume that methods of communication will change drastically.

the storage of books will be replaced by microfilms, which in turn will change the design of libraries. computing machines can already substitute for printed matter by storing knowledge. they will have any and all desired information available and ready when needed on short call, faster, more completely than research teams could, relieving and unburdening our brains of memory ballast. this suggests that we will write and read less and less, and the book may be eliminated altogether. the time may come when we have learned to communicate by electronic or extrasensory means

formalism and the straightjacket of a style lead to a dead end. the self-changing pulse of life is the nature of things with its unlimited forms and ways of expression. this we must recognize and not make new clichés out of old formulas.

(This essay was originally published in *herbert bayer: painter designer architect*, Reinhold Publishing Corporation, New York, 1967.)

typography and design at the bauhaus (1971)

in attempting a brief review of the typographic evolution which took place at the bauhaus, one must remember that its beginnings go back to the early 1920s. in fifty years of accelerated history many changes have taken place, and looking from such distance at these typographic statements they appear unique and revolutionary within the history of typography. these works have unfortunately entered history as "bauhaus style." style implies a superimposition of aesthetics, a stylistic beautification without deeper reasons. however, the new typography was a philosophy of function plus form and cannot be classified as a fashion movement. as its term in the german language *elementare typografie* implies, it had its foundation in the new consciousness of technology, in its functions as a medium of communication, in its social and humanistic role and in its relation to the other arts of the time.

no manifesto was formulated. jan tschichold's publication in *typografische mitteilungen*, 1925, was perhaps the first survey of what was happening in those days in the art of typography. moholy-nagy, a most ardent spokesman, wrote on contemporary typography in 1926 in the magazine *offset, buch und werbekunst*, a colorful publication which presented a view of bauhaus design for communication at the time when the bauhaus had already moved to dessau.

type was previously used in a static, conservative, often refined manner. but it was in the air to question and to analyze

inherited "truth" and it was concluded that type has distinctive optical properties of its own pointing towards specifically typographic expressions. the ornament, as in architecture, was taboo and we saw new possibilities of visual experiences in the exploration of the typographic material itself. it was made relatively easy to discard traditional concepts because most of us were not trained professional typographers and were therefore not limited by frozen attitudes. accepted rules had little meaning to us and we could therefore face design problems with unclouded eyes. not having recognized the finer points of this art may account for a certain crudeness and boldness in some of these works.

the new typographers called for clarity of design, conciseness of its elements, precision of execution, and more articulation and contrast. they called for tension in the black and white values of the typographic page which until then tended towards a balanced gray appearance and refrained from pronounced accents.

traditionally typography was arranged symmetrically. now the free dynamic-eccentric composition, balanced by proportions, sizes and areas, replaced it, shunning any axial grouping like the so-called christmas tree composition.

typographic lines used to run horizontally. the concept of the dynamic-eccentric layout introduced additional directions in placing test lines also vertically and diagonally.

the clear organization of the material on the page became the basic rule. typographic design was not to be executed along aesthetic considerations alone, but its first task was to support and to project with impact the contents, headlines, paragraphs, etc. these ideas did not drop out of the blue but had precursors like everything else, notably for the work of the russian el lissitsky with his unorthodox if decorative handling of typefaces, rules, slugs, etc. in the design of mayakovsky's poems.

the manual skill and the approach of the craftsman was seen to be eventually replaced by mechanical techniques and a future, more highly developed printing technology which would lead to still unforeseen visual concepts. at the bauhaus in weimar existed a printing workshop for the manual printing of lithographs, woodcuts, etchings, etc. it was symbolic for our new orientation in the mid-twenties toward an integration of design and industry that the new workshop at the bauhaus in dessau became a printing shop with movable type and mechanical printing machines. here most of the printed matter of the bauhaus, such as stationery, posters, etc., was set in type and printed. (I should not neglect to mention the artistic-romantic calligraphies of feininger and especially itten, which preceded the *elementare typografie*.)

once more it was reaffirmed that typography is not self-expression but that it is founded in and conditioned by the message it must convey and that it is a service art not a fine art, however pure and elemental this discipline is.

all period typefaces including the classic antiqua were discarded for the exclusive use of the sans serif grotesk face, adopted because its clear forms were seen to correspond with the image of the modern times. additional typographic elements included only geometric forms such as squares, lines, circles and slugs as they were sold with fonts of type. the simplified arrow,

because of its symbolism, became a favored element. when, besides black, a second color was used, it was usually a bright red.

in all human endeavors a technology had adjusted to man's demands while no marked change or improvement had taken place in man's profoundest invention—printing-reading—since gutenberg five centuries ago. to touch upon the sanctity of the alphabet is like disturbing a beehive. sentiments and awe before this time-honored treasure have long postponed independent and new thinking on the subject. experimentation with typographic communication leading to an investigation of the alphabet—the visualized sound—was unavoidable. it would lead too far to present the many reasons why our traditional alphabet is antiquated and why it needs new concepts to become the efficient tool which the 20th-century communication explosion must expect from it. however, some of the conclusions must be listed to understand my personal concern with this issue: I asked for simplification of its forms for better legibility, for a coordination of form with sound, for an optophonetic alphabet, for the use of one alphabet instead of using capitals *and* lower case letters which represents unnecessary duplication and enormous material and handling ballast.

my proposal to abandon capital letters in all bauhaus correspondence and printed matter was adopted with great courage by gropius. it became, however, a case of severe criticism. the bauhaus was, after all, a school.

typography is the art of designing with typefaces and printing from it. as such, it is a limited technique. I soon recognized it to be only *one of many* mediums of visual communication. the concept of typography as an isolated discipline and technique was soon expanded to join with the new vision of fotography which was then named typo-foto. in communication with pictorial images fotography was used almost exclusively. it was seen as the most objective and realistic medium. its exactness and documentary qualities were seen as superior to manual representations. this coordination of typographic and fotographic elements was always dominated by the desire to create unity and integration of image and text.

the foto was not much used as a squared conventional image but was cut out and treated to bring forth the essentials. the combination of various fotographs by way of montage became a preferred technique because of its flexibility and the psychological associations it could create.

the bauhaus urged the contemporary artist to take part in the issues of his time by solving those problems which only the artist can, that is, giving form to our environment, to the spaces we live in, to the goods we use, to communication. the conviction and fervor with which the *elementare typografie* was carried out and the uncompromising statements have without doubt produced a strong stimulus toward the shape of communication of today and of the future. I should like to acknowledge the contributions to this subject made by individual artists simultaneously, but outside the bauhaus.

(Bayer's text was used as one of several introductory essays to an exhibition catalogue of the Busch-Reisinger Museum at

Harvard University, Cambridge, for their exhibition Concepts of the Bauhaus, April 30–September 3, 1971 [45]. In several instances Bayer's eccentric orthography, which has been part of his usage for decades, has been retained and the essay is reprinted without alteration. It is published here with the permission of the Busch-Reisinger Museum.)

design, designer, and industry (1951)

not so long ago, an artist was only a real artist when he gave himself the air of being different from ordinary mortals. he had at least to wear a beret, velvet jacket and flowing black bow tie. the artist-designer of today, however, is no more distinguishable from his contemporaries in his normal appearance and behavior. he wants to belong and to fit into everyday conventions when communicating with others. in this respect he has returned to society. in the early years of the bauhaus, students arriving in conventional clothes felt compelled to sell them for something more fantastic, to demonstrate their opposition to the existing order. today businessmen dealing with artists are meeting more and more with responsibility, respect for deadlines and understanding of other prosaic necessities.

for better human relations between artist and businessman, however, it should be pointed out that emotion is necessary for creation and cannot always be switched on and off in an instant. but this should be taken as a contribution, not a weakness, of the artist, since he brings into every assignment a great deal of extra enthusiasm. because the artist cannot produce without it, the businessman during the process of collaboration should be aware of keeping this spirit alive. however responsibly the "reasonable" artist behaves, and however businesslike he may appear, every artist—and this perhaps includes the looked-down-upon commercial artist—has his struggle with himself: a struggle between vision and accomplishment, a fight towards maturity in his work, a conflict between imagination and reality. let us not forget that his soul is involved, and that he is often inclined to be a perfectionist, which makes life hard, anyway.

with the development of design as a function of business, new words and terms have come into use, and some old ones no longer seem to be correct. some are antiquated or misleading and emphasize unnecessary distinctions. we have perhaps reached a point where we should review our terminology and attempt a revision or classification of such terms as artist, commercial art, decorator, graphic designer, visualizer, or the expression "patronage of art." this latter term implies an analogy—a flattering one—with the renaissance prince who was the patron of a michelangelo or a raphael. but if we can see that art needs industry as much as industry needs art, there will be no more patronage, in the sense of benefaction or material support. instead a new collaboration and interdependency have grown up. some large industries, assuming the role of patronage of the artist, have organized fine arts exhibitions and competitions. however admirable such promotional interest in art may be, I believe that it constitutes a misinterpretation of a more basic concept of design and the relation

between management. because of its former associates. therefore, the term "patronage of the arts" should no longer be used within our scope.

the terms "visual communication" and "visual language" have become familiar in recent years. the artist communicates with symbols. he will always tend to reduce the written words and tell his story with pictures. the modern artist believes that much of the tiresome copy could be omitted in the interest of better communication. it is my own contention that we find ourselves today suffering from an acute case of poisoning by too many words, which cruelly invade our minds every second of the day. too many words can act like a screen between us and our visible world. advertising must become simpler, more direct, and for that reason more pictorial. the fact that the poster, in the true sense of the term, has no proper place in this country is one proof that the pictorial message is undeveloped. die-hard experts will tell us that all copy in ads is read practically word for word, and that without it the purpose of advertising would be defeated. in reply I would point to the successful use of visual language and of the minimum of copy in the messages of the container corporation.

advertising and motion pictures are the most powerful instruments in molding public taste. why are their standards so low? both are media through which the artist could make his greatest contribution to society. yet "commercial art" is still treated somewhat as a stepchild in our museums and other cultural institutions. I recommend the formation of an organization whose authority would back up the designer's courage, help him to raise standards in his ethical and esthetic mission, and could do much to give advertising art its proper standing as one of the most potent art forms of our day.

in this connection, I would like to touch on a curious situation which has always puzzled me. some of the world's largest industries are headed by men whose collections of fine art, and at that of modern art, are among the best. yet where the cultured minds of these businessmen could be most influential and do most for public taste—namely in design within their own industry—their influence is conspicuous by its absence. is this because it would entail taking too great a chance, mixing art with such delicate things as sales? or is the split between "fine" art and "commercial" art still too wide to be bridged by the cultured, intellectual mind?

the notion that practical life is only a necessary evil, tough and uninteresting, in contradistinction to the serene dream-life of beauty and ideals, must soon be outgrown. if everybody knows or learns how to contribute to the creativeness of daily life, work and business will come nearer to this utopian existence and will be worthy of devotion and enthusiasm. business, social activities, politics, everyday work must then be more than just money-making, egocentric pursuits. we must inspire everybody with the visual experience in which we—artists and businessmen—can cooperate. our future well-being depends on the concrete interchange of all human energies.

as in other fields of human endeavor, the specialist has also invaded the creative arts. but here specialization can take place only in techniques or special knowledge. the term *design*, as gropius puts it, "broadly embraces the whole orbit of man-made

surroundings, from everyday goods to the complex pattern of the whole town." the principle of design remains the same throughout. design is a fundamental outlook at the service of the visual improvement of life; it is not merely detached self-expression. the artist is not a luxury. his function in society is as important as that of the banker, the businessman, the factory worker, or the farmer.

with this philosophy, a new kind of artist is emerging, who testifies to reality without sacrificing his vision. to illustrate that design is one principle which can be the basis of integrated activity and also of one individual. I may—perhaps immodestly—cite my own work. my practice has extended over a wide range of functions: design for advertising in its various forms, typography, book design, type design, some industrial design and packaging, various kinds of exhibitions, some interiors, color organization, some teaching, painting. but I am not the only artist who exemplifies such practices and beliefs. the fact that many of us think in such terms seems to me to promise the eventual extinction of that unfortunate split between fine art and commercial art; between thinking and feeling—a distinction detrimental to our culture.

my aim is the total design process, because it is a vision which I am pursuing, not perfection nor specialization in a technique. In this over-all belief, painting plays an important part. I do not separate it as such from my "functional" work. painting is functional too. in fact, my experiences in painting have often influenced my practical work, and vice versa. but, above all, I want to be aware that art and business must converge and co-operate in the new visual experience towards total integration.

(Bayer's essay was coupled with an essay by the American industrial designer Charles Eames on the general theme Design, Designer, and Industry, and was first published in *Magazine of Art* [18], 1951. It is republished here without alteration.)

4. Photography

from an optical diary (1928)

even though photography was invented over a hundred years ago, it was only recently, very likely in connection with the increasing acuteness of our visual faculties (it is in modern times that the eye has developed into the dominant organ) that a new way of perceiving visually tangible objects from the world around us has occurred. not only do we observe today many new and different forms, but we regard them differently as well. through the camera we are enabled to focus upon a single phase in a succession of images. however, we do not see in the manner of an impressionist painter, but rather we approach the physical world of our environment based upon a perception formed by the principles of the camera, that is, to discover (even at the present time) as well as to reveal the nature and purpose of the experimental photographer. the goal of the steady, clear, unblinking eye is to define images accurately and objectively without sentiment or subjective emotion. it reveals all objects just as they are, in all their movement, tension, their subtle gradations of light and shadow and their physical substance. it is precisely like an optical diary which records and registers, yet beyond the purely objective (realistic) rendering is the point of view as seen through the eyes of the camera and the images which it records.

this recognition alone offers an abundance of creative possibilities. a new image emerges each time any object is considered from various angles, in shadow and in motion. it is the task of the photographer to be aware of the uniqueness in every given moment and to capture it.

("Aus dem optischen Notizbuch," Bayer's first essay about his photographic work, was published in *Das Illustrierte Blatt* [4] in 1928. It was illustrated with a group of photographs taken during the summer of 1928 after he left the Bauhaus and includes photographs of Marseilles fishingboats, the beaches at Wannsee, etc. The piece is signed by one Willi Pferdekamp, who in Bayer's rather uncertain recollection was a writer for the *Illustrierte Blatt*. The translation from the German is by Elliot Junger and appears in English for the first time.)

the aerial tramway of marseilles (1929)

if you walk past the sweltering, colorful commercial district of marseilles out into the glaring sun on the pier of the tiny harbor, the angular roofs along the dingy waterfront, and the turreted ramparts of a bygone era forming a vague, jutting outline can be seen off in the distance facing the ocean. the pont transbordeur, a suspension bridge, is responsible for the flow of traffic between the two bodies of land at the narrows of the entrance to the harbor. it is one of those daring iron structures from the turn of our industrial century which still commands admiration today (as does the eiffel tower in paris) for the tremendous foresight of its engineer, in this case arnodin. on either bank, partially buried under water, are two pillars both 54m. high which carry a cable line on to a gangway stretching clear across the land-based pillars. this footbridge is

240m. long, supporting a pavilion on either end which serves as a café. the actual tram is suspended above the water (with a traveling crane overhead). the footbridge is located at a considerable height in order that tall ships may pass through unhindered. an open elevator brings passengers from shore onto the footbridge. from this point, a spiral staircase suspended freely from the cable leads to the upper half of the pillar where one may enjoy a wonderful view of the mountains along the coast, the city, as well as the ocean. the iron is brilliantly employed as a component element throughout the entire structure (notably in its tensile strength). solid yet movable operating parts appear in constant interaction and facing the ocean one may observe the silhouette of the bridge in between the two embankments, entrenched in sturdy stone walls; a surreal study in metal against a naked sky. the *pont transbordeur* was destroyed in world war II.

(Bayer's second essay in *Das Illustrierte Blatt* [5], "Die Schwebefähre von Marseilles" ["The Aerial Tramway from Marseilles"], is a lyric essay about one of his favorite photographic subjects and a favorite, almost emblematic, subject of a number of the great photographers of the century. The essay is illustrated with Bayer's photographs of the pont transbordeur as well as photographs taken in Milan and elsewhere. Bayer was in Marseilles during the early summer of 1928 after leaving the Bauhaus, although this essay was not published until 1929. It is translated by Elliot Junger and appears in English for the first time.)

a statement about photography (1935)

I am applying the methods of mechanical optics as a technical means of representation, much as I would use the palette, the spraygun or color. with modern optics, the artist who expresses himself with photography has at his disposal a completely new means of rendering the physical world not to speak of the transformation of a desired subject matter. it is necessary to recognize the principles inherent in photography (and as a result, montage) in order to produce an authentic "photo"-graph. I consider photography and photomontage to be an extraordinary summation of carefully organized elements used in visual presentation and just as readily applied to fine and graphic art. unfortunately, at the moment the pure photograph has run itself into the ground owing to a massive resurgence in contemporary photography. it has become too self-serving at the present time for it to move in the direction of a more fruitful development. the full exploitation of the latest techniques will perhaps be able once more to provide a renewed impetus in the discovery of other visual and artistic qualities.

(Bayer was frequently asked for his assessment of the state of this or that discipline in which he was engaged. This evaluation of the condition of photography was written in August 1935, in response to an inquiry from an unknown source. It is published for the first time in a translation by Elliot Junger.)

an acceptance speech (1969)

I suspect that over the years the deutschen gesellschaft für fotografie has dealt with practically every aspect of photography. therefore, I must ask you to bear with me if this all sounds somewhat familiar. I hope, too, that you will allow me to adhere to my printed text. in all the years I've spent abroad my "austro-german" has become a little rusty.

whenever I talk about photography and photomontage as one possibility among many possibilities, I am reminded of the jewish mother who gave her son two ties for his birthday, a green one and a red one. the following day, the boy wore the red tie, whereupon his mother said: "what's wrong, you don't like the green one?"

I am humble concerning the experiment for which I have just been awarded the kulturpreis. to be sure, it was not research ("bewußte forschung") which enabled me to solve a given problem but rather search ("die suche nach ausdrucksmitteln") to meet the demands of the time and express the contemporary idiom.

I am inclined to believe that famous discoveries and inventions in history did not so much shape the destinies of their era as did certain cultures motivate these great inventions. great personalities are not the primal force in a culture but rather its manifestation.

I am recalling the anthropologist peter farb when I remark that for the invention of the steam-engine, for instance, a tremendous leap forward was necessary. the principle by which steam functions was already known in earlier times. the combination of ship with steam took place at a time when european civilization was receptive to new ideas and when its level of technology was sufficient for the realization of the steamship. but if the inventors had not completed the synthesis of the two ideas, steam and ship, it probably would have been left to someone else.

a few examples should also serve to illustrate how discoveries and inventions came about simultaneously:

the telescope—jansen, lippershey, metius 1608

oxygen—priestley and scheele 1744

telegraphy—morse, henrey, steinheil, wheatstone, cooke, *ca*. 1837

photography—daguerre and talbot 1839

it is not enough to explain away this simultaneity in terms of "coincidence" or "something was in the air." the credit which I am being given today should in this sense also go to those who have had similar ideas over the past twenty years.

I first came to the bauhaus in 1921, bringing with me an interest in what is today dubbed "the visual arts," owing to my previous experience as a commercial illustrator.

there was a printer's workshop for lithography and related fine arts at the bauhaus in weimar. since there was no workshop for "graphic design," I entered the workshop for mural painting which was already quite typical of my later orientation towards all forms encompassed by the plastic medium.

at this time, the bauhaus had undergone a huge shift from the prevailing trend of craftsmanship to the idea summed up by gropius with the slogan "art and technology—a new unity."

I was impressed by el lissitzky's work as well as by moholy-nagy's technologic-scientific ideas. as a master at the bauhaus in dessau I set up a workshop for "typography and advertising" in which we could experiment with new techniques.

1. invitation to the bauhaus dance "the white festival" with its slogan composed of various elements from the typecase, "dotted, checkered, and striped." 1925.

2. poster for the kandinsky exhibition where a photograph is mounted on the layout. a modest beginning for a so-called typophoto. 1926. structural incorporation of the photograph into the typeface. a unique aspect of the bauhaus was its ability to instantly realize ideas, irrespective of what was at one time thought to be correct. moreover, with design function as the standard, the main consideration wherever design is concerned is to expedite achievement of the desired goal. whoever has something to say about his environment, he manages to attract an audience without having to advertise. it seemed a logical jump from typography to photography. just as typography is human speech translated into the visually legible, so photography became for us reality translated into readable images. at the bauhaus we were not concerned with *l'art pour l'art* but were preoccupied rather with the business of concrete communication.

at the time, I had written that manual craftsmanship would lead to personal expression and that a personal style would be too subjective to render reality objectively. I am reminded of this by the way in which the personal, art, poster-board style of a ludwig hohlwein, for instance, underlines each of his images, and how in the end a poster for chocolate looks like one for shaving cream. the development of photography and film gave us the means to objectivity. to ignore these possibilities would be wrong. we must adopt them and implement them.

at that time, I was designing advertising and informational media with great enthusiasm. I was idealistic and honestly believed in "truth in advertising."

3. poster of the teutoburger wald. simple placement of two photographs face to face in order to achieve a depth of field. 1926.

4. bauhaus catalogue. the employment of special angles. (our visual speech today consists of unusual vantage points.) I must remind you though that even they had to be discovered once upon a time. 1926.

5. washable wallpaper. papier lavable. 1927. the photograph tells the entire story.

I was young and not especially aware of the different currents and fashions in the art world during those years. how was this possible at bauhaus, you ask? the answer is that my work at that time was motivated more by instinct than by a consciousness. also I could only take a limited amount of art instruction for I had to work in the workshop in order to support myself. the average member of the bauhaus was as poor as a church mouse.

I remember having seen dadaist collages as well as kurt schwitters himself, who would drop over for an occasional visit. the influence of dadaism is quite noticeable in one-of-a-kind dance posters, invitations, and birthday cards (both personal as well as those for public display).

6. poster for a bauhaus soirée. 1923. collage made from miscellaneous materials. 1923.

7. invitation to a party at the bauhaus. 1928.

8. part of a birthday montage for walter gropius in which I, as the speaker, gently poked fun at him. 1933.

when it came to solving complicated assignments effectively, such as the cover design of a magazine, I had to switch back and forth between creative resourcefulness and pragmatic thinking.

for the cover of the bauhaus magazine of november 1927, it was my intention to express something of the content of the magazine without the use of words. the basic patterns, the symbolic elements essential to the tenets of the bauhaus, are united with the draftsman's tools along with the magazine itself. this montage, that is the "assemblage" of various elements, takes place wholly before photographing.

9. cover for the bauhaus magazine. 1928. which was honored with a first prize at the premiere exhibition of european advertising photography in new york (1930).

I am making a fundamental distinction between this and an actual photomontage because it is based upon a different creative process.

the moment a photograph is being used for a montage it will be adjusted for a combination with other photos and other media. the advantages of montage lie in its natural harmony in terms of the combination of photograph with color, of hand-lettering with typeface, making it possible for us to create "imitations of reality" that at the same time are photographically true to life.

the photomontage has shown itself to be particularly suitable for advertising in which psychological suggestion or allusion are desired.

10. additional assemblage: international statistics on the amount of food consumed by the average sixty-year-old man during his lifetime in relation to his body size. 1934.

11. assemblage for the fashion magazine *vogue*, in which models have been posed in air-travel outfits set against transparent backgrounds. 1944.

12. representation of the human muscular system. montage for an exhibition on hygiene. 1934.

13. advertisement pamphlet for a soft, feathery type of fabric.

14. brochure for deutschland ausstellung (germany exhibition).

15. cover for magazine *die neue linie*. 1935.

16a, 16b, 16c.

17. cover for the fashion magazine *harper's bazaar*. 1940.

18. brochure for exhibition of summer flowers. 1934.

(at that time color photography posed some problems, for each color was poured onto the photographic plate. it was hard to keep the flowers fresh for very long.)

to unite form and function, the objective and the sales point within a single advertisement must remain the artist's objective. therefore, any method which best solves a specific problem is acceptable. precisely how one chooses to go about it is thus

Folder for Mont Tremblant ski resort (1939).

determined by the nature of the problem. often the result is that different techniques will be used at the same time. at the heart of all these experiments lies the desire to unite photography and graphic design in order that word and image may become one.

19. brochure for the canadian winter sports stadium mont-tremblant. an example of combining various elements. 1939. the traditional attitude of contemplating a given subject (idea or issue) from a single, invariant point of view (as in vanishing-point perspective during the renaissance) has given way to a powerful new concept, receptive to a large number of differing points of view. through this concept we not only experience one side of a particular event but all sides simultaneously; therefore, we seek to probe and to expose its inner meaning. photomontage is able to provide this. (an example of this is the brochure for adrianol.)

20. advertisement for adrianol nose-drops for colds. 1935. the medical dispenser itself is placed in a dampish atmosphere (mental associations). on a colored section of the human head made from classical greek plaster is a realistic-looking, photographed hand indicating how to insert the medication into the nasal passage.

the montage makes images of a surreal character, of the impossible and the invisible, possible.

20a. brochure for the uses of the electron.
21. photomontage *the lonely metropolitan*. 1932.
22. self-portrait. 1936.
23. dunstlöcher. 1936.
24. metamorphosis. 1936.

as an example of a photomontage in three dimensions I mention the exhibition "road to victory" at the museum of modern art, new york, 1942. photographs were selected by edward steichen from a considerable number of entries. in order to fully convey the pictorial impact (the display consisted only of enlarged photographs), which were set against a plain backdrop without frames or any visible means of support, mounted diagonally on the floor or hung on the walls and ceiling. the exhibition narrated without the use of words a panorama of living, working america during the war. (I had often used enlarged photographs during the previous twenty years.)

25. graphic demonstration of the principal goal of the exhibition.
26. photography exhibit road to victory. 1942.

while at work on the latter exhibit, it became clear to me again that all artistic expression is a reaction to life. painting had turned inward, towards the personal, emotional and intellectual. photography on the other hand is instantly accessible and all-embracing. it was of course the great painters whose discoveries and whose work have enriched our lives. in the right hands, painting can be the most powerful form of expression. the value of photography, however, lies in its directness. thus, it bears the seed of a nameless, popular art form of our industrial age.

a painting is necessarily an abstraction which creates a visible or imaginary image upon a blank wall. photography in fact, necessarily begins with the final product and creates through the process of selection. I can sum up this comparison between painting and photography by saying that both art forms are most persuasive and effective so long as they remain true to themselves.

Advertisement for Men's Wear Fabric (1943).

upon leafing through illustrated magazines today, one must admit that photography is dispensed with considerable freedom, yet without developing and indeed barely employing the possibilities of montage.

28. design course 1939 [reproduced in *pm*, 62]. assignment: to illustrate a stable and an unstable situation in both story and pictures.

29. assignment: create the illusion of space in both close proximity and distance.

30. assignment: create a different story with photographs taken from another source.

assignment: perspective.

assignment: create a contrast between the subject and illustration. a panorama as seen from a single point of view. in new york in 1939 I gave a course in photomontage. the students were eager and produced many interesting works.

just recently, I gave a similar course and the results were most disappointing. to concern themselves with content (which is what montage requires), seemed alien to contemporary art students (who think in terms of form amd color primarily).

I foresee further developments in the area of photomontage, in the uniting of sight, sound, and movement, and in the spatial abstractions which play a role in happenings. the concept of montage has extended into film as well and is making itself felt in the kinetic arts. I predict a great future for photography in its growing technical proficiency, the increasing fidelity of color as a finely tuned instrument of communication with which to explore the universe.

in conclusion, allow me to express my great joy at having been allowed to share this day with you where the events and focus of my youth have been so readily acknowledged.

(In 1969, Bayer received the Kulturpreis of the Deutschen Gesellschaft für Fotografie in Cologne. On that occasion he delivered the preceding address, which presumably was illustrated with slides. Most of these images are reproduced in this book or, if absent, may be found in the catalogue of the Bauhaus-Archiv, *Herbert Bayer: Das Künstlerische Werk 1918–1938* [142] or *herbert bayer: painter, designer, architect* [40]. However, Bayer's descriptions of the designs in question seem sufficiently vivid as to require no additional illustration. The speech was translated by Elliot Junger. It is published here for the first time.)

statement about fotomontages (1975)

collage, montage, assemblage are techniques of image making for which fotos, newsprint, old engravings, bits and pieces of material, *objets trouvés* (found objects) are used to produce an abstract composition. the art movement of dadaism in the twenties made extensive use of this medium.

the once static viewpoint from which to look upon a given subject (linear perspective of the renaissance) gave way to a dynamic "multi-point-of-view" to which montage lends itself naturally. in this view the painter looks at a subject in a picture from all sides.

simultaneously, he looks through it, he gets into the midst of it, adding a super real dimension.

furthermore, montage lends itself to making images of an unreal nature because of the seemingly unrelated character of the assembled or incidentally found design elements.

surrealism, depicting the subconscious or the unreal, expanded on the montage technique because of the pictorial possibilities inherent in it. it is also a suitable tool to convey the invisible as well as a succession of events.

(Bayer's statement about photomontage was apparently written in 1975 at the time his portfolio of Fotomontagen and Fotoplastiken were republished by Galerie Klihm in Cologne. However, Bayer has no exact recollection of the origin and occasion of this text. It is published here for the first time.)

about the fotoplastik and the fotomontage (1977)

to the enclosed blurb "about fotomontages" (I do not remember where this was published), I add, hoping to satisfy your inquiry, a few words about the actual technique:

fotoplastik—I use this term to signify the plastic quality which dominates in these images. I made sculptural elements like frames, rings, or wheels, and placed them in spatial arrangements with the proper lighting. this was then photographed. the print obtained was worked over with brush and airbrush and then rephotographed. the prints were then made from the negatives obtained. there are, of course, variations within this technique, as for instance in *hands act*. here actual hands (my own hands) were photographed, cut out and montaged over the image of a map, and shadows added to the map.

fotomontage—lonely metropolitan—the background is a photograph of a typical courtyard in a building in berlin. the hands were cut out and the shadows on the background painted in. the eyes were cut out and montaged into the palms of the hand and retouched so that they would look organic with the hands. all elements (and this holds for all montages and photoplastiks) were carefully planned beforehand.

you mention *look into life*, but you seem to make a mistake because the background is not a building but a reproduction of a cheap oil print representing the sun breaking through the clouds over a water area. the photograph of the frame was simply montaged over this and the string painted in.

briefly, I would say that the techniques of fotomontage and fotoplastik do not really differ except that in the fotoplastik I have used sculptural elements which I made and with which I made the composition before photographing it. in both categories cut-out photographs pasted together, retouched, and then rephotographed, were used.

(The eminent German-born Israeli photographer and historian Tim Gidal asked Bayer in August 1977 what distinction he made between his Fotomontagen and Fotoplastiken. Bayer replied on September 16, 1977, referring to the "Statement about Fotomontages" and expanded on these remarks in this letter. It is published here for the first time.)

5. Exhibition Design

in the present article I give attention to some of the more fundamental ideas as they have crystallized in my concern with the subject of exhibition design and as I see them now, partly in retrospect. It is also my intention to shed light on the history of some of the innovations that today are integral parts of a design language for exhibitions and museums.

exhibitions are usually designs in space. as such, architectural elements define the major spaces and serve the structural requirements. the elements of communication and display must be incorporated and integrated into a scheme that conforms to a desired sequence of impressions and to the visitor's abilities of perception. the organization of the floor plan should insure an uninterrupted flow of traffic and permit and induce the visitor to view all exhibits.

the designer's aim here must be to improve and to intensify communication. the human being is mercilessly exposed today to a never-ending attack of influences, messages, and impressions. we cannot readily reduce the quantity of these attacks, but we must learn how to concentrate the messages, how to omit the non-essential, and, above all, how to improve our techniques of communication.

exhibitions are, generally speaking, of a temporary nature. they are often of an experimental character. their content may vary from a presentation of the beer industry to the history of transportation to mankind's religious aspirations. there are commercial exhibitions; there are educational and cultural exhibitions; museums with special problems of presentation; and art exhibitions. there are street-window displays and trade fairs. each poses different problems and demands different handling.

exhibition design has evolved as a new discipline integrating all media and powers of communication and of collective efforts and effects. the combined means of visual communication constitutes a remarkable complexity: language as visible printing or as sound, pictures as symbols, paintings, and photographs, sculptural media, materials and surfaces, color, light, movement (of the display as well as of the visitor), film, diagrams, and charts. the total application of all plastic and psychological means more than anything else, makes exhibition design an intensified and new language. it becomes an integrated use of graphics with architectural structure, of advertising psychology with space concepts, of light and color with motion and sound. to play successfully with this modern instrument of possibilities is the task of the exhibition designer.

organization of the floor plan

in an exhibition in the newly opened zeughaus, in berlin, 1844, it was evidently deemed necessary to guide the visiting public along a predetermined path. lacking other means in the rigidly symmetrical museum building, the visitors were moved in the desired direction in a prussian soldierly fashion, by spoken commands.

the first attempt to organize an exhibition space was made during the world exhibition of 1867 in paris. the exhibits were

arranged on an oval floor plan with corresponding galleries. this organization of the interior was expressed in the architecture of the building.

many years later, in a typical exhibition hall in england in 1935, we observe that the need for an organic floor plan had not yet been recognized and that confusion still prevailed.

the isometric drawing of an exhibition in 1936 in berlin exemplifies the fact that symmetry still was an effective medium towards order, but, employed to produce an organic traffic flow of the visiting public, the symmetry appeared too rigid and inflexible.

figure 7 from the same exhibition, on the other hand, is an example of an asymmetrical floor plan of displays arranged freely. it is equally inadequate, as orientation and direction are absent.

two simple diagrams make the difference between disorder and an organized flow obvious. they suggest that designs for museums and exhibitions must, at an early stage of planning, cope with the problems of traffic control.

one of the first attempts known to me to organize an exhibition according to an organic flow and sequence of exhibits was in the german werkbund exhibition in paris in 1930. a serviceable plan of circulation proved difficult here, as the use of space, cut up into several rooms, was conditioned by the old building in which the exhibit was housed (exposition internationale des arts décoratifs, grand palais). an exceptional feature was a bridge (by gropius) over which the circulation flowed and from which one gained a bird's-eye view over part of the show (collaborative exhibition design by w. gropius, h. bayer, m. breuer, moholy-nagy).

added fluidity was introduced by a curved wall, as the diagram of figure 9 demonstrates. this was effectively utilized as a new feature in the exhibition above, by moholy-nagy.

similar principles were carried out successfully in the exhibition of the building workers' union in berlin in 1931. a more elaborate bridge was introduced here to raise the visitor to a higher level for an over-all view of the entire space. viewing from above provided the opportunity for the design of special displays. figure 11 shows a general view of the bridge and the exhibits. many new techniques were developed for this project.

the movement of the public in a planned direction was the central theme of the plastic concept for the exhibition "the community" in berlin in 1936. the model shows the special form and space concept created by exploiting the idea of circulation. the exhibits were placed on large overhead panels under which the visitor passed towards the core of the exhibit.

an exhibition, "bauhaus: 1919–1928," was staged in temporary quarters of the museum of modern art in new york in 1938. the experiment was made here to suggest walking directions with directional and decorative shapes and footprints painted on the floor. the sequence of the exhibits had to be adjusted to the given layout and the sizes of the rooms. two illustrations show parts of the floor treatment.

a photographic exhibition, "road to victory," depicting the life of the american nation during the war, was installed at the museum of modern art in new york in 1942. the complete dependence of the layout on the directional flow of the visitor, so that he could pass through the exhibition and look upon the displays in the

desired sequence, is evident from the model. more than half of the linear length of the visitor's walk was over a ramp which enabled him to get long views as well as close views of small and giant photographs. by raising the viewing point it became possible to place many of the exhibits on the floor.

the idea of a planned circulation was carried so far that it became the central motif for an entire building in le corbusier's musée d'art moderne. the design motif of an endless spiral is appropriate in its use when, as in this case, it serves to demonstrate a historical development. a similar idea was the basis for the guggenheim museum in new york by frank lloyd wright. here, however, the arrangement of exhibits along a predetermined path is inappropriate, as this museum is not primarily historical. the path itself in this case over a continuous ramp is confining in effect.

the diagrams of two exhibition buildings at the world's fair in paris in 1937 induce us to assume that by this time the concept of a planned circulation had been generally accepted as one of the fundamentals of exhibition design.

a more playful design along the same lines is the children's labyrinth at the triennale in milan, 1954, a very attractive solution derived directly from the idea of a continuous and leisurely movement while the viewer is looking at the presentations along the varied curved spaces. curved walls were used again in the united states pavilion at the brussels world's fair in 1958. here, the curved wall does not have the appeal as in the previous example. furthermore, curved surfaces are not well suited to display the precision of architecture's straight lines, as they cause distortion.

display and exhibits

in the imitative beaux arts style of early exhibitions, displays were usually designed as decorative stage sets, oblivious of purpose and character of the displayed objects; as long as they were "beautiful," they apparently were satisfactory. Today it would be considered a misconception if the subject itself were not put forth convincingly, while the auxiliaries necessary to this end would assume no more than the required importance. any analysis as to purpose and content of a projected exhibit will result in a specific solution. the subject must be brought close to the spectator and leave an impression on him. it must explain, demonstrate, and persuade him, and even lead to a planned reaction. the presentation must serve in support of the subject. the italian designer carboni says, " . . . tutto viene subordinato all'idea contrale espressa in sintesi. . . ."

we have today for our convenience an elaborate and diverse language with which to operate in the expression and special formulation of any exhibition topic. a brief historical review will serve to explain some aspects of its development.

the picture of the crystal palace, london, 1851, shows an orderly arrangement of many small displays within the elegant architectural structure. if we take a closer look at some individual displays of the gewerbe ausstellung in berlin, 1896, we can hardly identify the nature of the exhibits. they are in themselves overpowering to the degree of subordinating the exhibited material. the purpose of the pompous attempt to lift the exhibited products onto a higher plane of beauty seems to be to add an air of dignity by means of autocratic, architectural creations.

the tower of 1871 built with matches and matchboxes also suggests that the exhibit was designed for its own design's sake and that the product itself, used as building stones, was reduced to a secondary role. this sort of superficial beautification and historical eclecticism ruled exhibition design of the nineteenth century, and it was not until the 1920s that the tide turned towards analytical methods.

the display productions of recent years would be different were it not for experiments and inventions of some of the art "isms." in the exhibition of the russian constructivists in moscow in 1921, we notice that a radical elimination of the unessential took place. space and sculpture were created with elements of construction, largely linear members, in the pursuit of lightness and weightlessness with a minimum use of matter. a revolutionary turning point came when el lissitzky applied new-constructivist ideas to a concrete project of communication at the "pressa" exhibition in cologne in 1928. the innovation is in the use of a dynamic space design instead of unyielding symmetry, in the unconventional use of various materials (introduction of new materials such as cellophane for curved transparency), and in the application of a new scale, as in the use of giant photographs. at the "pressa" and subsequently at the trade fair in leipzig el lissitzky first used montage techniques with photo-enlargements.

exhibition techniques and new concepts in graphic design in conjunction with a new architecture were actively pioneered in germany from the mid 1920s on. italy and countries such as switzerland and sweden have further developed this new medium and have had occasion to practice extensively.

visual communication

in the sign of the sicilian blacksmith painted on the wall of his workshop, what the blacksmith is doing and what product he is manufacturing become precisely clear without the use of one word. this is communication by picture language at its simplest. it has been stated above that communication in museums and exhibitions must be governed by directness, simplicity, brevity, and by ways allowing for precision and ease of perception. a great variety of techniques is at our disposal to this end, as the following discussion of a few successful examples will point out.

the advertising folder for a ski resort illustrates the freedom in the use and in the combination of various media. not only are photographs and photo-montages used here, but also a map projection and other illustrations. but the traditional static point of view towards a perspective space illusion has been abandoned in favor of altogether different viewpoints. the result is a dynamic design which captures the reader's attention and retains his interest.

the designer is often faced with the task of making non-visual ideas visible. in a folder for a biology exhibition, "das wunder des lebens," one of the problems was to explain the physical power of the human heart. the illustration shows that the heart beat, transformed into electrical power, can generate sufficient strength to operate the elevator of the funkturm, a landmark of berlin.

one of the most important areas of work for the graphic designer today is in the service of science. there are innumerable problems which require the gifted visual communicator. this is a

field of much greater import than advertising to which most graphic designers turn because of the existing demand and because of monetary advantages. good graphics in support of science and education will in the future receive increasing attention. the abbreviated visual explanation of how television works only touches on the multitude of scientific subjects that need the artist in the task of the dissemination of knowledge.

a chart of the organization of a large chemical concern is expressed with suggestive, decorative forms and colors in an attempt to make a chart more attractive than is usually seen.

the function of the human brain by way of electromagnetic streams was explained in *life* magazine. the event of an approaching car and a pedestrian's reaction to avoid being run over were pictorially reconstructed. the series of immediate electrical impulses in the brain leading to the automatic reaction of the pedestrian are shown in consecutive stages.

the diagrammatic drawing of traffic control by radio beams and the stacking of airplanes over a crowded airfield demonstrates the necessity for this kind of visualization in the service of our complex technology.

statistics often lack imagination, but they too can be made graphic and arresting, as was illustrated by a photograph that appeared in a british magazine showing a densely massed crowd of 7250 people, equivalent to the number killed in great britain's road accidents in 1934.

the amount of food that one man consumes in an average lifetime of fifty-five years is presented in exact relation to the man's own size, another visual interpretation of statistical content.

these examples of effective visual communication have by no means exhausted the possibilities, but call attention to an important subject.

field of vision

traditionally the direction of viewing in museums and exhibitions is horizontal. during the design of the exhibition of the german werkbund in paris in 1930, the author explored possibilities of extending the field of vision in order to utilize other than vertical areas and activate them with new interest. the normal field of vision becomes larger by turns of the head and body, whereby the direction of viewing and the relative position of exhibits gain new possibilities.

the first application of the principle of extended vision is shown in the photograph from the exhibition "deutscher werkbund" in paris in 1930. the freedom gained from this theory is also demonstrated in the unorthodox display of chairs on the wall. that the field of vision can be further extended by raising the visitor up to a higher viewing and walking level becomes evident in a diagram of later origin.

the idea of the visitor's improved vision has also led to the concept of the "outside-in" world globe of the exhibition "airways to peace" at the museum of modern art in new york in 1943. the larger a globe is, the less is the surface area that can be seen from one point. the outside surface of the globe was for this reason projected onto the inside of a hollow globe into which the visitor could walk. here he could more easily get a composite picture of

the world map and the true relationship of land and sea areas. flat maps are always distorted, whatever kind of projection is used. to show the real facts of given geographic situations, concave semiglobes were devised in the same exhibition to produce a true vision. it is known that many strategic errors were made in wars and that grave misconceptions were the result of consulting distorted maps instead of globes.

means of display

it has been expressed above that in most exhibitions and displays of the late nineteenth and the beginning of the twentieth century, the subject of the exhibition itself was often overpowered and suppressed by the design of the display.

every subject is conditioned by its individual nature, by content, size, or special limitations. out of these conditions, concepts of display will develop in a different manner in every case. originality often follows in the course of an analytical working process. this logical approach represents no monopoly of the exhibition designer but is the basis of all good design. it may be said, however, that this is, unfortunately, not sufficiently understood. each subject calls for and suggests evocative expressions which are exclusively derived from this particular subject. the physical means by which the content of exhibits is brought to the attention of the visitor should not in themselves be autocratic or domineering. they are employed to serve the intent of the exhibition in the best possible manner and are, therefore, not the primary elements.

in an exhibition of giant photographs depicting the american nation at work, the photographs were placed without frames and without visible supports. it was possible here to eliminate all elements, structural and otherwise, that might detract from or interfere with the images themselves. the ultimate solution of this train of thought would be displays created without any material effort or visible support, placed in midair by methods of the future.

sequence and walking direction

an exhibition can be compared with a book insofar as the pages of a book are moved to pass by the reader's eye, while in an exhibition the visitor moves in the process of viewing the displays. reading a book, however, is a more restful occupation as compared to the physical efforts that are necessary for perceiving communications simultaneously with the act of walking. attempts to ease perception must, therefore, be made in exhibition design. the reading method of western man is from left to right. the walking direction in exhibitions must, logically, also be from left to right. even a succession of displays in depth implies a movement from left to right. only if presentations are executed with pictures or by picture language can a succession of images or a story in sequence be told while a viewer is moving from the right to the left.

lighting

lighting of exhibitions is often complex, but it is of great importance. the accompanying figures show some of the principles of lighting in museums, where the problem is largely that of an overall illumination. however, direct spotlights and individual brighter sources of light must be used to break the monotony of an even illumination in a lower key, to emphasize individual exhibits.

above all, changes in light intensity are desirable to keep the visitor's interest alive. museums and exhibitions have largely become independent from daylight for the simple reason that artificial light can be better controlled towards the intended purpose.

a sectional drawing of le corbusier's museum of modern art in tokyo shows the utilization of diffused daylight plus the use of indirect and direct lighting systems.

the section of the museum of modern art in turin suggests that the architectural concept of this building has been guided by the efficient utilization of diffused daylight.

exhibition structures

the ever-increasing dissemination of information and exchange of thought has produced a traveling form of exhibition which is no longer localized in permanent buildings but consists of lightweight, standardized, flexible, movable, structural units which can be erected independent of walls or any floor space.

these structures were initially influenced by the art theories of de stijl as well as by works of constructivism. the former fathered innumerable versions of demountable frameworks for traveling shows initiated by frederick kiesler's austrian theater exhibition at the exposition internationale des arts décoratifs in paris in 1925. this is, to the author's knowledge, the first known space definition by a structural skeleton and is an extension of the art theories of de stijl into the three dimensional and exposed framework supporting exhibits and text on various colored panels.

a prefabricated system of tubular members was used in 1934 in milan as a large framework to support exhibits. in the exhibition "studies of proportion" in milan, 1951, a more elegant framework was used in the author's sense of "extended vision" and thereby added new dimensions to the definition of open spaces.

since then many systems of demountable frameworks have been devised for the purpose of traveling exhibitions. of more recent origin are two connector systems, one for round tubes and one for square tubular members. in general, however, it must be stated that most of these systems are as yet too complicated to erect and to take apart. even industrial systems such as the american "unistrut" product require too much labor for larger structures to be economical.

probably one of the simplest systems is that of round posts onto which panels are hooked. the exhibit is stabilized through the pleated arrangement.

one of the first wooden structures for demountable traveling exhibitions was that of the container corporation of america in 1945.

in the design of the united states air force museum, an attempt was made to incorporate the previously made observations. most museums are traditionally monumental structures and rigid in their layout. I believe, however, that the museum exists to serve the visitor, not only to impress him. it must, therefore, be on a human scale. the air force museum was limited to a size which would not overtax the visitor's strength nor tire his capacity of perception.

a major attraction in this museum will be the many interesting historical aircraft that have been collected here. displaying very

large objects such as these next to very small ones presented a problem. to prevent exhibits from being touched or mishandled, they must be placed beyond reach or protected in showcases. to comply with these facts a ramp has been designed for the purpose of leading the visitor clearly in chronological order through the museum. the ramp will raise him to a viewing point that will be adjusted to large and small objects. it will extend his vision by including the floor as exhibit area and by permitting him to view objects not only horizontally but in all directions. the ramp also will keep him at a distance from valuable objects, and restricting the walking area mostly to the ramp will facilitate maintenance and cleaning. floor areas that are not to be walked on will be painted white.

the focus and interest will be directed to the displays themselves. structures that support exhibits and objects will be as inconspicuous as possible and will let the subjects speak for themselves.

a grid ceiling of a large module will diffuse and reasonably well conceal the over-all illumination suspended above. this will be supplemented by spotlights and other light sources for special exhibits.

(One of Bayer's longest and most carefully documented discussions, this essay was first published in *Curator* [30], the quarterly periodical of the American Museum of Natural History, in 1961. It appeared with sixty drawings, plans, models, and photographs of installations of his own and historical exhibitions; many of the relevant illustrations appear in the section dealing with Bayer's exhibition and architectural design. It is published here with minor alterations.)

All unattributed quotes are from letters from
Herbert Bayer to Arthur Cohen. Dates,
when available, are in parentheses following
the quote.

1900
Born on April 5 in Haag am Hausruck, a peas-
ant village near Salzburg in upper Austria. The
second son of four children born to Maximilian
Bayer (a native of Passau, Germany, and tax
collector in the region) and Rosa Simmer
Bayer (whose peasant family in Haag owned
the local Gasthaus). Although Bayer was not
close to his father, his mother, despite her lack
of education, was very sympathetic to his
childhood interest in drawing.

Rosa Simmer Bayer holding infant Herbert.
1900.

Herbert Bayer in kindergarten in Windisch,
Garten, Austria (first row, third from the left).
1905.

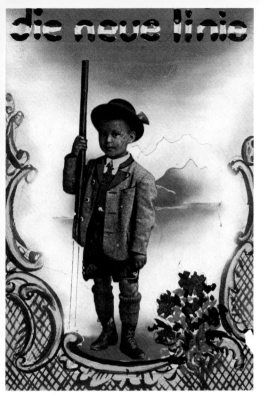

Herbert Bayer in 1921. (Photograph by Liesl Aron)

Photocollage by Bayer of himself at about six years of age. Sketch for cover of Berlin monthly *die neue linie*, circa 1928.

1912

Before settling in Linz in 1912, family moves from Haag to Windisch-Garsten and Ried in Innkreis, where he begins studies at the local Gymnasium. Bayer active as a mountaineer and skier, often spends weekends alone in the mountains. During teenage years becomes active in the Wandervogel, an outdoors movement that emphasized conservative values, contact with nature, folk traditions, and indigenous peasant culture. Attends Gymnasium in Linz, where his favorite subjects are history and descriptive geometry. Draws constantly throughout his youth.

1917

Maximilian Bayer dies suddenly at age 46, and plans to send Bayer to Vienna to further his art education become financially impossible. Serves for eighteen months in the Fourteenth Infantry Regiment of the Imperial Austrian Army but sees no combat during last years of the World War. Becomes friendly with older Linzer, Gustav Guggenbauer, an art historian of the Austrian baroque, who opens his art library to Bayer. Visits sites of baroque architecture in Austria and southern Germany and does extensive sketching of landscapes and cities.

1919

Apprentices himself from October through September 1920 to Georg Schmidthammer, who conducted an arts and crafts atelier in Linz. Becomes familiar with the work of the principal artists of the Vienna Secession and the early activities of the German Werkbund, which had been founded in 1907. Draws extensively and makes first lithograph. Designs posters, letterheads, advertisements and arts and crafts design in the office of Schmidthammer, where he also learns rudiments of architectural drawing.

1920

Leaves Schmidthammer and Austria and attaches himself to the Viennese architect Emmanuel Margold, whose workshop had been established in the Darmstädter Künstler Kolonie (Darmstadt Artists Colony) founded on the Mathildenhöhe by Grand Duke Ernst Ludwig of Hesse. Drawing of design (unexecuted) for armchair and stool. Reads Kandinsky's *Über das Geistige in der Kunst* (*Concerning the Spiritual in Art*) and sees Walter Gropius's *Bauhaus-Manifest* (Bauhaus manifesto) published in April 1919. Determined to join the Bauhaus, Bayer leaves Margold and walks to Weimar.

1921

Interviewed by Gropius in Weimar and, after review of his portfolio, is accepted as a student. From October through the spring of 1922, Bayer studies in the Vorkurs (preliminary course) taught by Johannes Itten. During 1921 and the following year makes series of linocuts printed in small editions.

1922–1923
From March 8, 1922, until July 1923, and from October 1924, until February 3, 1925, when he passes his journeyman's examination at the Bauhaus, Bayer is attached to the Wandmalerei Abteilung (wall-painting workshop) directed by Kandinsky in association with the technical master Carl Schlemmer. Executes three-part mural for stairwell at the Bauhaus as well as exterior signage for the Bauhaus building. Assists in painting the Kandinsky mural for the Juryfrei in Berlin. Briefly studies painting theory with Paul Klee, whose work he greatly admires. With fellow students paints Gropius's Sommerfeld House in Dahlem (Berlin) and other assignments generated by the wall-painting workshop in Weimar. Bayer designs binding for the exhibition publication *Staatliches Bauhaus in Weimar 1919–1923* and contributes drawings to the publication, among which is his isometric rendering of Gropius's study. Designs three postcards for the Bauhaus exhibition series and paints exterior signage for Bauhaus building with Josef "Sepp" Maltan. Bayer work exhibited in Kunst und Technik–Eine Neue Einheit (Art and Technics–A New Unity), the official name of the Bauhaus Ausstellung, which was held during August at the Bauhaus and the Staatliches Landesmuseum in Weimar. Probably meets El Lissitzky and Kurt Schwitters, who visited the Bauhaus during 1922–23.

Working on the Juryfrei canvas of Kandinsky in the wall-painting workshop at the Bauhaus in Weimar. Bayer kneeling in white smock; Oskar Schlemmer stands in rear, third from left. 1922.

1923–1924
In company with fellow Bauhäusler "Sepp" Maltan, Bayer hikes throughout northern and southern Italy and Sicily from fall of 1923 through spring 1924, and spends winter in Rome. Draws and paints during spring stay in Sicily, visiting Agrigento, Taormina, Palermo, Segesta, and other sites of Greek ruins in Sicily. Supports himself during travels by painting theater sets in San Gimignano and house painting in Rome. Passes summer of return to Germany in Maltan's house-painting workshop in Berchtesgarten, where he completes series of paintings based on his travels. Returns to the Bauhaus in the late fall.

1925
On February 3 passes his Bauhaus journeyman's examination in Weimar, consisting of a theoretical examination and a practical application, which, in Bayer's case, is designing and painting a nightclub on the square where the Goethe-Schiller theater is located. Accompanies move of Bauhaus from Weimar to Dessau. On April 1, 1925, Bayer is appointed by Gropius to direct the newly founded workshops for Druck und Reklame (printing and advertising). In October Bayer establishes lower case as style for all Bauhaus printing and introduces explanatory text on all Bauhaus letterheads to interpret "klein schreiben." Designs signage for the new Bauhaus building complex. Projects for advertising and publicity kiosks. Marries Chicago-born Bauhaus student Irene Angela Hecht, who becomes photographer active in the documentation of Bauhaus activities and later represented in Stuttgart Film und Foto exhibition (1929). Designs Katalog der Muster (product catalogue), a descriptive and sales catalogue for products designed and produced by the Bauhaus workshops. Designed virtually all typographical material of the Bauhaus. Executes designs for Fagus-Werk printed matter and sales literature. Brief visit to Paris, where Bayer does straight photography for the first time, preserving, however, only one photograph, *Morgen in Paris* (*Morning in Paris*, 1925), for printing and exhibition. Assists Jan Tschichold in selection of examples of functional typography for Tschichold's special supplement, *Elementare Typographie*, included in the October number of *Typographische Mitteilungen*.

The Bauhaus masters photographed on the roof
of the new Gropius building at Dessau. From left:
Josef Albers, Hinnerk Scheper, George Muche,
László Moholy-Nagy, Joost Schmidt, Walter
Gropius, Marcel Breuer, Vassily Kandinsky, Paul
Klee, Lyonel Feininger, Gunta Stölzl, Oskar
Schlemmer. 1925.

Koch, Bayer, and Schawinsky on terrace of
Bauhaus building. Dessau, 1925–26. (Photo-
graph by Irene Bayer)

1926
Designs poster for Kandinsky sixtieth-birthday
exhibition in which use of photographed asym-
metric design is confirmed. In special issue of
Offset devoted to the Bauhaus, Bayer contrib-
utes important essay, "Versuch einer neuen
Schrift" ("An Attempt at a new way of writing")
in which combinations of upper and lower case
alphabets anticipate Bayer's universal type, for
which drawings were completed the same
year. Formulates "Schema der Gestaltungs-
möglichkeiten" (Schema of Design Possibili-
ties) in which he notes seven major elements
of design: "Schrift, Zeichen, Bild, Farbe, Ware,
Licht, Bewegung" (type, symbol, image, color,
product, light, movement).

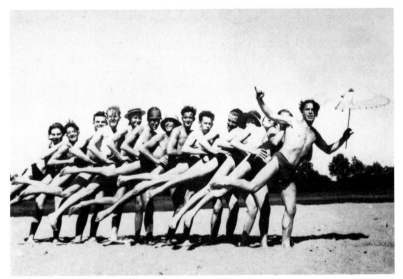

Bathing party. Dessau, 1925–26. With umbrella,
Alexander (Xanti) Schawinsky; third, Marcel
Breuer; fourth, with hat, László Moholy-Nagy;
sixth, the architectural photographer Max Kra-
jewsky; eighth, with hat, Bayer; ninth, with hat,
Hinnerk Scheper; tenth, in straw hat, Georg
Muche; eleventh, Erich Consemüller; others
unidentified. (Photograph by Irene Bayer)

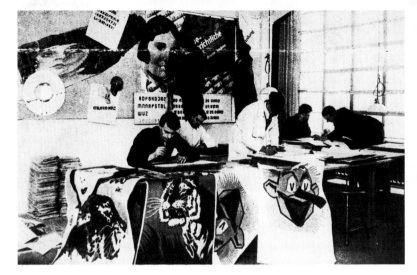

Workroom of the poster workshop that was part of the printing and advertising workshop at the Bauhaus in Dessau. About 1926. (Photograph courtesy of the Bauhaus-Archiv, Berlin)

As master of the new printing and advertising workshop of the Bauhaus. Dessau, 1926. (Photograph by Irene Bayer)

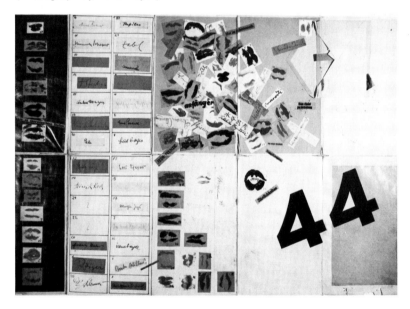

Portion of immense Bayer collage *Prospekt der Mund* presented to Gropius on his birthday in May 1926, reproducing the kisses and greetings of the faculty and student body of the Bauhaus. (Ise Gropius loan. Photograph courtesy of the Bauhaus-Archiv, Berlin)

1927
Poster and catalogue for Europäisches Kunstgewerbe Ausstellung (European Arts and Crafts Exhibition), Leipzig. Bayer changes name of the Bauhaus workshop from Druck und Reklame (printing and advertising) to Werkstatt für Typographie und Werbsachengestaltung (workshop for typography and advertising design). Assists in organization of Design Instruction Week at the Bauhaus. Meets Alfred Barr, Jr., of the Museum of Modern Art, New York, at the Bauhaus during late November or early December, prior to Barr's departure for the Soviet Union.

1928
Executes photomontage cover for *bauhaus zeitschrift* (*bauhaus review*). Designs exhibition space on Elementare Buchtechnik (functional book design) for the German section at the Pressa Ausstellung (Press Exhibition) in Cologne. Sees Soviet pavilion designed by El Lissitzky at the same exhibition. With Gropius's resignation, Marcel Breuer, Moholy-Nagy, and Bayer leave the Bauhaus. During bicycle trip to Marseilles, Nice, and Corsica, Bayer begins program of straight photography, including photographic series on the Transbordeur-Marseilles bridge. Also photographs in Milan. Participates as guest exhibitor—along with Lajos Kassak, Moholy-Nagy, Cassandre, and others—in exhibition of Kurt Schwitters's Ring neuer Werbegestalter (circle of new designers) in Magdenburg, Germany, during the summer.

Establishes himself in Berlin, where he becomes art director of German edition of *Vogue* and design director of the international advertising agency Dorland Studio. Designs extensive range of prospectuses, posters, advertisements, letterheads, and other graphic materials for German and foreign clients of the studio. Begins design of series of photomontage covers for the monthly periodical *die neue linie* (*the new line*). Begins series of paintings dominated by use of elements arranged like theatrical flats.

Irene Bayer, first wife of Herbert Bayer, in 1928, shortly after the Bayers left the Bauhaus. (Photograph by Herbert Bayer)

Exhibition announcement for Neue Typographie, organized by Der Ring Neuer Werbegestalter with guest participation of Bayer, among others. Magdeburg, 1928.

Marcel Breuer. 1928. (Photograph by Herbert Bayer)

Bicycling in Southern France after leaving the Bauhaus. Summer 1928.

Sleeping at the beach. Probably 1928.
(Photograph by Alexander Schawinsky)

1929
Birth of only child, Julia Alexandra Bayer.
Exhibition of paintings and drawings at Galerie
Povolozky, Paris (with catalogue preface by
Paul Dermée), and exhibition of work at Küns-
tlerbund März, Linz (catalogue introduction by
his wife, Irene Bayer). Executes first photo-
montage, *Profile en face* (*Frontal Profile*). Par-
ticipates in Neue Typographie exhibition at the
Kunstbibliothek, Berlin. Participates in the
international Film und Foto exhibition in Stutt-
gart, where nineteen of his photographs are
exhibited.

KUNSTLERBUND MÄRZ
ausstellung
herbert bayer
geöffnet 18. mai
2. juni
10 - 13ʰ **berlin**
14 - 18ʰ
volksgarten

Bayer poster for exhibition of his work at the
Kunstlerbund März. Linz, 1929. (Photograph
courtesy of the Bauhaus-Archiv, Berlin)

1930
With Walter Gropius, Moholy-Nagy, and Marcel
Breuer, Bayer designs display, exhibition circu-
lation, catalogue, and poster for the Section
Allemande of the German Werkbund Exhibi-
tion at the Paris Exposition de la Société des
Artistes Décorateurs. Earliest sketches for
Bayer-type, as well as for his Konturlose
Schattenschrift (Open Face Shadow Type).
Design for stencil type cast and manufactured
by H. Berthold, Berlin, the type foundry for
which Bayer freelanced as type designer and
designer of prospectuses and advertising.
Designs display for Paris exhibition of
H. Berthold.

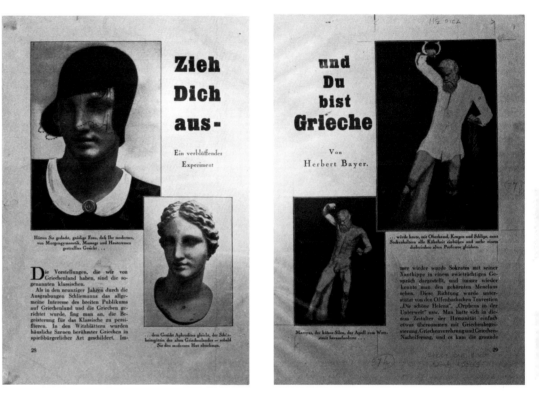

Opening pages of Bayer's article "Undress
and You Are Greek" for popular magazine *Uhu*.
Photomontages by Bayer. 1930. (Photograph
by Javan Bayer)

1931
With Gropius, Breuer, and Moholy-Nagy, Bayer
designs the Baugewerkschafts Ausstellung
(Building Workers Union Exhibition) in Berlin.
Designs exhibition with Breuer for the German
cork industry (Berlin). One-man exhibition of
paintings, drawings, and other media at the
Bauhaus Dessau. Wins first prize in the inau-
gural international exhibition of advertising
photography representing fifty photographers
from eight European nations.

Feeding his daughter. About 1931. (Collection
Irene Bayer)

Brochure for Lippe-Detmold in the Teutoburger
Forest, employing self-portrait montaged to
photograph of landscape. 1931.

1932

Designs freeform outdoor billboard in Berlin advertising the periodical *die neue linie*. Participation in group show at the Julien Levy Gallery, New York, where he will be represented until 1940. Privately publishes portfolio of ten photomontages published in small edition of five signed and numbered copies. Separates from Irene Bayer.

1933

Bayer-type manufactured and distributed by H. Berthold, Berlin. Executes prospectus for Weltausstellung in Chicago: Ein Jahrhundert des Fortschritts (World's Fair in Chicago: A Century of Progress).

Herbert Bayer, Alexander (Xanti) Schawinsky, Walter Gropius. 1933. (Photograph courtesy of the Bauhaus-Archiv, Berlin)

Playbox for Julia Alexandra Bayer. Playbox contained four removable parts incorporating games such as pegboards, dominoes, letter games, adaptation of Bayer Fotoplastik, and painting with detachable elements. Berlin, 1932.

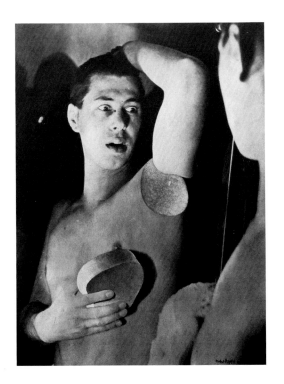

Self-portrait. The ninth in a series of ten photomontages published in a small edition in 1932.

1934

With Marcel Breuer, travels by kayak down the Danube to Belgrade and overland to the now-destroyed medieval city of Skopje in Dalmatia, Yugoslavia, through Macedonia, mainland Greece and the Greek islands. Extensive photography and painting series based on Greek motifs. Develops style and direction for the implementation and typographic organization of the Fabrikausstellungen (industrial fairs).

Aboard the kayak on the Danube during summer trip with Marcel Breuer. 1934.

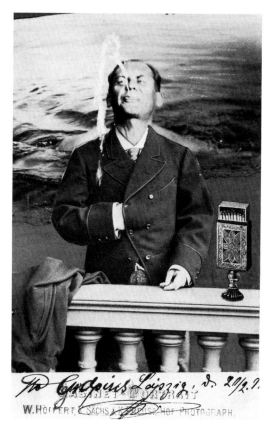

Photomontage by Bayer for the fiftieth birthday of Walter Gropius, about May 18, 1934.

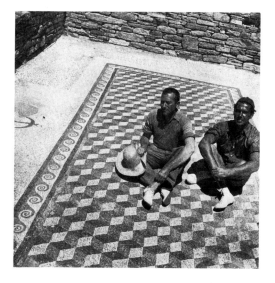

Marcel Breuer and Bayer in Delos, Greece. 1934.

1935

Important series of advertisements for Adrianol-Emulsion in which Bayer employs classical statuary in photomontage. Executes brochure for exhibition Das Wunder des Lebens (The Wonder of Life). Designs the Hamburg Freizeit-Bewegung (leisure time exhibition).

1936–1937

Begins "Dunstlöcher" series of paintings based on Austrian peasant architectural motifs. Designs catalogue for summer exhibition, Deutschland Ausstellung, in which insertion of propaganda material confirms Bayer's conviction that free design is no longer possible in Germany. Nonetheless continues extensive graphic-design program at Dorland, maintaining loyal relations with Jewish clients who found it otherwise impossible to secure design services. Designs traveling exhibition for the German wallpaper industry (Hamburg). Publishes portfolio of ten fotoplastiken (photoplastics) in edition of five signed and numbered copies. Exhibition at the Kunstverein, Salzburg. Work represented in Alfred Barr's Museum of Modern Art exhibitions Fantastic Art, Dada and Surrealism, and Cubism and Abstract Art. Three works by Bayer removed from German museums by Nazi authorities and exhibited as examples of Entartete Kunst (degenerate art) at the Haus der Deutschen Kunst, Munich, and in museums at other locations throughout Germany and later Austria.

With Julia Alexandra. Berlin, about 1937. (Collection Irene Bayer)

1937

Exhibits paintings, drawings, and photomontages at the London Gallery, London, during spring. Catalogue essay by Alexander Dorner, whom Bayer had met when he was director of the Hannover Kestner-Gesellschaft. Prepares photomontaged door for entrance to London Gallery. During June travels from London (in company with Marcel Breuer) to the United States to explore possibilities of employment after emigration. Meets with Gropius, Moholy-Nagy, Alexander Dorner, John McAndrew (then director of the Department of Architecture at the Museum of Modern Art in New York), Mary Cook, and others at Gropius's summer home near Providence, Rhode Island. Discusses the constitution and program of Moholy-Nagy's New Bauhaus in Chicago. Moholy-Nagy invites Bayer to teach graphic design at New Bauhaus. Preparatory discussions with McAndrew about prospective exhibition, Bauhaus: 1919–1928. Bayer agrees to return to Germany to gather material for the exhibition.

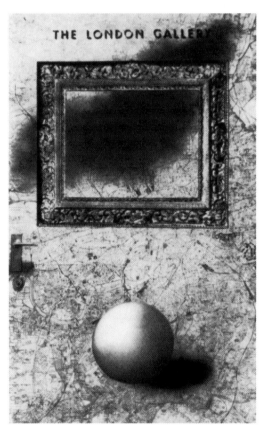

Announcement by Bayer reproducing montaged entrance doorway to the London Gallery during his first exhibition in England. 1937.

1938

While accumulating material for the Bauhaus exhibition from, in several cases, reluctant and timorous German collaborators, Bayer designs last exhibition in Germany, The Community (Berlin). With the Anschluss, Bayer loses Austrian passport and becomes German national. Sends gathered Bauhaus material ahead in crate addressed to Gropius in Lincoln, Massachusetts. Following complicated and dangerous attempts to secure emigration documents, Bayer leaves Germany on the SS *Bremen* departing from Bremerhafen on August 15, in company with Alexander Dorner and his wife, who are also emigrating. On shipboard they engage in extensive discussion about the museum of the future for which Bayer made drawings, none of which survive. Arrives in New York on August 22 with less than twenty dollars. Determines to improve English immediately.

Begins work on the design and installation of the Bauhaus exhibition at the Museum of Modern Art, which opens December 7. Working with a series of small rooms, Bayer devises innovative exhibition that receives international acclaim. Lux Feininger helps Bayer with installation. Visits Josef Albers at Black Mountain College in September to discuss Bauhaus exhibit and to persuade him to permit copies of student's works from his Vorkurs to be reproduced. During installation, museum visited by Alvar Aalto, Fernand Léger, Richard Neutra, and others to see the exhibition. Collaborating with Walter and Ise Gropius, works simultaneously on editorial organization and design of *Bauhaus: 1919–1928*, the monograph that accompanies the exhibition. Lives in small apartment at 19 West 56th Street in New York City. Shortly after his arrival, he meets Joella Haweis Levy, then separated from her husband, art dealer Julien Levy, at a small party. Wife and daughter arrive in the United States on December 13 aboard the *President Roosevelt*.

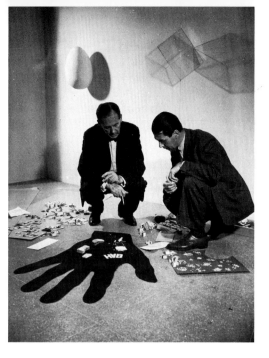

Gropius and Bayer discussing lettering for entrance to the Museum of Modern Art exhibition Bauhaus: 1919–1928, during November 1938. (Photograph by Hansel Mieth)

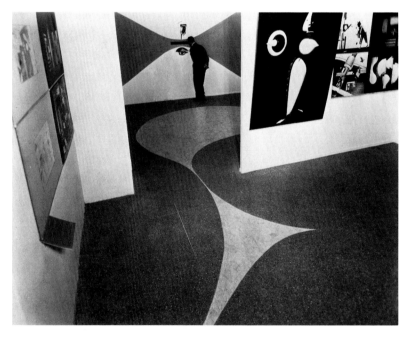

Bayer checking the installation of Bauhaus: 1919–1928. (Photograph by Soichi Sunami, the Museum of Modern Art)

1939

With Xanti Schawinsky devises display for the State of Pennsylvania's exhibit at the New York World's Fair whose architecture and interior were designed by Gropius and Breuer. Early in the year receives from Germany all the paintings, drawings, photographs, etc., that had been held by German tax authorities following their return from the London Gallery exhibition (1937). Graphic design for *Life*, John Wanamaker, Bamberger's department store, and other clients. Meets Egbert Jacobson (longtime admirer of Bayer's graphic design and director of design for the Container Corporation of America since 1935) and begins series of advertisements for CCA. One-man exhibition at P. M. Gallery, New York, and at Black Mountain College, North Carolina. *PM*, the magazine of the art directors and graphic design establishment published by Dr. Robert Leslie, devotes special issue to Bayer in December, publishing three Bayer essays on poster design, exhibition design, and typography. Joella Levy introduces Bayer to Alexander Calder during fall and a lasting friendship develops. Concentrates on "Signs and Signals," a series of small-format pictures painted in his apartment.

1940–1942

Graphic design practice expands with work for variety of drug companies, magazines, department stores, and industrial corporations. Designs book jackets for Siegfried Giedion's *Space, Time and Architecture* (1941) and Jose Luis Sert's *Can Our Cities Survive?* (1942). Leo Lionni, then art director of N. W. Ayers, commissions Bayer to design major brochure for the General Electric Company. *Electronics—A New Science for a New World*, a narrative brochure integrating drawing, photomontage, and text and making innovative use of typographic and material devices, becomes a design sensation. Series of unique offset prints from collages on leftover paper from the electronics brochure for General Electric Company realized (Makulaturdrücke). Designs packaging exhibition for Aluminum Company of America and traveling exhibits for the Coordinator of Inter-American Affairs, as well as Women at War (1942), an exhibit for the Australian News Bureau. Road to Victory exhibition (directed by Edward Steichen) at the Museum of Modern Art establishes new direction for presentation of individual photographs as sequential narrative (1942). Small exhibit for Museum of Modern Art, Arts in Therapy (1942). Exhibition of work at Yale University, New Haven, in 1940; is represented in group shows in San Francisco (1940), the Katherine Kuh Gallery, Chicago (1941), and the Addison Gallery of American Art, Andover, Massachusetts (1941). Consultant art director at John Wanamaker's department store (1941–42) while maintaining increasingly large and wholly personal graphic design practice. Begins "Communication and Space" series of paintings, in which his interest in the climatic conditions of the stratosphere are visualized. Joella Haweis Levy is divorced from Julien Levy on October 13, 1942.

Alexander Calder and Bayer beneath "Dunstlöcher" painting. Locust Valley, New York, summer 1940. (Photograph by Fred Hamilton)

Walter and Ise Gropius, Herbert Bayer and Joella Haweis Levy. Summer 1942.

Airways to Peace, traveling exhibition launched by Museum of Modern Art, features demountable freestanding globe into which the viewer may enter. Introduces Bayer to technical aspects of geography, cartography, and issues of graphic representation. Drawings for theater exhibition mural contemplated by Museum of Modern Art (unexecuted). James Prestini arranges small exhibition of Bayer's work at North Texas State Teachers College, Denton, Texas, which elicits enthusiastic comment from Albers, Gropius, Moholy-Nagy, Giedion, Dorner, and others. Represented in traveling group exhibition of Museum of Modern Art, Art and Advertising. Moves to larger apartment at 835 Seventh Avenue in New York City and begins spending summers on the grounds of Marion Willard's country estate on Peacock Lane in Locust Valley, Long Island. Becomes friendly with Constantino Nivola, Robert Osborn, and sees friends from Bauhaus days and other artists vacationing in eastern Long Island. Mattá, Siegfried Giedion, Stamo Papadaki, Mary Callery, Fernand Léger, Frederick Kiesler, and others come to visit Bayer and Jose Luis Sert, who rented the dairy building on the Willard estate. Paul Lester Wiener, an architect from Vienna and Berlin, develops friendship with Bayer that lasts until Wiener's death in 1967. Visits Piet Mondrian's studio at 15 East 59th Street late in the year and proposes a walk in Central Park, but Mondrian avows his hatred of green trees and begs off. Bayer and Mondrian enjoy each other and agree to meet again; Bayer decides to purchase a picture.

Bayer returns to Mondrian's apartment during early February and learns that Mondrian has just died. Attends Mondrian's funeral on February 3. Spends several months during the winter in Stowe, Vermont, where he discovers American Analogues to the Dunstlöcher ("vapor holes") he had used in his paintings of the middle 1930s. Uses notebooks and journals extensively for annotation, diary records, and drawing, filling more than a score of ledger books over the coming years. From cross-country walking and skiing rediscovers his passion for mountains and their formation, out of which important series of paintings, "Mountains and Convolutions," emerges. Summers again in Locust Valley, Long Island. On July 27 Bayer is naturalized, becoming a U. S. citizen. Becomes consultant art director at the J. Walter Thompson advertising agency. Designs displays for Art in Progress, the fifteenth-anniversary exhibition of the Museum of Modern Art; and for the medical and pharmaceutical industry, an exhibition in Chicago, Medical Products. On October 19 divorces Irene Hecht Bayer in Reno, Nevada, and on December 2 marries Joella Haweis Levy in New York City.

At work on painting in the "Mountain and Convolution" series. 1944–45.

During January becomes vice-president in charge of design at Dorland International, Pettingell and Fenton. Designs Modern Art in Advertising, an exhibition for Container Corporation, which opens at the Art Institute, Chicago. The following year, Modern Art in Advertising (edited by Egbert Jacobson), an extensive documentation of the exhibition, is published. Posters for the Office of War Information, the Rural Electrification Administration, and the Civil Aeronautics Administration. Becomes director of art and design for Dorland International, which has reopened its New York office. Works for government agencies as well as design consultation for Douglas Aircraft and other corporations. Meets Walter Paepcke, president and chairman of the board of the Container Corporation of America and his wife, Elizabeth. "intelligent, cultured, distinguished, cynical, interesting, but difficult," is the way Bayer describes the remarkable Paepcke, who was to become his first American supporter and close friend. Paepcke becomes interested in Aspen, a moribund mining town in the mountains of Colorado, during the spring and invites Bayer to visit and give an opinion on its development; Paepcke invites Walter Gropius to visit as well and to address the Aspen City Council on development possibilities. Following a two-month summer visit to Mexico (which made a lasting impression on Bayer), he and his new wife travel from Chicago to Aspen with the Paepckes to spend Christmas and New Year's. "we liked the aspen idea and bought an old house on the second day. I am forever grateful for joella's readiness to agree to such an adventurous move. she had previously lived mostly in cities. life in the country, particularly in a ghost town such as Aspen, posed unforeseen problems. leaving new york meant giving up a new career in a new country; however, new york was not the city for me. I was only interested in how to get out into the country on weekends. I was aware that I would be moving away from a center of culture where things for an artist generally happen; however, as it turned out, we created a new center of culture in aspen, which, in turn, attracted city people" (October 26, 1982).

With Walter Paepcke, chairman of Container Corporation of America, at the opening of Modern Art in Advertising exhibition at the Art Institute, Chicago. 1945. (Photograph by Gordon Coster)

1946–1947
Leaves New York and moves to Aspen on April 9, arriving in the middle of a snowstorm. Stays in the Paepckes' Victorian home until remodeling of his own house is completed in the summer. Continues "Mountains and Convolutions" paintings. Alexander Dorner visits in Aspen, and they work together on the text of Dorner's book on Bayer and modern art. Becomes design consultant for the development of Aspen as a ski resort and ultimately as a cultural center. Consultant and architect for Aspen Institute of Humanistic Studies, which Paepcke has founded. Designs Sundeck Ski Restaurant, his first architectural design project, situated on Ajax Mountain at an elevation of 11,300 feet. Paepcke appoints Bayer design consultant to Container Corporation of America and art director for the innovative series of institutional advertisements produced by the corporation, Great Ideas of Western Man. Designs interiors and color scheme for the offices of Container Corporation in Chicago. Establishes small design office in Aspen, initially involved in the promotion of local ski and service facilities. On March 19, Wittenborn publishes Alexander Dorner's the way beyond "art": the work of herbert bayer, the first comprehensive monograph on his work. Dorner curates retrospective of his work which travels for the next two years to ten museums coast to coast.

With Fluffy in Aspen. About 1946. (Photograph by Betty Rosenzweig)

1948–1950
Undertakes design of the interiors and color scheme program for the offices of the Title Insurance and Trust Company (Chicago, 1948) and the offices of Henry Hurst & McDonald (Chicago, 1950). Designs exhibition on packaging products and procedures for Container Corporation of America (1950). "in the fall of 1949, I built the studio on red mountain in aspen and finished it by christmas. it was a particularly long and beautiful fall period. there was no other house near the studio. there wasn't even a road. I had to walk on skis during the winter. I did not live in the studio. I only came to work. it was ideal because once there, there was absolutely no disturbance, but there was interesting and charming wildlife all around the area" (October 26, 1982). Becomes friendly with fellow Aspen resident Gary Cooper, who brings him two baby owls as house pets. Bayer sketches owls; later, both birds are killed by hunters (1948). Executes series of seven two-color lithographs based on the "Mountains and Convolutions" paintings in an edition of ninety for the Colorado Springs Fine Arts Center (1948). Bicentennial celebration of the birth of Goethe, which leads to founding of Aspen Institute for Humanistic Studies. Bayer reads paper "Goethe and Art Today" (1949). Walter Gropius commissions Bayer to undertake two murals for installation in the Harkness Graduate Center, one of a group of buildings designed by The Architects Collaborative, Cambridge, for Harvard University (1950). The mural painting Verdure is installed in the faculty dining room of Harkness, and the tile mural, executed in uniform pattern of light and dark gray squares interrupted by clusters of various colors, is situated on a curved wall extending along ramp for two floors to the restaurant. Begins research on World Geo-Graphic Atlas, to be published privately by Container Corporation of America. Travels to Europe to visit cartographic institutes in England, Scotland, Italy, and Germany. Paintings and photomontages represented in first postwar German exhibition of Bauhaus artists, Die Maler am Bauhaus, curated by Ludwig Grote for Haus der Kunst in Munich (1950).

Gary Cooper with owls he had found in the woods surrounding Aspen and given to Bayer. 1948. (Photograph by The Tintype)

During August 1948, Bayer relaxes in the mountains surrounding Aspen. (Photograph by Patrick Henry)

Bayer with surviving owl. Aspen, 1948.

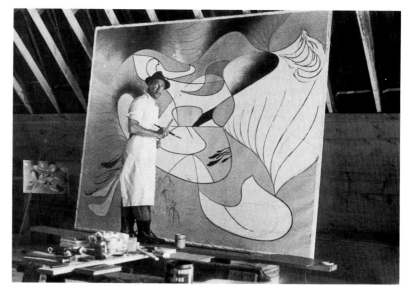

At work in Aspen studio on mural painting *Colorado*. 1948.

Julia Bayer. 1949.

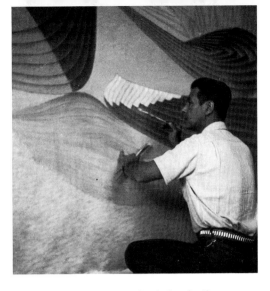

At work on *Verdure*, mural painting for the Harkness Graduate Center designed by Gropius and The Architects Collaborative for Harvard University. 1950.

Christmas greetings from the Bayers, 1950. (Photograph courtesy Herbert Bayer Archive, Denver Art Museum)

1951–1957

Reputation as a pioneer of modern graphic design consolidated by numerous essays, articles, addresses delivered and published during the early 1950s. *World Geo-Graphic Atlas*, completely written, edited, and designed (with collaborative assistance of Joella Bayer and technical experts), published in noncommercial edition of 30,000 copies by Container Corporation of America (1953). Meets Robert O. Anderson, founder and acting executive officer of the Atlantic Richfield Company, who acquires Bayer's remodeled Aspen house during the fall (1953). Anderson becomes active in the community life of Aspen and particularly in the Aspen Institute. A strong friendship (which has continued to grow over the succeeding decades) begins between Anderson and Bayer. Designs seminar building for Aspen Institute for Humanistic Studies and executes sgrafitto mural for exterior of the building (1953). During November of 1953 drives with Joella from Paris to southern Italy and crosses over to Sicily, where they settle for four months in Taormina. Bayer begins "Linear Structures" paintings, which will occupy him for the next few years, interrupted only by the small group of pictures "The Forces of Time" (1954). During the winter of 1954, they cross over to North Africa and briefly explore the medieval sites of Tunisian Islam, particularly Kairouan. Upon return to Aspen in the spring of 1954, after temporary stays at various locations in Aspen, they buy Bowman Block and remodel it into a two-level apartment, with a large space for the design office at street level.

During 1955 conceives the first recorded "earthwork" environment, *Grass Mound*, and designs and executes the *Marble Garden*, both of which are sited on the grounds of the Aspen Institute. Among architectural design projects of these years are the Health Center, Aspen (1955), and additional work on Orchestra Hall in Chicago (1955), as well as development and design consultation for the New York office of Container Corporation of America (1955). In 1956, upon the retirement of Egbert Jacobson from Container Corporation, Bayer made chairman of department of design for the corporation, responsible for the overall planning and coordination of all aspects of architecture and design affecting the corporation. Designs factories and paper mills for Container Corporation between 1955 and 1957 in

Santa Clara, California, Brewton, Alabama, Hoya, Germany, and folding carton plants in Seattle, Washington, Muskogee, Oklahoma, Dolton, Illinois, and Fort Worth, Texas. Designs exhibition Indians of the Northwest for the Taylor Museum of the Colorado Springs Fine Arts Center (1955), and a major United States government postwar exhibition in Berlin, Volk aus Vielen Völkern (Nation of Nations, 1957). Extensive design of books and book jackets for Alfred A. Knopf, the Bollingen Foundation, Pantheon Books, Harvard University Press, for works by Siegfried Giedion, Sir Kenneth Clark, Sir Herbert Read, Dora and Erwin Panofsky, Frank O'Connor, John Crowe Ransom, and many others (1955–1965). Drawing on his now extensive cartographic experience, executes two historical map murals for Colonial Williamsburg, Virginia, as well as the first louvered movable sculpture, the *Kaleidoscreen* (1957), installed on the grounds of the Aspen Institute.

During these years exhibits often; one-man shows at the Cleveland Institute of Art (1952), Hanns Schaeffer Galleries, New York (1953), Kunstkabinett Klihm, Munich (1954, 1957), Galleria del Milione, Milan (1954), Aspen Institute for Humanistic Studies (1955), and a number of group shows, the most important of which is Subjektive Fotografie at the Schule für Kunst und Handwerk in Saarbrucken, Germany (1951). This period culminates with a substantial traveling retrospective, Herbert Bayer 33 Jahres Seines Schaffens (Herbert Bayer: 33 Years of His Work), which opens at the Germanisches Nationalmuseum, Nuremberg, in 1956 and continues to Die Neue Sammlung, Munich, Kunstgewerbemuseum, Zurich, Hochschule für Bildende Kunst, Berlin, Städtisches Museum, Braunschweig, concluding at the Kunst und Industrie Museum, Vienna, in 1957.

Photographers' seminar. Aspen, 1951. Bayer standing at left near column. Others include Beaumont Newhall, Walter Paepcke, Ansel Adams, Joella Bayer, Franz Berko, Minor White, Dorothea Lange. (Photograph by Berko)

Birdhouses designed by Bayer. The birds preferred the duplex lower right. Aspen, 1953.

At luncheon party in Southern France with Jean Arp (others not shown include Mrs. Hagenbach-Arp and Joella Bayer). 1954.

1958–1959
Designs building for Research Center of Container Corporation of America in Valley Forge, Pennsylvania, the most significant achievement of his corporate architecture (employing an earthwork similar to *Grass Mound* in the landscaping). Restaurant building in the Aspen Meadows completed. Works for two years on unrealized project for U.S. Air Force Museum at the Wright-Patterson Air Force Base in Ohio. Completes series of paintings based on the "Linear Structure" motifs first devised in 1954 and begins early pictures in the "Moon and Structures" series. Small exhibition of recent paintings travels to Fort Worth Art Center, Walker Art Center, and University of Oklahoma Museum, and the following year has third exhibition at his principal German dealer, Galerie Klihm, Munich. Participates in V Bienal in São Paulo.

One of Bayer's many sketchbooks, where he works in pencil, pastel, gouache, crayon, and collage, developing ideas for painting. Shown: September 1959. (Photograph by Elaine Lustig Cohen)

Bayer studio. Aspen, 1950. (Photograph by Berko)

1960
On the occasion of the International Design Conference held in Tokyo, at which he is invited to talk, makes first visit to Japan. "the contact with japan and its concept of life and culture was a profound one, however my own studio and house in aspen were built before this trip to japan and before I was really conscious of japanese architecture. I saw a certain affinity to the american system of the balloon frame construction; however, new to me was the sensitive treatment of hand-treated wood and the affinity of the man-made world with nature. most impressive were the gardens, the craftsmanship, sensitivity towards all materials, and the total integration of visual concepts with everyday life and religion. one of the highlights was a visit to the katsura palace. (I later designed the layout of a book on the katsura palace with texts by gropius, kenzo, tange, and photographs by yosuhiro ishimoto" (November 1982). Spends five weeks in Japan visiting with Japanese designers, architects, and planners. Pursues a series of paintings marked by the hieratic relation of terrestrial structures and lunar forms influenced by Japanese culture. Works on small series of sculptures based on the "Linear Structure" paintings. Exhibits at Städtische Kunsthalle, Dusseldorf, and Museum am Ostwall, Dortmund. Close friend Walter Paepcke dies unexpectedly in May and Bayer commemorates loss with prose poem and memorial sculpture sited in small wood where later the poet Mina Loy (1882–1966), mother of Joella Bayer, and his daughter Julia are buried.

1961
Bayer realizes designs for Walter Paepcke Auditorium and Memorial Building for Aspen Institute for Humanistic Studies. Paul Theobald in Chicago publishes Bayer's *Book of Drawings*. Exhibition of work at the Bauhaus-Archiv in Darmstadt and representation in the 27th Biennial Exhibition of the Corcoran Gallery in Washington, D.C.

1962
Numerous architectural projects, including building for the Institute for Theoretical Physics at the Aspen Institute for Humanistic Studies, the Aspen terrace house of Robert O. Anderson, and the remarkable private chapel, integrating old Spanish ecclesiastical artifacts into a New Mexican-style modern chapel, built for the Anderson family in Hondo Valley, New Mexico. First version of the *Walk in Space* three-dimensional project for the gardens of the Roswell Museum and Art Center (unrealized). Extensive exhibitions in museums throughout the United States and Europe. Participates in first exhibition at Marlborough Fine Arts, London, Painters of the Bauhaus, as well as exhibition at the Museum des 20. Jahrhunderts in Vienna, Kunst von 1900 bis Heute.

1963–1966
Executes most ambitious and original architectural commission for the Music Associates of Aspen, the Music Festival Tent, which he begins in 1963 and completes in 1964. Galerie Klihm reissues two major portfolios of Bayer photographs and Fotoplastiken in 1965, and Container Corporation of America publishes portfolio of fourteen reproductions of paintings in the same year. Retires from Container Corporation of America and from 1966 on becomes consultant designer to the Atlantic Company, which later becomes the Atlantic Richfield Company. In 1966 begins series of paintings based on chromatic and geometric progressions that will occupy him for the next ten years, producing over a thousand drawings, paintings, lithographs, and serigraphs (working closely during the 1970s with his principal assistant of those years, Dick Carter). Exhibitions in the United States continue; participates in Documenta III in Kassel (1964) and Les Années 25 at the Musée des Arts Décoratifs in Paris (1966). Executes series of ten monochromatic lithographs at the Tamarind Lithography Workshop in Los Angeles after receiving a Tamarind Fellowship (1965). There follow ten additional lithographs with varying subject matter at Tamarind (1965) and additional serigraphs in 1966. With Joella Bayer, makes his first trip to Ibiza and Morocco in 1963, which results in annual visits to Morocco thereafter until 1966 when he buys a house in Tangier. Visits Tangier at least once a year until 1974; the house is still owned by the Bayers. Draws, paints, photographs in Morocco, concentrating mostly on paintings marked by strong abstract architectural space. Bayer's only child, Julia, dies in Santa Monica of an aneurysm at the age of 34 (1963).

Photographing in the Tangier casbah. About 1966.

The Bayer house in Tangier; acquired in 1966
and occupied every year until 1974.

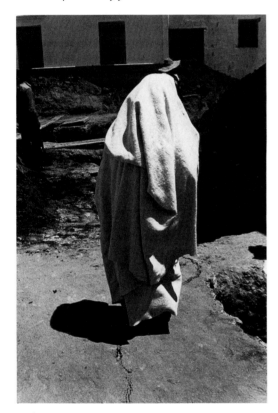

Photograph by Bayer of Moroccan woman.
Tangier, about 1966.

1967–1969

One of the most important periods in Bayer's
career, marked by an immense variety of
activity and focused energy. H. A. Reinhold
publishes *herbert bayer: painter, designer,
architect*, the first coherent visual repertoire of
the range of his work from his youth through
the 1960s. In addition to advancing his
research into chromatic painting, executes
series of sculptures making use of prefabri-
cated elements, the most important of which is
the *Articulated Wall* commissioned by the art
director for the Olympics, the sculptor Mathias
Goeritz. The *Articulated Wall* is installed on
the highway from Mexico City to Azteca Sta-
dium, where the Olympic Games were held in
1968. Portfolio of six serigraphs based on
his chromatic paintings published in 1968 by
Edition Domberger, Stuttgart, and other seri-
graphs follow over the next few years from
Domberger. At the insistence of German art
historian and museum director, Dr. Ludwig
Grote, Bayer is invited to design the vast
exhibition (as well as the accompanying cata-
logue and poster) 50 Jahre Bauhaus (50 Years
Bauhaus), which opens in 1968 in Stuttgart
and proceeds to London, Amsterdam, Paris,
Chicago, Toronto, Pasadena, Buenos Aires,
and Tokyo. Installs the exhibition again at the
Royal Academy in London during the fall,
where it receives tremendous reception. More
than a million people throughout the world see
the exhibition. Exhibits at Galerie Klihm,
Munich, and Galerie Conzen, Dusseldorf, in
1967 and at Marlborough New London Gallery
in 1968. On the occasion of the exhibition of 50
Years Bauhaus in London, Bayer receives the
Award for Excellence of the American Ambas-
sador. Spends part of semester as Regent
Professor at the University of California, Santa
Barbara (1969), functioning principally as visit-
ing critic.

Memorial sculpture for the poet Mina Loy, mother
of Joella Haweis Bayer, designed by Bayer and
installed in the Aspen cemetery after her death in
1966. (Photograph by Javan Bayer)

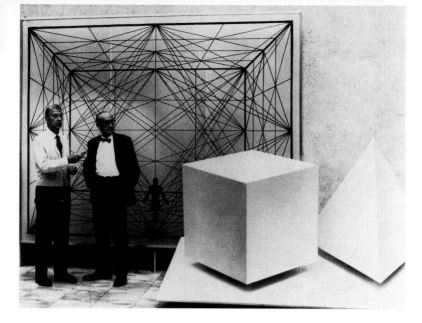

Gropius and Bayer at the installation of 50 Jahre Bauhaus exhibition at the Württembergischer Kunstverein, Stuttgart. 1968.

1970–1973
Principally engaged in painting during these years, Bayer completes important sculpture *Double Ascension*, for ARCO Plaza in Los Angeles and major tapestry *Reversed Squares*, for the lobby of the ARCO Building on the Plaza (1973). Series of visionary drawings for highway sculptures (1971–72). Proposes extensive program for beautification of Philadelphia refinery complex of Atlantic Richfield Company (1972). Executes eight serigraphs for Marlborough Gallery in New York (1970) as well as two additional serigraphs for Marlborough in 1971. Travels to Tokyo to install the final presentation of 50 Years Bauhaus.

A period of prizes and international honors: the important Gold Medal for Excellence of the American Institute of Graphic Arts (1970); the Austrian award, the Adalbert Stifter Preis für Bildende Kunst Verliehen, Linz (1970); an honorary degree from the University of Graz in Austria (1973). Numerous exhibitions in the United States and Europe, including Dunkelman Gallery, Toronto (1970), Germanisches Nationalmuseum, Nuremberg (1970), Marlborough Gallery, New York (1971), Centre Culturel Allemand, Paris (1971), Die Neue Sammlung, Munich (1971) Österreichisches Museum für Angewandte Kunst, Vienna (1971), a traveling exhibition to four German museums, and a major retrospective, installed by Gwen Chanzit, curator of the new Herbert Bayer Archive established at the Denver Art Museum (1973).

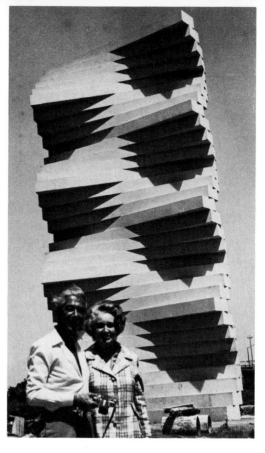

The Bayers beneath the *Articulated Wall*, sculpture constructed on the highway from Mexico City to Azteca Stadium for the Olympics of 1968. March 1970.

Willy Brandt, former chancellor of the Federated German Republic, with Bayer in Aspen on the occasion of being honored by the Aspen Institute for Humanistic Studies. September 1973. (Photograph by Berko)

1974

On March 20, visiting Zurich on the occasion of the Marlborough Gallery exhibition of his work, suffers major coronary attack. After five weeks in hospital, followed by four weeks in sanatorium, spends a month in Berlin designing the Aspen Institute's facilities. Returns to Aspen during the summer where he continues painting and in September returns again to Berlin to complete design of the interiors of the Aspen Institute for Humanistic Studies, which has opened a study center in Berlin. With Joella, visits museums on the Côte d'Azur where, during December, he suffers heart failure, which compels decision to leave the high altitudes of Aspen. Nonetheless, despite all difficulties of health, completes *Anderson Park*, the extensive earth environment begun in 1973 for the Aspen Institute for Humanistic Studies. Completes as well design of executive offices for the Philadelphia offices of the Atlantic Richfield Company, the color styling and signage for a German bank, the Sparkasse in Essen, and a metal mural for the Philadelphia offices of Atlantic Richfield. Following the Marlborough exhibition in Zurich, new works exhibited at Galerie Klihm and traveling exhibition to four German museums mounted. Receives an honorary degree from the Philadelphia College of Art. In December Bayer departs Aspen with great sadness and takes up new residence in Montecito, California, in a large house to which he shortly adds a comfortable studio.

1975–1976

Concludes the extensive series of chromatic paintings and begins, in 1976, the summation series of his work, the "Anthology" paintings, on which he is still engaged. Extensive work on sculpture models, principally employing tubular structures, Fibonacci motifs, and receding progressions. Exhibitions at Marlborough Gallery, Toronto, as well as major exhibition of graphic work through 1971 at Marlborough in New York (1976). The Alliance Graphique Internationale installs him as honorary member (1975) and the Royal Academy of Fine Art in The Hague makes him honorary fellow (1975). In 1976 receives gold medal for Gobelin tapestry from the Bayerische Handwerksmesse. Receives Austrian Honor Cross for Art and Science.

Robert O. Anderson, 1975. (Photograph courtesy of Atlantic Richfield Company)

Bayer in his studio, Aspen. Early 1970s.

1977–1978
Painting, sculpture, architectural consultancies for various projects of the Atlantic Richfield Company. *Organ Sculpture Fountain* installed before Bruckner Concert Hall in Linz (1977) and complex marble sculpture completed for the Anaconda building in Denver (1978). Major traveling retrospective, Herbert Bayer: From Type to Landscape, selected and annotated by Jan Van der Marck of the Hopkins Center at Dartmouth College, is circulated by the American Federation of Arts to five museums and exhibition of his photography organized by ARCO Center for Visual Arts circulates to thirteen museums in the United States and Canada. Visits Jerusalem at the invitation of Mayor Teddy Kollek and stays for a month at artists' and writers' retreat at Mishkenot Shaananim, overlooking the Old City. Executes lithographs in Jerusalem. At the suggestion of Mathias Goeritz, among the art advisers to the mayor, proposes projects for fountain sculpture in Jerusalem. In 1978 spends three months in Rome as artist in residence at the American Academy.

1979
Designs mounds and water retention basins as earth environment for flood control in Kent, Washington. Executes for Rosenthal in Germany *Jahres Teller* and two color schemes (Bauhaus Hommage), for the porcelain coffee-tea service originally designed by Walter Gropius. "The Herbert Bayer Tribute," a multi-media program, designed by Louis Danziger, shown for the first time at the International Design Conference.

Bauhaus Hommage I, Bayer's decoration of the Gropius-designed porcelain coffee-tea service, commissioned and manufactured by Rosenthal. 1979. (Photograph courtesy of Rosenthal USA)

1980–1983
ARCO Conference Center at the Breakers in Santa Barbara, California, opens with permanent installation of Bayer *Walk in Space Painting* and large collection of work by Bayer in all media. Work on "Anthology" series pursued and work exhibited at Marlborough Gallery, New York, in 1979 and 1982. Exhibition at Saidenberg Gallery, New York, in 1983, with departure from Marlborough Gallery. Major exhibition in Los Angeles at the Janus Gallery (1983) as well as exhibition at Galerie Thomas, Munich, which becomes Bayer's German dealer following closing of Galerie Klihm. Retrospective, Herbert Bayer Das Künstlerische Werk 1918–1938, covering Bayer's prewar activity, mounted at Bauhaus-Archiv in Berlin and Basel's Gewerbemuseum in 1982. Rochester Institute of Technology organizes the First Symposium on the History of Graphic Design, where Bayer's work is reviewed and Louis Danziger's multimedia program on Bayer is presented (1983). Freak accident in November 1982 damages Bayer's painting hand, inhibiting work; however, during April, begins to paint again.

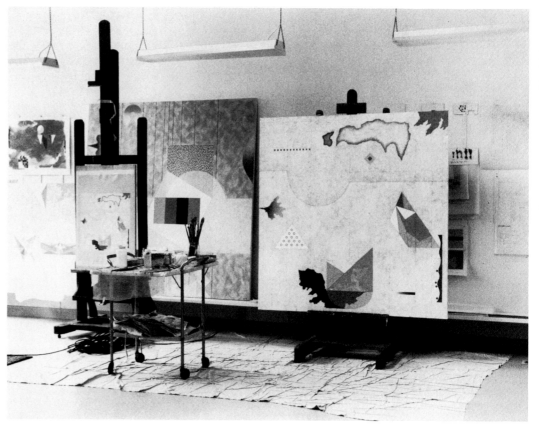

Studio in Montecito, California. 1982. (Photograph by Elaine Lustig Cohen)

The Bayers in Montecito, California, 1977. (Photograph by Phil Kirkley)

Selected One-Man Exhibitions

1929
Künstlerbund März, Linz, Austria.
Galerie Povolozky, Paris.

1931
Bauhaus, Dessau.

1936
Kunstverein, Salzburg.

1937
London Gallery, London.

1939
Black Mountain College. Black Mountain, North Carolina.
P.M. Gallery, New York City.

1940
Art Gallery, Yale University, New Haven, Connecticut.

1943
Willard Gallery, New York City.
North Texas State Teachers College, Denton, Texas.

1944
Outline Gallery, Pittsburgh.

1947–49
Retrospective: The Way Beyond Art. Brown University, Providence, Rhode Island; Harvard University, Cambridge, Massachusetts; Institute of Design, Chicago; Colorado Springs Fine Arts Center, Colorado Springs, Colorado; Joslyn Art Museum, Omaha, Nebraska; Boise Art Museum, Boise, Idaho; Bozeman Museum, Bozeman, Montana; Portland Art Museum, Portland, Oregon; Seattle Art Museum, Seattle, Washington; San Francisco Museum of Art, San Francisco.

1952
Cleveland Institute of Art, Cleveland.

1953
Hanns Schaeffer Galleries, New York City.

1954
Kunstkabinett Klihm, Munich.
Galleria del Milione, Milan.

1955
Aspen Institute for Humanistic Studies, Aspen.

1956–57
Retrospective: Herbert Bayer: 33 Jahres Seines Schaffens. Germanisches Nationalmuseum, Nuremberg; Die Neue Sammlung, Munich; Kunstgewerbemuseum, Zurich; Hochschule für Bildende Künste, Berlin; Städtisches Museum, Braunschweig; Kunst und Industrie Museum, Vienna.

1957
Kunstkabinett Klihm, Munich.

1958
Recent Works of Herbert Bayer. Fort Worth Art Center, Fort Worth, Texas; Walker Art Center, Minneapolis, Minnesota; University of Oklahoma, Norman, Oklahoma.

1959
Kunstkabinett Klihm, Munich.

1960
Städtische Kunsthalle, Dusseldorf.
Museum am Ostwall, Dortmund.

1961
Bauhaus-Archiv, Darmstadt.

1962–63
Retrospective: Herbert Bayer. Paintings, Architecture, Graphics. Städtisches Kunstmuseum, Duisberg; Roswell Museum and Art Center, Roswell, New Mexico; Colorado Springs Fine Arts Center, Colorado Springs, Colorado; The Art Gallery, University of California at Santa Barbara, Santa Barbara, California; La Jolla Museum of Art, La Jolla, California; Joslyn Art Museum, Omaha, Nebraska; Memorial Art Gallery of the University of Rochester, Rochester, New York; Galleria del Levante, Milan; Kunstkabinett Klihm, Munich.

1963
Andrew Morris Gallery, New York City.
Neue Galerie, Linz, Austria.

1964
Aspen Institute for Humanistic Studies, Aspen.
5207 Galleries, Oklahoma City, Oklahoma.

1965
Byron Gallery, New York City.
Esther Robles Gallery, Los Angeles.
Boise Art Association, Boise, Idaho.

1966
Scudder Gallery, University of New Hampshire, Durham, New Hampshire.

1967
Galerie Klihm, Munich.
Galerie Conzen, Dusseldorf.
Philadelphia Art Alliance, Philadelphia.

1968
Marlborough New London Gallery, London.

1969
The Art Gallery, University of California at Santa Barbara, Santa Barbara, California.
Two Visions of Space (joint exhibition with Ingeborg ten Haeff), the Hudson River Museum, Yonkers, New York.

1970
Dunkelman Gallery, Toronto.
Germanisches Nationalmuseum, Nuremberg.
Galerie Conzen, Dusseldorf.

1971
Marlborough Gallery, New York City.
Centre Culturel Allemand, Paris.
Goethe-Institut, Paris.
Die Neue Sammlung, Munich.
Österreichisches Museum für Angewandte Kunst, Vienna.

1972
Marlborough Gallery, Montreal.
Galerias Mer-kup, Mexico City, D.F.

1973
Retrospective: Herbert Bayer. Fotografien. Fotomontagen. 1926–1937. Landesbildstelle, Hamburg; Kaiser Wilhelm Museum, Krefeld; Fotohistorisches Museum, Leverkusen; Saarland Museum, Saarbrucken. Retrospective: Herbert Bayer. A Total Concept. The Denver Art Museum, Denver, Colorado.

1974
Marlborough Galerie, Zurich.
Galerie Klihm, Munich.
Small traveling retrospective: Galerie Nächst St. Stephan. Vienna; Galerie im Taxis Palais, Innsbruck; Neue Galerie am Landesmuseum Joanneum, Graz, Austria.

1974–75
Traveling Exhibition: Herbert Bayer. Lithographs and Screenprints. 1969–1973. Marlborough Graphics, New York City; Benjamin Mangel Gallery, Bala Cynwyd, Pennsylvania; Malvina Miller Gallery, San Francisco; Current Editions Gallery, Seattle, Washington; Van Straaten Gallery, Chicago; Hokin Gallery, Palm Beach, Florida; Collaborative Gallery, Los Angeles; Desmond Muirhead Galleries, Newport Beach, California; Michael Berger Gallery, Pittsburgh.

1974–78
Retrospective: Herbert Bayer. Das Druckgrafische Werk bis 1971. Haus Deutscher Ring, Hamburg; Landesmuseum für Kunst und Kulturgeschichte, Munster; Museum Wiesbaden, Wiesbaden; Bauhaus-Archiv, Berlin; Kunstgewerbemuseum, Zurich; Museum Bochum, Bochum, Germany; Hochschule für Gestaltung, Offenbach, Germany; Museo Calouste Gulbenkian, Lisbon; Museo Nacional de Machado de Castro, Coimbra, Portugal; Museo Nacional de Soares dos Reis, Porto, Portugal; Museo Español del Arte Contemporaneo, Madrid; Museo del Arte Moderno, Barcelona.

1975
Marlborough Gallery, Toronto.
Arte Contacto Galleria, Caracas, Venzuela.

1976
Retrospective: Herbert Bayer. Beispiele aus dem Gesamtwerk 1919–1974. Die Neue Galerie, Linz, Austria.
Marlborough Gallery, New York City.

1977
Retrospective: Santa Barbara Museum of Art, Santa Barbara, California.
Marian Locks Gallery, Philadelphia.

1977–78
Retrospective: Herbert Bayer: From Type to Landscape (traveling exhibition sponsored by the American Federation of Arts). Hopkins Center, Dartmouth College, Hanover, New Hampshire; Santa Barbara Museum of Art, Santa Barbara, California; The Art Gallery, State University of New York, Stony Brook, New York; The University of Texas at Austin, Austin, Texas; Georgia Museum of Art, University of Georgia, Athens, Georgia.

Retrospective: Herbert Bayer: Photographic Works (traveling exhibition organized by ARCO Center for Visual Art). ARCO Center for Visual Art, Los Angeles; Museum of Modern Art, New York City; Fine Arts Gallery, San Diego, California; Portland Art Museum, Portland, Oregon; South Dakota Memorial Art Center, Brookings, South Dakota; Witte Memorial Museum, San Antonio, Texas; University of Texas Art Gallery, Arlington, Texas; University of Iowa Museum of Art, Iowa City, Iowa; Center for Creative Photography, University of Arizona, Tucson, Arizona; Center for the Arts, Simon Fraser University, Burnaby, British Columbia; San Francisco Museum of Modern Art, San Francisco; Davison Art Center, Wesleyan University, Middletown, Connecticut; Baltimore Museum of Art, Baltimore, Maryland.

1978
Galerie Klihm, Munich.
Museum Bochum, Bochum, Germany.

1979
Marlborough Gallery, New York City.
Galerie Breiting, Berlin.

1980
Inaugural Exhibition of the Herbert Bayer Archive. Denver Art Museum, Denver, Colorado. Die Neue Galerie, Linz, Austria.
Inaugural Exhibition of the Herbert Bayer Collection. The Breakers Seminar Building, Atlantic Richfield Company, Santa Barbara, California.

1981
Aspen Center for the Visual Arts, Aspen.
Galerias Mer-kup, Mexico City, D.F.
Ruth Schaffner Gallery, Santa Barbara, California.
Herbert Bayer: A Selected Survey. Paintings. Sculpture. Photographs. Grapestake Gallery, San Francisco.

1982
Marlborough Gallery, New York City.
The Photography of Herbert Bayer. The Keystone Gallery, Santa Barbara, California.
Herbert Bayer: Das Künstlerische Werk 1918–1938. Bauhaus-Archiv, Berlin; Gewerbemuseum, Basel.
Herbert Bayer. Sixty Years of Paintings. Denver Art Museum, Denver, Colorado.
Herbert Bayer. Photographic Works. Galleria, The Arizona Bank, Phoenix, Arizona.

1983
Galerie Thomas, Munich.
Saidenberg Gallery, New York.
Janus Gallery, Los Angeles.

Selected Group Exhibitions

1923
Kunst und Technik—Eine Neue Einheit. Bauhaus and Staatliches Landesmuseum, Weimar.

1928
Neue Typographie. Ringnauer Werbegestalter. Magdeburg, Germany.

1930
Bauhaus Weimar Dessau. Harvard Society for Contemporary Art, Cambridge, Massachusetts.

1931–34
Julien Levy Gallery, New York City (participation each year in group exhibitions with paintings, drawings, photographs).

1936
Entartete Kunst. Haus der Deutschen Kunst. Munich (and other cities in Germany and later in Austria).
Fantastic Art, Dada and Surrealism. Museum of Modern Art, New York City.
Cubism and Abstract Art. Museum of Modern Art, New York City.

1938
Bauhaus: 1919–1928. Museum of Modern Art, New York City.

1950
Die Maler am Bauhaus. Haus der Kunst, Munich.

1951
Subjektive Fotographie. Schule für Kunst und Handwerk, Saarbrucken, Germany.

1956
Modern Art Influences on Printing Design. The Library of Congress, Washington, D.C.
Bauhaus in Germany and America. Busch-Reisinger Museum, Cambridge, Massachusetts.

1959
V Bienal. Parque Ibirapuera, São Paulo, Brazil.

1961
27th Biennial Exhibition, Corcoran Gallery of Art, Washington, D.C.

1962
Kunst von 1900 bis Heute. Museum des 20. Jahrhunderts, Vienna.
Painters of the Bauhaus. Marlborough Fine Arts, London.

1963
Werbegrafik 1920–1930. Göppinger Galerie, Frankfurt am Main.

1964
Documenta III. Staatliche Werkkunstschule, Kassel, Germany.
Bauhaus. Göppinger Galerie, Frankfurt am Main.

1965
Traum Zeichen Raum. Kunst in den Jahren 1924–1939. Wallraf-Richartz Museum, Cologne.

1966
Les Années 25. Musée des Art Décoratifs, Paris.

1967
Bauhaus. Carpenter Center for the Visual Arts, Harvard University, Cambridge, Massachusetts.

1967–71
50 Jahre Bauhaus. Württembergischer Kunstverein, Stuttgart; Royal Academy of Arts, London; Stedelijk Museum, Amsterdam; Musée National d'Art Moderne, Paris; Illinois Institute of Technology, Chicago; Art Gallery of Ontario, Toronto; Pasadena Art Museum, Pasadena, California; Museo del Arte Moderno, Buenos Aires; The National Museum of Modern Art, Tokyo.

1970
Trends in 20th Century Art. The Art Galleries, The University of California, Santa Barbara, California.

1971
Albrecht Dürer zu Ehren. Germanisches Nationalmuseum, Nuremberg.

1972
The Aldrich Museum of Contemporary Art, Ridgefield, Connecticut.

1973
Die Zwanziger Jahre—Kontraste eines Jahrzehnts. Kunstgewerbe, Zurich.

1977
Tapestries. Dalzell Hatfield Gallery, Los Angeles.
Tendenzen der Zwanziger Jahre. 15. Europäische Kunstausstellung, Nationalgalerie, Berlin.

1978
Sculptors as Photographers. Los Angeles County Museum, Los Angeles.
Colorado Artists. Denver Art Museum, Denver, Colorado.
Das Experimentelle Foto in Deutschland 1918–1940. Galeria del Levante, Munich.
Paris-Berlin 1900–1933. Centre National d'Art et de Culture Georges Pompidou, Paris.
Architekturbezogene Kunst in Deutschland. Junior Galerie, Goslar, Germany.

1979
La Photographie sous la République de Weimar. Institut für Auslandsbeziehungen, Stuttgart.

1980
Avant-Garde Photography in Germany 1919-1939. San Francisco Museum of Art, San Francisco.

1981
Photographies Surréalistes. Centre d'Arts Plastiques Contemporains de Bordeaux, Bordeaux.
Sited Sculpture and the Environment. Santa Barbara Museum of Art, Santa Barbara, California.
Architektur Design Malerei Graphik Kunstpädagogik. Bauhaus-Archiv, Bonn.

1982
Art of the Bauhaus. Galerie de la Boetie, New York City.

1983
Herbert Bayer and Other Artists of the Bauhaus. Saidenberg Gallery, New York City.
Realism and Abstraction. German Art of the Twenties. De Saisset Museum, University of Santa Clara, Santa Clara, California.

Architecture, Environments, Interior Design, Sculptures: Selected Works of Herbert Bayer

Only sited sculptures and executed architectural projects are included.

1946
Sundeck Ski Restaurant. Aspen.

1946–47
Container Corporation of America: design and color coordination of offices. Chicago.

1948
Title Insurance and Trust Company: design and color coordination of offices. Chicago.

1950
Herbert Bayer studio building. Aspen.
Henry Hurst & McDonald: color coordination of offices. Chicago.
Orchestra Hall: remodeling. Chicago.
Harkness Commons Building: mural and glazed tile wall for building designed by Walter Gropius and The Architects Collaborative. Harvard University, Cambridge.
Opera House: restoration. Aspen.

1953
Seminar Building. Aspen Institute for Humanistic Studies. Aspen.
Seminar Building: sgraffito mural for external wall. Aspen Institute for Humanistic Studies. Aspen.

1954
Fort Worth Art Center. Fort Worth, Texas.
The Aspen Meadows: hotel development. Aspen Institute for Humanistic Studies. Aspen.

1955
Container Corporation of America: design and color coordination of offices. New York City.
Marble Garden. Aspen Institute for Humanistic Studies. Aspen.
Grass Mound. Aspen Institute for Humanistic Studies. Aspen.
Health Center. Aspen Institute for Humanistic Studies. Aspen.
Spring Street Elementary School: *Five Signs*, glazed brick wall mural. (Architects: The Architects Collaborative.) West Bridgewater, Massachusetts.
Orchestra Hall: rehabilitation. Chicago.

1955–57
Container Corporation of America: papermills in Santa Clara, California; Brewton, Alabama; Hoya, West Germany. Folding carton plants: Seattle, Washington; Muskogee, Oklahoma; Dolton, Illinois; Fort Worth, Texas.

1957
Colonial Williamsburg: two historical map murals. Colonial Williamsburg, Virginia.
Kaleidoscreen. Aluminum Company of America. Aspen Institute for Humanistic Studies, Aspen.
Lackritz House: Metal Space Divider. Palm Springs, California.

1958
Aspen Meadows Restaurant. Aspen Institute for Humanistic Studies. Aspen.

1958–59
Container Corporation of America: research center. Valley Forge, Pennsylvania.

1961
Walter Paepcke Auditorium. Aspen Institute for Humanistic Studies. Aspen.
Walter Paepcke Memorial Building. Aspen Institute for Humanistic Studies. Aspen.

1962
Roswell Museum and Art Center: courtyard sculpture projects. Roswell, New Mexico.
Institute for Theoretical Physics. Aspen Institute for Humanistic Studies. Aspen.
Terrace House. Mr. and Mrs. Robert O. Anderson private residence. Aspen.
Pabst House. Project for private residence. Aspen.
Private Chapel. Mr. and Mrs. Robert O. Anderson. Hondo Valley, New Mexico.

1963
Music Associates of Aspen: project for music hall and music complex. Aspen.

1964
Music Associates of Aspen: Music Festival Tent and related facilities. Aspen.

1966
Atlantic Richfield Company: consultant designer for offices. New York City.

1968

Articulated Wall. Sculpture on highway between Mexico City and Azteca Stadium. Mexico City, D.F.
Eight houses for Aspen Institute trustees. Aspen Institute for Humanistic Studies. Aspen.

1969

Atlantic Richfield Company: consultant designer for offices. Chicago.

1972–73

ARCO Towers and ARCO Plaza: consultant designer. (Architects: Albert C. Martin and Associates.) Los Angeles.

1973

Atlantic Richfield Company: consultant designer for company offices and executive floors. (Interior designer: Rex Goode and Associates.) Los Angeles.
Mural with Wooden Slats. Atlantic Richfield Company. Los Angeles.
Double Ascension. Sculpture. ARCO Plaza. Los Angeles.
Reversed Squares. Tapestry for lobby. ARCO Building. ARCO Plaza. Los Angeles.

1973–74

Anderson Park. Aspen Institute for Humanistic Studies. Aspen.
Sparkasse Essen: color coordination and signage. (Architects: Hentrich-Petschnigg.) Essen, Germany.
Atlantic Richfield Company: consultant designer for company offices and executive floors. (Interior designers: Interspace, Herbert Kramer.) Philadelphia.
Atlantic Richfield Company: metal mural. Philadelphia.
Gate with Receding Circles and *Water Column*. Marble sculpture and fountain. Atlantic Richfield Company. Executive offices. Philadelphia.
Fibonacci. Sculpture for executive offices. ARCO Building. ARCO Plaza. Los Angeles.
Boettcher Seminar Building. Aspen Institute for Humanistic Studies. Aspen.

1977

Aspen Institute Seminar Building (in collaboration with Thomas Wells and Associates). Hawaii.
Beyond the Wall. Title mural and mini-park. Philadelphia College of Art. Philadelphia.
Organ Fountain. Sculpture. Bruckner Concert Hall. Linz, Austria

1977–78

Consultant architect to high-rise office building. Los Angeles.
Anaconda Industries: consultant interior design for offices and main lobby. Denver, Colorado.
Anaconda. Sculpture for lobby of Anaconda Building. Anaconda Industries. Denver, Colorado.

1977–82

Chemical Research Company. ARCO Chemical Company. Consultant architect. (Architects: Davies & Brody). Mosaic pool, tile floors for six atria, sculpture, and tapestry. Newtown, Pennsylvania.

1977–84

Atlantic Richfield Company: consultant architect for highrise building. (Architects: I. M. Pei Associates.) Sculptures and murals. Dallas.

1979–82

Mill Creek Park: design of mounds and basins for flood water control. Kent, Washington.
Atlantic Richfield Company: consultant for interior design. Tubular mural. Mexico City, D.F.

1980

Atlantic Richfield Company: carpet mural. Washington, D.C. *Walk in Space Painting*. Sculpture with pool. The Breakers (ARCO Conference Center, including large collection Bayer paintings, sculpture, other media), Santa Barbara, California.

1981

Atlantic Richfield Company: consultant for interior design. Six tapestries and two carpets. Anchorage, Alaska.
Central Development Group: three large tapestries. Denver, Colorado.

1983

Atlantic Richfield Company, Dallas. Two wall sculptures in main lobby. Executive floor: tubular mural, glass space divider, elevator lobby mural.
Atlantic Richfield Company: four tapestries. Anchorage, Alaska.

List of Exhibitions Designed

All exhibitions of importance designed by Bayer alone or in collaboration with others are included. Also listed are important exhibitions for which Bayer designed posters and/or printed materials.

1927

Ausstellung der Städte Dessau und Zerbst (Exhibition for the cities of Dessau and Zerbst).

1928

Elementare Buchtechnik (Functional book design) exhibit of the German publishing industry at Pressa Ausstellung (Pressa Exhibition). Cologne.

1930

Schriftgiesserei H. Berthold (Design of commercial stand for H. Berthold Type Foundry of Berlin). Paris.

Section Allemande, Deutscher Werkbund Ausstellung, Exposition de la Société des Artistes Décorateurs. Paris (With Walter Gropius, László Moholy-Nagy, Marcel Breuer; also designed poster and catalogue.)
Sommer Blumen Ausstellung (Summer Flower Show; Poster and prospectus only). Berlin.
Das Zeitgemässe Gebrauchsgerät Ausstellung (Useful Objects Exhibition; poster only). Berlin.

1931

Vereinigte Kork-Industrie Ausstellung (United Cork Industry of Germany); with Marcel Breuer. Berlin.
Baugewerkschafts Ausstellung (Building Workers Unions Exhibition; with Walter Gropius, Marcel Breuer, and László Moholy-Nagy). Berlin.
Lippe-Detmold Ausstellung (Exhibition for the province of Lippe-Detmold in the Teutoburger Forest; poster and brochure). Detmold.

1932

Westfalen-Ausstellung für den Westfälischen Verkehrsverband (Westphalian exhibition for the Westphalian Trade Association).

1934

Die Strasse Ausstellung (exhibition on the construction, planning, installation of highways; poster only). Munich.
Jahresschau für das Gastwirts-Hotelier-Bäcker-u. Konditoren Gewerbe (Annual exhibition of the inn, hotel, baking, and pastry crafts of Germany; poster only). Berlin.

1935

Freizeit-Bewegung Ausstellung (Leisure Time Exhibition). Hamburg.

1936

Tapeten Ausstellung (wallpaper exhibition for the German wallpaper industry). Hamburg. (Traveling exhibition; also poster.)
Deutschland Ausstellung (Germany Exhibition). Berlin. (Only poster Deutsches Volk-Deutsche Arbeit and catalogue, as installation was executed by the Berliner Messeamt that generally handled popular Berlin exhibitions.)
Rundfunk Ausstellung (Radio Exhibition). Berlin.
Wunder des Lebens Ausstellung (Wonder of Life Exhibition). Berlin. (Only poster and catalogue, as exhibition was designed by the Berliner Messeamt.)

1937

Gas und Wasser Ausstellung (Gas and water exhibition on behalf of Junkers Industries; collaboration with the architect Gustav Hassenpflug). Leipzig.

1938

Die Gemeinschaft Ausstellung (Exhibition of the Community). Berlin.

Bauhaus: 1919–1928. The Museum of Modern Art, New York City. (Also designed catalogue.)

1939
State of Pennsylvania Building. New York World's Fair, New York City. (With Xanti Schawinsky for Gropius and Breuer building.)

1941
Alcoa Aluminum Exhibition. Aluminum Company of America, New York City. (Traveling exhibition.)
Arts in Therapy. The Museum of Modern Art, New York City.

1942
Road to Victory. The Museum of Modern Art, New York City. (Exhibition curated by Edward Steichen with running text by Carl Sandburg. Traveled to San Francisco, Cleveland, Detroit, Chicago, London.)
Traveling exhibitions. Coordinator of Inter-American Affairs. Washington, D.C. (Traveling exhibition to Central and South America.)
Women at War. Australian News Bureau, New York City.

1943
Airways to Peace. The Museum of Modern Art, New York City. (Exhibition curated by Monroe Wheeler.)

1944
Medical Products Exhibition. Chicago.
Arts in Progress. Fifteenth-anniversary exhibition of the Museum of Modern Art, New York City. (Display for the film library.)

1945
Modern Art in Advertising. Container Corporation of America, The Art Institute, Chicago. (Traveled thereafter to museums throughout the United States, Mexico, and Germany.)

1950
Packaging Exhibition. Container Corporation of America, Chicago. (Exhibition of paper products and their development.)

1951
Indians of the Northwest. The Taylor Museum, Fine Arts Center, Colorado Springs, Colorado.

1957
Volk aus Vielen Völkern. (Nation of Nations). United States Information Agency (in collaboration with Nancy Newhall and Ansel Adams). Kongresshalle, Berlin.

1968
50 Jahre Bauhaus (50 Years Bauhaus). Württembergischer Kunstverein, Stuttgart. (Traveled through 1971 to London, Amsterdam, Paris, Chicago, Toronto, Pasadena, Buenos Aires, Tokyo; designed poster, catalogue, and all printed materials in addition to designing the exhibition itself.)

1981
Herbert Bayer Permanent Exhibition. The Breakers, Atlantic Richfield Company, Santa Barbara, California. (Installation of *Walk in Space Painting*, sculpture, and work in all media as permanent collection of Atlantic Richfield Company.)

Selected Public Collections

Bauhaus-Archiv, Berlin.

Staatliche Museen Preussicher Kulturbesitz Nationalgalerie, Berlin.

Schubladen Museum, Bern, Switzerland.

Museum Bochum, Bochum, Germany.

Busch-Reisinger Museum, Cambridge, Massachusetts.

Fogg Art Museum, Cambridge, Massachusetts.

Museum Ludwig, Cologne, Germany.

Wallraf-Richartz Museum, Cologne, Germany.

Colorado Springs Fine Arts Center, Colorado Springs, Colorado.

Bayer Archive, Denver Art Museum, Denver, Colorado.

Städtische Sammlungen Duisberg-Rheinhausen, Duisberg, Germany.

Wilhelm-Lehmbruck-Museum der Stadt, Duisberg, Germany.

Städtische Kunsthalle, Dusseldorf, Germany.

Folkwang Museum, Essen, Germany.

Evansville Museum of Arts and Sciences, Evansville, Indiana.

Fort Worth Art Center, Fort Worth, Texas.

Kunsthalle, Hamburg, Germany.

Landesgalerie, Hannover, Germany.

Kulturabteilung des Landes, Innsbruck, Austria.

Landesgalerie, Karlsruhe, Germany.

Staatsgemälde Sammlung Museum, Kassel, Germany.

Städtisches Museum Leverkusen, Leverkusen, Germany.

Städtische Kunsthalle, Mannheim, Germany.

Museum of Modern Art, Mexico City, D.F.

Bayerische Staatsgemäldesammlungen, Munich, Germany.

Landesmuseum für Kunst und Kulturgeschichte, Munster, Germany.

Guggenheim Museum, New York City.

Museum of Modern Art, New York City.

Whitney Museum of American Art, New York City.

Germanisches National Museum, Nuremberg, Germany.

Oklahoma Art Center, Oklahoma City, Oklahoma.

Aldrich Museum of Contemporary Art, Ridgefield, Connecticut.

Museum of Modern Art, Rome.

Roswell Museum and Art Center, Roswell, New Mexico.

Saarland Museum, Saarbrucken, Germany.

San Francisco Museum of Modern Art, San Francisco.

Santa Barbara Museum of Art, Santa Barbara, California.

Staatsgalerie, Stuttgart, Germany.

Museum des 20. Jahrhunderts, Vienna.

Museum Wiesbaden, Wiesbaden, Germany.

Hudson River Museum, Yonkers, New York.

Bayer Photographic Archive, Center for Creative Photography, University of Arizona, Tucson.

Painting, Sculpture, Environments

1. Guillaume Appollinaire, *Les Peintres cubistes. Méditations ésthetiques*, presented and annotated by L. C. Breunig and J.-Cl. Chevalier (Paris, 1965), p. 51. "Mais on peut dire que la géométrie est aux arts plastiques ce que la grammaire est a l'art de l'écrivain."

2. From his earliest years, Bayer had been fascinated by the imaginative possibilities of geometry. Although he lost his own textbook in descriptive geometry, used during his gymnasium years in Linz, a fellow student, Karl Pichler, gave him his own copy. Pichler's textbook is now marked and annotated. Moreover, Bayer keeps in his Santa Barbara studio volumes on the geometry of curves (notably E.H. Lockwood, *A Book of Curves* [Cambridge, 1961]), and other technical volumes on mathematical proportions.

Painting: 1919–1983

3. Gustav Guggenbauer corresponded with Bayer until several years before his death in 1980 at the age of 95. In great measure Bayer ascribes his early exposure to the Austrian architecture and folk traditions, as well as to the Jugendstil and impressionism, to his free access to Guggenbauer's library.

4. Schmidthammer's arts and crafts atelier was quite traditional. Apprentices were involved in learning the fundamentals of poster and package design, letterheads, arts and crafts techniques, painting china. Schmidthammer did not practice architecture.

5. A pen and pencil drawing of 1919, *Morning*, details a deformed humanoid riding backward on a grotesquely proportioned canine. An illustration of a fable, a caricature, a nightmare; whatever it may be, a disturbing and puzzling drawing.

6. There is no indication that Bayer regarded Margold's atelier as more than an opportunity to broaden his visual education, to introduce him to architectural drawing as well as to the attitudes of the Darmstädter Jugendstil. The link, however, between the Darmstadt art colony and the mounting postwar interest in the revision of the foundations of art education, emphasis on contact between the arts, crafts, and industry advocated by the Werkbund, and the newly established Bauhaus in Weimar must have created a favorable climate for Bayer's encounter in Margold's studio with the *Bauhaus-Manifest* and Kandinsky's *Über das Geistige in der Kunst*.

7. Barbara Miller Lane, *Architecture and Politics in Germany, 1918-1945* (Cambridge, Massachusetts, 1968), pp. 19-20. Lucius Burckhardt, ed., *The Werkbund. History and Ideology. 1907-1933* (Woodbury, New York), pp. 25-34. Hanno-Walter Kruft, "The Artists' Colony on the Mathildenhöhe," (186:2).

8. Written in 1910, *Über das Geistige in der Kunst* went through three printings during its first year of publication by Piper Verlag, Munich, 1912. An English translation appeared in 1914 in London, and parts of the work were translated into Russian and published in Moscow in 1913.

9. As Eberhard Roters has observed (208:163), *Concerning the Spiritual in Art* is a philosophy of sensibility grounded on a metaphysics, whereas Kandinsky's later work, *Point and Line to Plane* (*Punkt und Linie zu Flache*, published in 1926 in Munich as the ninth volume in the Bauhausbücher series edited by Walter Gropius and László Moholy-Nagy and translated into English by Howard Dearstyne and Hilla Rebay [New York, 1947]), is an exact mathematical system of sensibilities worked out through forms borrowed from geometry.

10. Vassily Kandinsky, *Concerning the Spiritual in Art* (New York, 1947), p. 54.

11. Bayer was exposed to Kandinsky's *Über das Geistige in der Kunst* in the circle of the Wandervogel in Darmstadt where the book was read and discussed in community.

12. The so-called *Bauhaus-Manifest* (or proclamation) is not actually identified as a manifesto. The pamphlet is four pages long; the first page (and cover image), Lyonel Feininger's woodcut *The Cathedral* (also called *The Cathedral of Socialism*), shows an aspirant church steeple moving toward a heavenly centric star whose rays and side stars form a quasi-Masonic compass around the steeple. Moreover, Gropius's text is composed in the most conventional typographic style, with extra letter spacing to signify italics (a convention in old-style German typography). The text is little more than a call to faith and after faith to enrollment. The last two pages set forth the curriculum and fee structure of the Bauhaus. In the author's copy, a loose sheet is inserted bearing the first Bauhaus seal (a collaborative signet of considerable confusion and bad design), which is an abridgment of the Bauhaus program. The anonymous translation is quoted from 11:18-19. As well see 187:31-33. The signet, designed by J. Auerbach and Blüthner (?), is reproduced in 187:36.

13. Wulf Herzogenrath, "Zur Rezeption des Bauhauses," *Studien zur Kunst des 19. Jahrhunderts* (Munich, volume 29, 1975), p. 129. "Die Schwierigkeit und die unterschiedliche Bereitschaft zur Rezeption des Bauhauses liegt in der Tatsache daß es *das*

Bauhaus nicht gab, sondern mindestens fünf verschiedene 'Bauhäuser,' daher z. T. die vielen Mißverstandnisse." See also idem., *Die fünf Phasen des Bauhauses. Paris-Berlin. Colloque de l'Office franco-allemand pour la Jeunesse* (Centre Georges Pompidou, Paris, 1978), p. 1, where the thesis is elaborated. See discussion in 246:30.

14. Siegfried Giedion, *Walter Gropius. Work and Teamwork* (New York, 1954), pp. 96–97.

15. In the English edition of 213:44–50, Paul Citröen's essay "Mazdaznan at the Bauhaus" as well as Felix Klee's reminiscence "My Memories of the Weimar Bauhaus" (213:38–39) describe the cultic enthusiasms of Itten. See also 246:33, 104; Walter Dexel underscores his hostility to Itten's romanticism while praising van Doesburg's opposition to it (213:105), likewise Erich Buchholz (212:111).

16. The discussion of van Doesburg's parlous and ambiguous relations with Gropius and the Bauhaus is marked by considerable and virtually unresolvable areas of confusion. Cf. Joost Baljeu, *Theo van Doesburg* (New York, 1974), pp. 39–44 and H.L.C. Jaffe, *de Stijl/ 1917–1931. The Dutch contribution to modern art* (Amsterdam, 1956), pp. 190–194. Wingler acknowledges (187:5) that van Doesburg's presence in Weimar was catalytic, although he denies to van Doesburg and De Stijl any original contribution to the Bauhaus. Further discussion of van Doesburg at the Bauhaus is offered by Werner Gräff, "The Bauhaus, the De Stijl Group in Weimar and the Constructivist Congress of 1922" (213:73–75). Alexander Bortnyik confirms Gräff's opinions in "Something on the Bauhaus" (213:82–83).

17. Baljeu, op. cit., pp. 41–42. Baljeu summarizes the entire controversy between van Doesburg and Gropius, citing both Doesburg's epitome of his side of the debate from the Jubilee issue of *De Stijl* (1927) and Gropius's letter to Bruno Zevi, quoted in the latter's *Poetics of Neo-Plasticism* (1953), where Gropius asserts: "I have never invited van Doesburg to the Bauhaus.... He hoped to become a professor at the Bauhaus, but I did not give him a position since I judged him aggressive and fanatic and considered that he possessed such a narrow, theoretical view that he could not tolerate any diversity of opinion." Bayer confirms this point of view. Lyonel Feininger, in a letter of September 7, 1922, writes to his wife: "Why is there this voluntary submission to the Tyranny of van Doesburg...? It is a crass sabotage against everything the Bauhaus is aiming at" (196:9), although Feininger goes on most temperately about the possible impact of Doesburg were he in fact at the Bauhaus (187:56). Baljeu correctly adduces that the invitation Gropius tendered to Moholy-Nagy at their 1922 meeting in Berlin may have been a way of accommodating constructivist tendencies at the Bauhaus without running the risk of the continuous warfare that might have been the result of van Doesburg's appointment to the faculty. It is certainly possible, as Baljeu suggests, that Gropius offered Doesburg a position before coming to know him, and decided against him after watching him in pedagogic action in Weimar. Moholy, however, was not a compromise without difficulties. He was treated very rudely by the students, who turned his paintings to the wall during their first exhibition at the Bauhaus and regarded his teaching ideology as no less fanatic than van Doesburg's. On the connection between van Doesburg and Moholy-Nagy, see Hannah L. Hedrick, *Theo van Doesburg. Propagandist and Practitioner of the Avant-Garde, 1909–1923* (Ann Arbor, Michigan, 1973, 1980), p. 9.

18. Itten's letter of resignation, written on October 4, 1922, focuses on his profound disagreement with Gropius over the relation of art and technics (Willy Rotzler, ed., *Johannes Itten. Werke und Schriften* [Zurich, 1972, p. 73]). Roters sees the matter as one of disagreement between an ideology of contemplation and one of functional application (208:54). Gropius sets forth his view of the conflict clearly in the draft of a circular letter he distributed to the Bauhaus masters, written on February 3, 1922 (187:51–52). See also 246:32–34.

19. It is particularly difficult to secure confirmed interpretations of ideological shifts in the Bauhaus now that a whole school of Bauhaus interpretation has arisen in East Germany following the "repatriation" of the Bauhaus to the East. Until recently, the Bauhaus had been treated in the D.D.R. as yet another bourgeois educational institution of an enfeebled Weimar culture. Now celebratory colloquia convoked in Dessau claim the Bauhaus as part of the patrimony of the East. But although the Bauhaus has entered East-West cultural politics, the publication of documents and archival resources has been sluggish, with most energy being concentrated on the aggregation and display of works of arts and crafts rather than on the development of materials from which an authoritative history of the Bauhaus could be established. In this latter respect the work of Rainer Wick, Wulf Herzogenrath, and Hans Maria Wingler is much appreciated.

20. The political pressures on the Bauhaus from rightist Völkisch parties, themselves proto-Nazi in orientation, became explicit and relentless after the Thuringian state elections of February 1924, which brought to power the Ordnungsbund, a coalition of conservative political parties aligned with the extremely vocal "group of extreme nationalists and proto-Nazis known as the '*völkisch-soziale Block*.'" Shortly before this election, in October 1923, following the entrance of Communists into the Thuringian ministry, the state was occupied by Reichswehr units under the command of Lieutenant-General Hasse, who removed the Communists from power and on November 24 conducted a house search of the Bauhaus seeking subversive Communist literature. The complexities of the battle over the Bauhaus, the trumping up of charges against Gropius in the infamous Yellow Brochure (a document composed of falsifications and gossip about Gropius, the Bauhaus, and the morality of its masters and students), the newspaper castigations and replies are splendidly documented in Lane's *Architecture and Politics in Germany*, pp. 69–86, 237–244. For extensive quotation from the relevant documents, see 187:76–77, 84–85.

21. The economic situation of the Bauhaus is exemplified in the "Report on the Audit of the Bookkeeping at the Staatliche Bauhaus in Weimar" prepared by the Thuringian State Treasury during September 1924. Wingler observes that the business manager of the Bauhaus at the time (there were five different managers during the six years of the Weimar installation) was correct to doubt that "the producing workshops of the Bauhaus, uncompromising in their designs, would be able to support themselves financially at a time when neither industry nor the public were ready and willing to accept the new technological forms. In fact, up until the end of the nineteen twenties, the expenditure for the production and the returns were always out of balance. Furthermore, the pressing problems—in Weimar—were aggravated by the fact that the office personnel were unable to keep up with the multitude of problems. Inflation depreciated the budget before it could be used, and at times it was impossible to keep orderly accounts" (187:87–89).

22. For additional comment by Feininger that reveals his acute sense of the change in Gropius's presentation of Bauhaus orientation, see his letter of October 5, 1922, to his wife (187:56).

23. Although I allude to Freud's denigration of the oceanic spirit in his elegant rebuke of Romain Rolland in *Civilization and Its Discontents*, Gropius's aesthetic romanticism carried with it an embracing, quasi-religious sense of the building arts as the utopian instrument of modern civilization. Gropius's enthusiastic vagueness—practical and generous though it was—shared the same nonspecific sense of the mystical unity of mankind that is apposite to Rolland's naturalistic oceanism.

24. See Paul Klee's amusing letter about Itten's class technique of January 16, 1921, and Oskar Schlemmer's letter to Meyer-Amden in 1921 (208:50–51).

25. This, more than anything else, generated the split between Itten and Gropius. At the same time that Gropius was being pilloried by constructivist critics of the Bauhaus for being unproductive, Itten was insisting that the work of art be maintained as the pure object of creativity, not to be confused with or contaminated by the needs of a marketplace interested in newly designed or reconceived environments. This is well illustrated by the amusing comment of Xanti Schawinsky that in the metal workshop directed by Paul Klee the students turned out "spiritual samovars and intellectual doorknobs" (Sibyl Moholy-Nagy, *Moholy-Nagy. Experiment in Totality* [New York, 1950], p. 38).

26. Wingler clarifies the role of Josef Albers in the development of the Vorkurs: "The workshop instruction by Josef Albers . . . beginning in 1923 was an independent component of the preliminary course. The cornerstone of that workshop course was the study of materials. Albers had developed his methods of instruction during his own studies at the Bauhaus and had already practiced them shortly before Moholy-Nagy joined the staff. Because of the lack of a vacancy on the faculty, he taught unofficially until the end of the Weimar period of the Bauhaus; as head of the department Moholy-Nagy was responsible for the entire preliminary course" (187:291). See also 245:49–58 on the Albers Vorkurs.

27. See extensive documentation in Bayer's own writings (40:18–19) and the section of Magdalena Droste's essay "Lehrjahre in Linz und Darmstadt 1918–1922" (142:18–22).

28. See Roters's discussion of Klee (208:94–106) and Clark V. Poling's illuminating catalogue essay on Bauhaus color theory and practice (224).

29. Lou Scheper gives an account of this wall-painting activity (213:115).

30. Otto Stelzer, "Moholy-Nagy and His Vision," postscript to László Moholy-Nagy. *Painting Photography Film* (Cambridge, Massachusetts, 1969), p. 146.

31. (68:131). *Study in Various Media of Different Textures* 1921 is in the collection of the Busch-Reisinger Museum in Cambridge, Massachusetts.

32. (68:131–133). *Pflanze* 1922/7 is reproduced in color (125:13).

33. Evident principally in Itten's 1918 painting *The Red Tower*, reproduced in Eberhard Roters (208: plate 18). See as well his discussion of Itten's symbolic painting *Child Portrait*, completed the same years as Bayer's two *Birthday Greetings* (208:53–54).

34. See *Oskar Schlemmer* catalogue Folkwang Museum, Essen, 1970, notably *Abstrakte Halbfigur von der Seite* (1923), reproduced on page 7, and all the drawings from 1915 through the Bauhaus period reproduced there.

35. Grosz's portfolio *Mit Pinsel und Schere* (1922) contained a suite of what Grosz called "Materialisationen"–photographic elements collaged with drawing satirizing the moral void and anomie he identified about him. The spirit of Dada and the impact of de Chirico's alienating cityscapes are much present in this remarkable portfolio.

36. "Two elements formed the fundamental basis of the work of De Stijl, whether in painting, architecture or sculpture, furniture or typography; in form the rectangle; in color the 'primary' hues red, blue and yellow" (Alfred H. Barr, Jr., *Cubism and Abstract Art* [New York, 1936], p. 141); see also Jaffe, *de Stijl*, pp. 92–175.

37. Two architectural drawings by Bayer are reproduced in *Staatliches Bauhaus in Weimar 1919–1923* (146: illustration 108), "Funktionelle Darstellung der Treppen und Fluren des Bauhauses" (Hauptgebäude) and (146: plate XII), "Arbeitsraum," designed by Gropius and executed as an axonometric drawing by Bayer. Although Bayer has said it was common for Bauhaus draftsmen to make use of axonometric perspective when appropriate (see the drawing of Breuer [146: illustration 107] and B. Otte's rendering of Georg Muche's design for a single-family housing unit [146: plate XI]), the revival of interest in axonometry and its relation at the Bauhaus to the architectural drawing of van Doesburg and van Eesteren, as well as El Lissitzky, has focused interest on Bayer's rendition of the Arbeitsraum. Bayer does not recall meeting van Doesburg while at the Bauhaus, although he may well have seen or heard of van Doesburg and van Eesteren's method of architectural drawing. Unfortunately, there is no record of what works were exhibited at the Bauhaus in conjunction with Bauhaus festivals and the visits of non-Bauhaus artists and architects. See Yves-Alain Bois, "Metamorphosis of Axonometry," *Daidalos 1*, Berlin, 1981, pp. 40–58.

38. Bayer developed the series of imaginary kiosks and display stands in 1924 to deal with the problem of constructing exhibits and public displays with prefabricated and demountable elements.

39. Jaffe, *de Stijl*, pp. 190–193.

40. *Manifest I van "De Stijl"* 1918, De Stijl, 2nd Year, November 1, 1918, Leiden. Printed in Dutch, French, English, and German and signed by van Doesburg, van 't Hoff, Huszar, Kok, Mondrian, Vantongerloo, and Wils, the manifesto generalizes the revulsion of the plastic arts against the merely individual in favor of the universal. De Stijl's founders "call upon all, who believe in the reformation of art and culture, to annihilate these obstacles of development (viz. 'traditions, dogmas and the domination of the individual') as they have annihilated in the new plastic art (by abolishing natural form) that, which prevents the clear expression of art, the utmost consequence of all art notion." The execrable English translation printed in *De Stijl* does not obscure the fact that although De Stijl clearly agreed with Gropius's latterly wish to reduce the influence of individualist expressionism at the Bauhaus, their views of the utopian objectives of their pedagogy were significantly different.

41. Kandinsky's leitmotif is reproduced in an original lithograph by R. Paris (146: plate V).

42. Will Grohmann's catalogue essay, "Kandinsky's years at the Bauhaus," *Kandinsky. The Bauhaus Years* (London, 1966), makes clear Kandinsky's interest in fundamental geometry and its origins in the "inner necessity" of the artist. Although Kandinsky acknowledges that his geometry may be linked to the universe, it is first and foremost geometry–circle, square, triangle. This metaphysical precision riveted Bayer while at the same time freeing him to use Kandinsky's plastic language in as romantic a fashion as he did (although Bayer's romanticism is invariably confused by critics with surrealism, whose conjurational possibility he allowed, but whose unconscious origins never interested him).

43. The later series of "Dunstlöcher" paintings is alluded to by a picture made while visiting Monreale in Palermo. The small pen-and-ink sketch (8¼ x 7¾") *Advertising for a Blacksmith* 1924/95 reproduced a blacksmith's signage. Arranged on a wall without visible means of suspension are products of the blacksmith's craft–scythes, battleaxes, metal instruments–organized in rigid, emblematic linearity, while the blacksmith, his forge and anvil, and the implements of his trade are depicted realistically. A curious tension between realistic drawing and unnatural emplacement, itself one of the hallmarks of Bayer's mature style, is annotated in this arresting anticipation of the "Dunstlöcher" series of the middle 1930s.

44. Bayer painted a large version of *Segesta* at the Bauhaus during 1925. This picture,

which he recalls having been about 6½ x 8', elaborating its original simple format by the addition of cacti and flora that had been used in *Sicily* 1924/82 and his (by then) favorite cloud device, was given to Xanti Schawinsky when Bayer left the Bauhaus in 1928 and has since been lost.

45. See examples in 40:165. See also discussion of use of Greek statuary in design in 68:148–149.

46. 208:185–186. Roters has correctly dated this picture from 1925, although in 11:204, where it is reproduced, it is assigned to 1926.

47. It is appropriate at this juncture, having already referred to Alexander Dorner several times in passing, to identify him and his interest in Herbert Bayer more specifically. Until his emigration to the United States in the summer of 1937 (on the same ship that brought Bayer to the summer home of Gropius in Providence, Rhode Island, to confer on the Bauhaus exhibition mounted the following year at New York's Museum of Modern Art), Alexander Dorner had been director at the State Museum (*Landesmuseum*) in Hannover and president of the Kestner Gesellschaft in Hannover. From 1938 to 1941 he was director of the Museum of Art at Rhode Island School of Design, a position he had secured through the good offices of Walter Gropius, and following his resignation as director, he taught—first as lecturer and then as professor of art history and aesthetics at Brown University and afterward Bennington College. Dorner's distinction and achievement as a sponsor and enthusiastic advocate of constructivist art and functional design was well known before his arrival in the United States and his book *the way beyond "art": the work of herbert bayer* (68) was an extension of his conviction that formalist art history was severed from its living context. Dorner pursued this conviction in his critique of the museum (a work which was never published), although the biography of Dorner prepared by Samuel Cauman (with an introduction by Walter Gropius), *the living museum, alexander dorner* (181) elaborates this viewpoint. The exaggerated claims Dorner had made for Bayer's art in early drafts of *the way beyond "art"* had made the artist uneasy. Bayer encouraged Dorner to rewrite and soften his enthusiasm; nonetheless, the book as it was finally published remains one of the finest examples of art history as interpretive advocacy and makes clear Dorner's sense of Bayer as an artist who conceived of art in all its domains as the achievement of a concrete and transmissible grammar of visual communication. *the way beyond "art"*, despite its occasional excess and tendentiousness, is the first exposition of the artist as communicator of a total system of visual signs, encompassing without discrimination of "high" and "popular" the arts of painting and graphic design.

48. 187:332. "The determining idea underlying the training in the workshop was the integration of color as a factor into the architectural environment." See also 11:68–71 and 224:38–39.

49. The importance of Hirschfeld-Mack's experiments in the relation of light and color has not been sufficiently emphasized, particularly as they apply to Bayer's paintings of this period. See 11:87, where Hirschfeld-Mack's experiments are described.

50. See Eckhard Neumann's "Interview with K.W. Matthess," the owner of Dorland Studio in Berlin (142:105–108).

51. It has been one of the characteristic and justifiable criticisms of National Socialist art (no less of Italian Fascist art) that it indulged a penchant for a monumental, heroic, and romantic stylization of the healthy human body, deriving most of its imagery from a routinized reconception of classical models. It is not difficult—since it is well documented—to understand the reasons for such a Fascist vocabulary, but clearly Bayer's impulse was different. Bayer regarded the classical image as a means of effecting an estranging perfection, employing such classical images not as the subject of his painting but as a device of graphic communication. Inspired by his visit to Greece, he used classical material in his paintings of 1934–35, but his interest was archaeological topography—the remains of antiquity—rather than the presentation of those remains as a model for contemporary civilization. Bayer's paintings tended to depict the Greek face as cracked or eroded by time, an indication that he regarded them as ancient artifacts rather than as models for contemporary society. At the same time, there is a narcissistic duplicity in such imagery, since Bayer either employed classical Greek statuary or photographs of himself as elements in his design. Bayer explains that his use of himself (his hand, his face, his body) in advertisements and photomontages enabled him to instruct the photographer more easily than if a model were employed.

52. *Sail Sculpture* 1934/2, later retitled *Wind*, was originally intended as a painted annotation of what was conceived of as a sculpture. Bayer wanted to execute "a wind sculpture" like the surf sculptures he would design for Las Cruces in Baja, California. The painting exhibits the movement of sails before the wind. Bayer had intended a sculpture fashioned of sails, which would respond to the wind in the same way his artificial mole in Las Cruces would receive and shape the pounding of the surf.

53. Mircea Eliade has used "archaic societies" in correlation with "primitive societies" to indicate the proximity in which such societies live with the sacred. See Mircea Eliade, *The Sacred and the Profane* (New York, 1957), pp. 12–13; *The Myth of the Eternal Return* (New York, 1954).

54. In 1970 Bayer returned to Austria for a brief vacation. While in Salzburg and the surrounding area, where he had passed his youth, he reencountered the Dunstlöcher, but the pictures that reflected this renewed contact were quite different from those of 1935–36. There was no attempt at a throwback to the style of the 1930s, rather, in the two watercolors entitled *Austria Revisited* 1971/6, 10, Bayer built up from the linear structure pictures with which he was then engaged, piling sticklike structures before a brown barn wall into which only a single aperture has been punched and laying more realistic scythes and implements against a wall fashioned of whitewashed stone. The series had ended thirty years earlier and the watercolors of 1971 were rehearsals of and reflections on the earlier mode, but in no way extensions of its theme and format.

55. Bayer in those days was a political ingenue. Like many others of the most talented artists in Germany, he was too occupied with his work to be much interested in the political events of the day. He did not believe that National Socialism would thrive and only late in the day as the hold of the party tightened did he become aware that the artist could not survive unaffected. The two catalogues of 1936 demonstrated to him that the ministry of propaganda intended precisely that—to insure that every publication made its contribution to the national political will as conceived by the Nazis. Even after Bayer had emigrated, designs he had left in his office were used by others to serve political ends, one—a drawing of springtime—being forced to bear the most odious of Nazi slogans, "Arbeit macht Frei," and signed completely without his knowledge with his design stamp.

56. "Entartete Kunst" was employed by the Nazi custodians of Aryan German culture to signify infected and hence "degenerate" art. The bacillus or syphilis imagery employed by the theories of Nazi esthetics and art history has, of course, analogues to other corrupt usages of the German language during the National Socialist era, but its employment specifically for art infected by Bolshevism, or Jewishness, or esthetic modernism (principally cubism or expressionism) resulted in the confiscation and removal of thousands of works of art from German museums and the opening at the Haus der Kunst in Munich in 1937 of the Entartete Kunst Ausstellung, which traveled

throughout Germany and later to Vienna after the Anschluss. Bayer, whose paintings were hardly known from German exhibitions prior to his emigration in 1938, was nonetheless represented in the collections of several German museums. He recalls that three of his works were condemned as "degenerate" and removed. Thanks to the prodigious work of Franz Roh (*Entartete Kunst. Kunstbarbarei im Dritten Reich* [Hannover, 1962]), it is possible to identify two of Bayer's works that were condemned: from the Museum Folkwang, Essen, *Italienische Landschaft* (according to Bayer an untitled oil painting, 1924/87) was removed from the collection on July 7, 1937, and shipped to Munich; from the Landesgalerie, Hannover, *Frau von rückwärts*, a drawing, was removed from the collection during 1937 (according to Bayer it was a gouache called *Parable* 1928/27, acquired by the Landesmuseum in 1929). A third work, *Blue Hour* 1928/25, also a gouache, Bayer records as having been destroyed, but he does not recall from which museum it was removed and Roh does not list it.

57. There are virtually no paintings from 1937 (when Bayer began to organize his emigration from Germany) until early 1939, after the opening of the Bauhaus: 1919–1928 exhibition in New York.

58. See Bayer's 1939 design for a page in *Life* magazine (40:53), or the more commonplace employment of the classical body for any depiction of the human nude, as in the 1942 booklet for the General Electric Company (40:61). The classical nude was for Bayer ideal human form and as such clearly in order for his 1956 book jacket for Sir Kenneth Clark's *The Nude* (40:69).

59. Pasted into Bayer's remarkable painting journal–notebooks in which he has sketched, jotted, and annotated his visual vocabulary for more than forty years–there appears during 1940 a series of small photographs of the sides of New England houses covered with objects reminiscent of the archaic Dunstlöcher. The New England counterparts were covered with wheels, harnesses, stirrups, old guns, rakes, hoes–implements that already effect the transition between agrarian, pacific uses and military employment. Bayer characterizes these laden barn walls of New England as "Dunstlöcher," although they lack the "vapour holes" that defined the term in their Alpine environment. Clearly by the time of the "Signs and Signals" pictures, he had come to think of the implements themselves as Dunstlöcher, a psycholinguistic elision that indicates the real focus of Bayer's interests. The vapor holes were a spatial convention for the emplacement of soft form implements.

60. 117:24. Minor alterations have been introduced into the syntax for purposes of clarity. Note that in the major Denver exhibition the series of paintings is called simply "Mountains" (117), while in the full Bayer statement on these paintings, "Statement about 'Mountains and Convolutions' Paintings," the group is differently titled. Bayer has also called them "Moving Mountains" (40:13, footnote) following the Dorner's nomenclature (68:158–165).

61. "One could call this Bayer's tectonic period using 'tectonic' in its geological sense of the formation of the earth's crust. These are not mountain landscapes, but rather the swell of waves, that rising and falling of slopes which one's whole body experiences in a ski descent. Tectonics has become dematerialized to abstract planes whose collisions, upward folding and subsidence into cavities are depicted by means of parallel lines and sharply defined shadows" (106:5).

62. Bayer's titling of paintings, here as elsewhere, is remarkably precise and informative. Although some of his paintings were titled after the fact, his command of nuanced English (even if culled from dictionaries of synonyms) is evident, disclosing not only his ability to find analogues but to address his pictures with a verbal precision consistent with their pictorial precision. I have generally found Bayer's titles disclosive. They are not, as are the titles of many contemporary painters, responses to the mere sound of words or the discovery of vague similitudes between attitude in painting and attitude in language, nor are they efforts to ransack literary culture for metaphors that intensify the mystery and allusion of painting. The only exception is Bayer's titling of several of his "Anthology" paintings (1976 to the present), where titling becomes an undertaking of purposeful concealment.

63. Bayer recalls his joy at having moved to Aspen, built his studio, and set up a design and architectural practice. He has expressed an occasional wish to have become an indigenous regional painter in Austria, acquiring some reputation without the difficulties of fame. The first years in Aspen were as close as he ever came.

64. Bayer defines sgraffito technique as follows: "sgrafitto technique is many centuries old. in this case [referring to the wall of the Aspen Seminar Building] one dark underlayer of plaster was overlaid with light-colored plaster. while still wet, lines were scratched out of the light layer, exposing the dark one" (40:179).

65. "Mountains and Convolutions" paintings interpret the secret–that is, the invisible–dimensions of space.

66. "observations on a series of paintings with linear motifs" (unpublished, written in 1970).

67. Ibid.

68. Ibid.

69. Ibid.

70. Ibid.

71. Although it is doubtful that Bayer knew these paintings by Picabia, they do reflect a shared interest in the problem of a post-cubist interpretation of planar space. See William A. Camfield, *Francis Picabia* (New York, 1970), plate 23, p. 67; plate 26, p. 71.

72. During the early 1950s, when these "Architectural" pictures were made, Bayer had begun his architectural practice in Aspen, designing a number of buildings for the Aspen complex.

73. Bayer's chromatic paintings, unlike the "Architectural" series completed in 1958, step back from the issue of light and volumes to that of colored geometry.

74. Bayer recollects that his invitation to Wilhelm Ostwald had been taken up in 1927, and this is confirmed by a note in Oskar Schlemmer's unpublished diary (made available through the kindness of Magdalena Droste of the Bauhaus-Archiv) for June 1927, which wittily notes that Ostwald's color theories had impressed Schlemmer as a "Farborgel" (color-organ). Bayer had early recognized that Ostwald's color theorems were useful for technical employment in the craft rather than for painting. He sometimes used Ostwald's color theories in his own design work, notably for a carpet design of 1933 based on Ostwald's color system (drawings for which are on loan from Bayer to the Bauhaus-Archiv). See discussion of Ostwald's color theories in Faber Birren, *History of Color in Painting* (New York, 1965), pp. 119–138, particularly pp. 122–125. See also Arthur B. Allen, "The Ostwald System of Colour Harmony," *Industrial Arts*[1, 3] (London, 1936), pp. 218–222 (Bayer's essay "Towards a Universal Type" [9] appeared in the same issue). Joost Schmidt made use of Ostwald's theories in his course in lettering at the Bauhaus (187:145), and Gropius refers to both Runge and Ostwald in detailing his proposal for the remodeling of the vestibule of the Weimar Art Academy for the Bauhaus Ausstellung of 1923 (187:64). As Daniel Poling points out, "the most complex color model used at the Bauhaus was the double cone developed by the chemist Wilhelm Ostwald. Based on research in the fields of chemistry, physics and perceptual psychology, it appealed to the desire for scientifically established standards. This system was to be exhibited, along with Runge's, in the remodelled vestibule of the

Weimar Bauhaus, proposed by Gropius in 1923.... Developed from a circle of 24 hues, the color solid shows the relationships of a total of 680 color variations, for which Ostwald had a system of notation. The theory, therefore, was especially concerned with precise color measurement and classification and aimed at broad applications, from industrial purposes like standardizing dyes to problems of painting such as rules for color combinations. While some of the practical workshops valued these goals, a number of painters, most notably Klee, were disdainful of the rigidity and industrial orientation of the system" (224:12f.). When I asked Bayer about his views of color systems, he wrote back as follows: "as an apprentice in the painting workshop at the bauhaus in weimar, I studied various color theories, above all goethe's, philip otto runge's, and wilhelm ostwald's. I was interested in color theories because of the structure of the work of color it conveys. to speak about the world of color and to teach color remain arbitrary unless we can revert at least to an organization of color. color theories have tried to organize color within systems, systems such as the keyboard of the piano represent. if you want to express certain sounds, you know where to find them. we do not have that in color unless we can rely upon some theoretical system... in the case of practical application of color in industry and manufacturing, knowledge and use of systematic organization of the world color is of great help. egbert jacobson was successful in interesting the color manufacturer martin-senour in chicago. this company produced paint according to the ostwald system. they were keyed to the numbers of the manual so that one could order ready mixed shades of paint from the manual. this made it possible to control color jobs for architecture and interiors by proxy instead of personally mixing the desired colors on the site. egbert jacobson is to be credited with this idea and its realization as well as for the creation of the color manual itself. after a few years martin-senour gave up the ostwald system because of the public demand for pastel shades." Referring to his invitation to Ostwald to lecture at the Bauhaus in Dessau in 1927, Bayer recalls ordering "for use in the bauhaus typographic workshop the so-called ostwald color organ which consisted of a cabinet containing something like 500 colors in little jars ready to be used with brush and water." As for Egbert Jacobson's book *Basic Color* (Chicago, 1948), Bayer acknowledges that he read it carefully and worked with Jacobson on the development of his ideas for a color manual. Jacobson's book, itself an interpretation of Ostwald's color theory, makes clear the applicability of its organization to industrial uses.

75. Bayer designed a book of photographs taken by the Japanese photographer Yasuhiro Ishimoto, *Katsura* (New Haven, 1960), which contains this image.

76. With the exception of several small exhibitions in Europe prior to the war (in Linz in 1929 and at Galerie Povolozky in Paris the same year; the Kunstverein, Salzburg, in 1936 and the somewhat larger and more impressive exhibition at the London Gallery in 1937), the first major exhibition was in 1956, traveling from Nuremberg throughout Germany and concluding in Vienna. In the United States there were small, local exhibitions until 1962 (except for the 1947 exhibition mounted by Alexander Dorner, which traveled to ten museums but concentrated more on design than on painting), when a comprehensive retrospective visited six American and three European museums and galleries. All such exhibitions, inevitably selective, scarcely represented the range and internal development of his oeuvre, concentrating principally on his youthful Bauhaus painting and Berlin years.

77. Jacques Leenhardt, "Pas d'accord avec Vasarely," *Journal de Génève*, October 10–11, (Geneva, 1970). See Bayer's archival memorandum "on vasarely's paintings" (1970).

78. Karl Gerstner, *kalte Kunst? zum Standort der heutigen Malerei* (Zurich, 1957).

79. Max Bill, "The Mathematical Approach in Contemporary Art," *Max Bill* (Buffalo, New York, 1974), p. 96.

80. 40:196–203; 118:34–35; text quoted from 112:34.

81. Serpentine lines appear in *Line at Dawn* 1964/4 and *Two Lines* 1964/3, for example, as well as in such "Moon and Structures" images as *Red Meander* 1962/58, *Celestial Snake* 1962/70, and *Celestial River* 1962/57. Clearly, the line is both a sign pointing to river, snake, any serpentine shape, and a symbol of archaic authority and eternity.

82. Matila Ghyka, *The Geometry of Art and Life* (New York, 1946), p. 16.

83. Ibid., pp. 13–14.

84. Ibid., p. xi.

85. Ibid., pp. 7–19.

86. Ibid., p. 13.

87. William C. Seitz, *The Responsive Eye*, Museum of Modern Art (New York, 1965).

88. "in 1963 he conceded to herbert lange, 'although I have been a painter all my life, I have only recently paid attention to showing it more consistently'" (113:7).

89. Barr, *Cubism and Abstract Art*; Seitz, *The Responsive Eye*, p. 7. As well see Alfred H. Barr, Jr., *De Stijl 1917–1928*, *Bulletin*, Museum of Modern Art 20, 2, pp. 3–13.

90. Bayer's 1923 painting *With Head, Heart, and Hand* may certainly be interpreted as a response to neoplasticism.

91. See Seitz, *The Responsive Eye*, pp. 18–19, for some of Albers's objections to optical and retinal art. See also Josef Albers, *Interaction of Color*, rev. ed. (New Haven, 1973).

92. Moholy-Nagy's famous "Telephone Pictures" of 1922, can be construed as anarchic gestures intended, as Poling says, "to demonstrate the principle of standardization" possible in the arts by having ordered his paintings over the telephone from a sign factory. "Using graph paper to determine the design and the factory's color chart, he plotted a simple rectilinear arrangement of black, red and yellow bars on a white background. In this way he underlined the industrial nature and democratic availability of the process, ideals he had formulated partly through the influence of Russian Constructivism" (224:13). See Lucia Moholy, *Marginalien zu Moholy-Nagy. Dokumentarische Ungerheimtheiten* (Krefeld, 1972), pp. 32–38, 74–79 (English translation). Gerstner devised a picture, *Carro 64*, made up of sixty-four "accurately tooled aluminum cubes which are set in an adjustable white frame." The purchaser of this object is encouraged "to arrange and arrange and rearrange these colored cubes until you are satisfied.... You get thousands of pictures by buying one, one of a limited edition of 120, issued by Staempfli Gallery," where Gerstner's first New York exhibition took place in 1965.

93. Bayer made extensive investigation of cartographic institutions and map-publishing companies in the United States and Europe in order to find maps with a minimum distortion without sacrifice of accuracy. Those he located at the Instituto Geografico de Agostini in Novara, Italy, satisfied his requirements for Europe and the rest of the world, while Rand McNally's were appropriate for the United States.

Sculpture and Environments: 1937-1983

1. Translated from passage cited in 114:18.

2. 187:5. See also translation of Gropius's critical essay on the new unity of art and technology in "The Theory and Organization of the Bauhaus" (*Idee und Aufbau des Staatliches Bauhauses Weimar*) (11:22–31).

3. Piet Mondrian, *Plastic Art and Pure Plastic Art* (New York, 1945), p. 63.

4. Ibid; p. 63; with the minor alteration in the translation of changing "surroundings" to "environment."

5. Bayer was concerned that his mural *Verdure* be positioned to permit exterior light to play upon its surface and provide additional visual interest.

6. Bayer noted that: "*wall sculpture with two holes* (1977/48S) was executed as a multiple in an edition of 37, cast in white marble by editions press in san francisco. it is being distributed by them" (personal communication, January 1983).

7. Bayer has commented on his notion of sculpture within the environment as follows: "some of the sculptures were planned for execution in large dimensions for outdoor areas, preferably always in connection with water. it is difficult to separate sculptures and environmental design because they are closely related, and I see outdoor sculpture always in relation to its immediate environment" (personal communication, January 1983). See also 128:38–39.

8. Van der Marck refers to the work as *Earth Mound* (128:40–41), although Yves Alain Bois, who has written the only significant essay on Bayer as an earth artist, refers to it as *Grass Mound* (114).

9. Yves-Alain Bois, in "Herbert Bayer: Précurseur de l'art écologique" (114:19), quotes from Bayer as follows: "the buckminster fuller dome was constructed over a circular outdoor swimming pool so that it would be possible to bathe during the winter. it didn't work out, however, and the aluminum structure remains there simply as a decoration. the environmental notions of buckminster fuller are of a technological nature. I am not aware of the bearing of his thought on the integration of man with the natural environment."

10. These drawings are called *Grass Mound*, *First Drawing* 1954/110 and *Project for Positive-Negative Grass Sculpture* 1954/111.

11. Bayer reports that the granite stone was found *in situ*, but was lifted up and reset in order that it might become a more protrusive and sculptural element in the composition.

12. Ion Miclea, *Brancusi a Tirgu Jiu* (Bucharest, 1973), pp. 12–13, 15.

13. See photograph with shadow, 128:41.

14. 114: note 1. See also Jack Burnham, "Robert Morris Retrospective in Detroit," *Artforum* (New York, March 1970).

15. Richard Long's *Sculpture Summer* is reproduced in *Op Losse Schroeven Situaties en Crypostructuren*, Stedelijk Museum (Amsterdam, 1969).

16. "Michael Heizer Section," *Live in your head. When Attitudes Become Form Works-Concepts-Processes-Situations-Information*, Kunsthalle (Bern, 1969).

17. *Spiral Jetty* photograph and related drawings, *Natur-Skulptur. Nature Sculpture*, Württembergischer Kunstverein (Stuttgart, 1981), pp. 72–77; Robert Smithson, "The Spiral Jetty," *The Writings of Robert Smithson* (New York, 1979), pp. 109–116.

18. If Smithson regarded his projects as the counter of the "romantic ruin" by virtue of their being constructions into ruin, or sites already on their way to nonsites, he has certainly succeeded in removing himself from the historical romanticism of the eighteenth century when such fabricated ruins were voguish. At the same time his invocations of ecstatic selfhood in the making of his various projects of earth transformation suggest the kind of narcissistic shamanism that has become almost common among the new generation of artists, who wish to think and create in that great isolation where only the world watches. It is a new romanticism of the self making the object (the ruin of selfhood), rather than making the objective ruin. Which is to be preferred?

19. Virtually all of Bayer's major public sculptures—*The Marble Garden*, *Anderson Park*, the Kent project, *Double Ascension* in Los Angeles, the *Anaconda* in Denver, the *Organ Fountain* in Linz, Austria, the *Walk in Space Painting* at Santa Barbara's the Breakers—entail the use of a live fountain, a pool receptacle and recirculator, a man-made lake. Water collaborates with sculpture, reflecting light, producing shadow, enhancing visual intensity.

20. The project was never executed for the museum in Roswell, and the museum building Bayer designed was so altered after its completion that Bayer no longer claims it as his own. See photograph, 114:18.

21. Bayer had conceived of the project well before the generosity of Robert O. Anderson made it possible. He intended what became *Anderson Park* as a stargazing preserve, orienting the elements. From the big dipper sculpture, one can sight the North Star over the highest mound. From this orientation also derived the relationship between other elements of the park. Only the basic concept was executed.

22. Doris Tarzan, "Kent Finds Earthwork Is Good Economics," *The Seattle Times*, September 2, 1982 (Seattle, Washington), section D, p. 1. See also 135:33–37.

23. "I was not in berlin when I worked on the kandinsky mural. kandinsky's mural was painted (on canvas) spread on the floor of the auditorium in the weimar bauhaus. I was asked by kandinsky to help him. my first visit to berlin was together with some students of the wallpainting workshop under the supervision of carl schlemmer to paint the yet unfinished sommerfeld house, designed by gropius. we were housed in the basement of the house. I saw nothing of berlin. we had to work all day and the house was located in dahlem, a suburb outside the city center" (personal communication, May 1982).

24. Bayer annotated this title mural in 1950: "glazed tile mural of 1" x 1" squares in patterns of 5" x 5" squares covering a curved two-story wall of 93' x 18'6" along a ramp leading to the upper floor restaurant. a uniform pattern of light grey and dark grey squares (checkerboard) is interrupted by clusters of varied colored squares in areas which are being seen most and best from the ramp and from the second floor."

25. The mural installed by Bayer in the mini-park at the Philadelphia College of Art (1977) did not prove wholly successful. Changes in design were adopted as the park was vandalized.

26. The Breakers, an Atlantic Richfield executive seminar center in Santa Barbara, California, owns and exhibits one of the largest collections of paintings, drawings, photographs, sculpture, models, graphics, and tapestries by Herbert Bayer to be found anywhere outside the archival collection of the Denver Art Museum in Colorado and the Bauhaus-Archiv in Berlin. The remodeling and landscaping of the property (including the outdoor pool sculpture, *Walk in Space Painting*) was overseen by Bayer with the active collaboration and support of Robert O. Anderson, chairman of the Atlantic Richfield Company. The Breakers publishes a descriptive brochure on its collection and installation, "A Guide to the Art at the Breakers," which is a brief, but accurate, introductory text to the work of Herbert Bayer.

27. "The visitor walking around the space painting experiences a series of different views and impressions. By walking *through* the space painting he views not only the objects, but becomes a participant in and part of the space-time concept" (Bayer statement on "Space Painting [1962]," a project for the Roswell Museum and Art Center).

28. Carola Giedion Welcker, *Brancusi* (New York, 1959), p. 33.

29. The one-piece granite, executed on the lathe by the Cold Spring Granite Company in Cold Spring, Minnesota, was not prestressed; however, what is remarkable is that each module has a natural chipping and irregularity (while maintaining the clarity of overall form) that evokes its timeless, archaic quality.

30. Memorandum on "Articulated Wall," 1968.

31. William G. Zimmerman Architectural Metals in Denver, Colorado, has manufactured many of the major Bayer sculptural commissions devised out of aluminum or other metals, including several editions. Zimmerman began work for Bayer in 1967 with *Primary Landscape in Ten Parts*, executed in bronze. In recent years, Bayer has used other fabricators, among them Dong Lim, Meyerhoff Fine Cabinetry, Fibreform Electronics, Master Metal Works, and Cohranizant, for the execution of models and small scale sculptures in various materials, including wood, plastic, and metal.

32. Following the dedication of the Calder sculpture in Jerusalem, Mathias Goeritz suggested to the mayor of Jerusalem, Teddy Kollek, that Bayer do a sculpture for the city. No decision has been made to date about either the details of the sculpture or its siting, and Bayer is dubious about its eventual execution. The absence of financing for it has inhibited discussion. The drawings for the project incorporate many of the same proportions as the *Surf Sculpture* of 1972 for Las Cruces, California, and are more easily realizable in a fixed and compassable urban siting.

33. The Weissenhofsiedlung in Stuttgart, sponsored by the Deutsche Werkbund, involved model contributions by such architects as Le Corbusier, Mart Stam, Mies van der Rohe, and Walter Gropius. The national competition at the Dammerstocksiedlung in Karlsruhe (1927-28) was won by Walter Gropius, acting as coordinator for a collaborative of eight architects. In both situations, many of the innovative contributions to the exhibitions were not built at the time on any "mass" basis, but have since become commonplaces of modern architecture.

34. "proposal for beautification of the arco refinery, philadelphia, december 12, 1972" (unpublished).

35. Memorandum on the "Surf Sculptures" (unpublished, 1972).

Graphic Design, Photography, Exhibition Design, and Architectural Design

Graphic Design: 1918-1983

1. See H.K. Frenzel, *Ludwig Hohlwein*, trans. Herman George Scheffauer (Berlin, 1926).

2. Heinz Peters, *Die Bauhaus-Mappen. "Neue europäische Graphik," 1921-1923* (Cologne, 1957); Hans M. Wingler, *Graphic Work from the Bauhaus* (Greenwich, Connecticut, 1965).

3. See Willy Rotzler, *Johannes Itten. Werke und Schriften* (Zurich, 1972), pp. 307-308 for cliché reproductions of design pages from *Utopia* and other drawings of the period that use expressionist typography.

4. Sophie Lissitzky-Küppers, *El Lissitzky. Life-Letters-Texts* (London, 1968). See also L. Leering van Moorsel, "The Typography of El Lissitzky," *The Journal of Typographic Research* 2, 4 (Cleveland, 1968), pp. 323-329.

5. Employing typography in the spirit of his Proun paintings, Lissitzky's *The Story of Two Squares* (1922) used the same abstract, plastic means to express something visually concrete. Lissitzky wrote of this work: "The key fact is here that the layout of word picture is achieved with the same technical means, i.e., phototype, photography.... Consequently, we are confronted with a form of book in which the presentation is of prime importance and the letter takes second place" ("Unser Buch," *Gutenberger Jahrbuch* [Mainz, 1926-27]).

6. *For the Voice* (*Dlja Golossa*) (Berlin, 1923). *Ex Libris* 6, (New York), no. 164; see also Lissitzky-Küppers, *El Lissitzky,* pp. 25, 94, 381, 88; figures 94-108.

7. "these ideas referring to functional typography did not drop out of the blue but had like everything else precursors, notably for me personally, the russian el lissitzky with his unorthodox if decorative handling of typefaces, rules, slugs, etc., in the design of mayakovesky's poems" (45:99-101). Bayer is referring, of course, to *For the Voice*. As Lissitzky was present in Weimar at the famous Dadaist-Constructivist Congress of 1922 and undoubtedly frequently communicated with Moholy-Nagy, his works were probably circulated at the Bauhaus in connection with his visits; the famous issue of *Merz* 8/9 (designed by Lissitzky for Kurt Schwitters) in which Lissitzky's theses on typography were set forth was certainly circulated and read at the Bauhaus after its publication in 1925.

8. See Ronny H. Cohen, "Italian Futurist Typography," *Print Collector's Newsletter* VIII, 6 (New York, 1978), pp. 166-170; Arthur A.

Cohen, "Marinetti & Futurism," op. cit., pp. 170-172; Arthur A. Cohen, ed., *"Futurism:" The Avant-Garde in Print* (New York, 1982).

9. See Arturo Schwarz, *Almanacco Dada* (Milan, 1979).

10. See reproduction in 45:103; variant designs represented in the private archive of the artist. See also 11:85; 40:20.

11. Although this sign is invariably credited to Bayer alone, Bayer is quick to point out that his friend Josef Maltan (known as "Sepp") was a professional house painter from Berchtesgarten and knew better than he how to prepare the area for the application of cassein (11:82).

12. The conservative German typographer F.H. Ehmke commented on Bayer's design for the cover of *Staatliches Bauhaus in Weimar 1919-1923*: "brutal in der Farbe, ohne Feinheit in der Form" ("wholly concerned with shopwindow effects, or, if one wants to be nasty, sheer bluff; brutal in color, without refinement of form") (11:95).

13. See 142:29, figures 15, 16, where a 1920 paper money design by Bayer, filled with heraldic emblems, letters shadowed with thin lines, crammed and unreadable information is contrasted with the design three years later for the State of Thuringia.

14. The typography workshop was located in the basement of the Bauhaus in Dessau, principally because of the weight of the equipment, which, according to Walter C. Allner, consisted of a large flat-bed press and two small *tiegelpresse* (platen presses). Bayer confirms Allner's recollections.

15. László Moholy-Nagy, "The New Typography (1923)," *Moholy-Nagy*, Richard Kostelanetz, ed. (New York, 1970). In Sibyl Moholy-Nagy's translation from the German of 146: "communication must never be impaired by an *a priori* esthetics."

16. László Moholy-Nagy, "The New Typography (1923)," p. 75. "communication must never be impaired by an *a priori* esthetics." Bayer rarely advanced a typographic aesthetic attitude. Quite the contrary, since there was no formal typographic instruction during his directorship of the typographic workshop at Dessau, teaching and learning consisting in the design and criticism of actual printing jobs. "in the bauhaus typography workshop, we printed all, or most, of the printed matter—like folders, announcements, posters, etc.—which were used at the bauhaus, teaching was largely confined to producing these typographic items. there was very little theoretical teaching because all the workshop's time was used up by producing. the students learned by participating in the production of the workshop. that

is, by self-experience and self-instruction" (personal communication).

17. 3:10. "ein beispiel für die verbreitung des 'bauhausstiles' zeigt die auftragstatistik einer frankfurter druckerei: nahezu 50% aller druckaufträge eines jahres wurden dort im 'bauhausstil' gewünscht. es blieben nur mehr derbe punkte und dicke balken."

18. DIN (*Deutsche Industrie Normung*) was established by the paper and stationery printing industry in 1924 to standardize commercial paper sizes and expedite postal service. The DIN norms standardized as well printed indications for date, sender, recipient, etc., making secretarial activity more orderly. The Bauhaus stationery, designed by Bayer in 1925, uses the DIN formulas, while adding to them "klein schrieben," that is, lowercase typography.

19. Bayer has designed more than a score of remarkably effective letterheads, including a considerable variety for the Bauhaus and its manifold activities, as well as for cultural and industrial enterprises. To the best of my knowledge, his letterheads of the early 1930s for Zieger & Wiegand and Die Neue Adler Standard Schriebmaschine (one a leather-glove manufacturer, the other a typewriter maker), are among the earliest, if not the first, to use photomontaged elements combined with type and color. By and large, his display letterheads made use of a single newly drawn san-serif letter in color, as the *p* in Puka or *k* for Ernst Kraus Glasmaler or *hb* for his own business letterhead. See 142:34, 35, 40–42, 159, 162, 191.

20. Because Bayer's cover photograph for *bauhaus zeitschrift* has become a signature image for his design, sculpture, and painting, supplying him with iconic essential forms with which he has built his own visual vocabulary, it is relevant to mention the recollection of the late Bauhäusler Heinz Loewe, transmitted to me by Egidio Marzona of Dusseldorf. Franz Ehrlich, Fritz Winter, and Heinz Loewe were working with plaster cubes, pyramids, and balls in the Joost Schmidt Plastische Werkstatt in late 1927, when Bayer visited them. Loewe did not offer this recollection in any spirit of competitiveness, but rather to suggest that such imagery was in the Bauhaus air. Undoubtedly true, but it was Kandinsky's fundamental vocabulary before it became Bayer's or supplied Joost Schmidt with relevant Unterrichten for his students. What matters is not who has an image first, but what is done with it. Bayer had been working with Kandinsky's vocabulary since 1923 but only in late 1927 did he make a photograph of three-dimensional plaster objects and construct them in such a way as to provide the Bauhaus periodical with a signature definition.

21. Franz Roh, *German Art in the 20th Century* (Greenwich, Connecticut, 1968), p. 107.

22. See Ute Brüning's excellent discussion "Zur Typografie Herbert Bayers" (142: 118–137). Note particularly the influence of W. Porstmann, *Sprache und Schrift* (Berlin, 1920). Porstmann supposedly had lectured at the Bauhaus, and Brüning remarks that Bayer's first publication on universal type (1:398–400) "ist jedenfalls teilweise eine Paraphrase Porstmanns." Moreover, on the various Bauhaus letterheads that Bayer designed in 1925 abstracts of Porstmann's views are cited in the explanatory text at the bottom. In the issue of *Offset* (1), Bayer's article "Versuch einer neuen Schrift und Struktur der Aussenwerbung" appears following Josef Albers's essay "Zur Ökonomie der Schriftform," in which Albers proposes his new stencil alphabet. Joost Schmidt, who became head of the Bauhaus typographic workshop following Bayer's departure in 1928, prepared a constructed alphabet based on a classical Antiqua as well as a sans-serif lowercase alphabet. Typographic invention was part of the productive intellectual preoccupation at the Bauhaus. Everyone at the Bauhaus, *pari passu*, "fooled" with type, however only Bayer and Schmidt made real contributions to the new typography.

23. Bayer earned no royalties from H. Berthold for the design of Bayer-type, although it sold very well in Scandinavia. Only now, with the version known as Bauhaus manufactured by the International Typeface Corporation, does he receive royalties.

24. See 142:105–107. The sequence of events leading Bayer to the Dorland Studio in Berlin was this: Dr. M.F. Agha, the overall art director of *Vogue* during the 1920s, hired Bayer to become art director of German *Vogue* after he left the Bauhaus. The advertising for French *Vogue* was handled by the Paris branch of Dorland, which was headed by Walter Maas. Through Maas, Bayer met Walther Matthess of German Dorland, who invited Bayer to manage all art for Dorland.

25. The equipment installed at Dorland was not, by contemporary standards, particularly grand; however, in those days—when designers were obliged to do all their own renderings, with absolutely minimum equipment—the availability of photography was a tremendous advantage.

26. The principal interpretation of Bayer's achievement at Dorland and his independent work as graphic designer in Berlin from 1928 until his emigration in 1938 is Alexander Dorner's *the way beyond "art"* (68). Following a somewhat iconoclastic and extreme interpretation of the breakdown of formalist

aesthetics and a description of the alienation of art from modern life, Dorner interprets Bayer's work up through the early 1940s as an art of rapprochement. Dealing in detail with Bayer's design work in Berlin, he interprets it as an art of common signs and symbols, that is, an art that reestablishes connection between the ideal and everyday life. Although this pragmatic interpretation has certain advantages as a means of understanding the tasks of the artist in the marketplace, it tends to flatten overdogmatically the function of imaginative free play in its reading of Bayer's paintings of the period. Nonetheless, this is one of the best discussions of Bayer's graphic design during this period. See particularly 68:167–191. Bayer provides excellent visual documentation, with annotation, of the Dorland period in his own book (40:28–34, 38–49); see also Magdalena Droste's essay (142:62–79), and Eckhard Neumann's interview with Walther Matthess (142:105–109).

27. Stanislaus von Moos deals with Dorner's interpretation of Bayer and discusses Bayer's classicism in 142:101.

28. 7. See also 40:40 for further illustrations.

29. I have not discussed the numerous design projects Bayer undertook as independent commissions following his arrival in the United States in 1938 but have concentrated rather on his corporate associations during the past four decades, in part because this period of his career is documented (142:138–143; 39), and the Herbert Bayer Archive at the Denver Art Museum in Colorado has a particularly comprehensive collection of Bayer's design after his emigration. It must be observed, however, that Bayer's graphic design in the United States reflects, much more than did his work in Germany, the undeniably cramping impact of the client and the client's advertising agency. Although his design of books and book jackets for Alfred A. Knopf, Harvard University Press, and the Bollingen Foundation maintained a consistently high level of ingenuity and elegance, his newpaper advertising and product campaigns for several large companies rehearse many of the design solutions familiar during the 1940s. Advertising had not yet reached any degree of sophistication at that time. His magazine covers for *Vogue*, *Harper's Bazaar*, and *Fortune*, as well as his early advertisements for Container Corporation of America, his famous brochure for the General Electric Company visualizing the conceptual structure of electronics (1942), his posters for Olivetti (1953) are realized with consistent excellence, but their idiom reflects the highly competitive, "lowest common denominator" approach favored by American business. The best of Bayer's American-period graphic

design no longer employs the classicist vocabulary, photomontage, or the strict typography of his Dorland, much less his Bauhaus, days. His visual language was more relaxed and unimperial, and where it softens, it reflects the presence in the United States of that overrated interpreter of public taste and corporate needs, the advertising expert.

30. Sibyl Moholy-Nagy, *Moholy-Nagy. A Biography* (New York, 1950), pp.210–211, 226, 228, 241.

31. Marquis W. Childs, "The World of Walter Paepcke," *Horizon* I, 1 (New York, 1958), pp. 96–103.

32. Ida Rodriquez Prampolini's *herbert bayer. un concepto total* (122) has, to my view, turned Bayer's work on its head. Although she has understood that Bayer's conception of "total design" has considerable social consequence and significance, since it depends for its viability on the receptiveness of the public to its own visual reeducation, the intent of Bayer's vision is neither Marxist nor collectivist. Quite the contrary, although Bayer is thoroughly nonpolitical in his viewpoint. His recognition that the large corporation is the single institution of modern economic life with the power and, where guided by enlightened and socially responsible management, the efficent will to effect visual communication and to institute a program of total design, is an acknowledgment, *faute de mieux*, of the dominance of a capitalist market system. Bayer passes no judgment on this state of affairs. As a pragmatist he adapts to it, but it is hardly likely that he would accommodate himself to any Marxist system of preferred and healthy social values any more than he was willing or able to press himself into the procrustean bed of Germanic Aryan values under the Nazis. It is hard to imagine any collectivist polity that can produce a free aesthetic. Bayer's free aesthetic happens to be devoid of perversity or obscurantism, but that is a consequence of his visual affinities and not because of any interest in advancing a public collectivity or a socialist sensibility.

33. Prior to Bayer's activity with CCA, the company had already used A.M. Cassandre for product advertising with minimum text. When Bayer (still working with the N.W. Ayers Advertising Agency) became involved with CCA in the 1940s, he continued the process of abstraction already begun, moving CCA's advertising from minimal product advertising toward institutional advertising. He first developed a series of advertisements using artists from each of the forty-eight states. After the war began, he involved artists from the members of the United Nations, and then finally, with Mortimer Adler choosing the texts in collaboration with the Aspen Institute for Humanistic Studies, the Great Ideas of Western Man series was established. The quotations were given to Bayer, who presented them, along with suggestions of possible artists, to Walter Paepcke. When they were approved and the selections accepted by Egbert Jacobson, the art director of CCA, Bayer would hire the artists through N.W. Ayers. For Bayer's views on design and industry see 19 (the entire issue was devoted to CCA's program) and 40:86–95.

34. Kurt Schwitters virtually terminated his activities as a designer by the middle 1930s, as he became more engaged with his work as collagist, and as the atmosphere in Germany darkened and the community of the avant-gardists began to splinter. El Lissitzky, returned to the Soviet Union during 1931 and from that time until his death, in 1941, his typographic innovativeness deteriorated under the repressive comformism imposed by Stalin. Despite a number of successful (but fairly uncomplicated) photomontages for *USSR in Construction*, notably for issues on the Dnelperden and the Red Army, Lissitzky's work became increasingly safe and repetitive. Moholy-Nagy produced some graphic design during his Berlin years after 1928 until his departure for England and the United States, but his principal activities beside painting and sculpture were photography (less so after his emigration) and education.

35. During the 1960s and '70s Bayer made use of images from his painting for posters and advertisements, sometimes replicating them without transformation (which is often a mistake), but sometimes introducing into the composition typographic elements that effect the transformation of the visual icon into an efficient and direct communication.

Photography: 1925–1938

1. See Lucia Moholy, *Marginalien zu Moholy-Nagy. Dokumentarische Ungerheimtheiten* (Krefeld, 1972). This little pamphlet—an essay in interpretation and correction—sets the record straight as Lucia Moholy views it on a number of critical issues relating to Moholy-Nagy's activities as artist, designer, writer, and photographer, and incidentally clarifies by implication the role she played in the definition and printing of Moholy's photography.

2. See reprint of the catalogue *Internationale Ausstellung des Deutschen Werkbundes Film und Foto Stuttgart 1929*, prepared by Karl Steinorth (Stuttgart, 1979), pp. 53–54, for listing of the twenty-six photographs of Herbert Bayer exhibited, as well as unlisted "Fotomontagen und Werbedrucksachen," and five photographs by his wife, Irene Hecht Bayer.

3. Kees Broos, "een nieuwe typografie," *Piet Zwart*, Haags Gemeentemuseum (The Hague, 1973, 1982). "Het eerste fotogram van Pietz Zwart verscheen in een normalisatieboekje voor de NKF in 1924." It was customary for Zwart to take his own photographs of materials he would employ in his brochures or advertising booklets, notably for the Netherlands Cable Company (NKF), for whom he designed numerous catalogues and advertisements beginning in 1923 (op. cit., pp. 44–51).

4. Lucia Moholy, *Marginelien zu Moholy-Nagy*. In conversation with Dr. Tim Gidal, the German-born Israeli photographer, I learned of the important role that Lucia Moholy played in the technical realization of Moholy-Nagy's photographs.

5. See Moholy-Nagy, "Applied Photography" (extract; 11:154).

6. László Moholy-Nagy, *Painting Photography Film*, with a note by Hans M. Wingler and a postscript by Otto Stelzer (Cambridge, Massachusetts, 1969). This was the eighth volume in the series of Bauhaus books and was originally published as *Malerei, Fotografie, Film* (Munich, 1925).

7. On Walter Peterhans, see 186:498–499; see also *Walter Peterhans. Elementar Unterricht und photographische Arbeiten*, Bauhaus-Archiv (Darmstadt, 1967).

8. László Moholy-Nagy, *Painting Photography Film*, p. 39.

9. Sophie Lissitzky-Küppers, *El Lissitzky*, plates 114, 118, 119, 120, 122.

10. See *Alexander Rodshenko 1891–1956*, Museum of Modern Art, (Oxford, 1979), pp. 20–21, for color reproductions of many of the covers Rodshenko designed for *LEF* (1923–1925) and *Novyi LEF* (1927–28).

11. For extensive reproductions see 142:75–78; 40:48; 103:40–41.

12. Bayer took several photographs in Paris in 1925, only one of which, *Morgen in Paris*, was printed and preserved.

13. Andreas Haus, *Moholy-Nagy. Photographs and Photograms*, trans., Frederic Samson (New York, 1980), pp. 66–67, discussion of photographs 41 and 42.

14. Bayer has listed for me the cameras he has owned and used, beginning with his first camera (whose make he no longer remembers), which was a 3 x 4″ small bellows camera. This was followed by a 2¼ x 2¼″ Rolleiflex (5½ x 5½), a Zeiss Contax, a Leica, and a Pentax.

15. In *Moholy-Nagy. Photographs and Photograms*, Andreas Haus has discussed the relationship between abstract photographic composition and the plastic abstractions devised by Lissitzky and Rodshenko, in the course of documenting the photographic compositions of Moholy-Nagy, who was certainly more conversant with constructivist art than was Bayer. If, indeed, Bayer's abstract photographs relate to constructivist composition, the affiliation must be more coincidental than causal, since there is little evidence that he had more than a casual familiarity with the vocabulary of constructivism (although he was quite familiar with the premises of De Stijl). Indeed, one can argue that such connections, at best, are psychological affinities, recognizing the power of abstract forms in such immense structures as Pont Transbordeur and composing a photographic image to record them. The relation of diagonals to solids in the photographs of Bayer and Moholy-Nagy relate to similar formal relations in constructivist painting precisely because the relation of thick and thin, line and solid, space and volume, occupies so much of the vocabulary of constructivist art. It may also suggest a connection between modern engineering and architecture and constructivist art that is only beginning to be investigated.

16. "I have no education in the use of the camera. I, like some others, simply became interested during the early twenties in taking a camera and shooting. I was not instructed by moholy in any way in the art or craft of photography. my first wife, irene, took some instruction in photography in leipzig. later on she developed and printed my photographs. I also produced some of my early advertising photography in collaboration with her" (personal communication, September, 1982).

17. "moholy's influence on my photography was simply that his enthusiasm rubbed off on me, as well as on others like umbo [Otto Umbehr] and finsler [Hans Finsler]. I was not impressed by his photograms. . . if we went somewhere together, both of us always took a little camera with us. we did not, however, go on photo expeditions in berlin" (personal communication, September, 1982).

18. Andreas Haus, *Moholy-Nagy. Photographs and Photograms*, p. 71, plate 90. Although Moholy's photographs of the Pont Transbordeur were shot the year after Bayer's, it has never seemed quite relevant to speak of "imitation" in photography. The issue is rarely the identity of subject matter (in the case of fixed architectural phenomena, for instance) or even the similarity of subject matter (whether beggar sleeping in the street of Marseilles or working man taking his siesta in Greece), but rather intention and execution: how the

camera sees and what it is exposed to see. The suite of photographs that Bayer, and later Moholy-Nagy, did of the Pont Transbordeur reveal the same order of curiosity and speculation; both sets of photographs are superb and both endure. The situation is somewhat different in the case of Bayer's *Siesta* (125:26; plate 12) and Moholy's untitled photograph of a Marseilles beggar sleeping in the street (1929). Both subjects are ragged and poor; however, Bayer's—shot much closer—is a weary man sleeping in the sun, resting his head on his arm, positioned against a wall; Moholy's is a beggar dropped in estranged aloneness with a long rubble-strewn street behind him. Haus brings forth similar photographs by Emile Strassburg and an anonymous photograph that appeared in 1930 in the Communist periodical *Der Arbeiterfotograf* to contrast with Moholy's composition, but all three are in profound contrast to Bayer's. Reality (both for subject and photographer) varied and dictated a different intention and disclosure.

19. *Flohmarkt* 1928 is reproduced in 126:36, plate 18; *Schatten auf der Treppe* 1928 is reproduced in 126:25, plate 11.

20. *Posters in Athens* (126:48, plate 34); *Street Café, Greece* (126:49, plate 35), *Beggar in Serbia* (126:50, plate 36); and others printed during the mid-1970s from photographs taken during this trip of 1934.

21. *At the Acropolis* (126:51, plate 37), *Midday* (126:53, plate 39), *Parapoatiani Chapel* (126:54, plate 40), to name only a few examples. Photographs from this series of 1934 have been exhibited at Denver Art Museum in 1973, Galerie Klihm in 1974, ARCO Center for Visual Art in 1977, and Marlborough Gallery, New York in 1982.

22. Lucia Moholy, *Marginelien zu Moholy-Nagy*, p. 73.

23. Arturo Schwarz, *The Complete Works of Marcel Duchamp* (New York, 1969), p. 98. See also discussion in 128:21.

24. 128:21 See also a letter of September 1977 from Bayer to Dr. Tim Gidal of Jerusalem, in which Bayer corrects Gidal's misreading of the image as involving airbrushing to achieve plastic accentuation, which he reserved for his Fotoplastiken. Bayer explains: "you mention *blick ins leben*, but you seem to make a mistake because the background is not a building but a reproduction of a cheap oil print representing the sun breaking though clouds over a water area. the photograph of the frame was simply montaged over this and the string painted in."

25. See 126:8–9 for Leland Rice's discussion of the photomontages.

26. See 126:8 for Leland Rice's observation regarding Bayer's painting *The World of Letters*.

27. *Atelier-Strand*, a watercolor and collage acquired by Julien Levy, is reproduced in 40:159, and reproduced in juxtaposition to *Profile en Face* in 103:36–37.

28. The hand on the door handle is surely that of the artist. Reflecting on his use of himself as the source of anatomical elements in his photographs, Bayer has written: "when I needed parts of the human anatomy, it was simpler to use myself than to go and have somebody else's features photographed. I knew better than another person, for instance, to hold my hand or to move it in the way I wanted. it is probably difficult for you to realize that the most experimental work was done with the least effort and with the least expense. costly presentation of ideas and sketches was unknown. nobody paid for them" (personal communication, September 1982). This explanation applies not only to advertising and commercial work, but to his photomontages as well.

29. Eduard Jaguer, *Les Mystères de la Chambre Noire. Le Surréalisme et la photographie* (Paris, 1982), p. 103. But Jaguer is wrong to think that Bayer's painting *Communication in Space* is impelled by surrealist considerations. Jaguer's misperception derives from the not unusual fact that he is unaware of the body of Bayer's painting and hence judges from isolated exempla what is in fact a completely nonsurrealist exploration.

30. Lucia Moholy, *Marginelien zu Moholy-Nagy*, pp. 69–74.

31. Irene-Charlotte Lusk, *Montagen ins Blaue. László Moholy-Nagy. Fotomontagen und collagen 1922–1943 (Berlin, 1980)*.

32. Lucia Moholy, *Marginelien zu Moholy-Nagy*, p. 70.

33. Franz Roh, and Jan Tschichold, *Foto Auge-Oeil et Photo-Photo Eye* (Stuttgart, 1929).

34. László Moholy-Nagy, *60 Fotos* (Berlin, 1930).

35. Lucia Moholy refers to Bayer's use of Fotoplastik, but her syntax suggests that there was only one photoplastic made by Bayer in 1936, rather than a whole series that bore that name. "It now occurs only in quotations and historical context, Herbert Bayer's 'Photoplastic' of 1936 being an exception" (p. 70).

36. *Hands Act* was also called *Handlung* in the Klihm portfolio of 1968, although Bayer has titled it more allusively in English.

37. The earliest Bayer sculptures were two soft form sculptures drawn from the imagery of the "Dunstlöcher" paintings.

38. Rosalind Krauss builds her interpretation of Bayer's photograph of a hand holding a pencil (1937) from a skewed perception (Rosalind Krauss "When Words Fail," *October* 22, [1982], pp. 91–104). Apparently, the organizers of the conference When Words Fail (International Center of Photography and Goethe House, February 19–21, 1982) used Bayer's photograph as a persistent design element in all their conference literature. Of this photograph Krauss writes: "it is very curious that this pronouncement of the antiverbal culture-of-the-visual should have been accompanied in all the announcements and programs for the colloquium by a photograph holding a pencil—and holding it, moreover, not in a position to draw so much as to write." There are a number of obvious misperceptions underlying Krauss's reading of this photograph: the hand is poised over a large field of white (a piece of paper so vast as not to be in any way associable with a writing pad or a piece of notepaper); the pencil is clearly a drawing pencil, not a writing pencil—the way it is sharpened, the extremely long point, which even most careful word-writer would be bound to break; the index finger and thumb are positioned for drawing, not writing; the photograph is called *Self-Portrait* and whatever Bayer's claim to being a total artist, he has never considered himself a writer. The photograph is certainly full of ironies and ambiguities, but about its relation to writing there can be no doubt. *Self-Portrait* is about drawing.

Exhibition Design and Architectural Design: 1928–1968

1. Sophie Lissitzky-Küppers, *El Lissitzky*, plates 206–207.

2. The press response to Lissitzky's installation at the Pressa Ausstellung in Cologne was overwhelmingly enthusiastic. Ibid., pp. 85–86.

3. See documentation of Lissitzky as exhibition designer, ibid., plates 184–229.

4. Lissitzky was at the Constructivist-Dada Congress in Weimar during 1922 and undoubtedly a visitor at the Bauhaus on that occasion. Unfortunately, there are no records (or guest books) in the Bauhaus-Archiv to document when important visitors were present; the result is that assertions of this kind are conjectural unless supported by other documentation.

5. Yves-Alain Bois, "Metamorphosen der Axonometrie. Metamorphosis of Axonometry," *Daidalos* 1 (Berlin, 1981), pp. 45, 46.

6. See Daniele Baroni, *The Furniture of Gerrit Thomas Rietveld* (Woodbury, New York, 1978).

7. Lucia Moholy is not quite correct in her assertion that the lettering on the spine of the Bauhaus books was "almost throughout" made to run from top to bottom in contravention of prevailing convention. In fact only volumes 1 and 9 through 14 obeyed Moholy's innovation. The rest ran, like Bayer's JOURNALE, from bottom to top. Moholy's innovation has generally won out in Anglo-American bookmaking, although not in Germany, where even Wingler's *Das Bauhaus* is printed on the spine from bottom to top. Lucia Moholy, *Marginelien zu Moholy-Nagy*, p. 85.

8. Siegfried Giedion, *Walter Gropius. Work and Teamwork* (New York, 1954), p. 49.

9. See the unpaginated catalogue *Section Allemande* (Paris, 1930), p. 4.

10. Siegfried Giedion, *Walter Gropius*, p. 49.

11. Ibid., p. 50.

12. See 156; see also *Section Allemande*, Salle 2.

13. *Section Allemande*, Salle 3.

14. Siegfried Giedion, *Walter Gropius*, p. 49.

15. *Section Allemande*, p. 36 (unpaginated).

16. Bayer had experimented with the display of typefaces earlier the same year at the Paris exhibition stand of H. Berthold Type Foundry, Berlin, where he angled panels of cast-type matrices resting on a simple wood stand to face a vertical mirror that reflected the type for those approaching the exhibition down the alleyways of the general exhibition space. Bayer's archival photographs of this installation were taken by André Kertesz.

17. Siegfried Giedion, *Walter Gropius*, p. 51.

18. Ibid., pp. 51–52.

19. Monroe Wheeler, "A Note on the Exhibition (Road to Victory)," *Bulletin*, Museum of Modern Art 5–6, 9 (June, 1942), pp. 18–20, with press comments on p. 31.

20. Monroe Wheeler, "Airways to Peace. An Exhibition of Geography for the Future," *Bulletin*, Museum of Modern Art 1, 11 (August, 1943), where installation photographs make clear the immense ingenuity of Bayer's installation.

21. A private memorandum prepared by Bayer for his own archives, which he has called "report on exhibition '50 years bauhaus.'"

22. Ibid.

23. See translation of "Unser Buch" from the *Gutenberger Jahrbuch*, Mainz, 1926–27; see also Sophie Lissitzky-Küppers, *El Lissitzky*, p. 359.

24. 146:223, figure 145. Of this drawing Bayer has written: "it incorporates geometric as well as building details. it has no purpose beyond that of a painting except that this is a drawing. this was unusual at the time only because using geometry as the essential character of a drawing seems only recently to have become fashionable" (personal communication, March 1983).

25. Henry-Russell Hitchcock, Jr., and Philip Johnson, *The International Style: Architecture Since 1922* (New York, 1932), pp. 77–78.

26. "I was not given a chance to develop an approved master plan. the layout of all institute land which evolved over the years, is due to my personal (secret) concept of a master plan. (walter paepcke did not want to be tied down by a plan.) the various structures were built piecemeal whenever a building was needed" (personal communication, March 1983).

27. Bayer's memorandum on the Seminar Building, 1953.

28. Bayer's memorandum on Private Chapel, Circle Diamond Ranch, Hondo Valley, New Mexico, 1962.

Selected Bibliography

This bibliography is divided into three sections: (I) books, articles, essays, and portfolios written or edited by Herbert Bayer; (II) books, articles, essays, exhibition catalogues, and films exclusively about Herbert Bayer; (III) book, articles, and exhibition catalogues that include or discuss Herbert Bayer. The bibliography does not pretend to be exhaustive, as many works mention Herbert Bayer without advancing the interpretation of his work. Page references are given where available.

I. Books, articles, essays, and portfolios written or edited by Herbert Bayer

1. "Versuch einer neuen Schrift und Struktur der Aussenwerbung"; "der neue briefbogen." *Offset. Buch und Werbekunst* 7. Leipzig, 1926: pp. 398–400, 402–404, ill.

2. "Typographie." *Typographische Gesellschaft.* Leipzig, 1926.

3. "Typografie un Werbsachengestaltung." *bauhaus. zeitschrift für bau und gestaltung* 1. Dessau, 1928: p. 10.

4. "Aus dem optischen Notizbuch." *Das Illustrierte Blatt* 49. Berlin, 1928 (3 pp., ill.).

5. "Die Schwebefähre von Marseilles." *Das Illustrierte Blatt* 49. Berlin, 1928 (3 pp., ill.).

6. "Werbephoto." *Wirtschaftlichkeit.* Leipzig, 1928 (4 pp., ill.).

7. "Zieh Dich aus–und Du bist Grieche." *Uhu.* Berlin, 1930: pp. 28–32, ill.

8. *11 Fotomontagen.* Portfolio privately printed by Bayer with eight photomontages. Berlin, 1932.

9. "Towards a Universal Type." *Industrial Arts* 1, 3. London, 1936 (7 pp., ill.).

10. *fotoplastiken.* Portfolio privately printed by Bayer with eight fotoplastiks. Berlin, 1937.

11. *Bauhaus 1919–1928* (with Walter and Ise Gropius). The Museum of Modern Art, New York, 1938; Charles T. Branford Co., Boston, 1952; Gerd Hatje Verlag, Stuttgart, 1955. ("Typography," pp. 148–152, ill.).

12. "contribution toward rules of advertising design"; "fundamentals of exhibition design"; "towards a universal type." *PM Magazine,* December-January 1939–40. New York: pp. 6–11, ill., 17–25, ill., 27–32, ill.

13. "Design Analysis." *Advertising & Selling,* February 1940. New York (4 pp., ill.).

14. "Notes on Exhibition Design," *Interiors,* July 1947. New York: pp. 60–77, ill.

15. *Seven Convolutions.* Portfolio of seven original lithographs. Colorado Springs Fine Arts Center, Colorado Springs, Colorado, 1948.

16. "Towards the Book of the Future." *Books for Our Time.* Edited by Marshall Lee, with a preface by George Nelson. Oxford University Press, New York 1951: pp. 22–25, ill.

17. "Goethe and Art Today." *College Art Journal* 11, Cleveland 1951: pp. 37–40.

18. "On Design." *Magazine of Art,* December 1951. Washington, D.C.: pp. 324–325, ill.

19. "Design as an Expression of Industry." *Gebrauchsgraphik,* 9. Munich, 1951: pp. 57–60.

20. *World Geo-Graphic Atlas.* Edited and designed by Herbert Bayer, with Henry Gardiner, Martin Rosenzweig, Masato Nakagawa, Joella Bayer. Container Corporation of America, Chicago, 1953.

21. "Preface." *Erberto Carboni, Esposizioni e Mostre.* Milan, 1954 (7 pp., ill.).

22. "Per un Carattere Tipografico Universale." *Linea Grafica* 1/2. Milan, 1954.

23. "On Communication." *One-Quarter Scale* 3, 2. Cincinnati, 1955–56.

24. "a contribution to book typography." *Print,* March-April 1959. New York: pp. 75–77, ill.

25. *Grande Atlante Geografico.* Italian adaptation of *World Geo-Graphic Atlas.* Istituto Geografico de Agostini, Novara, 1959.

26. "Design reviewed." *World Design Conference.* Tokyo, 1960: pp. 17–21.

27. "un contributo alla tipografia del libro." *Linea Grafica,* March-April 1960. Milan (8 pp., ill.).

28. "on typography." *Print,* January-February, 1960 (3 pp.). New York. An earlier and more comprehensive version, "über typografie," was published in *Kunst des Gestaltens* 10. Frankfurt, 1960.

29. "Walter Paepcke." *Print,* September 1960. New York.

30. "Aspects of Design of Exhibitions and Museums." *Curator* 3. New York, 1961: pp. 257–288, ill.

31. *herbert bayer. book of drawings.* Foreword by Otto Karl Bach; introduction by Herbert Bayer. Paul Theobald & Co., Chicago, 1961.

32. "A Statement for an Individual Way of Life." *Print,* may 1962. New York: pp. 26–33, ill.

33. "Introduction to Great Ideas of Western Man." Introduction to exhibition catalogue. *Graphic Design,* October 1962. Tokyo.

34. "On Environment." *New Mexico Architect.* Roswell, New Mexico, 1963.

35. "homage to gropius" ("Ehrung für Gropius"). Translated by Eckhard Neumann. *bauhaus. Idee-Form-Zweck-Zeit.* Exhibition catalogue. Göppinger Galerie, Frankfurt am Main, 1964: pp. 98–103.

36. "Typography U.S.A." *Print,* January-February 1964 (1 p., ill.). New York.

37. "basic alfabet." *Print,* May-June 1964 (4 pp., ill.). New York.

38. *eight monochromes.* Portfolio of original lithographs. Tamarind Lithography Workshop, Los Angeles, 1965.

39. *Bayer.* Portfolio privately printed for Container Corporation of America, with fourteen color reproductions of paintings. Foreword by David Gebhard. Chicago, 1965.

40. *herbert bayer. painter designer architect.* Reinhold Publishing Corp. New York 1967;

Otto Maier Verlag, Ravensburg, 1967; Studio Vista, Ltd., London, 1967; Zokeisha Publications Ltd., Tokyo, 1967.

41. *herbert bayer*. Six serigraphs, with introductory text by Dieter Honisch. Edition Domberger, Stuttgart, 1968.

42. "reflections from one of the sculptors who contributed to the 'route of friendship.'" *Architecture Formes et Fonctions*. Lausanne, 1969.

43. *herbert bayer. 10 fotomontagen. 1929–1936. mappe 1*. Galerie Klihm, Munich, 1969.

44. *herbert bayer. 10 fotomontagen. 1932–1936. mappe 2*. Galerie Klihm, Munich, 1969.

45. "Typography and Design." *Concepts of the Bauhaus: The Busch-Reisinger Collection*. Cambridge, Massachusetts, 1971: pp. 99–101, ill.

46. "Bilder im Raum"; "Über Typographie." *Bauhaus Weimar Dessau Berlin, Form + Zweck. Fachzeitschrift für industrielle Formgestaltung* 3. Leipzig, 1979: pp. 58–59, 75–77.

47. Arthur A. Cohen. *Interviews with Herbert Bayer*, November 3–6, 1981. Oral History Program. Archives of American Art/Smithsonian Institution, San Francisco, 1981.

II. Books, articles, essays, exhibition catalogues, and films exclusively about Herbert Bayer

48. Paul Dermée. "Un Message de bonheur." Exhibition catalogue. Galerie Povolozky, Paris, 1929.

49. Paul Westheim. "Herbert Bayer. Photograph und Maler." *Das Kunstblatt*. Berlin, 1929: pp. 151–153, ill.

50. Kurt Hirschfeld. "Umbo–Herbert Bayer." *Gebrauchsgraphik* 7. Berlin, 1930: pp. 44–51, ill.

51. H.K. Frenzel. "Herbert Bayer." *Gebrauchsgraphik* 5. Berlin, 1931: pp. 2–19, ill.

52. "A Selection of Bayer Advertising Designs." *Dorland* 1. Berlin, 1933.

53. Luigi Poli. "Herbert Bayer, un Maestro dell'Arte Grafica." *Natura* 11/12. Milan, 1933 (9 pp., ill.).

54. "A Berlin Exhibition 'The Wonders of Life.'" *Industrial Arts*, winter 1936. London (5 pp., ill.).

55. *Herbert Bayer. Jahresausstellung des Kunstvereins*. Salzburg, 1936.

56. Eberhard Holscher. "Herbert Bayer." *Gebrauchsgraphik*, April 1936. Berlin: pp. 18–28, ill.

57. *herbert bayer (austrian)*. Exhibition catalogue with text by A[lexander] Dorner. London Gallery, Ltd. April–May 1937. London.

58. S.L. Righyni. "The Work of Herbert Bayer." *Art and Industry*, May 1937. London: pp. 205–209, ill.

59. Eberhard Holscher. "Herbert Bayer." *Gebrauchsgraphik*, January 1938: Berlin: pp. 2–16.

60. Percy Seitlin. "Herbert Bayer." *PM Magazine*. New York, 1939 (32 pp., ill.).

61. Julien Levy. "From a Portfolio of Fotomontages by Herbert Bayer." *Coronet*, January 1940. New York: pp. 30–37, ill.

62. "H.B.'s Design Class." *A.D.* 5. New York, 1941: pp. 18–30, ill.

63. Charles T. Coiner. "Herbert Bayer: Recent Work for Advertising." Exhibition catalogue. Art Headquarters, New York, 1942.

64. H. Felix Kraus. "Herbert Bayer—Architect and Artist." *Art and Industry*, July 1942. London: pp. 9–13, ill.

65. *herbert bayer. exhibition of paintings, posters, montages, advertising design*. Exhibition catalogue with commentary by Charles T. Coiner and James Johnson Sweeney. North Texas State Teachers College, Denton, Texas, 1943.

66. Doris Brian. "Bayer Designs for Living." *Art News*, March 1943. New York (1 p., ill.).

67. Siegfried Giedion. "Herbert Bayer und die Werbung in Amerika / Herbert Bayer and Advertising in the U.S.A." *Graphis* October-November 1945. Zurich: pp. 348–358, 422–424, ill.

68. Alexander Dorner. *the way beyond "art": the work of herbert bayer*. Wittenborn & Schultz, Inc., New York, 1947.

69. Bernard Rudofsky. "Notes on Exhibition Design." *Interiors*, 1947. New York: pp. 60–77, ill.

70. "Container Corporation of America's Offices." *Architectural Forum*, February 1948. New York: pp. 65–68, ill.

71. "Eyrie on Red Mountain: Bayer's Studio." *Interiors*, June 1951. New York: pp. 88–93, ill.

72. F. Fortini. "Herbert Bayer." *Linea Grafica* 3/4. Milan, 1954: pp. 67–76, ill.

73. "Hexagonal Seminar Building." *Architectural Forum*, July 1954. New York: pp. 106–107, ill.

74. Eberhard Holscher. "A New Atlas of the World." *Gebrauchsgraphik* 2. Munich, 1954: pp. 2–7, ill.

75. Groff Conklin. "World Geo-Graphic Atlas." *Print*, July-August 1955. New York: 44–58, ill.

76. "Herbert Bayer, la Casa e le Opere." *Domus* 306. Milan, 1955: pp. 11–18, ill. Cover by Herbert Bayer.

77. Yusaku Kamekura. "Herbert Bayer." *Idea* 10. Tokyo, 1945: pp. 2–17, ill.

78. Sibyl Moholy-Nagy. "World Geo-Graphic Atlas: A Composite of Man's Environment." *College Art Journal*, winter 1955. New York: pp. 177–178.

79. "Personality in Print: Herbert Bayer." Introduction by Egbert Jacobson *Print*, July-August 1955. New York: pp. 33–51.

80. "The Aspen Meadows Development." *Interiors*, March 1956. New York: 86–89, ill.

81. *Herbert Bayer. 33 Jahre seines Schaffens*. Exhibition catalogue. Die Neue Sammlung, Munich, 1956.

82. Katzumie Masaru. "Herbert Bayer as Visual Designer." *Industrial Art News*, May 1956. Tokyo: 26–32, ill.

83. Franz Roh. "Die Zwischenposition von Herbert Bayer." *Die Kunst und das schöne Heim* May 1956. Munich: pp. 290–293, ill.

84. Juliane Roh. "Herbert Bayer, 33 Jahre seines Schaffens." *Werk und Zeit* 12. Dusseldorf, 1956.

85. "Centre sportif." *Aujourd'hui*, April 1957. Paris: pp. 66–69, ill.

86. "Concrete and Marble among the Mountain Streams at Aspen." *Interiors*, April 1957. New York: pp. 118–121, ill.

87. Ludwig Grote. "Herbert Bayer, 33 Jahre seines Schaffens." *Bauen-Wohen*, January 1957. Munich (2 pp., ill.).

88. "Health Center." *Architectural Forum*, July 1957. New York: pp. 132–135, ill.

89. Juliane Roh. "Herbert Bayer, der Weg eines Designers." *Baukunst und Werkform* 1. Nuremberg, 1957: pp. 36–38.

90. "Ad Aspen, Colorado." *Domus*, February 1958. Milan (3 pp., ill.).

91. "Aspen Meadows, Colorado." *Revista Informes de la Construcción*, June-July 1958. Madrid (10 pp., ill.).

92. "Gezondheidscentrum en Conferentieoord Aspen Meadows, Aspen, Colorado." *Bouw*, July 1960. Rotterdam: pp. 894–896, ill.

93. François Stahly. "Aspen, an American Culture Center." *L'Oeil*, February 1961. Paris: pp. 52–59, ill.

94. "Aspen." *Werk*, July 1961, Zurich: pp. 249–251, ill.

95. *Herbert Bayer*. Exhibition catalogue with foreword by Gerhard Handler. Städtischen Kunstmuseum, Duisburg, 1962.

96. *Herbert Bayer. Paintings, Architecture, Graphics*. Foreword by David Gebhard. Roswell Museum and Art Center, Roswell, New Mexico, 1962.

97. *Herbert Bayer: Paintings, Architecture, Graphics*. Art Gallery, University of California, Santa Barbara, 1962.

98. Carlo Belloli. "Dipinti di Herbert Bayer." Exhibition catalogue. Galleria del Levante, Milan, 1963.

99. Gerhard Händler. "H.B.–Zeichnungen und Bilder." *Speculum Artis* 1. Zurich, 1963 (6 pp., ill.).

100. Herbert Lange. "Herbert Bayer." *linz aktiv* 9. Linz, Austria, winter 1963: pp. 29–33, ill. (cover).

101. "Institute for Theoretical Physics—Aspen, Colorado." *Arts & Architecture*, January 1964. Los Angeles: pp. 18–19, ill.

102. "Geometry in New Mexico." *Architectural Forum*, August–September 1964. New York: pp. 154–155, ill.

103. Eckhard Neumann. "Herbert Bayer's Photographic Experiments." *Typographica II*. London, 1965: pp. 34–44, ill.

104. "Private Chapel at Circle Diamond Ranch, Hondo Valley, N.M." *New Mexico Architect*, March–April 1965. Roswell, New Mexico: pp. 15–19, ill.

105. "Sculptured Garden." *Arts & Architecture*, August 1965. Los Angeles: p. 21, ill.

106. *herbert bayer*. Exhibition catalogue with foreword by Ludwig Grote. Marlborough Fine Art, Ltd., London, 1968.

107. Bill Jay. ed. "Herbert Bayer of the Bauhaus." *Creative Camera*, November 1968. London: p. 404.

108. *Herbert Bayer. Some Recent Works on Paper*. Art Gallery, University of California, Santa Barbara, 1969.

109. *Herbert Bayer, Ingeborg ten Haeff: Two Visions of Space.*

110. Josef Müller-Brockmann. "Herbert Bayer: The Bauhaus Tradition." *Print*, January–February 1969. New York: pp. 40–44.

111. Eckhard Neumann. "Herbert Bayer und seine fotografischen Experimente." *Foto Prisma*, November 1969. Stuttgart: pp. 516–517, ill.

112. *herbert bayer. 9 Wandteppiche und 34 Entwürfe*. Albrecht Dürer Gesellschaft, Germanische Nationalmuseum, Nuremberg, 1970, ill.

113. *herbert bayer. recent works*. Exhibition catalogue with introduction by Jan van der Marck. Marlborough Gallery, New York, 1971.

114. Yves-Alain Bois. "Herbert Bayer. Précurseur de l'art écologique." *L'Art Vivant*, April 1971. Paris.

115. Mathias Goeritz and Ida Rodriquez Prampolini. "Advertencia sobre y para Herbert Bayer." *Arquitectura/Mexico* 107. Mexico City, 1972: pp. 220–231, ill.

116. *Herbert Bayer. Aquarelle, Zeichnungen, Ölbilder. 1936–1956*. Galerie Klihm, Munich, 1973.

117. *herbert bayer. a total concept*. Exhibition catalogue with introduction by Otto Karl Bach. Denver Art Museum, Denver, Colorado, 1973.

118. *herbert bayer. neue werke und projekte*. Exhibition catalogue with introduction by Ida Rodriquez Prampolini and afterword by Herbert Bayer. Marlborough Gallery, Zurich, 1974.

119. *Herbert Bayer. Ölbilder, Aquarelle, Foto*. Exhibition catalogue with text by Margit Staber. Neue Galerie am Landesmuseum Joanneum, Graz, Austria; Galerie Nächst St. Stephan, Vienna; Galerie im Taxis Palais, Innsbruck, Austria. 1974.

120. *herbert bayer. das druckgrafische werk bis 1971*. Exhibition catalogue with foreword by Hans M. Wingler and introduction by Peter Hahn. Bauhaus-Archiv, Berlin, 1974.

121. *Herbert Bayer. The Man and His Work*. Motion picture made by Max Ewing. The Aspen Institute for Humanistic Studies, Aspen, Colorado, 1975.

122. Ida Rodriquez Prampolini. *herbert bayer. un concepto total*. Instituto de Investigaciones Esteticas, University of Mexico, Mexico City, 1975.

123. Karl Steinorth. "Herbert Bayer (1900)." *Color*, October 1975: pp. 36–37.

124. Peter Erni. "A Multifaceted Designer. The Exhibition at the Kunstgewerbemuseum." *Tages-Anzeiger*. Zurich: pp. 36–37.

125. *Herbert Bayer: Beispiele aus dem Gesamtwerk 1919–1974*. Exhibition catalogue with essay by Peter Baum. Neue Galerie der Stadt Linz, Austria, 1976.

126. *herbert bayer. photographic works*. Exhibition catalogue with introduction by Leland Rice and text by Beaumont Newhall. ARCO Center for Visual Art, Los Angeles, 1977.

127. Leland Rice. "Herbert Bayer and Photography." *Exposure* 15, 2. New York, 1977: pp. 32–35, ill.

128. Jan van der Marck. *herbert bayer. from type to landscape*. Catalogue for traveling exhibition of the American Federation of Arts. 1977.

129. Peter Baum. "Herbert Bayer—Ein universeller Gestalter." *Forum Metall Linz*. Linz, Austria, 1978: pp. 56–62.

130. *Herbert Bayer. Photographs, Paintings, Drawings*. Exhibition catalogue with text by Eckhard Neumann and David Gebhard. Goethe-Institut, Munich, 1978.

131. *herbert bayer. recent works*. Marlborough Gallery, Inc., New York, 1979.

132. Grady Clay. "King County's Earthwork Symposium Breaking New Ground with Land Reclamation as Sculpture." *The Arts* 8, 7. Seattle, Washington, July 1979, pp. 1–2, ill.

133. "tribute to herbert bayer." Multimedia presentation originated by Jack Roberts, directed by Louis Danziger, produced by Tom Woodward. International Design Conference, Aspen, 1979.

134. *Earthworks: Land Reclamation as Sculpture*. King County Arts Commission, Seattle, Washington, 1979: pp. 29.

135. Nancy Foote. "Monument-Sculpture-Earthwork." *Artforum*, October 1979. New York: pp. 32–37, ill.

136. Gwen Chanzit. "Herbert Bayer. From Bauhaus to Aspen." *Artspace*, December 1980. Albuquerque, New Mexico: pp. 32–39, ill.

137. Gwen Chanzit and Dianne Vanderlip. *the herbert bayer archive inaugural exhibition*. Denver Art Museum, Denver, Colorado 1980.

138. Gloria Green. "City of Kent Approves Herbert Bayer's Earthwork Design." *The Arts* 9, 5. Seattle, Washington. June 1980, pp. 1, 4–5, ill.

139. John Farrell. "Herbert Bayer: An Interview." *Santa Barbara Magazine*, February–March 1980. Santa Barbara, California: pp. 22–32, 62–66, ill.

140. Peter Wollheim. "Herbert Bayer. A Modernist Drama." *Vanguard* 9, 4. Vancouver, British Columbia. May 1980, pp. 17–19.

141. Janis Bultman. "Masters of Photography: An Interview with Herbert Bayer." *Darkroom Photography*, January–February 1981. San Francisco.

142. *Herbert Bayer. Das künstlerische Werk 1918–1938*. Exhibition catalogue with texts by Hans Wingler, Magdalena Droste, Stanislaus von Moos, Eckhard Neumann, and Ute Brüning. Bauhaus-Archiv, Berlin, 1982.

143. *herbert bayer. recent paintings*. Marlborough Gallery, New York, 1982.

144. *herbert bayer. photographic work*. Exhibition catalogue with text by Susan Ruff. Galleria, The Arizona Bank, Phoenix, Arizona, 1982–83 (4 pp., ill.).

145. Eckhard Neumann. "Gestaltung für die Werbung. Herbert Bayer Werk zwischen Bauhaus und Emigration Berlin 1928–1938." *Der Druckspiegel* 1. Stuttgart, 1983: pp. 65–72, ill.

III. Books, articles, and exhibition catalogues that include or discuss Herbert Bayer.

146. László Moholy-Nagy, ed. *Staatliches Bauhaus in Weimar 1919–1923*. Munich, 1923.

147. "Elementare Typographie." *Typographische Mitteilungen*. Leipzig, 1925.

148. A.M. Cassandre, ed. *Publicité. L'Art international d'aujourd'hui* 12. Paris, 1928.

149. Jan Tschichold. *Die neue typographie*. Berlin, 1928.

150. Werner Gräff. *Es kommt der neue Fotograf*. Berlin, 1929.

151. Karl Theodor Haanen. "Bauhausreklame." *Die Reklame*. Berlin, 1929: pp. 11–14, ill.

152. Ernst Kallai, ed. *Der Kunstnarr*, April 1929. Dessau.

153. Hermann Ubell. "Neue Wege der Kunst." *Linzer Tagespost*, May 1929. Linz, Austria.

154. Jan Tschichold. "noch eine neue schrift. beitrag zur frage ökonomie die schrift." *typografische mitteilungen* 3. Berlin, 1930.

155. *Photographie*. Arts et Métiers Graphiques, Paris, 1930.

156. "Zur Leipziger Mustermesse." *Neue Dekoration* 3, 11. Berlin, 1931: pp. 113–124, ill.

157. "Modern Art Gets Down to Business." *Commercial Art and Industry*, April 1935. London: pp. 156–161, ill.

158. Bodo Rasch. "Die neue Schrift." *Zirkel* 1. Stuttgart. July 1933.

159. Eberhard Holscher. "Photographie." *Gebrauchsgraphik*. Berlin, 1935: pp. 13–16, ill.

160. Alfred H. Barr, Jr., ed. *Fantastic Art, Dada, Surrealism*. The Museum of Modern Art, New York, 1936: pp. 516–522, ill.

161. John McAndrew. "Bauhaus Exhibition." *Bulletin*, Museum of Modern Art. New York, 1938.

162. Zdenek Rossman. *písmo a fotografie v reklamě*. Brno, 1938.

163. *European Artists Teaching in America*. Exhibition catalogue. Addison Gallery, Andover, Massachusetts, 1941: pp. 16–17, ill.

164. Sidney Janis. *Abstract and Surrealist Art in America*. New York, 1944.

165. Gyorgy Kepes. *Language of Vision*. Chicago, 1944.

166. *Modern Art in Advertising. Designs for Container Corporation*. Exhibition catalogue with texts by Carol O. Schniewind, Fernand Léger, and Walter P. Paepcke. Art Institute of Chicago, Chicago, 1945.

167. Egbert Jacobson, ed. *Modern Art in Advertising. Designs for the Container Corporation of America*. Chicago, 1946, ill.

168. László Moholy-Nagy. *Vision in Motion*. Chicago, 1947.

169. "The Modern Artist and His World." *Bulletin*, March 1949. Denver Art Museum, Denver, Colorado.

170. Dorothy Adlow. "Graduate Center Modern Themes." *Christian Science Monitor*. October 1949. Boston.

171. "Harvard Builds a Graduate Yard." *Architectural Forum*, December 1950. New York: pp. 62–71, ill. Cover by Herbert Bayer.

172. W.H. Allner. *Posters*. New York, 1952: pp. 18–20.

173. Otto Steinert. *Subjektive Fotografie*. Bonn, 1952: pp. 7–8.

174. Egbert Jacobson, ed. *Seven Designers Look at Trademark Design*. Chicago, 1952: pp. 48–52.

175. George Nelson, ed. *Display*. Interiors Library, New York, 1953: pp. 32–33, 108–119, 121.

176. Richard P. Lohse. *New Design in Exhibitions*. Zurich, 1953: pp. 26–27, 76–77, 142–143, 166–167, 230–231, 233.

177. "Ein Mann der Grossen Maßstabe." *Die Welt*, September 1957. Berlin.

178. *Photography of the World*. Tokyo, 1957, ill.

179. *The World of Abstract Art. American Abstract Artists*. New York, 1957.

180. André Dorin. "Documents étrangers." *Esthétique industrielle* 29. Paris, 1957 (4 pp., ill.).

181. Samuel Cauman. *the living museum. alexander dorner*. New York, 1958.

182. Marquis Childs. "The World of Walter Paepcke." *Horizon*, September 1958. New York (4 pp., ill.).

183. Richard Lohse. "Der Einfluß der modernen Kunst auf die zeitgenössische Grafik/ The Influence of Modern Art on Contemporary Graphic Design/ L'Influence de l'art moderne sur la graphique contemporaine." *Neue Graphik/ New Graphic Design/ Graphisme actuel* 1. Zurich, 1958.

184. Karl Gerstner and Markus Kutter. *die neue Graphik/ the new graphic art/ le nouvel art graphique*. Zurich and New York, 1959.

185. Wolf von Eckhart. "The Bauhaus." *Horizon*, New York November 1961. New York: pp. 58–75, ill.

186. *Painters of the Bauhaus*. Marlborough Gallery, Ltd. London, 1962: pp. 18–19, ill.

187. Hans M. Wingler. *Das Bauhaus, 1919–1933*. Cologne, 1962; *The Bauhaus. Weimar, Dessau, Berlin, Chicago*. Cambridge, Massachusetts, 1969.

188. *Werbegraphik 1920–1930*. Göppinger Galerie, Frankfurt am Main, 1963.

189. J.J. Beljou. "Bouwmesters van Morgen." *Pantoskoop*. Amsterdam, 1964.

190. Mildred Constantine. *Lettering by Modern Artists*. New York, 1964.

191. *Dokumentation der Graphik: Sieben Jahrzehnte Werbegraphik*. Exhibition catalogue. Landesgewerbeamt, Stuttgart, 1964.

192. Elizabeth B. Kassler. *Modern Gardens and the Landscape*. New York, 1964.

193. *Zweck/Zeit. Bauhaus Idee Form*. Exhibition catalogue. Göppinger Galerie, Frankfurt am Main, 1964.

194. Tobias M. Barthel. *Photo Graphik International*. Munich, 1965: pp. 16–23, ill.

195. Werner Hofmann. *Modern Art in Austria*. Vienna, 1965.

196. *Bauhaus Faculty*. Exhibition catalogue. Busch-Reisinger Museum, Cambridge, Massachusetts, 1966.

197. Eckhard Neumann. *Functional Graphic Design in the 20s*. New York, 1967.

198. Walther Scheidig. *Weimar Crafts of the Bauhaus, 1919–1924. An Early Experiment in Industrial Design*. New York, 1966.

199. Eckhard Neumann. "Typografie, Grafik und Werbung am Bauhaus/ Typography, Graphic Design and Advertising at the Bauhaus/ Art typographique, graphique et publicitaire du 'Bauhaus.'" *Neue Graphik/ New Graphic Design/ Graphisme Actuel* 17/18. Zurich, 1965: pp. 29–54, ill.

200. "Traum-Zeichen-Raum. Benennung des Unbenannten." *Kunst in den Jahren 1924 bis 1939*. Cologne, 1965.

201. Bernd Lohse. "Photo-Journalism: The Legendary Twenties." *Camera*, April 1967. Lucerne: pp. 5–23.

202. László Moholy-Nagy. "From the Bauhaus." *Camera*, April 1967. Lucerne: 24–35.

203. Mildred Constantine and Alan Fern. *Word and Image. Posters from the Collection of the Museum of Modern Art*. New York, 1968.

204. *50 Jahre Bauhaus*. Exhibition catalogue. Württembergischer Kunstverein, Stuttgart, 1968; *50 years bauhaus*. Royal Academy of Arts, London, 1968; *50 Jahre Bauhaus*. Stedelijk Museum, Amsterdam, 1968; *1919–1969 bauhaus*. Musée National d'Art Moderne, Paris, 1969; *50 years bauhaus*. Illinois Institute of Technology, Chicago, 1969; *50 years bauhaus*. Art Gallery of Toronto, Toronto, 1969; *50 years bauhaus*. Pasadena Art Museum, Pasadena, California, 1970; *bauhaus*. Museo del Bellas Artes, Buenos Aires, 1970; *50 years bauhaus*. National Museum of Modern Art, Tokyo, 1971.

205. *50 years bauhaus. supplement*. Supplementary catalogue with text by Hans M. Wingler, "history of the graphic printing workshop of the bauhaus." Stuttgart and at other locations of the exhibition listed in no. 204, 1968-1971.

206. Herta Wescher. *Collage*. New York, 1968.

207. *Architecture, Formes, Fonctions*. Lausanne, 1969: pp. 152-153.

208. Eberhard Roters. *Painters of the Bauhaus*. New York, 1969.

209. Klaus-Jergen Sembach. *Um 1930. Bauten, Möbel, Geräte, Plakate, Fotos*. Munich, 1969.

210. Herbert Spencer. *Pioneers of Modern Typography*. London, 1969: pp. 138-146.

211. Ala Story. *Trends in Twentieth Century Art*. Exhibition catalogue. Art Gallery, University of California, Santa Barbara, 1970.

212. Roland Graf von Faber-Castell. *Albrecht Dürer zu Ehren*. Nuremberg, 1974.

213. Eckhard Neumann. *Bauhaus und Bauhäusler*. Bern and Stuttgart, 1971.

214. Herbert Schindler. *Monografie des Plakats*. Munich, 1972.

215. Hans M. Wingler. *Bauhaus in America*. Berlin, 1972.

216. Jan van der Marck. *American Art. Third Quarter Century*. Seattle, Washington, 1973.

217. *Kreative Fotografie aus Österreich*. Kulturhaus der Stadt, Graz, Austria; Museum des 20. Jahrhunderts, Vienna, 1974: pp. 6-9.

218. Bernard Rau. *Der Konstruktivismus*. Stuttgart, 1974.

219. W. Rotzler. *Photographie als künstlerisches Experiment. Von Fox Talbot zu Moholy-Nagy*. Lucerne and Frankfurt am Main, 1974.

220. *Less Is More: The Influence of the Bauhaus on American Art*. Exhibition catalogue with text by Arlene R. Olson. Lowe Art Museum, 1974: p. 11.

221. Colin Naylor and Genesis P-Orridge, eds. *Contemporary Artists*. London and New York, 1974: pp. 76-78.

222. Cecil Beaton and Gail Buckland. *The Magic Image. The Genius of Photography from 1839 to the Present Day*. Boston, 1975.

223. *Images of an Era: The American Poster 1945-75*. Washington, D.C., 1975.

224. Clark V. Poling, *Bauhaus Color*. The High Museum of Art, Atlanta, Georgia, 1975.

225. Alan Porter, ed. "Photography—A Contemporary Compendium: Biographies." *Camera*, November 1975. Lucerne.

226. Karl Steinorth. *Photographen der 20er Jahre*. Munich, no date (between 1974-75).

227. Dawn Ades. *Photomontage*. New York, 1976.

228. *Die Dreißiger Jahre, Schauplatz, Deutschland*. Munich and Essen, 1977.

229. *Kunstlerphotographien im XX Jahrhundert*. Hannover, 1977: pp. 38-46.

230. Klaus Popitz. *Plakate der Zwanziger Jahre*. Berlin, 1977.

231. David W. Steadman, *Works on Paper 1900-1960 from Southern California Collections*. Claremont, California. 1977.

232. *Tendenzen der Zwanziger Jahre*. Berlin, 1977.

233. *bauhaus 3*. Exhibition catalogue. Galerie am Sachsenplatz, Leipzig, 1978.

234. Peter Baum and Helmuth Gsollpointer. *Forum Metall Linz*. Linz, Austria, 1978: pp. 4, 28, 49-69, ill.

235. *Paris-Berlin 1900-1933*. Centre National d'Art et de Culture Georges Pompidou, Paris, 1978.

236. *bauhaus 4. Franz Ehrlich: Die frühen Jahre*. Exhibition catalogue. Galerie am Sachsenplatz, Leipzig, 1978.

237. *60 jahre bauhaus*. Exhibition catalogue Galerie Kul, Graz, Austria, 1978.

238. *Die Zwanziger Jahre Manifeste und Dokumente Deutscher Künstler*. Cologne, 1979.

239. "bauhaus kolloquium." *Wissenschaftliche Zeitschrift der Hochschule für Architektur und Bauwesen* 26, 4/5. Weimar, D.D.R., 1979.

240. *Ein Museum für das Bauhaus*? Bauhaus-Archiv, Berlin, 1979.

241. Helmut Schmid. "Typography Today." *Idea*. Tokyo, 1980.

242. Peter Davenport and Philip Thompson. *Dictionary of Visual Language*. London, 1980.

243. Renate Gruber and L. Fritz Gruber. *Das imaginäre Photo-Museum*. Cologne, 1981.

244. Roswitha Fricke, ed. *Bauhaus Fotografie*. Dusseldorf, 1982.

245. *Sammlungs-Katalog (Auswahl): Architektur Design Malerei Graphik Kunstpädagogik*. Bauhaus Archiv-Museum, Berlin, 1981: pp. 156-159, 170-172, 216-218, 296-298.

246. Rainer Wick. *bauhaus pädagogik*. Cologne, 1982.

247. Willy Rotzler with Jacques N. Garamond. *Art and Graphics*. Zurich, 1983: pp. 34-43, ill.

248. Philip B. Meggs. *A History of Graphic Design*. New York, 1983.

Photo Credits

Index